THE PELICAN HISTORY OF ART

EDITED BY NIKOLAUS PEVSNER

Z 5

PAINTING IN BRITAIN : THE MIDDLE AGES

MARGARET RICKERT

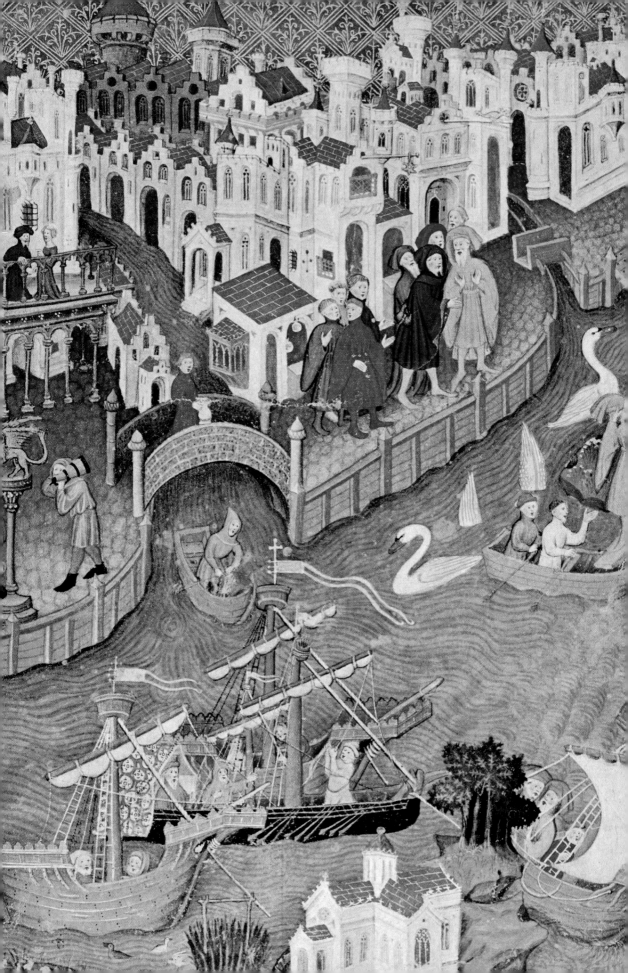

MARGARET RICKERT

PAINTING IN BRITAIN

THE MIDDLE AGES

THE · PELICAN · HISTORY · OF · ART

PUBLISHED BY PENGUIN BOOKS

Penguin Books Ltd, Harmondsworth, Middlesex
Penguin Books Inc., Baltimore, Maryland, U.S.A.
Penguin Books Pty Ltd, Ringwood, Victoria, Australia

★

Text printed by R. &. R. Clark Ltd, Edinburgh
Plates printed by Lund Humphries & Co. Ltd, Bradford
Made and printed in Great Britain

★

Copyright 1954 Penguin Books Ltd
First published 1954
Second edition 1965

TO

FRANCIS WORMALD

★

CONTENTS

CONTENTS

LIST OF PLATES

The measurements given for manuscripts are of the whole page when not otherwise indicated

1 Hiberno-Saxon (Northumbria?): Decorative Page, from Book of Durrow. Seventh century (second half). $9\frac{5}{8} \times 6\frac{1}{8}$ in. MS. A.4.5, fol. 192 verso. Trinity College, Dublin

2 (A) Hiberno-Saxon (Northumbria?): Symbol of St Matthew, from Book of Durrow. Seventh century (second half). $9\frac{5}{8} \times 6\frac{1}{8}$ in. MS. A.4.5, fol. 21 verso. Trinity College, Dublin

(B) Hiberno-Saxon (Northumbria?): Symbol of St John, from Book of Durrow. Seventh century (second half). $9\frac{5}{8} \times 6\frac{1}{8}$ in. MS. A.4.5, fol. 84 verso. Trinity College, Dublin

3 (A) Anglo-Saxon: Great Buckle, Sutton Hoo Treasure. Seventh century (first half). $5\frac{1}{4} \times 2\frac{1}{8}$ in. Department of Medieval Antiquities, British Museum

(B) Anglo-Saxon: Hanging Bowl Escutcheon, Sutton Hoo Treasure. Seventh century (first half). $2\frac{5}{8}$ in. diameter. Department of Medieval Antiquities, British Museum

(C) Anglo-Saxon: Gold Clasp, Sutton Hoo Treasure. Seventh century (first half). $2\frac{1}{2} \times 2\frac{1}{8}$ in. Department of Medieval Antiquities, British Museum

(D) Hiberno-Saxon (Northumbria?): Decorative Page, from Book of Durrow. Seventh century (second half). Detail approx. actual size. MS. A.4.5, fol. 3 verso. Trinity College, Dublin

4 Northumbrian (Lindisfarne): Cruciform Page, from Lindisfarne Gospels. 698–721. $13\frac{1}{2} \times 9\frac{3}{4}$ in. Cotton MS. Nero D.iv, fol. 26 verso. British Museum

5 Northumbrian (Lindisfarne): Text Page, from Lindisfarne Gospels. 698–721. $13\frac{1}{2} \times 9\frac{3}{4}$ in. Cotton MS. Nero D.iv, fol. 95. British Museum

6 (A) Northumbrian (Lindisfarne): Canon Table Page, from Lindisfarne Gospels. 698–721. $13\frac{1}{2} \times 9\frac{3}{4}$ in. Cotton MS. Nero D.iv, fol. 15. British Museum

(B) Irish (Iona? and Kells): Canon Table Page, from Book of Kells. 760–820. $13 \times 9\frac{1}{4}$ in. MS. A.1.6, fol. 2. Trinity College, Dublin

7 (A) Northumbrian (Lindisfarne): St Matthew, from Lindisfarne Gospels. 698–721. $13\frac{1}{2} \times 9\frac{3}{4}$ in. Cotton MS. Nero D.iv, fol. 25 verso. British Museum

(B) South Italian(?): The Scribe Ezra, prefixed to Northumbrian Bible. Late sixth century. $19\frac{3}{8} \times 13$ in. Codex Amiatinus 1, fol. v. Biblioteca Medicea Laurenziana, Florence

8 (A) Irish (Northumbria?): St Luke, from Gospel Book of Chad. Late seventh or early eighth century. Miniature $9\frac{3}{4} \times 7\frac{1}{4}$ in. Fol. 109 verso. Cathedral Library, Lichfield

(B) Northumbrian (made at Echternach?): St Matthew, from Echternach Gospels. Early eighth century. Miniature $10\frac{1}{4} \times 7\frac{5}{8}$ in. MS. lat. 9389, fol. 18 verso. Bibliothèque Nationale, Paris

9 (A) South English: St Mark, from Cutbercht Gospels. Eighth century (last quarter). Miniature $10\frac{1}{4} \times 8\frac{1}{4}$ in. MS. lat. 1224, fol. 71 verso. Österreichische Nationalbibliothek, Vienna

(B) Irish: St Mark, from Gospels. c. 750–60. Miniature $9\frac{1}{4} \times 7$ in. MS. 51, p. 78. Stiftsbibliothek, St Gall

10 (A) Northumbrian: David as a Warrior, from Cassiodorus, *Commentary on the Psalms*. c. 725. Miniature $14\frac{7}{8} \times 10\frac{3}{4}$ in. MS. B.ii.30, fol. 172 verso. Cathedral Library, Durham

(B) Canterbury: David as a Musician, from Canterbury Psalter. Mid eighth century. $9\frac{1}{4} \times 7$ in. Cotton MS. Vesp. A.i, fol. 30 verso. British Museum

11 (A) Canterbury: St Matthew, from Gospels. c. 760. Miniature $12\frac{1}{2} \times 10\frac{1}{2}$ in. Codex Aureus, MS. A.135, fol. 9 verso. Royal Library, Stockholm

(B) Mercian(?): St Matthew, from Rome Gospels. c. 800. $13\frac{1}{2} \times 10\frac{3}{8}$ in. MS. Barb. lat. 570, fol. 11 verso. Biblioteca Apostolica Vaticana, Rome

12 Mercian(?): XPI Page, from Rome Gospels. c. 800. $13\frac{1}{2} \times 10\frac{3}{8}$ in. MS. Barb. lat. 570, fol. 18. Biblioteca Apostolica Vaticana, Rome

ACKNOWLEDGEMENTS FOR THE PLATES

ACKNOWLEDGEMENTS are made for permission to reproduce the following: Plates 8A, 10A, 18A, 18B, 47A, 47B, 56B, 57A, 57B, 58, 64, 65, 76, 78, 86, 88, 89, 95, 97A, 106, 123, 144, 157A, 158, 162, 165, 185, 188, by courtesy of the Victoria and Albert Museum – Plates 67B, 121, 139, 140, 142A, 143, 181A, 189 (V. and A. Crown copyright) – Plates 26, 27, 38B, 61, 62A, 62B, 69A, 69B, 73, 83A, 83B, 84A, 84B, 85A, 85B, 118, by courtesy of the Warburg Institute – Plates 29B, 31, by courtesy of the Bibliothèque Nationale, Paris – Plates 38A, 117B, by courtesy of Dr G. Zarnecki and the Courtauld Institute of Art – Plates 63A, 77, 170B, by courtesy of the Courtauld Institute of Art – Plate 138, by courtesy of the Courtauld Institute of Art, and reproduced from the Holkham Bible Picture Book by permission of the Dropmore Press Ltd – Plate 63A, by courtesy of Corpus Christi College, Cambridge – Plates 74, 149A, 149B, 197A, 197B, 198, 199, 200 (National Buildings Record and Sydney Pitcher) – Plates 109, 113A, 113B (National Buildings Record and C. J. P. Cave) – Plates 190, 191 (National Buildings Record and E. C. Le Grice) – Plate 75, A and B (Helmut Gernsheim, reproduced by permission of Miller's Press, Lewes) – Plates 87, 92B (Foto Mas) – Plates 119, 177, by permission of the Trustees of the British Museum and the Courtauld Institute of Art – Plate 98B, by courtesy of the Bayerische Staatsbibliothek, Munich – Plates 102, 157B, by courtesy of the Victoria and Albert Museum. Reproduced from the originals in the Fitzwilliam Museum, Cambridge, by permission of the Syndics – Plates 103A, 132, 152B, reproduced from the originals in the Fitzwilliam Museum, Cambridge, by permission of the Syndics – Plate 114B, by permission of Mrs Eileen Tristram, the owner of the copyright, from supplementary plate 18 in *English Medieval Wall Painting (XII century)*, by E. W. Tristram, Oxford University Press, 1950 – Plate 146 (R. P. Howgrave-Graham) – Plate 147A (Rev. A. F. St John, Rector of Peakirk and Glinton) – Plate 147B (E. C. Rouse) – Plates 148, 180B (W. J. Green) – Plates 150, 151, 179 (Walter Scott) – Plates 154C, 156B, by permission of the Ministry of Public Building and Works (Crown copyright) – Plates 155A, 156A, 156B, 195, by permission of the Controller of H.M. Stationery Office (Crown copyright) – Plate 163, by courtesy of the Oxford Architectural and Historical Society – Plate 168, by permission of the President and Fellows of Corpus Christi College, Oxford – Plate 170C, by courtesy of the Royale Bibliothèque de Belgique – Plates 180A, 196A, 196B (Dennis King) – Plate 181B (G. Bernard Wood) – Plate 192, A and B (Country Life) – Plate 193 (Harold Allen. Copyright by the Vicar of Sarum St Thomas) – Plate 194, by courtesy of Philip B. Chatwin.

ABBREVIATIONS

Anc. Lib. Cant. and Dover	Ancient Libraries of Canterbury and Dover
Archaeol. Jnl	Archaeological Journal
Art Bull.	Art Bulletin
Brit. Mus. Quart.	British Museum Quarterly
Bull. de la S.F.R.M.P.	Bulletin de la Société Française de Reproductions de Manuscrits à Peintures
Burl. Mag.	Burlington Magazine
Jnl Brit. Archaeol. Assn	Journal of the British Archaeological Association
Jnl Brit. Soc. Master Glass-Painters	Journal of the British Society of Master Glass-Painters
Jnl Roy. Soc. Antiq. Ireland	Journal of the Royal Society of Antiquaries of Ireland
Jnl Warb. Court. Insts	Journal of the Warburg and Courtauld Institutes
N.B.R.	National Buildings Record
New Pal. Soc.	New Palaeographical Society
Pal. Soc.	Palaeographical Society
Proc. Brit. Acad.	Proceedings of the British Academy
Proc. Camb. Antiq. Soc.	Proceedings of the Cambridge Antiquarian Society
Proc. Royal Irish Acad.	Proceedings of the Royal Irish Academy
Proc. Soc. Antiq.	Proceedings of the Society of Antiquaries
R.C.H.M.	Royal Commission on Historical Monuments
Roy. Acad. Arts Exhib. Brit. Prim. Paintings, Cat.	Royal Academy of Arts Exhibition of British Primitive Paintings, Catalogue
Roy. Soc. Lit. Trans.	Royal Society of Literature, Transactions
Summary Cat.	A Summary Catalogue of Western Manuscripts in the Bodleian Library
Walpole Soc.	Walpole Society

FOREWORD

T HE preparation of the material for this book, which had to be done largely in England, has incurred deep obligations to friends and associates on both sides of the water. The Administration of the University of Chicago, by granting for purposes of research generous periods free of teaching, and the Chairman, Dr Ulrich Middeldorf, and my colleagues in the Department of Art at the University, by assuming additional academic responsibilities on my behalf, have made possible the necessarily frequent visits to England and the Continent during the past five years. The University also contributed towards the purchase of the many photographs needed. Of my personal and academic associates in America who have assisted materially in the preparation of the book, I am especially grateful to Miss Winifred VerNooy, Reference Librarian at the University of Chicago, and the staffs of the various libraries there for timely help with difficult problems. My former student, Mr Frank Horlbeck, who gave me faithful clerical and research assistance over a period of more than two years, has my sincere thanks. My friends Miss Lucile Gafford and Mrs Rose Jameson who carefully read the text of this book, the one in typescript the other in proof, made many valuable suggestions as to content and form from the point of view of the 'intelligent lay reader'. And my friends, Arthur and Alfred Thurner, stood by loyally as expert typists helping on more than one occasion to meet a dead-line for the delivery of manuscript.

On this side of the Atlantic there have been too many helping hands to permit naming them individually. The staffs of the Reading Room and the Department of Manuscripts and the Photographic Department at the British Museum never failed to meet the unusual request and to attempt the impossible in order to facilitate maximum results in minimum time. Dr Otto Pächt and the Librarian and Staff of the Bodleian Library, and the Librarians of University Library and of many of the colleges at Cambridge also have been exceedingly helpful in making their resources available to me.

In the task of assembling the hundreds of photographs from which the final selections for reproduction were made, I gratefully acknowledge the unfailing courtesy and helpfulness of the many libraries and museums to which I applied for photographs and for permission to reproduce them. Among these I should like to thank especially the following: the Trustees of the British Museum, from whom I obtained almost one-third of the photographs used in the plates of this book; the Director of the Victoria and Albert Museum, where I found excellent photographs not only of objects in the Museum but of a large number in other collections; the Directors of the Warburg and the Courtauld Institutes who gave me access to their photographic files and allowed me to select from them any prints which would serve my purpose. For permission to reproduce photographs of objects in their collections, thanks are due to the following libraries, galleries, and museums: the Walters Gallery, Baltimore; Museo Civico, Bologna; Bibliothèque Royale de Belgique, Brussels; the Fitzwilliam Museum, Cambridge; University Library, Cambridge;

Trinity College Library, Dublin; Cathedral Library, Durham; Biblioteca Medicea Laurenziana, Florence; Library of St Godehard, Hildesheim; the National Gallery, London; the John Rylands Library, Manchester; the Library of Monte Cassino; the Pierpont Morgan Library, New York; the Bodleian Library, Oxford; Bibliothèque Nationale, Paris; Musée de Cluny, Paris; Biblioteca Apostolica Vaticana, Rome; Bibliothèque Publique, Rouen; Stiftsbibliothek, St Gall; the Royal Library, Stockholm; Österreichische Nationalbibliothek, Vienna. The following individuals and governing bodies also have kindly given permission to reproduce photographs of objects in their possession or under their care: His Grace the Archbishop of Canterbury and the Church Commissioners; the Dean and Chapter of Canterbury; the Trustees of the Chatsworth Settlement; the Bishop of Chichester; the Dean and Chapter of Gloucester; the Dean and Chapter of Lichfield; His Grace the Duke of Northumberland; the Dean and Chapter of Norwich; the Dean and Chapter of Westminster; the Dean and Chapter of Winchester; the Dean and Canons of Windsor; the Dean and Chapter of York; the Society of Antiquaries, London; the University of Glasgow; the Master and Fellows of Corpus Christi College, Cambridge; the Master and Fellows of Magdalene College, Cambridge; the Master and Fellows of Pembroke College, Cambridge; the Master and Fellows of St John's College, Cambridge; the Master and Fellows of Trinity College, Cambridge; the Provost of Eton College; the Warden and Fellows of All Souls College, Oxford; the Dean and Students of Christ Church, Oxford; the President and Fellows of Corpus Christi College, Oxford; the Master and Fellows of University College, Oxford; the Warden and Fellows of Winchester College; the Vicar of St Helen's, Abingdon; the Vicar of Barton Turf; the Rector of Cawston; the Vicar of Clayton; the Rector and Churchwardens of East Harling; the Vicar of Hardham; the Vicar of Malvern; Canon John Waddington, Vicar of St Peter Mancroft, Norwich; the Rector of Peakirk and Glinton; the Vicar of Tewkesbury; the Rector of Thornham Magna cum Parva; the Vicar of St Mary's, Warwick; the Vicar and Churchwardens of All Saints, North Street, York.

For personal kindness and assistance in countless ways, my special thanks go to Sir Sydney Cockerell, friend and counsellor over many years; to Mr C. W. Dyson Perrins who during a whole wonderful afternoon allowed me to browse among his treasured manuscripts; to Mr E. Clive Rouse who shared with me on various occasions his exceptional knowledge and experience in wall paintings and lent me his own lists of churches where paintings had been newly discovered; and to Mr A. Wyndham Payne, the fortunate owner of the magnificent new 'Herman' miniature, who enthusiastically supported my desire to make this miniature public first of all in this volume.

Finally, my greatest single debt is to Francis Wormald to whom by his permission I have dedicated this book. His initial encouragement to me to undertake a task for which he himself was eminently qualified and subsequently his unfailing generosity with information, suggestions, and criticism have contributed no small measure of whatever merit the book may possess.

A few notes of explanation should be made regarding some features of the text. The historical summaries at the beginnings of the chapters make no claim to being either comprehensive or balanced as to their historical contents. They are intended to serve merely as a framework for placing names and events connected with the works of art discussed. The exposition of artistic influences

shown in the form of a chart likewise is necessarily imperfect and limited in its application. Only the general trends could be shown and many exceptions to these must be assumed. The maps are intended mainly to illustrate two characteristic features of medieval art in Britain, namely the persistence throughout the Middle Ages of certain main centres of production, such as Canterbury and Winchester, and the emergence of different local centres under divers influences in successive periods. And the glossary, as is noted elsewhere, has been compiled solely with the purpose of clarifying technical or unfamiliar terms as used in this volume.

It is evident that in a volume covering so long a period of time, many examples of the pictorial arts have had to be omitted. Those which are included were chosen partly because of their quality but mainly because they furnish the best evidence for illustrating the development of successive styles. Much of this material and most of what has been omitted is dealt with fully in other sources and these are generally referred to in the footnotes. In the case of manuscripts, the supplementary illustrative material is particularly important, for a single manuscript may show a considerable variety of styles within its pages and a facsimile or monograph reproducing it completely will furnish the reader with a much clearer idea of the manuscript as a whole than can be obtained from only one or two plates.

Books referred to in the footnotes by a short title are listed in full in the Bibliography at the end of this volume. Magazine articles also, where mentioned in the footnotes without sources, will be found with complete references in the Bibliography.

The University of Chicago, and London, England, 1953

FOREWORD TO THE SECOND EDITION

THE scope of the present revision has expanded greatly since it was undertaken in the autumn of 1961. Much textual material has been added, particularly in Chapters 5 and 7. Some of this is new and some was needed to clarify or amplify stylistic relationships and developments in important areas. The new material has brought with it about thirty new illustrations, of which some are replacements and some additional. Grateful acknowledgement is hereby made for permission to publish manuscripts and paintings in the following museums and libraries, in addition to those already mentioned: the National Museum, Barcelona; the Biblioteca Comunale, Imola; the Bibliothèque Municipale, Rennes; the Staatsbibliothek, Munich; the Biblioteca Nazionale, Turin; and the Ministry of Public Building and Works, London.

The physical difficulties of revising a text already set up in type have been great and in many cases could be surmounted only by inserting new blocks of text or greatly augmenting the contents

of the notes to a degree which may appear disproportionate. In Chapters 5 and 7 almost all the footnote numbers have been altered, and even so in the final stages of the revision some notes were inserted bearing numbers and letters. These always indicate new notes wherever they may occur throughout the book, but a great many other new ones are not so designated.

A fabric composed of so many separate items of such varied nature as this, is necessarily shaken by the removal and replacement of any of them or the insertion of additional ones, and it is possible that the joins are not always covered as smoothly as in a completely rewritten text. There may also be errors of contradiction, repetition, or omission which have persisted in spite of the most careful checking. It is the author's hope that any such defects may be offset by the enrichment and consequent increased usefulness of the book as a whole, in this its revised form.

London, England, and Chicago, U.S.A., 1963

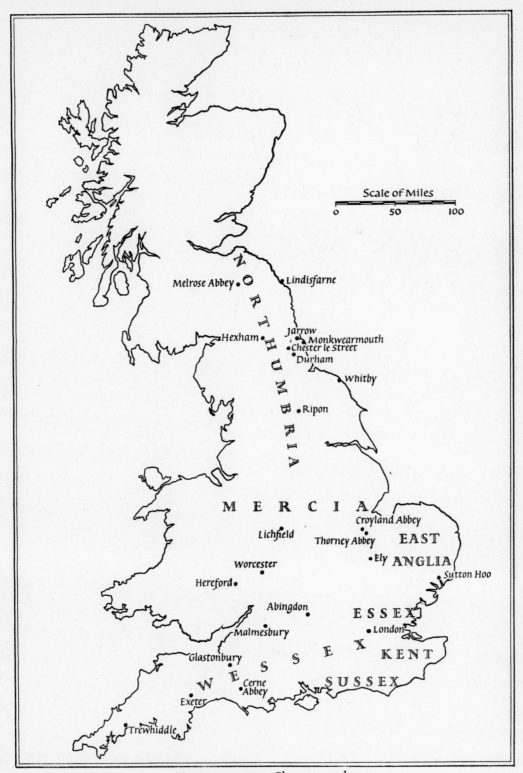

Scale of Miles

0 50 100

Melrose Abbey • • Lindisfarne

NORTHUMBRIA

Hexham • Jarrow
•Monkwearmouth
•Chester le Street
•Durham

•Whitby

•Ripon

MERCIA

Croyland Abbey•
Lichfield• Thorney Abbey• EAST
 •Ely ANGLIA
Worcester•
Hereford• •Sutton Hoo

Abingdon• ESSEX
Malmesbury• •London
Glastonbury• WESSEX KENT
 •Cerne SUSSEX
Exeter• Abbey
 •Trewhiddle

Map to accompany Chapters 1 and 2

xxvii

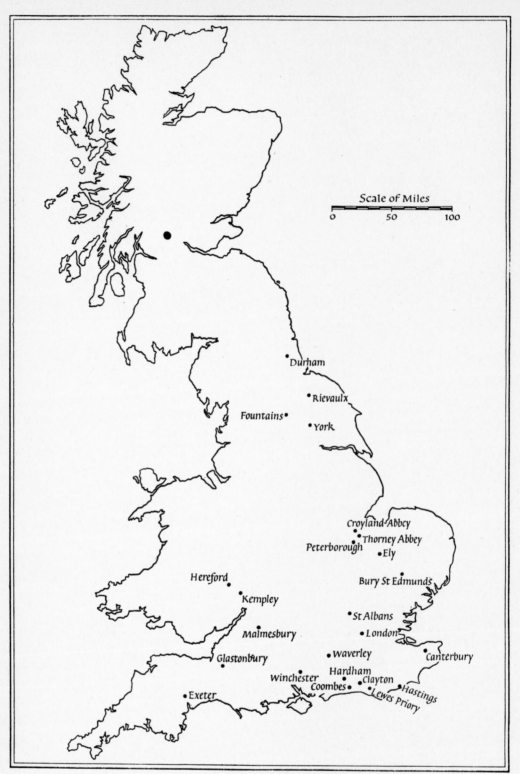

Scale of Miles

0 50 100

Durham

Rievaulx

Fountains

York

Croyland Abbey

Thorney Abbey

Peterborough

Ely

Hereford

Bury St Edmunds

Kempley

St Albans

Malmesbury

London

Glastonbury

Waverley

Canterbury

Hardham

Winchester

Clayton

Coombes

Hastings

Lewes Priory

Exeter

Map to accompany Chapters 3 and 4

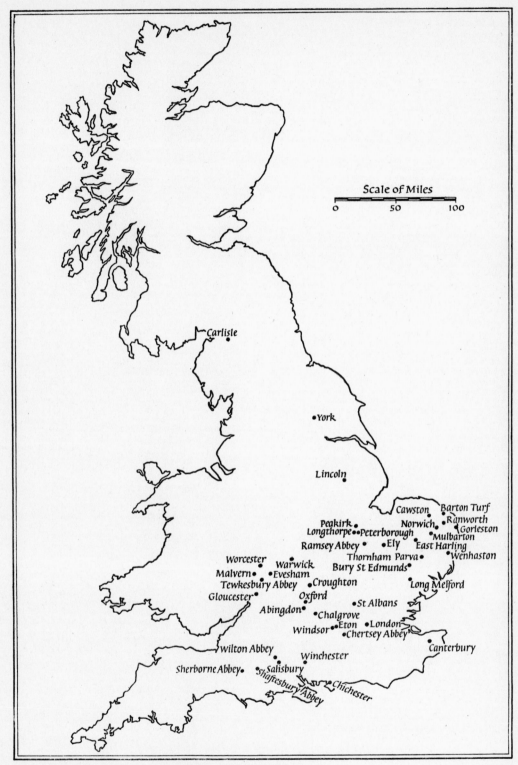

Scale of Miles

0 50 100

Carlisle

York

Lincoln

Cawston Barton Turf
Peakirk Norwich Ranworth
Longthorpe Peterborough Gorleston
Ramsey Abbey Ely Mulbarton
Thornham Parva East Harling
Worcester Warwick Bury St Edmunds Wenhaston
Malvern Evesham
Tewkesbury Abbey Croughton Long Melford
Gloucester Oxford
Abingdon St Albans
Chalgrove
Eton London
Windsor Chertsey Abbey
Wilton Abbey Canterbury
Winchester
Sherborne Abbey Salisbury
Shaftesbury Abbey Chichester

Map to accompany Chapters 5 to 8

INTRODUCTION

MEDIEVAL painting, in England as elsewhere in western Europe, must be viewed through a special lens to be understood and appreciated on its own merits. By the criteria of Renaissance painting, medieval artists fell far short of successful accomplishment, for they knew nothing of correct anatomical modelling, foreshortening, or vanishing point perspective. In medieval painting, figures are almost always strongly outlined whether painted and shaded with colours or sketched with a pen. A three-dimensional representation of a figure, therefore, scarcely exists in medieval art, not because the artist did not know that natural objects had depth but because he did not try to imitate nature. Figures in groups, by the same token, have no real spatial relation to each other: those which are not in the front row are indicated by their heads showing above the others, as though they were standing on a higher plane. Settings, whether indoor or outdoor, are not of any importance until nearly the end of the Middle Ages when influence of the Italian Renaissance began to affect medieval style. Even then, in England settings for scenes scarcely served to do more than help identify a figure or explain a story. And English medieval painting does not in any of its forms ever show an interest in true perspective.

What then are the principles and purposes of English medieval painting? To this fundamental question there is no answer that would be applicable to the whole span of its development. However, by examining the art period by period and noting relationships to what precedes and what follows, it is hoped that the continuity of successive styles will appear and that this will lead in the end to some understanding of the art.

At the outset, certain basic facts may furnish some slight preparation for this study. These can be stated briefly.

The *dates* of the Middle Ages in Europe are usually given as *c*. 800–*c*. 1400, from the so-called Carolingian Renaissance of learning and art in central and western Europe generally, to the beginning of the true Renaissance of classical art and literature in Italy. In the British Isles, medieval art began as early as the late sixth century, with Celtic and Saxon art, and lasted until nearly 1500 when Flemish art well-nigh swept it away.

The *subject matter* of medieval art in general, or at least of that portion which has survived, is preponderantly religious, but secular detail also is often interpolated by individual artists, drawn from nature and the imagination. The religious subjects come mainly from the Vulgate Bible – the Old and the New Testaments, together with many so-called apocryphal writings commonly excluded from the modern Bible. Other sources are religious commentaries and histories of the lives of saints. In England the most popular parts of the Bible were those which lent themselves best to illustration: Old and New Testament narratives, the Psalter, and the Apocalyptic Vision of St John in the Book of the Revelation. This rich material was augmented by another popular text, the Bestiary, a medieval compilation of fact and fancy derived from Pliny's Natural History. In the later Middle Ages literary material becomes important, and in the fifteenth century in England the works of Chaucer, Gower, Lydgate, and Hoccleve, among others, appeared in a

number of illustrated copies. English medieval painting was always more narrative than didactic and displayed considerable originality in the treatment of familiar stories.

The *forms* of medieval pictorial art are many, but, both in importance and in number, illuminated manuscripts hold first place, and England was no exception to this rule. Only a very small number of English panel paintings survive, and even fewer wall paintings have come down to us in anything like their original style, most of them having been repainted at least once and thereby ruined for stylistic analysis. A good deal of early stained glass still exists at Canterbury and at York, and there are even larger amounts of later painted glass, all of which has suffered more or less from breakage and removal and restoration. A considerable number of fine examples of *opus anglicanum* (English embroidery) are scattered over Europe, chiefly Italy, southern France, and Spain, and some still can be seen in England, but judging from the number of fine embroideries recorded in inventories, those that remain must represent only a small part. Finally, of the coloured floor tiles made in England there remain only a pitiful few. In view of the fragmentary representation of English medieval panel and wall painting that has survived, the task of evaluating it is particularly difficult.

The *techniques* used in medieval painting are, in general, two – painting and drawing – and English artists both early and late preferred line drawing to painting with the brush and heavy pigments. Early line drawing was done in the brown ink of the script or in red as in the rubrics (headings or annotations) of the text. Thin colour in bright or pale hues might be added to enhance the line pattern in drawings, but rarely did it completely obscure the line. Towards the beginning of the eleventh century, ink of other colours – green and occasionally blue – began to be used both in text and in illumination. About the same time these pale colours began to appear also in shading or decorative patterns, thus enhancing the outlines of figures and draperies. Occasionally the coloured red or green line followed the brown contour line, enlivening or strengthening it. This double use of outline with colour was a distinguishing feature of early English medieval art.

Painting in manuscripts, usually called illuminating because, originally, of its effect in 'lighting up' the text resulting from the use of gold and colours, was most often done in flat, pure colour which might or might not be overpainted with fine lines of white or with deeper or lighter colour tones for the purpose of suggesting modelling or of producing a decorative surface pattern. Gold grounds were usual in fine manuscripts; the painting was not done over the gold, but rather the gold was laid on with size around the areas which were to be painted, and it was burnished before the painting was done so that the process of burnishing it might not damage the colour. Usually a heavy black line was drawn around the painted figures to tidy up the edges, which sometimes overlapped the gold ground slightly, and to set the painting off from the background. Gold grounds were often tooled in patterns as well as burnished; the effect of the gold ground was to increase greatly the brilliance of the colour scheme.

The technique of panel painting was tempera, mixed with egg white and often probably with oil, applied on a smooth plaster ground. Gold grounds were usually used also. In general, the procedure in English panel painting was as described for manuscripts. English wall painting was not done, for the most part, in true fresco technique, which consists of

applying the colour on wet plaster, but in tempera either on a bare wall or on dry plaster. The execution of surviving wall paintings, like their technique, is usually rather rough and shows little modelling of the figures but, at least judging from their present state, places strong emphasis on the outlines. A curious use of very dark, almost black, underpainting of flesh can be seen in many examples where the outer layer of paint has flaked off. This technique was common but not universal and, where used, the faces appear to have been modelled.

The technique of stained glass consists of three processes: the making of the coloured glass; the cutting of pieces from it according to a pattern and joining them together to compose the figures and details, in the manner of a jigsaw puzzle; and the painting with brown enamel, mixed with some glass, of features and of shadows on the glass panels, which were then fired to fuse the surface painting with the glass base. These last two processes may have been done by separate craftsmen; but in medieval England the glass-makers were known as 'painter-glazers' and formed a single guild. The process of making the glass itself is too complicated to describe in detail here, but it consisted essentially of mixing chemicals with silica and other substances under great heat to infuse the colour into the molten glass. In England it is known that much of the glass used for windows was shipped in from the Continent, and only the cutting, glazing, and painting were done locally.

The *colours* in medieval painting are chiefly the following: ultramarine made from ground lapis lazuli, and lighter blues from (?) copper; vermilion, lake or madder reds, and pink made by mixing these with white; verdigris and, later, a dark, bluish mixed green; yellow in small amount, brown, and white. Other colours introduced into English painting at various times, perhaps under foreign influence, are purple, violet, and grey. Mixed colours appear most frequently in later work, but some of the heavier colours used in the early Winchester painting also appear to be mixed and are probably to be explained by influences from Carolingian and thus ultimately from classical painting sources.

The *centres of production* of English painting in the Middle Ages, particularly in the early centuries, were the great monasteries, but it is by no means certain that all the artists were monks. Few names of painters survive and these usually do not indicate the status of the artist although often they do suggest the place of his origin. Of the two thirteenth century illuminators whose names and work are known, one was a monk (Matthew Paris) and the other (William de Brailes) appears to have been a clerk who lived or worked in the illuminators' quarter (Catte Street) in Oxford. At Westminster in the late fourteenth century a lay scribe and an illuminator were brought in to write and illuminate a missal for Abbot Lytlington. London must have been a centre of much artistic production of all kinds but only late in the thirteenth century was there a recognizable London style, and this seems to stem from, though it is not always identical with, the Westminster or Court style. The other main centres of English art production in successive periods are marked on the three maps (pp. xxvii, xviii, xxix).

Continental contacts with England were numerous throughout the Middle Ages but seldom operated in one direction only, as the diagram on the following pages shows. These influences can best be understood individually in the discussions of the different

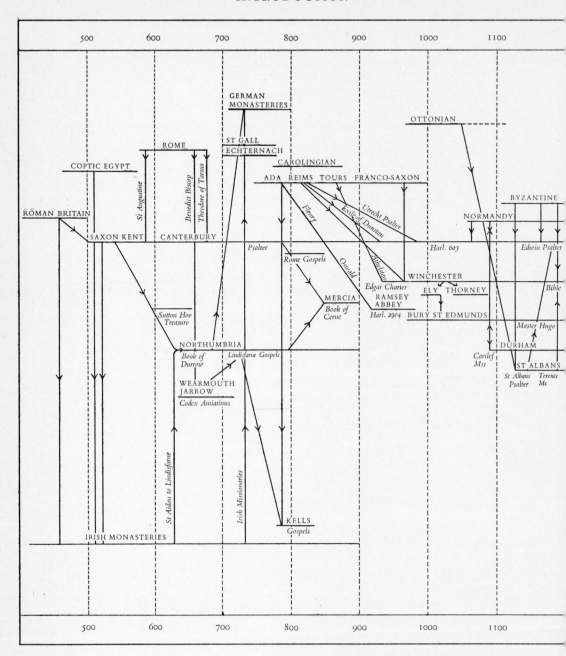

| 500 | 600 | 700 | 800 | 900 | 1000 | 1100 |

GERMAN MONASTERIES

ST GALL
ECHTERNACH

ROME

CAROLINGIAN

COPTIC EGYPT

ADA REIMS TOURS FRANCO-SAXON

OTTONIAN

St Augustine

Benedict Biscop
Theodore of Tarsus

BYZANTINE

ROMAN BRITAIN

Fleury

Exile of Dunstan

Utrecht Psalter

NORMANDY

SAXON KENT CANTERBURY

Psalter

Oswald

Ethelwan

Harl. 603

Edwin Psalter

Rome Gospels

WINCHESTER

Edgar Charter ELY THORNEY
RAMSEY
MERCIA ABBEY
Book of *Harl. 2904* BURY ST EDMUNDS
Cerne

Bible

Sutton Hoo
Treasure

NORTHUMBRIA

Lindisfarne Gospels

Carilef
Mss

Master Hugo

DURHAM

ST ALBANS

Book of
Durrow

WEARMOUTH
JARROW

Codex Amiatinus

St Albans *Terence*
Psalter *Ms*

St Aidan to Lindisfarne

Irish Missionaries

KELLS
Gospels

IRISH MONASTERIES

| 500 | 600 | 700 | 800 | 900 | 1000 | 1100 |

Chart showing by means of lines (a) the principal centres, beginning with Canterbury, where pictorial art was produced in medieval Britain and indicating the continuity of these 'schools' through the centuries; (b) the foreign centres with which British art shows contacts during the Middle Ages; and (c) by means of arrows, the direction in which the main currents of influence passed between these insular and continental centres. The left side of the Chart covers, in centuries, the period before 1200. The right side of the Chart covers,

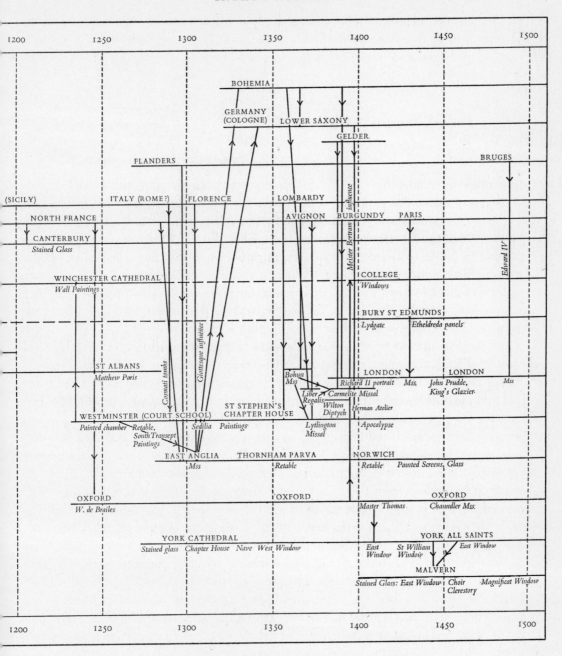

in half-centuries, the more prolific period between 1200 and 1500. Whereas the early part of the Middle Ages in Britain presents few producing centres and far-flung foreign contacts, the latter part shows many producing centres with strong influences coming from comparatively few foreign sources and closer stylistic connexions between various local centres. It is evident that any attempt to represent by graphic means such complexity of interrelations over more than a thousand years can only be selective and approximate.

periods, but the increase in their complexity and scope is clearly indicated even in the diagram, and their appearance in the development of English styles is to a large extent a reflection of general trends in chronological developments in other aspects of English medieval history.

Periods of Development

Hiberno-Saxon and Anglo-Saxon	650–1050 : Chapters 1 and 2
Romanesque	1050–1200 : Chapters 3 and 4
Gothic	1200–1500 : Chapters 5 to 8

Hiberno-Saxon manuscripts had first to formulate their idiom, then bring it into line with Continental styles. The period of formulation encompasses many different mixtures of the three basic components: Irish calligraphy and calligraphic ornament; Anglo-Saxon geometric and animal ornament as found in jewellery designs; Mediterranean figure types and foliage forms, chiefly the acanthus and the vine. Since both Anglo-Saxon and Celtic art were from their very nature wholly linear, whatever Mediterranean forms – whether figure or foliage – went into the Hiberno-Saxon mill came out as linear pattern. The outcome of the Hiberno-Saxon artistic activity was the clear statement for all time of the essential linear and decorative character of English pictorial art.

The modification of Hiberno-Saxon style in conformity with Continental developments means, in simple terms, its exposure to the great Carolingian Renaissance (784–850) during the latter part of the English formative period. The process consisted of receiving into the insular style a considerable amount of Mediterranean influence in the diluted form resulting from its having passed through the hands of Carolingian copyists. This material included figure subjects and ornamental motifs. The decorative style stemmed not only from the acanthus and other classical motifs, but also, in Carolingian manuscripts known as Franco-Saxon, from these motifs used with the Celtic interlace and animal heads which had been introduced from the British Isles. There is little doubt that it was this long-familiar and well-loved interlace and other decorative motifs of Franco-Saxon designs that made the style so acceptable to the Saxon illuminators of the Winchester School. It was a much more surprising feat for them to adopt whole-heartedly, and often with such meticulous respect for their model, the foreign technique of figure painting, which involved the modelling of faces and draperies in heavy pigments. In the full tide of sophisticated Continental painting style, the Saxon artist's obvious delight in occasionally expressing himself in terms of line is easily understood. His unique achievement in these cases is that he has employed his linear technique not to reduce the figure to pattern, as formerly, but to embody, by means of the merest linear suggestion, all the physical monumentality and spiritual dignity of the painted Continental figures which furnished his models. Whatever Anglo-Saxon art produced subsequently – and it was much and of high quality – it never surpassed the consummate skill displayed in the noble renderings of the figures in late tenth century drawings.

But Anglo-Saxon style had still another adjustment to make to Continental art before its powers reached complete maturity. The arrival, under what circumstances is not known, of the Utrecht Psalter in Canterbury about the year 1000 was certainly one of

6

the most momentous events imaginable for the future of English drawing. The technique of this manuscript from the Carolingian school of Reims is light and sketchy outline drawn swiftly without calculation and without correction. This type of line was unknown to Hiberno-Saxon illuminators, but at once it struck a spark from their descendants at Canterbury because of the sureness and speed of the technique which, though so different from Celtic line, nevertheless evoked the same degree of dynamic excitement. So the sketchy, broken line took its place beside the firm contour line as a means of dealing with the human figure; the one spun out tales of human actions with the dizzy speed of a moving picture reel, the other grasped firmly but with acute sensitiveness the nobility of the human body and spirit. Needless to say the two techniques did not remain separate, nor were they confined in their application to any single place or time in English medieval art.

The Romanesque period again brought Anglo-Saxon art abruptly face to face with Continental work, but this time the contact was with more nearly contemporary art than was previously the case. However firmly rooted and sure of itself Saxon art had become before 1066, the Norman influx, by sheer mass of newcomers with new ideas, must have stirred it into new life. Moreover, in Europe great events were afoot – the Crusades and journeys to strange and distant lands, in which Englishmen and Normans alike took part. There were not only the budding Romanesque art in France and its parents in north Italy, but in south Italy and Sicily and beyond, in the East itself, all the riches of Byzantine art were opened up to the western artist. Thus, while the first phase of Romanesque art in England was concerned with formulating again its idiom under Norman influence, as at Canterbury and Durham, in the second part of the period it was engulfed in another wave of influence from a Mediterranean figure painting style, this time stronger than before, because Byzantine art was closer to its classical figure origins than Carolingian art had been. St Albans first received this style, but it was at Canterbury that it emerged triumphant in a superb dynamic linear rendering, while from Bury St Edmunds came a monumental if somewhat more controlled version. At the end of the twelfth century, St Swithin's at Winchester produced a Bible that surpassed all previous English Bibles in the boldness and scale of its decoration and in the variety and vigour of the styles of its figure painting.

The Gothic period ushered in with the latest work on the Winchester Bible a long and very fruitful and peculiarly significant time for English art. Across the Channel the French Gothic flame, burning fiercely, was spreading northward and eastward; would the Channel prevent its sweeping England too? In the end, it was not the Channel that saved English art, but the sturdiness of the English temperament, which refused to surrender to fads but insisted on taking time to weigh the new elements and consider what, if anything, it wanted of them. So it was that while a vaulted chevet was admitted to Henry III's new choir at Westminster, the walls were covered with diapered ornament brightly painted with gold and colours. The new French style of small-scale books with tiny miniatures containing minute, unmodelled figures left its mark on certain groups of English manuscripts of the early thirteenth century, notably at Canterbury. There too in this period the Cathedral itself was filled with stained glass close in style to that of the French cathedrals, which, as in France, was reflected in the design of the illuminated

pages in manuscripts. At the same time, a monumental drawing style, fostered at St Albans under the influence of the earlier Byzantine wave, emerged independent of the exquisite if somewhat formal French style, in the work of Matthew Paris and his school. Thus the French Gothic style, tested but not wholly accepted, in the end left only a slight impress on English work of the mid thirteenth century: the rich output of psalters and also apocalypses, illuminated by English artists, can nearly always be distinguished from French work. In the third quarter of the thirteenth century, it is true, the two styles, French and English, again draw close together under the common influence of medallion designs in stained glass; but this phase was of short duration in England.

By the end of the thirteenth century, and almost simultaneously, two of the most internationally famous forms of English art made their appearance: East Anglian manuscript illumination and *opus anglicanum*, as English embroidery was called – both superb types of English decorative design and craftsmanship. The East Anglian manuscript style may have received some initial stimulus from the borderland of present France and Belgium, where illumination was being done with comparable verve, but its fundamental features are those which are most typical of English medieval art as a whole – love of nature, of the whimsical, and of rich decorative pattern. Coupled with these in East Anglian work is the delight in narrative and the incidental. The influence of this style was felt on other forms of English art, notably embroideries and stained glass, and even spread outside England, as far as Cologne and Bohemia.

Manuscripts in East Anglian style were produced almost down to the middle of the fourteenth century, but both the motifs and the design tended increasingly to coarsen. However, it was in this later phase particularly, and possibly under new Flemish stimulus, that interest in nature produced some of those series of scenes from daily life that, used as illustrations for books on medieval history, have made English fourteenth century art known far and wide in modern times.

The mid fourteenth century itself is a sterile period in England, reputedly because of the Black Death, but in the third quarter of the century East Anglian style still showed signs of life, though it lacked vigour. This was supplied by contacts with north Italian figure painting which first influenced a group of fine manuscripts made for members of the Bohun family, and subsequently the style of the so-called Westminster or Court School of painting.

At the end of the fourteenth century other Continental influences passed across the Channel: from Bohemia, perhaps via Cologne or Westphalia; from Gelderland; from Burgundy; from Paris; and at the end of the fifteenth century, from Bruges, the very hub of Flemish Renaissance art. But by this time East Anglian art had taken refuge in showy rood screens and broad windows filled with rather strongly coloured, painted figure glass, the raw material for which was largely shipped in from abroad. An occasional clear note echoing the glory of earlier English linear art is still sounded from East Anglia and the Midlands, but London Court art of the late fifteenth century is more foreign than English.

CHAPTER I

HIBERNO-SAXON ART IN THE SEVENTH, EIGHTH, AND NINTH CENTURIES

*

HISTORICAL BACKGROUND:
INVASIONS AND INTERNAL STRUGGLES

POLITICAL

PRE-SAXON PERIOD

Celtic invasions of Britain and Ireland third to second centuries B.C.; brought in late La Tène art (chiefly metalwork).

Belgae settled in south-east Britain mid first century B.C.; perhaps introduced enamelling.

Roman occupation A.D. 43–410; late Roman and provincial Roman art; especially architecture, sculpture, and mosaics; metalwork (silver and pewter).

SAXON PERIOD

Angles, Saxons, and Jutes settled in various parts of Britain 400–600; they were pagans, and drove out the Roman Britons, many of whom had become Christians. Principal kingdoms were Kent, Northumbria, East Anglia, Mercia, and Wessex; art chiefly metalwork (chip carving and cloisonné enamel).

Northumbrian Supremacy: under Kings Oswald (633–41) and Oswy (654–70).

Mercian Supremacy: established by the invasion of Northumbria 740; Offa, King of Mercia, 'Rex Anglorum' (757–96); conquered Kent 775; close relations with Rome.

West Saxon supremacy: Egbert, King of Wessex (802–39); conquered Mercia at Battle of Ellendun 825; became supreme in South England from 830; Viking raids began in South England 835.

MONASTIC FOUNDATIONS

St Patrick established Celtic Christianity in Ireland fifth century; Irish monks were missionaries; founded monasteries at St Gall (Switzerland), Bobbio (north Italy), and elsewhere on the Continent.

Missionaries from Rome to south England: St Augustine at Canterbury 597–604; manuscripts and other art objects brought and sent from Rome: St Augustine's Gospels (Camb., Corpus Christi Coll., MS. 286).

Irish monks to Northumbria: St Aidan from Iona to found monastery of Lindisfarne 635: Irish scribes and Irish script brought into Northumbria.

Synod of Whitby 664 established authority of Roman Church over Celtic in north of England; Irish influence waned and Canterbury influence increased in Northumbria; St Cuthbert at Melrose, Hexham, and Lindisfarne 664–87. His relics moved because of Danish invasions to Chester-le-Street, to Ripon, and finally to Durham 875.

Wilfred, Archbishop of York 664–91, spokesman for Roman side at Synod of Whitby; rebuilt and furnished York Cathedral; built church at Ripon; had a gospel book written in gold on purple vellum.

9

Eadfrith, Bishop of Lindisfarne 698–721. Wrote Gospels of Lindisfarne, in honour of St Cuthbert (Brit. Mus., Cott. MS. Nero D.iv).

Theodore of Tarsus, Archbishop of Canterbury 668–90.
Art objects imported which introduced Roman and perhaps Eastern influences.

Benedict Biscop founded Wearmouth and Jarrow monasteries in Northumbria 674–82; brought 'furniture, vestments, relics, pictures, and a library of valuable books' from the Continent.

Ceolfrid, successor to Benedict, Abbot of Wearmouth and Jarrow 688; made several journeys to Rome, on one of which he carried the Bible known as the *Codex Amiatinus* (made at one of these monasteries) as a present to the Pope.

Venerable Bede, monk, first at Wearmouth then at Jarrow *c.* 681; wrote *Ecclesiastical History of England* 731, earliest illuminated copy of which was made probably at Canterbury in the late eighth century; also wrote *Life of St Cuthbert* of which a number of illuminated copies were made.

Chad (Ceadda) Bishop of Lichfield (Mercia) 669–72.
Gospels of St Chad (so-called), Lichfield Cathedral, early eighth century.

St Guthlac founder of Croyland Abbey *c.* 697–714.
Long cycle of illustrations from his life (Brit. Mus., Harl. Roll Y.6), *c.* 1200.

Willibrord, second English missionary to Friesland, founded Abbey of Echternach near Trier 698.

Aldhelm, studied at Canterbury; Abbot of Malmesbury, Bishop of Sherborne 705–9. Wrote for nuns of Barking Abbey *De Laude Virginitatis*, of which several illuminated copies were made.

*

CHRISTIAN Art in Britain traditionally begins with two specific dates: 597 when St Augustine established a monastery at Canterbury in the south of England; and 635 when St Aidan, coming from the Irish foundation at Iona off the coast of Scotland, founded a monastery on the island of Lindisfarne off the coast of Northumbria. These two monastic centres with their respective orbits of influence in south and north England set the stage for the development of English pictorial art.

The earliest form of this art is found in illuminated manuscripts, for the missionaries had need of books and what they did not bring with them had to be made, that is, the text had to be copied by any monk who could read the Latin passably well and was reasonably skilled in the art of writing. The books most needed at first were biblical texts to be used for reading scriptural passages in the church ritual, primarily the four Gospels and the Book of Psalms. A Gospel Book with pictures believed to have been made in Italy and sent to St Augustine at Canterbury (Camb., Corpus Christi Coll., MS. 286) probably furnished one of the texts later copied there; at any rate, the pictures in this manuscript influenced the illumination of manuscripts made later at Canterbury.

But the earliest Hiberno-Saxon[1] illuminated manuscript was made not at Canterbury but in the North of England or, as some maintain, in Ireland or at the Irish monastery of Iona. There is no record as to whether St Aidan brought manuscripts with him when he settled at Lindisfarne, but he may have done, for the Irish monks were famous as scholars and are known to have copied books. What is not known is whether they illuminated their books, and since no early painted illumination and no fine early examples of any

other form of pictorial art can certainly be identified as of Irish origin, their skill as artists is problematic. Thus the earliest known example of insular illumination, the famous Gospel Book of Durrow[2] (Dublin, Trin. Coll. Lib., MS. 57 [A.4.5]) now generally dated in the middle or second half of the seventh century, has for many years been the centre of lively controversy as to the place of its origin.

The illumination in the Book of Durrow (Plates 1, 2, and 3D) is of four types: (1) five pages with symbols of the Evangelists[3] within decorative borders; (2) six pages containing only decorative patterns, one each at the beginning and end of the manuscript and one before each of the four Gospels; (3) decorative text pages, of which the six most elaborate introduce important parts of the text; (4) five pages at the beginning with the Eusebian Canon Tables[4] arranged in columns, each page bordered with interlace and cable pattern.

The first and third leaves of the Book of Durrow as it is now bound are decorative pages: fol. 1 verso, a cruciform page facing fol. 2 which contains the four symbols; fol. 3 verso a page of spirals bordered by interlace (Plate 3D) which precedes introductory matter. The symbol of Matthew on fol. 21 verso (Plate 2A), until recently[5] misplaced at the very end of the book, now precedes the Gospel text. The scheme of arrangement of the decorative pages in the other three Gospels is that the page with the symbol comes first in order, and is followed by the page of decoration on the verso of a leaf facing the ornamental first page of Gospel text. Though this is the original arrangement of the manuscript, a very curious inconsistency occurs in the order of the pictures of the symbols of the Evangelists: the order, Matthew, Mark, Luke, John, which is usual and is the text order of the Book of Durrow, is different in the Durrow pictures, Mark and John being interchanged. It would seem that the painter of the symbols and the text writer were following different copies.[6]

The five pages with the symbols of the Evangelists (see Plate 2) are remarkable for the simplicity and clarity of the drawing of the figures and for their total lack of life-like character. The symbol of Matthew, the winged man, who is represented here without wings, is a reduction of the human draped form to the absolute minimum of representational means: he has a head in full-face view with large eyes, prominent ears, and wig-like hair, and he is completely enveloped in a shapeless mantle, like a paper dress on a paper doll, which conceals his body except for the feet which extend from beneath it in sharp profile view. The same anomalous treatment of the figure in a combination of front and profile views is seen in the eagle, symbol of John (Plate 2B). Both the feathered body of the eagle and the cloak and hose of the man are utilized for the display of simple geometric patterns in colour.[7] The man's cloak is further stylized by outlining it with a heavy double line which continues unbroken even at the hem of the garment.

Of the pages filled entirely with decorative patterns, only one contains animal ornament (fol. 192 verso; Plate 1). This faces the opening text page of the Gospel of John. The bands of elongated biting animals (so-called lacertines) seem to be all of one breed, but so varied in their positions and in the resulting curves which they form in the design as to suggest at first glance three different types. The animal has an elongated head and a biting snout, and two legs, of which the hind one is so flexible below the thigh joint that it can be twisted into a knot and tied behind the creature's neck. The animals in the short

vertical bands have shorter bodies and more prominent ears; the others have extremely elongated eel-like bodies, and those in the two inner horizontal bands have the foreleg placed very far back from the head. The possibilities of contorting this beast into different patterns are great, and depend only on the degree to which the body is extended with its head flattened, or pushed together as in the cramped position of the leading beast in the vertical bands. The black background shows up the pattern with niello-like sharpness. This is also found in the centre medallion, where closely plaited interlace with flat wide bands forms circles and triangles which enclose at three different points smaller circles containing stepped patterns. The centre of the great circle, and the exact centre of the decorated part of the page, is a small medallion containing an equal-armed Greek cross. The colours are red, green, and yellow; no gold is used.

Another type of all-over pattern fills a page with spiral motifs arranged in varying numbers and designs within interconnected circles (Plate 3D). This page is bordered with interlace in a four-strand 'stopped-knot' design (see below).

Finally, there are the pages of decorative text which in Durrow contain fairly simple calligraphic pen ornament, designed to enhance the script.[8] Little colour is used on these pages, except for two special types of ornament: the S-chain patterns in red connecting the large initial with the block of text, and the myriads of tiny red dots used to outline the initials, to connect text and initial, and to form a solid background for the first two or three text lines. The whole of the decoration on these ornamental text pages can be thought of only as the work of a scribe; and for this reason they will be seen to throw some light upon the knotty problem of the origins of the Hiberno-Saxon style as represented in the Book of Durrow.

Into the formation of this highly complex art, artistic impulses from at least five distinct sources – Ireland, the Mediterranean, the Britons, the Picts, and the Anglo-Saxons[9] – undoubtedly entered in varying degrees, but oddly enough, evidences of the early stages of their fusion, which should precede the Book of Durrow, are lacking. Thus in spite of a great deal of exhaustive research ranging far afield into little known Continental material,[10] no completely convincing evidence has been or perhaps ever can be produced as to the place of origin and the predominating influence in the development of the Hiberno-Saxon style as it first appeared in the Book of Durrow.

Two main kinds of stylistic evidence have been brought to bear on the problem: one points to the theory of Irish origins, the other to that of English (Northumbrian). And because they do not seem to be contradictory, they will both be considered here.

One of the arguments concerns specifically the decoration of the text pages. Early examples of such calligraphic ornament in Irish manuscripts are, it is true, very rare, although the Irish monks were noted for their learning and their assiduous copying and dissemination of books.[11] However, one early ornamented Irish manuscript has survived, the Psalter or so-called Cathach[12] of St Columba. Its date, based on both legendary-historical and paleographical grounds, is now thought to be shortly after the middle of the sixth century – if it is actually the copy made by St Columba before 561.[13] At least four ornamental elements found in Durrow can be seen in their rudimentary beginnings in the earlier manuscript: the practice of graduating the sizes of the letters from the large initial to the

following text letters; the introduction of simple spirals and trumpet patterns as terminals of the letters; the use, though rare, of open-mouthed animal heads as terminals; and the frequent use of the S-chain both as filling and as external ornament for the initial letter.[14] These ornamental features of the Cathach text are rudimentary and crude, but colour (rubric red) is introduced in addition to the ink of the text and the intention obviously is to create calligraphic ornament. It is noteworthy that similar means of decoration are not found in the initial letters of late classical manuscripts.[15] Such as it is, this ornamental text art seems to be unquestionably Irish.

The other source of recent evidence is metalwork, especially that found in the ship burial at Sutton Hoo in East Anglia in 1939.[16] The date of the burial is tentatively placed as 655–6, and many of the objects seem to have been family or tribal heirlooms, so that their date would probably fall in the earlier part of the seventh century at latest – perhaps in the time of King Redwald (d. 624 or 625). The correspondence between patterns included in the decoration of the various objects and the four chief motifs found on the decorative pages of the Book of Durrow is striking: the interlace is represented in very similar forms on the great gold buckle[17] (Plate 3A); the animal ornament is found at the tip of this buckle and also in the border of the gold clasp set with garnets and glass[18] (Plate 3C); the spirals are found on the escutcheons of the hanging bowl[19] (Plate 3B); the stepped patterns and the diagonal fret are used also on the gold clasps and other jewellery, notably the purse mountings.[20] Moreover, the patterned cross design, as on fol. 1 verso in the Book of Durrow, occurs on the silver bowls of the Sutton Hoo find, though not with the interlace pattern.[21] Thus it appears that much of the ornament of the Book of Durrow parallels Anglo-Saxon metalwork of the first half of the seventh century. The incorporation of these ornamental motifs, in colours corresponding to those of gold, rubies, and glass enamels, into the decorative pages of a manuscript, seems to be the explanation of the marvellously complex decorative style in the Book of Durrow. Whether this assimilation was the accomplishment of Irish illuminators or Anglo-Saxons trained by the Irish is not known, but since there is evidence of writing and of ornamenting the text in earlier Irish manuscripts,[22] it would seem likely that these also had an important if not a determining part in the evolution of the decorative manuscript pages. What appears certain is that this development could not have come about except for the stimulus of fresh contacts with such rich and varied patterns in colour as are displayed in the Sutton Hoo and other metalwork, whether Saxon or Celtic.[23]

The Book of Durrow, though the simplest and most restrained of the Hiberno-Saxon manuscripts, displays a perfection of technique and a mastery of design that could hardly be expected in the earliest stages of an artistic development. It must be assumed, therefore, that the technique of calligraphic decoration had been perfected by illuminators before this superb specimen was produced.

Between the Book of Durrow and the Lindisfarne Gospels (Brit. Mus., Cott. MS. Nero D.iv), written by Eadfrith,[24] Bishop of Lindisfarne (698–721), not many years can have intervened. The decorative style which was maturing in Durrow is applied in the Lindisfarne Book to the five cruciform pages and six pages of decorative text on a more lavish scale and with the introduction of some new types of motifs, but the work shows the same

kind of calligraphic skill as does Durrow. The link between Durrow and Lindisfarne is too close to be the result of the mere influence of the earlier book on the later and seems to indicate illuminators trained in the same tradition. The Lindisfarne Gospel Book, measuring 13½ by 9¾ inches, contains, in addition to the decorative pages mentioned above, sixteen pages of Canon Tables under decorated arcades and four remarkable pages with the 'portraits' of the Evangelists together with their symbols. It is these two latter features chiefly that distinguish the decoration of the book as a whole from that of Durrow.

The scale and elaborateness of the calligraphic decoration on the text pages is evident in the page (fol. 95) reproduced on plate 5. It is partially surrounded by a border, which stops on each side of the large initial monogram INI (Initium) and consists of panels containing stopped knot and plaitwork designs, diagonal stepped patterns, and biting animal interlace. Many of these same patterns are found in the bars of the initial monogram, while the terminals are filled with spiral or trumpet motifs. In the Book of Durrow the interlace and trumpet patterns constitute the only decoration of the initials. Red dots are used profusely in Lindisfarne as in Durrow, not as a solid background, however, as in Durrow, but for tracing interlace, diamond, and even animal patterns between the letters. The red dots also follow the contours of the letters, as in Durrow. The S-chain patterns used in Durrow to connect the large initials with the text are omitted in Lindisfarne. One very significant feature which occurs in Lindisfarne and not in Durrow is the animal or bird heads[25] which are used as terminals of the border, and also in some of the letters, as the two E's on plate 5. The increase in the number and variety of the patterns introduced on any one page is accompanied by a greater variety and richness in colour: in addition to the red, green, and yellow of Durrow, a good deal of purple and blue is found. On fol. 95 both these colours are used for filling some of the letters, and in the d in the centre of this page there has even been experimenting in overpainting with purple on blue.

One of the finest of the cruciform pages, especially as to colour, is fol. 26 verso (Plate 4).[26] The prevailing tone is a shimmering blue which together with soft pink is used for the lacertines in the field surrounding the cross; clear, light green and bright red are used for the patterns within it and for some of the ribbon interlace in the lower part of the field. The outline of the cross is soft purple. The border bands are purple and green; the corner ornaments are yellow with the pattern outlined in brown. The other border ornaments are red, green, and yellow. The technique of this page is unbelievably fine. Each strand of the interlace is carefully painted with both edges reserved in the plain vellum[27] so that the upper ribbon passes cleanly over the under strand. The background of the pattern in the cross is purple; that of the field is black. The effect of this meticulous technique and consummate skill is a sparkling liveliness of pattern, where the strands weave in and out in a rich and varied network within which animals and birds are entangled and over which the flickering variations of colour pass like cloud shadows across the sun. There is rhythm, balance, and rich variety; but the central pattern of the cross stands out strongly defined by its clear purple contour set off by the reserved edges of plain vellum. In the centres of the arms and at their crossing there are small uncoloured roundels, suggesting rivets or bosses, each containing a tiny cloisonné-like cross; in the central medallion is a rosette. It is difficult to imagine a more exquisite piece of all-over decoration. It is a *chef-*

d'œuvre of barbaric ornamental design, yet it is tempered and controlled by a symmetry and orderliness in the principal lines of the pattern that are not barbarian in origin but derive from Mediterranean art.[28]

Mediterranean influence is even more startlingly evident in concept, in technique, and above all in colour on the folio which immediately precedes this one (fol. 25 verso; Plate 7A), containing a full-page 'portrait' of the Evangelist Matthew with his symbol, the winged man. The Evangelist is clothed in a dull purple gown, painted spottily between the curved lines, which were reserved in the vellum when laying on the paint and afterward filled with colour to indicate drapery folds. His mantle is bright green and the heavy lines on it are bright red. The technique is completely linear but the contour line is irregular to suggest the folds of drapery around the figure. The feet are bare and very pink, and the thongs of non-existent sandals can be seen on them; the mat on which the feet rest is attached to the wooden brace of the stool, inches from the ground; the book is a solid block with no indication of separate pages. The curtain is heavily painted with deep folds and zigzag edges, and the rings at the top are carefully threaded on a rod attached to the frame of the miniature. The symbol of Matthew appears above and behind his head, the body partially obscured by his halo. The symbol holds a trumpet which he is blowing, and a book.[29]

The decorative treatment of the details of hair and beard, wing feathers, drapery folds, and formal geometric ornament on the bench and on Matthew's gown betray the same delight of the artist in ornamental design which characterizes the pages of the Book of Durrow; but the figures cannot be accounted for by the style of the symbols in the earlier Durrow manuscript. Obviously the Lindisfarne picture reflects a different type of model, one which has its roots in representational rather than in ornamental tradition.

This other prototype apparently was copied in the so-called *Codex Amiatinus*[30] which contains on fol. v a 'portrait' of the scribe Ezra with the books of the Bible (Plate 7B). The text of this manuscript was copied from a South Italian Bible[31] brought to Northumbria by Benedict Biscop together with other books and works of art. The present condition of the Ezra picture is very bad, much of the paint having flaked off; but a close examination shows the technique to be wholly that of painting with thick, opaque pigments; gold and silver, badly deteriorated, also are used. There is no evidence at all of Saxon or Irish motifs in the decorative details which might betray a Northumbrian artist's style. On the contrary, the staring eyes and hard drapery folds and the general lack of competent figure modelling suggest that the copyist himself might have been an ungifted Continental artist working in Northumbria.[32]

As to the relation of the St Matthew of the Lindisfarne Gospels to the Ezra there is no doubt; the details of the pose and the accessories, with the omission of the bookcase and table, correspond as exactly to the Ezra picture as is possible. Here is the explanation of the sandal thongs, the floating rectangular mat under Matthew's feet (which is supported on legs in the Ezra picture and is clearly a footstool), the block-like book, the cushion, and the drapery folds. But the technique in the Lindisfarne miniature is a translation of the painted modelled style into the linear idiom of the insular artist. It is clear that into the Hiberno-Saxon, i.e. Northumbrian, decorative style as represented most typically in the

ornamental pages of the Lindisfarne Gospels, a new element has been introduced, namely the human figure rendered intentionally with a semblance of its natural form, and that here two separate, co-existent artistic worlds have met: the Mediterranean with its heritage of classical culture and representational form, and the barbarian with its long history of abstract, dynamic linear pattern. That these two fundamentally opposed methods of artistic expression could co-exist and be successfully combined not only within the covers of the same book but within the same page design is a foreshadowing of the susceptibility of the English artist to alien influences and of his willingness to tolerate and even adapt to his own purposes any acceptable new elements which came his way.

Finally, a brief word as to the Canon Tables in the Lindisfarne Gospels (fol. 15; Plate 6A). They are of a very different design from those in Durrow: the large arch supported on a flat profiled column with base and capital, enclosing other arches resting on similar columns, is reminiscent of Eastern manuscript design. But the ornament of the arches is completely Northumbrian, consisting of the characteristic Lindisfarne biting birds in the arch and shafts of the columns and of interlace on the capitals and bases. Other pages of Canon Tables vary somewhat in motifs and in their arrangement, the chief difference being the substitution for the biting birds of animals in ribbon ornament design or occasionally in pairs. The designs on facing pages correspond in motifs and arrangement. The Canon Table pages display a certain monotony in design as compared with the Canon Table pages in the Book of Kells (Plate 6B).

Several other manuscripts can be associated with the Lindisfarne style. One, a fragment of the Gospels in Durham Cathedral Library (MS. A.ii.17), has an elaborate text page (fol. 2)[33] which looks closer to Durrow than to Lindisfarne. In the Durham Gospels, as in the Book of Durrow, the decorative emphasis is on the relation between the ornamental initial letters and the remainder of the text, a relation which is expressed primarily by means of the graduated sizes of the letters and the S-chain pattern. The animal ornament[34] is combined, however, with the trumpet and interlace on the same page, as in Lindisfarne, and the ornament is richer and more elaborate than in Durrow. The colours are purple, yellow, and green. Folio 383 verso in the Durham fragment contains a full-page Crucifixion, the draped figure of Christ in frontal position suggesting an Eastern prototype; Longinus and Stephaton and two feathered[35] angels flank the cross. The Durham manuscript is usually dated in the first quarter of the eighth century, but may be even earlier.

Very close to Lindisfarne in its decorative pages, and not unrelated to the Durham Crucifixion in the style of its Evangelist pictures, is a defective Gospel Book, known as the Gospels of Chad, now in Lichfield Cathedral.[36] On the fine cruciform page (fol. 3 in the manuscript) the trumpet pattern is combined with a running band of Lindisfarne birds; fol. 110 verso of this manuscript has animal interlace on a cruciform page closely resembling fol. 26 verso in Lindisfarne, but with less distinction in the Lichfield manuscript between the patterns within and outside the central cross design. It is dated in the late seventh or early eighth century, perhaps about the same time as Lindisfarne.

The two surviving pictures of Evangelists, Mark on fol. 71 verso and Luke on fol. 109 verso (Plate 8A), in the Chad Gospels are far removed in style from those in Lindisfarne; the differences are due not only to a different type of original but to a rendering of the figure

in a different idiom. The figure of Luke is designed almost entirely in a series of curves. The hair consists of rope-like twists, the hanging locks terminating in spirals; the ears are C-spirals, as are the nostrils; the chin has a deep cleft dividing it into two symmetrical curves. The patterns of the drapery folds are broad uniform bands of colour with the edges reserved in the vellum. The only variation in this complete symmetry is in the feet which, oddly enough, are seen, one in profile, the other in front view, and in the heads of the two staffs. From one of these sprout conventionalized leaf forms on interlacing stems which issue from the double scroll, while the other staff has a simple head with a cross and a circle containing a rosette. The symbol of the Evangelist, the calf, is in a curious position: its front legs are partly obscured by the halo, as in Lindisfarne, its horns extending over the decorative border, while its wings are under the border, the tips showing in the margin – forming in itself a kind of interlace design. The Chad Evangelists are fine Irish versions of figures that suggest Coptic prototypes; similar examples of this style are found also in later Irish manuscripts.[37]

An interesting comparison can be made between the St Luke of the Chad Gospels and the symbol of Matthew – a wingless man – in a manuscript illuminated by a Northumbrian artist probably at Echternach, near Trier, in the first half of the eighth century (fol. 18 verso; Plate 8B).[38] In the Echternach miniature the representational concept of the human figure and its draperies and appendages is not so much translated into pattern as eliminated altogether, the figure being reduced to a masterly arrangement of ornamental motifs; if the head, hands, and feet were removed, one would never suspect that a human figure was intended. Compared with the earlier stylized Evangelist symbol of Durrow, it is, however, much more sophisticated and impressive, And in spite of the ridiculous crossed eyes and the yellow hair sprinkled with brown dots, there is a tenseness of expression in the face which contrasts with the wide-eyed blankness of the Chad Luke. The animal symbols in the Echternach Gospels, though highly stylized, also have this dynamic quality as compared with the Chad symbols.[39] The calf (fol. 115 verso) is actually walking; the lion (fol. 75 verso) rears up on his hind legs, with darting tongue, bared claws, and an angrily coiled tail. The background of the animal symbol pages is divided by red lines into irregularly spaced rectangular patterns which set off effectively the lively creatures. The colours are yellow, red, and purple, the two latter in two shades; no green is used at all. The technique is superb, and this and the simplicity of the designs would seem to date the Echternach Gospels early, close to Durrow and perhaps even before the Lindisfarne Gospels.

Though the Lichfield and the Echternach Gospels differ somewhat from each other in the style of their Evangelist pictures, both these manuscripts display such marked contrasts to the Lindisfarne Gospels with regard to the Evangelists and their symbols as to indicate that an entirely different prototype must have inspired them. In fact, Benedict Biscop, founder of the monastery of Monkwearmouth in 674, is known[40] to have brought back with him from repeated visits to Italy, pictures and manuscripts for this monastery and neighbouring Jarrow. The original of the Ezra in the *Codex Amiatinus* may have been one of these, but certainly there were other Early Christian, Byzantine, or Coptic pictures, from which Irish artists in Northumbria also drew their inspiration.

With the figures in the Lichfield and Echternach manuscripts it is interesting to compare another Northumbrian manuscript in Durham (Cathedral Library, MS. B.ii.30), Cassiodorus's *Commentary on the Psalms*, containing two full-page pictures of David, one as a warrior (fol. 172 verso; Plate 10A), the other as a musician.[41] The warrior figure is standing frontally but is not symmetrical; the hair and drapery are stylized in hard, linear patterns, but there is a softness in the contours and a grasp of the proportions of the body which an Irish artist would never have attained. Clumsy as the figure is, the intention is unmistakable here, as in the Lindisfarne Gospels, to suggest the modelled figure by means of a linear technique, not to transform it completely into pattern. The ground on which David stands ends with two animal heads of Northumbrian type, and blocks of stepped pattern and interlace fill the panels let into the border of the page; the red-dotted circles which pepper the background are purely ornamental space-filling. The inventiveness and skill of the decorator's art has by no means been supplanted by his interest in the new representational form.[42]

About the same time as Irish and Northumbrian illuminators were experimenting with the rendering of the human figure, artists in the south of England were finding new decorative and figure styles. At Canterbury where, at the coming of St Augustine in 597 and subsequently, books from Italy were arriving, the classical figure style underwent a much less drastic change, as compared with its prototype, than in Northumbria. A gospel book traditionally said to have been sent to St Augustine by Pope Gregory[43] may have been influential in setting the style. At any rate, as early as the mid eighth century several manuscripts were produced at Canterbury which show evidence not only of classical models but of a considerable degree of sympathy with and understanding of the figure style. A comparison of David as a musician in a Canterbury Psalter (Brit. Mus., Cott. MS. Vesp. A.1, fol. 30 verso; Plate 10B) with David the warrior (Plate 10A) in the Durham Cassiodorus will demonstrate the differences. In the Canterbury Psalter, David is seated on a cushioned throne surrounded by musicians and dancers, in a crowded composition which more than fills the space between the columns under the arch, so that the figures are cramped by the architecture. The poses of David and of the other musicians, the vigorous clapping of hands by the two dancers in the foreground, and the general liveliness and movement of the scene, in spite of its tight linear rendering, reflect the representational purpose of such a manuscript as the St Augustine Gospels. But the modelling itself[44] is done with heavy, rich colours and strong linear high-lights and shadows, contrasting markedly with the flat, decorative rendering of the Cassiodorus David. Particularly the face of David in the Canterbury Psalter shows modelling with green shadows under the eye and on the upper lip, and pink patches on the cheek, though the other features are painted with brown lines. He wears a red tunic, a brownish mantle, and pale blue stockings. Gold is used freely in the framework and for details of the miniature, enriching the heavy colour.

Many of the decorative elements in the Canterbury Psalter, such as the trumpet pattern in the arch of the David miniature and in the column panels, can be traced in large part to Irish and Northumbrian sources. Animal ornament also is present in Canterbury work but in a new form: single birds and confronted beasts are framed in medallions[45] which

are used in place of bases and capitals of the columns; the Eastern rosette motif is combined with the whorls of the trumpet scroll; and most significant as new elements are the two symmetrical acanthus-type plants which never grew from Northumbrian roots.[46]

The initials introducing individual psalms are of two types, and evidently come from two different sources. On the page opposite David as a harpist (fol. 31) is an initial letter D introducing the psalm *Dominus illuminatio*, which encloses two figures clasping hands and each holding a spear, probably David and Jonathan; and on fol. 53 is another initial letter D enclosing a picture of David surrounded by sheep and goats, holding his hand in the mouth of the lion which, as a shepherd, he miraculously dominated. Both of these pictures within initials are examples of the so-called historiated initial, and certainly the earliest examples known either in England or on the Continent.[47] They appear to be an English invention, and this might partly account for their persistent popularity during the whole later history of English illumination.

Other initial letters introducing psalms are purely ornamental and not illustrative and are much more Hiberno-Saxon in designs and motifs. The scrolls, the stopped-knot interlace, panels of geometric design and animal head terminals and everywhere red dots thickly sprinkled combine with naturalistic animals in a variety of forms, placed in heraldic positions chiefly in profile view. Some of the bands of ornamental letters which give the first line of a psalm (fol. 64 verso) are in gold on a purple ground; others are in colour on the uncoloured vellum.

The Canterbury Psalter is an almost unique example of the well-balanced blending of the two antipodal styles, Hiberno-Saxon and Mediterranean, the success of which is a tribute to the ability of the artist.

Slightly later (*c.* 760) and even closer in some respects to its Italian or Byzantine original are two Evangelist pages of the large *Codex Aureus* in the Stockholm Royal Library,[48] of which fol. 9 verso is reproduced in plate 11A. In this miniature,[49] apart from the hard, linear technique, the only features which betray its twofold heredity are the interlace pattern on St Matthew's chair and on the lintel of the arch, and the general tendency to formalize the patterns of the drapery and of the looped curtains. Again, like David, the figure is placed within an architectural setting which, it is true, has lost its structural solidity though it retains the architectural details of columns with capitals and bases. But the spatial tradition is present, as is the use of paint in a technique of light and shade, especially in the facial modelling, and the figures of both Matthew and his symbol are solid and imposing and full of dignity. The ribbon pattern in the arch might have come straight out of a Byzantine manuscript or mosaic.

The Celtic ornamental style with its animal and geometric motifs, however, was by no means replaced by motifs taken from late classical models. Two other manuscripts from Canterbury, both of *c.* 800, furnish ample evidence of the modified Celtic forms in use there. One containing a portion of the Gospels[50] (Brit. Mus., Roy. MS. I E. vi, fol. 43; Plate 16), formerly at St Augustine's Abbey, Canterbury, has Canon Tables decorated with patterns which may be traced to the Northumbrian style, including animals and interlace patterns in red dots as in the Lindisfarne Gospels; there are also framed roundels

containing single or confronted animals (fol. 4)[51] such as are found in Vesp. A.I. The colours are red, light bluish-green, yellow, purple, and gold. The arches as shown on this page have lost all semblance of architectural forms and have become mere bands of ornament with roundels of interlace at the top. Lion masks occur occasionally in the decoration as on fol. 6 and in the initial[52] on fol. 42. One of four purple pages in Roy. I E. vi, fol. 43 (Plate 16), has a remarkable half-length representation of the symbol of Luke in the tympanum of the arch, and a bust of the Evangelist in a medallion above it. Elaborate gold and silver lettering is used for the first words of the Gospel of Luke, which are distributed over the space beneath the arch.[53]

Another manuscript usually ascribed to Canterbury, a late eighth century copy of Bede's *Ecclesiastical History*[54] (Brit. Mus., Cott. MS. Tib. C.ii) contains ornamental text pages in a style very close to that of Roy. I E. vi. Folio 5 verso (Plate 15) illustrates well the mingling of the Northumbrian and South English styles. The initial letter D is divided into framed panels containing various kinds of ornament including interlace and foliate animal scroll, and ends in a metallesque interlace which is a continuation of the framing bands of the initial. Enclosed in the centre space is a field divided by a flowering rod into four quarters, alternately red and green, in each of which a lively little toy animal with knotted tail yaps fiercely or grins foolishly. Many of the decorative text letters which follow the initial are formed by animals which bite at the adjacent letter or rear their heads pertly above the framework of the red and green background. It is a gay, pretty style, very much softened by its contacts with the south, but with the loss of its northern intensity it has become distinctly weakened. Its final phase can be seen later, in the Rome Gospels of *c.* 800.

For the South English figure style, it is important to look at one more example (Vienna, Nationalbib., MS. lat. 1224) which is certainly not later than 800 and perhaps as early as *c.* 770. This is the so-called Cutbercht Gospels, written by Cutbercht, a South English scribe, perhaps in Salzburg itself where the manuscript is known to have been in the first half of the ninth century. Folio 71 verso (Plate 9A) shows the Evangelist Mark with his symbol.[55] The type is that of the Lindisfarne Evangelists; but the style, though linear, carries over more of the modelled figure technique. The face shows traces of modelling in the form of triangular blotches on the cheeks, and the huge eyes have a marked intentness of expression. The drapery folds form a rich and lively pattern; one little fold even flips up at the hem. It is probable that there is Continental influence here, mingling with the South English style, as nothing so free as this is known in earlier manuscripts.[56] But the columns and the base of the architectural framework retain their interlace and animal patterns, and in the centre of the lower band is a panel with the interlocked bodies of two animals which recall similar designs in the Canterbury manuscripts.

Of about the same date or slightly earlier (*c.* 750–60) is a Gospel Book in the library of the monastery of St Gall, an Irish foundation. This manuscript (No. 51, Plate 9B), which is purely Irish in style, was probably written and illuminated in some monastery in Ireland.[57] The figures show certain affinities with the Lichfield Evangelists (cf. Plate 8A) but are even closer both in style and in iconography to its slightly later and much more sumptuous successor, the Book of Kells. The decoration in St Gall 51 consists of one full

page of varied ornament – plaitwork, trumpet pattern, geometric designs, and animal interlace – each kind confined within rectangular panels on the page, the centre rectangles forming a cross.[58] There are also ornamental text pages at the beginnings of the gospel books, and these too are surrounded by a formal patterned frame within which the large ornamental initials and a few words of text are placed. In addition, there are four Evangelist portraits: three, Matthew, Luke, and John,[59] with their symbols; the fourth Evangelist (Mark, p. 78, Plate 9B) occupies the centre of the page surrounded by a decorative border, in the four corners of which are all four of the symbols. It is questionable whether all the pictures are by the same artist; two of the Evangelists, Mark and John, have something of the monumentality of the Kells figures.

The finest of the figures is Mark. He is represented in strictly frontal and nearly symmetrical position, and it is impossible to determine whether he is seated or standing, but no chair is visible. The head is large and round and is joined to the shoulders without any neck. The hair is in ropy, yellow locks curling at the ends (cf. the Luke of the Chad Gospels, Plate 8A); the yellow beard is sprinkled with red dots. The eyes are enormous with a pin-point pupil, and they give the face an intent almost eerie expression. In the drapery of the brown mantle and the reddish-brown gown showing a little at top and bottom, the folds are indicated by a heavy dark brown line beside a light yellow line; this is obviously an echo of a painting technique by which the highlights and shadows were to be suggested. The figure, in fact, recalls a prototype closest to the Christ in Majesty of the earliest Carolingian manuscript of the Ada group, the Godescalc Gospels,[60] dated 781–3. The decorative panels on the Mark page of the St Gall Gospels have black or dark brown backgrounds, as in Durrow. The symbols of the Evangelists in the corners of the frame are of a different type from any yet seen and are closest to some of the various forms in Kells. The lion and the calf at the bottom, with symmetrical winged bodies and crossed paws in frontal position and heads in profile, recall similar treatment in Durrow, as does the patterning of the feathers.

In addition to the Evangelists there are two gospel illustrations, both at the end of the Gospel of John – a crucifixion with Longinus and Stephaton and two angels, as in Durham A.ii.17, and a Last Judgement, with a half-length Christ, two trumpeting angels, and twelve half-length figures – apostles – below.[61] In all the designs of the St Gall Gospels, there is even greater insistence on symmetry and formality than in the Lichfield figures, and this must be due, it would seem, to fresh contacts with an Eastern style. This same characteristic is one of the striking features also of the Book of Kells, which represents the culmination of the Hiberno-Saxon style.

The Book of Kells (Dublin, Trin. Coll. Lib., MS. A.1.6) takes its name from the monastery of Kells (County Meath), but there is a theory that it might have been brought there from the parent monastery of Iona, where it was largely written and illuminated, by monks driven out by the Vikings in the early ninth century. The date of its production lies between 760–70 and 815–20.[62] It is not completely finished, some pages having the border only drawn in and many of the ornamental motifs either left uncoloured or painted in a different and obviously later technique. Several hands collaborated in the decoration,[63] and there seem to be indications in the different types of colouring and technique

that all of them may not have been contemporary. The scheme of illumination, though partially resembling St Gall 51 and having many elements in common with both Lindisfarne and Durrow, is more elaborate as well as more lively and exciting than any of these.

There are six main types of decoration in the Book of Kells: (1) Canon Table pages, some under arcades with beasts, i.e. the symbols of the Evangelists, in the tympana (Plate 6B); (2) pages containing only Evangelist symbols; (3) portraits of Christ and of the Evangelists, each on a separate page (Plate 14); (4) miniatures representing the Virgin and Child, the Temptation of Christ, and the Betrayal of Christ; (5) cruciform pages, preceding each of the gospels; (6) decorative text pages (Plate 13) including not only extremely elaborate initial monograms and first words, but verse initials composed largely of animals and human figures combined with decorative motifs; there are also line-endings often consisting of animal or human figures. Such a wealth and variety of decoration is impossible to describe adequately; only an examination of the original pages[64] can give any idea of the amazing intricacy and richness and the inexhaustible inventiveness of its detail.

Perhaps the best way to arrive at a basis for evaluating the good and bad qualities of the Book of Kells is to compare the various types of decoration with similar pages in other manuscripts of the Hiberno-Saxon group, especially the Lindisfarne Gospels, the chief rival of Kells in beauty and richness.

Plate 6B illustrates one of the best 'beast canon' pages (fol. 2) which were painted by two hands, one greatly inferior. This manner of decorating the arches of the Canon Tables does not occur in any other manuscript of the group and undoubtedly comes from a Carolingian model of the Ada school. Nowhere in any surviving Carolingian manuscript, however, are the symbols of the Evangelists organized into such a compact design as in Kells, where they completely fill the tympanum space and, together with the other decorative elements, make up a rich and beautiful page. Many of these elements are familiar components of the Hiberno-Saxon style: the stopped-knot interlace, the trumpet pattern and whorl, the stepped pattern (seen in one small lozenge in the centre of the middle capital), the lacertine animals in dizzy coils, and the 'Lindisfarne birds' (middle column). But there are also newcomers: the main arch is bordered with a rope-like twist and filled with Northumbrian vine scroll;[65] and at the bottom of the central text columns there are loosely drawn, curved sprays tipped with trefoil flowerets or perhaps grapes.[66] More novel still, and stemming from Irish rather than Northumbrian taste, is the running pattern of human figures and birds, each of the latter viciously gripping in its beak the leg of the man above. The same interlacement of limbs and tails and feathers is seen in the admirably designed tympanum figures and the beautifully disposed bird and interlace ornaments in the top corners and at the bottom of the outer text columns. The symmetry of the page design as a whole and the careful matching of the types of ornament in corresponding panels is not characteristic of barbaric decoration and is to be traced, perhaps, partly to Northumbrian (cf. Plate 6A), partly to Carolingian sources. The firm drawing and cloisonné-like patterning of the animals goes back to the technique of Durrow, as does the amazing fineness of the geometric patterns. But the colour, especially the overpainting in thick white and yellow pigment (the latter closely resembling the colour and richness of gold) and the mixing of blue and green with enamel-like translucence, as also the rich

reds and browns and purples, come either from Carolingian painting or from the East. Often this colour has been applied (later?) to the fine-line spiral and other linear patterns, thus obscuring them or allowing them to appear only where the paint has flaked off.

Folio 28 verso (Plate 14) contains the figure of the Evangelist Matthew apparently standing but perhaps seated, for there is a throne under the arch; he is seen frontally with symmetrically designed drapery decorated with flat squared or dotted patterns. The hieratic character of the figure, the throne with its lion back and its decorated cushion – the ox and the eagle heads appear one on each side, to complete the Evangelist symbol roster – suggest the Byzantine features of Ada School Evangelists.[67] The figure stands out with monumental dignity, closely framed by bands of fine spiral ornament which turn at a sharp angle just below his shoulders and end at the sides in a square filled with spirals of symmetrical C form. The fact that these bands terminate at the bottom in decorative roundels suggests the possibility that the artist was still adapting the square capitals and round bases of columns, which are normal architectural features in the designs of the Hiberno-Saxon Canon Tables, to the purposes of his design: if the shafts of the columns had continued the line of the arch, they would have joined the framework border, and the rich designs of both would have suffered from their proximity. As it is, the insertion of space with the boldly painted animal heads and the draped cushion open up the background and appear to place the figure behind the framing bands. This is indeed something new in the Hiberno-Saxon figure concept, and may come from the Ada tradition. The contrast between the fine-line decorative technique and the bold painting of the figures gives a superb balance to the page, which is a consummate example of Irish skill intelligently combined with a magnificent figure style. There is no suggestion of grotesqueness in the stylization of the figure, as, for example, in St Gall MS. 51 (Plate 9B).

Contrasting sharply with this Matthew page is the miniature representing Christ Betrayed,[68] illustrating St Matthew's Gospel (fol. 114). Illustrative scenes from the life of Christ are not usual subjects in Carolingian manuscripts, and the question arises whether the Kells artist had access to some Syrian prototype such as the Rabula Gospels[69] where such scenes do occur. The introduction of an unmistakable vine pattern springing from a vase, in the tympanum, and its rambling, unsymmetrical design further suggests such a source, rather than the more byzantinized forms as found in Ada Group manuscripts. The miniature of the Virgin and Child[70] on fol. 7 verso seems to be by the same hand; this subject, also rare in Carolingian manuscripts, occurs in another Eastern manuscript of the Rabula style, the Etchmiadzin Gospels.[71] The predominance of purple and yellow – representing gold – in these pages of Kells supports the theory of direct Eastern influence.

The XPI[71a] monogram page (fol. 34; Plate 13) displays this same oriental richness in pattern and colour. Besides the usual geometric motifs exquisitely drawn and mostly free of overpainting, angels with spread wings are introduced into the ornament, and also two human heads, one forming the terminal of the loop of the P, the other finishing the spiral ornament in the upper part of the field. Tucked into the right loop of the lower tip of the letter X is a group of well-observed naturalistic animals including two rats nibbling a round wafer – the Eucharistic bread? – while two cats sit watching them. Above, or behind, the cats are two more animals, apparently also rats, who await their turn at the

food. The meaning of these figures has been interpreted symbolically,[72] but since no other symbolism has been recognized in the manuscript, the rats and cats may only record the artist's observation of these most familiar household animals. At any rate, the beautifully drawn little creatures serve as a healthy reminder of the humanness of the artist whose almost magical skill in the spinning of his endlessly varying patterns on a page like this leaves one breathless and dizzy.

It is apparent that there are many differences between the illustrative content and style of the Book of Kells and the Lindisfarne Gospels, especially where human figures are concerned. These may largely be traced to the differences in the models available to the artists of the two manuscripts. But there is one less obvious though more fundamental difference even in the decorative style as displayed on the pages of calligraphic ornament such as are common to the two manuscripts. This is not primarily a difference in the motifs used nor even in the patterns which are evolved from them; but it is rather a psychological difference based on the orderliness and consistency and clarity of the Lindisfarne pages as contrasted with a kind of wildness and incongruousness in many of the pages of Kells. Lindisfarne is a marvel of balance between movement and stability, and this gives the design a tremendous dynamic power. In Kells, the control is released and the designs with their bizarre motifs work themselves up into a frenzy of excitement that sparkles and crackles and dazzles and bewilders the beholder. Unlike the Lindisfarne book, Kells is full of whimsies and enigmas. Some pages are hideously ugly as to colour and overloaded as to design; others contain some of the most incredibly fine and intricate calligraphic ornament executed with inconceivable skill. Thus the two greatest exponents of Hiberno-Saxon art, though rivals in the high degree of their accomplishment, will always stand apart, each in its own niche: the only real basis of choice between Lindisfarne and Kells must be a matter of the temperament of the beholder.

The quality of the best pages in the Book of Kells is even more apparent when other Irish manuscripts of about the same time and later are compared with it. Of these, five are well known:[73] the Book of Dimma (Dublin, Trin. Coll. MS. 59) of the second half of the eighth century; the Book of Mulling (MS. 69 of the same collection) of the same time; the Book of Armagh (MS. 52) dated 807–45; the Mac Regal (Rushworth) Gospels (Oxford, Bod., MS. Auct. D.2.19) before 820; and the Gospels of Mac Durnan (London, Lambeth Palace Library) late ninth to tenth century, given, according to an inscription, to Christ Church, Canterbury, by King Æthelstan (d. 940). Although these manuscripts vary among themselves as to the amount and quality of the ornament and the style of the Evangelist figures, all are inferior in drawing, in colouring – one, the Book of Armagh, is done with pen and ink only – and most of all in the richness and variety of the decoration.

Not earlier than *c.* 800 and, according to Kendrick,[74] perhaps of Mercian origin, is the so-called Rome Gospels, an example of the final phase of the South English style, which, like the Hiberno-Saxon, was becoming exhausted in the early ninth century and rapidly losing the vigour of its earlier robust form. Two pages from this manuscript (Vat. Lib., MS. Barb. lat. 570) are illustrated in plates 11B and 12. The seated Evangelist Matthew[75] on fol. 11 verso (Plate 11B) is a feebly-drawn figure with a weak, pink face and tidy blue hair and beard. He is surrounded by a rich border divided into panels, red, green, purple, and

yellow, of interlace and animal and bird ornament, intertwined or confronted, but without the sharply incised crispness of the Northumbrian ('Anglian') beasts, or the wiry liveliness of the Canterbury-Merovingian animals. The birds look like hung game, and the confronted animals, instead of glaring and snarling at each other, gnaw contentedly on their own legs or graze peacefully nose to nose. The monogram XPI page (fol. 18; Plate 12) is a maze of intricate patterns of every sort, including naturalistic leaves and fruit, which covers the page with a filmy web of dainty prettiness. Evidence of the complete disruption of the tradition of surface pattern is the partial interpenetration of the hook of the P and the I in the monogram, thereby breaking the calligraphic rhythm of the letters and the smoothness of the flat surface pattern. The colours are muddy and harsh, and in spite of some good drawing in the ornament, the design is discordant and lacking in unity.

Indubitably Mercian in origin, according to Kendrick,[76] is the Book of Cerne (Camb., Univ. Lib., MS. ll.i.10), a collection of Passion narratives from the four Gospels together with hymns and prayers, written for a certain Bishop Ethelwald, whose name is mentioned in the text, probably the holder of the see of Lichfield 818–30.[77] At the beginning of the passages from each Gospel is an Evangelist and symbol page. The Luke page (fol. 21 verso; Plate 17), which is typical in arrangement, with the symbol under the arch and the portrait in a medallion above, is similar in design to the Luke page in Roy. 1 E. vi (Plate 16). The Evangelist busts are also very much alike in the two manuscripts, especially Matthew and Mark in the Book of Cerne (fols 2 verso and 12 verso) and the Luke of 1 E. vi. Moreover, the forepart of the ox in the Book of Cerne is so like the half length ox in the tympanum of Roy. 1 E. vi as to seem to be copied from it; and the hind quarters are so absurdly clumsily drawn in relation to the head and front quarters that they must have been added from the Cerne artist's imagination.[78] The colouring is strong and harsh; the body of the ox is purple, its feet blue. The decoration on the Evangelist pages includes lion masks (fol. 31 verso) and curious nondescript plant and animal ornament.[79] The decorative letters of the first words of text on the opening Gospel pages are composed of animal heads and tails, but two different styles can be distinguished[80] (fols 32 and 43). Folio 43 represents the type closest to Tib. c.ii and Roy. 1 E. vi; the other type is smothered in patterns of red dots, the most common motif being a pyramid composed of dots. Yellow and red in addition to blue and purple are used and there is some gold in bands on the decorative text.

Summary

From an examination of the principal examples of pictorial art produced in England and Ireland during the period from the end of the seventh to the first third of the ninth century, three facts are evident:

1. There is a consistent predilection for decorative art, both in the metalwork and in the calligraphic ornament of the manuscripts. Most of the motifs used in the decoration are formal, that is, geometric patterns or stylized animals; but there is an important importation in the form of the 'naturalistic' vine scroll, with or without birds and animals of the naturalistic type. The variations which are evolved out of these comparatively few motifs are the measure of the decorative ingenuity of Hiberno-Saxon art.

2. Very early in the development of this art, there appears a willingness on the part of the artist to accept the human figure as introduced from various Christian Continental sources, but on his own terms: he refuses to copy it slavishly or to learn and adopt the painter's technique of trying to represent the figure as a solid form.

3. The result of the fusion of the two foregoing factors was the formulation of a new linear idiom as applied to figure subjects. This idiom varied locally according to (a) the special type of model known to the artist and (b) the skill of the individual.

It is noteworthy that in this period Irish and Anglo-Saxon traits can, at least to a limited degree, be distinguished: in figure types, the Irish artist is inclined to translate the details of human form – as hair, eyes, noses, feet and hands, drapery folds – into sheer linear pattern; the Anglo-Saxon artist, recognizing the fundamental differences between figures and decorative patterns, applies his linear technique to the problem of catching and expressing the human qualities of the figure as presented in his models. Thus the ultimate rendering in Celtic representational form, often hideous and grotesque as figure style, was still fine as ornament, while the Anglo-Saxon artist progressively develops his ability to grasp the liveliness of bodies and draperies in movement and the emotional intensity which they express. The Irish style, lacking the moderation and control of the Northumbrian, could merely spin itself out in a bewildering profusion of hybrid decoration incorporating indiscriminately human and ornamental motifs, while the Anglo-Saxon style of South England under fresh stimulus from the Continent was preparing the way for the emergence of a new linear technique to be applied to figure representation.

ANGLO-SAXON ART FROM THE LATE NINTH TO THE MIDDLE OF THE ELEVENTH CENTURY

*

HISTORICAL BACKGROUND:
POLITICAL UNITY UNDER THE SUPREMACY OF WESSEX

POLITICAL

Raids of Vikings and Danes

Æthelwulf, King 839–58: fought the Danes; made two journeys to Rome with his youngest son, Alfred, 853–5; married as his second wife Judith, daughter of Charles the Bald, Emperor of Germany (875–7).

Alfred (b. 849), King 871–99: fought the Danes and finally settled with them (878) to remain north of Watling Street and keep out of Wessex; from *c.* 884–5 to the end of his life engaged in literary activities, in which Grimbald, monk of St-Bertin at St-Omer, and Asser of St David's, Wales, joined him; translated Gregory's *Pastoral Care* of which an illuminated copy was made during his lifetime (Bod. Lib., MS. Hatton 20); sponsored the beginnings of the Anglo-Saxon Chronicle.

Edward the Elder (son of Alfred), King 899–925: built New Minster Abbey (Winchester) which was consecrated in 903, and appointed as abbot there the monk Grimbald; his second wife was Ælfleda (d. 916) who ordered the embroidered vestments for Frithestan, Bishop of Winchester (909–31).

Æthelstan (son of Edward the Elder), King 925–39: 'Rex totius Britanniae'; gave the Frithestan vestments to the shrine of St Cuthbert at Chester-le-Street *c.* 935; his five half-sisters married foreign princes, of whom one was the future Emperor Otto I, founder of the Holy Roman Empire (962–73); many foreign gifts to Æthelstan and many manuscripts given by him to monasteries.

Edgar (younger son of Edmund, Æthelstan's half-brother), King of Mercia 957–9; King of 'all England' 959–75; gave a charter to New Minster in 966, of which an illuminated commemoration is Cott. MS. Vesp. A.viii.

Æthelred the Unready (son of Edgar), King 979–1013; dispossessed by Swegn Forkbeard, King of Denmark; married Emma daughter of Richard I, Duke of the Normans; died in exile in Normandy.

Cnut, King of Denmark 1014; King of England 1016–35; married first Ælfgyfu; then Emma widow of Æthelred 1017.

Edward the Confessor (son of Æthelred and Emma), King 1042–66 (5 January).

MONASTIC REFORM

On the Continent: Cluny and its dependencies; Abbot Odilo (994) established Cluny as the Mother House of an Order of Benedictine monasteries; reform also in Lorraine and Flanders.

In England:

Dunstan (b. 909), Abbot of Glastonbury *c.* 943–57; exiled 957–8 in Ghent at St Peter's (Blandinium), which had been reformed in 937; Bishop of Worcester and London 958; Archbishop of Canterbury 959–88; manuscripts made for him show both Glastonbury and Franco-Saxon stylistic connexions and brought both of these influences to Canterbury.

Æthelwold, monk at Glastonbury under Abbot Dunstan *c.* 946; Abbot of Abingdon *c.* 954; close connexions with Fleury; Bishop of Winchester 963–84; refounded Ely, Thorney, and Peterborough Abbeys under reformed Benedictine Rule; manuscripts made for him show strong, direct Continental influences, particularly from Fleury (reformed 926–44 under Odo, Abbot of Cluny).

Oswald, monk at Worcester; studied at Fleury till 958; Bishop of Worcester 961; Archbishop of York 972–92; founded Ramsey Abbey *c.* 968.

Robert of Jumièges (Normandy), Bishop of London 1044–51; Archbishop of Canterbury 1051–2 (expelled); ordered a manuscript in Winchester style to be made for him and presented it to the Abbey of Jumièges (Rouen, Bib. Pub., MS. Y.6).

Stigand, Bishop of Winchester 1043–52 and Archbishop of Canterbury 1052–70 (deposed by William the Conqueror).

*

THE century and a half covered by this chapter is a period of great names in both church and state. If King Alfred had not succeeded in checking the invasions of the Vikings and Danes in Wessex, Anglo-Saxon civilization in England would have been wiped out. And if a settlement with the invaders had not been made, the steps taken by Alfred in internal political organization, in establishing a school for the education of both courtiers and churchmen at his own court, in encouraging the writing and translating of books, and in countless other ways fostering Anglo-Saxon culture, would not have borne fruit. Moreover, he had personal contacts with the Continent, beginning perhaps even with early journeys with his father to Rome and certainly continuing through his stepmother Judith, daughter of Charles the Bald, and most important of all, through the arrival at his court of the monk Grimbald,[1] sent by Fulk, Archbishop of Reims. These were crucial in opening the way for the introduction of the influence of the Carolingian Renaissance on England. Foreign contacts were further developed through monastic channels, especially by the sojourn of English monks like Dunstan and Oswald in Continental monasteries. Here the results of the earlier transmission of classical culture were available to learning and here the Continental example of regeneration in religious spirit and reorganization in the administration of the Benedictine Rule were already in practice and could be carried back to English monasteries. The immediate results for the development of art in England were revolutionary; without these fresh strong impulses from the vigorous Continental styles which sprang up under the influence of the Carolingian Renaissance, Anglo-Saxon art probably would have suffered a lingering death by attrition.

In the pre-Conquest Anglo-Saxon period, as in the preceding Hiberno-Saxon period, illuminated manuscripts furnish nearly all the surviving material for the study of English pictorial art.

Alfred's own patronage of learning in the later years of his reign left few traces on art. A copy of his original translation into Anglo-Saxon of St Gregory's *Cura Pastoralis*, made under his sponsorship and supervision in 890–7 and sent by him to the Bishop of Worcester,[2] is preserved (Bod. MS. Hatton 20). Its decoration is simple: initial letters terminating in open-beaked bird or crested animal heads with gaping or biting mouths are in a style unmistakably derived from that of the Canterbury Bede (Plate 15) and the Rome Gospels (Plate 12) or from the later and cruder Book of Cerne.[3] The initials of the *Cura Pastoralis*, therefore, offer nothing new in decorative elements, but furnish valuable evidence of the survival of a local art[4] through the violent period of the Danish invasions.[5]

Even more important for reconstructing the style of the Alfredian period is the famous Alfred Jewel in the Ashmolean Museum at Oxford.[6] The half-length figure in cloisonné enamel on the face of the jewel shows a certain similarity to the type of the Evangelist Luke in the Chad Gospels at Lichfield (see Plate 8A) and also to the half-length Evangelists in the Book of Cerne (Plate 17). But the cloisonné technique is not English, and this, in combination with the further fact that the enamel has been trimmed to fit the mount, suggests the possibility that the enamel might be earlier[7] than the mount and perhaps was imported from some Continental source.

The mount is even more important than the figure; for it supplies a link between the earlier decorative style of Mercia and the new Continental elements that are to appear in the decades immediately following Alfred's reign. The all-over surface granulation and the beading of the mount recall the use of multiple dots as decoration in the Book of Cerne and in the so-called Trewhiddle[8] metal style; and the animal head terminal is an old Saxon ornamental motif which goes back even to the Sutton Hoo treasure.[9] On the other hand, the fleuronné ornament on the reverse of the Jewel is a rough version of the symmetrical acanthus[10] spray found in the earlier Canterbury Psalter (Plate 10B); but it is also found in a more finished form, probably under direct Frankish influence, on the slightly later Durham vestments, which are our first major example of tenth century pictorial art.

The Durham or St Cuthbert vestments consist of an embroidered stole and two maniples, now preserved in Durham Cathedral Library; they can be dated between 909 and 916,[11] and were given by King Æthelstan to St Cuthbert's shrine at Chester-le-Street probably *c.* 934. They are remarkable as introducing a wholly new figure style unmistakably related to that of Carolingian manuscripts, particularly those of the School of Tours[12], as well as to that of a group of Byzantine manuscripts (see note 13 below).

The bands are long and narrow (only about $2\frac{3}{8}$ inches wide) and are bordered by a woven braid in gold and red patterned with tiny acanthus leaves and paired animals in repeated series of seven. Between these borders are full-length figures of prophets and saints standing on conventional bits of rocky ground which, together with the acanthus sprays introduced above the head of each, separate the figures from one another. Of the original sixteen major and minor prophets, thirteen survive (Plate 18); they are well-proportioned, dignified figures seen in three-quarter or front view. The drapery is rich in folds similar to those of sixth century mosaics as at Sant' Apollinare Nuovo in Ravenna, but the figures themselves have lost most of the formality of the earlier Byzantine types.[13]

The softness of the Durham prophets' hair and beard, the easy gestures and well-balanced poses, and the free-hanging, sometimes lightly fluttering drapery ends certainly seem to suggest influence of Carolingian as well as Byzantine models; and the curling, fleshy acanthus-type leaf ornament might also come from Carolingian manuscripts.[14] The colours, which now appear almost uniformly as soft tans, were originally rich and varied. Gold is used with the coloured silks in the combined technique of weaving and embroidery.[15] The vestments are a priceless relic of the early manifestation of that English skill in embroidering which was famous later all over Europe by the name of '*opus anglicanum*' (see Chapter 6 below). They also represent the earliest manifestation of the full and direct impact of Continental influence in Britain.

The fleshy acanthus leaf in the Durham embroideries finds its way into the ornamental initials of manuscripts. Perhaps the earliest example is in the Durham Ritual already referred to:[16] the acanthus leaf is held in the mouth of a winged beast whose tail is in turn bitten by another animal head forming the terminal of the initial letter. The technique is drawing in line of varying thickness with some suggestion of shading on the leaf. Heavier and fleshier in form with modelling indicated by white lines on colour are similar acanthus leaves and animal or bird heads used as terminals of the initials[17] in a copy of Bede's Life of St Cuthbert (Camb., Corpus Christi Coll., MS. 183). A different use of the same acanthus motif, which is closer to the symmetrical type of sprays in the Durham embroideries, is found in some of the border panels of the miniature on fol. 1 in the Bede manuscript (Plate 20A). This motif, which sometimes resembles even more closely a vine leaf with attached bunches of grapes, is worked into running scroll patterns enclosing at intervals lively figures of birds and animals – the so-called inhabited scroll. The colours are white for the pattern and dark red for the ground, which is bordered with yellow.

The miniature itself in the Bede manuscript is painted in a style that is remarkable for England at this time. It represents King Æthelstan offering a book (presumably this very manuscript which he actually did present to St Cuthbert's shrine *c.* 934) to St Cuthbert who stands before a chapel. Both figures are stiffer in pose and the draperies are more stylized than are the prophets of the Cuthbert vestments, but the resemblance in type of figure, especially of St Cuthbert, is extraordinarily close. In contrast to the brilliance of the gold and colour mingled in the embroideries, the miniature appears even flatter and heavier, with thick opaque colours, chiefly red, purple, and blue, against a plain vellum background. The architecture shows the curious rising perspective characteristic of Carolingian painting, but the artist has put in every tile and every stone with no less care than he drew the graceful border designs in which he took such obvious delight. Both the miniature and the initials in this important manuscript, especially the fine P on fol. 5 verso, are, as Wormald points out, 'a thoroughly Continental production'.[18]

The explanation of the sudden appearance of Continental influences in the south of England, in both figure and decorative styles, may lie, partly at any rate, in the introduction of Continental models by gifts to Æthelstan or others of his court. Some of these importations have survived, and many more undoubtedly have perished or remain unrecognized. The best documented Continental manuscript gift to Æthelstan is a late Carolingian Gospel Book with Evangelist portraits, which, according to an inscription, was

presented to him by Emperor Otto I and his mother Mechtild, perhaps in 929 on the occasion of the marriage of Otto to Æthelstan's sister Eadgyth.[19]

Another Continental manuscript which belonged to Æthelstan, a Psalter (Brit. Mus., Cott. MS. Galba A.xviii) has some initials in Franco-Saxon style, others in pure insular style,[20] and four miniatures which were inserted (fols 2 verso, 21, 120 verso, and 85 now a loose leaf in Bod. MS. Rawl. B.484) and may have been copied from Continental models. They were painted by at least two artists, both presumably English, perhaps at Winchester to which the manuscript was given by Æthelstan.[21] The better of the artists painted fol. 21 (Plate 20B) which contains a full-page miniature within a narrow border decorated with acanthus sprigs and, on the two upper corners, heads with curly leaves issuing from their mouths. Within the rectangular frame are two mandorlas, the inner filled with a fine figure of Christ in Majesty holding the Cross in his left hand. He is clothed in a blue mantle, except for the right arm and the side displaying the wounds. At his feet is a rectangular red-brick building with a yellow-tiled roof, similar to that in the Cuthbert miniature (Plate 20A). The solid, cushioned throne, the heavy drapery, and the firmly seated figure with protruding knees are clearly copied with some degree of understanding from a Carolingian original, perhaps of the Ada School,[22] as suggested by the large head and wide-open staring eyes. The figure of Christ is impressive and monumental. The other figures in the 'choirs of martyrs and virgins', though of the same general type, show little differentiation among themselves except in dress and in the colour of their hair. The wings of the angels in the corners of the rectangle are designed to fit well into the triangular spaces. The all-over pattern of the composition is further emphasized by the use of a black ground, against which the soft, dull colours – blue, green, brown, and yellow – stand out effectively. Very little red is used, and no gold at all.

A large miniature painted in a modelled technique forms the frontispiece of a manuscript probably from Canterbury[23] in Trinity College Library, Cambridge (MS. B.16.3) and must be a close copy of a Continental, probably a Fulda,[24] archetype by an English artist in the tenth century (Plate 19). The curious domical arches with the draped curtain and the columns with acanthus leaf capitals, under which Rabanus Maurus and his fellow monks are presenting the book to St Gregory, are Carolingian features; and the idea of the presentation picture occurs first in medieval art in the Tours School. The figures are broad and stocky with great round eyes and solemn expressions. The enormous gesturing hands and the tight linear folds of the drapery betray the English artist's propensity for exaggeration and for pattern. The scale of the miniature – the book measures $16\frac{1}{2}$ by $13\frac{1}{2}$ inches – and the absence of any unnecessary detail suggest a derivation from wall painting or mosaics, and the type of composition, with depth of space indicated by the curtain twisted round the column and by the overlapping of figures and architecture, together with the total lack of any decoration either within or without the miniature, further bears out the effect of monumental painting. The picture is a solemn and painstaking copy, totally lacking in originality, but valuable none the less for the transmission of a pictorial conception which was to bear fruit in the next generation of English art.

The monumentality which characterizes the Rabanus Maurus miniature helps to explain another figure, very similar in type, which is prefixed[25] (fol. 1) to Bod. MS. Auct.

F.4.32 (Plate 22), a drawing of Christ adored by a kneeling St Dunstan. The date of the drawing may be before 957, while Dunstan was still in Glastonbury.[26]

The magnificent, fully draped figure of Christ and the solemn, intent face with its large eyes, firm, curved lips, and even the little vertical lines on the upper lip seem to be derived from some model[27] similar to the figures in the Rabanus Maurus miniature. The flying fold of drapery in the St Dunstan drawing can be paralleled in the billowing ends of the curtains in the other. The prostrate figure of St Dunstan with his enormous hands and tightly drawn drapery might be derived from the Rabanus Maurus group of monks. The technique is purely linear, yet solidity of the figures has been admirably achieved by the firm, rounded contour line. The only colour used is solid red for the halo, and touches of it in the garments of Dunstan. The Carolingian prototype of such a style (as, indeed, also of Galba A.xviii) is to be sought in the Ada School and its later derivatives.[28]

Dunstan returned from exile in Ghent in 958, to become Bishop of Worcester and then Archbishop of Canterbury in 959. Probably towards the end of his life, in 988 or perhaps later, the early part of the Pontifical now in Paris (Bib. Nat., MS. lat. 943) was written for use at Sherborne Abbey[29] and illustrated with four drawings – a Crucifixion in an acanthus frame (fol. 4 verso; Plate 24) and three nearly identical figures representing the Trinity (Plate 23). The stylistic relation between these drawings, especially the Trinity figure, and the Christ with St Dunstan is exceedingly close: the linear patterns in the drapery[30] are much alike in the two miniatures as are the heavy figures with large hips and enormous hands. The faces have the same large eyes and heavily marked eyebrows and the same tense, solemn expressions. The feet of the Christ in the Bodleian manuscript are hidden by clouds and the truncated figure appears, therefore, exaggeratedly heavy in proportions as compared with the Christ in the Paris miniature. The Paris figure stands on the frame of the picture, the foot actually extending slightly over the edge, thus appearing even more firmly rendered and more solidly posed than the Christ of the St Dunstan miniature.

The Crucifixion from the Sherborne Pontifical (Plate 24) is drawn in brown and red and seems to be by the same hand as the Trinity figures. There are features in this miniature which relate it to the earliest phase of the Winchester style, as we shall see it in a painted form in Brit. Mus., Cott. MS. Vesp. A.viii (Plate 25). The angels with trim wings and flying heels, the stiffly fluttering drapery ends, and the filleted heads are very like those in the Vespasian manuscript, and the round spots on shoulders and thighs may represent the painted technique of shading these parts of the body to suggest roundness; the angels are also related to sculpture.[31] The Crucifixion is a superb example of the Anglo-Saxon artist's ability to convey by pure line the monumentality of the painted human figure.

The appearance in the latter half of the tenth century of this monumental style of outline drawing of figures following Continental models is not entirely new in the south of England. Two centuries earlier at Canterbury a similar translation of painted figures into linear ones had occurred (cf. Plates 10B and 11A) combined with an initial style based on a mixture of linear ornamental motifs from Hiberno-Saxon and Continental, perhaps Italian, sources. Likewise, in this same Pontifical of St Dunstan a type of ornamental initial

occurs which combines animal heads taken from the Canterbury and Mercian repertoire and the Celtic interlace with a simple version of the Carolingian acanthus leaf.

This hybrid type of initial is not unique nor is this its first appearance in English manuscripts. The beginnings of the style reach back to the early tenth century – to the Durham Ritual in which the acanthus leaf was first introduced into the stock of motifs available for designing decorative initials. The acanthus leaf also occurs modestly in the border of Corpus Christi Coll. MS. 183 (Plate 20A) and more boldly in some of the initials. Shortly after the date of this manuscript in the second quarter of the tenth century, zoomorphic initials incorporating knotwork with the acanthus motif occur profusely in a psalter (Bod., MS. Junius 27)[32] containing 152 letters using many different combinations of these motifs. Some enclose human heads and one is historiated with a scene of David and the lion (fol. 118) painted in dull colours. The style thus evolved in the Junius Psalter sets off a whole series of manuscripts with decorative initials which combine in varying proportions the insular and the Continental elements, but which tend steadily towards greater size and sumptuousness and heavier and more lush acanthus ornament in manuscripts produced subsequently at Winchester.

The initial type described above is already well developed in a psalter called, from a later owner, the Bosworth Psalter (Brit. Mus., Add. MS. 37517) written at Christ Church, Canterbury, for Archbishop Dunstan.[33] The fine initial B introducing the first psalm (fol. 4; Plate 21A) shows clearly the lines of the drawing, but the ornament has been filled in with dull colour – red, blue, green, violet, brown, and yellow, but no gold. At the junction of the two loops of the B is a mask; this motif, which occurs in the Book of Cerne and earlier, becomes a distinctive feature of the large B of the Beatus in English psalters; the fully developed form can be seen in Harl. MS. 2904 (Plate 21B) of slightly later date. In the Bosworth Psalter initial both the letter itself and the foliage ornament which fills it consist of rather stringy bands, usually double, weaving in and out in a kind of interlaced acanthus scroll, and occasionally breaking in sharp 'elbows', and terminating in either a thick bunchy leaf or a bird or animal head. The initial is painted against the plain vellum and touches the adjoining text letters, thus demonstrating its calligraphic purpose of enhancing the text, as in the earlier Hiberno-Saxon ornamental text style.

Up to this time, outline drawing partly in brown, partly in rubric red, as in the Dunstan Pontifical, and outline filled in with colour, as in the Bosworth Psalter initials, have been the two most commonly used techniques in English pictorial art. About the end of the tenth century two changes occur in the manner of combining colour with line: one seems to be connected with the introduction of the use of different coloured inks for the writing of the text; the other, with the transference of certain effects of the painted figure style which was being introduced into England through fresh contacts with Continental manuscripts. The two new techniques will be distinguished in this book as coloured outline, where the line is in different coloured inks, and tinted outline, where the drawing in brown ink is shaded with colour. The two techniques do not remain separate in English work but are often combined and thus present considerable variety in style. The earliest example of the coloured outline technique is probably the Leofric Missal; and of the tinted outline, the Harleian Psalter.

The so-called Leofric Missal (Bodley MS. 579) is another example of those composite manuscripts which were common in England in the tenth century. It consists in great part of a Gregorian Sacramentary which was written for the diocese of Arras or Cambrai in the early tenth century;[34] an English calendar and Paschal tables almost certainly written at Glastonbury before 979;[35] and some introductory matter at the beginning, probably added by Leofric, Bishop of Exeter 1050–72, at the time the manuscript was rearranged and given by him to the Cathedral of Exeter. The late tenth century text written in coloured inks, on fols 38–59, and three coloured outline drawings included in it are the parts which concern us here. Folio 49 shows two very lively figures drawn in blue or red outline within a border of linear acanthus leaves placed against a blue or a green background; fol. 49 verso (Plate 29A) contains a crowned figure, 'Vita', holding a scroll which bears the 'good numbers' of the Easter Tables; and fol. 50 has a corresponding figure, 'Mors', horned and nude, holding the 'bad numbers'.

The figure 'Vita' on fol. 49 verso (Plate 29A) is drawn with much the same monumentality, especially as to the upper part, as the Christ and St Dunstan (see Plate 22), but the technique of the line is totally different. In place of the firm, continuous contour outline and the almost unbroken drapery lines often running in parallel groups, the Leofric figure is sketched lightly with a ragged line which appears even more broken because of the different colours with which it is drawn – red, green, blue, and purple. The roughened hair and beard, the drapery folds thrown loosely about the body, the fluttering ends, and the irregular hem-line flipping up around the feet all give the figure an effect of lightness and instability as though it were poised in air and shaking itself, stirring the draperies and allowing the breeze to catch them. It is a remarkable style, both for the quality of the line and for the effect produced by the combination of delicate colours against the plain vellum of the page, and it seems to have originated, not in the heavy coloured Franco-Saxon initials contained in the earlier, Continental part of the manuscript, but in some other Carolingian style which developed in the school of Reims.[36] By whatever channel or under whatever circumstances this style entered England, the outline drawn in colour as in the Leofric Missal seems to be an invention of the English artist; the fashion spread in English manuscripts of the early eleventh century.

The other new use of colour with outline, the tinted outline style, is first seen in England in the magnificent drawing of the Crucifixion, preceding a psalter (Brit. Mus., Harl. MS. 2904, fol. 3 verso; Plate 30), otherwise decorated only with more or less elaborate initials in very beautiful, heavy acanthus style (fol. 4, the B of the *Beatus*; Plate 21B).[37] The attribution of this fine manuscript to Winchester has been supported recently by liturgical evidence pointed out by Sisam which links Harl. 2904 with three other unquestioned Winchester manuscripts.[38]

In the Crucifixion (Plate 30) the figure of Christ is in reddish-brown line shaded to suggest form; the hair and the drapery edges are accented with black and shaded in the deep folds with brown. The mouth, halo, and wounds are touched with pale red wash. The *suppedaneum* for the feet of Christ is blue. The Virgin has a veil and dress shaded blue in the folds; the dress is patterned with blue and red ornament; her mantle is outlined in brown accented with touches of black. John has a blue-tinted gown with a red-patterned

border; his mouth is touched with red. The essential difference between this tinted outline technique and the coloured outline of the Leofric figure is that here the outlining is all done in brown line accented in places with black, and the internal detail – as the facial features and drapery ornament – is put in with colour, red and blue. The effect is that of a sketch with colour notes for painting: the figures have both solidity and delicacy. It is, in fact, almost an illusionistic technique which gives an impression of modelled forms painted in colour without actually modelling the form in heavy pigments. This method of drawing is an amazing accomplishment for an English artist of this early date, when compared to what he was doing with the human figure barely two generations earlier (cf. Plate 20). While it is obvious that a new conception of the human form has been introduced into English art, perhaps from some noble Continental model,[39] nevertheless the Harleian Crucifixion could only be the work of a consummate original artist who was creative enough to be able to grasp the essentials of the modelled form and to translate them into this effective outline style.

Nor has the artist missed the emotional significance of the picture: the Virgin's head is bowed and half-concealed in her mantle which she clutches convulsively with clenched hands; John stands with eagerly upturned face, holding with outstretched arm the scroll on which he has written his testimony, 'This is the disciple who bears witness'. Between and above the two figures towers the cross bearing the powerfully proportioned body of the dead Christ with drooping head and slightly sagging body – a God in human form. Truly nothing finer of its kind had yet been produced on the Continent or in England; it is a foreshadowing of the English version of Romanesque art.

Romanesque elements are also present in the splendid initial B of the Beatus introducing the Psalter (Plate 21B), though the technique is painting with rich colour and gold, in contrast to the delicate tinted outline of the Crucifixion miniature on the facing page. The colours are all overlaid: green with yellow for the mask; yellow with green, pink with violet, green with yellow, and greenish blue with a darker tone for the acanthus leaves. The effect of modelling is due, however, to the use of superficial lines of a colour contrasting with the ground colour, rather than to any real building up of the forms by areas of colour. Nevertheless, the total impression is rich and heavy as compared with the Bosworth Psalter initial shown on the same plate. It is noteworthy that in the Harleian B interlace is used, together with large animal heads, in the Franco-Saxon manner, and the acanthus foliage is kept separate, as in the Continental style, not combined with the acanthus stems as in the Bosworth initial. The general interlace principle, however, is applied in the Harleian initial, where the tips of the leaves often pass over or under the stems. The panels containing more conventionalized designs of acanthus leaves painted against a dark background, in their design recall a similar use of them in outline in the large P of the Corpus Christi College Life of St Cuthbert (see note 18 above). But the style in the Harleian initial is bolder and firmer in drawing and the effect is infinitely richer, owing to the strong colouring. The initial style of the Harleian Psalter is wholly in the manner of late tenth century art as developed at Winchester.

Winchester from 963 onward was the scene of Bishop Æthelwold's vigorous reforms of the Old and the New Minster following the pattern of Continental Cluniac monasteries,

especially Fleury with which he had had close contacts while Abbot of Abingdon. Continental influence, it is true, was already present at Winchester at least from the time of Grimbald of St Bertin's who died there in 901; it was evident stylistically in the St Cuthbert embroideries and in the manuscripts associated with King Æthelstan (see above). But it is not until the second half of the tenth century that the full force of Carolingian art under Æthelwold's sponsorship of the production of manuscripts resulted in the development at Winchester of the famous Winchester style.

The reform of New Minster by Æthelwold and its refoundation under a new charter granted by King Edgar in 966 was the occasion for the making of the first known Winchester manuscript in the new manner (Brit. Mus., Cott. MS. Vesp. A.viii).[40] It contains only one miniature (fol. 2 verso; Plate 25) representing King Edgar between the Virgin and St Peter offering his charter to Christ who appears in the clouds surrounded by fluttering angels. The composition is painted on purple vellum now much faded and is surrounded by a complete decorative border consisting of a framework from the centre of which curling, hybrid leaves of the acanthus-vine type spread outward over the two bands. The technique is basically linear, though pale colour is used as a wash over parts of the composition, both figures and decoration. The figures are firmly outlined in the manner of the Pontifical of Dunstan, and the drapery folds are indicated by lines of varying width. Shading is suggested in the draperies by means of contrasting coloured lines, as white and black on blue or red ground, black on green, blue on white, red and green on pale yellow, and red on gold. The features are drawn in brown with a touch of red on the lips. The gestures are vigorous and the draperies are loose and fluttering. Edgar is seen in a somewhat curious and puzzling position, with his right side, roundly shaded on the hip, towards the spectator and his head flung back over his right shoulder. His left leg is seen from the back, the sole of his gold shoe showing. The liveliness of the composition as a whole suggests a Tours or St Gall model, of such a subject as David and the Musicians. The border motifs are found in later Tours manuscripts, as the Lothaire Gospels (Paris, Bib. Nat., MS. lat. 266, dated 840–3); or perhaps an even better example is the Sacramentary of Drogo of the School of Metz.

In the last quarter of the tenth century, and obviously under the impact of further direct Continental influence, the new foliate border style, which appears somewhat tentative still in the New Minster manuscript, bursts forth in all the exuberance and lushness of a plant fully adapted to a new and congenial soil. The splendid Benedictional[41] made for and probably at the order of Bishop Æthelwold of Winchester c. 975–80 is decorated as lavishly in gold and heavy colours as any late Carolingian manuscript.

The miniatures of the Benedictional of Æthelwold seem to come from two different prototypes. This difference in style is evident both in border decoration and in figure compositions, and is well illustrated in plates 26 and 27. Fol. 5 verso (Plate 26) contains a very beautifully composed Annunciation, bordered by a solid frame which suggests the division into panels and the chamfered corners of a carved ivory frame.[42] Within the panels are acanthus leaves with curled tips, placed sometimes vertically, sometimes horizontally or even aslant. In the centre of each side is an ornament of acanthus leaves springing from a small central medallion and extending laterally to curl over or under the plain

bands of the framework. The principle used in the arrangement of these ornaments is that
of the borders of Vesp. A.viii (Plate 25); they suggest sections of this frame cut off and
applied to the panelled border in the Benedictional. The figure composition of the An-
nunciation is completely contained within or behind the frame, some of the curling leaves
overlapping it. This is true also with a few minor exceptions, such as feet and wing-tips,
in Vesp. A.viii. The Annunciation figures are very similar in facial and drapery types, but
more graceful and elegant, with rich patterns in the Virgin's dress and on the halo, sceptre,
and wings of Gabriel. The elaborate, domed baldacchino under which the Virgin is seated,
the architectural setting, the cloud background, and especially the dignity and monu-
mentality of the figures point to an ultimate Byzantine source, probably via Carolingian
manuscripts of the Ada School.[43] The style, though flat and linear, is evidently based on
a good painted original: the patterns of the drapery folds and swirls[44] suggest a painting
technique. The colours are pale: blue, green, madder red, brown, cream, and fawn. The
shading is in thick white or madder lines. The facial modelling is in white on brownish
flesh tone. The gold is not burnished but is sometimes tooled or overpainted with colour.

Plate 27 (fol. 102 verso: Death of the Virgin) exemplifies the second type of design in
these miniatures. The frame is an arch supported by 'columns' whose capitals and bases are
composed of acanthus leaves curling on a frame. An ornament contrived out of the same
elements crowns the arch, and the space within the gold bands that define both the arch
and the columns is filled with a pattern of detached conventionalized acanthus leaves. This
arched frame seems to develop out of the more architectonic forms of fols 1–4, against
which are placed the groups of Confessors, Virgins, and Apostles. The arches derive from
Evangelist or Canon Table pages of the Carolingian Ada School. The combination of the
stylized acanthus leaf panels with the ornaments, as on capitals, bases, and arch crowns,
results in the rectangular border frame with corners and intermediate medallion ornament
as found on many other pages, while the arched frame continues to be used also, as in
plate 27. The lushness of the foliage and the variety of ways in which it is used in the
frame constitute the typical characteristics of the Winchester ornament. The text pages
facing the miniatures in the Benedictional always have borders of the same design.

Plate 27 illustrates well the figure composition of the developed Winchester style. A
crowded group fills the upper part of the space, with the Virgin lying on a bed suspended
between the capitals of the arch, and beside her, three attendant women. Both the figures
and the bed are superimposed on the frame; above them, four angels and the hand of
God holding the crown are seen behind the arch, and below are the Apostles, some be-
hind the frame, others on the centre ground. The crowded composition, like the acanthus
motifs, weaving in and out of the frame, is in the typical English decorative manner, con-
ditioned by an inherent love of all-over ornament and especially of the intricacies of
interlace. In rectangular framed miniatures sometimes the frame disappears altogether
behind the figures. The rich patterns of the draperies further confuse the figures with the
border motifs. The faces are monotonously alike; the modelling is conventionalized. In
spite of the emotion shown by the women and some of the Apostles, it is evident that the
Winchester artist was carried away by the new wealth of ornamental material rather
than by an interest in the representational possibilities of his figure groups.

The style of the Benedictional of Æthelwold has been called the typical Winchester style. Recent textual research, however, seems to indicate that manuscripts illuminated in this style were made for and possibly at other centres than Winchester itself. The textual contents of the Benedictional of Æthelwold include features distinctive to the monastery of St Etheldreda at Ely,[45] which was refounded by Æthelwold in 973. The stylistic relation of some of the features in the Benedictional to the earlier New Minster Charter, however, and the fact that Winchester was the centre of strong, direct contacts with Continental sources which might have furnished other features, still would seem to point to Old Minster, Winchester, as a more likely place for the production of this style than the more remote, newly re-established monastery at Ely. The most plausible explanation of the production of the Benedictional, therefore, seems to be that it was made at Winchester for the use of Æthelwold particularly at Ely, and the chances would be, in that case, that the manuscript would be known also at Ely where its influence may be seen on a later generation of illuminators.

Another manuscript in the Winchester style (known as a benedictional but actually a pontifical) found its way to Normandy and is now in Rouen (Bib. Pub., MS. Y.7). It was probably executed at Old Minster, Winchester.[46] Only three miniatures now remain: those for Easter, Pentecost, and the Assumption of the Virgin (fol. 54 verso; Plate 29B). There are also some acanthus-framed text pages, arranged, as in the Benedictional of Æthelwold, so that the miniature and the text on facing pages are framed with borders of the same design, whether arched or rectangular. The figure types and the heavy painting in colour are very similar to the Benedictional of Æthelwold, though the style seems firmer and the drawing sharper than in the Æthelwold manuscript. In type of composition Rouen Y.7 follows that of fol. 102 verso rather than 5 verso of this manuscript, but the foliage is more plastically rendered than on fol. 102 verso. The colours are stronger than those of the Æthelwold Benedictional – dull green, red, blue shaded with white and black, violet, and a very little bright green; the foliage of the border is placed against a black ground which sets off the heavy colours.[47]

Two manuscripts decorated in the Winchester style show evidence of being made for and probably at Christ Church, Canterbury. One of these (Camb., Trin. Coll., MS. B.10.4),[48] a gospel book preceded by Canon Tables, has five full-page miniatures with Christ in Majesty and the four Evangelists with their symbols all under richly decorated arches, painted in a style similar to that of the two Benedictionals. In the Christ in Majesty (fol. 16 verso; Plate 28A) the rich foliage ornament, the monumental figure type, the fluttering draperies, and the heavy colours and magnificent gold are all characteristic of the Winchester style. But the type of leaf is closer to that used in the New Minster style (Plate 25). It is a narrower, lobed leaf with a wiry stem which winds in and out between the double bars of the frame in a manner very like that of Vesp. A.viii. The figure technique is more linear than in the Benedictional, with the drapery folds making a rich surface pattern. The style of the Trinity Gospels, therefore, seems to bear out the suggestion of a possible direct origin in the New Minster manuscripts.

The other Winchester style manuscript, also a gospel book (Brit. Mus., Roy. MS. I D. ix) which was executed for and probably at Christ Church, Canterbury, has four fine illu-

minated pages framed with Winchester borders and enclosing decorative initials which introduce the first words of the Gospels. Folio 70 (Plate 28B) represents the border style. The colours are mainly dull red of two tones, grey and brownish green; in the background of the initial a bright, pure green is used. The gold is rich and heavy and reddish in hue, as in Winchester manuscripts. The initial letter containing the Christ in Majesty is an example of the so-called historiated initial,[49] a form of illumination which occurred occasionally even much earlier but became particularly popular with illuminators at Canterbury and elsewhere in England after the Conquest.

The so-called missal, which is actually a sacramentary, of Robert of Jumièges (Rouen, Bib. Pub., MS. Y.6) probably was written for use at Ely[50] between 1006 and 1023. It was given by Robert as a memorial of himself to the monastery of Jumièges in Normandy, while he was Bishop of London (1044–50).

The general stylistic dependence of the Sacramentary of Robert of Jumièges on the Benedictional of Æthelwold is clear; in fact, it appears that the designs of the overloaded borders and the scheme of placing matching designs on facing pages, as well as the general type of composition, may actually have been taken from the earlier Benedictional which seems to have been made for use at Ely. But the strange flat-headed types of figures, the restless draperies, and most of all the sketchy technique and pale, thin, but brilliant colouring have little in common with the typical Winchester style. The elements of the Nativity composition (fol. 32 verso; Plate 31) are spread about loosely under the arch, with no spatial relation either to the arch or to the columns which support it (cf. Plates 26–28, and also Plate 29B), and the background is treated in the 'illusionistic' technique of pale washes of streaky colour in the manner of the Carolingian style of Reims.[51] The background colours are violet under the arch, yellow shaded with red, and green around the Virgin's bed, and stronger (lake) red in the lower part of the miniature; Mary wears a bright green dress, with the folds shaded with blue, and she has a blue veil. The bedding is orange shaded with red, the bedstead is gold; the coverlet is white shaded with blue and the pillows are red and green patterned with white. The angel wears a yellow gown shaded with red, and a white mantle shaded with blue. The wings are extraordinarily beautiful, with the large feathers green, the smaller ones red, yellow, and gold tipped and edged with green and blue. The haloes are gold. The faces are painted with a flat, pinkish white, and the features are drawn in brown; there are red areas above the eyes and around the nose, lips, jaw, and chin. The technique is minute in the handling of detail and the colour is unimaginably varied and sparkling. There is a lightness of touch, both in the drawing and the painting, which is not found in the earlier Winchester benedictionals, nor, indeed, in either of the Winchester style manuscripts probably made at Canterbury (see above). It is clear that a new element has entered the Winchester style, one which has little to do with the monumental, heavily painted figure style of the Ada school.

In fact, there is evidence of the presence in Canterbury,[52] perhaps as early as the second half of the tenth century, of a Carolingian manuscript of a quite different type, illustrated in an amazing linear style without colour, the famous Utrecht Psalter. The importance of this Psalter to the Canterbury illuminator is evident from the fact that it was copied there no less than three different times, each time in the current English style.

The earliest of these copies is Brit. Mus., Harl. MS. 603, which was begun about the year 1000 and is in many respects the most important and interesting of the three. It was not all done by the same hand: folios 28–49 are written in a different script from the preceding and following parts, and the few illustrations in this part are by a different and later hand of the second quarter of the eleventh century,[53] and perhaps were even copied from a different prototype. Folios 1–27 verso (fol. 4; Plate 32) and 50–7 verso (fol. 56 verso; Plate 33) both follow the illustrations of the Utrecht Psalter very closely, even though these two sections of Harl. 603 were apparently done by two different contemporary artists. From folio 58 to the end, yet another hand is at work departing strikingly from the original in the picture compositions but clearly displaying the tremendous effect of the Utrecht style on later English draftsmen (Plate 48B). The vigour of the linear style with its extremely active, attenuated figures, swinging draperies, and dramatic gestures, which seems to have been evolved largely out of copying the Utrecht Psalter, becomes a key feature – almost a hall-mark – of later English illumination.

As for the two artists who followed the original most closely, the first (Plate 32), while copying the composition in all of its details, goes further in the matter of treating them as decorative features:[54] his trees and architecture are elaborated, his hills are multiplied into a swirl of curves and countercurves; the spears and arrows are accentuated; a weathercock is carefully perched atop a building. Everything swings and whirls in a dizzy pattern, closely knit and with no empty space. But the most striking difference from the original drawing in the Utrecht Psalter, which is done wholly in brown ink, is the use of colour for the line – red, green, brown, and purple, employed arbitrarily for details, according to the whim of the artist in weaving his decorative pattern.[55] This will be recognized at once as the coloured outline technique characteristic of the drawings of the Leofric Missal (Plate 29A).

Folios 50–7 verso, one complete gathering (Plate 33), are certainly copied by another hand:[56] the artist of these pages has stayed so close to his original that scarcely a penstroke is wanting in the copy. Such meticulous duplication of the swift illusionistic style in the Utrecht drawings can result only in a tightening and hardening of the free sketchy line. Thus flying folds which are only suggested in the original by a zigzag line become flatly pressed pleats; details which are sketched in lightly in the original are given firm contours, as in the ground line and the shading.[57] The action in the original composition is retained but the vibrant aliveness has vanished. Two details will illustrate this artist's typical pre-occupation with decoration: the star has become a jewelled ornament, and the spring from which the river rises has turned into a Celtic scroll.

The characteristics of the English linear art that developed under the direct influence of the Utrecht Psalter are seen very clearly in a comparison of two miniatures of about the same time – early eleventh century – representing the occupations of the month of January in the calendars prefixed to two different manuscripts of uncertain provenance (Brit. Mus., Cott. MSS Jul. A.vi, a hymnal and calendar,[58] fol. 3; Plate 34A; and Tib. B.v, Astronomical Treatises,[59] fol. 3; Plate 34B). The scene in both miniatures represents winter ploughing. Manuscript Jul. A.vi is much closer in style to the Utrecht Psalter: the drawing is in brown with touches of green, and is firmer and less nervous than most of Harl. 603; the figures are

not extraordinarily attenuated, although the heads are rather small, and they are almost always seen in profile. In Tib. B.v flat profiles are used also; in fact, the composition of the miniature in Jul. A.vi is duplicated in every detail except the border in Tib. B.v, but the technique is that of painting: the oxen are modelled with white highlights in lines and spots, as is also the drapery of the figures. The technique apparently was influenced by the illustrations in the prototype from which the text of this manuscript was copied, but the style is very similar to that of Vesp. A.viii (cf. Plate 25).

Thus in these two early calendar illustrations two distinct contemporary techniques are represented, reflecting two different Carolingian prototypes.[60] The technique of coloured outline drawing in Jul. A.vi seems to have developed in connexion with the use of different coloured inks for the text initials, as in the Leofric Missal; Tib. B.v, on the other hand, could represent that kind of painting technique which, when transferred to line drawing, resulted in the tinted or shaded outline of Harl. 2904. The painting technique continues to appear together with outline drawings during succeeding periods.

From St Augustine's Abbey, Canterbury,[61] comes an illustrated copy, dating from the second quarter of the eleventh century, of Ælfric's *Metrical Paraphrase of Pentateuch and Joshua* (Brit. Mus., Cott. MS. Claud. B.iv) with miniatures drawn in firm, continuous contour lines, partially painted with shaded colour in the earlier part. Folio 19 (Plate 35), representing the building of the Tower of Babel under the supervision of God the Father standing on a ladder, is typical of the painted style.[62] The composition though framed is not confined within the border but pushes out over the edges. The figure drawing is crude but very vigorous, and the artist's fondness for detail is shown in the way each phase of the construction, from the iron work on the door to the laying of the tiles on the roof, is depicted with meticulous exactness, though with considerable naïveté. Also, the interest of the artist in the patterned effects inherent in brick and tile work and in the arrangement of different shaped areas set off by colour is obvious, even though here, as in other instances, he seems to be following some earlier painted prototype in his illustration. These two characteristics – interest in exact detail and love of pattern – are traditional in English art from its earliest appearance, and are to become more firmly established as time goes on.

Meanwhile at New Minster, Winchester, as at Canterbury, a linear type of composition was developing in the early eleventh century, side by side with the Winchester painted style which it was soon to supersede. Four manuscripts can be assigned to this place and date, all very close in style though differing in technique, and all dependent on the style of the earliest New Minster manuscript (Vesp. A.viii; Plate 25).

The first of these, the so-called Grimbald Gospels (Brit. Mus., Add. MS. 34890),[63] has a scheme of decoration similar to that of the Benedictional of Æthelwold, that is, facing pages with miniature and text surrounded by heavy borders both using the same design. At the beginning of each gospel in the Grimbald manuscript there is an Evangelist picture and a decorative text page. Both the miniature of Luke (fol. 73 verso; Plate 36A) and the decorative page opposite have frames formed by silver bands enclosing red, green, and grey-blue acanthus leaves, and gold medallion ornaments from which rather stiff leaves extend in pairs. The Evangelist picture, like the text opposite, is on the uncoloured vellum ground; the curtain is suspended from one of the decorative leaves of the border

and is looped over a gold hook attached to the silver bar of the framework. The Evangelist's face, hands, and feet are outlined with red and washed over with pale, flat, pinkish colour. The draperies are patterned richly with dark and light linear folds on green or blue grounds. The symbol of Luke – a red calf with green wings and brown tail and hooves – holds a gold ink horn in its mouth. The style is linear but the line is not of the nervous, sketchy type of the Utrecht Psalter and Harl. 603. The square-jawed heads, the large round haloes, the heavily swinging drapery ends are derived rather from the style of the miniature of King Edgar (Plate 25). The heads of the Evangelists are all in the same position and almost identical, as can be seen in the miniature on folio 114 verso (Plate 36B).[64] The border on this page, however, as also on the facing text page, is divided by gold and silver bands into panels and medallions containing figures instead of acanthus leaves. Across the top are three medallions with Majesty[65] figures, identical except for the cruciform halo of the centre figure, representing the Trinity; each medallion is supported by four angels with spread wings. Kings, apostles, and saints occupy other medallions and panels, and in the centre at the bottom are two angels holding a number of figures – souls of the dead – in a napkin. The figures in the medallions and panels on the text page opposite (fol. 115) also are kings and saints; the centre top medallion contains a Madonna and Child supported by angels, while seraphim fill the corner roundels. The subjects of the two pages are parts of the same idea: Christ, or as represented, the Trinity, in judgement on the one side, and the Incarnation of Our Lord on the other. The theological scheme suggests a Continental origin, since nothing of this kind has hitherto appeared in English illumination, but no Carolingian or Ottonian manuscript has been found to supply the prototype.[66]

The three other early eleventh century manuscripts associated with New Minster are illustrated in pure outline, but the figures still hark back to those of the Edgar miniature, in pose and gesture and especially in the continuous outline technique used for contour and drapery folds. The edges of the draperies swing more freely than in the earlier manuscript, the figures are lithe, and the heads are thrust forward with something of the eagerness of the Utrecht Psalter style, which may well have spread from Canterbury to Winchester. Plate 37A (Brit. Mus., Stowe MS. 944, fol. 6) shows King Cnut and his first wife Ælfgyfu presenting an altar cross, while Christ above in a mandorla between the Virgin and St Peter (cf. Vesp. A.viii) blesses the gift; beneath the altar is a group of monks. The manuscript, known as the *Liber Vitae*, is a register of New Minster and can be dated *c.* 1020–30. The technique is continuous brown outline tinted with colour.

The two other manuscripts illustrated in a very similar tinted outline style (Brit. Mus., Cott. MSS. Titus D.xxvi and xxvii) were written by Abbot Ælfwin (Ælsinus) for the monks of New Minster about the same time as Stowe 944.[67] Titus D.xxvi, a collection of prayers, hymns, and other material, contains on fol. 19 verso a full page drawing of St Peter adored by a monk. St Peter, who resembles very strongly the same figure in the *Liber Vitae* miniature (Plate 37A), is shown between columns which support a trefoiled canopy. The drawing is in brown, shaded lightly with green, blue, yellow, and red.[68] Titus D.xxvii, the New Minster Offices (1023–35), contains a miniature (fol. 65 verso; Plate 37B) of the Crucifixion with the Virgin and a bearded St John. The outline, which

is very broken, is in red or brown accented with black in the drapery folds and in other details, such as ornament on the drapery (cf. Harl. 2904). Green is used outside the figure contours giving the effect of shadow; it is also used to deepen the folds. The personified Sun and Moon,[69] the jewelled haloes, and the careful labelling of everything suggest an Eastern prototype perhaps via a Carolingian manuscript, but the tinted outline style is typically English. In New Minster miniatures the true profile head is used only rarely.

Somewhat earlier than the New Minster manuscripts just discussed and of unknown provenance is a copy of Aldhelm's *De Laude Virginitatis* forming part (fols 66–112) of a composite manuscript now in the library of Lambeth Palace (MS. 200). The prologue to this work is accompanied by a drawing of Bishop Aldhelm presenting his book to the nuns of Barking (fol. 68 verso; Plate 38A). The handwriting is late tenth century or *c.* 1000.[70] The drawing, which is presumably contemporary, is not in the style of Harl. 603 but is closer to the Christ and St Dunstan drawing in Bod. MS. Auct. F.4.32 and the Sherborne Pontifical. The figures have the monumentality of the Winchester style in the Benedictional of Æthelwold and somewhat similar draperies are delineated with a stiff, wiry line. In the Aldhelm text there are a number of delicately coloured initials composed of beast heads and acanthus leaves within interlace.

The technique of coloured outline is nowhere more effectively and charmingly used than in three late tenth or early eleventh century copies of Prudentius's *Psychomachia*, all of which follow one prototype, possibly a fifth century classical manuscript. The earliest, according to James,[71] and certainly the best is Cambridge, Corpus Christi Coll., MS. 23 (fol. 21 verso; Plate 38B). The figures are solid and well-proportioned and they stand in plausible contrapposto, though their feet and ankles seem scarcely adequate; draperies hang full and heavy yet reveal something of the form underneath; folds are indicated conventionally, merely by two parallel lines, but the edges swing free with light puffs at the hem. Colour – red, green, blue, and brown – is used indiscriminately for bodies, drapery or foliage. The line is clean-cut and sure and appears to be drawn directly on the vellum without preliminary sketch. The Cambridge *Psychomachia* came from Malmesbury and may have been made there.[72]

Of the two early copies of the *Psychomachia*[73] in the British Museum, Cott. MS. Cleop. c.viii is closer both in quality and in date to the Corpus manuscript, and the same cycle of pictures is repeated in a style still unaffected by the Utrecht Psalter. In some of the pictures, profiles are used freely. The other copy in the British Museum, Add. MS. 24199, James says, may be slightly later;[74] it was probably planned to contain the same cycle of illustrations, plus two more not in the Corpus copy. The Additional manuscript once belonged to Bury St Edmunds.[75] Though following in large part the classical manner of drawing, as in Corpus 23 and Cleop. c.viii, Add. MS. 24199 contains one figure in unmistakable Utrecht style (fol. 26 verso).

One of the most interesting and, as will appear later, one of the most influential of the Canterbury productions of the early eleventh century is Brit. Mus., Arundel MS. 155,[76] a psalter preceded by the Easter Tables which are illustrated with a partially coloured drawing (fol. 9 verso) of St Pachomius receiving them from an angel. It can be dated *c.* 1012–23. The psalter contains illustrations in both the painting and the tinted outline

technique; on one page the two techniques are found within the same miniature (fol. 133; Plate 41). Another page (fol. 93; Plate 40) shows a very vigorous scene of David slaying Goliath in an historiated initial, and is surrounded by a border of the general Winchester type.

The miniature on fol. 133 represents St Benedict with a kneeling monk under his feet. These two figures are painted in heavy, rather streaky colour: Benedict wears a purple tunic with gold ornaments and a gold cape. He is seated under one of two arches enclosed within the larger arch supported by columns which are partly painted, partly gold. Very strange and ugly acanthus leaf ornaments stick out awkwardly from the capitals of the columns. The background both behind Benedict and above in the tympanum of the arch is streaked with colour to suggest sky, in the manner of Reims manuscripts and also the Sacramentary of Robert of Jumièges (Plate 31). Much of the technique of the Benedict figure is linear in spite of the painting; the drapery folds over his knees are both linear and painted; the features of his face are in outline, but his beard and hair are painted as a soft mass. The other half of the miniature is wholly in a tinted outline technique. It is an interesting experiment, but more interesting than beautiful, and it is evident that the drawing has more life and character without the paint.

The historiated initial on fol. 93 (Plate 40) is composed as a picture behind the frame of the initial letter: a considerable part of Goliath's body is cut off by the letter. The drawing is full of life and the action is vigorously if rather awkwardly portrayed, with David apparently standing on Goliath's arm with one foot while the other seems to be tangled in some manner with the giant's spear. The relative size of the two figures is clearly suggested, and the realistic manner in which David saws off the head of his enemy leaves nothing to the imagination. The colour both of the initial and of the framework border is applied with a brush in heavy lines and swathes. The acanthus ornament which springs from the bands of the frame is stiff and meagre, and the curious shape of the outer part of the frame gives it the appearance of a Victorian picture frame. All in all, the decorative elements of Arundel 155 leave much to be desired both in motifs and in design. But the artist qualifies better as a figure painter than as a decorator, and is at his best in the expressive pen-drawn figures. It is extremely interesting and valuable to be able to see, as in the Benedict miniature, the relation of the two techniques, and the type of line that approximates most closely to the painted technique of a modelled figure in this style.

By the second quarter of the eleventh century, Anglo-Saxon drawing had come into its own, with all the swiftness and vitality of the Utrecht Psalter style but with a firmer, cleaner-cut line. The psalter in the Vatican Library (MS. Reg. lat. 12) made for Bury St Edmunds not earlier than 1032,[77] is one of the finest examples of this style. There are fifty drawings in the margins, often running into the text, executed mainly in brown and red outline, with an occasional touch of green. On fol. 22 (Plate 39B) there is a picture of David which, in the dignity and poise of the figure and in the vitality of the line, is unsurpassed in early English drawing. There is a suggestion of the figure style of Arundel 155 here, as shown in the St Benedict on fol. 133 (Plate 41); but the technique is more skilful in the David. Except for the sketchy quality of the line there is little resemblance in this figure to the typical Utrecht style. However, in the other drawing reproduced (fol. 28;

Plate 39A) the flat broad head of the Christ and the more distorted poses and lively gestures are vivid reminders both of the Harl. 603–Utrecht style and of the drawings in Arundel 155. The artist of all the drawings in the Vatican Psalter was probably the same person; the differences in the style could be accounted for by the various models which might have been available to him.

In the Vatican Psalter the *Beatus* page has the usual initial B with a framework border painted in a rather coarse version of the Winchester style.[78] The initial is filled with foliage terminating in large animal heads; and in a roundel on the upright of the B is a tiny figure of a monk writing, possibly the scribe or illuminator of the manuscript.

The last of the manuscripts to be assigned to the first half of the eleventh century is known as Cædmon's Poems (Bodleian Library, MS. Junius 11). It is copiously illustrated with figure drawings[79] and decorative initials in two or more different styles. Its attribution and precise date are exceedingly controversial.[80]

The first style seems to be a rather crude derivation from a painted style, and some of the drawings echo compositions that might be found in Carolingian Bibles of the Tours School.[81] From page 49 onwards the artist appears to have come under the influence of the Utrecht style (page 66; Plate 44). The figures suddenly become more attenuated with flat heads, thin legs, and large flat feet, and although sometimes they show more liveliness, the heavy contour line and the stolid poses and the interest in architectural setting which are characteristic of the first style are still recognizable. Later in the manuscript, from page 73 onwards, this Utrecht influence dominates, with its typical sketchy outline technique in colours – red, brown, and green. It is difficult to be certain whether these three styles indicate three separate hands or one hand passing through different stages of development. Page 66 (Plate 44), with a picture of Noah's Ark, represents the second or middle style with elements of the stolid Carolingian figure types and the painstaking drawing of architectural detail and the ragged but continuous contour line. However, there are also the lightness of touch – no colour is used here – and the naive informality which characterize the Harl. 603 illustrations.[82]

The story of Noah's Ark, like the structure itself, is represented in several stages and suggests a strip narrative running from bottom to top. At the left, below, Noah stands at the oar ready to propel the 'Viking' type of craft, but God in the centre has other plans, as witness the two seraphs in the upper corners. At the right Noah's wife is being difficult and refusing to enter the Ark. In the middle stage all is serene with the animals. In the centre of the upper stage Noah releases the dove and on the right it is about to nip off the sprig of green. The story is told solemnly enough but with childlike simplicity. The design seems to follow some prototype which the artist has not bothered, or known how, to adapt either to his space or to the formal composition of a miniature in a frame. His greatest skill shows in the decorative elements both of design and of detail. The fine dragon's-head prow of the ship was to his taste, and the architectural details and even the wings of the seraphs display that love of linear pattern which is characteristic of the Anglo-Saxon artist.

Summary

The key to the pictorial art of the earlier part of this period lies in two successive waves of Continental influence, mainly from two Carolingian schools: the Ada School with its Byzantine tradition of painting and modelling of monumental figures, which took root most strongly at St Swithin's, Winchester; and the Reims School and especially its most remarkable production, the Utrecht Psalter, with its sketchy, linear style and intense vitality, which exerted its most direct influence at Canterbury. In the early eleventh century these two influences became mingled and diffused to other centres, chiefly in East Anglia and the Fen country. The result of the fusion of the painted and the outline techniques is a variety of gay and charming outline styles using colour with line; this is the outstanding invention of the Anglo-Saxon artist of this period. The surprising thing is that the figures themselves retain so much diversity in type, for the solidly conceived figures of the Ada style are handled in this technique equally effectively with the lightly sketched, impressionistic figures of the Utrecht Psalter type. It is this facility with types and techniques that gives the work of this period its freshness and originality.

CHAPTER 3

PRE-ROMANESQUE ART

⟨1050– *CIRCA* 1110⟩

*

HISTORICAL BACKGROUND:
TRANSITION FROM ANGLO-SAXON TO NORMAN

POLITICAL

Edward the Confessor, King 1042–66 (5 Jan.).

Harold Godwinson, King 6 Jan.–14 Oct. 1066; Battle of Hastings.

William I, Duke of Normandy, King 1066–87; reorganization in government and Church; systematized feudalism; Domesday Book.

William II (son of William I), King 1087–1100; first Crusade 1096; capture of Jerusalem 1099.

Henry I (son of William I), King 1100–35; Duchy of Normandy annexed to England; organized internal government.

ECCLESIASTICAL

Stigand, Saxon Bishop of Winchester 1043–52; Archbishop of Canterbury 1052–70; great fire at Christ Church Priory, Canterbury, destroying the Cathedral and many manuscripts 1070; Stigand is represented on the Bayeux Tapestry.

Odo, Bishop of Bayeux, brother of William the Conqueror; powerful in England until banished in 1083.

Lanfranc (an Italian), Abbot of Caen (Normandy), Archbishop of Canterbury 1070–89.

Anselm (an Italian), Abbot of Bec (Normandy), Archbishop of Canterbury 1093–1109.

William of St-Carilef (St-Calais), Bishop of Durham 1081–96; exiled in Normandy 1088–96; d. 1096; gave fifty manuscripts to Library of Durham Cathedral.

*

THE Anglo-Saxon figure drawing style with its varying uses of colour reached its full development in the first half of the eleventh century. The year 1050 opens no new chapter in this development. In fact, some examples of the style which will be discussed here might well have been included earlier since they have been dated both before and after the year 1050. What is surprising is that the Norman Conquest which changed so much in England affected English art so little, except as to architecture. Wormald was the first to observe this phenomenon of the continuity of English pictorial style in manuscripts after the Conquest.[1] Subsequently Dodwell demonstrated by documents and examples the soundness of Wormald's observations in the case of the manuscripts produced at Canterbury,[2]

where Norman influence was felt earliest and most strongly. For it was at Christ Church that Lanfranc, newly appointed Archbishop of Canterbury, came in 1070 with some Norman monks from Bec to undertake a 'regeneration' of monastic life there on the Norman pattern. The change in script which is noticeable thereafter has been used by Dodwell to date the Christ Church manuscripts.[3] The monastery of Bec particularly encouraged the art of writing, though there is no evidence that this included illumination. What changes there were in English illuminative art after the arrival of the Normans mainly affected decorative and historiated initials.

At Winchester, the other long-established centre of Anglo-Saxon art, very few manuscripts are known to have been produced after the Conquest. At this time, in fact, there seems to have been a trend to export manuscripts made in Winchester to the Continent. Though the figure style at Winchester changed somewhat after the mid-century, there is no evidence that increased Norman influence after the Conquest was responsible.

At Durham, however, in the last decade of the eleventh century, Norman illumination (by this time undoubtedly strongly affected by Anglo-Saxon influence) was imported directly in manuscripts made for Bishop William of St-Carilef, many of them in Normandy.

The mixture of Norman and Anglo-Saxon stylistic elements after the Conquest has largely accounted for the difficulty in attributing the most famous example of art in this period, the so-called Bayeux Tapestry, long a matter of controversy. However, a recent exhaustive study of the embroidery[4] has thrown further light on it and it seems now to be established fairly clearly as English in origin.

Manuscripts: Canterbury

The continuity of the Anglo-Saxon figure style at Christ Church, Canterbury, before and after the middle of the eleventh century is well illustrated by a chain of three manuscripts, linked by borrowings one from another and all probably made there. The earliest is the Psalter, Arundel 155, already described, dating between c. 1012 and 1023. The miniature of St Benedict and his monks on folio 133 (Plate 41) was copied with some changes in arrangement in a miniature of the same subject in Cotton Tiberius A.iii also from Christ Church,[4a] dating from c. 1040–70. The other miniature, on fol. 2 verso in Tib. A.iii, representing King Edgar with St Dunstan and St Ethelwold was, in turn, copied much more closely, but omitting the figure of Edgar in the centre,[5] in a third manuscript,[5a] Durham Cath. Libr., B.III.32, fol. 56 verso, dating from 1050–70. The style of these three miniatures progresses from the sketchy impressionism of the early part of the century to a greatly hardened contour line and stylized poses and drapery patterns. But it is evident that no outside influence needed to intervene in the process. The fire of 1067 probably destroyed other pre-Conquest manuscripts which, Dodwell observes, might have supplied further evidence of the survival of the Anglo-Saxon tradition at this time.

Also at St Augustine's Monastery the continuity in Anglo-Saxon style was preserved, perhaps with even less modification because Norman influence there was resisted more effectively.[6] Very close connexions exist between the later drawings[7] in Harl. 603 and

those in earlier parts of the same manuscript. On fol. 17 verso is a sketch inserted in a blank space at the end of the text, which is a direct copy of three similar figures in one of the earlier miniatures on fol. 17. The copy (Plate 48B) is many times larger than the original, and the technique is much less free and illusionistic, but the style is pure Anglo-Saxon, such as developed under the influence of the Utrecht Psalter, in respect to the sureness of the line drawing, the vigour of the poses and gestures, and the use of coloured line in place of or in addition to the brown outline. The style of the sketch on fol. 17 verso is that of the latter part of the Harl. 603, from fols. 58 to the end. This manuscript also is a direct carrier of the earlier Anglo-Saxon tradition into the post-Conquest period.

Finally, earlier English precedents can be pointed out also for the historiated initial which developed so vigorously at Canterbury after the Conquest: Vesp. MS. A.i (the eighth century Canterbury Psalter) contains some small ones; Royal MS. I D.ix (the Dunstan Gospels, late tenth century) has a Q (fol. 70) containing Christ in Majesty (Plate 28B); and Arundel MS. 155 (fol. 93) has a fully developed example (Plate 40) with David slaying Goliath. It is true, the initial letter in these early instances is used as a frame around the small picture, with little or no foliate ornament on the initial itself, as post-Conquest historiated initials have.

This type of historiated initial, that is, the decorative text letter containing a figure subject, seems to be a favourite Norman form, deriving perhaps from the Carolingian school of Corbie, and particularly from the Sacramentary of Drogo,[8] where it takes its place as the first letter of the text, instead of being treated, as in Arundel 155, as the central feature of a framed page. At Canterbury, as elsewhere in England, decorative initials had, of course, long constituted important ornamental features of the text page; at Canterbury, especially, animals, both naturalistic and fantastic, were familiar motifs among the foliate intricacies of the designs of initials.[9] Occasionally even a human figure, climbing and jumping among the branches, replaced or accompanied the decorative animals, as in a tenth century manuscript, Bod. MS. Tanner 10;[10] but such examples are rare earlier, even in Canterbury work. The wholesale introduction of these human figures into the initial seems, therefore, to be one of the results of Norman influence on book art, and perhaps began at Canterbury under Lanfranc. These human figures were used in two ways, sometimes both in the same initial; decorative, 'gymnastic' figures often naked, which were treated in the same manner as the ramping, clambering animals; and figures represented as actors in a scene which usually illustrates the text introduced by the initial.

Initials containing human figures can be associated with the St Augustine's scriptorium at Canterbury by means of one of the finest early examples of a manuscript containing only this kind of illumination, Brit. Mus., Cott. MS. Vit. C.xii, a martyrology with obits which seem to date it in the first decade of the twelfth century.[11] At the beginning of each month there is a KL monogram of the decorative foliage type and containing birds or animals or the sign of the Zodiac for the month. Only seven now survive: January, with animals and birds (fol. 114); February, with Aquarius, the January Zodiac sign, holding a water jug in one hand, while he warms the other over a fire, thus combining the sign of the Zodiac with the occupation of February (fol. 117 verso); March, with several little figures pruning the luxuriant vines which fill the letters (fol. 121); May, a dragon

and foliage initial with a ram, the Zodiac sign for April, poised on top of the upright of the K (fol. 127); August, with a man fighting a dragon in the letter, and on top of the K, a lion biting its own tail – probably the Zodiac sign for July (fol. 134); September, with a fine coloured drawing of Virgo, the sign for August, in the best impressionistic outline style (fol. 139; Plate 46c); and finally October, with a woman holding the scales, which is the Zodiac sign for September. In all of these initials, the background is coloured, usually purple, more rarely blue and green. There is very little vermilion, but when used, its purpose is clearly to enliven, by its contrasting brightness, what is otherwise rather a dull colour scheme. The figures, both animal and human, are well drawn and shaded with colour; the initials are beautifully designed, with the delicate stems and foliage contrasting pleasingly with the solid or cross-hatched coloured backgrounds. In this manuscript the KL monogram is not set apart from the text, but serves both to introduce it and to enliven and beautify the page, which has no decorative border.

More elaborate in the number and kinds of decorated initials, yet so close in style as to suggest the same group of illuminators, is Brit. Mus., Arundel MS. 91, also a collection of Lives of the Saints, each of which is introduced by a decorative initial in the same colouring and technique as in Cott. Vit. C.xii. This manuscript, therefore, belongs likewise to the very early twelfth century, perhaps c. 1100. The initials are of all kinds; there are old-fashioned zoomorphic scroll initials[12] in red, blue, green, and purple; there are acanthus foliage and animal or dragon initials; there are plain initials containing 'histories', in this case, scenes illustrating the lives of the saints of which the text is introduced by the initial (fol. 188; Plate 46A); and there are initials composed of human figures. The figure style is extremely lively, the drawing is expressive and competent in its suggestion of violent action and of the excitement accompanying it. Indeed, there seems to be evidence that in some cases the colourist was less able than the draughtsman, for the flat solid colour of the backgrounds tends to obscure the clarity and precision of the outline.

Some features of the historiated initial T in Plate 46A should be noted because of their obvious kinship with the vigorous narrative style of the Bayeux Tapestry (see below). Chief among these are the spirited, well-drawn horses, especially the one which has fallen on its head, with feet and tail high in air; and the equally extraordinary figure of a knight still clutching his spear, while his shield falls downward ahead of him. Both horse and rider are very much in the spirit of the battle scenes of the Bayeux Tapestry (Plate 47B). So, too, are the idea of the strip narrative, which is especially well-fitted to the form of this initial T, and the disregard of the framing bands in the arrangement of the compositions, which push out over the edges and even beyond the limits of the initial, just as the scenes in the Bayeux Tapestry often continue beyond the main panel into the lower border.

The initial M in Arundel 91 (fol. 26 verso; Plate 46B) is an even better example than the T of the intricate design of a well-composed historiated initial. The subject – St Michael fighting the dragon – lends itself superlatively well to this type of illustration. The wings of both angel and beast, the flying drapery fold and the coiled tail are all most effective decorative elements to weave in and out of the initial frame. Even the body of Michael is used in this way. The figures are in brown outline tinted with red and green and silhouetted against a solid purple ground. A heavy purple contour line is painted around

the outside of the initial letter and around parts of figures which are free of the background, as Michael's wings and the dragon's tail. The wings are shaded blue and green. It is an extremely fine, vigorous style which must be kept in mind for later comparison with that of the Durham Carilef manuscripts.

The historiated initial, combining illustration with ornamental text in the design of the page as in this manuscript, seems to satisfy in a peculiar way the decorative sense of the English illuminator, for the form persists, in greater or less degree, throughout the later history of English manuscripts.

The figure style of the historiated initials, as described above, obviously is derived from the outline miniature; but in the St Augustine's manuscripts, and, in fact, in Canterbury illumination as a whole at the beginning of the twelfth century, there are very few freely designed miniatures such as were found in the earlier period under the influence of the Utrecht Psalter. One manuscript which does contain such miniatures on a full-page scale, and which can be associated with the scriptorium of St Augustine on the grounds of its figure style, is a copy of St Augustine's *De Civitate Dei*, MS. Plut. xii.17 in the Laurentian Library in Florence. The hand in which this manuscript is written looks like late eleventh century script,[13] but the illumination seems to be rather of the early twelfth. Dodwell thinks it can be attributed with certainty on stylistic grounds to Canterbury, and, less categorically, to St Augustine's.[14]

It contains illuminated initials in colour without gold, plain or with foliage and animal designs, at the beginning of each book; and prefixed to the text are four full-page miniatures with subjects as follows: fol. 1 verso, the Weighing of Souls, examples of sudden death, and a ploughing scene; fol. 2 verso, the City of God; fol. 3 verso, a large figure of St Augustine with monks (Plate 54); and on the facing page, fol. 4, a number of figures apparently in animated discussion with St Augustine (Plate 55). The figures are drawn in the firm, lively coloured outline style characterizing the Canterbury manuscripts of the post-Conquest period. St Augustine is silhouetted against a purple background powdered with dots and circles; he is flanked by two circular ornaments filled with conventionalized leaves and other decorative motifs such as are found also in the framing bands of the miniature. St Augustine's vestments are richly ornamented with geometric designs some of which are used in other English manuscripts, as the Benedict of Arundel MS. 155 and David in Cott. MS. Tib. c.vi (Plate 51). The drapery folds of the figures are represented with shaded lines, and the draperies themselves cling to the bodies or flap loose as though at the mercy of a violent wind. Hair also appears blown by the wind; faces are eager and animated, gestures are dramatic; even the ground line is whipped up into frothy hummocks. The draperies and the awkward, crossed-leg positions and the general liveliness of expression suggest French Romanesque sculpture of the school of Aquitaine, but these features are also characteristic of earlier Anglo-Saxon drawings, especially of Canterbury work. There may be Continental influence also in these miniatures, as the architectural framework of the border and the series of medallion heads suggest. The figure style, however, has a good deal in common with the initials of Arundel MS. 91. The decorative initials in the Laurentian manuscript also are, apparently, English and close to initials in the Canterbury manuscripts, more particularly those made at St Augustine's.[15] Plain coloured

backgrounds are used, against which the lively patterns of animals and grotesques, human figures and even heads in medallions stand out with striking decorative effect.

Winchester

At Winchester in the later eleventh century little if any evidence of contemporary Norman influence is traceable. True, very few manuscripts are known to have been produced there, none that can be dated later than 1070.

Shortly after the middle of the eleventh century, however, some interesting developments did take place in the Winchester style: a Psalter and four Gospel Books, more or less closely related, form a group, into which a revitalizing spirit has been infused. It seems unlikely that this new liveliness comes from any immediate Continental contact, but it might be the result of a reworking of early Reims painting style. Its effect on the more staid and monumental Winchester style is akin to that of the Utrecht Psalter on Canterbury drawing half a century earlier, but it was not necessarily Canterbury influence that was responsible for the change.

Perhaps the earliest of this group, shortly after 1050, is a psalter (Bod. MS. Douce 296) made for an East Anglian monastery, or possibly for Croyland Abbey (Lincs.).[16] Folio 40 (Plate 42) has a full-page miniature of Christ treading on a lion and a dragon, framed by a border of gold bands and waving acanthus leaves. The figure is extremely attenuated and lively. It is outlined in reddish brown; the tunic is tan, shaded lighter and darker with colour applied in broad swathes to indicate the shadows and highlights of the drapery folds; the mantle is a dull blue, also shaded in the deep folds. The exaggerated height, the long swinging curves of the drapery, the tall cross-headed lance piercing the lion's mouth, and the narrow, bearded head of Christ with pinched features and crossed eyes give an effect of nervous tenseness contrasting with the monumentality of the Christ of Harl. 2904 (Plate 30). The technique is interesting in its use of streaky colour heightened by white patches, which further accentuates the linear tension.

Two eleventh century gospel books in the Pierpont Morgan Library (MSS 708 and 709) are illustrated in much the same style as Douce 296. Morgan MS. 709 appears to be closer in both style and date to the Douce Psalter, that is, after rather than before 1050; its provenance is uncertain but probably Winchester.[17] There are five miniatures: a Crucifixion (fol. 1 verso; Plate 43) remarkable for its emotional power, and four Evangelist portraits. The figures of John and Mary in the Crucifixion are exaggeratedly tall and the drapery over the angular bodies is drawn with long swinging lines, very much in the spirit of Douce 296. The cross is a crooked tree trunk with thick lopped branches. The kneeling woman who convulsively clasps the foot of the cross, and the personified Sun and Moon with faces half covered by their raised arms, give the picture a dramatic force which is climaxed in the tense expression on the face of Christ and the impulsively tender gesture of Mary who holds up her mantle to staunch the blood from his side. The colours are chiefly pale yellow patterned and shaded with brown, blue, soft green, and brick red; gold is used only for haloes, for dress trimmings, and for the frame.

The Gospel Book belonging to the library at Monte Cassino[18] (MS. BB. 437, 439) has

writing Evangelists, who are seated under decorated arches supported by columns with acanthus capitals and bases. Their symbols hover over them in fussy solicitation; the eagle of St John (page 166; Plate 45) perches familiarly on his head, and with bent neck and open beak seems to be exhorting the Evangelist as he writes. John leans over his desk, the drapery of his mantle folded around his body and falling in rich, but artificial, linear patterns which are shaded with colour in the deep folds. The position of the figure is distorted; the feet and shoulders are in profile, the head, waist, and legs in three-quarters view. The background is painted with zigzag, streaky lines, probably to indicate sky. Several of these features suggest that the prototype of this manuscript was a derivative of the Reims school: the ramping lions on the arch, the dynamic intensity of both Evangelist and symbol, the round-shouldered, distorted figure, the impressionistic background.

Closely similar to this manuscript is the Gospel Book which was made for Countess Judith (Morgan MS. 708).[19] Here, too, the figures are seated under arches, from the capitals of which spring stiff, interlaced foliage sprays in the manner of the earlier Trinity Gospels at Cambridge, as well as of some of the pages in the Benedictional of Æthelwold (cf. Plates 26 and 27). As compared with the Monte Cassino Gospels, the drawing in MS. 708 is stiffer and more stylized: the drapery folds are hard, and are indicated by uniform streaks of paint; the faces and hair are painted with strong colour (the John of fol. 66 verso has blue hair and beard and a pink face with red spots on the cheeks). It would seem to be a composite style resulting, perhaps, from a linear technique executed with brush and paint instead of pen and ink.

A small gospel lectionary[20] (Bod. MS. Lat. liturg. f.5) is closest in technique to the impressionistic painting of Reims,[21] the modelled figures and shaded draperies being only partially reduced to pattern. No symbols accompany the Evangelists (fol. 3 verso; Plate 48A). The colours are blue, green, and dark red; dull reddish gold is used for halo and book, and for details of the reading desk and bench and for the frame. The flat head and sharply broken contours of the figure, the broadly shaded draperies and curtains, and the humped ground line all recall, in simplified and conventionalized form, Reims painting, for example as in the Ebbo Gospels. The background is the plain vellum, and there is no decorative border, which is unusual in English manuscripts.

Coloured outline drawing of the mid eleventh century at Winchester is represented by a magnificent Psalter, Brit. Mus., Cott. MS. Tib. c.vi, the earliest known example of a psalter containing a preliminary series of Bible pictures. These and the other illustrations in the Psalter[22] fall into four groups: (1) those connected with the *compotus* (fols 5 verso and 6 verso); (2) eighteen full-page preliminary drawings (fols 7 verso–16) beginning with the Creation and ending with St Michael killing the dragon, and including five pictures from the life of David and eleven from the Passion cycle of Christ; (3) drawings of various musical instruments, including one page with David playing the psaltery (fols 16 verso–18); (4) four full-page miniatures within the psalter itself, *viz.* Christ in Glory (fol. 18 verso, preceding the prefaces to the psalter), David and the Musicians (fol. 10 verso, preceding Psalm 1), St Jerome (?) (fol. 71 verso, preceding Psalm 51), and Christ treading on the lion and the asp (fol. 114 verso, preceding Psalm 101). At the very end (fol. 126 verso) is a quatrefoil containing the Trinity. Wormald thinks the archetype of

the drawings may have been a set executed in the style of the tenth century Harley 2904. Two of the miniatures in Tib. c.vi are painted in full colour: Christ in Majesty (fol. 18 verso) and David and the Musicians (fol. 30 verso). There are also painted foliage initials with decorative framework borders without animals or figures, in the general style of the much earlier New Minster King Edgar manuscript (Cott. Vesp. A.viii; Plate 25). The stylistic characteristics of all the illumination in Tib. c.vi, both outline drawing and painting, seem to be those of a single hand. The manuscript offers, therefore, exceptionally interesting material for a comparison of the same style as developed in the two techniques, for example, fols 10 and 30 verso (Plates 50 and 51).

The painted miniature of David and the Musicians (fol. 30 verso; Plate 51) was evidently derived from some good Carolingian original.[23] The figures are compact and well-proportioned, with thick, wig-like hair coloured red or blue. The drapery folds, though much stylized, are shaded with white or yellow for high-lights and darker tones are accentuated with black or brown for the shadows. A curious use of stylized light and shade is seen in the circles or ovals of white pigment on David's elbow and on the abdomen and thigh of the musician Ethan. This feature occurs also on the knee of Christ in the other painted miniature (fol. 18 verso). Ornamental patterns consisting of quatrefoils, circles, and dots in bands are used on David's tunic. Similar patterns are found on the bars of the border framework of this page. The colours are light red, green, blue which when shaded with yellow produces a dull green – as in the tunic of the musician at the lower right – dull purple, and yellow used in place of gold for the crown and for the bars of the border framework. All the details of the composition are outlined with a broad, painted contour line of dull purple which has the effect of a shadow around the figure,[24] thus accentuating the modelling. The foreground consists of a series of little humps which are painted blue and shaded with a yellow high-light in the centre of each.

Turning now to the coloured drawing of King David on fol. 10 (Plate 50), one can see the linear technique in all its precision and clarity unencumbered with the heavy, shaded pigments, and in consequence both freer and more monumental in the rendering of the figure. With the exception of the hands (which are in pale red outline and hardly show in the reproduction) all the drawing has been done in brown ink and the colour applied to the line with the shadow technique, described above in the painting; not, however, wholly to accentuate the modelling, but also to differentiate between the colour of the mantle, which is blue, and the tunic, which is dull reddish brown. On knees and elbow appear the round spots in dull red which are carried over from the high-lights of the shading technique. On other pages they often appear as blue or green spots (e.g. fol. 13 verso). The ornamental bands with circles and dots and the humpy foreground are used here as in the painting, but with much greater effectiveness in this swift, impressionistic style.

In spite of the totally different techniques of painting and of coloured drawing used in the two miniatures in Tib. c.vi the artist seems to have been one and the same person: the head and face – eyes, eyebrows, nose, ear – are identical in the two Davids. A curious difference in the manner of representing hair and beard is that in the painting they are very linear and stylized though washed over with colour; in the drawing they are shaded softly with colour and appear more natural. On the whole, there is no question that the

artist was much more at home with the coloured drawing than with the painting.

In Brit. Mus., Arundel MS. 60, another fine psalter, made for Winchester *c*. 1060,[25] there are also two styles, one very much closer to a painted original than the other; but in this manuscript the illumination is certainly by two different hands, one later than the other. The first pages of the manuscript, illustrated with drawings of the signs of the Zodiac, and a full-page Crucifixion on fol. 12 verso (Plate 52) seem to be the work of an uninspired copyist of the figures and technique of the outline drawings in Tib. C.vi.[26] The shadow outline technique, the stiff drapery folds, and the quatrefoil and circle ornamental patterns appear again here; but the line is flat and hard and has the meaningless complexity of a design that was copied without being well understood. The Christ in this miniature seems to have been taken, with some adaptation, from the Christ of the Crucifixion in Tib. C.vi (fol. 12 verso); the Virgin from Mary Magdalene of the Three Marys at the Tomb (fol. 13 verso); and John from an angel above the arches of the Easter Table on fol. 3. The clumsy folds of the Virgin's veil and the draped mantle of John are good examples of this copying of misunderstood drapery. In Arundel 60, as in Tib. C.vi, yellow simulates gold in the miniature and also in the decorative border.

The *Beatus* page (fol. 13) opposite the Crucifixion in Arundel 60 has a typical late Winchester border with slender bars and twining foliage. The initial B is half historiated with David playing the harp in the lower loop and 'gymnastic' with a figure climbing in the branches of the upper loop. The figure style is totally different from that of the Crucifixion miniature. Both the initial and the border are painted in brighter colours, with crisp, sharp outlines and jewel-like ornament.[27]

The second Crucifixion miniature on fol. 52 verso (Plate 53) is very different from the first and is probably somewhat later. The source of this style is puzzling; it is exaggeratedly stylized into an angular linear pattern and the face shows some conventionalized modelling in pink lines, with red spots on the cheeks. The hair and beard are dead black; the torso and limbs are reduced to an anatomical scheme of pink and blue lines; the drapery is pleated in flat geometric folds and bordered with a jewelled pattern. The sharp angles of the crucified Christ are echoed in the swaying curve of the two flanking trees, which have pink trunks and branches, atop which are perched solid blue ovals patterned with foliage and red flowerets; the foreground consists of a series of blue and pink disks. Black outline is used around all the details of the composition. Except for the yellow bars of the framework border and the green backgrounds of the symbols of the Evangelists in the corner roundels, only vermilion, blue, and a dull pink are used. Yet the effect of the page is striking. Though the model may have been Byzantine,[28] this artist has injected into it a new element of powerful abstract pattern based on line and colour, which gives the miniature an eerie, other-worldly effect.

A different form of Byzantine influence is found even earlier in two stylistically related manuscripts of the mid eleventh century (Plate 49); this too probably was not introduced through direct contact with Eastern models but rather through Ottonian manuscripts, perhaps of the Reichenau school.[29] One of the two (Camb., Pembroke College, MS. 302), a Gospel Book, contains a description in Anglo-Saxon of the boundaries of the see of Hereford, and the manuscript itself may have been made there;[30] the other (Brit. Mus.,

Cott. MS. Caligula A.xiv), a troper,[31] is so close in style that it too has been assigned tenta-tively to Hereford.[32] Both manuscripts are remarkable for the boldness of their figure drawing and for their use of burnished gold and of strong, heavy colours, chiefly brick red and reddish purple, yellow, and dull green. With these colours, white, now oxidized, is used for the high-lights of the modelling. Backgrounds are painted in strong colour – sometimes purple, perhaps imitating a stained vellum leaf – with conventionalized wavy patterns representing clouds. The illustrations in Caligula A.xiv have crowded composi-tions barely confined within the formal frames (fol. 25; Plate 49A). Heads, hands, and feet are large, and features are boldly modelled. Characteristic of the heads are the stiffly curled coiffures, the strongly arched eyebrows, and the heavy square jowls. The drapery folds are so heavily stylized as to suggest stripes. Violent gestures and much use of long, swinging phylacteries intensify the excitement, as in the scene of the martyrdom of St Lawrence.

The Evangelist miniatures in Pembroke 302 are also in long, narrow panels similar in proportions to those in Caligula A.xiv. Though the single figures appear more monumental in themselves there is the same extraordinary excitement in their poses and gestures (cf. Luke, fol. 60 verso; Plate 49B), and the same strong colours are used; the mantles are burnished gold, patterned with incised lines which were originally filled with some dark or perhaps black pigment resulting in a niello-like effect. In the Luke miniature, the draped curtain of the background is light red shaded with white and darker red, and tucked into the folds are gold ball ornaments. Luke's hair and beard are blue, and red lines are used to model his face and hands. His tunic is light purple shaded with darker tone. The richness of the colouring and the strong shading are unusual in English illumination and are the characteristics that suggest Ottonian or late Carolingian figure style with strong Byzantine elements. It is noteworthy that the symbols of the Evangelists are not represented – an omission suggestive of Eastern iconographic sources.

Durham

More important even than the Canterbury and the Winchester manuscripts for the problem of English and Norman attribution of post-Conquest art, are some sixteen manuscripts with illuminations which formed part of a gift of about fifty by William of St-Carilef (now St-Calais), Bishop of Durham (1081–96), to the Cathedral Library.[33] The Carilef manuscripts fall into two groups: those made before his exile[34] in Normandy in 1088; and those made after that date, presumably in Normandy. Differences in the style of illumination can be distinguished, and it seems reasonable to assume that the style of the earlier group represents the survival in the north of England of pre-Conquest decora-tive elements with influence from the Continent, as at Canterbury, while manuscripts of the later group were perhaps illuminated in some Norman monastic scriptorium. For both of these assumptions the only evidence is stylistic.

The finest and most typical representative of the first group of Carilef manuscripts, made in great part before 1088, is the large Commentary of St Augustine on the Psalms, a manuscript originally in three volumes; a colophon in the last volume (B.ii.14) records

that it was written in Normandy. The second volume (MS. B.ii.13) contains on fol. 102 (Plate 56B) an initial I with a portrait of Bishop William under a bust of Christ Blessing, and in the bottom loop of the initial, a kneeling figure of a monk labelled 'Robertus Beniamin' who is assumed to be the illuminator. The decorative style of this and of several other initials in the volume (fol. 68; Plate 57A) consists of motifs drawn from earlier English initial style – animals and animal heads, interlace and acanthus leaves – all sprinkled liberally with rows of red dots. The designs are placed against solidly coloured backgrounds, as in the Canterbury post-Conquest initials. The English elements of this decorative style are the small, complete animals or animal heads of gentle, kitten-like type – tame descendants from remote South English and Mercian ancestors – and the interlace patterned with dots. Foreign to this tradition are the fierce and gaping mask type of animal heads used as terminals (usually with acanthus leaves issuing from their mouths) and the coloured backgrounds. The colouring of the design also is typically Norman: much red and green in rather streaky lines and thin wash are used.

The figure style of the initial containing the two portraits is flat and linear and distinctly feeble. Characteristic of the heads are the enormous round eyes and heavy arched eyebrows; both the heads and the hands are too large for the body. If this work was typical of Robert Benjamin, he was not much of an artist, and the style would be of little interest were it not for its close relation to some similar work of bolder character which is thought to be the product 'of one and the same atelier'.[35] This second manuscript is a copy of St Jerome's Commentary on Isaiah (Bod. MS. 717) and contains at the end of the last page (fol. 287 verso) a small picture of a little man in a blue cowled and sleeved mantle over a white gown, with green hair, labelled: 'Hugo pictor' and 'imago pictoris et illuminatoris huius operis'. The manuscript contains, indeed, some fine pages of painting in the grand style: fol. v verso has a full-page miniature of the Prophet Isaiah seated under an arch draped with curtains and supported by marbled columns with acanthus capitals and bases. Above the arch is an elaborate display of architecture. The figure is dignified and well-proportioned and richly clothed, with much decorative pattern on the drapery. Opposite this page (fol. vi) is a miniature of Jerome and St Eustochium[36] also seated under arches which form part of a building. The figures are solidly drawn and delicately modelled, although the technique in both miniatures is more linear than painterly, and the colour is thin and shaded only with lines. The miniatures[37] are clearly the work of a painter and Hugo had reason to be proud to claim them. There are also in Bod. 717 two historiated initials with elaborate decorative designs (fol. vi verso; Plate 56A) which have many of the features of those in the Carilef St Augustine: the animals and huge animal heads with acanthus branches in their mouths, the acanthus foliage and the interlace; and within roundels formed by the branches, figures which are so similar to those of the initial I in the Durham manuscript that they could easily be by the same artist, in this case by 'Hugo pictor'. The question then arises whether 'Robertus Beniamin' is, after all, the illuminator of the Durham manuscript, and it must be admitted that on this point there is no evidence. The Durham St Augustine portrait initial, therefore, might also be the work of the 'Hugo painter and illuminator' of the Bodleian manuscript. In view of the differences in style between the decorative initials of the Durham manuscript and the I containing the

portraits, it may very well be that most of the initials were done by a 'native' artist, and that the initial with the portraits, which has much less fine decoration, was the work of a 'foreigner', that is, Hugo, who was perhaps a Norman.

The other group of illuminated Carilef manuscripts is best represented by a great Bible (Durham Cath. Lib., MS. A.ii.4), originally in two volumes of which the first is now lost. The illumination in this manuscript also consists of elaborate decorative and historiated initials but in a style which is different in many respects from that of the St Augustine. Plate 57B illustrates one of the types of initials (fol. 87 verso), and Plate 58 another (fol. 65). All the initials are of large size and contain florid, rather coarse designs of acanthus foliage, and interlace terminating in enormous gaping dragon heads; there are also whole dragons swallowing acanthus leaves and waving their acanthus tails behind them. These are features, as we have seen, of the St Augustine, but the 'kitten' heads and the rows of dots and other smaller decorative details in the St Augustine are replaced in the Bible by the rank foliage and the writhing clawed and winged dragons who swallow everything they can get their mouths on. The backgrounds are strongly coloured – red, purple, green, or blue – and the design is drawn with a broad pen in brown, red, and green. The angel, symbol of Matthew (fol. 87 verso; Plate 57B), is a good example of the treatment of the figure, which is wholly linear, with the mantle painted in broad bands of red and blue and the tunic washed with flat vermilion and bordered in fawn colour. Wings are gay with spots and lines of all colours, and the angel's hair is bright green. The background is painted with flat green and purple. The style is startling in its sharp contrasts of strong colour, but the drawing is bold and free and the initials constitute brilliant and varied ornament on a scale suitable to the great size of the pages.

One of the very finest of all is the B of the *Beatus* beginning the first psalm (fol. 65; Plate 58). The form and design of the initial may be compared with the Winchester style B of Harl. 2904 (Plate 21B): the upright of the letter with knots of interlace at top and bottom, terminating in a large animal head, corresponds fairly closely, but the loops of the B in the Durham Bible, instead of forming a frame for the panels of acanthus, are themselves acanthus scrolls which coil and twist back and forth, catching their fleshy stems or curling leaf tips in the meshes of their own convolutions. Ramping in the midst of this whirling coil is a winged animal with curly tufted mane and leafy tail hardly to be distinguished either in form or in colour from the foliage around him. Below, seated on a curved branch, is David with his harp, a figure painted in streaks and washes, bold in drawing and strong in colour. The background shows in the interstices of the branches as flat areas of colour – alternately red, purple, blue, and green.

To evaluate properly this striking style one must see the originals, for the colour is an essential element of the design. Nothing like it can be seen in English illumination of an earlier date, and it seems not to have affected later English style, except as the decoration in initials tends to become increasingly large and heavy under the general influence of Romanesque painting. Recently, illuminated manuscripts in Normandy have been discovered which have so much in common with this flamboyant style that they would seem to have come from the same centre.[38] In drawing, in colouring, in figure and fiery dragon types, the style is almost identical; and although the provenance of the Norman

manuscripts is not known, it seems to fit better with the hard linear version of the Winchester style which developed in Normandy as a result of earlier importations from England than with the developments in England itself. This fact, in combination with the known sojourn of William of St-Carilef in Normandy during the latter part of his life, points to the possibility if not the certainty that the Durham Bible style is Norman and not English. More precise attribution of this style to specific centres awaits further study of the Norman manuscripts.

The Bayeux Tapestry

The Bayeux Tapestry (Plate 47) is a strip of embroidery over 230 feet long and about 20 inches wide; it is now displayed under glass in a special room in the town hall of Bayeux, but it was made to be hung on the wall of the Cathedral. The subject matter consists of scenes from the life of Harold both before and after he became king of England, culminating in his defeat at Hastings in 1066. A narrow border, now destroyed at one end, originally surrounded the whole panel. It contains a variety of animal and bird motifs and many different subjects such as fables, genre scenes (perhaps taken from calendar illustrations), and representations of the constellations. The border usually has no relation in subject to the story as it unfolded in the embroidery strip, each episode of which has an inscription identifying what is happening.

The English provenance of the embroidery, though still lacking conclusive proof, seems most plausible when we compare its lively illustrative 'strip narrative' style with such manuscripts as the 'Cædmon' Paraphrase (Bod., MS. Jun. 11; Plate 44) and with the historiated initials in later manuscripts of the post-Conquest Canterbury groups (Plate 46A). As for the animals of the border, as Kendrick remarks,[39] they 'might have come straight out of the Trinity Gospels, MS. B.10.4 (e.g. fol. 57)'; and the charming little hunting and agricultural scenes in the borders suggest Cott. MS. Julius A.vi and the Canterbury copy of the Utrecht Psalter (Harl. 603). The influence of the Utrecht Psalter style, which could in itself account for a great many individual figures as well as for the general style of the embroidery, was, it is true, also felt on the Continent; it might be argued, therefore, that the design and style of the tapestry could be French as well as English; yet the fact remains that both English embroidery and English illumination seem to have been sufficiently known and admired on the Continent to support the assumption, which the stylistic qualities suggest, that the design as well as the workmanship was English. In the most recent study of the embroidery Wormald notes English influence also in the inscriptions, especially proper names.[40] The latest consensus is that the Bayeux Tapestry was ordered in England by Bishop Odo, brother of the Conqueror, for his cathedral at Bayeux (consecrated in 1077) in the decade immediately preceding.[41] In the latter part of the tapestry Odo figures prominently in a number of the scenes.[42]

The embroidery is on linen in wools, formerly of eight colours but now much faded: three shades of blue, two of green, red, yellow or buff, and grey, all used arbitrarily as in English coloured outline miniatures.[43] The accuracy of the details, such as the distinction between the Normans and English by the difference in their haircut, the ships, the armour,

and even the architecture – Westminster Abbey in the scene of the funeral of the Confessor – would indicate that the designer of the embroidery was thoroughly familiar with both Norman and Saxon characteristics and customs. This interest in details, together with the vivid narrative spirit, is an outstanding trait of English eleventh-century illumination. Probably the most dramatic and exciting scenes are those of the mêlée itself (Plate 47B) in which horses and riders fall headlong, and dead and dismembered soldiers fill the lower margin.

The two details of the Bayeux Tapestry reproduced in plate 47 are typical of the most frequently recurring motifs (horses and boats) but convey no idea of the impressiveness of the design as a whole. The principal actors in the drama appearing singly or in groups, in architectural settings, on horseback, or in boats, give accent to the pattern as the story unrolls, and incidents are set off from one another by decorative trees, which serve the purpose of dividing the epic into stanzas of unequal length. The rhythm is kept by the recurrence of these same few motifs. Seen as a whole, the design is astonishingly well-balanced, varied and interesting, and in the original bright colours with which the embroidery was done must have been startlingly gay and brilliant, though now it appears rather dull and uniform in tone.

Summary

The latter half of the eleventh century, especially after 1066, was primarily a period of political and monastic reorganization in England, hence it was one of the meagre periods for art, as to both quality and quantity. The Canterbury manuscripts, as produced at St Augustine's and Christ Church throughout the period, the Bayeux Tapestry produced no one knows where, and the Durham manuscripts probably made partly at Durham and partly in Normandy, are almost the sum total of pictorial art of the period. At Christ Church, Canterbury, Norman influence was direct and constant but not revolutionary in its effect; it served rather to stimulate the decoration of books with new forms of initials, especially the historiated initials which combined rich decorative designs and bright colours with representational subject matter. At Durham also the conservative tradition of animal ornament and interlace, with small patterns and a modest form of acanthus foliage, was perhaps the current style. Figure painting is limited in amount and its style probably stems from some other atelier, perhaps that of a Norman artist in England, or from Continental importations of miniatures. The later manuscripts of Bishop William of St-Carilef are much closer to Norman than to current English work and may have originated in Normandy.

Thus in pictorial art the period is one of assimilation of new elements which fitted into the insular tradition, and of reorganization of new and old elements in readiness for the flowering of the great Romanesque Period which is to follow.

ROMANESQUE ART OF THE TWELFTH CENTURY

★

HISTORICAL BACKGROUND:
ANGLO-NORMAN FEUDALISM AND MONASTICISM

POLITICAL

Henry I, King 1100–35. Organization of Anglo-Norman feudalism and internal law in England.

Stephen, nephew of Henry, crowned 1135; deposed 1141 (April); recrowned 1141 (December); died 1154. Political upheavals over the succession. Second Crusade 1147–8, in which many English took part.

Henry II, nephew of Henry I, King 1154–89. Married Eleanor of Aquitaine 1152; spent much time in France; his son Henry crowned king 1170; used style 'rex Anglorum et dux Normannorum et comes Andegavorum'. Died 1189.

ECCLESIASTICAL

Thomas Becket, Archbishop of Canterbury 1162–70; martyred 29 Dec. 1170; canonized 1173; translated 7 July 1220.

Henry of Blois, brother of King Stephen, brought up at Cluny (1110–26); Abbot of Glastonbury 1126–9; Bishop of Winchester 1129–71; journey to Rome 1151–2.

White monks (Cistercians) arrived at Waverley (Surrey) 1128; Rievaulx (Yorkshire) founded by Bernard of Clairvaux 1132; Fountains founded same year; 1135–67 (death of Ailred, Abbot of Rievaulx) Cistercians at their height; about forty houses founded in this time.

★

FOR twelfth century art in England, the reign of Henry I, and even the turbulent one of his nephew Stephen, were extremely important not only because of the close political and ecclesiastical connexions with France but even more because of the 'traditional relation with the Norman rulers of Sicily who were then planning a Mediterranean empire'.[1] Moreover, further direct connexions with the Continent followed upon the establishment in London by 1157 of German merchants, who imported goods from Constantinople via the Danube and the Rhine.[2] In England itself, 'the reign of Henry I was the heyday of Anglo-Norman monasticism', according to Knowles,[3] who continues: 'Norman and Anglo-Norman abbots continued to build, both materially, intellectually, and spiritually, upon existing foundations, and not only houses at important centres such as Canterbury and Winchester, and at shrines such as Bury, Malmesbury, and Durham, but also those in the remote fenland, such as Thorney and Croyland, became seats of an intense literary

culture and schools of calligraphy and illumination.' Likewise, in the reign of Stephen there was an extraordinary exuberance of life among all the new religious bodies of men, and nunneries also were founded in great numbers. With the prohibition of further Cistercian houses in 1167, in the last decades of the twelfth century the rate of increase in religious foundations perceptibly slackened.

Of the two main sources of Continental influence noted above – Byzantine and Cistercian – the former was overwhelmingly more important in its effect on pictorial art.[4] The new stylistic elements characteristic of twelfth century art derive not from western monastic centres in France and Germany, as in the preceding period both before and after the Conquest, but from further east, from Byzantine art in Norman Sicily and from Constantinople itself through contacts opened up by the Crusades. Saxl[5] has summed up this Byzantine heritage received into English art under three heads: the idea of hieratic deity; the monumental style of wall painting inspired by Byzantine mosaics; the use in manuscripts of a framed composition with painted or gilded background and, within this frame, a well-defined and elaborated arrangement of figures. This threefold heritage from Italo-Byzantine sources largely determined the character of Romanesque pictorial art in England, as distinguished from Anglo-Saxon.

The firm, unbroken contour line of the early twelfth century seems to have been re-invigorated through new contacts with classical prototypes, or their Carolingian intermediaries. An early twelfth century Bestiary[6] (Bod., MS. Laud. Misc. 247), probably the earliest copy after illustrated Carolingian manuscripts of this text, has line drawings in brown ink, without colour or shading, which have the monumentality of classical modelled figures. This manuscript perhaps comes from Christ Church, Canterbury, and in Canterbury at an early date other Carolingian manuscripts of classical type are known to have existed and been copied. Indeed, some of the animals in Bod. MS. 247 suggest, in the firmness of their technique, animals in the Harleian *Aratus*,[7] and its superb copy, Harl. MS. 2506. Another drawing in this same style, also from Canterbury, probably from St Augustine's Abbey, is the full-page figure of Christ which was added to the Bosworth Psalter (Brit. Mus., Add. MS. 37517), 'almost certainly ... copied from a pre-Conquest drawing',[8] towards the middle of the twelfth century.

An example of early twelfth century outline technique of the firm contour type, but painted in strong colours, can be seen in the pictures of the four Evangelists in a Gospel Book in the Morgan Library (MS. 777, fol. 24 verso; Plate 63B). The Evangelists are clearly derived from much earlier Carolingian models[9] in a curious representation showing them seated on their symbols, which is thought to come from oriental sources.[10] A rhythmic pattern is evolved from the contours, poses, gestures, and curling scrolls of these figures and their symbols; the heavy black contour line suggests twelfth century stained-glass technique. The colours, principally green, blue, and tan, are fine and clear, shaded only with lines, and are used indiscriminately for details;[11] faces, hands, and feet are outlined or lightly shaded with red. This manuscript also possibly was produced at or near Canterbury.[12]

The framed composition with its orderly arrangement of figures and its firm contour technique was well suited not only for single scenes as in the Bestiary, but also, and perhaps

even better, for narrative scenes in a series. At the same time, fresh material for such treatment was furnished by a newly awakened interest in illustrated lives of local saints. This combination of lively subject matter and clear-cut technique gave rise to the 'outburst of pictorial narrative' which Pächt describes as 'one of the most astonishing phenomena in the history of medieval art'.[13] The earliest English example is a copy of Bede's Life of St Cuthbert (Oxford, Univ. Coll., MS. 165). The scene reproduced in Plate 59B represents one of the miracles in the life of the Saint: at the end of a day's journey he found himself without food or shelter, but seeing some deserted shepherds' huts he tied his horse inside and began to pray. Suddenly he saw the horse seize the thatch with its mouth and drag down amid the straw a folded cloth, containing a loaf still warm. Such action packed into a single scene is typical of early twelfth century pictorial narrative. The St Cuthbert manuscript is illustrated in three different styles, all apparently, judging by peculiarities of detail, produced by the same artist. The styles are as follows: the miniature opposite fol. 1, of the author writing and presenting his book to the monks, is in a completely painted style, with a blue background and a formal border containing stylized acanthus leaves. The colours are dull green and grey, with brown shading for drapery folds; faces have been painted with a pigment which has now turned black. On fols 1 and 5 are decorative initials in the painted style, on red and blue painted grounds. On fol. 4 verso is a miniature framed like the one above, but in outline; the figures, however, push out in all directions, as though the composition could not be contained within the limits of the frame; the technique is outline, in brown ink except for faces and hands which are in red; red or green shaded colour is used for garments, which are ornamented with bands of gold edged with white dots, or beads. The third and final stage in the evolution of this style, in which the artist obviously comes into his own in perfection of technique, appears on fol. 11 verso (Plate 59B), following several other tentative efforts to free himself from the formal, painted miniature style. The clear, fresh drawing on fol. 11 verso and thereafter is done in colours: red, green, and violet. Brown is used only for heads and hands. Though the composition of the picture suggests the rectangular form of a miniature, there is no frame; the pictures are literal illustrations of the text, in the manner of the Utrecht Psalter. In some of the later miniatures there is evidence that figures and architectural details are lacking which may have been present in a prototype,[14] perhaps cut off at the sides, as in the Utrecht Psalter. Echoes of an earlier style can be seen also in the figure types, especially those in profile.

Of two early twelfth century examples closer to the Utrecht style, one (Durham Cathedral Library, Hunter MS. 100) was executed before 1135 and perhaps even before 1128,[15] probably at Durham. The drawings illustrate the text, a collection of short pieces dealing with medicine, the Compotus, and astronomy; they are partly tinted in red and green.

The other example of this same impressionistic style (Brit. Mus., Cott. MS. Titus D.xvi) contains (fols 1–36) Prudentius's *Psychomachia*, which is illustrated with much the same spirit as the eleventh century copies but in a different technique. It is dated *c*. 1100 and is particularly important because of a (contemporary?) inscription (fol. 37) stating its ownership by St Albans Abbey.[16] The figures (fol. 17 verso; Plate 59A) are very tall, slender, and lively, and are frequently represented in profile and poised for action, on tiptoe.

Their faces are eager, their gestures are free and usually well and correctly drawn. The technique is coloured outline tinted in the deep drapery folds with thin colour used as a wash. The draperies are ragged in contour and whip round the figures revealing the shape and movement of the bodies. The faces are not modelled, but the hair is darkened around the face to suggest the soft, thick mass. The miniatures have no frames and almost no indication of ground line.

Finally, Wormald has called attention[17] to a remarkable twelfth century 'copy' of the Harl. 2904 Crucifixion (cf. Plate 30) in a manuscript of the Chronicle of Florence of Worcester (Oxford, Corpus Christi Coll., MS. 157, fol. 77 verso; Plate 60) in which colour is used both for outline and for shading on the drapery and faces as in the earlier Harl. 2904. There is an amazing clarity and repose as well as a monumental solidity in the figures; but the emotional fervour of the Harleian Crucifixion has subsided. Drapery ends still fall in intricate linear patterns, but the curves are exaggerated and conscious; the figures are gracefully posed and stand firmly on their feet, but their faces are blank and they point with self-conscious moral purpose to the figure of Christ crucified, of which the accompanying text gives the symbolic explanation. This drawing is very much twelfth century in spirit; it may have been done as early as 1130, but seems to have been redrawn, as Pächt has suggested, under the influence of mid twelfth century style, such as is found in Bod. MS. Auct. F.2.13, an illustrated Terence[18] manuscript made at St Albans, of which more will be said later on in this chapter.[19]

The manuscripts of the first half of the twelfth century thus far discussed can be accounted for as variations on earlier English or Continental models tending towards a new monumentality characteristic of Romanesque art in general. Their subject matter, too, with one or two exceptions, is carried over from preceding periods, but the scale and magnificence of the psalters and gospel books and commentaries common in the earlier period is greatly increased in the second quarter of the twelfth century. This period has been called the 'first flush of Romanesque', and its style results from contacts with Byzantine art, probably in the first place through Continental intermediaries.[20]

The new elements first appear in a psalter written between 1119 and 1146, probably before 1123, at the Abbey of St Albans, known as the St Albans or Albani Psalter,[21] now in the Library of St Godehard, Hildesheim. The St Albans Psalter is fully and splendidly illuminated with calendar pictures, a fine *Beatus* (Plate 62A), and other initials introducing individual psalms; following the Calendar are forty-three full-page miniatures of the life of Christ, and at the end (pp. 416 and 417) two additional pictures: the martyrdom of St Alban and David and the musicians. In addition to the psalter, the Hildesheim manuscript contains (pp. 57–68) a poem on the life of St Alexis, with a picture, and three full-page scenes from the Emmaus story.

The illustration in the Albani Psalter is by several hands. The calendar pictures and the initials, except the *Beatus*, and two miniatures at the end of the psalter are by two very similar ungifted hands, probably St Albans illuminators.[22] The preliminary miniatures are by a very different hand. (Cf. Plates 61 and 62B.) The *Beatus* initial, and also the spirited sketch of a knightly combat in the upper part of the page (p. 72; Plate 62A), and the Alexis and Emmaus miniatures seem to be in a style which falls between that of the biblical

miniatures and the psalter initials: it is flatter in modelling, more stylized and linear in treatment than the miniatures, and is coloured with thin wash. In spite of these differences, all the preliminary miniatures may be by the same hand. As for the *Beatus* figure, especially the head of David seems to have been copied from the Christ in plate 61, except that in the David the artist has somehow missed the effect of foreshortening of the face on the far side, has increased the size and prominence of the ear, which hangs like a gypsy hoop ear-ring outside his hair, and has lost the expression in the eyes. These differences between the David of the initial and the figures in the miniatures seem to indicate that the competent painter of the miniatures had an assiduous follower who was striving to imitate the master's style. He was not, it would seem, the illuminator of the other initials, who also was affected by the style of the miniatures, but who understood much less well what it was all about. His figures (Plate 62B) are completely linear with thigh and drapery, hose and hair all heavily outlined and coloured with thin wash put on with a striped effect to suggest shading. Faces too are delineated with lines only, and all, except the frontal Christ, are seen in full profile. No ears at all are shown and hands are enormous. The decorative motifs in this initial are only interlace, also painted with the striped effect, and circles in the background. It is impossible to attribute the two initials on plate 62 to the same artist; yet, on the other hand, it is almost equally impossible to attribute the David to the painter of the preliminary miniatures. The most reasonable explanation of the differences in the style of the illumination, therefore, seems to be two hands learning from the work of a very competent master.

The style of this master, which apparently was formed on Byzantine models[23] (Plate 61), is impressive, if rather heavy and solemn. His figures are tall, and thin in the shoulders, but have solid, fleshy thighs, long legs, and huge feet usually represented as though on tiptoe. The faces are elongated ovals with a firm, rounded chin. When seen in profile a suggestion is retained of the face beyond the nose; when in three-quarter view, the far side is foreshortened, but there is trouble with the far eye which gives the face a curious flattened contour. The drapery is painted in heavy solid colour, with high-lights in white lines which often are arranged in odd cobweb-like patterns, as over the thigh and arm. Deep shadows are indicated by heavy dark or black lines, and the ridges of folds between these deep lines are lighter than the foundation colour. The architectural setting is a Byzantine derivative, with twisted columns and domical cupolas with arcades and many openings shaded with dark and light areas and broad lines in the manner of conventionalized Byzantine buildings. The background is divided into compartments – by the architecture, in this miniature – which are coloured differently; but the figures are not kept within these panels, or even within the field of the miniature itself, toes and fingers protruding beyond the conventionalized foliage frame which surrounds the picture.[24] The frame is treated somewhat like the border on a carved panel or book-cover, with the upper corners chamfered, but the lower band of ornament runs clear across the bottom, joining awkwardly the side panels.

Who was the fine artist of the preliminary miniatures and where did he come from? Swarzenski assumes that he was English and attributes to him, correctly, the surviving miniature in an English manuscript in Verdun.[25] No other work by the 'Alexis Master'

is known.[25a] If he was English, he must at some time have had close contacts with a Continental monastic centre where the influence of the great Reichenau school of illumination of a century earlier lingered on[26] and was further invigorated by fresh Byzantine contacts. Or is it possible that a Continental artist came to the scriptorium at St Albans among those who were invited by Abbot Paul (1077-93), of the Abbey of St-Étienne, Caen, of whom it is recorded that he collected scribes from everywhere to work in the St Albans scriptorium?[27]

Although the source of the St Albans miniature style may never be decided, its influence is incontestable. Probably the first to register this influence is a magnificent manuscript with pictures and text of the Life and Miracles of St Edmund of East Anglia (New York, Morgan Lib., MS. 736), datable 1125-50 and perhaps even more closely before 1135.[28] The figures (fol. 9; Plate 65) have the same long, narrow bodies, heavy, shapeless legs, large feet and hands; and the faces show the same large wide-open eyes and drooping mouths. But the technique of the painting is less crisp than in the Psalter miniatures, and there is much more interest in decorative detail, not only in the setting of the picture, but in the treatment of pattern on the clothing of Edmund and even of the skin garments of the petitioners, and in the stylization of the shading of the drapery folds. Yet it does not seem to be the thin, completely linear style of the artist of the initials in the Albani Psalter, but rather the hand of the competent and assiduous imitator, who painted the *Beatus* initial. In the St Edmund miniatures the solidity of the St Albans style has disappeared: ridged folds have become mere double lines; a rounded thigh has turned into an oval where a series of diagonal white lines are meant to suggest its roundness. Faces are seen in almost paper-flat profile, except that of Edmund which, though seen in three-quarter view, has the regular oval contour of a full front view. The decorative patterns of the frame are geometric linear motifs, as is also the design on the under side of the arch and on the buildings at the back and the details of decoration on the throne. This seems to be a faithful attempt on the part of the St Edmund artist to absorb the essentials of the figure technique as found in the preliminary miniatures of the Albani Psalter, but his medium of expression is so fundamentally linear that in applying the painted technique, he must needs regularize even the painted areas of the originals by confining them within hard lines.

The identification of the Edmund artist with the illuminator of the St Albans *Beatus* initial seems to be confirmed by comparison of the miniature (fol. 7 verso) of the Morgan manuscript representing the Battle with the Danes (Plate 64) with the very lively single combat scene above the B on the same *Beatus* page of the Psalter. The horses are identical, both in position and in the treatment of the heads, both ears showing, though the animal is seen in profile; and the riders, in the manner of representing their chain mail armour as well as in their violent gestures, seem too close to have been done by a different hand and certainly, if one can judge by the spirit of the drawing, are not copies. The Battle miniature in the Life of St Edmund is painted only with thin colour; the technique is fundamentally outline, and the figures are silhouetted against the magnificent plain blue ground with the clarity and effectiveness of a tapestry design. But it is to be noted that, as in the Albani miniatures, the figures will not be confined within the frame but partly disappear behind it and partly push out over its edges.

The superb draughtsmanship of the artist of the St Edmund manuscript shows to even better advantage in the few uncoloured full-page miniatures which precede a copy of the gospels given to Bury St Edmunds in the early fourteenth century, but believed to have originated there in the mid twelfth century (Camb., Pembroke Coll., MS. 120). The text, which according to James[29] was written in the first decades of the twelfth century (copied from a Bury St Edmunds Gospel Book), may be somewhat earlier than the series of twelve Bible pictures (see Plate 66, fol. 5 verso). These are without any doubt dependent upon the style of the miniatures by the Alexis Master in the St Albans Psalter. Their characteristics seem to betray the same hand as the St Edmund miniatures in the following details: the exceedingly tall figures with cramped, narrow shoulders and heavy thighs and large feet and hands; the flat profiles, except for the Virgin in the upper picture, whose face is seen as an unforeshortened oval though represented in three-quarter view; the large, wide-open eyes, long noses with a hump on the bridge, the drooping mouths and the decorative treatment of the architecture. It would appear that the drawings in Pembroke 120 were intended to be painted, since there is no indication whatsoever of shading in the drapery folds, and such pure contour drawing would be rare in England at this time. In fact, the first few miniatures (fols 1–3) have been very badly painted in pale colours, certainly by a different hand, though perhaps not much later. The historiated initials in the text of Pembroke 120 were probably drawn at the time the manuscript was written, but were painted at the same time as the preliminary miniatures; the initials show signs of being influenced by the preliminary drawings and might easily have developed out of this drawing style at Bury itself. What seems certain is that the Pembroke miniatures were drawn by the artist who painted those in the St Edmund manuscript, and that his style came directly out of the miniatures of the St Albans Psalter.[30]

Closely related to the St Albans–Bury style are four large leaves[31] containing a long series of small scenes from the Nativity, Ministry, and Passion cycles of Christ. The leaves were almost certainly intended as preliminary leaves to a psalter, and on stylistic grounds have been assigned most recently to Canterbury (see Note 33 below). There is, however, no documentary evidence for either provenance or dating, nor are there any indications as to the manuscript for which they might have been painted. They are now scattered among three different collections as follows:

New York, Morgan Library, MS. 724. Recto: twelve scenes from the lives of Moses and David. Verso: an additional two scenes from the life of David; the Jesse Tree; the Visitation, Birth of the Baptist, Naming of the Baptist, and the Nativity.

Brit. Mus., Additional MS. 37472. Recto: Shepherds, six scenes from the Magi story; Presentation of Christ, Angel appearing to Joseph, Flight into Egypt, Slaughter of the Innocents, and Death of Herod. Verso: Baptism; Wedding at Cana, Three Temptations of Christ, and a series of the Miracles.

New York, Morgan Library, MS. 521. Recto: continuation of the Ministry of Christ. Verso: early Passion cycle, up to the Betrayal.

London, Victoria and Albert Museum, MS. 661. Recto: continuation of the Passion Cycle, ending with the Deposition. Verso: end of the Passion Cycle, the Appearances, the Commissioning of the Apostles, the Ascension, and Pentecost.

Each leaf is divided into twelve squares framed by borders consisting of double gold bands enclosing stylized leaf and other motifs; the whole page is surrounded by a similar border containing a different pattern at the top and bottom from that of the two sides. On the first leaf (Morgan 724) each square contains only one scene; on the verso, the Tree of Jesse occupies the space of several squares. The Infancy cycle on Add. MS. 37472 recto (Plate 67A) also contains one scene to a square; but on the verso of this leaf, the scenes of the Ministry occur two to a square, and this practice continues on the second Morgan leaf (MS. 521) and on the Victoria and Albert leaf (Plate 67B). Important scenes, however – the Crowning with Thorns, the Crucifixion, the Deposition, the Ascension, and Pentecost – occupy a whole square. The cycles are amazingly complete.[32] The inclusion of so elaborate a series of scenes of the Ministry and Miracles of Christ suggests the possible influence of Early Christian or Carolingian wall paintings; on the other hand, it recalls a partial, surviving series of similar small scenes in rectangular panels found in the sixth or seventh century Gospels of St Augustine (Camb., Corpus Christi Coll., MS. 286) which was still at his abbey in Canterbury at this time. The fashion of prefixing Bible pictures to psalters is not known earlier than the eleventh century Cotton manuscript Tib. c.vi (q.v.) and all the early examples are English.

The Bible picture leaves are not all by the same hand, and this fact complicates their attribution on stylistic grounds to any one centre. The British Museum leaf, for example, is painted in a flat and linear 'old-fashioned' style, that is, the technique seems to be outline drawing with flat colour used to fill the area between the lines. The figures are more normally proportioned than in the miniatures of the St Albans Psalter and more informally posed. Drapery is less deeply shaded for the folds, and when these are indicated, they are likely to form stylized patterns. The figures are not very lively in pose and gesture, and their heads are rather large for their bodies. The designs of the individual scenes are all planned in relation to that of the whole page, with alternating colours used for the backgrounds, and compositions balancing each other on the page. This is also true to a certain extent of other leaves, such as the one in the Victoria and Albert Museum, No. 661 (Plate 67B), but the compositions in this case do not always balance, since some are two to a square and others only one. But the style of the figures in the Victoria and Albert leaf is much livelier: the gestures are more violent, the bodies more roundly modelled, the actions and poses more exaggerated. Although the figures are not of the long, narrow type of the St Albans and Bury style, they certainly have picked up somewhere the painted type of drapery folds and the more modelled heads. The style of this page is, however, much more in the tradition which developed at Canterbury about the middle of the century, and culminated in the wonderful Lambeth Bible (Plate 73). There is the further fact that such a cycle of scenes as is found on the four Bible leaves, in the completeness of its subject matter and the absence of any decorative features except the formal framing bands, suggests wall paintings more than miniature pages in manuscripts; and it is at Canterbury that the most considerable remains of wall paintings of the twelfth century are found. While there is no more evidence for Canterbury provenance than for either Bury or St Albans, the Bible leaves seem to fit better stylistically into the painting tradition already established there.[33]

Even closer to the miniature style of the St Albans Psalter, in the type of figures and the manner of representing drapery folds with deep shadows and white lines, is an exceptionally fine psalter (Brit. Mus., Lansdowne MS. 383) made not later than the mid twelfth century for an abbey of nuns dedicated to St Edward at Shaftesbury (Dorset).[34] This manuscript has been shown[35] to represent the earliest example of the typical scheme of psalter illustration used in English psalters in the late twelfth and succeeding centuries. The principal features of this scheme are: a calendar illustrated with the signs of the Zodiac and the labours of the months in small roundels (fols 1-12); full-page preliminary miniatures of New Testament subjects (fols 12 verso-15); three large historiated initials introducing Psalms 1, 51, and 109, and smaller initials introducing the other psalms. At the end of the Lansdowne Psalter there are two additional[36] full-page miniatures: the Virgin and Child with a kneeling nun (fol. 165 verso), and the Last Judgement represented by the Archangel Michael offering a napkin full of souls to Christ (fol. 168 verso; Plate 68B).

The figure of St Michael, at least in such parts as the thigh and leg, is an extraordinary combination of modelled form revealed under the drapery, and surface pattern made by drapery folds and ornamental bands applied smoothly like a bandage to parts of the figure. As in the Albani miniatures, the drapery folds are painted with deep coloured and white areas and stripes, but in the Shaftesbury Psalter these are much more patternized. Again, the type of folds is inconsistent: some of the edges lie long and straight, folded into stiff pleats, while others are lifted by an invisible wind and suspended in mid air in puffs and curls. The technique of treating the folds, which appeared in a different version in the Edmund miniatures, is Byzantine in origin, but the English artist once more has interpreted the modelled technique in terms of colour pattern, and has made a design which, although certainly effective as a decorative arrangement of the draped human figure, has little to do with modelling. The same treatment in the bust of Christ, in the roundel above, resulted in an extremely hieratic frontal type of figure which, even more than the Michael, reminds us of a figure of Christ in an initial in the St Albans Psalter (Plate 62B), that is, of the English artist's interpretation of this typically Byzantine form. The background in the Shaftesbury miniature is striped with colour – purple, green, blue, and yellow – in a manner found in some Ottonian manuscripts derived from the Reichenau school[37] and ultimately stems from Byzantine 'skies' painted similarly in coloured stripes. Other interesting features betraying the English artist's love of ornament are the threading of the wing-tips of Michael through the gold bars of the frame, and the snail-like clouds on which he stands. The faces, hands, and feet are shaded with green and red, but all the figures are firmly outlined with a heavy black line.

Although the style and iconography of some of the miniatures in Lansdowne 383 are related to the St Albans Psalter, and the historiated initials are reminiscent of the earlier Canterbury style, the Lansdowne manuscript does not seem to be attributable to either of these centres, a fact which is borne out by entries in the Calendar. Two other twelfth century manuscripts, without Calendars for comparison, have been found,[38] however, which show close stylistic affinities with Lansdowne 383, and one of these which is now in Hereford (Cathedral Library, MS. O.5.xi) furnishes a possible clue to the localization of this style. Evidence that it may have originated at Hereford at an earlier date is offered by

certain peculiarities of the other of the two manuscripts stylistically associated with Lansdowne 383, namely, an illustrated Boethius in Oxford (Bod., MS. Auct. F.6.5). Folio 1 verso contains a full page miniature of Boethius in prison visited by Philosophy (Plate 68A). The peculiar facial type of Boethius with its strongly accented line from temple to chin joining at a sharp angle the drooping moustache, and the extremely heavy, arched eyebrows and stiffly curled hair, together with the strongly shaded, regular drapery folds and similar architectural details are echoes, though in less exaggerated form, of MS. Caligula A.xiv and its sister manuscript associated with Hereford, viz. Pembroke 302 (Plate 49B). The Boethius may thus present the typical twelfth century hardening and formalizing of an earlier, freer style, rather than evidence of new influence of the Byzantine monumentality, as reflected in the St Albans Psalter. The Oxford Boethius is placed by Farley and Wormald earlier than the Shaftesbury Psalter, and this dating is supported by its closer dependence on the eleventh century Hereford style of the Caligula and Pembroke manuscripts.

Between the Bodleian Boethius and Lansdowne 383, a new influence has intervened, patently that of the St Albans–Bury style.[39] The miniatures in the Psalter are more formal and symmetrical in composition; the figures are more hieratic, draperies are flatter and more highly stylized and patterned. The historiated initials in Lansdowne 383 are even closer, in ornament and design, to the Boethius initials, since the figures in them show more liveliness and less hieratic symmetry than do those in the miniatures.

The third of this group, the Sermons of St John Chrysostom in the library of Hereford Cathedral, is also close to Lansdowne 383 in composition and figure types, but the technique is a reversion to the linear style of earlier Anglo-Saxon manuscripts, and thus something of the liveliness of this earlier style has been regained.

A second wave of Mediterranean influence which perhaps came directly from contact with the Near East seems to have determined the style of the earliest of the fine twelfth century Bibles, the magnificent Bury Bible (Camb., Corpus Christi Coll., MS. 2), for which apparently[40] the illuminator Master Hugo was paid between 1121 and 1148. The decoration consists of miniatures and historiated initials, one or the other introducing each of the Books of the Bible. At the beginning of the manuscript (fol. 1 verso) is a very fine decorative initial F filled with scrollwork and lush acanthus leaves, with modelled human heads in profile and lively human figures among the vines, and also animals and birds. On the shaft of the initial are two roundels with a mermaid and a centaur – forebears of the progeny of grotesques that a little later are to people the pages of manuscripts. The page itself is often framed with double bands enclosing conventionalized acanthus and vine patterns in rich, heavy colours including much dark green.

The historiated initial with the prophet Amos (fol. 324; Plate 69A) is typical of the figure style, which retains something of the St Albans and Bury type of head but with less conventionalized modelling and more individualization. The modelling of the face, especially around the eyes, is heavy and greenish in colour; the hair and beard are treated as soft masses but the hair line is strongly marked by a black outline to separate it from the forehead. The face is heart-shaped, with a pointed chin. The type is monumental and impressive. The body, too, has much more solidity of form than the St Albans and

earlier Bury figures, and the drapery, instead of being decorated with a conventionalized dark and white line pattern, is painted in sweeping folds that swing around the body following its contours and emphasizing its gestures. The folds themselves are still ridges but are handled more softly than in the St Albans Psalter.

These characteristics, together with the deep, rich colour and the free use of gold, suggest comparison with specific examples of Byzantine art – the mosaics of Norman Sicily,[41] and particularly with those of the Cappella Palatina at Palermo. Although the mosaics have the same flatness emphasized by firm, contour outlines as in the Bury Bible, the Bury master has still further reduced the pattern to a series of curved ridges; and although the faces may be derived from Byzantine mosaics, the conventionalized modelling has fallen into a formula of fixed patterns; for example, the hook between the eyes. Nevertheless, the style of Master Hugo is sufficiently reminiscent of characteristics of the Cappella Palatina mosaics to suggest that he may actually have seen them. Millar sums up the quality of the Bury Bible as follows: 'It is difficult to exaggerate the beauty of this book, which is … unique, its deep rich colour and the firmness of its draughtsmanship alike placing it in the first rank of illuminated manuscripts of this or almost any century.'[42]

Meanwhile, c. 1150, at Christ Church, Canterbury, the text and illustrations of the Utrecht Psalter were again copied[43] in the current outline style (Camb., Trin. Coll., MS. R.17.1). The scribe was the monk Eadwine, whose portrait appears on fol. 283 verso (Plate 71). The psalter text is tripartite,[44] and each psalm and canticle has a decorative initial introducing each of the three versions, but the initial of the Gallican version is the largest and most elaborate (Plate 72B). Before each psalm there is an oblong picture extending the full width of the page, illustrating the text literally as in the Utrecht Psalter and its first copy, Harl. 603. Colour is used with the outline – blue, green, vermilion and brown – not in place of the ink line but following and shadowing it. The style is characteristically twelfth century, with a heavier, stiffer line, larger, coarser figures, and more formal detail stylized with decorative purpose.

The miniatures in plate 72, if compared with corresponding illustrations in the Utrecht Psalter or in Harl. MS. 603, show that the compositions have changed very little in the one hundred and fifty years since the first copy was made. The style, however, is quite a different matter. Features of the composition which are recognizable derivatives of the earlier versions are the tall, long-legged figures with their tiny heads, usually seen in profile, the curly ground lines, and the architecture – the classical temple in the upper miniature, the eastern type of tomb in the lower. But the poses of the figures, their gestures, their very clothes are different; they hardly seem to belong to the same race of men, so staid and sober have they become. The fact is that the lively spirit of the original, which was successfully transferred to the first copy by means of the sketchy technique, has been tamed or even almost completely eliminated by this tight, patterned rendering of figures and draperies, and conventionalized trees and landscape, and no matter how closely the poses and gestures may correspond to those in the original, in order that the meaning of the picture may not be lost, the rendering is clumsy and lifeless and without interest as a figure composition. However, from the point of view of decoration, the case is somewhat different, for the bright pure colours distributed in lines and bands of varying breadth

over the surface produce a pleasing pattern which has more of the quality of illumination in relation to the text page than has either the earlier or the later copy (see Plate 93).

The initials are in the typical twelfth century Canterbury style: slender ribbon scrolls ending in acanthus leaves or stylized animal heads, against coloured grounds.

That the full-page miniature of Eadwine (Plate 71) is intended to be a portrait there can hardly be any doubt;[45] but his garb, though monastic, is painted, like Joseph's coat, in many colours. The use of colour in this miniature is exceptionally interesting since it serves three purposes and represents a kind of synthesis of all linear colour techniques thus far known in English art. Primarily, the colour, as is usual, accentuates the linear patterns of the drapery and the contours of the figure under it. It also is used heavily, not in lines but in areas, to model the face. And finally, it is used to produce an all-over pattern of decorative detail which includes fancy scrolls on the monkish robe itself, in the elaborate architectural setting and furniture, and in the formal border with scroll patterns and corner ornaments. The result is brilliant but over-ornate, and the application of colour in the modelling is distinctly odd: Eadwine's hair and beard are blue; there are bright green patches on his forehead and nose, around the eyes and on the cheeks and neck; also his tonsured head and his hands are shaded with green. The eyebrows and eyes are dark brown, and the eyes are suspended in the midst of the eye-socket and have a pop-eyed, wild expression. The drapery is tan with brown and green folds, and has a scrolled all-over pattern which matches that in the border of the miniature. The ground behind the figure, and the chair and desk are solid blue, and the details of architecture and furniture are picked out in red, green, and brown. The figure is outlined with a black or dark brown painted contour line. From this description, as well as from the reproduction, it is obvious that the picture is not a portrait in the accepted sense, but a fine *tour de force* in human figure drawing in the coloured outline technique. But there is more to the picture than this. The face is, after all, modelled with areas of colour and white – a technique which is foreign to that of coloured outline. It is certain that the artist of the Eadwine portrait had knowledge, albeit somewhat confused, of the use of greenish flesh-tones such as are seen in a much more intelligent and restrained application in the Amos picture of the Bury Bible. In other words, at Canterbury also, whether through direct contact with Byzantine art and techniques or through some intermediary such as the Bury Bible, the idea of building up flesh with coloured pigment had made its appearance. The result, as might be expected in the stronghold of coloured outline technique, is not from the standpoint of modelling exactly successful. But as decoration it is superb; and there is something about the great staring eyes with their strong green shadows which, though foreign to the technique of true modelling, gives the figure an other-worldly quality that defies the beholder to ridicule or to ignore.

Whether or not the Bury Bible was the source of inspiration for the Eadwine portrait – the technique of this picture has hardly any relation to that of the illustrations of the Psalter itself – there is no doubt that the style of the Eadwine manuscript was powerfully effective in furthering the spread of the Byzantinesque fashion in miniature painting at Canterbury. Another great Bible with magnificent miniatures and historiated initials with strong Byzantine leanings both in drawing and in colour was made in the first decades

after the middle of the twelfth century. The Dover[46] Bible (Camb., Corpus Christi Coll., MSS 3 and 4) seems to have been written at least in part by Eadwine, judging by the script and some very similar marginal drawings in the ink of the script, introduced in connexion with catchwords at the ends of quires.[47] The Dover Bible is in two volumes, of which the illumination of the second (MS. 4) is the earlier. Some miniatures are very similar in general type of figure to the Eadwine portrait and may have furnished models for it, as, for example, the Matthew (fol. 168 verso; Plate 70).

The Dover Bible style, however, is painting, not coloured outline. The figure is massive in proportions and solidly posed (cf. the cramped, stiff pose of Eadwine on the plate opposite); the head is thrust forward and the hands are stretched out eagerly offering the book of his Gospel which he holds in a hand covered by a veil. The strong twist of the torso, the thrust of the knees and the weight resting heavily on the left foot while the right drops lightly forward, are all characteristic of monumental painting, not of outline drawing style. The colour is rich and heavy. Matthew has blue hair, like Eadwine, and a gold halo; the drapery is bordered with burnished gold, as is the frame around the initial, and is painted in different tones of purple and blue, combined with orange. This colouring is markedly different from the red, green, and brown of the Eadwine picture, but much more like the Bury Bible of Master Hugo. The drapery folds are indicated by ridges, as in the Bury Bible, but the patterns in the Dover Bible tend to fall into more decorative motifs, in the form of parallels and zigzags, and delicate surface lines in formal designs fill up the spaces otherwise left plain by the fall of the drapery. The head is the most impressive feature of the miniature, and it is this which constitutes the closest link with the Eadwine portrait, except that the latter, strangely enough in view of the linear technique of the body, shows even fewer lines and a broader use of paint than does the Matthew of the Dover Bible. The Matthew has the same large eyes with very white eye-balls in which the dark pupils are suspended, and the same heavy shadowing in green under the eye. But the forehead is strongly lined, as is the nose, and the hair and beard are divided into separate sections by heavy black lines, whereas Eadwine's are treated as soft masses.

A strange type of figure replaces the typical Evangelist Luke at the beginning of his gospel in the Dover Bible (fol. 191 verso; Plate 63A). At first sight Luke appears to be killing his symbol, the ox, but recent opinion has it that the figure actually represents a priest performing a sacrifice. He holds what looks like an ink horn but really is a knife in his right hand, and with his left he lifts the head of the ox almost as in the ritual of sacrifice. This curious figure is represented purely in contour outline; the pattern on his mantle is not at all affected by any drapery folds. The tunic is completely linear. But the head is modelled in the same manner as that of Matthew and looks strangely out of place with the ill-matched body and the unusual iconography. The Luke miniature is another one of those multiple instances in medieval painting where an Old Testament subject has been given a typological meaning,[48] in this case partly on the identity of the animal (the sacrificial ox), partly as typifying the Sacrifice of Christ as recorded in the New Testament.

To sum up the techniques of these two outstanding Canterbury productions of about the middle of the twelfth century: the Eadwine artist seems to have been trying to reconcile,

as others before him had done, two incompatible figure styles; while the artist of the Dover Bible had grasped the monumentality of the painted figure style and was competently translating it into linear idiom. His technique consists not of a thin contour or shading line, but of broad, ridge-like lines that carry and enforce the body contours of the massive figure. Some of the details of this type of linear design are introduced for the sake of sheer ornamental pattern, like the puffed or clinging drapery around the feet, yet even these are related to the intensity of the pose, and add to rather than detract from the monumentality of the composition as a whole. This feature later on will be very much further developed at Canterbury.

In view of the prevalence in twelfth century manuscripts of miniatures within frames, of the monumental scale of the figures, and of the general interest in the use of decorative pattern and strong, shaded colour, it is not surprising to find remains of extensive schemes of twelfth century wall painting in England.[49] In manuscripts the colour, the shaded technique, the framed miniature, and even the iconography and composition of some of the subject matter show unmistakable evidence of having been derived from Byzantine mosaics such as were being produced in Sicily. Likewise, such fragments of wall painting as survive in England, while demonstrating on the one hand some dependence on the style of contemporary illumination, show on the other an even closer correspondence to the mosaics because of their monumental scale.

At Canterbury, wall paintings were executed in various parts of the Cathedral at different times during the twelfth century. The earliest still survive in the apse of St Gabriel's Chapel in the crypt, and belong to the period of the completion of Conrad's choir, c. 1130. Since they were walled up before 1199, probably for structural reasons, the paintings that remain are in remarkably fine condition. In the centre of the vault is a large figure of Christ seated on a rainbow within an aureole supported by four flying angels,[50] and towards the west is the Heavenly Jerusalem with seraphs. In tiers on the walls are scenes, on the south side from the early life of Christ, and on the north from the life of St John. The theme is essentially apocalyptic. In Plate 77, John (below) is writing in a book labelled *Apocalypsis*. Above are angels with candlesticks, representing two of the Churches. The faces show evidence of modelling in the conventionalized Byzantinesque style.

While the wall paintings in the apse of St Gabriel's Chapel display some affinity with earlier and contemporary manuscript illumination in general, a closer stylistic correspondence can be observed in the single surviving figure on the wall of St Anselm's Chapel in Canterbury Cathedral. This painting, which is usually dated about mid twelfth century, represents St Paul and the viper[51] (Plate 76). Since the chapel was dedicated to Saints Peter and Paul, there may have been a corresponding figure of Peter on the opposite wall.[52] Again, the fine condition of the painting of Paul is the result of its protection by a buttress built across the apse in the thirteenth century and not removed until 1888.

The quality of the painting, as well as of the pigments used for it, marks a distinct advance over the work in St Gabriel's Chapel. The correspondence of the style of the St Paul to that of Amos in the Bury Bible (Plate 69A) points to a Byzantine source: the solidity of the rendering, in spite of the linear technique, in both figures suggests direct

contact with Italo-Greek style, as it may be seen in the mosaics of Norman Sicily.[53] On the other hand, there is a tendency, already noted in the Matthew of the Dover Bible, towards mannerism in the drapery patterns, such as the cascading fold of the edge of the mantle, which suggests a stage further removed from the Byzantine prototype than the Bury Bible. The graceful S-curve formed by the heavily falling mantle from shoulder to hem, as Paul stoops forward, helps to stabilize the pose and keep the figure from seeming to pitch forward; but this axial line is also a central decorative feature of the complex pattern of ridged, curved folds. The contour, as usual at this time, is strongly marked by a black outline. The face is modelled with high-lights on forehead, nose, and cheek, in the Byzantine manner, but the eyebrows and wrinkles on the forehead are strongly linear. The colour is superb: the background is blue; St Paul wears a white gown shaded with grey and a tan mantle with brown shading and white high-lights. The cloud border is red and brown. The richness of the colour scheme and the competence of the painter in the representation of so monumental a figure suggest influence from some fine Continental centre, such as a Cluniac church,[54] where contacts with Italy were strong. In any case, no other English wall painting of this century can compare with the Canterbury St Paul in the sureness of the drawing and the beauty of the colouring.

The nave of St Gabriel's Chapel, in the crypt of the Cathedral, probably represents the latest phase of painting at Canterbury in the twelfth century. The best preserved fragments are in the vaulting sections of the two western bays: medallions with branches and stems contain half length figures of (?) bishops and angels. The scheme suggests most closely the Jesse Tree of Lambeth MS. 3 (fol. 198), and the style, though probably later (c. 1184), retains something of the character of this manuscript.[55]

Other wall paintings have been found in recent years in Sussex, dating from the twelfth century. Since they were near Lewes Priory, the chief Cluniac house in England,[56] these, too, may be derived from Cluniac sources, although no record remains of wall paintings at Lewes itself. The earliest of the surviving paintings are at Hardham (Plate 75A) and are thought to date from c. 1125, when the church was built. The interior of the building was entirely covered with paintings of which a large portion survives. Above the chancel arch on the nave side are the Adoration of the Lamb and the Labours of the Months; continuing at the level of the upper zone, on the north and south walls are scenes from the Infancy of Christ; at the west end of the nave is a representation of the Torments of the Damned. In the second zone of the nave are the Baptism, Lazarus carried to Heaven, and the full story of St George. On the west wall of the chancel, over the arch, are Adam and Eve (Plate 75A); on the east wall, Christ in Majesty, flanked by the Elders and the Apostles, on the north and south walls, in the upper zone. In the second zone are scenes from the Passion. The entire bottom zone in both chancel and nave seems to have been filled with painted draperies, now almost entirely destroyed. The scheme is formidable: the complete story of Salvation clearly and systematically presented, and one cannot help being reminded, as Tristram noted,[57] of the cycle and even of some individual drawings in the remarkable 'Cædmon' manuscript in the Bodleian Library (MS. Junius 11; Plate 44).

The style of the Hardham painting is largely linear, though modelling of the heads is suggested by the use of white with the red outline, and by a few strokes of red for shading.

There is no underpainting for the flesh. The most striking of the figures in their present state are the Adam and Eve (Plate 75A) on the west wall of the chancel, above the arch, and these figures show better than any others their dependence on Anglo-Saxon models as in the 'Cædmon' manuscript. They are enormously tall and completely nude, and the anatomy of the bodies is indicated by a schematized design of white and red lines. The Tempter at Eve's left hand looks less inept, partly, perhaps, because less clearly visible now than Adam and Eve. It seems to be a dragon-like creature with animal head and ears, wings, and a round body with legs. Though the style of the painting is crude, the figures have a certain naïve charm, especially in the faces.

The paintings at Clayton (Plate 75B) are somewhat later than those at Hardham; they are better preserved and of more monumental dignity. The scheme is an early version of the Last Judgement based on the Apocalyptic Vision of St John: over the chancel arch is Christ supported by angels with the twelve apostles; below, on the left side of the wall, Christ delivers the keys to St Peter; on the right, He gives the book to St Paul. The nave walls are divided into two zones of which the upper one is almost intact: on the north wall are an angel trumpeting, the death of Antichrist, the Blessed wearing crowns, and a group of laymen in short coats with bishops leading them (the Heavenly Jerusalem) and another angel trumpeting. On the south wall, corresponding scenes introduced by a trumpeting angel include souls awaiting judgement, an Apocalyptic rider, an angel receiving the souls, and others supporting the Cross. In the lower zones, the very fragmentary paintings include the general resurrection, the weighing of souls, and probably also Hell. The subject suggests one of the favourite themes of the church portal tympana of French Cluniac monasteries, as at Conques.[58] The technique is still linear, with the dark red outline and a second white line accentuating it, but black underpainting is used as a base for flesh tints. The figures are monumental in scale and extremely impressive. Particularly fine are the praying saint (Plate 75B) and some of the angels.[59] The scale of the figures and the sweeping draperies are much closer to Poitevin paintings, as at St-Savin-sur-Gartempe,[60] and it is obvious that influence from either mosaics or Continental wall painting has left its mark on the English outline style.[61]

At Kempley (Glos.) another small Norman church, dedicated to St Mary, contains a completely painted chancel, both barrel vault and walls. In the summit of the vault is a large Christ in Majesty in a triple Glory, his head towards the west, his feet resting on a rainbow. Surrounding him are the symbols of the Evangelists, the eagle on his right, the angel on his left above, the lion and the ox to right and left below. The Virgin and St Peter, two cherubim and two seraphim, the seven candlesticks and the sun and moon fill the remainder of the vault. On the walls below are the twelve apostles seated under arches (Plate 74), six to a side, looking up in adoration. At the end of the row, on one side is Bethlehem, on the other, Jerusalem. On the east wall of the apse are standing figures of a bishop, pilgrims, and angels. The scheme is again one of the grandiose themes found commonly in sculpture of the mid twelfth century, which probably were often inspired by manuscripts.[62] The painting at Kempley is in earth colours – red, yellow, and grey – with black and white for features and drapery folds. It is a bold, monumental style which has no connexion with English miniature art and must, it seems, have been done by some

painter, perhaps a local artist, who was familiar with Continental wall painting. The Kempley paintings belong to approximately the same period as the apse paintings in St Gabriel's Chapel at Canterbury Cathedral, although the fuller iconographic detail might suggest a slightly later date for Kempley.

From the foregoing survey of the few surviving[63] examples of twelfth century wall painting, it is obvious that with the exception of the St Paul at Canterbury, the medium has little to contribute to the development of Romanesque art in England. And it is to the manuscripts that we must turn once more for English Romanesque art in its maturity during the second half of the twelfth century.

At Canterbury, probably at Christ Church, another great Bible was made of which only the first volume[64] has survived intact (Lambeth Palace Lib., MS. 3). It is superbly illuminated in a style which, though obviously influenced in its origins by Byzantine models, illustrates well the new and startlingly dynamic type of linear figure design which was evolved. There are six large miniatures, each divided into two or three registers, the whole surrounded by a frame consisting of two plain gold bands usually filled with a conventionalized leaf pattern of a type used in the Albani Psalter (cf. Plate 61). The miniatures are in the continuous narrative style, with consecutive scenes sometimes separated by architecture and sometimes not (Plate 73). In addition to the miniatures, fine historiated initials introduce the Books of the Bible, and usually decorative initials introduce the Prologues.

Most of the illumination, both miniatures and initials, appears to be by the same hand, which is represented on fol. 258 (Plate 73). The figures are effectively silhouetted against a plain background and their arrangement constitutes a lively over-all pattern which is dependent partly on the figure contours and partly on the manner of treating the drapery. The folds are drawn as ridges and lines, as in the Dover Bible, and all the areas between them are filled, as in the Eadwine portrait, with decorative surface ornament; but the figures vibrate as though charged with an electric current which had lifted them on their toes and set them aquiver. The drapery folds cling to the bodies, except where whipped out as by a gust of wind, yet reveal no modelling of the form beneath.

The finest expression of this extraordinary dynamic style can be seen in an initial by a master hand on fol. 284 verso (Plate 69B). The design of this figure too is linear, but instead of forming a dizzy surface pattern, the drapery folds have depth, and the lines which indicate them have some relation to the contours and movement of the body, even though they obviously are not determined by them, as in normal figures. The draperies are whipped about the prophet so violently that one can almost hear the crack of the flapping ends, and they are only kept from blowing clean off him, because they are caught round his heel and over his arm. The body faces left, and the head is bent back towards the right; a lock of fuzzy hair has been blown loose and stands out from his forehead; and the phylactery in his hand sweeps upward in a full curve, caught by the same violent wind. The closest analogy to this curiously unnatural yet powerful type of figure is found in the sculptures of Aquitaine, of which the prophet Isaiah at Souillac[65] is an outstanding example. The explanation of the difference between the two styles in the Lambeth Bible may lie in the fact that the principal master (Plate 73), working in the

traditional Anglo-Saxon linear manner from some Byzantine model, had simply infused new life into the conventional linear patterns. The painter of the prophet Daniel (Plate 69B), however, belonged to a new school of artists who, with more complete understanding of the possibilities of the figure itself, not simply of its flat outer surface, had treated form and draperies as inseparable elements and evolved out of them a linear pattern with depth and consequently with greatly intensified dynamic life. The style of the Daniel is a forerunner of one of the styles of the Winchester Bible, and even influenced late twelfth century work in other media.[66]

Manuscripts painted in the style of the Lambeth Bible are found also on the Continent. Two leaves at Avesnes,[67] surviving from a Gospel Lectionary formerly at Metz (MS. 1151), contain miniatures which are so close to some of the Lambeth Bible illuminations as to appear to be by the same hand or hands. This raises the question as to whether the Canterbury style originated on the Continent or was carried there from Canterbury. The Metz Gospels were written in 1146 by a scribe Johannes. An abbot of Liessies, Wedric (1124–47), is represented in both this and the Avesnes miniature of St John. Dodwell discusses the question of origins of this style and concludes on the basis of present evidence 'that the rudiments of the Lambeth Bible style appeared in England before they did on the Continent'.

The steps that have been followed in the development of the typical English Romanesque style in painting have been localized chiefly in a very few centres, mostly in the south of England, that is in Canterbury and in Sussex and in St Albans, Herts. Bury St Edmunds, the other great centre where the new style was germinating in the early part of the century, lay only a short sea journey from Canterbury, and stylistic interchange between the two great monasteries has already been noted in earlier periods. There is, however, also evidence that the new monumental linear style spread farther afield. Two fine examples of the new style in figures, expressed only in coloured outline, are a manuscript which belonged to and perhaps was made at Ramsey Abbey in the Fenlands (Camb., St John's Coll., MS. H.6), and a single leaf with a magnificent Madonna and Child prefixed to Bod. MS. 269. Both differ markedly from the dynamic style of the Lambeth Bible.

The text of the Cambridge manuscript is Bede's Commentary on the Apocalypse. On folios ii and iii are four very fine full-page drawings: a bearded, nimbed apostle (John?); John vested as a bishop with a prostrate monk, 'scriptor libri', at his feet (fol. ii verso; Plate 78); a vaulted building with a tiled roof and three towers (Heavenly Jerusalem?) and beneath, the seven-branched candlestick; and Christ enthroned holding with both hands a sword which issues from his mouth. The figure of John as bishop is hieratic in pose and symmetrical in the formal patterning of the draperies. Yet the body is firmly modelled and the heavy drapery folds follow the contours of the form in the sinuous S-curves which characterize the magnificent figure of St Paul in St Anselm's Chapel at Canterbury (Plate 76). The face is lightly touched with colour to suggest the modelling under the eyes and on cheek and chin. The composition of the drawing as linear pattern is superb, with its well-ordered economy of line, yet the solidity of the figure has in no way been weakened by the reduction to linear techniques. The date is probably not earlier than the third quarter of the twelfth century.

The second of the two monumental drawings is perhaps slightly earlier.[68] It is a coloured drawing of the Madonna and Child on the recto of the first leaf of text of Augustine's Commentary on Psalms 101–50. It is of large scale (10⅜ by 6½ inches) and tremendous power (Plate 79). The colour is extraordinary because of the complete absence of blue; soft tones of vermilion, purple, and green are used both for the bands of the double mandorla and for the outline and wash-shading of the figures. Both Virgin and Child are extremely elongated figures with small heads but heavy bodies. The Virgin's draperies are not over-rich in folds but almost all of those indicated fall in long unbroken vertical lines over her shoulders and from behind her knees and seem to be so designed as to constitute a background pattern for the figure of the Child. The play of vertical and curved folds and the rounded figure contours repeatedly carry the eye through returning curves back to the central area and the focal figure, the Child, who is placed exactly at the intersection of the two circles. The arrangement of the colours in the central area repeats and intensifies this emphasis: the circular area behind the Virgin's shoulders is purple, as is the outer band of the lower circle; the inner band of the upper circle is green, like the inner area behind the throne in the lower circle; and the striking band of vermilion which forms the outer rim of the upper circle terminates exactly at the throne on which the Virgin and Child are seated. The drawing and the colour harmony constitute a masterpiece of mature twelfth century design and are wholly in the Romanesque tradition of monumental painting at its grandest. Unfortunately there is no indication of the centre where this consummate work was produced.[68a]

At St Albans, however, where the monumental style had made its first formal appearance in the first quarter of the century, other interesting developments were taking place. Not long after the middle of the century, a Terence manuscript (Bod. MS. Auct. F.2.13) was illustrated with drawings by four artists of whom the two distinguished by Morey[69] as A and B seem to have collaborated in the evolution of the monumental style at Winchester.[70] Some figures in the Terence miniatures are tall and thin, as in the St Albans Psalter, but they have taken on an extraordinary liveliness (Plate 82), perhaps under the influence of the dramatic character of the text illustrated. The poses and gestures are stagy; and the masks which cover the faces introduce a new type of head with exaggerated features and grotesque, often coarse, expressions. From this source presumably was evolved a liveliness of action in the representation of figures that is different from the optical liveliness produced by a linear surface pattern as in the Lambeth Bible.

The fusion of the styles of the Lambeth Bible and the Terence, perhaps in the person of a single artist, is responsible for most of the illumination in a magnificent psalter (Brit. Mus., Cott. MS. Nero C.iv) executed between 1150 and 1160, probably for Henry of Blois, Bishop of Winchester and a patron of the arts, either at the Cathedral Priory of St Swithin or at Hyde Abbey (formerly New Minster).[71] The psalter is preceded by a series of Bible pictures (Plate 80) – thirty-eight full-page miniatures in two zones, within frames of foliate and other conventional patterns and edged with bands of gold. Inserted in the midst of the series, and probably not forming part of the original manuscript, are two (later?) pictures, the Death (fol. 29) and the Enthronement of the Virgin (fol. 30; Plate 81) in Italo-Byzantine[72] style and colouring. In comparison with the other miniatures, fols

29–30 appear at first sight to be indeed by an Italian artist; but in spite of their more convincingly modelled figures and their richer, shaded colouring, they too are linear in technique. Although Italo-Byzantine characteristics have been noted in earlier English illumination, notably the St Albans Psalter and manuscripts influenced by it, nothing so strikingly Byzantine in feeling as these two miniatures in Nero c.iv has been found in earlier English work. The influence of this style was by no means limited to this one manuscript.

The Bible pictures in Nero c.iv have been extremely fine in colour, but most of the ultramarine pigment which originally covered their backgrounds has been removed, possibly for use elsewhere, the colours have become pale through the effect of damp, and most of the gold has disappeared. What remains, therefore, has to be judged primarily as drawing (fol. 12; Plate 80). The clinging 'damp' drapery with patterns formed by ridged folds are similar to those of the Lambeth Bible, but in Nero c.iv they have been further clarified and organized on the basis of fewer lines, and these more often of the contour and swinging S-curved type, such as characterize the painting of St Paul in St Anselm's Chapel at Canterbury Cathedral. The source, however, is probably to be sought not at Canterbury itself but in a common Continental prototype as represented in the miniatures of fols 29 and 30 of the Psalter. From the same source perhaps are the large, solemn heads, almost always seen in three-quarter, not profile, view, with enormous eyes and heavy masses of hair and beard which contrast with the symmetrically curled locks and the pinched, tortured drapery edges of the Lambeth Bible. In the Winchester Psalter there is evidence, too, of the Terence master's style, in the figures with their exaggerated facial expressions, and in the elaborate architecture which suggests stage settings for the scenes, in which the relation of the participants to each other and to the setting is spatial rather than decorative. The flowering of this composite style takes place in the next decades.

The giant of twelfth-century English manuscripts – in scale, in quality, and in artistic importance – was produced at Winchester: the great Bible now in the Cathedral Library.[73] This manuscript was originally in two volumes, but has recently been rebound in four. In size (23 by 15¾ inches) and in the variety and magnificence of its illumination it surpasses even the fine Bibles made at Bury St Edmunds and Canterbury. It was probably begun c. 1160–70, i.e. during the lifetime of Henry of Blois. Before the illumination was completely finished, the manuscript was apparently obtained from Winchester by King Henry II for his new foundation at Witham, but it was returned to Winchester by St Hugh of Lincoln, then Prior of Witham.[74] At some time during its history a number of the historiated initials which introduce the Prologues and the Books of the Bible were cut out.[75] Somehow concerned with the making of the Bible is the single full-page miniature of unmistakable Winchester style now in the Morgan Library (MS. 619; Plate 86) which is believed to have been originally intended for inclusion in the Bible.[76] The only miniatures in the Bible, as differentiated from the historiated initials, are two full pages of drawings illustrating the apocryphal books of Judith (fol. 331 verso) and Maccabees (fol. 350 verso) in Vol. IV. The artist of these pages, who also drew some of the initials (as fol. 363; Plate 83A), has been designated as the Master of the Apocrypha Drawings.[77] At least five other artists have been distinguished: the Master of the Leaping Figures, whose style is

represented by the historiated initial on fol. 148 (Jeremiah; Plate 83B); the Master of the Genesis Initial (fol. 209), Prologue to Zephaniah (Plate 84A); the Amalekite Master (fol. 69, Joshua; Plate 84B); the Master of the Morgan Leaf (fol. 190, Daniel; Plate 85A); the Master of the Gothic Majesty (fol. 131, Isaiah; Plate 85B).

The distinction between the styles of the six masters in their most typical work is fairly easy. The so-called Master of the Apocrypha Drawings is primarily a draughtsman. His principal work is the two pages of drawings composed like pictures without frames and with no decorative features. One initial only has been attributed to him (fol. 363; Plate 83A), preceding II Maccabees, and that is treated exactly as if it were a miniature, with architectural setting and no decorative elements except some interlace. It is true, the initial is not finished and undoubtedly was intended to be coloured; but this master's style is recognizable in the facial type, the stance, the drapery, and especially in the sensitive way in which he has defined the contours of the limbs under the draperies. The gold borders on the draperies and the sharpening of the double line ridge-like folds appear to be preparation for the painting of the figure, perhaps by the Master of the Leaping Figures (cf. below). Another initial in the Bible, fol. 278 verso, at the beginning of Ecclesiasticus, with a wonderfully fine figure of Wisdom, seems to be another example of the Apocrypha Master's drawing[78] (cf. the equally impressive figure of King Antiochus, fol. 350 verso) with the gold borders and sharper drapery lines added as on fol. 363 by the Master of the Leaping Figures.

The Master of the Leaping Figures is well represented in the initial introducing the Book of Jeremiah (fol. 148; Plate 83B). He, too, is an extraordinary draughtsman, but his figures are not designed in normal lively activity but sway and 'leap', with swinging draperies and wide-flung arms in a design that is primarily decorative in arrangement and emotional in tone. The colouring of this and other initials by the same Master is violent: strong red shaded with yellow and yellow with red, and much reddish purple, are used; blue is used for the ground; there are dull gold edges on the draperies (as noted above) as well as for the initial letters. The colouring undoubtedly derives from Byzantine painting, but as used by this artist it is showy rather than beautiful.

The source of the Byzantine colouring and also of the type of facial modelling used by the Master of the Leaping Figures seems to be recognizable in the work of the artist who did the first two historiated initials in the Bible, the Genesis Master so-called from his fine initial to the Book of Genesis (fol. 5). His style is well illustrated in the initial on fol. 209 at the beginning of the Book of Zephaniah (Plate 84A). His modelling is heavy, his faces solemn, with sullen, almost baleful expressions resulting from the frowning wrinkled forehead, strong accentuation of the white of the eye, and mouths drawn down at the corners. Hands are broad and flat, and the open palm is modelled with a well-marked pattern. Drapery folds are designed in relation to the figure beneath, with no nonsense as to independent decorative patterns they could form on their own; they are heavy and tend to drag and impede the movements of legs and arms. This master's colouring also is strong, but the combinations of colour are more pleasing and the overpainting is more delicate than in the work of the Master of the Leaping Figures. A good deal of green is used, in the design and for shadowing the contour of the initial letter, outside. The gold

used for backgrounds and for the letters is highly burnished, and in backgrounds it is tooled with groups of tiny dots. The Christ head in the nimbus strongly suggests an Italo-Byzantine mosaic (cf. below, Morgan Master).

The fourth artist, the so-called Amalekite Master (Plate 84B), is a curious anomaly. His faces are painted in a yellowish flesh colour with strong high-lights and shadows, but according to a formula rather than as a well-understood technique of facial modelling. His figures are very active, in a clumsy, unstable way. The soldiers wear over their long chain mail hauberks a divided skirt or very long tunic which swings outward as they move. Their thighs are strongly outlined but the drapery folds are linear. The mushroom-like trees are extremely old-fashioned for this time. A striking feature of the decoration of the initial is the three fine profile heads of different types which are carefully modelled and differentiated. The persistent profiles and the long, thin, shapeless yet lively figures suggest the style of the Bury St Edmunds Gospels (Pembroke 120; Plate 66); but something new has been added in the way of facial modelling. This could be the result of influence from the technique of the Genesis Master, but in any case it is only superficial, for the technique of the miniature on the whole is linear.

The style of the Master of the Morgan Leaf is well represented in the Bible by the initial on fol. 190 (Plate 85A). His figures are of more nearly normal proportions, though the heads are perhaps a little too large for the bodies. They are roundly modelled in Byzantine light and shade technique softened and modulated by the exquisite colouring; all are outlined with heavy black line. The figures are dignified and restrained in action and gesture. The faces, which are usually seen in three-quarter view, are shaded around the eyes and cheeks, and are darkened on the far side to suggest foreshortening. There is little variety in the facial types and it is clear that the modelling is the result of a formula; yet the eyes are focussed and there is expression in them. The background is of burnished gold but the details of the setting – the table set for a feast, the figures seated behind it, and the servants in the foreground – are clearly arranged with some idea of spatial relationships. The table top is even foreshortened, so that the dishes do not appear to be sliding off it. This conception of a clearly organized spatial setting is something new in English illumination, and the Morgan Master in this respect is far ahead of his collaborators, except the Apocrypha Master (cf. Plate 83A) who seems to have had the same idea. The initial letter in the work of the Morgan Master also has a clarity of design and a crispness in form and colouring which are less marked in the rather overcrowded compositions of initials by the other Winchester artists. The rich colour effect of the initial as a whole is set off by the line of green paint surrounding it.

The fine style of the Morgan Master cannot be fully appreciated apart from the large full-page miniature which suggested his name (New York, Morgan Library, MS. 619; Plate 86). The puzzling problem of the origin and purpose of this leaf in relation to the Winchester Bible has been referred to, but no satisfactory solution offers itself. The subject comprises scenes from the life of David, and the miniature, if intended for the Bible, would probably have been placed before the Book of Samuel, which in the Bible is now introduced by an historiated initial. It is useless to suggest hypotheses to explain the existence of the leaf, but it is an extremely lucky accident which preserved it to us, for without

it the full power and amazing beauty of the Morgan Master's style could never have been realized.

The page[79] is divided into zones: in the top zone, at the left, David is aiming a stone at an enormous Goliath who occupies the centre of the scene; at the right, Goliath lies on the ground with David holding his severed head. In the centre zone, at the left David is harping and dancing – at the same time, apparently – before a threatening Saul; at the right, David is anointed by Samuel. And in the lower zone is one of the most moving scenes of all, Absalom with his hair caught in the branches of a tree and David mourning his death. The backgrounds of the zones are painted in plain heavy colours, red, tan, and blue alternating. Against these backgrounds the wonderfully modelled figures stand out with almost sculpturesque clarity. The well-proportioned bodies, the softly shaded draperies which flow around them and reveal their form, and the powerful heads with broad, rounded foreheads and prominent cheek-bones correspond to these features in the Daniel initial, but the monumental scale of the scenes on the Morgan leaf shows them to the best advantage. The faces are painted with a yellowish flesh tone as a base, and the modelling is done largely with green. Otherwise, there is very little green used on the page, the dominant colours being red and blue.

The superb quality of the Morgan Master's style would inevitably have influenced the work of other artists[80] who might have seen it, and it seems to be reflected, though feebly, in the last of the Winchester artists to be distinguished, the Master of the Gothic Majesty, so called from his unfinished initial to Psalm CIX with the imposing figures of the two Persons of the Trinity.[81] His painted style (fol. 131; Plate 85B) is interesting to compare with that of the Morgan Master included on the same plate. The proportions of the figures, the types of heads, even the manner of shading the drapery folds are all very similar to those of the Morgan Master, but the figures have somehow lost their substance and become silhouettes outlined with black line and covered with an arrangement of shaded patterns. The drapery of Christ and that of the servant on the right in the Morgan initial will illustrate the difference. The contour of the Morgan figure is clearly determined by the rounded shape of the thigh and leg; that of the Christ is apparently deliberately broken by the clumsy ridged folds which cut across it and swing outward at the bottom of the mantle, instead of clinging to and revealing the roundness of the leg as in the other picture. The faces, too, in the initial by the Gothic Master are flatter, less firmly modelled, and less intense in expression. The differences between the two styles, subtle though they are, in a sense are the differences between Romanesque and Gothic, the vigour and monumentality of the former contrasted with the suavity and grace of the latter. Yet, in itself, without comparison with the stronger style, the miniature by the Gothic Master is a very beautiful thing, with its gentleness and dignity, its pleasing arrangement of linear patterns, and its soft pink, blue, and grey colouring and brilliant burnished gold background. This style will be seen again in the early manuscripts of the next century.

The six main illuminators of the Winchester Bible were all great masters, and it is not reasonable to imagine that they sprang fully formed out of an artistic void. The bold, intense facial style of the Genesis Master, it is true, seems foreign to previous English style

H

83

and perhaps reflects further Continental influence resulting from the various contacts of Englishmen with Italy and the Byzantine East. The Master of the Leaping Figures is certainly the most dynamic artist at work on the Bible, and his style can be accounted for largely by two earlier English manuscripts. His damp draperies, for instance, with formal, ridged patterns and whipped edges, are found also in the Lambeth Bible; but the same type of drapery on more violently active figures, as in the Winchester Psalter (Nero c.iv), are much more like the 'leaping figures'. If unpainted drawings by this Master are compared with miniatures in Nero c.iv which have lost their colour, the same patterns in the folds and the same lively, somewhat exaggerated poses and gestures can be recognized. The other influence which helped to determine the Leaping Master's style was undoubtedly his association with the Master of the Apocrypha while he was illuminating the Bodleian Terence (MS. Auct. F.2.13; Plate 82). It is apparently in this manuscript, perhaps because of the nature of the subject matter to be illustrated, that his violent theatrical gestures and poses were developed.[82] The other artists of the Bible, including the somewhat colourless Amalekite Master, were more or less influenced by the Genesis Master's technique of modelling and colour; but this is not wholly true of the Morgan Master who displays an understanding of the modelled figure which could come from first-hand contacts with Byzantine art, again perhaps in the mosaics of South Italy.[83]

The collaboration of a number of artists with individual styles on the same work in the Middle Ages usually not only resulted in the production of an outstanding monument but constituted the starting point for important new things to come, and in this respect the Winchester Bible was no exception. Its influence was felt immediately in several large Bibles comparable with it in the magnificence if not in the quality of their illuminations. Two of these are in the Bodleian Library: a great Bible illustrated with narrative scenes in miniatures or initials[84] (MS. Laud Misc. 752) and a two-volume Bible[85] (MS. Auct. E. infra I and 2) which has only a few historiated initials but a wealth of decorative letters in a fully developed Romanesque style – 'perhaps the greatest English repertory of Romanesque pattern'.[86] These Bibles, like the Winchester manuscript, were certainly illuminated by a number of artists over a considerable period. There is no evidence as to their provenance, but they may be Winchester products.[87]

A bridge between the Italo-Greek mosaics of South Italy and the style of the Winchester artists, especially the Morgan Master of the Bible, seems to be supplied by the amazing cycle of wall paintings, formerly in the chapter house of the monastery at Sigena (Huesca, Spain), now transferred, in a ruinous condition as the result of a fire, to the Museum at Barcelona.[88] The chapter house was entirely filled with a rich cycle of pictures consisting mainly of Old and New Testament scenes and long rows (in the soffits of the arches) of the Ancestors of Christ, some seventy busts, 80 cm. high. The work as seen by Pächt before the fire seemed to him all to be designed by a single master and executed by him and his staff.[89] Certainly there are stylistic differences in the paintings, but the basic character of the figure drawing and composition is uniform in its strength and monumentality. The date is between 1183 (when the house was founded) and 1200.

The two details reproduced (Plates 87 and 92B) were chosen because they represent the closest stylistic parallels both to the later Winchester style and to the contemporary St

Albans and Westminster Psalter style. If these two parallels are valid, the frescoes would supply a direct link between these centres in the last decades of the twelfth century.

Plate 87, representing the Anointing of David by Samuel, in subject as well as in style is suitable for comparison with the same scene as represented by the Master of the Morgan Leaf (Plate 86). Striking similarities are: the proportions and solidity of the figures; characteristic poses, gestures, and stances; drapery folds rendered with richness and plasticity but, for the most part, with relation to the form or position of the body; and modelled faces with strongly shaded features and tense, solemn expressions. Where lines are used, they accentuate mainly the contours, as in the forward-striding leg of David. The drapery material hangs heavily on shoulder, arm, and thigh, and the figures stand solidly on the ground. The monumental scale of the Morgan Leaf pictures, which suggests wall painting in style as in composition, raises the question whether this Master could actually have been the artist of the Sigena paintings; but this perhaps is pushing the analogy too far.

The other detail reproduced (Plate 92B) brings the Sigena style closer to St Albans Abbey. Plate 92A, which illustrates this style, has some striking similarities with the Sigena figure of God in the Expulsion picture: the details of modelling of the face, even such precise rendering of the features as the hair, the ear, the mouth; and the exact pattern made by the fold of the sleeve, in the rather awkward gesture of the right arm crossing over the left, the position of the fingers, the wrinkles of the lower sleeve, and, of course, the very heavy contour line that defines adjacent areas.

Finally, the facial type of the Sigena Christ-God should be compared with that of the Christ in Majesty in Roy. MS. 2 A.xxii, which may have been painted at St Albans for the Westminster Psalter (see below). Allowing for the hieratic pose and conventional gesture of the Majesty figure, and for less personal intensity in the expression of the face, the two figures are strikingly alike. By comparison, the Sigena figure takes on even greater strength and grandeur. It is a truly phenomenal exposition of the finest qualities of Romanesque painting at its highest level, beginning to be tempered by the more human suavity of the Gothic – the Divinity in the mood of a justly angry man.

Since the technique of the heavy contour line used in the painting inevitably suggests the technique of stained glass, it is interesting to compare this figure with the splendid Methuselah from Canterbury (Plate 95). In spite of having much in common in such details as pose, drapery, and facial rendering the two are far apart. The Sigena figure is simpler, starker, less easy in pose and gesture but perhaps by this same token more forceful and intense in mood.[89a]

Less closely related in figure style to the Winchester Bible than to the Winchester Psalter are frescoes in the chapel of a royal manor built by Henry II in Normandy in 1160. The chapel was converted to the use of lepers in 1183 and probably then was decorated with eight medallions in pairs containing scenes from the Infancy Cycle.[89b] The drapery folds are ridged as in the earlier Winchester style (cf. Plate 80). A most striking decorative detail is the large sprawling lobed leaf with tentacle-like hooked tips which combines with interlace in the design of some English *Beatus* initials of *c.* 1200, as in the Munich Psalter.

Contemporary with the developments at Winchester, but stylistically very different,

are two large and splendid psalters written before 1173 (since no feast for St Thomas, canonized in that year, appears in the calendar) and perhaps made in the diocese of York. One (Glasgow, Hunterian Museum, MS. U.3.2)[90] has decoration consisting of the usual calendar illustrations; twelve full pages of preliminary pictures – three each from the Old and the New Testament, the Ascension, Pentecost, and Christ in Majesty, and three subjects connected with the Death and Assumption of the Virgin; a full-page *Beatus* and eight large initials to the psalms of which two are historiated. The biblical pictures (Plate 89) are divided into two registers and surrounded by a formal frame, as in the miniatures of the Winchester Psalter (Plate 80), but the style is very unlike this manuscript although also a mixture of Byzantine modelling and linear drawing. In the York Psalter linear pattern is predominant. The figures are spread over the splendid gold tooled ground with complete indifference as to whether they are supposed to be in heaven or on earth, or as to what their spatial relation to one another may be. Wings, flying draperies, scrolls, ridged clouds are all arranged in a beautifully disposed surface pattern, which is still further enriched by the sinuous contours of the drapery and the elaborate design formed by the lines indicating their folds. Even the torso of Isaac in the lower scene and also the ram come in for their share of decorative treatment. Yet the figures themselves, especially the two representations of Abraham, are monumental in proportions and imposing in the type of head, which retains traces of modelling in the Byzantine manner around the eyes and on the cheek.[90a]

The style of the miniatures illustrating the death and assumption of the Virgin is somewhat different from that of the biblical pictures. The strongly marked formal patterns of the anatomy and drapery folds have become softened in the Virgin pictures; there is less violent movement; and the expressions on the faces are less intense. The changes may be due to a different (perhaps, as Boase suggests, a younger) hand working in the same style.

A further step in the softening of the style of the Hunterian Psalter can be seen in the other psalter of similar size, date, and provenance, now in Copenhagen (Royal Library, MS. Thott 143 2°). There are sixteen full-page preliminary miniatures illustrating the Nativity and Passion cycles of the life of Christ, and a great many decorative and historiated initials introducing the Psalms, some of which may be by an illuminator who worked on the York Psalter. The miniatures, which apparently are not all by the same hand, seem in general closer in style to the three illustrations of the death of the Virgin than to the biblical pictures in the York Psalter. The Copenhagen miniatures[91] are designed as single scenes instead of two to the page and with less emphasis on pattern and more on the arrangement of figures in relation to each other and to the properties of the scene. Also the mood is milder, the draperies softer, and there is a fine sense of rhythm in design which is lacking in most of the York Psalter miniatures but which begins to be evident in the death of the Virgin series. Boase describes the difference in style between the two psalters as 'Romanesque angularity yielding to a new elegance which foreruns Gothic'.

The final examples of twelfth century English manuscripts of great size are somewhat of an anti-climax when compared with the achievements of the Winchester scriptorium, though in scale and in the elaborateness of their decorative schemes they belong with the other great productions of the period. The four-volume Bible now in Durham Cathedral

Library (MS. A.ii.1) was presented by Hugh de Puiset[92] (or Pudsey), Bishop of Durham 1153–95, but there is no indication as to whether it was made there or not. As in the Winchester Bible, each Book and Prologue had originally an illuminated initial, but the style both of the ornament and of the painting (fol. 173; Plate 88B) is on a much less lavish scale than in the Winchester manuscript. The initials were done by several hands, of which the one illustrated in the plate in some respects seems to have stylistic affinities with the Amalekite Master of the Winchester Bible, perhaps before he had been influenced by the Genesis Master's manner of modelling and colouring. At any rate, the figures in the initial introducing II Kings (Plate 88B) are in a much simpler, more wholly linear technique than any of the Winchester work, though the manner of treating the drapery folds and the types of the heads betray their Byzantine derivation. The poses are comical in their ineptness and the figures are flat in spite of the prominent shoulder, arm, and leg which are 'modelled' with oval patches forming part of the whole essentially linear pattern. The decoration of the initials is very simple and plain, with narrow bands constituting the shaft of the letter which ends in a scroll of conventionalized leaves. The background is of burnished gold and the colours are rather strong and bright.

Another illuminated manuscript, however, also given by Bishop Pudsey to Durham Cathedral (MS. A.ii.19 in the Cathedral Library), seems to suggest a closer stylistic link between the Durham and the Winchester Bibles. Manuscript A.ii.19, a copy of the glossed epistles of St Paul, contains at the beginning of each epistle a fine historiated initial, usually on gold ground surrounded by a green painted line, as introduced into the Winchester Bible by the Genesis Master. The shaft of the initial is filled with conventionalized monochrome patterns as in the Winchester Bible, and the coloured ground is further decorated with dots and circles of white. Roundels containing lively animals are applied to the initial shafts. Some of the figures are strongly modelled in brown with white high-lights (fol. 87 verso; Plate 88A), and there is something of the vigour but little of the competence of the Winchester Byzantinesque style. The Pudsey manuscripts have also some stylistic affinities with manuscripts known to have been at St Albans at the beginning of the thirteenth century; there is a possibility that the Durham manuscripts might have been produced there, or somewhere under the influence of the St Albans scriptorium.

The source of the animal roundels in Durham MS. A.ii.19 is probably to be found in the twelfth century Bestiary, one of the most typically English medieval books. The finest Bestiary examples belong to the latter part of this century, and although only one can be localized – and that only as to ownership, not necessarily as to production – the style of the drawing in some of them points again to St Albans. (See Bod., MS. Ashmole 1511 below.)

James[93] dealt with thirty-four English copies of the Latin prose text which forms the basis for the medieval Bestiary, the earliest dating from the eighth to the tenth centuries. Between these and the twelfth century manuscripts no intermediate copies are known, and the sudden popularity of the work in the twelfth century seems to have been due to the pictures which illustrate the text rather than to the text itself.

The earliest twelfth century manuscript is Bod. MS. Laud Misc. 247 with thirty-six chapters of text illustrated with lively pictures mainly in brown outline.[94] Later in the

twelfth century, the text of a manuscript in Cambridge (Univ. Lib., MS. ii.4.26) has expanded to 110 chapters, with a corresponding increase in the illustrations which in this manuscript were drawn first, the text then being written around them. The style is finer[95] than that of Bod. 247, though similar in that most of the drawings are uncoloured.

In the late twelfth century the illustrated Bestiary comes into its own. A fine painted manuscript in the Morgan Library (MS. 81) is said to be the one that was given to Radford Priory (now Worksop, in Nottinghamshire) in 1187 and, if so, was perhaps made there as early as *c.* 1170 (Plate 90B). Close to the end of the century and perhaps even finer in style is Bod. MS. Ashmole 1511 (fol. 14 verso; Plate 90A). The characteristics of the drawing and painting typical of Bestiary illustrations are well illustrated in these two examples. The trend towards Gothic elegance in the linear patterns of the composition, which is characteristic of the later style, is evident in this manuscript.

Plate 90B illustrates the amusing procedure described in the text for stealing a tiger cub, namely, throwing a mirror to the tigress who, seeing her own reflection, thinks it is her cub and therefore does not notice that the cub is being carried away.[96] The galloping horse, the flying cloak, and the tigress rearing up on her hind legs are the elements *par excellence* of a fine medieval design. The drawing is firm and is further accentuated by the black contour line and the strong colour. The choice of colours is far from realistic – the horse is blue and the tigers are vermilion – but they form a brilliant pattern against the gold background.

The illustration from Ashmole 1511 on the same plate (Plate 90A) represents the popular medieval story of the unicorn which, when hunted, could not be caught except when it took refuge with a virgin. The drawing here is even finer than that of Morgan 81 in the decorative handling of the design, yet it has lost nothing of the intense vitality of the representation. The technique is painting rather than drawing, yet line plays a dominant part in the arrangement of the design as a whole. The suave curves of the ground, trees, and figures are echoed in the violent gestures and tense expressions of both the hunters and the virgin. The colours are chiefly blue and vermilion with some pink, yellow, and green, against a burnished gold ground. This type of composition represents the turning point between Romanesque with the heavy serious faces and the exaggerated anatomy of the figures, and the linear elegance of the Gothic.

Bestiary pictures seem frequently to have copied each other or some common original. The Morgan Bestiary illustrated in plate 90B was apparently copied both as to text and pictures in the now imperfect manuscript in the British Museum, Roy. MS. 12 C. xix, of slightly later date and equally fine style; and to these two must be added the Leningrad Bestiary.[97] Bodleian MS. Ashmole 1511 likewise forms a trio with Bod. MS. Douce 151 and Aberdeen Univ. Lib., MS. 24.[98] Bodleian MS. 764 and Brit. Mus., Harl. MS. 4751, form a pair. Apart from their fine quality, particularly as to the drawing, the Bestiaries were very important from the end of the twelfth century as sources for animal subjects and even for grotesques, which became such a prominent feature of thirteenth century psalters. Animals and grotesques from the Bestiary are found too in wall painting, floor tiles, and carved misericords of the thirteenth and fourteenth centuries in England.

Summary

In looking back over the productions of English art in the twelfth century, we find them to be considerable in number and high in quality even in a period of great art everywhere in Europe. The century began with outline drawing, often prettily coloured, still holding the field, until a fresh wave of Continental influence produced the revolutionary St Albans Psalter. It was followed in unbroken succession by the magnificent Life of St Edmund in full colour, four very large, fine Bibles – Bury, Dover, Lambeth, and Winchester – and five great psalters – Lansdowne, Eadwine, Winchester, Glasgow, and Copenhagen. The century ended with miniature painting on a monumental scale, by the Morgan Master, who may even have designed the grand scheme of wall paintings formerly at Sigena. This monumental style was destined to play an important part in Continental as well as in English art at the turn of the century.

The outstanding accomplishment of English art in the twelfth century was the development of a dynamic figure style which differed from earlier styles less in spirit than in technique. Whereas in Anglo-Saxon art contour line was the principal means of expressing the form and movements of the human figure, in twelfth century English art this technique applied to modelled figures, learned from Byzantine sources, changed them into linear pattern by the manipulation and arrangement of drapery folds, poses, and gestures. The figures themselves are solidly conceived and lively in a curious unrealistic sense; they live and move, as it were, in another world, charged with vitality and emotion and freed from the heaviness of earthly matter. In short, the twelfth century English artist has finally succeeded in mastering to his own satisfaction the problem of the human figure which had long plagued him, by converting it, modelling and all, into a dynamic decorative pattern.

THE THIRTEENTH CENTURY

*

HISTORICAL BACKGROUND

POLITICAL

Richard I (son of Henry II), King 1189–99; Third Crusade and captivity in Germany 1189–94; in France 1194–9.

John (brother of Richard), King 1199–1216; Magna Carta 1215; Fall of Constantinople 1204; loss of Normandy.

Henry III (son of John), King 1216–72; married Eleanor of Provence; great period of artistic activity under royal patronage 1230–50; veneration for Edward the Confessor; brought in foreign craftsmen to work on new choir and shrine of the Confessor at Westminster Abbey 1245–70; Treaty of Paris 1259, all south-west France ceded to Henry as vassal of Louis IX (d. 1270).

Edward I (son of Henry III), King 1272–1307; married Eleanor of Castile 1254; on Crusade 1270; beginning of Statutes in Parliament; Treaty of commerce with Flanders 1274.

ECCLESIASTICAL

New type of bishop, the 'University-trained professional secular'; Edmund Rich, Archbishop of Canterbury 1234–40; canonized 1246.

Richard Poore, Bishop of Salisbury 1217–28; of Durham 1228–37.

New cathedral begun at Salisbury 1220; scriptorium there c. 1250.

Richard Wych, Bishop of Chichester, d. 1253, canonized 1262.

Establishment of the four mendicant Orders: Dominicans 1221; Franciscans 1224; Carmelites c. 1240; Austin Friars 1248.

*

As the historical background suggests, in the thirteenth even more than in the preceding century foreign contacts played a part in the formation of English style. The monumental linear figure which appeared in the later twelfth century is still characteristic of the earliest thirteenth century manuscripts in England and apparently influenced contemporary French manuscripts such as the Ingeburg Psalter.[1] In the second and third quarters of the century French influence is evident in English stained glass and miniatures, and in the third quarter, craftsmen in other media, notably mosaics, are known to have come from Italy to work in the new choir of Westminster Abbey. Nevertheless, the pictorial style even of this Westminster or Court School of artists retained a strong continuity with that of the earlier thirteenth century as represented by copies of paintings, now destroyed, in the royal palaces. Thus English work, although Gothic, is clearly distinguishable from French·

Several new features appear in English manuscripts during the first half of the thirteenth century. Most noticeable of all is the reduction in their size and consequently also in the scale of the script and of the illumination. Historiated initials, which in the twelfth century had consisted of a picture framed by a more or less formally designed letter, once again are treated as decorative features of the text or, as in the case of the great B of the *Beatus* page of psalters, as the sole decoration of a whole page. With the increase in importance of the initial, both decorative and historiated, new ornamental elements were introduced: scrollwork filling, diapered backgrounds, small scenes in roundels, and grotesques. Miniatures with conventionalized frames continue to be used for the preliminary series of Bible pictures in psalters and for illustrations in other texts, of which some new ones are apocalypses and chronicles. Psalters, which constitute the greatest number of English illuminated manuscripts in this century, begin to include private devotional offices for the canonical hours, thus preparing the way for that most prolific type of medieval illuminated manuscript, the *Horae* or Books of Hours, which flooded the market in the later Middle Ages. During the thirteenth century, names of artists appear more often, and in a few cases enough of their work can be identified to establish individual artistic styles. Chief among these illuminators are W., probably William, de Brailes and Matthew Paris; among painters, William of Westminster and Walter of Colchester.[2] Finally, in the thirteenth century not only is art produced in more media than previously, but there are clearer stylistic relations between the various forms.

Because of the richness and variety of thirteenth century material, the continuity of its successive stylistic phases in the various media can be seen most clearly if the century is divided into chronological periods.

These periods are five:

1. The transition in the years immediately before and after 1200, between late Romanesque style, as developed mainly out of Canterbury and Winchester, and early English Gothic. This transitional style is found in manuscripts which have been attributed to both sides of the English Channel.

2. The early English Gothic style as represented (1200–25) in a group of psalters which are related stylistically in spite of having calendars indicating that they were meant for use in various places, such as Westminster, St Albans, London, and the University centres of Oxford and Cambridge.[3] The period also includes stained glass.

3. The full flowering of the Gothic style (1225–50), again mainly in richly illuminated psalters but including some Bibles, attributed for the most part to three centres: the Canterbury scriptoria; a lay shop probably under the direction of W. de Brailes at Oxford; and the scriptorium of the new cathedral at Salisbury. Other examples in the general style of this period are unidentifiable as to provenance and use.

4. The reappearance (1250–70) of a new version of the tinted outline style, sometimes combined in the same manuscript with flat painting in full colour, and used mainly for illustration. It appears chiefly in new types of text, as apocalypses and chronicles. The chronicles were primarily the work of Matthew Paris and his associates at St Albans; the apocalypse manuscripts can be divided roughly into stylistic and textual groups, but variations in individual manuscripts make their localization problematic. The stylistic

differences between groups can be most clearly distinguished according as they are more closely related to the Matthew Paris style or to that of an entirely different illuminator, the Master of the Evesham Psalter (see below).

5. In the last third of the century, the final phase of thirteenth century style in England showing foreign, mainly French, influences and known as the Westminster or Court style, since it appears in the choir and the Confessor's Chapel of Westminster Abbey and also in paintings and other work done for the King at Westminster Palace and elsewhere in England. This last period includes, besides manuscript and other paintings, some embroideries and floor tiles.

1. The Transitional Style of circa 1200

Two manuscripts of *c.* 1200 from St Albans Abbey,[4] and probably illuminated there, will serve to introduce the earliest thirteenth century style in England: a Glossed Epistles of St Paul (Camb., Trin. Coll., MS. 0.5.8), and a Glossed Gospels (MS. B.5.3). Of the two, the illumination in the Gospels is the finer in quality, although, apart from the Canon Tables, it is limited to the symbols of the Evangelists in foliated initials at the beginnings of the Gospel Books. The winged man, symbol of St Matthew in the tetramorph on fol. 4 verso (Plate 92A), is painted in a masterly style which, in the solidity of the figure, in the modelling of the head, and in the colouring – rich blue and red, and delicate pink and green – furnishes a link between the late twelfth century style as developed at Winchester, especially by the Morgan and the Gothic Masters, and that of the five preliminary Bible pictures of a psalter made for Westminster Abbey (Brit. Mus., Roy. MS. 2 A.xxii; Plate 91). In fact, the technique of these two manuscripts is so similar that there seems little doubt that the pictures were painted by the same artist. The miniatures of the Westminster Psalter[5] are also close in style and feeling to the work of the so-called Master of the Gothic Majesty of the Winchester Bible[6] (cf. Plate 85B), and this suggests the possibility that the Winchester artist may have worked later at St Albans, to which centre James[7] long ago tentatively attributed the Westminster Psalter.

The style of the Westminster miniatures is magnificent in the firmness and clarity of the drawing (fol. 14; Plate 91) and in the richness of the gold and colours. Against a burnished gold ground within a framed mandorla Christ is seated frontally on a red and green rainbow, his feet resting on a similar smaller one. He is clothed in a deep blue tunic having a red embroidered neck band and powdered with groups of tiny white dots. His mantle is pale tan shaded with deeper tones of the same. The border of the miniature is in blue monochrome. The flesh of the face, hands, and feet of Christ is modelled on a yellowish ground with shadows in brown or green; his hair and beard are reddish brown. The figure is the solid, bulky type of the Morgan Leaf and the Sigena frescoes but draperies are flatter and the contour line is irregular as in the style of the Master of the Gothic Majesty. Still, it is amazing what a convincing figure has been produced by means of the heavy black outline and the lightly shaded drapery folds. It is the drawing which is primarily responsible for the monumentality of this figure, as of the Trinity College St Matthew and the Sigena figures (cf. Plate 92, A and B).

The five miniatures on three leaves inserted at the beginning of the Westminster Psalter furnish no evidence that the Psalter was made at Westminster Abbey. Their figure style has no relation to that in the fine decorative illumination of the *Beatus* and nine other decorative initials in the psalter. The miniatures could have been added after the manuscript was written, as certainly happened with the ones at the end. The latter are by a follower of Matthew Paris of St Albans and may strengthen the theory that the preliminary pictures also originated there. The decorative initials painted in gold and colours and the delicate red and blue penwork letters and other textual ornament may represent the quality of the writing done by Westminster Abbey scribes.

At Canterbury at the beginning of the thirteenth century large manuscripts were still being made. A psalter, the third and last of the copies made of the Carolingian Utrecht Psalter (Paris, Bib. Nat., MS. lat. 8846), was written and partly illustrated there[8] with framed miniatures which follow in general the subjects of the original and of the two other copies, but most closely those in the Eadwine Psalter. In addition to the psalter illustrations, a series of magnificent Bible pictures[9] in the same style precedes the Paris text.

Plate 93 reproduces the miniature on fol. 90 verso which illustrates Psalm 51; the composition can be compared with the Eadwine Psalter illustration for the same psalm in Plate 72A. The picture space is divided into two main compartments – Heaven and earth – by an irregular formal band, following the idea of the rolling ground line used with the same purpose in the Eadwine Psalter. In Heaven, the half-length figure of the Deity appears in an oddly shaped frame, which was derived from the mandorla as in plate 72A but without its meaning; outside this frame is a conventionalized cloud-band. The other figures, 'the righteous' (verse 6) who see and laugh at the downfall of the wicked 'mighty man', are more solemn than in the Eadwine miniature; but their number is the same and they are in relatively similar positions. In the earth compartment, the wicked man sits in his 'tent' – a columned basilican building in Romanesque style, with a nave and aisles and a clerestory above the aisle roof – holding his sword and presumably giving orders for more wickedness. The figures are larger in the Paris miniature and they completely fill the spaces between the columns of the building; there is room for only three instead of four. The Psalmist and the 'green olive-tree' to which he likens himself occupy central positions in the lower compartment in oth bminiatures, and the Psalmist holds in his right hand the 'sharp razor' (verse 2) and points upward to God with his left hand.

Evidently the empty lower right corner in the Eadwine miniature did not please the artist of the Paris manuscript, especially since the punishment of the wicked man found no place in the picture he was copying. So he introduces the offender again in this space and shows him falling on his head, 'rooted out of the land of the living' (verse 5), and in addition, true to the thirteenth century artist's *horror vacui*, he fills the lower corner of his miniature with more architecture, brightly coloured and shaded, to balance that on the other side.

The styles of the two miniatures are strikingly different. If the artist of the Eadwine Psalter sacrificed most of the excitement of the earlier models to his interest in coloured patterns, the artist of the Paris Psalter has deliberately eliminated what remained of its informal narrative interest and endowed the theme and the actors with the uncompro-

mising solemnity of a justly administered judgement scene. The figures are marvellously painted, with heavy drapery swinging about them in bold sweeping curves, and with strongly modelled faces. The style was undoubtedly affected by the Winchester Bible and is perhaps closest to that of the Genesis Master (Plate 84A); but it is more linear. There is much of the imposing monumentality of the Dover and Lambeth Bibles and of Canterbury glass (Plate 95). This is mature Romanesque painting at its finest – in scale, design, technique, and in the rich colouring set off by the burnished plain gold background.

Several large illuminated Bibles of *c.* 1200 are also connected with Canterbury, but it is problematical whether their decoration was executed at Canterbury or in Normandy. The connexion with Canterbury is documented by a colophon in the three-volume 'Manerius Bible' in Paris (Bib. Ste-Geneviève MS. 8–10), written by 'Manerius scriptor cantuariensis'.[10] The illumination consists of historiated and decorative initials, painted in colour on gold grounds, but the style does not seem to agree with the Canterbury style as represented by the Paris Psalter, and it may be Continental. Two related Bibles are in the Bibliothèque Nationale[11] in Paris (MSS lat. 11534–5 and 16743–6).

Another large Bible[12] (Morgan MS. 791) surpasses in scale and magnificence the Manerius Bible; it has similar initials which have been painted on separate pieces of vellum and pasted into spaces left for them in the appropriate text.[13] The full-page Trinity (fol. 4 verso; Plate 94) with choirs of angels, and creation scenes in roundels is a superb example of the style. The gold ground is very highly burnished and against it the richly coloured draperies of the figures, and the fine-coiled ribbon ornament with little animals crushed between the strands which fill the spaces between the roundels in the lower half of the page, give it a brilliance which is not surpassed in any other work of the period. The design is formal, arranged in compartments, like the miniatures in Paris MS. 8846. The central group of the Trinity has an unusual representation of Christ, the Second Person, as a small figure standing enclosed within the mantle of God the Father, and the Dove flying upward between them. It is particularly impressive because of the plain gold space surrounding it. Other interesting details of the page are the creation and fall of the angels, the four Continents – the names *Parse* and *Ethiopia* are legible – and the twelve prophets arranged in two rows of three on each side of the quatrefoil medallion containing the Trinity. The faces are modelled strongly with reddish brown colour and suggest the technique of the Ste-Geneviève Bible; but the pale lovely colour of the Morgan Bible and the decorative designs constituting a well balanced all-over pattern seem closer to Paris MS. 8846 than to Ste-Geneviève MS. 8. Perhaps the miniatures of the Morgan Bible can be characterized best as Channel style, not necessarily Canterbury work. The text of this manuscript shows evidence of having been written at St Albans, and ownership there in the fourteenth century is attested by the St Albans pressmark.[14]

Channel style also describes stained glass of the late twelfth and early thirteenth centuries in Canterbury Cathedral.[15] It all belongs to the period of rebuilding after the fire of 1174; there is nothing earlier. The scheme of subject matter in the glass was elaborate. In the choir clerestory was a double row of figures representing the ancestors of Christ and Old Testament scenes dating from *c.* 1180. In the choir aisles were twelve theological windows, a concordance of Old and New Testament scenes of which fragments are now

gathered in two windows of the north choir aisle (c. 1200–15). There were twelve windows in the aisles of the Chapel of the Holy Trinity with scenes of the miracles and probably of the life and martyrdom of Thomas Becket. Of these only the miracle scenes survive; they date from the second and third decades of the thirteenth century. In the Corona, at the extreme eastern end, are medallion windows of c. 1220 with further scenes from the Old and the New Testaments.

The Old Testament figures comprising the genealogy of Christ in the earlier windows are in rectangular panels. One of the finest of these is Methuselah (Plate 95). It is monumental in conception with the imposing proportions and gestures and the intense expression characteristic of the best Byzantinesque late twelfth century style. The pose is conceived on a grand scale and magnificently rendered: one knee is drawn up, with the foot supported on the step of the seat and the elbow of the bent arm resting on the knee. Balance is maintained by the outstretched foot and the left hand tensely holding the left knee. The drapery is wrapped round the body in heavy folds which follow the curves of the figure and accentuate the balance of the composition as a whole. The loose fingers of the right hand stroking the beard and the gaze of the eyes turned away from the direction in which the head is facing give to the figure an overwhelming feeling of power and repose. The massiveness of the Methuselah figure is relieved by the bands of decorative pattern on the tunic, by the design of the cushion, and by the scrollwork in the spandrels of the arch under which he is seated. The colours are chiefly blue and red, with lighter tones in tan and a very little yellow and green.

The imposing style of the patriarch Methuselah, which is unquestionable Canterbury work, further supports the Canterbury attribution of the miniatures in the Paris Psalter and possibly some others in Channel style (cf. Plates 93 and 95). Especially striking are the similarity in the massive heads, in the firm poses, and in the thick, heavy draperies that swing about the body with no loose flying ends. The dignity and solemnity of the mood, though characteristic of Romanesque art in general, seem particularly consistent in the Canterbury manuscripts and glass. The designs of the fine late twelfth century figures in the clerestory windows at Canterbury may well have been drawn from a manuscript such as the Paris Psalter.

Two manuscripts in the British Museum dating from c. 1200 which show some evidence of intended use in other arts, painting and stained glass, are the fully illustrated lives of two saints: Bede's Life of St Cuthbert (Add. MS. 39943) made perhaps at Durham,[16] and Harl. Roll Y.6 containing eighteen outline drawings of the life of St Guthlac in roundels, made at or for Croyland Abbey, near Peterborough, in the Fenlands.[17]

Of the Cuthbert manuscript (Add. MS. 39943) there is a Durham record[18] that it was loaned to Richard le Scrope, Archbishop of York, presumably to serve as a model for a projected window dedicated to St Cuthbert in York Cathedral. Scrope was executed in 1405 and the window was not actually inserted until nearly half a century later.[19] But there is further evidence that the Cuthbert manuscript was ultimately used for designs not of stained glass but of painting, in the choir stalls of Carlisle Cathedral in the late fifteenth century.[20] Forty-five pictures from the life of St Cuthbert now remain in Add. 39943 out of a probable fifty-five.[21] Among the many interesting scenes from the life of

the Saint, the first miniature (fol. 1 verso; Plate 97A) stands out because of the fine quality of the painting and also for the general resemblance it bears to an earlier wall painting at Durham now, unfortunately, much restored.[22] The technique of the miniature is that of monumental painting. The Saint stands firmly and quietly against a panelled ground the centre of which is gold, while the pinkish border is powdered with groups of white dots. The modelling of the drapery and of the face is done with heavy pigments, much white being used on brownish flesh-tone for the face. The pigments are so thick that they have flaked off in places. The figure is well-proportioned and the hands and feet are drawn with considerable skill. The prostrate figure of a monk embracing the foot of the Saint is eloquent. Other miniatures in the manuscript show these same qualities of fine painting and tender devotional spirit. They represent some of the best examples of narrative style at the time of transition between Romanesque and Gothic.

The Guthlac Roll (Plate 97B) is not painting but outline drawing with heavy, firm, continuous contours and very little use of colour. If the Cuthbert miniatures resemble wall painting, the Guthlac roundels suggest designs for stained glass (cf. Plate 101) or possibly enamels.[23] The simple, flat, canopy-like architecture with the figures in an undefined spatial relation to it; the tall, slender forms with long straight or elegantly curving drapery folds; the many lines used as shading on the figures as well as for contour; and the use of inscriptions to explain the scenes, place the compositions of the roundels in the category of glass painting, although no body colour is used. The form of the Guthlac Roll is almost unique in late medieval manuscripts, that is, the rotulus or roll rather than the codex or book form. It would seem that the pictures were indeed intended for use in some other form of art; but there is no evidence of what or where this may have been.

2. The Early Gothic Style (circa 1200–25)

Closely related in style to Roy. MS. 2 A. xxii is a group of psalters made for use in different centres in England in the first quarter of the thirteenth century. It is in this group of unknown origins but nearly contemporary date that the elaborate scheme of English psalter illustration reached its full development. Before considering individual manuscripts which make up the group, therefore, it will be well to describe the main features of this scheme.[23a]

1. Preliminary pages,[24] varying in number, containing scenes mainly from the Old and New Testaments arranged in a sequence. At the turn of the thirteenth century these scenes, though sometimes limited in number (as in Roy. MS. 2 A. xxii), tended in general to increase greatly. (Cf. Munich Psalter, below.)

2. Calendar pages[25] containing illustrations of the signs of the Zodiac and the occupations of the months, usually in roundels in the late twelfth and early thirteenth centuries, but later in rectangular frames or free in the margins.

3. A page containing a large and elaborate initial B and sometimes smaller decorative letters of the word *Beatus*, beginning the first psalm. In Roy. MS. 2 A. xxii the B of the *Beatus* follows the general form which was established as early as the late tenth century (cf. Plate 21B), but the scrolled acanthus which earlier filled the letter has been reduced to a fine-sprung pattern of bare ribbon scrolls, overlapping and interlacing at intervals, and

ending in conventionalized leaf motifs.[26] Within the scrolls, little animals clamber about. Another new feature is the introduction of roundels containing small scenes from the life of David in place of the interlace at the terminals of the upright of the B. The whole initial is on a patterned coloured ground surrounded by a green painted outline such as was first used, perhaps, in the initials of the Winchester Bible. This style has undergone some changes in the group of slightly later related psalters (see below). The patterned background has been replaced by jewel-like diapering; the scrolls have become more tightly sprung, and the leaves have been reduced to the scale of the stems. Animals are livelier, even though often they are not true animals but only lacertine-like heads crushed between the coils of the spirals. There is brilliance and tautness in the intricate design of the initial, and the page with its rich diaper is well set off by the surrounding line of green. This style of *Beatus* pages is repeated, with variations, in many other early thirteenth century English psalters.[27] (See Plate 104.)

A new type of *Beatus* page is introduced in the Imola Psalter, the basic elements of which come from twelfth century Jesse Tree windows, the earliest known being at St-Denis.[28] Jesse lies on a couch and from his side springs a vine branching into two main stems which cross, forming medallions in which are figures representing the genealogy of Christ. In the Imola *Beatus* there are only four figures: David, the Virgin, Christ, and the Dove of the Holy Spirit. In six medallions at the sides are (below) Kings Solomon and Hezechiah and (above) four prophets: Isaiah, Jeremiah, Micah, and Ezechiel, all bearing scrolls with their names. In seven roundels applied to the frame of the letter are scenes from the life of David, one showing him in the familiar pose of a writing evangelist. The design of the Imola *Beatus* is symmetrical as in a window, the letter B filling the whole page, with strong emphasis on the central axis which contains the four main figures.

Another early example of a Jesse *Beatus* shows additional subject matter and more elaborate design but with stronger emphasis on the form of the initial. This is in the so-called Huntingfield Psalter.[29] The subject matter has increased both in amount and in meaning: besides the central axis figures (David, Solomon, the Virgin, and Christ in Majesty) the subsidiary branches contain the twelve prophets. On the frame of the page, which contains also some words of the text introduced by the initial, is (above) the Coronation of the Virgin and (below) Hell and the punishment of the damned. In six other medallions on the frame are the twelve apostles in pairs and between them, the Elect and cherubim. The theme is the Last Judgement.

Combinations and variants of these two types, together with greatly increased decorative elements, were introduced subsequently into the Jesse *Beatus* until in East Anglian Psalters the page became a veritable jungle where almost any subject, religious or secular, and any variety of flora and fauna might be found (see Plates 131 and 133).

4. Large historiated initials introducing the psalms which mark the principal divisions[30] according to its liturgical use. In the thirteenth century these usually were ten:[30a] 1, 26, 38, 51, 52, 68, 80, 97, 101, and 109. Additional historiated and decorative initials were introduced in increasing numbers, and in some especially elaborate manuscripts of this period and later, every psalm and even every verse has its illuminated initial. The subject matter of the historiated initials, apart from the *Beatus*, was drawn mainly from three sources:

(a) scenes from the life of David; (b) the text of the psalm itself interpreted in terms of contemporary life; (c) Old and New Testament and Apocryphal scenes.

5. Decorative line fillings containing all kinds of extraneous subject matter such as heraldry, grotesques, and ornamental patterns. The spaces for these resulted from the scribal practice of beginning each verse of the psalm on a new line.

6. Finally, with the increase in the number and elaborateness of the initial letters, a tendency quickly appeared to extend the terminals of the letters into the margins in the form of leafy branches, at first with only a few leaves and buds, later with a profusion of foliage and even flowers. Illustrative material of biblical, historical, personal, and fantastic nature soon found its place also in this marginal paradise, particularly in the wider bottom margin, where endlessly varied so-called *bas de page* scenes were introduced. The latter features were most highly developed in East Anglian manuscripts, when the use of preliminary miniatures had been largely abandoned (see Chapter 6).

The early Gothic psalters can be grouped, primarily on stylistic grounds, less certainly on evidence in the calendar as to the local use for which they were written. There are three main groups:

1. Munich, Bib. Nat. Clm 835: the earliest of the group, with indications of Gloucester use.[31]

 Camb., Trin. Coll. MS. B.11.4: partly copied from Munich, partly later.

 Brit. Mus., Arundel 157 and Brit. Mus., Roy. 1 D.x:[32] both before 1220 with indications of Oxford use.[33]

 Imola (Italy), Bibl. Comunale, MS. 100: between 1204 and 1216;[34] Amesbury-Fontevrault (?) use.

 Bod. Lat. liturg. 407: Amesbury.

 Edinburgh (ex-Dyson Perrins): Oxford calendar?

2. Brit. Mus., Lansd. 420: London calendar.

 Brit. Mus., Harl. 5102: lacks calendar and preliminary miniatures.

 Camb., St John's Coll., MS. D.6: London calendar. Made for Robert de Lindesey, abbot of Peterborough 1214–22.

 Berlin, Kupferstichkabinett, MS. 78 A.8.[35]

3. Brit. Mus., Lansd. 431: calendar of Barnwell Priory, near Cambridge.

 London, Lambeth Pal. Libr., MS. 563; calendar of St Neots, also near Cambridge.

The first group is by far the best in quality, and although the indications of local usage vary in their calendars, they furnish the strongest internal evidence for a common production centre. The evidence is of two kinds: the identification in some cases of the same illuminators' hands in more than one of the manuscripts; and the correspondence in number, type, and arrangement of the series of preliminary miniatures which usually precede the Psalter.

The Munich Psalter has much the longest series – eighty pages containing, besides the usual Old and New Testament scenes, some uncommon subjects such as (fols 65–72) illustrations of the public life of Christ (the temptations, miracles, and parables), a Tree of Jesse (fol. 121), and, as a most unusual feature, five pictures illustrating the last three psalms (fols 146–9 verso). It is evident that such a varied series of subjects must have been

derived from more than one earlier exemplar; for the scenes of Christ's public life one thinks at once of the cycles in Ottonian gospel books of the Reichenau School. Some of the Munich miniatures are copied in a different style in the preliminary pictures of Camb. Trin. Coll. B.11.4, and these in turn clearly influenced the illustration of the Psalter itself, which is somewhat later.

Roy. 1 D. x and Arundel 157, which are closely related in their preliminary scenes and in the arrangement of the pictures two on a page (as also is largely true in Munich), have a much smaller number of pictures and none of the unusual subjects. Roy. 1 D. x is typical. On eight thick stiff vellum leaves are thirty-one pictures beginning with the Annunciation and ending with Pentecost, followed by a full-page Majesty. The same arrangement and many of the same subjects (though the series is incomplete) are found in Arundel 157. It is probable that Imola had a similar series on pages that have been cut out of the manuscript. The style of all the miniatures is more or less closely based on that of the five preliminary pages in Brit. Mus., Roy. 2 A. xxii, and all, including this latter psalter, are related to the long series in the Ingeburg Psalter, although the artists are by no means the same. It is unfortunate that the pictures in the Imola Psalter are missing, since the style of the initials in this manuscript seems to be closest of all to that of the Ingeburg manuscript, a fact that may be explained perhaps in part by the early date of Imola and its suggested connexions with Fontevrault and the Channel style.

The Imola Psalter has one miniature which is unique and most interesting. The subject is the genealogy of Anna and of her sister Esmeria (Plate 96B). On a gold ground three sets of medallions, suggesting the scheme of a Jesse Tree, contain as the central figures Mary, Christ, and the Baptist. The right-hand series contains (from top to bottom) Anna, mother of Mary by Joachim, her first husband, Mary Salome, daughter by her second husband, and Mary Cleophas, daughter by her third husband. The two lowest medallions contain John the Evangelist and the Apostle James (issue of Mary Salome), and Simon, James the Less, Jude, and Joseph (sons of Mary Cleophas). On the other side, the issue of Esmeria include Elizabeth (by her first husband) and John the Baptist; by her second, Eliud and Emiu, from whom St Servatius, Bishop of Tongres, was descended; he is represented, according to tradition, receiving the crozier from an angel who points upward to the figures representing his distant kinship with Anna.[36]

In group 1 the miniature master seems also to have done at least some of the psalm initials in the same manuscript, which was not so in Roy. 2 A. xxii. Besides possibly having collaborated in the miniatures of the Munich Psalter, the artist of the initials in Roy. 1 D. x certainly painted some of the initials in Imola (Plate 99, A and B). The drawing of the figures, the colouring, and even certain iconographic details are almost identical.

This same illuminator's hand is recognizable in a third psalter, Bod. Lat. liturg. 407, a smaller and less elaborate manuscript, which both stylistically and iconographically forms a link between 1 D. x and Imola. The calendar, which has the feast for St Melor, an Amesbury saint, in blue (October 1), is not illustrated and there are no preliminary biblical pictures. The Beatus initial contains the familiar scenes from the life of David as in Roy. 1 D. x, but the figures are very close to those in the calendar roundels of Imola. A Madonna and Child in the initial to Psalm 97 is found also in 1 D. x alone of this group, and the

uncommon subject of Christ blessing a woman holding a chalice (the Church?) in the initial for Psalm 101 occurs also in the Imola Psalter. Thus Bod. Lat. liturg. 407, Roy. 1 D. x, and Imola constitute the closest sub-group among the early thirteenth century psalters.

One of the Munich artists probably did most of the miniatures in Arundel 157 (Plate 98, A and B). The figures are less monumental in proportions, the faces are pinched and expressionless and the draperies are more linear even though the figures themselves show considerable liveliness. The style in general is much less pleasing both in design and in colouring than that of Imola and 1 D. x. Of the first group, Arundel 157 is the least good in quality.

Arundel 157 style (though probably not the same artist's hand) is found in the preliminary miniatures in Lansdowne MS. 420. The scenes are contained in roundels rather than in rectangles, two to a page, with stem-like frames interlocked. The two loops fill the page and are surrounded by a rectangular frame. The figures are less supple and the drapery folds are indicated by broad lines on flat colour; the colouring as a whole is sharper and less pleasing than in group 1.

Harley MS. 5102, a sister manuscript to Lansd. 420, probably also had preliminary Bible pictures and a calendar, now lost. However, five full-page miniatures of nearly contemporary date have been inserted at intervals in the text.[37]

The most important new feature in the psalters of the second group is the animal-human grotesque. Animal grotesques, it is true, appeared even in the late twelfth century, notably in Durham manuscripts (see Plate 88A). Their origin seems to have been in large part the Bestiary. But the animal-human grotesque is a different creature. Its basic idea is the application to animals (sometimes rendered naturalistically, sometimes as monsters) the attributes of human beings, usually with the intention of caricaturing or even satirizing human types or their occupations. The *Beatus* of Lansd. 420 (Plate 96A) illustrates well this species of grotesque. There is a band of musical animals, among which are a donkey, a goat, and a pig, perhaps caricaturing the musicians of David who sits harping on one side, or perhaps all musicians! Other pages in this manuscript and also in Harl. 5102 show animals in even more pronounced human roles, as a fox in a cowl leaning on a crutch (caricaturing a friar?) and a goat's head wearing a bishop's mitre. These grotesque figures multiply rapidly as the century progresses (see Rutland Psalter, below) and reach their extremes of ridiculousness and even vulgarity in the East Anglian style of the following century. Besides appearing in the marginal decoration they often are used in the exquisitely fine penwork of line-endings.

The two other manuscripts of group 2 also form a close stylistic pair; they are: St John's College MS. D.6 (with a London calendar) and Berlin, Kupferstichkabinett MS. 78 A.8. Both are related in style to the other pair in the group, but most closely perhaps to Lansd. 420, except that the compositions of the preliminary miniatures are in rectangular frames, not in roundels as Lansd. 420. The heads in all four of these manuscripts are of the same strange heavy-jowled, flat-cheeked type and the drapery is represented by the same heavy lines on flat colour.

Between St John's D.6 and the Berlin Psalter, the correspondence in style is particularly close, and some unusual details of the miniature compositions seem to be actually copied

one from the other: for example, the scene of the Entry into Jerusalem, with the brick wall topped by a row of heads looking over, and the ass with its nose inside the gate.[38]

The quality of this whole group is much less fine than that of group 1 and it seems unlikely on stylistic grounds that the two groups were made in the same place. It is possible that group 2 represents London shop work.

There is no close stylistic similarity between Lansd. 431 and Lambeth 563, which have been associated solely on the basis of the proximity to Cambridge of both the monasteries to which the calendars point. Lansd. 431 is three times the (present) size of Lambeth 563 and is illustrated with larger and finer initials, mainly historiated, which are not dissimilar to those in Trin. Coll. B.11.4 of group 1. The lively animals characteristic of this manuscript (as also of some of group 2, notably Harl. 5102), together with climbing human figures in the *Beatus* initial (fol. 11), in a way are reminiscent of twelfth century Canterbury style. Even more suggestive of Canterbury technique are the tiny figures drawn in outline in Lambeth 563. The largest and best miniature in this manuscript (fol. 100) has an unusual initial to illustrate Psalm 109, the subject of which appears to be the creation of Eve.

Unrelated to any of the early psalter groups either stylistically or iconographically is one made between 1203 and 1218, for Worcester use (Oxford, Magdalen Coll., MS. 100). The evidence is unmistakable: three Worcester bishops, Egwin, Oswald, and Wulfstan, the latter canonized in 1203 and translated in 1218, are entered in the original hand, and Wulfstan's octave is added in the calendar; there is also the Dedication of the Church of Worcester (June 7) which occurred in 1218. The *Beatus* page is missing. Only four psalm initials remain and these are pasted in – a fact that obviously accounts for the spaces where initials are lacking. The figure style seems to be traceable to the Winchester Bible rather than to any other source; the faces are strongly modelled and the draperies are often shaded, although black lines also are used to define them. It is a strange style, more Romanesque than Gothic.

Some inconclusive evidence for a Worcester connexion has been noted in the litany of a psalter without a calendar, MS. G. 25 in the Glazier Collection, New York, but the miniatures are very different from those in Magdalen Coll. 100. The date is somewhat later and the text, which Plummer[39] identifies as a recent import from France, is closest, he thinks, among English psalters to Robert de Lindesey's Glossed Psalter, St John's Coll. D.6. The six preliminary miniatures arranged in pairs with an interesting iconographical significance[40] suggest the style of the miniatures in Trin. Coll. B.11.4. Taken altogether, the evidence of provenance seems to point to London or at any rate to some monastery in south-east England.

Obviously the problem of localizing the production of the early Gothic psalters cannot be solved easily. It is presumed that psalters would have been made at this early date in monastic scriptoria rather than in lay shops, the existence of which in England is uncertain before the mid thirteenth century, and even then is almost entirely undocumented. Of the two great monastic centres productive in the late twelfth century and earlier, Canterbury was still active in the thirteenth, but there is no evidence for Winchester after *c.* 1200. St Albans, where the miniatures in Roy. 2 A. xxii probably were painted and which had

been continuously active during the twelfth century, may have produced some of the first group of early Gothic psalters, notably Imola, Roy. I D. x, Bod. liturg. 407, and Arundel 157. This would pose the problem of Munich, with its Gloucester indications and stylistic affinities with Arundel 157. There is no evidence, however, of a scriptorium at Gloucester except the survival of carrells in the (later) cloister. As for the Oxford calendars in group I, this need not rule out a St Albans provenance for the illumination or even for the writing of the manuscripts; often, no doubt, these were not done in the same place. Much more evidence is needed for the reconciliation of liturgical use and local styles, particularly where large centres such as St Albans and London are concerned.

Cambridge St John's College MS. D.6 was made as noted above for Robert de Lindesey, abbot of Peterborough 1214–22, probably in London. Also made for him but in a very different style is a much finer manuscript of about the same time.[41] On fols 35 verso and 36 of this psalter (London, Soc. of Antiquaries, MS. 59) are two full-page miniatures, the Crucifixion and Christ in Majesty,[42] painted in rich colour on patterned gold grounds, preceded by three pages each with two scenes from the life of Christ in brown and green tinted outline. A magnificent *Beatus* initial on fol. 38 verso (Plate 104) has eight roundels and two trefoil medallions with David and the Musicians and four prophets. The background is diapered in deep blue with white and red patterns. The richly shaded leaf motifs and the charming little rabbits and squirrels playing hide and seek among the branches give variety and life to the fine but otherwise rather formal designs.

Very close stylistically to the painting in the Lindesey Psalter are a single leaf from another one containing the *Beatus* on one side and a Majesty on the other (formerly inserted in Brit. Mus., Cott. MS. Vesp. A.1), and a complete psalter in the Fitzwilliam Museum, Cambridge (MS. 12). The *Beatus* side of the single leaf is almost a twin to that in the Lindesey Psalter except that the coiling vines of the B have budded in small trefoils. The Majesty, however, appears to be by the same hand as that in the initial to Psalm 109 (fol. 159) in Fitzwilliam 12. The style is clear-cut and brilliant with colour and burnished gold. Heavy black outlines point up the design, which is strongly suggestive of stained glass. A Crucifixion miniature preceding the *Beatus* page (fol. 12) and three historiated psalm initials are the only other figure subjects[43] in Fitzwilliam 12. All the remaining initials have exceedingly beautiful decorative designs in gold and brilliant colours. An interesting subject, an abbot and a monk before an altar (Psalm 101), and the similarity of style suggest that this manuscript also may have been made for Robert de Lindesey, abbot of Peterborough, both probably in the monastery of Peterborough.

3. The Fully-Developed English Gothic Style (1225–50)

It is in the second quarter of the thirteenth century that the style of manuscript illumination approaches most closely to that of stained glass windows, not necessarily because of direct influence of the one on the other, but rather as a parallel development. In the thirteenth century, the Canterbury glass, like that of contemporary France, was designed in medallions arranged in geometric patterns,[44] each medallion containing a small complete scene often including many figures (Plate 101). The whole window, therefore, is organized into

a unity both of design and of iconographic theme. So also the manuscripts (Plate 100). The liveliness of the figures, the brilliance of the colour, and the sparkling jewel-like effect of the medallion glass has much more of the quality of illumination in colour on gold than of outline drawing. There is a possibility that the Canterbury glass directly influenced the design of manuscript pages produced there about the same time; the similarity in designs of stained glass and manuscripts becomes even more marked towards the middle of the thirteenth century.

The Bible of Robert de Bello[45] (Brit. Mus., Burney MS. 3; Plate 100), referred to above in connexion with the Canterbury medallion glass, illustrates well the thirteenth century trend towards smaller size in manuscripts and greatly reduced scale in figures and compositions as compared with manuscripts of the preceding centuries. Folio 5 verso, the Genesis page, has an initial I filled with medallions, some overlapping, others linked together, containing scenes from Genesis and Exodus, and a Trinity. The figures are small and, though lively enough, are drawn and coloured with little attention to modelling. The spaces around the medallions are filled with leafless stem scrolls such as are used for other initials in the Bible. The influence also of French manuscripts[46] accounted for certain characteristics of English manuscripts of this period, such as the flat, linear draperies, the white faces with features drawn in ink, the pale colouring, and the increase in decorative elements, especially the drolleries and ornamental penwork in red or blue introduced into the margins. There are some presumably English manuscripts of slightly later date which follow the contemporary French style so closely during this period as to be hardly distinguishable from them; but in general there is greater liveliness and variety in the English figures and often a quaint unconventionality in the representations which distinguish them from the consistently meticulous but sometimes monotonously repetitious Parisian work.

From about the mid thirteenth century come two such manuscripts in the British Museum, a Bible and a small Book of Hours (Roy. MS. 1 D. i and Egerton MS. 1151), which show strong French influence though they are of undisputed English workmanship: Roy. MS. 1 D. i is signed in a colophon on fol. 540 verso by the scribe: 'Willelmus Devoniensis scripsit istum librum.' Egerton 1151 was obviously illuminated by the same artist.

The vellum of both these small books is very fine and thin as in French thirteenth century manuscripts, and the style is linear and flat and the faces have the features drawn in with black lines (Plate 105). The subject matter is extraordinary in its liveliness and humour. In the Genesis initial, scenes of the Creation and Fall and the Crucifixion are placed under canopies instead of in roundels (cf. MS. Burney 3; Plate 100); all manner of grotesque whimsies are represented in the margins. The borders are still simple in design and almost without foliage, differing from the borders in the Rutland Psalter (q.v.). A miniature preceding fol. 5 in the Bible of William of Devon representing a Crucifixion and a Coronation of the Virgin, and a Virgin and Child flanked by Peter and Paul, contains, in the central panel, St Martin dividing his cloak with a beggar, and in the lower margin a kneeling monk or friar. The inclusion of St Martin in so important a position has led to the theory that the Bible may have been intended for someone at Canterbury, where this Saint was particularly venerated, and this theory is further borne out by the

representation in a miniature prefixed to Psalms (fol. 321 verso) of the Martyrdom of St Thomas and some legendary incidents in his life. The French characteristics of the style would fit very well with a Canterbury origin.[47]

A third manuscript closely related to the style of these two is a psalter in the Morgan Library (MS. 756) also tentatively attributed to the neighbourhood of Canterbury.[48] This is the most richly illuminated of the three, having eight large miniatures and many smaller ones, twenty-three medallions in the Calendar, seven large and 176 smaller illuminated initials. The margins are filled with grotesques and hunting scenes, and the style has a strong French flavour as in the case of the other two.

To the middle third of the thirteenth century (*c.* 1230–60) belongs the first work 'signed' by an English illuminator, W. de Brailes.[49] Three times his name appears beside the picture of a tonsured cleric: twice in the margins of a small book of Sarum Hours (Brit. Mus., Add. MS. 49999), on fol. 43 with the words 'qui me depeint', and on fol. 47 the name alone; and once with the words, 'qui me fecit' on one of the six single leaves[50] now in the Fitzwilliam Museum (MS. 330), containing the Last Judgement (Plate 103A). Other works recognized by their style as partly by him are a psalter in New College, Oxford (MS. 322), one historiated initial (for Psalm 109; Plate 103C) in a psalter from Sir Sydney Cockerell's collection, and some initials in a small Bible from the Dyson Perrins Collection (MS. 5).[51] To this list have been added in recent years twenty-seven small leaves unsigned (MS. 500 in the Walters Art Gallery, Baltimore) containing single miniatures with Old and New Testament subjects (Plate 103B) which Swarzenski suggests may have been prefixed originally to the Perrins Hours.[52] Seven additional leaves obviously from the same series were discovered later by Eric Millar in Paris.[53] Finally, one large historiated initial in a Bible described by Cockerell as 'Richard Smartford's Bible', now in Perth Museum, is attributed to de Brailes.[54] The style in all of these illuminations is unmistakable, but they are certainly not all by the same hand, and it must be concluded that W. de Brailes directed a scriptorium or atelier in which there were a number of assistants.[55]

The characteristics of the 'signed' work may be taken as typical of de Brailes' style. They may be described briefly as the peculiar facial types, the unusual subjects, originality in the representations, and scrolls with Latin or French inscriptions. The facial types are well represented in plates 102 and 103: short, round faces with broad foreheads; long straight noses almost joining the mouths; eyes with accentuated whites and the iris crowded into one corner; and all the features strongly indicated with black lines. There is, however, some shading in white on the faces and in some cases considerable shading in dark tones and occasionally cross-hatching in white on the drapery. Colours are mainly pink and blue with a little red; the backgrounds are gold.

The originality of de Brailes's treatment of his subjects is well illustrated in his interpretation of the Fall of Man (Plate 102). In the top left roundel is recorded Adam's shame-faced excuse to an accusing God: 'The woman gave it me'; Eve's defence, top right: 'The serpent tempted me'; and the smug smile on the face of the serpent; God's 'no-nonsense now' manner as he puts shifts over the heads of his disobedient children; Adam's furious spade work and Eve's sullen and clumsy efforts to spin; Cain balefully watching his

brother and plotting his murder which he executes with an evil leer, while Adam and Eve sit apart mourning over the tragedy; an inexorable God driving a remonstrating Cain out to be a wanderer and an outcast; and Cain's sad end, killed accidentally by his own grandson while hunting in the forest. The human tragedy in William de Brailes' eyes was evidently the story of a family disaster with a strong moral cast.

In the medallion from the Last Judgement (Plate 103A), de Brailes, looking none too happy, hopefully carries his credentials ('W. de Brailes me fecit') in his hand which is grasped firmly by a lusty angel flourishing a huge sword over the heads of the other shivering souls. De Brailes is a lively artist if not a great one; what his figures lack in monumentality they make up in originality of interpretation, with the result that in pictures by his hand there is never a dull moment.

Swarzenski suggests[56] a chronological order for the de Brailes manuscripts on the grounds of development of their style from Romanesque to Gothic; he places the Fitz-william leaves earliest and the Walters leaves last. The closeness of the style of these two manuscripts, however (Plates 102 and 103B), seems not to support this sequence. On the other hand, the decoration of the New College Psalter which, as Swarzenski notes, is very close to the Rutland Psalter dated about 1250, would suggest that the New College manuscript may be the most Gothic phase of de Brailes's style. Moreover, the fact that only the most showy of the miniatures in the New College manuscript are by his own hand seems to indicate a late date when richer decorative elements, perhaps influenced by the French Gothic style, have further affected the design of the miniatures.

These designs are clearly related to roundels of stained glass and wall painting; and it is interesting to note that several medallions containing single figures of apostles occur also in some contemporary paintings in the vaulting of the Chapter House of Christ Church Cathedral, Oxford, which have been attributed by James and Tristram[57] to de Brailes, or at least to designs by him. The condition of the paintings at present makes it difficult to establish any clear stylistic connexion, but the general form and the types of the figures seem to be similar to his style in the manuscripts.

Nothing is actually known of the provenance of the psalter belonging to the Duke of Rutland[58] (Belvoir Castle), though an obit occurs in the Calendar (May 24, fol. 3) of 'domini Edmundi de Laci', who may have been Edmund de Lacy, Earl of Lincoln (d. 1258). The Sarum Calendar (fols 1–6) contains the signs of the Zodiac and the labours of the months in roundels. Every text page up to fol. 111 verso has a band down the left margin containing initials in gold or colour for each verse of every psalm. On folio 8 verso is a magnificent *Beatus* initial with David playing the harp and the Judgement of Solo-mon; and preceding six of the principal psalms are fine full-page biblical miniatures. But the glory and distinction of the Rutland Psalter is the wealth of marginal grotesques and occupational scenes and the exquisite and lavish decoration which excels that of de Brailes.

Also contemporary with de Brailes but differing greatly from his style is a small group of very beautiful manuscripts executed *c.* 1240–60 for different monastic houses or indi-viduals in them and first associated by Sir Sydney Cockerell[59] with the scriptorium of the new cathedral at Salisbury, built 1220–36. These are: (1) a Psalter made for a convent of nuns[60] (Oxford, All Souls Coll., MS. lat. 6); (2) a Psalter made for Wilton Abbey, near

Salisbury (London, Royal College of Physicians); (3) the Missal of 'Henry of Chichester' in the John Rylands Library in Manchester (MS. lat. R.24); and (4) the Bible of William de Hales in the British Museum (Roy. MS. I B. xii). The figure style of these manuscripts seems to be derived from the earlier Peterborough style of the Psalter of Robert de Lindesey and is more tranquil in mood and without the captiousness of William de Brailes. There is also a stronger feeling of Gothic elegance, particularly in the draperies. The All Souls Psalter has four preliminary miniatures representing the Annunciation (fol. 3), the Virgin nursing the Child (fol. 4), the Crucifixion (fol. 5; Plate 106), and Christ in Majesty (fol. 6). The Calendar (fols 7–12 verso) has no illustrations. On fol. 13 is a magnificent *Beatus* initial with a Tree of Jesse, a sybil, and prophets; and in roundels, small Old Testament scenes.

The Crucifixion is a very fine example of the style which uses line both for emphasis on contour and for decorative patterns, as on the thigh and shoulder of John. The figures are tall and slender and without solidity. The poses and gestures are unnatural, but are designed to express intense emotion; the swaying Virgin half turns away from the cross, with hands clasped tightly and head bowed in grief; John, nervously fingering the fold of his mantle with one hand, rests his cheek momentarily on the other as he strides towards the cross. Between these two is the dead Christ, quiet on the cross, emaciated and bleeding but sublime in features and form. Only the fluttering end of knotted drapery shows movement. The cross is the usual English form of lopped tree trunk. Above, God the Father, flanked by censing angels, receives the spirit of Christ represented by a dove. Below are the dead rising from the tomb, and at the sides the triumphant Church and the toppling Synagogue. The burnished gold background is incised with diamond patterns enclosing quatrefoils. The colour is intense – blue, pink, red, and green; the heavy contour lines are black.

The Crucifixion of the All Souls Psalter illustrates perfectly the balance between rich linear pattern and strong contour drawing in the figures, between symbolism and human emotion.

By contrast, this balance is rudely upset in the almost identical composition of the same subject in the Evesham Psalter[61] (Brit. Mus., Add. MS. 44874, fol. 6, Plate 107). The very similarities in such details as the Tree-Cross, the poses and gestures of the figures, and the arrangement of the draperies serve to accentuate the differences between the two styles. Of these differences, the most striking are the absence of Gothic softness in the Evesham Psalter, a stylization of even the simple conventions of anatomy, and an obsession with broken chiaroscuro patterns not only in the drapery but in the torso of Christ; and a gripping emotional tension which is centred in the contrast between the suffering, drawn expression of the dying Christ and the wide-open, staring eyes of Mary and John. This emotion is reflected even in the faces of the sun and the moon held by the solemn angels who lean out of the picture above the cross. The technique is shaded line drawing, suggestive of the Matthew Paris style (see below) but crisper, harder, and much more patternistic owing to the deep angular drapery folds, the broken body contours, and the heavy shading. The colours are green, blue, brown, and red. The body of Christ and all the faces are modelled in brown with a red spot on the cheek. The background of the minia-

ture is burnished gold except behind the cross where a design in flat red sprinkled with small white star and circle motifs follows the shape of the cross and extends down the sides and across the bottom of the miniature. A plain frame (contrasting with the ornate border with medallions in the All Souls miniature) surrounds the picture, but it is indicative of the dramatic character of the painting that the cross and the figures of Mary and John extend boldly out beyond the frame, overlapping it. The monumental scale of the composition, again as in the Matthew Paris style, suggests wall painting, but no work associated with Matthew Paris can compare with this in dynamic power. Eric Millar has rightly described the Evesham Crucifixion painting as 'reaching the high water mark of English illumination of the period'.

On the verso of fol. 6 of the Evesham Psalter there is a fine vernicle which also suggests Matthew Paris in subject though different in style. The Calendar and the principal psalms are illustrated with historiated initials in a similar style but apparently by another hand;[62] however, it is possible that the smaller scale and the lighter character of the subject matter may account for the differences. Some of the historiated initials contain grotesques, mainly of the type with serpent body and human head, and even these are painted in the shaded technique. The Evesham style is crucial for some developments in the Apocalypse manuscripts (see below).

The most typical of the other manuscripts in the Salisbury group, the Wilton Psalter,[63] originally must have been as lavishly decorated as the All Souls manuscript and in much the same style. It now retains only two of the large initials (fols 33 and 66 verso[64]), but 181 smaller historiated initials and 77 decorative ones plus a great number of decorative line endings indicate the richness of the illumination.

The Manchester Missal has eight full-page miniatures and twelve fine historiated initials.[65] The Virgin and Child (fol. 150; Plate 108), with a votive figure[66] under a foliated arch and flanked by censing angels, is close in style to the exquisite Madonna and angels of the Chichester[67] roundel (Plate 109), dating from about the same time and not far removed geographically from Salisbury, where it is suggested that the Manchester Missal was made. The figures in the miniature, like those of the roundel, have the same completely flat, linear quality in the handling of the drapery which results in graceful curves but shows no evidence of the form under it. For example, the drawing of the knee of the votive figure in the miniature with the drapery dragged over it is so similar in treatment to that in the roundel that the same artist's hand might be suspected. The roundel was designed, apparently, as a unit of ornament on the wall of the chapel of the Bishop's Palace, not as part of a larger scheme of wall painting – the kind of design, therefore, which might very well be supplied by a miniaturist. The fineness of the decorative detail with its use of silver (now badly tarnished) also suggests the work of an illuminator. In spite of the fleur-de-lis in the blue background, the style seems to be wholly English, and the closest parallel to it is found in the Salisbury style,[68] especially as in the Manchester Missal.

The Bible of William de Hales, with small historiated initials at the beginnings of the Books, is a modest member of the Salisbury group.[69] It may even be by the same hand as the All Souls Psalter, perhaps an earlier or at any rate a less sumptuous example of his art.

Contemporary with the Salisbury manuscripts, i.e. *c.* 1250, but with a calendar that

fixes its provenance as York, is an imperfect psalter in the collection of Eric Millar.[70] The York evidence is unmistakable: St William, Archbishop of York, Wilfred, John of Beverley, Oswald – all with high feasts in the calendar. Edmund (Rich), Archbishop of Canterbury, canonized in 1246, is entered in the original hand, thus setting the *terminus post quem* for the writing of the manuscript.

The *Beatus* page is missing, but there are nine historiated initials in the psalter and a large decorative one at the beginning of the Canticles. These and the calendar roundels with the labours of the months seem to be by the same hand, that of a very individual artist whom Dr Millar has not identified elsewhere. There is also a unique subject used in the initial introducing Psalm CI, the scene of Judith and Holofernes.[71]

4. Thirteenth-century Tinted Drawings

From the first half of the thirteenth century there are only a few examples of outline drawing style, that most deeply rooted and most accomplished technique of the English artist in preceding periods. At the beginning of the century the Guthlac drawings carry on the tradition in pure outline without shading and almost without colour (Plate 97B). To the first quarter of the century belong some remarkable preliminary drawings[72] of Old Testament subjects prefixed to a Bestiary (Camb., Univ. Lib., MS. KK.4.25), in a shaded line technique with coloured washes applied over parts of the figure. The pictures suggest that the artist may have been copying the fine shaded painting style of the artists of the Winchester Bible, especially the Morgan Master (Plate 86). The figures are large and solid in their contour modelling and the drapery folds fall heavily over the body. Gold is used for haloes and decorative details of dress, but the drawings have no backgrounds and no borders. The technique is new in respect to the artist's obvious intention to accomplish with line shading what the late twelfth century painter did with pigments. In the second quarter of this century the technique is found in some preliminary miniatures in the Peterborough Psalter. But it is mainly associated with Matthew Paris at St Albans.

This artist, who, like W. de Brailes, identified himself by name on one of his works, has long been known as illuminator, painter, scribe, and historian.[73] His influence from 1217 at St Albans Abbey, where he was a monk, is reflected in the production of a great many illustrated manuscripts, but their very number precludes the probability that they were all the product of his own hand. Moreover, the styles, not only of the various manuscripts but of portions and even of individual pictures in them, demonstrate beyond a doubt that he had assistants. Although Matthew Paris's handwriting and literary style now seem fairly well established, there is no agreement as to his pictorial ability and accomplishment.[74] In the present writer's opinion the best and most authentic examples of his work, out of the large number, many of mediocre quality, which have been attributed to him, are the following: (1) the well-known Virgin and Child, with a self-portrait bearing his name, Frater Mathias Parisiensis, fol. 6 of Roy. MS. 14. C. vii (Plate 110); (2) two fine heads of Christ and one of the Virgin, all on fol. VII (Plate 112) of the *Chronica Maiora* (Camb., Corpus Christi Coll., MS. 26);[75] (3) an even finer head of Christ (Vernicle), (Corpus Christi Coll., MS. 16, fol. 49 verso; Plate 114A); (4) all the drawing and some of

the tinting in the illustrations of the lives of Saints Alban and Amphibalus (Dublin, Trin. Coll., MS. E.1.40, fol. 31; Plate 111A), perhaps his earliest and certainly his best work; (5) many original sketches visible under the marginal drawings in the two Cambridge manuscripts named above; (6) some drawings in Bod. Libr. MS. Ashmole 304.[75a]

The first of the drawings listed exemplifies a monumental style based on late Romanesque painted figures such as in the preliminary miniatures of Roy. MS. 2 A. xxii (Plate 91); the style may even have been derived from these very miniatures. Characteristic features of this monumental style are the firm, heavy proportions of the figures, the strong black contour lines which define the figure, the large, solid heads with solemn expressions, the draperies arranged either in broad, rhythmic curves or flowing about the feet to form a roll at the edges; and, finally, the shading with colour which reflects a painting technique rather than an all-over pattern. The *Historia Anglorum* (Roy. MS. 14 C. vii) was the last work of Matthew Paris. On fol. 218 verso is a picture by another artist of Matthew Paris lying on his deathbed, his elbow resting on a book inscribed 'Liber Cronicorum Mathei parisiensis', accompanied by an inscription, 'hic obit matheus parisiensis'. The date of the last item of the *Historia* written in his own hand is 1259, and it is believed that he died in June of that year.

The extraordinary 'painterly' quality of the heads of Christ and of the Virgin in Corpus Christi College MSS 26 and 16 (Plates 112 and 114A) is evident when they are compared with the earlier wall paintings in the Chapel of the Holy Sepulchre, Winchester Cathedral (Plate 113). The head of Christ at Winchester might well have furnished the model for both the drawings by Paris, but especially the finer one (Plate 114A). The frontal facial type is the same, and the eyes, ears, and hair, and even the jewelled neckband (as in Plate 112) are alike. The other head of Christ on this page might have been drawn from the Deposition scene in the Winchester paintings. No close painted parallel for the Virgin and Child has been found, but the heads surrounded by clouds suggest compositions in medallions such as those which still exist in the Chapel of the Holy Sepulchre at Winchester.

Although there is some evidence as to the activity of Matthew Paris as a panel painter, at St Albans, where one might expect to recognize his hand in some of the paintings on the piers of the nave, the work bears no resemblance to his style and, in fact, is known to have been done largely by another artist, Walter of Colchester,[76] and his associates. At Windsor, however, in the cloister of St George's Chapel, there are remains of paintings of kings' heads (Plate 114B) which seem very close to the large-scale heads of Paris and perhaps may be attributed to him.[77]

Judging from the most obvious differences in style among the various miniatures attributed to him, Matthew Paris had at least two principal assistants, and probably there were other scribes and illuminators who participated in the large number of manuscripts to be ascribed, largely on a stylistic basis, to the scriptorium at St Albans. To one of the most competent of these assistants should be attributed at least part of the illustrations in *La Estoire de Seint Aedward le Rei*[78] (Camb., Univ. Lib., MS. EE.3.59; Plate 111B) and the five tinted pen drawings on fols 219 verso to 221 verso of Roy. MS. 2 A. xxii in the British Museum. These drawings are also on a monumental scale and clearly are inspired by Paris's style, if not copied from his own drawings.[79] The style of this assistant's work,

however, seems to have a more irregular contour line, richer decorative detail, more painstaking execution, and less convincing figure modelling. The King (fol. 219 verso) and the Bishop (fol. 221) have something of the crispness and elegance of mid thirteenth century French sculpture. Though wash colour is applied, it is not always used for shading to indicate depth of drapery folds or modelling of face or figure but often merely for decorative purposes.[80] The St Edward miniatures imitate most closely Paris's illustrative style as seen in the Life of St Alban (Dublin, Trin. Coll., MS. E.1.40; Plate IIIA).

The second of Paris's recognizable assistants draws even closer to the Master's style in the thickset figures and the convincing gestures and expressions; but this assistant uses a linear formula which gives the pictures a monotonous sameness in figure types. To this second assistant could be ascribed the marginal pictures which, with their text, may have been added later than the original writing, to Corpus Christi Coll., MSS 26 and 16. Some of this work is certainly by the Franciscan, Brother William the Englishman, whose picture appears on fol. 67 of MS. 16. A full-page picture of the Apocalyptic Christ (fol. 156) in the *Lives of the Offas* (Brit. Mus., Cott. MS. Nero D.i) is attributed to him in an inscription written by Matthew Paris.[81]

It is inevitable to connect the tinted outline technique and the illustrative style of Matthew Paris and his associates at St Albans with similar characteristics found in many of the twenty or more illustrated manuscripts of the Apocalypse which were produced in England mainly in the third quarter of the thirteenth century. Although several of these probably date within Paris's lifetime, none can be attributed to him, nor is there any evidence, other than these stylistic similarities, to localize them at St Albans.

However, the English apocalypse manuscripts can be separated into 'families'[82] on the basis of (1) their language (Latin or French) and their textual contents (full or abbreviated text and inclusion of the life of St John); (2) the number of illustrations, especially those illustrating this life; (3) stylistic traits, especially peculiar and distinguishing details of figure types and iconography. The difficulty of localizing any of these families lies in the contradictory results of the evidence, some of which points to one group and some to another. James[83] explains this anomaly by what he calls 'contamination' of one group by another, which may imply either that more than one exemplar existed in any one centre or that exemplars travelled about. Thus the key member of James's so-called Canterbury group (Lambeth MS. 209) is 'contaminated' by his so-called St Albans group. (See below.)

More recently, Delisle's and James's families have been questioned on both iconographic and stylistic grounds by Freyhan[83a] who, in a study of the English apocalypse manuscripts from various angles, has greatly clarified some relationships between them. According to Freyhan, the archetype of the entire cycle is Morgan 524 'because it is the only one which is connected with a series of twelfth century apocalyptic scenes in the *Liber Floridus* on which it is partly modelled, and because it contains, picture for picture, the germ of the subsequent development'.[83b]

On the basis of adaptations of this archetype, Freyhan establishes his main groups which are three: I, before 1260, represented by Bod. Auct. D.4.17, which copies Morgan 524; II, after 1260, of which Camb. Trin. Coll. R.16.2 is the earliest example; and III, also after 1260, represented by former Perrins MS. 10 and Brit. Mus., Add. MS. 35166.

Except for group I, which Freyhan still associates with St Albans and also Westminster (see below), the new grouping does not appear to help much in the matter of attribution and localization of the apocalypse manuscripts. One important feature of it, however, is the later dating of Trin. Coll. R.16.2, and this in fact accords with what seems to this writer to be one of two sources of the striking stylistic differences between the apocalypses as a whole, namely the Evesham Psalter Crucifixion style (after 1246) and the Westminster Retable style (*c.* 1258?).

The first of these sources has been described already (see Plate 107). The impact of this style is clearly seen in the great Trinity College Apocalypse and in the Paris Apocalypse (Bib. Nat. MS. fr. 403), both stemming from Freyhan's archetype, Morgan 524, but belonging respectively to his group II and group I.

In its relation to the Evesham Psalter, the Paris Apocalypse is closer since the miniatures are almost entirely by the illuminator of the historiated initials in the Evesham manuscript. These follow closely the style of the Crucifixion figures but are not by the same hand. The style of the Paris Apocalypse varies in quality and it is possible that the first pages are actually by the Master. In any case, the vigorous types, gestures, and movements of the figures, especially the often repeated striding figure of John, and the deeply shaded, broken, pocketed folds of the drapery are unmistakably close to the Crucifixion style. The technique is tinted (or rather, heavily shaded) outline on plain vellum grounds.

The most magnificent of all the English manuscripts of the apocalypse is that at Trinity College, Cambridge (MS. R.16.2).[84] It measures 17 by 12 inches and contains thirty-one finished miniatures richly painted in gold and colours, most of them the entire width of the page. Two techniques are used: painting and shaded outline, sometimes in the same miniature. There are several styles which are distributed throughout the manuscript. Some pictures at the end are unfinished.

The first two quires (fols 1–16) contain miniatures in heavily modelled fine painting style.[85] A Christ in Majesty (fol. 4) has a green face, hands, and feet, and is patently reminiscent of the Byzantine manner, as are the fine, delicately modelled figures and the rich colouring. Folios 17–24 and other pages thereafter are by the artist who is closest in style to Matthew Paris. His figures are drawn in firm outline technique sometimes without colour, sometimes with deep shading in the painted drapery folds. Backgrounds and draperies are often patterned in small dots and circles or arabesques. The figures have very large round heads with broad foreheads, especially the angels with their close-cropped curly hair. In later phases of this master's style the figures tend to become somewhat coarse, but the faces in the miniature on fol. 27 (Plate 115) are delicately painted, with shading around the eyes and spots of pink on the cheeks. The faces are all very much alike in type and expression; all have the same very large, wide-open eyes and somewhat surprised expressions. The combination of the painted and the tinted outline techniques in the same miniature is a feature of this style. The third artist's style can be seen on fol. 25 verso in one of the most magnificent pages, designed in a formal, decorative style in superb colours on a burnished, tooled gold ground. The figures are exquisitely drawn with a precision of detail and a flatness of colour which seem more French than English, though the vigour of the poses and the eloquence of the gestures is in the English tradition.

This style, and that of the first pages, can be distinguished in the matter of colouring and technique from that of the second artist; but it is possible that (except for fol. 25 verso) all these miniatures, whether by one artist using different techniques, or by two or more different artists, represent variants of one style, resulting from the Evesham Psalter, perhaps both master and assistant, under the influence of Matthew Paris and his associates at St Albans. It is interesting to compare details of drapery and pose with those in the Paris Psalter, and especially to note how often the striding figure of St John in the Crucifixion by the Evesham Master recurs here as John or as an angel.

Freyhan's group I includes one other manuscript (Bod. Auct. D.4.17) which is almost a replica of the archetype, Morgan 524 (Plate 116). The technique and style of Morgan 524 are more easily attributable to St Albans although the figure type has changed somewhat from that of Matthew Paris himself. Many of these miniatures could be by one of the better of his followers[86] influenced by the Evesham style. Some, however, in Auct. D.4.17 (e.g. fol. 5) could be by the Evesham Master himself. In general the figures are well-proportioned and the draperies are used both to reveal the form and increase the liveliness of the movements. These miniatures are among the most beautiful of all in the Apocalypse manuscripts. A similar style but less fine as pure drawing characterizes two other possibly later manuscripts (of Freyhan's group III): the apocalypse formerly number 10 in the Dyson Perrins collection[87] and Add. MS. 35166 in the British Museum. In these latter two copies more painting is used together with the drawing.

Where the Evesham Master worked is not known, but influence of his style seems to have spread even to Canterbury. The Lambeth Apocalypse (Lambeth Pal. Libr., MS. 209, Plate 117B), almost certainly produced there, probably at St Augustine's,[88] and two other apocalypse manuscripts, former Yates Thompson 55 (now Gulbenkian Coll., in Lisbon) and the Abingdon Apocalypse,[89] Add. MS. 42555 in the British Museum, have figures with heavily shaded 'plastic' draperies as in Lambeth 209.

The miniatures in the Lambeth manuscript are not all finished; many are drawn and only partly painted. The difference in the figures that are finished shows clearly that the strength of this style lies mainly in the manner of shading. It seems possible that a feebler 'learning hand' assisted the main illuminator, and it seems to be this assistant who added the full-page pictures, mainly of saints, at the end of the manuscript, some of which almost copy the drawings added to the Westminster Psalter (Roy. MS. 2 A. xxii) in a 'St Albans' style. The same illuminator inserted as a frontispiece to Lambeth 209 what is presumably his own portrait (unsigned), a Benedictine monk painting a statue of the Virgin and Child. These added miniatures are not much earlier than 1300 and echo the style of the wall paintings in the south transept at Westminster Abbey which, in turn, follow (but far behind in quality) the figures in the Westminster Retable (see below). These stylistic evidences of contact between Lambeth 209 and Westminster and St Albans support James's findings of contamination of the text.

The other generally accepted member of James's Canterbury group is the Douce Apocalypse[90] (Bod. MS. Douce 180, Plate 117A), but curiously enough its style does not seem to be very close to that of Lambeth 209. The Douce Apocalypse can be accounted for best by the later influence, namely, that of the Westminster Retable. In the Douce Apoca-

lypse the finished style is painting, but again many of the miniatures are left unfinished, either with only the drawing (which is very fine) or, in some cases, with the flat under-colour partially covering it. When finished, the effect of the shading is to give deep rounded folds more like those in the Retable. The Douce drapery is richer and softer than in Lambeth 209, and it envelops the figure in multiple overlapping folds, almost seeming to weigh it down as in later French Gothic sculpture. In contrast to Lambeth 209, where the crisply modelled figures are projected forward partly outside the frame, against a flat painted backdrop, the Douce illuminator pushed his figures back behind the frame, as in Italian pictures. Although the draperies are painted in strong colour, often contrasting, and with rich nuances of light and shade, the faces show no modelling but have either a touch of colour on the cheek, in the French manner, or are solidly pink. The technique and style seem to be a mixture of French Gothic traits, with something which in later manuscripts one would call Italian influence; in any case the example *par excellence* of this mixture in England is the Westminster Retable. The Douce Apocalypse was made (or at least begun) for Edward I and his wife, Eleanor of Castile, who are represented on fol. 1 (in a quite different style from the apocalypse miniatures), with their arms cancelled. The date therefore would be before his coronation in 1272, and thus almost contemporary with the Retable (see below).

The two main groups of Apocalypse manuscripts designated by James as connected with St Albans and Canterbury represent most of the stylistic developments of the latter half of the thirteenth century.[91] A few additional English apocalypses should be mentioned for other reasons.

Two of these form a pair as to the type of illustrations; they are of unknown prove-nance: Eton College, MS. 177 and Lambeth Palace Library, MS. 434. Of these, the Eton miniatures are by far the better. They are placed one on a page with a brief text, really only a caption explaining the picture, in French. Lambeth 434 has followed this arrangement in a feebler style.

The interesting feature of the Eton manuscript is the series of roundels and half roundels filling the first twelve pages preceding the Apocalypse. The subjects are scenes from the Creation story (pages I and II) and ten pages of typological concordance, the New Testa-ment scenes occupying the central medallions with Old Testament pictures above and below and single figures (prophets?) in the half-roundels. Each of these ten pages contains also the text of one of the ten commandments. The series of subjects, according to James, agrees closely with twelfth century wall paintings formerly in the chapter house of the cathedral at Worcester. The technique and designs, however, are closer to stained glass of the later thirteenth century.

Perhaps slightly later than Douce 180, but drawing more directly on the techniques of both the Evesham Master and the Retable, are the miniatures in the fine Oscott Psalter (Add. MS. 50000)[92] which precede the psalter proper. The full-page Apostle figures (Plate 119) especially are remarkable for their painting style. There seem to have been two artists, or at least two styles: one painted with superb skill the deep-pocketed heavy drapery, still more bulky and plastic than in Lambeth or Douce, or the Evesham Psalter, and left the faces almost untouched except for a spot of colour; the other artist modelled

the faces with flesh-colour and white, and painted the draperies softly as in Douce 180, that is, with rich ample folds in graceful Gothic curves. The trefoil arches of the Oscott miniatures echo those of the Retable and the architectural detail of the upper part of the frame is represented in their background.[93]

Where the Oscott Psalter and related manuscripts were made is problematic, but on the basis of a strong stylistic affinity between the Oscott and the Gulbenkian Apocalypse[94] (probably a Canterbury product), it seems possible that all were made there. In any case, the influence of the Retable with its superb 'new' style is clearly demonstrated: it was without doubt the main force which transformed the monumental English figure style into the elegant mannered Anglo-French Gothic style of the next century.

5. The Westminster or Court Style

The Court style is a term used mainly to describe paintings done under the patronage of Henry III and of succeeding kings in connexion with the royal castles, palaces, and chapels. Much contemporary documentary evidence exists as to the painters, materials, and subjects[95] of these paintings, and a good deal of more or less detailed description has been recorded by persons who saw them, but of the paintings themselves little remains, and that little is not from the royal residences but from chapels or churches under royal patronage. Thus it is impossible to discuss comprehensively the thirteenth century Court style, though the best examples that survive, battered as they are, still bear witness to its superb quality. These examples are found at Windsor, in the Dean's cloister of St George's Chapel (Plate 114B); at Winchester Cathedral, in the Chapels of the Guardian Angels and the Holy Sepulchre in the choir (Plate 113); and at Westminster Abbey, in the panel now placed against the choir wall of the south ambulatory, the so-called 'Retable' (Plate 118), and in the wall paintings of the south transept and of the Chapel of St Faith.

The fine king's head at Windsor (Plate 114B) is painted more than life-size on the wall of the south walk, about ten feet from the ground. The head is in full-front view like the Vernicles in the Matthew Paris style (Plate 114A); the hair and beard are white shaded with pale blue and grey; the face is pinkish white and the lips red; the crown is heavily outlined with brown and is studded with tiny spots of red for jewels. The features are so very similar to those of Paris's Vernicle in Cambridge, Corpus Christi MS. 16, that they would seem to have been designed by the same hand. If there is any surviving wall painting in England by Matthew Paris, it would seem to be this.

The scheme of the thirteenth century wall paintings at Winchester, which were extensive, is described in detail by Tristram.[96] Of those that survive, the finest are in the Chapel of the Holy Sepulchre and are dated about 1230. The best preserved portions are in the eastern bay; in the vaulting are the following subjects in medallions: Christ with the symbols of the four Evangelists (not all visible); the Annunciation, the Nativity, the Annunciation to the Shepherds. On the east wall, below the half-figure of Christ in the vaulting, a Deposition and Entombment are the central features of this bay (Plate 113B); on the side walls are the Entry into Jerusalem and the *Noli me tangere*. In the western bay of the Chapel are the remains of what appear to be lives of saints. The paintings, says

Tristram, 'seem to be the work of the hand which was responsible for the later miniatures in the Winchester Bible',[97] but nearly half a century is perhaps too great a time lag for establishing so direct a connexion. What is true of the Winchester paintings is that their technique, like some of the work in the Bible, still displays characteristics of Byzantine painting, such as the greenish underpainting for flesh and the modelling of faces and drapery with strong high-lights. The figures are designed with swinging lines which are echoed in the long scrolls, the swaying trees, and the rolling ground (Plate 113B). The head of Christ (Plate 113A), which is amazingly Byzantine, may have furnished the model from which one of the heads was drawn (by Matthew Paris?) on the last leaf of Camb., Corpus Christi Coll. MS. 26 (Plate 112), but the linear technique of the drawing, as compared with the Winchester head, makes it appear strikingly different. The bust of Christ in the Winchester vaulting against a blue ground forms part of the compositional scheme of the Deposition panel. The colours are chiefly red, yellow, and dull green.

The Chapel of the Guardian Angels at Winchester is somewhat later and may be the work of William of Westminster, who was appointed king's painter at Winchester by Henry III in 1239. The paintings[98] are in the vaulting and consist of busts of angels in medallions surrounded by scroll foliage and flowerets.

But the fact that the earlier paintings at Westminster, which may have been done by or under the supervision of William of Westminster,[99] between 1237 and 1239, have totally perished (as have also their repainted versions dating from after a fire in 1262) makes it impossible to judge whether any surviving work at Winchester represents the Court style. The paintings in the Great Chamber of Westminster Palace, even as restored in or after 1262, would have been of the very greatest importance for an account of English monumental painting of the thirteenth century. Unfortunately, all that remains of this splendid work are some copies made in the early nineteenth century,[100] before fire utterly destroyed them in 1834. Of the subject matter there is considerable knowledge, but of their style none.

The Westminster Retable has been the subject of much discussion[101] as to its date, its attribution, and even its original purpose, but no certain conclusions have been reached. This is all the more strange, especially as regards the style of the painting, since the vicissitudes of its history, unhappy though it was,[102] have at least preserved to us in the surviving fragments the characteristics of the original style untouched by later restorations. The difficulty about agreement on an attribution of the style rests chiefly on two factors: the combination within the panel of various elements which seem to be traceable to quite different sources; and the failure to recognize any other comparable example of painting where similar elements are combined. The panel is generally accepted as a work of the late thirteenth century, but recent opinion dates it perhaps earlier than c. 1270.[103] Finally, disagreement as to the original purpose of the panel[104] adds to the difficulty of dating it more closely. All in all, therefore, the Westminster panel is one of the most prickly problems with which the historian of English painting has to deal.

The purpose of the present discussion which, in the absence of any new evidence relating to the panel, cannot hope to arrive at more definitive attribution than have previous studies, is to re-examine carefully all the stylistic features of the fragments that have

survived and to attempt to explain them in the light of similar features, wherever they may be found. For this purpose, the style of the panel may perhaps best be considered under three main headings: the figure paintings – their subject matter, technique, and composition; the decorative detail introduced into the backgrounds and framing; the architectural framework – its design and its relation to the figure panels.

The fragments of the Westminster painting that have survived are all on a panel 11 feet long and 3 feet high. It is divided into five main parts. The central section consists of three trefoiled arches each within a pointed enclosing arch under a gable, and flanked by tabernacles; both arches and tabernacles are supported by colonnettes. In the central compartment, which is considerably wider than any of the others, Christ is seen standing. He holds in his left hand the world on which is a minute landscape with birds, fish, and animals, and he blesses with his right. On his right side is the Virgin, on his left the Apostle John, each holding a palm branch;[105] in thirteenth century iconography these two usually accompany the Crucifixion or Last Judgement. The panels at the two ends of the Retable have similar architectural frames of one arch each, and under the left arch is a standing figure of St Peter.[106] Between the architecturally framed panels the space is filled by four eight-pointed stars on each side, each containing a single scene; those which have survived represent miracles of Christ – the raising of Jairus's daughter, the healing of the blind man, and the feeding of the five thousand. The subjects of the other medallions are not known. The subject matter is unusual for the Gothic west, and its fragmentary state makes it impossible even to surmise with what intention these small-scale figure subjects might have been chosen in the late thirteenth century.

The style of the painting (Plate 118), as regards both design and modelling of faces and drapery, is superb. The figures are tall and elegantly slender and stand in graceful swaying poses which are further accentuated by the swinging lines of the richly bordered drapery, the bent heads, and the somewhat mannered but sensitively modelled gesticulating hands with their nervous wiry fingers. The drapery is painted broadly with the heavy folds of thick material shaded in white high-lights, and this rich treatment is further carried out in the convolutions of the embroidered borders of tunic and mantle. The faces are modelled with a yellowish undertone for the flesh on which white high-lights and brown shadows are used, largely in a linear technique. The white lines are particularly noticeable at the corners of the eyes and on the foreheads, and they pick out individual hairs in eyebrows, moustaches, hair and beards. The mass of the soft, loose hair is suggested by broad treatment in solid colour with darker streaks and shadows in the thicker parts. The eyes are curiously shaped, with a tendency to elongate the outer corner and flatten the inner one, and to crowd the iris as far as possible into the far corner; the iris and the darker pupil are clearly distinguished. The three-quarter position of most of the heads shows a bulging forehead with no foreshortening and a flattened cheek which betrays the artist's lack of understanding of the skeletal structure of the head. Some heads are seen in profile, and at least one figure, in the scene of the Feeding of the Five Thousand, is in three-quarter back view. The groups, which include a large number of figures, are closely composed and many show only the heads and the gesticulating hands; weaving in and out of the densely packed figures are the graceful patterned gold bands of the garments.

The colouring of the draperies is rich and dark, with fine blues, deep red and some dark green. The grounds are gold, patterned with diamonds and dots.

The attribution of the figure style is a puzzle. The facial modelling and the heavy drapery with its deep, soft, swinging folds would seem more Italian than French or English: French drapery of the late thirteenth century tends to stand out in stiff, deeply and sharply undercut ridges on the sculptured figures, and the manuscripts, such as the French type of apocalypse illustration, as Bod. MS. Douce 180 (Plate 117A), copy this deep, plastic drapery style; English drapery as seen in the manuscripts almost always produces a soft, rich surface pattern which has swinging curves but little weight (Plate 116). The decorative bands which are such a prominent feature of the style of the Retable and which carry the linear pattern, could be English, as could the tall, slender figures, however typical of Gothic art in general, and the somewhat linear treatment of the curly hair. Taken all together, the figure style seems to be a mixture of Gothic linear pattern and strong light and shade technique. The variety in the poses of the figures, especially the three-quarter back view, and the prominence of the gesticulating hands, also suggest Mediterranean influence. Such a combination of elements could be found in the second half of the thirteenth century both in France, especially in Paris and Avignon, and in Italy where the Pisan school of sculpture was furnishing a channel whereby French influence penetrated to Siena as early as 1265 and thence came to Rome through Arnolfo di Cambio at least by 1277.

Italian influence in specific motifs occurring in the decoration of the framework of the Westminster painting is more clearly identifiable. The tiny geometric motifs painted in blocks on a gold ground in the framework of the star-shaped medallions and in the borders of the larger panels, and covered with glass to simulate mosaic, if compared with the gold and coloured glass mosaic which lavishly decorates the tombs of both Edward the Confessor and Henry III in the Westminster sanctuary, suggest a source immediately at hand for this decorative work. The tombs are of Italian workmanship; the shrine of the Confessor is said to have carried formerly an inscription which read as follows: 'Hoc opus est factum quod Petrus duxit in actum romanus cives.'[107] Pietro Oderisi, who is possibly the Petrus of the inscription, was an associate of Arnolfo di Cambio in several of his sculptured works at Rome. But whether or not a name can be attached to the Westminster tombs, the work is Italian and typically Roman, the so-called Cosmati work which is found in great abundance all over central and southern Italy. The patterns – diamonds, squares, circles, quatrefoils, sexfoils, and, most typical of Cosmati work, the eight-pointed Moorish star – are used in rich profusion in the frames of the Westminster painting. Moreover, interspersed with these geometric painted panels are imitations in gesso of antique cameos and gems in relief.

Finally, the architectural framework itself of the Westminster panel should be considered. This is not, strictly speaking, architectural as to structure, but the decorative imitation of Gothic architecture found in the late thirteenth century primarily in Italy, notably in the tabernacles and tomb canopies which combined Cosmati work with the Gothic architectural detail introduced into Rome by Arnolfo. The closest similarities are found in the later examples in the environs of Rome, as the two tombs of Popes Clement IV and Adrian V in the church of S. Francesco at Viterbo.[108] But the Italian tombs are

later and the arch under a gable occurs earlier than this, even in the triforium of the choir of Westminster Abbey itself, and seems to typify the English version of French high Gothic style.[109]

As for the geometric motifs used in the Retable frames, these probably came originally from enamelwork and were imitated in many Catalan stucco altar frontals of the twelfth and thirteenth centuries.[110] Imitations of gems and cameos also occur there. By the mid thirteenth century geometric patterns in coloured glass are found in the Sainte-Chapelle in Paris, and these also might have furnished a precedent for their use on the Retable.

The mixture of French, English, Italian, and perhaps Spanish stylistic elements at the Abbey during the period of the rebuilding of the choir surely would have furnished a suitable climate for producing the characteristic features of the Retable; but the possibility of a more specific attribution might be worth consideration. A painter (or craftsman?) who could have known the stucco technique and designed the framework of the panel, Master Peter of Spain, is named in several documents of the 1250s as working for the King. In 1255 he was given gold for completing or repairing a hanging (painting?) in the Abbey.[111] In 1257 he made two shields for the King (? metal or painted gesso on wood or leather), and in the same year he was retained (with a stipend of 6d per day) to make paintings for the King when necessary. Most important of all is that document which records money given to him for making a journey together with his 'clerk of Toulouse' to parts beyond the seas and for returning. And finally in 1258 he was paid a large sum (120 marks, 80 pounds) 'pro duabus tabulis depictis' (two painted panels) which he sold to the King who placed them before the altar of the Blessed Virgin in Westminster, that is, in the new Lady Chapel which the King had ordered to be reconstructed in 1256.

Could the two panels have been brought back from abroad by Peter of Spain and set into frames which he made, perhaps, for this particular purpose? And could the surviving Westminster panel be one of these, as Noppen once suggested? If so, it would almost certainly have had to be the antependium or altar frontal rather than the Retable to be placed on the altar, since the altarpiece would surely have had a figure of the Virgin in the central panel. The earlier date, 1258, would be acceptable on the grounds of the influence it obviously had on a number of English manuscripts, some of them datable between 1257 (Abingdon Apocalypse, 1257–62) and 1284 (Alfonso Psalter). The Retable (or antependium) also greatly influenced wall paintings in the Abbey.

The thirteenth century wall paintings that survive at Westminster Abbey are in the Chapel of St Faith, which opens off the south transept, and in the south transept itself. Those in the Chapel[112] may be dated c. 1270–5. The principal figure, St Faith, stands under a gabled trefoiled arch flanked, as in the Retable, by slender columns and pinnacles which fill the centre of a niche in the east wall, over the high altar. Below the saint is a predella containing eight-pointed star medallions (now empty) as in the Retable, and in the centre a Crucifixion with Mary and John. On the left splay of the niche is a kneeling Benedictine monk. The figure of St Faith has been drastically 'restored' and no reliable estimate can now be made either of the technique or of the quality of the original painting, which must have been very beautiful. The figure is extraordinarily attenuated, almost ten heads high, and the draperies fall in tortured convolutions. The colours are vermilion

in the background, green for the Saint's gown and rose for her mantle, which is lined with vair. There are traces of gold and blue in the tracery of the canopy, and the ground outside it, now black, formerly was ornamented with gold fleur-de-lis.

The two paintings in the south transept, on the left side of the door opening into the Chapel of St Faith, are on an even larger scale than St Faith, the figures being nearly nine feet high. The subjects of the paintings are: on the left, the Incredulity of Thomas; on the right, St Christopher and the Holy Child.[113] The style of these figures has the characteristic English flatness, with the draperies forming involved linear surface patterns, much less shaded than in the Retable. The backgrounds are red patterned with fleur-de-lis and green patterned with roses respectively. Though much of the colour of the faces and draperies has now flaked off, the accent in the figure drawing is on the broad aspects: hands and feet are enormous, and heads are unforeshortened and strongly outlined.

The two transept paintings at Westminster are related to the Retable in many respects, but they are of much less fine quality and, perhaps by the same token, more typically English in their flat, linear technique. They have been attributed to Master Walter of Durham, the King's painter, who died in 1308.[114] As far as their style can be judged, they are less good than the St Faith. They may be somewhat later, but before 1300.

The Court style is represented not only in figure painting but also in decorative and figure sculpture, both painted. The spandrels of the arches of the triforium and other portions of the wall of the choir are covered with very beautiful diapered patterns, combined with foliage borders, all of which show traces of colour and gold. The famous angels in the spandrels at the ends of both transepts, and the figures of the Confessor and the Pilgrim in the south transept also were coloured and gilded. The effect of this colour and of the stained glass in the windows, of the gold and jewelled altar frontal and of the Cosmati pavement in the chancel and in the Chapel of the Confessor, together with the magnificent shrine itself, must have produced an unrivalled effect of splendour. There must also have been finely illuminated service books, and there are records of payments for rich embroidered vestments for use in the Abbey, as well as in St Stephen's Chapel.[115] Of neither manuscripts nor vestments of this period, however, are there remains certainly identified as made for Westminster, although the name of a woman embroiderer, Mabel of Bury St Edmunds, occurs eight times in the royal accounts of Henry III. The embroidered and jewelled altar frontal, now lost, has already been mentioned; it may have been the work of Mabel and her assistants.

Some fragments of embroidery which may date from this period, i.e. about the third quarter of the thirteenth century, may be seen in Worcester[116] and in London (Plate 120A). They are probably parts of a pair of buskins made for Walter de Cantelupe, Bishop of Worcester (1236–66), and they are embroidered with what appears to be a genealogy of Christ, the ancestor kings standing or sitting in circles formed by scrollwork with the same kind of rudimentary leaves and buds as are found in illuminated manuscripts of the earlier part of the century. The design suggests a typical late twelfth or early thirteenth century Jesse Tree, as found in manuscripts and in stained glass. The embroideries are perhaps not much later than c. 1250; similar foliage is found, it will be recalled, in the spandrels of the Chichester roundel (Plate 109). The embroidery in the Worcester

fragments is in gold on silk and already exhibits the fineness of quality which is to give to English embroidery, the so-called *opus anglicanum*, its wide reputation during the late thirteenth and early fourteenth centuries.

A slightly later example of thirteenth century embroidery, probably dating from before 1284, is the so-called Clare Chasuble[117] in the Victoria and Albert Museum (Plate 121). The design is in barbed quatrefoils, and the spaces between them are filled with slender scroll foliage as in the Worcester fragment. The areas outside the centre band contain also longer and more attenuated stems which twist in and out and enclose within medallions formed by them heraldic beasts, the lion and the griffin. The centre medallions contain a Crucifixion with Mary and John, a Virgin and Child resembling the Chichester roundel, the Apostles Peter and Paul, and the martyrdom of Stephen. The technique of the design is similar to that of the Worcester fragments; the embroidery is in gold and colours on a deep blue satin ground. This is the earliest of many such ecclesiastical vestments in *opus anglicanum* with increasingly elaborate designs and subject matter, which will be discussed in the next chapter.

One other form of pictorial art reached a high point of development during the second half of the thirteenth century, that is, ceramic floor tiles.[118] The earliest of these, so far as can be judged from surviving examples, used simple geometric patterns of many varieties. The usual procedure was to design them in sets of four or multiples of four, the individual tiles being so planned that their arrangement would result in a variation of the patterns when laid on the floor. The Chapter House at Westminster still has a floor made up largely of the medieval tiles laid down between 1253 and 1258. Some are patterned with running scrolls and designs of window tracery, such as that of the great rose windows in the transepts of the Abbey. Others have heraldic and grotesque animals, while still others contain representations of everyday scenes and stories.

More famous even than the Westminster tiles are the remains of a tiled floor of similar style and workmanship formerly in Chertsey Abbey, near Windsor. Besides the more conventional patterns as used at Westminster, the Chertsey tiles contain illustrations of the romance of Tristram and of the story of Richard Cœur de Lion (Plate 120B). The vigour and sureness of the drawing is in the best outline tradition of the thirteenth century, as exemplified by Matthew Paris and the St Albans school. The figure of the King in combat is comparable to similar figures of horsemen in, for example, *La Estoire de Seint Aedward le Rei* or the many fine Apocalypses, especially those of the St Albans group. The circle of grotesques with foliage tails can be matched in the initial decoration of manuscripts of the mid thirteenth century, and the foliage ornament filling the corners, while somewhat stiffer and more formally designed, is of the type found in both manuscripts and embroideries.

Summary

The material which has been selected as representative of English pictorial art in the thirteenth century includes only a part of the whole amount. By far the greatest proportion consists of illuminated manuscripts, particularly psalters and apocalypses. In the psalters

a scheme of decoration was first perfected. It includes preliminary Bible pictures, an illustrated calendar, a fine *Beatus* page (of which a new type of initial B contains a Tree of Jesse), and smaller initials and other decoration according to the degree of richness in the manuscript. A new element of the decoration in psalters is the animal–human grotesque, a monster sprung from twelfth century Bestiary animals which has acquired human attributes and sometimes even parts of the human body. It is used apparently as a medium for ridicule or satire. Although psalters are liturgical books in substance and purpose, they must also have furnished lively diversion for their owners.

The apocalypses are essentially picture books, however much text in Latin or French may accompany the illustration on the page to explain it. They must have served almost wholly for diversion, or possibly for instruction. But exciting though the text of the Vision is and full as it is of imagery, the illustrations, on the whole, show little variety or originality in interpretation. Moreover, compositions tend to repeat themselves, either in the form of replica copies or as derivations from other copies. One wonders for whom these manuscripts were made and why they were so popular during this century. The quality of the work in the thirteenth century apocalypse manuscripts on the whole is inferior to that in the psalters; their great contribution was their large and ever expanding picture cycles.

Although little now remains of thirteenth century wall painting, there probably were other examples such as Salisbury and Peterborough. Narrative picture cycles[119] may have been current, as used in the preliminary psalter miniatures or in medallion stained glass windows.

The most important single monument produced in the thirteenth century in England is undoubtedly the Westminster Retable or antependium. In its pristine state it must have been superb, especially as to the exquisite beauty of the figure painting. It is no wonder that it so greatly influenced subsequent painting as to inspire a fine new style which flowered in the East Anglian school in the next century.

THE EAST ANGLIAN PERIOD.

*

HISTORICAL BACKGROUND

POLITICAL

The Plantagenets and the Rise of Nationalism in England. Edward I, son of Henry III and Eleanor of Provence, King 1272–1307; married Eleanor of Castile (d. 1290) and Margaret of France 1299; first 'English' king of England; reformed the laws; conquered Wales and temporarily Scotland; Model Parliament 1295.

Edward II, son of Edward I and Eleanor of Castile, King 1307–27; married Isabella of France; deposed 1327 and murdered.

Edward III, son of Edward II and Isabella, King 1327–77; Hundred Years' War with France begun 1337; Battle of Sluys (naval victory for English) 1340; Crécy 1346; capture of Calais 1347; Poitiers 1356; Treaty of Brétigny 1360; Order of the Garter founded 1348; Black Death 1348–9.

ECCLESIASTICAL

Increased wealth and worldliness among the clergy, both monastic and secular.

John Grandisson, Bishop of Exeter 1327–69, typical wealthy ecclesiastical patron of the arts.

*

THE half-century with which the present chapter will deal is one primarily of a national English taste which had formed itself during the preceding century on the love for rich decoration, for narrative in illustration, and for the bizarre and the fantastic in details. It is this last characteristic that gave fourteenth century manuscripts their peculiarly distinctive feature, the combination of the natural and the absurd in animal life that runs rampant over the pages. Foliage ornament, too, combines these two extremes of naturalistic leaves and flowers, with conventionalized motifs of unknown species. Other arts also display these same characteristic elements.

Two aspects of English art of *c.* 1300 have become as well known, both in England and on the Continent, as Hiberno-Saxon and Winchester art of earlier periods; these are the East Anglian manuscripts and *opus anglicanum*[1] embroideries. These constitute the bulk of the material for the present chapter, although there are also in the period ending *c.* 1350 some few examples of good stained glass and a number of remains of wall and panel painting, mostly in bad condition and inferior in quality to the manuscripts and embroideries. It is significant that the two main typically English aspects of medieval pictorial art have much in common stylistically, and that both, during the half-century under

discussion, demonstrate the phenomenon of a quick flowering followed by a sudden decline in quality as well as in quantity of production. It has long been customary to explain this sudden decline, especially in the production of the manuscripts, by the ravages of the Black Death which took a heavy toll of all classes and professions of people, including, doubtless, scribes and illuminators.[2] The explanation is given further credence in the case of East Anglian manuscripts by the fact that many of them were, apparently, produced in monasteries, though not necessarily by the monks themselves but perhaps by a group or groups of travelling artists. In any case, the monasteries did suffer grievously under the plague,[3] and travelling craftsmen also must have been caught by it in one place or another, and have died. But a more careful examination of the products of East Anglian art in its later stages, that is, *c.* 1340, shows that actually the quality of the art had already deteriorated to such an extent that no sudden disaster is needed to explain its demise; a generation of gifted illuminators working in a style the origins of which are not yet fully understood came, in due time, to an end. On the other hand, the style did not wholly die, for we shall find in the second half of the fourteenth century survivals, particularly of its decorative features, which constitute recognizable components of later English style.

The relation of the successive styles in *opus anglicanum* to the manuscripts seems to be that of one medium following the developments in another; it is noteworthy in the case of the later embroideries that their designs seem to be taken not only from manuscripts but also from stained-glass windows, and they even reflect successive changes in window tracery and other architectural details.

The East Anglian Manuscripts

The roots of some of the characteristic features of the East Anglian style are found in thirteenth century English illumination, especially that of the fully illustrated English psalters. This is not strange in view of the fact that most of the East Anglian manuscripts are psalters, and thus their scheme of illustration follows that of the earlier books, namely, preliminary Bible pictures, calendar with the signs of the Zodiac and the occupations of the months, and historiated initials, with particular emphasis on the *Beatus* page.

The new elements may be summed up under the following three heads: (1) a quite amazing growth in the naturalistic features of the borders, as leaves and flowers, birds and animals, that fill the margins of the pages; (2) a corresponding increase in the number and variety of grotesques which mingle on equal terms with the denizens of field and forest and which often, especially in the later examples, tend to become gross in size and coarse in humour; (3) the incorporation in the marginal decoration not only of the naturalistic and grotesque matter, but of illustrative material drawn from other sources, as the Bible, the Bestiary, the Apocalypse, and even the lives and miracles of saints, literary romances, and daily life. The result of this indiscriminate tapping of all possible sources of illustrative material is, of course, a tremendously rich and interesting variety of subject matter which is still further enlivened by the artists' keen observation and extraordinary ability to represent things as they saw or imagined them. Unfortunately this wealth of material is

not always kept under control by a feeling for good design, and the tendency towards over-richness in amount and the lack of orderliness in arrangement of the marginal borders is an almost infallible criterion for distinguishing pure East Anglian from French work of the same period. The new characteristics, however, occur in English manuscripts in varying degrees; hence there are occasional examples which, although certainly more East Anglian than French, seem to have a modified character, approaching the French style.[4] The most outstanding of these is Queen Mary's Psalter (see below). The explanation of the variations in the East Anglian style seems to lie in the local provenance of the manuscripts. The principal centres where they were known to have been produced in the first quarter of the fourteenth century are the Diocese of Norwich, Peterborough, Bury St Edmunds, and York. In the second quarter of the century the style spread farther afield, and towards the middle of the century, manuscripts in the East Anglian style may have been made in London.

The beginnings of the style are found in the late thirteenth century. The earliest dated example is a psalter (Brit. Mus., Add. MS. 24686), begun for the marriage of Prince Alfonso,[5] son of Edward I, to Margaret, daughter of the Count of Holland, but not finished then, presumably because of the death of the Prince in 1284. Only the first quire of eight leaves in the Psalter (fols 11–18), including a magnificent *Beatus* page (Plate 122), is of this early date;[6] other leaves of this quire contain smaller historiated initials and borders with the naturalistic motifs characteristic of the East Anglian style. The quality of the work is exquisite, and the variety of flower, animal, and bird motifs attests to the artist's interest in natural life and his powers of observation and delineation of what he sees. There is reason to believe that the manuscript may have been begun at a Dominican house, possibly Blackfriars, London;[7] but the later part of the illumination is done in a style which we shall find to be characteristic of manuscripts made in Norwich. Whether the earlier style of the Alfonso Psalter was influenced directly by North French or Flemish illumination, or whether the new, freer style was the invention of English artists under the influence of the Westminster Retable is a matter for conjecture.[8] But the fact remains that with the Alfonso Psalter the East Anglian style is fairly launched.

Closely related to the Alfonso Psalter and also early in date (between 1283 and 1300) is Brit. Mus., Roy. MS. 3 D. vi (Petrus Comestor's *Historia Scholastica*), containing[9] at the beginning of each book a large historiated initial and borders with naturalistic birds, animals, and grotesques, and heraldic shields. Millar again suggests Blackfriars, London, as a possible place of origin and notes[10] that French influence is strong in the manuscript. This influence, if indeed it is present, is again that of North France or Flanders, not Paris, and the naturalistic elements correspond to those in the Alfonso Psalter.

A third early manuscript with East Anglian characteristics but of unknown provenance is MS. 102 in the Morgan Library, New York – the 'Windmill Psalter' – so-called from the windmill introduced into the decoration on fol. 2 (Plate 123). This page is unusual because of the elaborate red and blue ornamental penwork surrounding the E, the second letter of the word *Beatus*,[11] of which the B with a Jesse Tree fills the whole of fol. 1 verso opposite. The remainder of the first words of the first psalm (*Beatus vir qui non*) are found on the scroll held by the flying angel. The combination of painted figures and penwork,

and especially the use of pale washes as shading on the latter, are survivals of the mixed technique used in the thirteenth century.

The three early examples described above pose the problem of the origins of the East Anglian style; all three are certainly English,[12] yet in all three appear some elements of a new phase of English style: the charming informality of various kinds of naturalistic motifs, quaint, original types of grotesques, and exquisite draughtsmanship and colouring.

The earliest manuscript fully in this style and of certain provenance is the Peterborough Psalter[13] (Brussels, Bib. Roy., MS. 9961–2) dating from *c.* 1300. The decoration consists of the usual Calendar, a magnificent *Beatus* page (fol. 14; Plate 124) with David, and historiated initials with full borders for the principal psalms. An unusual additional feature is the series of types and antitypes, scenes from the Old and the New Testament, which are distributed throughout the manuscript and which are thought to have been copied from twelfth century paintings formerly in the choir of Peterborough Cathedral.[14] The best work in the manuscript is on fols 10–14 and recalls the finely drawn and spirited subjects of the first quire of the Tenison Psalter and the Ashridge Priory Peter Comestor. Folio 14 has an elaborate border with animals and birds and amusing figures, one on stilts, among branches of oak leaves and acorns. A vivid hunting scene in the lower margin, and in the upper a cock riding a fox and a monkey[15] seated backward on a goat are among the many novel and diverting features of the decoration. The text of the Brussels Psalter is written throughout in gold, red, and blue letters. Originally the miniature pages must have been even more beautiful than at present; for a later French royal owner somewhat disfigured the backgrounds by adding gold fleur-de-lis and shields, thus overcrowding the compositions and margins. The style of the decoration in the Peterborough Psalter seems to have changed during the course of its illumination; on later pages (from fol. 26) there appears, among other new features, the foliage motif christened by Cockerell[16] the 'serrated cabbage leaf', which becomes a hallmark of the East Anglian style, especially that of the Norwich Diocese. The borders on these later pages resemble in design and motifs the Ormesby–Gorleston group (see below).

Another psalter (Camb., Corpus Christi Coll., MS. 53; Plate 126) not only shows evidence of Peterborough use in the Calendar and Litany, but contains the obit of a Prior of Peterborough and the Chronicle of Peterborough down to 1229.[17] There is evidence, however, that the manuscript was written for use in the Diocese of Norwich,[18] but whether it was illuminated there or in Peterborough is impossible to say.[19] Apart from the usual illustrated Calendar and historiated initials to the psalms, the manuscript contains two exceptionally interesting features: a set of twenty-four full-page miniatures, twelve of the life of Christ and of the Virgin, interspersed with twelve pairs of prophets and apostles. James[20] first pointed out the unusual, in fact unique, arrangement of these pictures in groups of four after the manner of small painted diptychs: the prophets and apostles, under paired trefoiled arches, are drawn on the vellum background and lightly tinted, and are so placed that they seem to form the outsides – actually the backs of the leaves – of two facing miniatures painted in colours upon a tooled gold ground. The painted subjects are grouped as the Joys and the Sorrows of the Virgin, with a dramatic link between the two in the group where the Coronation of the Virgin, the culminating

Joy, faces the Betrayal of Christ, the first of the Sorrows. If the subjects and their arrangement are correctly interpreted, the prototypes of the miniatures might have been a series of panel paintings of which unfortunately no comparable set survives.

The styles of the miniatures, both the tinted drawings and those in full colour (fol. 16, Plate 126), which are not apparently by the same artist, are characterized by the fine, careful drawing in the faces and by the long, graceful lines of the draperies which swing round the figures enveloping them in a pattern of rich, Gothic curves. The faces are tinted with pale colour and the hair is swept back from the forehead in a loose mass of curls with a wave over the ear. The gestures and, especially in the tinted drawings, the positions of the hands and feet are somewhat mannered, and the tall, slender figures themselves seem to swing and sway with the draperies. These characteristics are normal in early fourteenth century Gothic art; but the English figures are flatter and less modelled than the French, and the drapery folds are linear surface patterns. The facial types too have a delicate charm and variety which is typically English.

In the miniature here reproduced the Virgin and St Christopher stand under a double enclosing arch against a burnished and patterned gold ground. The incongruity of placing a grass plot under the Virgin's feet and a small pond with fishes, even an eel, swimming around the feet of Christopher has not troubled the artist. The tall, slender, graceful figures with their sweeping draperies, the rich yet soft colouring against the brilliant gold ground are strikingly effective.

The preliminary miniature series in Camb., Corpus Christi Coll., MS. 53 constitutes one of the two extraordinary features of this fine manuscript; the other is the addition, at the end of the Psalter, of a completely illustrated Bestiary by the artist of the tinted drawings. This part of the manuscript contains some of the most original work in it. Although subjects drawn from the Bestiary had long since been introduced into manuscript decoration, this is the first time that the whole book has been incorporated as an integral part of the contents of a liturgical manuscript. This feature, together with the stylistic characteristics of the painted miniatures as pointed out above, forms the basis for the resemblance noticed by Cockerell[21] between MS. 53 and Queen Mary's Psalter (Plate 127).

One more manuscript should be noted in connexion with the 'Peterborough style', although it was actually executed at Ramsey Abbey, a Benedictine monastery near Peterborough.[22] The date is c. 1300. The manuscript is now separated into two parts: five leaves painted on both sides with Bible pictures constituting MS. 302 in the Morgan Library (Plate 125); and the Psalter to which these leaves originally belonged, now in the Benedictine monastery of St Paul in the Lavanttal, Carinthia (MS. xxv.2.19). The Psalter has the usual illumination including the Calendar and the *Beatus* and other historiated initials, and shows the characteristic early East Anglian variety and charm in the decoration.

The miniature on fol. 8 (Plate 125) is in two registers. The ogee arches under which the two central scenes are placed are very like those of the miniatures in the Brussels Peterborough Psalter. The figure types also are extraordinarily close, especially in the use of a spot indicating modelling on the cheek and in the arrangement of the hair. It is possible that the same artist worked on both manuscripts. In the miniature of the Ramsey Abbey

Psalter the upper subject, the murder of St Thomas Becket, is flanked by a bishop holding a model of a church, and by St Paul. Below, a mitred abbot is seated with his feet on a ram, and a tonsured abbot rests his feet on a species of goat (?). Whether the ram is introduced in reference to the name 'Ramsey' can only be conjectured; such whimsies would not be foreign to the bizarre spirit of English medieval humour. The faces of all the figures in this and the other miniatures are eager in expression and the gestures are lively as in the Brussels Psalter. The colour is particularly fine, with deep ultramarine and lighter blues used for draperies, and for background, alternating with dull pink; the arabesque patterns are in white and the roses are gold. As usually in Peterborough work, the gold ground is tooled with squares or diamonds enclosing groups of dots.

The manuscript known as Queen Mary's Psalter[23] (Brit. Mus., Roy. MS. 2 B. vii; Plate 127) contains no evidence of its origin or early ownership. The date is early fourteenth century. The figure style resembles that of the Peterborough manuscripts but it seems to have been most directly influenced by the Westminster Retable and probably was made in London. Millar considers it the 'central manuscript of the East Anglian group',[24] yet its decoration, apart from the wealth of miniatures and *bas de page*[25] illustrations, consists of fairly simple, often-repeated leaf and flower forms limited to groups of two or three attached to the corners of the rectangular miniatures which in this manuscript replace the usual large historiated initials at the beginnings of the principal psalms. The illumination seems to be wholly by one hand, even though the technique, like that of Corpus 53, is partly painting in full colour and partly tinted drawing. The artist, who was a consummate draughtsman, was primarily an illustrator rather than a decorator.

The illumination in Queen Mary's Psalter has been described so often and reproduced so widely that only a brief summary of the kinds of decoration it contains is necessary. The first sixty-six folios are filled with a long series of Old Testament scenes, from the Fall of Lucifer to the Death of Solomon, in the form of tinted drawings, usually two to a page, a total number of 223 drawings. Beneath each is a line of explanatory text in French. On fol. 67 verso is a full-page Tree of Jesse in a rectangular miniature. On fol. 68 are four miniatures representing the three Marys and the unusual subject of St Anne and her three husbands; there are also the Virgin and Child and Christ Enthroned. On fols 69 verso and 70 are two miniatures in six compartments, each with an apostle and a prophet (cf. Corpus MS. 53). The Calendar begins on fol. 71 verso and each month occupies two facing pages, with a miniature across the top of the leaf at the beginning of each month. The Psalter proper (fols 85–280) is illustrated with a series of miniatures from the life of Christ with a tinted drawing at the bottom of each page, the subjects drawn from all manner of sources (fol. 112 verso; Plate 127). Finally the Canticles (fols 280 verso–302) are illustrated with scenes from the Passion in miniatures, and the Litany (fols 302 verso–318) with miniatures of saints. No other known psalter has such a complete and varied complement of illustrations, and no other English manuscript equals it in the sustained high quality of its workmanship.

The technique of Queen Mary's Psalter, whether in the miniatures using colour against gold or diapered grounds or in the delicately tinted drawings against the plain vellum ground, is almost purely linear. Features, hair, and drapery folds are indicated with lines,

and only in the deep folds and on the cheeks is there a little shading in colour. In general, the scenes are represented on a very small scale, and in this respect the style differs from the Peterborough pictures, which suggest rather the scale of panel or wall painting. Many of the miniatures in Queen Mary's Psalter – in fact, all up to fol. 234 – are placed under architectural canopies, like the preliminary pictures in Cambridge MS. 53. These Early Gothic architectural frames with plate tracery, the rich drapery, the mannered poses, and the gesticulating hands suggest the Westminster Retable, in a linear rather than a painted version. The faces, though charming, are monotonously alike and fall into types. If Queen Mary's Psalter was made in London, the style could have been carried to Peterborough.

There are several other manuscripts illuminated partly or wholly by the artist of Queen Mary's Psalter. One is a Psalter (formerly Dyson Perrins, MS. 14) which belonged to Richard of Canterbury, a monk of St Augustine's Abbey.[26] Judging from the Calendar and Litany, the Psalter was made for use there, although not necessarily a product of that scriptorium. Its date is early fourteenth century, perhaps earlier than Queen Mary's Psalter.[27] Its decorative scheme is that of the conventional English psalter, with historiated initials for the fourteen more important psalms, but the partial borders have East Anglian naturalistic foliage and animal motifs. Another manuscript clearly in the style of Queen Mary's Psalter is a Bible (Cambridge, Univ. Lib., Dd. 1.14) with a fine Genesis initial decorated with a series of exquisite small scenes (fol. 5) and an historiated *Beatus* initial (fol. 179). Many of the decorative initials throughout the Bible are painted in gold and colours; others are pen-drawn.

The finest member of the Queen Mary's Psalter group, a copy of the Apocalypse with a French text (Brit. Mus., Roy. MS. 19 B. xv), was illuminated by three artists of whom the first was certainly the illuminator of Queen Mary's Psalter. A comparison of this style (fol. 5 verso; Plate 128) with fol. 112 verso (Plate 127) shows figures identical in the type of heads and of draperies. The shaded foliage in the Apocalypse can be matched in Queen Mary's Psalter, though the scale in the Apocalypse miniature is larger and the motifs are less naturalistically rendered. The background in the Apocalypse miniature is coloured red and blue as in many of the pictures in Queen Mary's Psalter, but it is plain, without diapering or other patterns, and the setting, though formal, has more suggestion of space than the architectural canopies or the barbed quatrefoil medallions in which the painted miniatures in Queen Mary's Psalter are usually placed. The Apocalypse, therefore, might appear to be somewhat later than Queen Mary's Psalter (*c.* 1320–30), the two techniques of painted miniature and free marginal drawing combining in these most lovely coloured drawings of typical English character.[28]

The styles of Corpus Christi Coll. MS. 53 and Queen Mary's Psalter represent only one branch of the main stream of development in East Anglian manuscript illumination;[29] the other branch is characterized by more lavish decorative elements, and appears to have been localized in the neighbourhood of Norwich. One of the earliest of the psalters in this style (Oxford, Bod. MS. Douce 366; Plate 130) was probably written and perhaps partly illuminated at Bury St Edmunds[30] at the close of the thirteenth century. It was finished in successive stages during the early fourteenth century. It may still have been

unbound when it was acquired by a monk of Norwich, Robert of Ormesby, and given to Norwich Cathedral *c.* 1325. Probably at this time the Psalter was given a second *Beatus* page and the earlier one was subsequently altered to receive the portraits of Robert himself and an abbot; the earlier style (*c.* 1300) can be seen in the remainder of the decoration on this page.[31] The tooled gold panels containing the two kneeling clerics have been placed over parts of the vine which enclosed further words of the opening text of the first psalm. The modelling of the faces and draperies in these portraits is much heavier than in other figures on the page, and there is a curious use of white pigment for the high-lights, which produces a strange, heavy-lidded, facial type with white on eyelids, nose, and around the mouth. This will be seen again in later stages of the East Anglian style. The same technique is found in the figure of King David harping, which fills the second *Beatus* initial on fol. 10. The earlier style of the first *Beatus* page is found on some other pages of the Psalter, where historiated initials against gold or finely diapered grounds send out a rich foliage border, broken at intervals by interlaced knots and peopled by all manner of birds, animals, and human and animal grotesques. Subsequent pages slightly later in date (*c.* 1310) with historiated initials introducing the principal psalms (fol. 147 verso; Plate 130) have similar full-page borders containing a wealth of leaf, flower, animal, bird, insect, human, and grotesque motifs used in a variety of ways and perhaps with more spirit than good taste.

The subject of the initial D, God the Father and Christ the Son who are seated side by side in an elaborate architectural setting, illustrates the text of Psalm 109: 'Dixit Dominus Domino meo: sede a dextris meis (The Lord said unto my Lord, sit thou at my right hand).' They are flanked by two seraphs and under the footstool of the figure on the left (Christ? on the right of God) five knights in full armour are kneeling. Flying about the initial are some most exquisitely drawn and painted birds, while in the border of the right-hand margin an alternating series of butterflies and beetles forms the central motif of the bar-branch. In the upper margin an owl seated backward on a rabbit is pursued by a monkey wearing falconer's gloves and riding on a greyhound. In the bottom margin a double fight rages fiercely: two naked men at fisticuffs are seated on a lion and a bear, and the lion has its teeth and claws buried in the neck of the bear. In the left margin, the most curious figure of all is shown: a semi-nude man is represented (intentionally?) with the upper and lower parts of the body facing in opposite directions; he is blowing a trumpet from which a pennant flaps. An explanation of this strange figure, Pächt suggested, may be found in certain phases of Italian influence.[32] Whatever their source, the lusty spirit of such drolleries as are found on this page is refreshing, and a study of these pages is its own reward in the light it throws on medieval fantasy and humour.

There are other manuscripts illuminated in one or more of the styles of the Ormesby Psalter; one of these furnishes a possible clue to the centre of their production. In the British Museum, the gift of Mr C. W. Dyson Perrins, is a psalter (Add. 49622) in the Calendar of which is entered the Dedication of the church at Gorleston, Suffolk. In the fourteenth century it was at the Cathedral Priory of Norwich.[33] The illumination, as in the Ormesby manuscript, consists of large historiated initials (Plate 131) to the principal psalms, with bar borders of very great richness in both the number and the variety of the

motifs and particularly in the lively and interesting animal scenes in the margins. An additional feature not found in the Ormesby manuscript is a full-page Crucifixion with Mary and John[34] painted in shaded colours including violet – unusual in English manuscripts – against a brilliantly diapered ground and surrounded by a frame containing the arms of England and medallions with portrait (?) heads. The date of the Gorleston Psalter must be close to that of the Ormesby middle style, that is, c. 1310–25 (cf. Plate 130). The Crucifixion page, however, is probably later and may have been added after the manuscript went to Norwich. The style on this page is a development of that of the Ormesby portraits which were added to the first *Beatus* page.[35]

The large historiated initials are remarkable for two special features: the extremely rich and varied patterning of the diapered and tooled gold background, outside and even inside the initial; and the wealth of heraldic devices, which greatly enrich the decoration. Among these the royal arms figure prominently, as on the *Beatus* page (Plate 131), where they fill the band which surrounds the initial. The calendar has a unique feature. In addition to the usual occupational and zodiac illustrations, in the margins opposite many of the entries are roundels with heads or figures illustrating the feasts. Some of the more interesting ones are the Lamb of John the Baptist (for his day, 24 June), and his head on a platter (for the Decollation, 29 August). Most charming is the roundel containing the Christ Child with the ox and the ass opposite 25 December.

The richness of the design and the brilliance of the colouring on the most elaborate pages of the Gorleston Psalter, especially the *Beatus* page (fol. 8; Plate 131), cannot be imagined from any reproduction of it. The subject of the initial is the Tree of Jesse. Three centre roundels formed by curving vines contain the Virgin and Child, the Crucifixion, and Christ in Majesty; at each side are four others with eight figures of kings, ancestors of Christ, and outside, two flanking each king, are the twelve prophets. The branches forming the initial extend upward and downward to make a border of other medallions containing more kings and (at the bottom) five scenes from the Nativity cycle: the Annunciation, Visitation, Nativity (centre), Adoration of the Magi, and Purification.

The Gorleston Psalter was matched in quality only by the slightly later Douai Psalter (now destroyed), which showed the same marvellous skill in draughtsmanship and the same exquisite balance of colour rivalling in its distribution over the page the rich mosaic effect of the best early French stained glass. The East Anglian style never surpassed the quality of the work in these two manuscripts and in the early part of another one, the St Omer Psalter (Plate 133), which is very similar in style and only slightly inferior in quality.

Several other manuscripts have illumination in the Ormesby–Gorleston style, perhaps by one or more of their several artists. Of these, the finest and most monumental in scale[36] is the Dublin Apocalypse (Trin. Coll., MS. K.4.31). The pictures which occupy half or more of the page (Plate 129) are designed in eight-foiled medallions placed against diapered grounds and surrounded by a rectangular frame filled with small geometric patterns. There are no foliage borders and the initials are of the plainest and simplest form, gold on pink and blue grounds. The figure compositions are on a large scale and almost completely fill the medallions. There is a suggestion of the technique of panel painting or perhaps even

of sculpture in the scale and clarity of the drawing and in the strongly shaded colour, but the details necessary for the understanding of the scene, the temple, the altar, the grapevine which the angel with the sickle is about to cut down, are arranged in a purely decorative manner with no indication of spatial relationship. The application of the East Anglian style to large-scale drawing will be found again in manuscripts of slightly later date (cf. Arundel 83 below).

One other group of four manuscripts, three psalters and one Book of Hours, of the first quarter of the fourteenth century, having East Anglian characteristics, has been localized in central England, in the vicinity of Nottingham, where a group of lay illuminators may have been working. Two of the psalters, it is true, have calendars pointing to Yorkshire (London, Lambeth Palace Lib., MS. 233,[37] and Munich, Bayerische Staatsbib., Cod. gall. 16); the Hours (Camb., Fitz. Mus., MS. 242; Plate 132) has no calendar; the third Psalter (New York, Pub. Lib., Spencer Coll., MS. 26) also has no calendar but an inscription on fol. 1 refers to Brother John Tickhill, Prior of the Monastery of Worksop, near Nottingham, 'who wrote this book ... and also gilded it ...'[38]

The illumination in these four manuscripts takes the usual form of historiated initials and borders; the Lambeth and Fitzwilliam manuscripts have the additional feature of a full-page Christ in Majesty. The borders are less florid in design and in motifs than in most other manuscripts decorated in the East Anglian style. In three of the group, the motifs are chiefly variations of the trefoil form (cf. Plate 132), perhaps denoting Parisian influence on the style, such as has been detected in the iconography.[39] The Tickhill Psalter, however, introduces many types of foliate forms including a number of recognizable naturalistic ones.[40] Another characteristic feature of the Tickhill manuscript is the lavish use of inscribed scrolls explaining the pictures; in some cases they are so numerous as to mar the design. The illumination in this manuscript was left unfinished and on the later pages the order of successive processes in the drawing and painting of them can be followed.

Undoubtedly the most charming feature of decoration common to all the manuscripts in this group is the great number of *bas de page* and other marginal scenes, especially those with hunting and other animal subjects (Plate 132). Though lively, varied, and quaintly humorous, as the squirrel praying in the upper left margin, they are never vulgar and there is admirable freedom and skill in their rendering. The date of the Fitzwilliam Hours is *c.* 1308.[41]

The East Anglian style reached its height early in the second quarter of the fourteenth century in the illumination of two superb psalters known as the Douai and the St Omer Psalters. The Douai Psalter most unfortunately was totally ruined by damp during the First World War and is now lost to us. The St Omer Psalter, formerly in the Yates Thompson Collection, is now in the British Museum.[42] The history of this fine manuscript is interesting: begun *c.* 1330, for members of the St Omer family of Mulbarton, Norfolk, whose portraits appear on fol. 7, it was finished only in the fifteenth century for the famous bibliophile, Humphrey, Duke of Gloucester.[43] The early style, best represented in the *Beatus* page (fol. 7; Plate 133), is profuse in the amount and infinitely varied in the elements of the decoration, both of the initial and of the full-page border; moreover, the vine branches and their motifs have become much smaller and more delicate in

their rendering than they were in the Gorleston group. The design of the initial, a Jesse Tree as is usual, fills but does not overcrowd the space, and the tooled gold ground sets off effectively the vine scrolls and figures and is itself set off by the finely diapered blue and pink background of the square field. The gold ground continues all round the border of the page, filling the medallions and joining them together under the connecting interlaced panels. The leaf and flower motifs of the border are set closely on fine, hair-line or slender tapering stems which issue from the interlaced knots at intervals; the coloured motifs, red, blue, green, are interspersed with groups of round or oval gold leaves. The variety of subject matter is bewildering. In addition to the Old Testament scenes in the medallions, some of which seem to be parodied in the marginal figures, almost every kind of wild and domestic animal and bird – and a butterfly and a snail to boot – and a wide range of human activities are represented. Strangely enough, there are none of the human-animal grotesques such as are found in many other East Anglian manuscripts. The drawing is exquisite, the design is well-ordered, the colouring delicate, and the total effect inconceivably rich. The modelling of the heads and draperies, especially in the initial and in the medallions of the border, is of the type found in the portraits of Robert of Ormesby and the abbot added to the *Beatus* page of the Ormesby Psalter. Besides the *Beatus* page, the fourteenth century illumination in the St Omer Psalter is found on three other pages with large historiated initials and full borders (fols 57 verso, 70 verso, and 120); still other pages show traces of the early decoration painted over in fifteenth century style. (See Chapter 8.)

Two late examples of East Anglian manuscripts dating from the later 1330s illustrate the trends of the style in its ultimate development. Both manuscripts are impressive in size (15 by 9 inches, and 14 by 9), in the amount of their decoration, and also in the scope of the subject matter treated. Both are now in the British Museum (Arundel MS. 83 and Add. MS. 42130).

Arundel MS. 83, known as the Psalter of Robert de Lisle,[44] is made up of two partial psalters, of which the first (fols 1–116) is perhaps twenty-five years earlier than the second. Some interesting preliminary pictures precede the first Psalter: a finely drawn and tinted seraph standing on a wheel (fol. 5 verso); a series of small pictures illustrating the twelve articles of the Apostles' Creed flanked by twelve apostles and twelve prophets (fol. 12); a page containing the seven scenes of the Passion, flanked by representations of the seven canonical Hours and the seven last words of Christ (fol. 12 verso), and a symbolic Crucifixion explained by texts on scrolls (fol. 13). The *Beatus* page (fol. 14) has a large initial with a Tree of Jesse topped by a Crucifixion and a rich border containing heraldic shields and a hunting scene in the lower margin. There are historiated initials with simple borders for the principal psalms. The decorative style is of good quality, as in earlier East Anglian manuscripts, but the symbolic subject matter in its formal arrangement would be suitable for wall painting design.

The second part of the de Lisle Psalter consists only of a second Calendar and a great many pages of miniatures which, both in subject and in monumentality of scale, also suggest wall or panel paintings. Some of the more unusual subjects are worth noting, as the Twelve Properties of the Human State (fol. 126), the Ten Ages of Man (fol. 126 verso), the Three Living and the Three Dead, with inscriptions in English (fol. 127; Plate 134B),

the ten Commandments with Christ and Moses (fol. 127 verso), the Tree of the Vices (fol. 128 verso) and of the Virtues (fol. 129, on facing pages), the Seven Spheres of the Wheel (fol. 129 verso), the Seraph on the Wheel (fol. 130 verso, cf. the same subject on fol. 5 verso). In addition to these didactic and symbolic pictures, there is a magnificent full-page Christ in Majesty (fol. 130) and an equally fine Virgin and Child (fol. 131 verso). A number of other pages are divided into panels or medallions containing scenes from the Nativity and Passion cycles of the life of Christ, and at the end of the book, full-page pictures on fols 133 verso–134 verso of the Ascension (Plate 134A), Pentecost, and the Coronation of the Virgin.

Two styles are easily distinguishable in miniatures of the second part of Arundel 83. Untinted outline drawing of exquisite delicacy (Plate 134B) is always used by this artist for the faces and sometimes for the draperies, though often the latter are painted and shaded heavily. There is a strong decorative emphasis in this work, which is seen in the elaborate architectural canopies and in the fine diapered patterns in the pages containing many scenes. This style, though certainly English, has a French delicacy in the technique and French good taste in the design.[45] The figures are not really modelled in spite of the shaded drapery and the strong firm contours.

The second style (fol. 134 verso; Plate 134A) which looks slightly later and is found mainly in the last pages of the book (except fol. 131 verso, which is by the first hand) has faces modelled in brownish flesh tone with white high-lights and touches of red on cheeks and lips. The draperies are exceedingly voluminous and richly shaded; the hands are especially well drawn and painted. There is certainly Italian influence in this style, which shows not only in the modelling and in the shaded draperies, but in the firmer conception of the figure under the draperies and in the grouping of the figures. By the same token, there is much less interest in the decorative patterning and less variety and precision in the ornamental designs. It seems possible that the second style developed out of the first under some form of influence from Italian painting, or perhaps from a mixture of French and Italian elements.[46] The draperies in this second style are incredibly rich in colour, owing to the display of 'double-faced' or lined materials, that is, one colour for the outer side and another for the inner side of a garment, the change of colour showing in the convolutions of the folds. The colours chiefly used in this way are blue or tan with green 'lining' and green with tan lining. Other colours are clear red and grey.

The other late example of the East Anglian style (Brit. Mus., Add. MS. 42130), the famous Luttrell Psalter,[47] illustrates particularly well the breakup of the decorative and grotesque elements of the style and at the same time the increased emphasis on illustrative pictures in the margins (Plate 135). This latter feature has already appeared, as in Queen Mary's Psalter, but there the pictures are confined to delicately drawn vignettes in the bottom margins. In the Luttrell Psalter the pictures are not only in the bottom margins, but run up the sides and across the top of the pages as well, or even, as in the case of the often reproduced Travelling Coach for Ladies,[48] across two facing pages. The scale of these scenes and also of the monstrous, often hideous and vulgar grotesques is disproportionately large in relation to the borders, and even the motifs in the borders usually are too large and coarse to be beautiful. It has been suggested[49] that the manuscript was not

completed as planned when written; but the picture of the Luttrells on fol. 202 verso,[50] which can be dated not later than 1340, is in the same style as many other pages in the 'cheap and coarse' style noted by Millar. Certainly some pages are better than others, but too often even a reasonably good initial and border (fol. 169 verso; Plate 135B) are spoiled by a repulsive grotesque.

Without doubt the most interesting feature of the Luttrell Psalter is the series of scenes from contemporary life, which have been reproduced repeatedly to illustrate books on medieval English life.[51] There are, for instance, agricultural scenes,[52] pictures of home life, travel, sports and games, occupations and trades, animal life, and illustrations from romances. Though often crudely drawn and painted, these scenes display a lively realism in the actions and expressions of the figures and a close observation of details which give the pictures a very special value for understanding the conditions of medieval living. The technique of most of the painting is related to that of the two portraits added to the first *Beatus* page of the Ormesby Psalter and also to the early part of the St Omer Psalter. The faces are modelled with much use of white, especially around the eyes and mouths, and the draperies are strongly shaded. The colours are somewhat different from those of earlier East Anglian manuscripts, in that a minimum of red and blue is used, and a considerable amount of violet and brown. The vigour of the modelling and the tendency to coarseness suggest a connexion with Flemish work, and it is obvious even in the earlier and better pages of this manuscript (Plate 135A) that the exquisite delicacy of the earlier East Anglian style has vanished and that whatever remains of its rich decoration and charming naturalism is far from producing such masterpieces as the Brussels Peterborough Psalter on the one hand, and the *Beatus* page of the St Omer Psalter on the other.

Yet certain elements of the East Anglian style in its earlier phases do survive, and chief among these is the love of marginal illustrations which had long been characteristic of some even earlier English manuscripts.[53] Two examples will serve to illustrate this trait: the so-called Taymouth[54] Hours (Brit. Mus., Yates Thompson MS. 13) and the Smithfield Decretals (Brit. Mus., Roy. MS. 10 E. iv; Plate 136). The outstanding feature of both these manuscripts, as of the Luttrell Psalter, is the amazing series of scenes illustrating all kinds of subjects in the bottom margins. Both manuscripts belong to the first half of the fourteenth century, probably near the middle. Neither can be considered fine illumination but both fall rather in the category of book illustration; the style is linear and the drawing, especially in the Decretals, is rather rough. There is very little border decoration in either, and only very few and simple leaf motifs are used.

The Smithfield Decretals, a large volume of the glossed decretals of Gregory IX, was written in Italy but illuminated in England, perhaps by the Canons of St Bartholomew's, Smithfield, in London.[55] The subject matter of the illustrations, some of which recalls that of the Luttrell Psalter, includes also Bible history and lives of saints, romances and fables, allegories and scenes of everyday life (Plate 136). The technique is outline drawing filled in or shaded with flat colour. Although the drawing is for the most part rather carelessly executed, there is a tremendous liveliness and verve in both the animal and the human figures, and the pictures, like those in the Luttrell Psalter, have often been used to illustrate medieval life.

Also in the category of illustrated books is the Treatise of Walter de Milemete entitled *De Nobilitatibus Sapientiis et Prudentiis Regum* (Concerning the Nobility, Wisdom, and Prudence of Kings)[56] which was written and presented to Edward III *c.* 1326–7 (Oxford, Christ Church Lib., MS. E.11). In this volume every page of text has a full border filled with heraldic shields, small miniatures and grotesques. The subjects illustrated are concerned chiefly with the life of the king: the royal sport of hawking, the king with his knights, the king in court and council, and the king in battle (fol. 68; Plate 137). James distinguished four different artists,[57] of whom the first painted the vigorous combat scenes in the borders beginning on fol. 60; his style, as James notes, is characterized by boldness of execution, and it is possible that his proper work was that of a mural painter. None of the artists are recognizable in any other manuscript and the source of the work is not known, but it probably was the product of a London shop. At the end of the book are some outline drawings, probably by the first artist, depicting engines of war, among them what is believed to be the earliest representation of a cannon.

One final example of East Anglian manuscript illumination is, like the Walter de Milemete, more closely related to other forms of painting than to book decoration. This is the Bible Picture Book, formerly Holkham Hall MS. 666, but recently acquired from Lord Leicester by the British Museum (Add. MS. 47682). There is no evidence, other than stylistic, as to its dating, but it undoubtedly belongs to the first half of the fourteenth century, perhaps not much later than Queen Mary's Psalter. It consists of forty-two leaves containing some two hundred scenes which James[58] divided into three groups: the beginnings of Old Testament History (fols 1–9); the Life of Christ (fols 10–38; and the Last Things (fols 39–42). The pictures begin by being full-page, then two registers are included on one page with several scenes in each register enclosed in lozenges with red hatched grounds. After fol. 9 few pages have these decorative grounds. The drawing of the faces and figures is broad and vigorous, not fine and meticulous as in the best illuminations; the colouring consists of washes of red and blue, with some green, yellow, and brown. The draperies are shaded but the faces show little modelling. In the Creation picture (fol. 2 verso; Plate 138) the imposing gesture of God in the act of creating the birds and animals has the effectiveness of monumental painting, but the poor little 'Noah's Ark' animals are lifeless compared with their charming prototypes in East Anglian manuscript borders. The birds are somewhat better.

The Holkham Bible Picture Book was apparently intended to be just that, namely, a book of pictures accompanied by a short explanatory French text sometimes in verse, sometimes in prose. On fol. 1 are represented, presumably, the artist and his employer who commissioned the book, a Dominican friar; an accompanying text, 'So I will, and if God grant me life, you will never see a better book than mine', suggested to James[59] that the book may have been illustrated by a professional artist in some other field, who was producing a set of copies from paintings which he knew, or else following descriptions perhaps supplied by the Dominican. At any rate, the assortment of subjects represented is exceedingly wide and interesting, and the miniatures demonstrate the influence of the freshness and charm of the East Anglian style even though they lack its exquisite quality.

Opus Anglicanum

It is no accident that English embroidery, which also flowered magnificenlty in the late thirteenth and the first half of the fourteenth century, shows affinities in design and motifs with East Anglian manuscripts (cf. Plates 138 and 139). But whereas the manuscripts display local and individual variations in their decorative styles, the embroideries, as Mrs Christie has pointed out,[60] as a whole show certain consistent changes in design during successive decades.

The principal stages in this evolution are three: (1) scroll work patterns, such as in the Worcester fragments (Plate 120A) of the late thirteenth century and similar patterns as in late twelfth century wall painting and stained glass, used in an all-over design; (2) geometrical panels, such as the barbed quatrefoils of the Clare Chasuble (Plate 121) and some medallions in thirteenth century stained glass, and the eight-point stars in the Westminster Retable; or other medallion forms, as plain or cusped circles; (3) architectural framework, which at first consisted of columns supporting foiled arches and gables, and later lost its architectural stability through the substitution of twisted stems for the columns; then, in the final phase, the arrangement of these stems to frame spaces of the desired shape and size for the figure subjects.

The three stages were by no means mutually exclusive nor is there any sharp chronological division between them; however, the order of their appearance is as given above, and the whole period covered by the evolution of the successive styles is little more than half a century. For example, the design of the Clare Chasuble consists of the characteristic features of both the first and second phases: scrollwork and barbed quatrefoil medallions simply arranged one above the other. In the last decades of the thirteenth century, the medallion designs began to appear more exclusively as, for example, on the cope in the Palazzo Comunale at Ascoli Piceno[61] in Italy, which was given by Pope Nicholas IV, 28 July 1288. The design is of the simplest geometric medallion type and consists of three rows of plain circles framing foiled circles enclosing the figure subjects. The shape of the cope using this design inevitably produces a number of partial medallions; there is, moreover, the problem of adapting the figure subjects not only to the shape of the medallion, but to their position on the cope when it is worn: the scenes cannot all be placed vertically in the medallions as they appear when the cope is laid out flat, because some of them would be upside down when it was worn. This type of design, therefore, rather quickly gave way to a more closely integrated arrangement – interlocked barbed quatrefoils as on the Vatican[62] and Syon[63] Copes (Plate 140), in which the figures could be arranged radially from the centre of the back. But this also resulted in some awkward problems, as the placing of the apostle and angel figures at the sides, which stand on a slant in the panel. Where the circles are formed by the scrolls of the branches of the Jesse Tree[64] the problem is much simpler. Orphreys or any small panels of embroidery such as burses[65] take the quatrefoil medallions admirably. But for copes the basis of the design quickly changed into bands of architectural framework as in the Bologna Cope[66] (Plate 141), the columns of which could be spread at the bottom while the arches, narrowed in at the top, left a series of spandrels into which the angels with spread wings fit so beautifully. Between

the two rows of arches a continuous band of star-shaped medallions[67] contains pairs of heads; a similar band tops the upper row of arches. The bands of the design accentuate the semicircular shape of the cope; the arches all point towards the central area at the back of the neck but the effect of lines radiating from this centre is offset by the circular bands which interrupt it. The balance is further maintained by the fact that the arches in the lower band correspond irregularly to those in the upper band. The advantage of composing the scenes in panels as in this design is the adaptability of the spaces. Architectural framework is suitable also for panels, as on orphreys[68] or altar dorsals (Plate 143), since they can be joined either vertically or horizontally as desired. The impressive figure of Christ Enthroned under such an arch probably formed part of an altar[69] frontal (Plate 139). The Annunciation above in similar architectural framework suggests that the design may have been affected by the frames of retables.[69a]

The final stage, the dissolution of the architectural framework into a radiating trellis-work of twisted branches which can be bent into any shape needed without breaking the unity of the design, is certainly the most satisfactory of all for ornamenting the cope; this design could be manipulated still further into what amounts to an all-over pattern, completely integrated yet allowing proper space for figures to stand upright in whatever part of the cope they might be placed. The twisted branch arcades developed, it seems, about 1325; good examples are the Pienza Cope,[70] the Butler Bowdon Cope,[71] and the chasuble matching it in the Metropolitan Museum, New York;[72] an example of the free vine pattern in all-over design is on the Steeple Aston Cope, divided into an altar dorsal and frontal and now displayed in the Victoria and Albert Museum.[73]

The subject matter usually found in ecclesiastical embroideries[74] was taken chiefly from the two main cycles of scenes from the life of Christ, the Nativity and the Passion, but the relative emphasis on these two series varies in different examples. The Bologna Cope (Plate 141) has seven scenes from the Passion in the upper tier of arcades, eleven scenes from the Nativity cycle and, in addition, the Martyrdom of St Thomas of Canterbury in the lower row. The central medallion of the upper band contains a head of Christ; in the other medallions are heads of apostles, saints, and prophets. The three central scenes of the Syon Cope (Plate 140) are the Coronation of the Virgin, the Crucifixion, and the Archangel Michael and the Dragon (Plate 142A). The Vatican Cope (Plate 142B) has a Madonna and Child in place of St Michael. In the lower rows of medallions in both copes are saints and apostles. Cherubs and seraphs standing on wheels (cf. Arundel MS. 83) fill the spaces between the medallions.

An unusual, in fact unique, subject is used for all but the three central medallions of the Ascoli Piceno Cope, namely, three groups of popes' heads, six martyred popes, six famed for their learning, and four nearly contemporary with Nicholas IV who held the See successively between 1242 and 1268. This cope was made to order for Pope Nicholas, between 1275 and 1280.

The techniques of English embroideries are clearly and fully explained with diagrams of the stitches in Mrs Christie's excellent book.[75] The workmanship in the early period generally is very good and the gold couching is used most effectively with the now faded but originally fresh and varied colours. It appears that much of the embroidery produced

during this, the great, period of *opus anglicanum* was shop work of good quality.[76] The earlier work usually is all embroidered, figures and ground, with gold and coloured silks combined. Later work tends to embroider the figures with coloured silks against a patterned gold ground – a practice which suggests their relation to East Anglian miniatures. Gold and coloured silks and even pearls are used for the figures and decorative details on a greyish-blue silk twill background in the panel of Johannis de Thaneto (Plate 139); and a similar combination of gold pattern and coloured ground is used in the Metropolitan Chasuble, the Butler Bowdon Cope, and an altar dorsal in the Victoria and Albert Museum, all of which are embroidered on red velvet (Plate 143).

The closest stylistic relationship between the embroideries and East Anglian manuscript illumination is found in the later work, that is, in the first quarter of the fourteenth century. The similarities appear in the architectural frameworks with foliated crockets and finials, in the patterned gold grounds, and in animal and leaf motifs. Chief among these latter are oak leaves with acorns, and trefoil or cinquefoil leaves. The animals consist mainly of mask heads, lively little dragons, and even naturalistic animals, as on the Steeple Aston Cope. Heraldic animals also are used, probably often as decorative motifs merely, but sometimes in connexion with the arms of owners or donors.

In the earlier work and in the less fine later work, drapery on the figures is represented by completely linear patterns indicated by colour and by the direction of the stitches. The figures always have a strong dark outline when embroidered against a gold patterned ground; when the ground is not embroidered this is not so conspicuous. Some figures in the later work have the faces modelled in dark and light colour, while others show no modelling, the features being indicated in outline and colour used only in spots of pale pink on the cheeks. These two techniques were also used interchangeably in later East Anglian manuscripts (cf. Arundel MS. 83).

The present distribution of ecclesiastical vestments of *opus anglicanum* throughout Europe reflects the extent of the popularity which this typical form of English art had in the Middle Ages. The greatest number of fine embroidered copes exists in Italy, obviously the result of gifts to various popes by English kings, nobles, and ecclesiastics. A Vatican inventory of 1295 mentions *opus anglicanum* 113 times, greatly exceeding, says Christie, the number of embroideries of other specified workmanship. Outside Italy, fine examples of English embroideries still exist in Spain (Madrid, Toledo, Vich in Catalonia); in France at Lyons (in the Textile Museum) is a late thirteenth century Jesse Tree orphrey, and in the sacristy of the cathedral of St-Bertrand-de-Comminges are two fine copes presented to the cathedral by Pope John XXII in 1309. There are several examples of *opus anglicanum* in Brussels (Musée Cinquantenaire) and a cope in Stockholm, from Skå, and one in Uppsala. In England the most representative embroidery collection is found in the Victoria and Albert Museum; there are also a few fragments in the British Museum. From the number of examples known to survive or mentioned in documents, the output must have been tremendous, and although no known centre has been established for the production of *opus anglicanum*, London has been suggested as the most likely. If, as Mrs Christie remarks, some of the pieces are no more than high grade hack work, this is not to be wondered at; yet in most of the surviving work of the great period (late thirteenth

to early fourteenth century) one must be critical indeed to find flaws in either the workmanship or the designs.

Painting

Few examples of painting on wooden panels or on walls survive from the first half of the fourteenth century. Of the panel paintings the most important are: (1) two full-length figures of kings (Plate 146) out of an original four on the inside of the Sedilia in the choir at Westminster Abbey, and one king and a fragmentary Annunciation on the outside, all dated *c.* 1308; (2) a retable at Thornham Parva[77] (Suffolk), also dated early fourteenth century, consisting of nine panels with (centre) a Crucifixion and Peter and Paul (Plate 144), and in the three side panels on each side, standing figures of male and female saints under arches; (3) a long altar frontal or possibly the lid of a chest in the Musée de Cluny (Paris)[78] designed with quatrefoil medallions, each showing a scene from the life of the Virgin, in a peculiar order; left to right, Nativity of Christ (Plate 145A), Death of the Virgin, Adoration of the Magi, and Education of the Virgin (Plate 145B); the date, *c.* 1325–30.

The two last-named panel paintings are unquestionably closely related to the East Anglian manuscript style, the Thornham Parva Retable to the Norwich–Gorleston group, the Cluny panel to pages with similar medallions containing scenes from the early life of Christ[79] in Arundel MS. 83 (fols 124–5 verso). The style of the two panels shows some differences which may be due partly to their date. The medallion figures of the Cluny panel are extremely tall and slender, with rich shaded drapery, such as is characteristic of the later part of Arundel 83, painted before 1339. The faces have the smooth, oval shape of those in this manuscript and some of them seem to be modelled; others, especially the women, have only a spot of pink on the cheek. The colours are duller and darker than in the manuscript, but this may be partly the result of prolonged exposure to light and dirt. The Thornham Parva Retable is architectural in its general design, with the nine panels framed in the three sections of a triptych and separated from one another by slender half-columns which support a carved arcade. In the spandrels there is carved and gilded ornament; the columns and the patterned gesso backgrounds also are gilded. The whole effect is very rich even though the individual colours tend to be rather dull – purples, greys, and browns prevailing. The total length of the Thornham Parva Retable is 12½ feet, its height about 3 feet.

The paintings of the Westminster Sedilia are probably by Master Thomas, son of Master Walter of Durham,[80] who is mentioned in the records as working for King Edward II *c.* 1308. He also was employed in restoring the Painted Chamber, and it has been suggested that the Sedilia figures resembled those in the Painted Chamber.[81] If there is a resemblance to surviving Westminster work, however, it would seem to be to the paintings in the south transept or to the still earlier Westminster Retable from which the general style of the transept painting was perhaps derived (see Chapter 5). On the inside of the Sedilia there are two kings perhaps representing, according to Wormald, Sebert and Ethelbert.[82] The figures are extremely tall and slender and the voluminous draperies lined with vair sweep about them in elegant, somewhat mannered curves. The colours are

now cleared of the effects of varnishing about a hundred years ago. On the back of the Sedilia is the lower part of a large painting of the Annunciation. The draperies have the same elegance and richness of linear pattern as those of the inside. On the two adjoining outside panels were figures of Edward the Confessor, of which the head only remains, and presumably of St John as a pilgrim to whom the King was offering the ring, as in the spandrel sculpture of the south transept.[83] The Sedilia paintings represent the later phase of the Court style initiated by William of Westminster in the first half of the thirteenth century.

Of the numerous traces of wall paintings from the first half of the fourteenth century, little survives which can give any clear idea of the style, but where it is possible to judge the quality, it would appear to have been on the whole rather poor. However, the schemes of wall decoration and the elaborate cycles of scenes represented evidently were fairly ambitious, and often the subjects and the novel manner of rendering them are very interesting. Four examples have been selected with typically elaborate schemes of mural painting dating from the first or second quarter of the fourteenth century. These are: Croughton (Northants), Chalgrove (Oxon), Peakirk (Northants), and Longthorpe (Northants). The dates are probably in this order: Croughton is dated c. 1300; Chalgrove and Peakirk at the end of the first or the beginning of the second quarter; Longthorpe in the second quarter of the century.

The Croughton and Chalgrove paintings were uncovered many years ago and have certainly deteriorated greatly since the descriptions of them were published;[84] Peakirk (near Peterborough), like the other two a tiny parish church (Plate 147A), was discovered[85] only in 1950–1; and Longthorpe, a private manor (Plate 147B) which is unique in having a tower with the walls completely painted with all kinds of subjects – religious, secular, allegorical, and purely decorative – was uncovered[86] in 1947. The paintings in Chalgrove Church still show a great many of the subjects listed below as forming the scheme, though most of them are now faded, and without a key would perhaps scarcely be decipherable; the Croughton paintings, which must have been much finer in style than those at Chalgrove, now show only as dim shadows of scenes, with here and there a figure which can be identified. The paintings at Peakirk and Longthorpe are still as clearly visible as when first uncovered, and it is hoped that, with the methods now used to preserve them, they will remain so. Although all four of these places are geographically fairly close together, there seems to be no stylistic connexion between them. It is likely that the work in each case was done by a local painter, perhaps from some set of biblical pictures such as commonly precede the text of psalters,[87] but no basis for closely relating iconographically any two series of these or other known wall paintings has been found. It is true that in the case of the Longthorpe paintings East Anglian features are present, especially in some of the foliage and animal motifs, and the work is good enough to have been done by an artist trained in so important an art centre as near-by Peterborough. But no close stylistic connexions between the Longthorpe paintings and any other known work, either manuscript or painting, have appeared.

Since little can now be seen of the style of the painting in the first two examples cited, their chief interest for the student of art is the scope and arrangement of the scheme. At

Croughton the paintings cover both walls of the nave; the south wall is divided into three tiers, the north into two. The south wall has a very complete series of scenes from the life of the Virgin and the early life of Christ, beginning with the rejection of Joachim's offering in the temple, and ending with the Assumption of the Virgin. Two particularly interesting and rather unusual scenes in this series are the Virgin leaving her home, and her marriage. On the north wall is the Passion cycle ending with the Ascension and Pentecost, both now lost. Two additional scenes from the life of the Virgin are at the east end of the north aisle, in the Lady Chapel: the Annunciation and St Anne teaching the Virgin. Tristram, who apparently saw much more of the paintings than can be seen now, says they are 'executed with extraordinary certainty and sleight of hand; they are full of dramatic life, and give at the same time evidence of a very fine sense of line and composition'.[88]

The Chalgrove paintings have an even more complete scheme and a more balanced arrangement of individual scenes on the north and south nave walls. The north side begins with a Tree of Jesse, with the Annunciation figures in the window jamb adjoining; in two lower tiers in the centre of this wall are the Nativity, the Adoration of the Magi, the Massacre of the Innocents, and the Presentation in the Temple. Above these scenes, in the top tier, are four scenes from the Passion preceding the Crucifixion which is at the east end; below it, the Descent from the Cross and the Entombment. Two female saints, Helena and another, are in the east window jamb on this wall. In the chancel, on the north side: the Descent into Hell, the Resurrection, and the Ascension; flanking the east window, Peter and Paul; at the west end of the south wall, the Last Judgement in three zones; Bartholomew and perhaps Lawrence in the window jamb. In the middle sections, the Death, Funeral, and Entombment of the Virgin, the Miracle of the Jews, the Giving of her Girdle to St Thomas, her Assumption, and finally, at the east end of the south chancel wall, the Coronation of the Virgin, corresponding to Christ's Ascension on the north side. In the jamb of the remaining window on the south side are the two Saints John. The intention of planning a complete scheme of individual events in the lives of the Virgin and her Son is clear. The elaborate cycle of the Virgin's Death, especially the scene of the miracle at her funeral, may date the paintings, even apart from their style, later than those at Croughton (cf. Queen Mary's Psalter, with similar scenes in the marginal drawings). The style at Chalgrove was apparently less fine than at Croughton; the colours were yellow, red, and (?)blue; the figures were drawn in red outline. The subjects again evidently come from some picture book series, and the work is obviously that of local artists.

At Peakirk the workmanship is fairly crude, but the handling of the incidents and some of the unusual subjects make the paintings appealing and interesting. Most of the pictures are on the north nave wall, and except for some extraneous subjects, they all belong to one cycle, that of the Passion. An interesting and naïve feature of the arrangement is the placing of a huge St Christopher on the wall directly opposite the south doorway, actually interrupting the series of the Passion scenes in both the upper and the lower tier (Plate 147A). In the north aisle is an early example of a subject frequently found in later wall painting, namely, the Three Living and the Three Dead[89] (cf. Arundel MS. 83; Plate 134B).

The three living kings are distinguished as to their ages. Over the north door is a scene which has been interpreted[90] as an allegorical representation of Gossip: two women in close converse, with a hairy devil leaning over their shoulders. The colours are the usual earth red, yellow, and dull green.

Of much better quality than anything that can now be seen in the other examples is the painting in the tower of Longthorpe, and unquestionably the finest single figure here is the king who stands behind the wheel of the five senses (Plate 147B), as it has been identified (see note 86). The senses are symbolically represented by a monkey (taste), a vulture (smell), a spider in a web (touch), a boar (hearing), and a cock (sight). Mr Rouse suggests that this subject, together with the fashionable young man and his dog above the wheel, might be interpreted as the secular or worldly life contrasted with the contemplative or spiritual life on the wall opposite, which may be represented by some teaching figures and by the morality of the Three Living and the Three Dead, as was perhaps intended at Peakirk. Other subjects in this interesting scheme are the Wheel of Life with the Seven Ages of Man (cf. Arundel MS. 83 with the Ten Ages of Man, fol. 126 verso); pairs of Apostles, each with a portion of the text of the Creed (cf. Camb., Corpus Christi Coll., MS. 53); and several of the Labours of the Months, usually found in the calendars of psalters and hours: January, a man warming himself at a fire, usually given to February; March, a man digging; December, killing a pig. In addition to these and other subjects only partially identified, there are a number of beautifully drawn and painted birds, several animals taken from the Bestiary, and some decorative foliage of the type found in East Anglian manuscripts. In fact, and this should surprise no one, the Longthorpe paintings have a great deal in common with the East Anglian style and, as already suggested, it seems likely that their artist was not a local dauber, but was trained in the school of Peterborough where figure paintings once adorned the choir and where the magnificent thirteenth century wooden ceiling of the nave with decorative designs, much repainted, can still be seen.[91]

Stained Glass Windows

Fourteenth century English glass, like that of the thirteenth, neither is plentiful nor has any of it survived without a great deal of mutilation, especially as to the heads of the principal figures, and without more or less questionable restoration. Moreover, in the fourteenth century as in the thirteenth most of the glass is localized, for the most part not in South England but in the North, primarily at York Minster, and in the Midlands, at Gloucester Cathedral and Tewkesbury Abbey. There is fourteenth century glass also in Somerset, notably at Wells Cathedral,[92] and a few isolated examples have even been preserved in small parish churches elsewhere, as at Deerhurst.[92a]

Unquestionably the richest collection of fourteenth century glass is found in York Minster,[93] and there may be an explanation for this in the fact pointed out by Knowles[94] that York is situated on a busy navigable river by which 'raw' glass – that is, sheets of coloured or white glass uncut and unpainted – could be and probably were brought into England from the Continent. For there is no positive evidence that the glassmaker's craft was practised at York or anywhere else in England during the Middle Ages.

At the beginning of the fourteenth century a number of innovations may be noted in respect to both the choice of colours and the design of stained glass windows, and in these developments it would seem that York took the lead. First in importance, perhaps, is the change in design from thirteenth century medallions with figure compositions[95] to panels with groups of figures or single figures under architectural canopies arranged in tiers in the long lights which were now unbroken by the formal patterns of the medallions as in earlier windows (cf. Plate 101).

Closely related to this fundamental innovation is another, the alternation in a single window light of coloured panels with grisaille panels containing shields or other small motifs. The arrangement of several lights in a single window with this alternation of colour and grisaille results in the banded effect which is characteristic of fourteenth century English windows.

These two new features are illustrated in the earliest fourteenth century glass at York Minster, the window in the north aisle of the nave,[96] given by Peter de Dene c. 1310 (Plate 148). Scenes from the life of St Catherine are arranged in two wide horizontal bands – two panels high, except for the central lower one containing the donor, which has three panels; between these bands and at the top and bottom are other bands of grisaille glass, one panel high, each enclosing a heraldic shield. The whole of each window light, the two tiers of coloured panels and the three of grisaille, is tied together by a coloured border containing heraldic devices and human and animal figures.

The third innovation to be noted in English fourteenth century glass is the discovery and subsequent excessive use of silver stain which, applied to white glass, colours it a rather strong yellow; this was used, apparently, to simulate gold in the tabernacle work of the canopies and also for details and sometimes for backgrounds. In the earlier windows, as the de Dene window at York, it is not excessive in amount, but the colour is usually too sharp to harmonize well with the duller red, blue, and green pot-metal glass. In another and later north aisle window at York Minster, the so-called Bell-Founders' or Tunnoc window, the yellow glass is used for dozens of bells hung in the tabernacle work and in the borders of each of the lights, which are banded like the de Dene window with grisaille and coloured panels. The date is before 1330.[97]

A fourth innovation in fourteenth century glass design is first found in the chapter house and vestibule windows at York, dating from before 1335. This is the use of recognizable flower and leaf motifs treated naturalistically, such as the oak, maple, thorn, ivy, hop, and strawberry. Grotesque animals also are there, and this type of ornament particularly recalls similar motifs used profusely in East Anglian manuscripts.[98] There is more grisaille glass in the chapter house and vestibule than coloured, and it seems possible that the influence of the near-by Five Sisters lancets filled with thirteenth century grisaille glass may be felt especially strongly here.

Finally, the great west window at York (c. 1338) illustrates well (Plate 150) the last fourteenth century innovation to be noted in glass, namely, the development of curvilinear patterns in the stone tracery of the upper part or head of the window. The earlier York windows described have foliated medallions of geometric plate-tracery in the heads, containing figure subjects (cf. Plate 148). Curvilinear tracery as in the York west window

is designed in flowing lines which curve upward from vertical mullions of varying thickness and divide the window head into leaf-shaped lights. So irregular are most of these spaces that figure subjects and heraldic shields could not conveniently be fitted into them, and decorative patterns suggesting unsymmetrical leaf forms – at York white leaves against coloured grounds – are used with rich and pleasing effect. The eight lights of the west window contain single figures under tabernacles arranged in three or four bands of colour separated from each other by grisaille panels: eight archbishops are in the lower band, eleven apostles in the second band, and pairs of figures forming subjects in the third band and in the two central lights of the fourth. The subjects are, left to right: the Annunciation, the Nativity, the Resurrection, and the Ascension. In the two top centre lights is the Coronation of the Virgin.

The windows in the choir clerestory of Tewkesbury Abbey are little later than the York west window, though the style both of the tracery and of the glass is rather different. There are seven windows, five of five lights, two of four. The central window contains the Last Judgement, set under elaborate tabernacled canopies of white glass against coloured ground. In the bottom panels are heraldic shields. The four flanking side windows contain single figures of prophets, patriarchs, kings, and historical personages. The two windows having four lights – those nearest the crossing – contain single figures of knights who were lords of Tewkesbury (Plate 149B). The date[99] of the windows is c. 1344.

The knights are boldly drawn figures clad in armour that is transitional between chain mail and plate, and in blazoned surcoats. They stand against backgrounds of green, red, or blue, diapered or decorated with delicate arabesque patterns. Yellow is used for the chain mail and for the blazon of the surcoats and shields. In spite of much patterning, and some confusion due to restoration, the figures are among the most impressive found in English glass of the first half of the fourteenth century.

The final development of glass in this period is in the great east window of Gloucester Cathedral[100] (Plates 149A and 151) which in one unbroken wall of glass 78 by 38 feet commemorates the Battle of Crécy (1346) and the siege of Calais (1347); an examination of the heraldry has led to the conclusion that the window was in place by 1349. The window is wholly Perpendicular – in tracery, in design, and in colour – and it is the earliest known example of this style. The perpendicular and horizontal stone mullions and transoms divide the whole area into rows of rectangular panels each of which contains a single figure under a canopy. These separate figures, however, were conceived in relation to a single theme, the Coronation of the Virgin, of which they appear as witnesses, as in the great Italian Trecento altarpieces. The single figures are angels, apostles, saints, ecclesiastics, and kings. The three lowest rows are filled with quarried glass, each panel containing a star ornament and, in addition, those in the third row contain coats of arms.

The figure panels (Plate 149A) each contain a single figure in white glass under a white glass canopy, the side shafts of which extend into the panel above and support the canopy there. The backgrounds are coloured, as are the borders of the draperies and the haloes: ruby for the two central series of panels, and alternately ruby and blue for the outer tiers. Thus the colour effect in general is of vertical stripes of colour against a pattern of white figures and canopies.

The figures are beautifully drawn with full, rich draperies bordered by a pattern which curves in and out with the turn of the drapery folds. The position of the figures is strongly 'hip-shot' as in the latter part of Arundel MS. 83 (Plate 134A), but there is no modelling of the body; the faces are carefully drawn, the hair and beard are thick and softly curling masses, the hands are delicately rendered with long, slender fingers. The drapery is shaded in the deep parts, as is the canopy, which has a certain suggestion of spatial depth partly because of this shading, partly because the cusps are made to project over portions of the figure. The style of the figure painting, like that of the window as a whole, shows progress as compared with Tewkesbury and York towards the clear and more natural rendering of the single figure, and heralds the plainer type of decorative painted glass which is characteristic of the late fourteenth and fifteenth centuries.

Summary

The first half of the fourteenth century well may be called the East Anglian period from the predominance of fine work known to have been produced there. The East Anglian style in general was marked by the variety of subject matter, by the originality with which this was treated, and by the rich and varied decorative elements. The sources of this style are to be found partly in the illustrated manuscripts of the preceding century, partly in the Westminster Retable. But it would appear that some new influence also, perhaps from North France or Belgium, helped to determine the special character of the style. For the essence of the East Anglian style is its freshness, its earthiness, its pungent humour verging on vulgarity, and, above all, its fine colour and, in the later phase, the painterly technique of modelling the draperies. Many of these characteristics are found in a manuscript made about 1300 at Maastricht, Holland, a small Book of Hours (Brit. Mus., Stowe MS. 17) with miniatures and marginal scenes which, in lusty vigour and amusing originality as well as in type of decoration and general spirit, are closely related to East Anglian manuscripts of the early fourteenth century. Such examples as this may have had an influence. The East Anglian style, however, in the best period, is always much more lavish in its decoration; indeed, apart from the Queen Mary's Psalter group, this profusion of ornamental features is its most strongly marked characteristic.

Whatever its origins, the East Anglian style quickly spread from manuscript illumination to the other arts in England; and from England to other parts of Europe. In the Lower Rhine, at Cologne, the Cathedral choir stalls are painted in a style which both in figures and in decoration shows signs of East Anglian influence. Even as far away as Bohemia its influence was felt and registered in the decorative style of a group of fine manuscripts made in the first half of the fourteenth century under the patronage of Johann von Neumarkt.

THE INTERNATIONAL STYLE
⟨1350–CIRCA 1420⟩

*

HISTORICAL BACKGROUND

POLITICAL

Foreign Wars and Domestic Revolts

Edward III, King 1327–77; Treaty of Brétigny 1360 temporarily ended the war with France; King John of France a prisoner in England 1357–60, again in 1363; renewal of war 1369; death of Edward the Black Prince 1376.

Richard II, son of the Black Prince, King 1377–99 (deposed and died, perhaps murdered); Peasants' Revolt 1381; married Anne of Bohemia 1382 (d. 1394); alliance with William, Duke of Gelder, 1389; married Isabella daughter of King Charles VI of France 1396.

Henry IV, son of John of Gaunt, Duke of Lancaster, King 1399–1413; married Mary daughter of Humphrey de Bohun 1380 (d. 1394), and Johanna of Navarre 1403.

Henry V, son of Henry IV and Mary de Bohun, King 1413–22; married Katherine of Valois, daughter of Charles VI; Treaty of Troyes 1420; assumed title of heir and regent of realm of France.

Humphrey de Bohun, 7th Earl of Hereford, father of Mary and Eleanor, d. 1372–3; Psalters made for him contain his name in prayers; went to Italy 1368 for marriage of Lionel, Duke of Clarence, to Violanta Visconti, daughter of Duke of Milan.

John of Gaunt, Duke of Lancaster 1362–99.

John Beaufort, son of John of Gaunt, Earl of Somerset, d. 1409.

Eleanor de Bohun, Duchess of Gloucester, d. 1399.

ECCLESIASTICAL

Great Churchmen, Patrons of Art

Nicholas Lytlington, Abbot of Westminster 1362–86.

Simon Langham, Abbot of Westminster, Bishop of Ely, Archbishop of Canterbury 1366–1368; cardinal 1368; Bishop of Palestrina 1374; died at Avignon 1376, bequeathing books to Westminster Abbey.

Henry Despenser, Bishop of Norwich 1370–1406.

William of Wykeham, Bishop of Winchester 1367–1404; founded New College, Oxford, 1380; and Winchester College 1382.

Richard Mitford, Bishop of Salisbury 1395–1407.

Thomas Arundel, Archbishop of Canterbury 1396–7 and 1399–1414.

Henry Chichele, Archbishop of Canterbury 1414–43.

Richard le Scrope, Archbishop of York 1398–1405.

*

THE second half of the fourteenth century and the first quarter of the fifteenth were again a period of strong, continuous foreign contacts, politically through foreign wars and foreign marriages, and ecclesiastically through close relations with the papal court at Avignon. In art, this period was one of rich production in every form, stimulated no doubt by these foreign contacts, but also resulting naturally from the growth of personal power and wealth among both royal and noble, ecclesiastical and lay, patrons. At first the foreign influence was strongest from north Italy and south France; later, it came from Bohemia through the marriage of Richard with Anne; and still later, during the last decade of the century, the alliance of Richard with William, Duke of Gelder, against France brought England and the Low Countries into close relations. Finally, in the first quarter of the fifteenth century, the French marriages of Henry IV and Henry V introduced the influence of the International Style[1] from France and Burgundy where it had chiefly developed.

In England, the second half of the fourteenth century was a period of building. The Royal Chapel of St Stephen in the Palace of Westminster, rivalling the earlier Sainte-Chapelle of St Louis in Paris, was completely painted and the windows were filled with fine stained glass. In this period also the Chapter House of the Abbey of Westminster was entirely painted with a magnificent Last Judgement and a series of Apocalypse pictures which constitute the best known paintings of this subject in England. The splendidly imposing Westminster Hall with its superb hammerbeam roof and carved and painted angels was Richard's contribution to the Palace of Westminster. And in the last quarter of the century William of Wykeham began his two great college foundations: New College, Oxford, in 1380, and Winchester College in 1382. These are only a few of the many rich and important works sponsored by royal and ecclesiastical patrons. Many more have been discussed and referred to by Joan Evans in the latest book to be published on English art of this period.[2] Although much of this art has perished, enough remains to indicate not only its amount but its generally high quality.

The middle years of the fourteenth century were unproductive of fine art in England, the East Anglian style having nearly spent itself whether through the natural processes of growth and disintegration, or through the extinction of its practising artists, or both. In the meantime, however, the style had spread to the Continent and had been felt particularly in the Lower Rhine (Cologne) and as far east in Germany as Bohemia.[3] In France (Paris), on the other hand, the followers of Jean Pucelle were busy producing manuscripts which display some decorative affinities with East Anglian style but probably are not directly influenced by them. The Pucelle mixture is French and Italian, under what specific circumstances has not been determined.[4]

Soon after the middle of the century, strong Italian influence begins to appear in the manner of modelling faces and draperies in English miniatures, while about the same time the more formal French ivy leaf border decoration is found in combination with East Anglian daisies. This mixture is illustrated in a psalter in the Vatican Library,[5] Rome (MS. Pal. lat. 537; Plate 152A). Many of the miniatures appear to have been inspired if not actually copied from those in Queen Mary's Psalter, but the Vatican pictures are more heavily painted as to figures and draperies. The expressionless faces modelled with white paint over a deep pinkish flesh tone, the great dark eyes, red lips, and reddish-yellow hair

are certainly not East Anglian in origin. The border and initial are in typical French style, but the daisy buds introduced at the corners of the bar and occasionally elsewhere, like the figure composition, surely come from East Anglian manuscripts of the Queen Mary's Psalter type, which the illuminator of this manuscript must have seen either in England or on the Continent.

A similar French-Italian influence on English style can be seen in a Psalter (Paris, Bib. Nat., MS. lat. 765) made for the Fitzwarin family, having a Calendar with many East Anglian feasts and the first pages of its decoration in a rather debased version of the East Anglian style.[6] During the course of the illumination, however, Italian influence appeared in the richer draperies and the modelling of the faces in white on a dark flesh tone, some-times, apparently, over the original East Anglian drawing. The colouring in this manu-script seems also to have been affected by Italian influence, the draperies being painted in richly shaded violet, pink, vermilion, and dull green. In the Fitzwarin Psalter a feature first appears, possibly from Continental sources, which becomes characteristic of some of the manuscripts to be discussed below, namely, the elaborate Late Gothic architectural settings (cf. Plate 154A).

In a third mid-century manuscript showing evidence of Continental influence (Camb., Fitz. Mus. MS. J.48), the Carew-Poyntz Hours,[7] the source seems to be almost entirely French, in the use of framed pictures and borders with ivy-leaf motifs and in the *bas de page* scenes within frames at the bottom of the pages (Plate 152B). Slight Italian influence appears in an accentuation of the features, especially the large black eyes under heavy lids, and in the strongly shaded draperies. Architecture, too, plays an important part in the scheme of decoration, and there is a certain awkward attempt at foreshortening and at spatial rendering in spite of the formal patterned backgrounds, which is absent in English examples of *bas de page* scenes of the preceding period (cf. Roy. 10 E. iv; Plate 136). There has been some later repainting in the miniatures of the Carew-Poyntz Hours, but the scene in Plate 152B (fol. 62 verso) represents fairly well the French-Italian-English mixture of the earlier decades of the second half of the fourteenth century.

This same French-Italian-English mixture of miniature styles with a Latin and French text written in an English hand and with English decoration and a Calendar and Litany pointing strongly to the diocese of Durham – all found in the M. R. James Memorial Psalter in the British Museum (Add. MS. 44949) – seems to settle the question of whether this style was produced in England or imported ready-made from abroad. The minia-tures are by two hands, the first of which (fol. 4; Plate 154A) is closer to the Fitzwarin and Carew-Poyntz style, especially as to the white faces and beady black eyes. The colouring is less fine than in the Fitzwarin Psalter, with much green and dull yellow. The style is not very good; the stiff, uninteresting arcading and the coarsely-patterned diapered back-ground do not seem to be quite suitable for the type of figure compositions which, in intention, follow Italian Trecento principles[8] of spatial relationships and therefore employ freely all possible aspects of the figures – frontal, profile, three-quarter, and back views. The artist, however, has not understood thoroughly what he was doing, and he combines in the same figure a side view of the feet of Christ in the scene with the Magdalene, a front view of his body from the waist up, and a three-quarter view of his head, which is

turned in the opposite direction from that in which his feet are pointed. The Magdalene is seen in one of those extraordinarily inept kneeling back views which appear occasionally in miniatures by artists who have seen Italian paintings and do not understand how to represent this difficult foreshortened view. The body of the Magdalene, therefore, is shown as almost paper-flat and her legs are like bundles, the roundness of which the artist hoped to suggest by shading them to set them off from the rest of the body. The other group, Christ before Caiaphas, is somewhat better; but there is no depth in the grouped figures and no spatial relation between them and the profile view of Caiaphas. The feet of Christ in both miniatures are flat as though partially cut off by the frame of a picture as seen from below. The faces show a curious confusion of modelling conventions suggested by lines.

Italianate types of heads in a mixed English Italianate style are well illustrated in the detail in plate 154B. This head, a fragment from the wall painting formerly in St Stephen's Chapel, bears a strong resemblance to the heads of Christ in the James Memorial Psalter. The eyes and eyebrows are treated in very much the same manner, as are the pinched mouth and drooping moustache and beard. The style of the St Stephen's painting, however, seems rather to be derived directly from north Italian (Lombard) types; in the James Psalter, the influence seems to be more Sienese, perhaps the Franco-Sienese mixture which was current at Avignon. The James manuscript cannot be dated earlier than the third quarter of the fourteenth century[9] – a time when Avignon was greatly influencing painting done in France.

The strong, direct Italian influence which is evident in the foregoing paintings can be seen in the process of entering the English, that is, East Anglian, style in one of the earlier members of the group of eight or more manuscripts which, by means of inscriptions or coats of arms, can be associated with one or another of the Bohun family.[10] Humphrey de Bohun, 7th Earl of Hereford (d. 1372–3), seems to have been the patron for whom the Psalter in Vienna (Nationalbibl., MS. 1826*) was written, since his name, now erased, was mentioned in several of the prayers. The first part of the illumination, as far as fol. 49, has historiated initials in poor East Anglian style; but from fol. 50 onwards, Italian influence completely transforms the feebly-drawn figures and introduces a different kind of border motif.[11] Some other members of the Bohun group of manuscripts use this Italianized style;[12] but there are a few which seem to have had no such contacts, but to be illuminated in some version of French or possibly Flemish style, with small, linear figures and a formal border of one particular kind of cinquefoil leaf.[13]

Elements of both styles are illustrated in the Bohun manuscript most recently discovered (Brit. Mus., Egerton MS. 3277; fol. 123; Plate 153A), containing in five places in the borders the Bohun arms and the royal arms of England, and suggesting thereby that, although written for Humphrey de Bohun,[14] it may have been finished for Mary de Bohun, daughter of Humphrey, who married Henry of Lancaster, later Henry IV, in 1380. In this manuscript the north Italian influence is fully developed; its characteristics are the beady black eyes, the black hair and beards, the white faces and the richly shaded draperies.[15] The elaborate decorative style of the large historiated initials and their marginal borders is, however, fully English. The initial is divided into compartments

having fine diapered or gold tooled grounds against which the figure subjects are placed. There is no interest in spatial representation, although a good deal of architecture is introduced and some elements of landscape – the green grass with East Anglian daisies growing in it. The East Anglian fondness for filling the margins with figures and decoration is here evident. It is a brilliant and extremely effective style with its fine burnished gold and strong, richly shaded colours, but little of the monumentality in the treatment of figures such as is found in Italian painting of the same time appears here.

The earliest date for the Bohun manuscripts is generally given as about 1370; judging from the style, the latest example may be a psalter made for Eleanor de Bohun (Edinburgh, Nat. Lib., MS. Adv. 18.6.5) who died in 1399. Where the Bohun manuscripts were made is unknown, although both Egerton MS. 3277 and the Eleanor de Bohun Psalter, in relation to certain later manuscripts, suggest a London provenance. The decorative style becomes less rich in the Eleanor de Bohun book, but the Italianate figure elements persist and even, it would seem, become more marked towards the end of the century, as can be seen in a Psalter in the British Museum (Add. MS. 16968; Plate 153B). Most of the illustrations in this manuscript are miniatures, but the text seems to have been written for historiated initials – the initial C of the first word, 'Crucifige', on this page is missing. The miniature contains foliated medallions such as occur in earlier English manuscripts (cf. Plate 134A) with interlaced frames placed on a rectangular panel. The figures are mainly behind the frames, but some of the feet extend into, or over, the framework. The background is burnished gold with no architectural setting indicated and no suggestion of depth in space, but the figures have the heavy-lidded, sullen faces of the Italianate Bohun style. The modelling is in white on a brownish flesh tone. This manuscript represents the fully developed late fourteenth century English style characteristic of two London manuscripts, the Lytlington Missal, made for Westminster Abbey, and some pages of the Carmelite Missal, probably made at Whitefriars (see below).

Further evidence that Italian influence was present in work done in London can be seen in a few fragments that survive from the series of wall paintings formerly in St Stephen's Chapel in the Palace of Westminster, now in the British Museum (Plate 155B). These paintings, though executed in fresco technique, are on a small scale and therefore easily comparable in style to the Italianate Bohun miniatures. It is difficult in the present battered and fragmentary state of the paintings to reconstruct the subjects as they were,[16] but enough remains to demonstrate Italianate characteristics apparently unmixed with French, and showing similarities to the figure style of Eg. MS. 3277 (Plate 153A). Characteristic of the St Stephen's frescoes are the richly gilded gesso backgrounds with patterns in relief, the architectural setting which is solidly and convincingly rendered, though without any real spatial depth, and the richly draped figures in three-quarter, profile, and full-face positions, with finely modelled features and expressive gestures. The style has neither the bulkiness of the Florentine nor the Gothic attenuation of the Sienese, but seems closer to the Lombard[17] style which developed at the end of the century in the frescoes of Altichiero and Avanzi at Padua.

The frescoes of St Stephen's Chapel can be dated on documentary evidence[18] in the 1350s and 60s. Two painters are named: Master Hugh of St Albans, appointed 1350, and

William of Walsingham, mentioned as assisting Master Hugh in 1352 and apparently as replacing him in 1363. The fragments of painting which survive (Plate 155B) seem to be among the latest in date.[19]

There were fourteenth century wall paintings also at Westminster Abbey. The Chapter House walls were decorated with a great Last Judgement centred under the arcades on the east wall and extending into the adjoining walls on both sides. The date is variously given from mid fourteenth century to *c.* 1370; at any rate part of the work was ordered or directed by a Brother John of Northampton,[20] a monk of the Abbey, who said his first mass in 1375–6. In the centre of the Judgement composition can still be seen part of the figure of Christ in Majesty, displaying the wounds, his feet resting on the globe; flanking him are two standing seraphs (Plate 155A) on each side, feathered in the manner commonly found in East Anglian manuscripts. Little can be seen except the heads, so damaged are the paintings, but in so far as the style can be determined, it seems to have no direct connexion either with the Bohun style or with that of the St Stephen's frescoes. The oval faces of the angels with their round chins and straight brows and serious expressions perhaps suggest slightly the figures in the later part of Arundel MS. 83 (cf. Plate 134A), but since its exact provenance is unknown, this manuscript is of no help in localizing the source of the style of the Westminster Judgement. This is primarily decorative, as is seen in the haloes with a wheel window design and in the downward spreading wings with the patterned feathers. It must have been extremely beautiful, and very effective in its position facing the entrance to the Chapter House. The other walls also were entirely painted, apparently all at a later date.

Slightly later but early in the last quarter of the century is a damaged wall painting in a room in the Byward Tower of the Tower of London.[21] The central subject is unknown, having been destroyed utterly by the insertion of a Tudor fireplace in the middle of the wall. The surviving figures are: left, Mary and John the Evangelist; right, John the Baptist and the Archangel Michael holding the scales (Plate 154C). He wears a greyish purple mantle over a yellow tunic with the deep folds shaded in red. The wings are softly tinted greyish white and tipped with light red. The hair is fair, the eyes dark. The style seems to be English, related rather to the Bohun manuscripts and the St Stephen's frescoes than to the paintings in the Chapter House. The figures are painted over a dull green (?) ground which had been decorated earlier with an all-over pattern of gilt birds, lions, and fleurs de lys. The same motifs on a green ground are seen on the great wooden beam which runs the length of the room.

Two manuscripts belonging to Westminster Abbey, both probably made there in the early 1380s, show Italian influence but no close stylistic analogy to either the Tower or the Chapter House frescoes or to each other. One, a large missal executed[22] for Abbot Nicholas Lytlington in 1383–4, contains many historiated initials and a fine Crucifixion (fol. 157 verso; Plate 158) composed in the crowded, dramatic Italian manner. The figures are tall with ample draperies, some richly patterned, and with faces modelled somewhat in the manner of the Bohun manuscripts (cf. Plate 153A), but with brownish flesh and broad white high-lights. Typical of the faces of the Lytlington Missal are the heavy eyelids and extremely arched eyebrows. There is considerable variety in the gestures and poses of

the figures; one, Stephaton with the sponge, is represented with upturned head seen from behind – the curious, distorted position found in Italian pictures but little understood outside Italy. The background of the Crucifixion is of tooled gold, with an entirely different pattern on the two sides of the cross. Bordering the picture is a wide frame consisting of small miniatures containing scenes from the Passion, and panels of very beautiful strapwork such as is found generally in English decorative work of the period. The marginal decoration consists of hair-line sprays containing gold balls and a few East Anglian motifs such as the daisy and the marigold, and oak and ivy leaves. In the corners are the symbols of the Evangelists, and in two panels at the bottom, the arms and monogram of Nicholas Lytlington. The colours are chiefly two tones of blue, pale vermilion, pink, brown, and tan; green is used for the foregrounds of the scenes. The quality of the painting is very good but the figure style is heavy and uninteresting, though the decorative effect of the page as a whole is exceedingly rich.

At about the same time as the Lytlington Missal, that is, perhaps shortly before or after Richard's marriage in 1382, the manuscript containing the order for the coronation of a king and a queen, the so-called *Liber Regalis*,[23] was made, probably at Westminster Abbey where it still is. The figure style and the technique of the painting in this manuscript (fol. 1 verso; Plate 159) are very different from those of the Lytlington Missal; in some respects the technique is closer to that in the Wilton Diptych (see below).[24] The heads are much more modelled than those in the Lytlington manuscript, with red and white highlights on a greenish flesh tone; foreheads bulge, noses project boldly, eyeballs protrude, and necks are soft and flabby. The eyes roll to one side or the other and the enormous, misshapen hands gesticulate animatedly. The background is of tooled gold, as in the Lytlington Missal and on the Diptych, but the pattern is in flowing arabesques rather than in geometric motifs. The foreground shows a tiled pattern with no attempt at perspective in the rendering of the lines. The colour is extremely beautiful and in this respect also the *Liber Regalis* seems closer to the Wilton Diptych than to the Missal. The use of white as overpainting on the greenish base, heightened and enriched by pink and by soft red, gives an opalesque effect to the flesh and to some of the draperies. The figures are not strongly outlined to set them off from the gold ground, but internal detail of the accessories is sharply drawn in black line, and sometimes gilt paint is applied over the gold for greater richness. The deep ultramarine blue is shaded with white and occasionally cross-hatched. The technique, the figure types, and the colouring all suggest the style of Bohemian illumination of the late fourteenth century,[25] and it seems likely that some artist in the large train of Anne of Bohemia when she came to England painted the miniatures. No other illumination exactly like it is known in England either earlier or at this same time, but the influence of the style is evident in some slightly later English work. The pictures have narrow frames decorated with conventional patterns, but attached to the frame are hair-line sprays containing gold balls and East Anglian daisies as in the Lytlington Missal. This and the decorative text initials are evidence that the *Liber Regalis*, like the Lytlington Missal, was probably made at Westminster.

The Italian-English and Bohemian-English mixtures which determined the styles respectively of the Westminster Missal and the *Liber Regalis* continued to dominate in

varying degrees a number of other illuminated manuscripts produced, apparently, mainly in London during the last decade of the fourteenth century. Some of these were made for Richard II, notably two books of Statutes, datable on internal evidence: Brit. Mus., Cott. MS. Nero D.VI, after 1386,[26] and Camb., St John's Coll., MS. A.7.[27] Another manuscript, *Contra Haereses Lollardorum*, by Dymok (Camb., Trin. Hall, MS. 17) of *c.* 1390 contains Richard's portrait and his arms with the white hart. An interesting *Liber Necromancie* dated after 1391 (Bod. MS. 581) is illuminated in the same style as Nero D.VI. Perhaps the latest of these royal manuscripts in the Italianate-English style is the Charter given to Croyland Abbey by Richard and dated 1393.[27a] It contains a fine initial with his portrait, and rich foliate decoration in gold and colours, possibly by one of the illuminators who worked on the decoration of the Carmelite Missal (Brit. Mus., Add. MSS 29704–5 and 44892, see below).

Of two later fourteenth century Italianate-English productions one has been noted, a psalter made for Eleanor de Bohun, Duchess of Gloucester (d. 1399). The other is a copy of William of Nottingham's *Commentary on the Four Gospels*, dated 1397, containing in a large initial a portrait of Thomas Arundel, Archbishop of Canterbury.[28]

All these manuscripts, however rich and ornate as befitted the patrons for whom they were made, are painted in a rather feeble style which shows little promise of future development either in the figure types or in the heavy but rather monotonous borders and initials. Some of the illumination may have been done in a London shop, possibly that of Thomas Rolfe (see note 22), or in some other, where illuminators had been trained in a similar Italianate-English style. It is important to realize, however, that before and even during the time when the great Carmelite Missal was being made for Whitefriars, London, this English version of the International Style[29] in its first phase was well established.

The second phase of this style in England, as in France, was determined less by direct Italian influence than by that of the Low Countries,[30] and curiously enough as it now appears, on both sides of the Channel this influence emanated not only from the same general milieu but from the same limited area, the duchy of Gelder, and even in part from the same painter family and their associates, namely, the Maelwael family to which the Limburg brothers belonged. The record of the activities and relationships of this family is now known in some detail[31] in so far as the Franco-Flemish artistic phenomenon is concerned. Less fully documented but unmistakably pointing towards similar conclusions as to its origin in this same Gelder region is the revolutionizing influence of the introduction into the uninspired Italianate-English painting style described above, of a new conception of the human figure, of careful facial modelling, and of spatial realization. This is the measure of the importance of the foreign artist's work on the great Carmelite Missal, written and illuminated (at least in large part) between 1393 and 1398.[32]

This manuscript, rightly called 'great' because of both its quality and its size,[33] had an enormous impact in England as a crucial factor of the later International Style *c.* 1400. Unfortunately no facts of its production are known, but internal evidence, both liturgical and pictorial, shows it to have been made unquestionably for the Order of Carmelite friars and almost certainly for their London house.[34] The illumination in the Missal consists of large historiated and decorative initials with rich foliage sprays running in the margins,

to mark the beginning of each mass, and with smaller decorative initials with sprays to introduce each separate part of the mass. The colours are rich and are used on brilliantly burnished gold tooled grounds and with border motifs in gold and colours. The text is written in a fine Gothic hand in two columns, and many pages, therefore, contain illumination in both columns. There is also a wealth of small (one-line) pen-drawn initials with illustrations of the biblical texts, portrait (?) heads, and decorative motifs.

The principal illuminations in the Carmelite Missal are by three artists, easily distinguished by their different styles, though all are contemporary. Thus the manuscript furnishes a veritable compendium of illustrative and ornamental painting in England in the last decade of the fourteenth century. Each of the three styles is almost always confined to a separate gathering and these are distributed throughout the manuscript. Unfortunately the whole 'winter' portion of the *Temporale* (containing the Nativity cycle) is missing, so that it is impossible to know which of the artists began the work. The first surviving miniature, that of Holy Saturday (fol. 6 verso of the reconstructed manuscript), is painted in a style entirely different from any of the typical late fourteenth century manuscripts listed above. It is representative of the foreign style to be found later in the *Temporale* (Dedication of the Church, fol. 68 verso) and in many historiated initials in the *Sanctorale* (see below).

The five other miniatures in the *Temporale* are painted in a beautiful ornamental style but with a curious type of figure representation and iconography, neither of which can be explained wholly by the style of the Bohun manuscripts and their successors (see Plate 166B). The subject of this miniature, which introduces the mass for Corpus Christi, is (above) the Last Supper and (below) the elevation of the Host at the ceremony of the mass, which is being administered by a priest and two Carmelite servers and is attended by two unidentified laymen who may be donors of the Missal. In the corners, outside the initial, are two other Carmelites and two white dogs, possibly in reference to the White Friars.[35]

The doll-like figures swathed in sinuous draperies and the round child-like faces, which are modelled in white and pink, with pale green for the shadows, are almost all alike, although some are bearded and some are not: the foreheads are broad and slightly bulging, the eyebrows are strongly arched, and the mouths droop heavily at the corners. A half-circle of white placed in the corner of the eye socket gives the eye a slightly sly expression – a characteristic also found in the figures of the *Liber Regalis* (Plate 159). In fact, the swirling draperies, the uniform facial types, and the magnificent colouring also are features of the *Liber Regalis*, the style of which (here described as Bohemian) furnishes the closest parallel to the work of this artist in the Missal. The decoration in these miniatures, consisting of a strange multiple-leaf form changing colour in its convolutions and placed, like the initial itself, against a brilliantly burnished, elaborately tooled gold ground, proclaim this artist to be primarily a fine decorator rather than figure painter.

The *Sanctorale* contains a large number of historiated initials by one or more illuminators of the late fourteenth century Italianate-English group (Plate 166A). The initial containing scenes from the life of St Lawrence is characteristic of this illuminator's interest and ability in story-telling. The four upper scenes are episodes in the life of the Saint; the three lower

illustrate the Golden Legend story[36] of incidents relating to the life and death of the Emperor Henry II, together with one illustrating the trial of the Empress Cunigunda by walking on hot ashes to prove her chastity. The hermit in the story (who stopped the devil flying to the deathbed of the Emperor) is a Carmelite!

The figure types and decoration in this initial are very close in style to those in the latest Bohun Psalter (see above); clearly there is nothing new here. This illuminator, like the one who painted the Corpus Christi initial, shows no sign of influence from the third and most important artist of the Missal, whose style is now to be described.

The miniatures chosen to represent typical features of this master's work are reproduced in Plate 167 A and B. A comparison of the two pictures will show that while they were undoubtedly painted by the same hand, the motifs and designs of the decorative sprays attached to them differ: the ornament of the Nativity of the Virgin (Plate 167A) is typically English except for the serrated scroll in the initial letter itself; the Presentation (Plate 167B) has sprays consisting of richly convoluted elongated acanthus leaves combined with delicate hair-line sprays containing tiny gold motifs which are totally unknown heretofore in English manuscript decoration.

The miniature of the Presentation (Plate 167B) uses as setting a hybrid Gothic chapel of which both exterior and interior are shown, together with a vestibule for entry – a type of architecture to be found in Franco-Flemish paintings[37] of this period, but hitherto unknown in English work. Here the interior space is conceived in such a way that nine persons can be grouped about an altar with some empty floor space in the foreground and a dim vaulted room in the background. The front plane of the building, accentuated by the tabernacle-like canopy overhead, seems to extend forwards, and the figures entering the vestibule have room in which to move. The group inside is placed not against the setting but within it. This new depth in space is found also in the Birth of the Virgin (Plate 167A). Here too the exterior and interior and the vestibule of the building are shown and the group of four women with the child, the bed on which Anna lies, and the table with the candlestick occupy the interior space without crowding. In both miniatures the concept is primarily pictorial, not decorative or illustrative only, and the two buildings exist as truly within the framework of the initial as they could in a picture with a frame.

But the most remarkable feature of this artist's representations is the modelling of the faces. Usually the underpainting of the flesh is dark-greyish or brown and the form is built up with high-lights in white, with touches of pink on the cheeks and red on nostrils and lips. Eyebrows are short and dark, not arched but tilted up or down to give expression, and the eyes are enlivened by a white spot which seems to make them shine. The far side of the face is accentuated either by placing it against a dark background or by a heavy dark contour line. There is some foreshortening of the far side of the face, and the far eye is usually lower than the near one. Not only are types distinguished but a certain degree of individualization is shown. The effect of this careful attention to detail is brilliant and charming and there is even a sense of realism[38] which one does not expect to find till decades later. The other two illuminators of the Missal show no signs of being affected by the new style. Among the Dutch artist's miniatures, however, there is evidence of one and perhaps two associates of his who were much less expert than the master and who

may have been learners. The part these learning hands played in the later development of the new style will be discussed subsequently.

Possibly one of these learners, or someone else who was copying closely the style of the Master, painted a large full-page miniature of the Crucifixion (Plate 168) inserted in another missal which (according to a colophon) was presented to the small parish church of Lapworth (in Warwickshire) in 1398. The miniature may actually be a copy of the lost Crucifixion which undoubtedly preceded the Canon of the Mass in the Carmelite manuscript. It is interesting to compare the style of this miniature with that of Plate 167. The technique of modelling the faces is strikingly similar but the effect is much less lively in the Crucifixion. The figures are so weighted down by the deep pockets and elaborate convolutions of the drapery as to make them appear incapable of moving. The proportions of the figure on the cross are wrong: the trunk is too large for the limbs. A similar but much better Crucifixion figure in the lower margin suggests that the Master might have drawn it as a model. The decoration of this miniature is purely English in motifs and designs.

But the Carmelite Missal is only one of two sources of influence which determined the course of the later International Style in England. The second is a single leaf containing a most beautiful miniature of the Annunciation with two donors (Plate 172). The leaf is now bound up with a Book of Hours dating not earlier than the 1430s (Roy. MS. 2 A.xviii) made for Margaret de Beauchamp.[39] There is no evidence whatever as to the circumstances of the production of the Annunciation miniature, but from the fact now established that it formed part of an earlier manuscript, a psalter in Rennes[40] which can be dated before 1415, and also because, with its facing text, it constitutes a double leaf which is blank on the reverse side, it seems possible that it was at first intended rather as a kind of votive diptych than as part of another manuscript. The Annunciation miniature is a superb painting; without the decorative sprays (which were certainly added) it suggests a small panel picture.

The architecture with the kneeling figures outside represents a small votive chapel within which the Annunciation takes place. The *prie-dieu* where the Virgin kneels is covered with a green cloth on which are diagonal bands with alternating scroll patterns and lettering which reads as follows: 'omnia leuia sunt amanti; si quis amat non laborat; de daer.' The baldaquin of the *prie-dieu* and the green and gold patterned backdrop are in fine contrast to the white architecture and the two very beautiful figures of the Virgin and Gabriel. The Virgin is clad in ultramarine blue and the angel in soft shaded pink. Their hair is pale gold with reddish high-lights; the floor is of the same colour slightly shaded with red towards the back to suggest depth. The faces are modelled in white and soft pink on a pale greyish-green flesh tone. The colouring and the quality of the modelling are closer to those of the Wilton Diptych than in any other known English painting; but the technique of the modelling is much softer and less linear, shading from light to dark with gentle gradations. All the faces, including the two kneeling donors, are seen in three-quarter view. The draperies envelop the figures in soft heavy folds, but these are determined by the form and pose of the bodies, with no Gothic play of pattern.

The attribution of the Annunciation miniature is problematic. The presence of the motto on the *prie-dieu* relates it to Herman Scheerre, in two of whose signed miniatures

part of this motto occurs. (See below.) But Herman's style is now well-defined (Plates 169–71) and it is not that of the Annunciation, though certainly closely related to it. The motto on the Annunciation miniature is found in other miniatures, not by Herman but from his atelier.

Many of the characteristics of the Annunciation correspond to those of the Dutch artist in the Carmelite Missal, for example the basic technique of facial modelling with the same use of white on a darker flesh undertone. (Cf. Plate 167.) Moreover, in both, the faces are foreshortened, with the far eye placed lower, an unusual feature of facial modelling at this time. In both styles the draperies tend to bundle up the figures, more gracefully, it is true, in the Annunciation; in both, the gestures are restrained and the mood is one of simplicity without affectation or Gothic elegance. The architecture in the Annunciation shows the same treatment of detail with grey shading on white, though the sense of space in the Presentation miniature, for instance, is more pronounced than in the shallower, niche-like structure of the Annunciation.

The differences suggested above are not fundamental but rather modifications which might result from some new influence on the Dutch master's style as seen in the Missal. This influence could easily have resulted if the artist, on leaving England, had come into contact with the important work which was in progress at the Chartreuse of Champmol at Dijon, especially if he saw the panels painted for it by Broederlam,[41] which were finished in 1399.[42] There is more than an accidental similarity between the architecture in the Broederlam painting and that of the Annunciation. Whoever painted the miniature, whether the Carmelite master or another, must, it seems, have seen and been influenced by the Dijon painting.

Pending further evidence for the attribution of the Annunciation (such as an explanation of the cryptic 'de daer' on the *prie-dieu*) it would seem possible that it represents a later stage of the Dutch Master's activity (but still close to 1400), after he had become acquainted with the Franco-Flemish version of the International Style at Dijon or elsewhere on the Continent. It is perhaps this same influence which results in a certain affinity between the Annunciation and the Wilton Diptych panels which, it now is generally agreed, were painted sometime during 1394–5 (Plates 160–1).

Hardly any other medieval work of art in England is known so well and valued so highly as the Wilton Diptych, yet offers such meagre information about itself. There is no documentary evidence at all as to either its date or the circumstances of its painting, though the literature setting forth theories on these points is voluminous.[43] The painting is in good condition and apparently has been little restored; the frame is original and is carved out of the same oak panels on which the two parts of the diptych are painted. The style of the painting is clear for anyone who wishes to try to attribute it, yet in the course of the years it has been assigned to four or more different countries including England, all apparently with good stylistic reasons.

The panels represent King Richard as a young man or, as some claim, as a boy of eleven, which was his age at the time of his coronation in 1377; with him are his three patron saints, John the Baptist, Edward the Confessor, and Edmund of East Anglia, all three recommending him to the Virgin and Child in the midst of eleven angels on the

opposite panel. The subject at first glance appears simple, but again controversy has arisen and continues to arise as to the interpretation and the occasion of the painting. The root of the difference of opinion as to the attribution of the painting lies in the fact that no other work has yet been found which is really close enough in style to indicate its provenance; one source of the difficulty in assigning a date and interpreting the meaning of the picture is the heraldry, namely, the broom cod collars and the white hart badges worn by Richard and the angels, and, in addition, the white banner bearing a red cross which might equally well, it seems, be the symbol of the resurrection of Christ and the banner of St George.

The size of the Wilton Diptych ($14\frac{1}{2}$ by 21 inches including the frame) and the scale of the paintings suggest that the picture was either a portable altarpiece – but it is a little large for that – or was meant for the altar of a small chapel; it would appear insignificant on the altar of a large church. The scale of the painting also suggests the work of a miniature painter, and the arrangement of the panels like a book bears out this similarity in general idea. The technique, however, is that of panel painting in the Italian manner, tempera on a coating of gesso applied to oak boards.[44] The background of both panels is gold leaf stippled in delicate patterns. Gold is used also as a base for the brocaded robes of Richard and St Edmund; the pattern was produced in the Sienese technique of painting around the motifs, which are stippled. The ground of Richard's robe is red patterned with a white hart lodged within a circle of broom cods and an eagle displayed; the ground of Edmund's robe is deep blue patterned with two long-tailed birds confronted, their necks encircled by a single crown with a star. The Christ Child is partly enveloped in a gold cloth, the folds of which are indicated by stippling; his halo is ornamented with a crown of thorns stippled on the gold and with three radiating pointed forms which have been identified as nails.

The colour scheme is extremely simple. The right panel is almost entirely in two tones of blue shaded and alternated so as to distinguish adjoining figures; the effect is of a shimmering pattern of lights and darks. The angels' wings are incredibly delicately shaded from white, through grey to black at the tips. Their hair is golden yellow painted with a glint on individual hairs and curls. Faces are modelled with thick pigments, white and pink on a greyish green base from which some of the overpainting has flaked off. In the opposite panel, Edward the Confessor is clad in a cream-coloured robe and mantle, shaded delicately in brown; John the Baptist wears a shaggy camel skin mantle tied around the waist with a rope girdle. The surface of the mantle is painted meticulously, each individual hair showing; and the same technique is used in painting the fleece of the lamb. The rocky foreground on this panel is brownish with a dull green clump of trees. The foreground of the right panel is also dull green sprinkled with small growing flowerets and larger, stiffer flower heads, chiefly roses and lilies, arranged rather consciously in all the open spaces.

The panels have never been considered otherwise than as a single composition. But there are discrepancies between the two sides which could, perhaps, be responsible for the disagreement as to the attribution and interpretation of the diptych. For instance, what exactly is the Child represented as doing? And what is the kneeling King doing? Does he hold out his hands to offer himself to the Child and his Mother or to receive something? Certainly not the blessing, for the Child points with the right hand towards the banner

and looks not at Richard but upward. The angels are mainly absorbed in themselves except the two in front on the right who point awkwardly at the Virgin; or does one point to Richard, the other to the Virgin? The very strange angel on the Virgin's right holds her open hand with an impossible gesture towards Richard while looking up at the Virgin.

The unclear mood and purpose of the right panel is not found in the left one. The patron saints are acting in their customary capacity of recommending their royal ward to the favour of whoever was represented in the adjoining panel which might originally not have been the present one.

Such queries about the meaning of the diptych as it is now constituted could be multiplied. But there are other odd features. Why are the gold tooled backgrounds so completely different on the two panels? Why is the colour scheme so different? Why is the foreground of the right panel not treated as in the left panel? And how could the same artist who painted the beautiful hands of Richard have painted also the boneless and nerveless hands of the figures on the right panel?

As a result of these and other observations of details in the two panels hypothesis arises that the diptych was not originally as it appears now; that in fact the panels were not painted at the same time or for the same purpose; that the left panel represents one wing of a votive diptych or perhaps a triptych, of a type common especially in north Italy in the last quarter of the fourteenth century, or more exactly in the 1380s and early 90s. If the left panel was one wing of a triptych, the other might have represented Queen Anne and her patron saints; and in the centre a more frontal composition, perhaps a seated Madonna. If a diptych, a Madonna enthroned as in the Brussels Hours[45] might have been in the right wing. Speculation on this original composition is, of course, pointless. But the fact that the two panels do not match in mood or in colouring or in the rendering of details opens up new possibilities for their attribution.

The antecedents of the left panel are certainly Sienese: the modelling of the faces and of the body of the Baptist are in the Sienese manner as is the technique of the draperies, the pattern being laid on in colour over the gold ground. The delicacy of the vine leaf pattern and the formal treatment of the background are also Sienese. The profile figure, however, seems to be more at home in the North and there may be a mingling of Italian influences in this painting. The right panel, by contrast, is much feebler in drawing and shows a drapery treatment which is strongly Gothic in the softness and richness of its ample folds. The faces are more lightly modelled, the gestures more mannered, and the conventional floral motifs filling up the foreground are typically French of about 1400. In short, the style closest to the right panel, in this writer's opinion, is that of Franco-Flemish painting of c. 1400, incorporating certain Italian features with a strongly Gothic linearity. Conceivably the right panel might have been painted by an artist of the Burgundian court or even, it is not too hard to imagine, by an Englishman immersed in this Continental International Style. There is a certain naïveté about the girlish angels and the intimacy of the scene as a whole which is English rather than French. And the circumstances here suggested as to the reconstitution of the diptych would have been most likely to occur in England, perhaps, though not certainly, in the lifetime of Richard, with what purpose is yet to be explained.

Two additional features of the diptych should be noted in relation to this new sugges-tion. The lack of balance in design between the two panels: one is filled by the figure compositions; the other has empty space above the figures. This is a disturbing feature of the diptych considered as a whole. Moreover, a close study of the gold background of the left panel reveals an unmistakable change in the patterning of the upper part, slightly above the heads of the saints; it is clear that there have been repairs to this ground: the overall leafy design with its balanced emphasis on all the motifs has, in the redoing, been slightly changed so as to give the effect of a medallion design. What could have been the reason for this reworking of the gold ground? The most plausible explanation is that originally there were some decorative architectural features above the figures – an arcade, perhaps, with foiled arches, such as are commonly found in Italian altarpieces of the Trecento. The crowded figures in the new panel, together with the banner, would not leave room for any fancy architecture, which, therefore, had to be removed from the earlier panel: again hypothesis, but some reason there must be for this imbalance between the two panels.

One final detail of the diptych must be noted: the heraldry. In spite of the results of infra-red photography which 'prove'[46] that the badges and broom cod collars were a part of the original design and not added, as formerly suggested, the ones on the angels are slightly different in design and are applied in a different technique; these collars have flaked off badly. If this panel was painted at a different time from the other, the argument as to the addition of the badges has no point. In the heraldry on the reverse of the diptych the beautiful white hart in a landscape on the back of the left panel is painted in the same exquisite manner and in precisely the same form as that of Richard's badge; the royal arms of England and France ancient are on the reverse of the other panel and could have been done by any heraldic painter at any date before c. 1408.

The theory of separate origins, dates, and purposes of the two panels now combined in the diptych has been presented here in some detail with the hope of stimulating fresh interest in the problem of its attribution.[46a]

Although simpler in composition, the more than life-size, full-length portrait of Richard II in full regalia on his throne (Plate 162), now in the nave of Westminster Abbey, is also controversial as to attribution, though 'it is generally agreed that it was executed in England'.[47] The picture has suffered much from restoration and it is questionable whether its present state represents accurately the original painting.[48] Nevertheless, since it seems to be fairly consistent as to drawing, modelling, and details of hands and drapery, it must be judged on its characteristics as they now appear.

It is a magnificent painting. Richard is represented with a short two-pointed beard as on his tomb effigy;[49] but his face in the portrait is rounder, less sharp and drawn than in the effigy. It is the face of a young man but not a boy, evidently older by at least ten years than as he is depicted in the Wilton Diptych. The modelling of the face is softly done, in carefully graded shading from dark to light, not in white lines and cross-hatching as in the Diptych. The hair is bushy and soft, but there is less emphasis on the gleam of single hairs and strands and more depth in the mass. The upper part of the body is very slightly modelled under the mantle; the knees are thrust forward, but in a position which is not entirely convincing. The gown is patterned with a diamond-shaped motif composed of

small conventional leaf forms, interspersed with crowned R's as on his tomb effigy. The folds of the mantle form a rich pattern of intricate curves, accentuated by the contrast of the ermine lining and the dark, soft red material. The throne is elaborate in design but curiously unsubstantial in construction owing to faulty perspective in the foreshortening. There is Gothic richness in the play of line in the drapery, but the modelling of the head is in a technique not generally found in French painting.[50] The hands with their curious tapering, widely separated fingers are reminiscent of those in the much earlier *Liber Regalis*, but certainly in the portrait they are less misshapen and awkward. A comparison of the portrait with the page from the *Liber Regalis* (Plate 159) will show how fundamental are the differences, in technique as in the rendering of the figure. But the Richard portrait does bear some resemblance to certain Bohemian panel paintings,[51] particularly as to the smooth modelling with areas of light and shade and the rich play of the drapery with its broad, deep folds. Even closer, perhaps, is the resemblance of the general style of the portrait to that of North German painting, which was strongly influenced by Bohemian style, as in the work of Meister Bertram.[52] The portrait of Richard shows even less evidence of the style of an English artist than does the Wilton Diptych; its connexions seem rather to be closer with the north of Europe than with either Italy or France.

Whoever the painter was, he has caught (if the painting can be trusted as it appears to-day) something of the tragic character of King Richard – a man young in years and in the lineaments of his face but old in experience, though bitter and sad rather than wise in the acquiring of it. It has been suggested that the painting may have been done to commemorate an occasion in 1390 when the King and Queen in full regalia heard mass in the Abbey on St Edward's Day,[53] but there is no evidence to prove this, though the date may not be far wrong.

Another late fourteenth century panel painting is the Retable lately displayed in the south choir aisle of the Cathedral at Norwich but originally made for the high altar;[54] it was probably given by a group of donors including Bishop Henry Despenser (1370–1406), whose arms are painted on the backs of some of the glass panels imitating enamel, which are inserted at intervals on the outer frame. The Retable consists of five oak panels, each with its own frame, at present thirty-four inches high; the total length is eight feet six inches. The subjects are: in the centre, a Crucifixion; on the left, the Flagellation and Bearing of the Cross; on the right, the Resurrection and Ascension (Plate 157A). The backgrounds are decorated with gilt gesso reliefs, with a running pattern of large vine leaves and tendrils in the centre and end panels, and in the other two, oak leaves and acorns in addition to vine leaves.

The figures are thin with narrow shoulders and large squarish heads. The modelling is somewhat stylized but is painted broadly, not in a linear technique. The eyes are shadowed with brown, and white is used for high-lights on nose, cheek, forehead, and chin. The eyes, many of which are blue, are large and remarkable for their variety of expression; Christ in the Resurrection scene looks straight out of the picture at the spectator, and the heads of the Apostles in the Ascension are tilted upward at different angles while the eyes are variously directed in their upward gaze. Draperies are soft and clinging and give the effect of being wrapped round the figures. The costume and armour are slightly fantastic as

frequently represented in late fourteenth century painting. The colours are soft and shaded: Christ wears a purplish-red mantle lined with greenish blue. Other colours used are bluish green shaded with yellow or darker green, vermilion lightly shaded with madder, and dull blue shaded darker or with white. Many of the figures wear gowns or tunics of gold brocade. The Resurrection scene has a curious architectural structure in the background on which are two eagles displayed, each bearing on a cord around its neck an armorial shield, emblazoned with the symbols of the Passion. Christ wears a crown of thorns; his gold halo is cruciform with a scalloped border; the Apostles and the Virgin in the Ascension also have scalloped gold haloes. Christ in the Resurrection is stepping out from the tomb carrying the Resurrection banner and blessing with his right hand.

Like most work of this period, the style shows Italianate[55] elements in the shading of the draperies and in the figure types and composition. The drapery folds show no Gothic linear patterns. The bold, often brutal types of faces, as the sleeping soldiers in the Resurrection panel, suggest North German sources;[56] nevertheless, the work is almost certainly English, probably influenced by some phase of north European style.

Additional evidence for English workmanship in the Retable is furnished by two panels in almost identical style now incorporated with parts of a much later altarpiece in the church of St Michael-at-Plea, Norwich.[57] Two other small fragments of larger panels in much the same style are now in the Fitzwilliam Museum (Camb., Nos 706, 707; Plate 157B). The Norwich style as represented in all these paintings has no close stylistic relation to either the Westminster portrait of Richard or to the Wilton Diptych, but has some general resemblance to a crowded Crucifixion in the Lee Collection (No. 16) in the Courtauld Gallery. This picture is commonly called East Anglian but the facial types and the over richly patterned, bizarre costumes look more German than English.[58]

In some respects, however, the Norwich paintings show closer affinities with wall paintings in the Chapter House, Westminster, which form part of the Last Judgement composition but are certainly later in date than the principal group (Plate 155A). The heads in the two panels on the right side of the Judgement (Plate 156A) show a similar variety of positions and facial expressions to those in the Norwich Retable; they also have rather similar large, heavy-lidded eyes and squarish heads. But the Chapter House paintings, which are executed directly on the stone masonry, are rougher in technique and therefore not clear and sharp in details. Their date is late fourteenth century and they may be more closely related, in some unexplained manner, to the general style of one of the few English artists of the period whose name is known, the Dominican friar John Siferwas.

For the remainder of the decoration of the Chapter House, which is apparently still later, the subject is an elaborate series of illustrations of the Apocalypse (Plate 156B) in a different style from the Judgement groups and looking perhaps even less English, though many of the panels are now so damaged that it is difficult to see clearly more than single figures in the scenes that remain.[59] The quality does not seem to be very good, and the same types are repeated endlessly and almost without variation. The strong, crude colouring again suggests Low Country or perhaps German influence.[60] The paintings are interesting for the completeness of the subject matter[61] and for its arrangement in an orderly sequence of pictures each with an explanatory text, which is unique in English wall or panel paint-

ings. The Apocalypse series may be dated not later than 1400, but the large Bestiary animals with their names in English, which fill the lower part of the walls, are not earlier than sixteenth century.

More interesting stylistically than the Apocalypse paintings are those on the ceiling of the inner north aisle of the church of St Helen at Abingdon[62] (Berks), dating shortly after 1391. The subject is a Jesse Tree of a unique design: a series of panels 4 feet 9 inches tall and 9 inches wide containing alternately prophets and kings fill the slanting sides of the ceiling and are connected at the bottom of the panels by a running vine scroll. On the last two panels at the east end of the north side is a Crucifixion with the lily between the Virgin Annunciate and Gabriel. The figures are full-length (Plate 163) and are painted in a full range of colours on red ground, and further enriched by the use of gold for crowns and sceptres. At least two different hands can be distinguished (cf. Plate 163, A and B). The prophet and king at the left are drawn in awkward unsubstantial poses and the draperies are designed in rich meaningless convolutions. The hands are clumsy and the eyes under their heavy white lids fail to focus. The figures on the right are not markedly different in type and pose, but they seem to be better realized and more competently painted. It is probably the quality, and perhaps the present condition of the paintings, rather than differences in the style itself, that distinguish them one from another, but even the better ones do not seem to show close relationship to any other contemporary painting.[63]

It is obvious from the mediocre quality of the painting both in the Chapter House paintings and in the Abingdon ceiling, that this is not the medium in which any considerable developments towards a more realistic style in England are to be expected. English medieval painting at its best was never monumental in scale. And so at the turn of the fourteenth century, when greater interest in representation of form and space is everywhere appearing under the stimulus of Italian influence, in England the new elements again find expression in manuscript illumination. The beginnings of this new style are first seen in the Dutch artist's miniatures in the Carmelite Missal, and there is evidence that their influence on other work produced in England was immediately fruitful.[64] A number of different illuminators can be distinguished in manuscripts illustrated and decorated in this new style, but the names of only two are known to us. These are John Siferwas, who was mentioned above in connexion with the style of the Chapter House heads, and Herman Scheerre. Both were fine artists who worked contemporaneously in very different styles, and both seem to have had a considerable number of assistants. The manuscripts illuminated under the direction of these two artists include most of the finest examples produced in England in the later Middle Ages.

The name of Johannes Siferwas is found in two manuscripts datable in the two decades before and after 1400: the large missal made for and almost certainly at the Benedictine Abbey of Sherborne in Dorset between 1396 and 1407;[65] and a Gospel Lectionary executed as a gift to Salisbury Cathedral to the order of John, 5th Lord Lovell of Tichmarsh (d. 1408).

The Sherborne Missal, now in the Library of the Duke of Northumberland at Alnwick Castle,[66] in its present form measures 21 by 15 inches and was originally even larger, as the trimmed margins show. It must, therefore, have approximated the great Carmelite

Missal in size and probably surpassed it in the amount, though certainly not in the quality, of its decoration. The Crucifixion (p. 380; Plate 165) of the Sherborne Missal, which it would have been interesting to compare with the corresponding page, now lost, in the Carmelite Missal, can probably be taken to represent the best work of Siferwas himself, who seems to have done most of the illumination in the earlier part of the book. The latter part is inferior in quality and was probably the work of several assistants.

The composition of the Crucifixion picture is of the dramatic Italian type seen earlier in the Lytlington Missal (cf. Plate 158) but much more crowded with figures, on foot and on horseback, and dressed in rich and somewhat fantastic costumes. The rendering of the figures is exceedingly lively but not correct either in anatomy or in pose and gestures. Even the foreground group of the women and John, who are most carefully painted with respect to draperies and faces, is flattened against a richly patterned carpet in the midst of the rocky landscape foreground, with no understanding of the relation of the figures to the ground or to each other in the group. The background figures are disposed in a similar flat manner against a rising landscape with trees and architecture, and above it in place of sky is a patterned backdrop, in the upper corners of which appear monochrome angels in banks of cloud. But apart from this flat treatment of the composition, individual figures demonstrate considerable interest on the part of the artist in the modelling of the faces. Typical features are the large eyeballs painted solid black in the background figures, but in the nearer ones showing a dark pupil in the lighter iris, and the very heavy eyelids accentuated with white. The modelling of the faces depends for its effect on the use of a strong contrasting contour line of colour on the far side of the face. Foreheads, noses, and chins are touched with white; hair is pale yellowish brown with individual hairs lightened and the under parts of the mass shaded dark to give the effect of depth. The colours are somewhat strong with much use of patterning and of gold ornament, but the filmy veils of the women in the foreground are painted with great delicacy. The miniature is surrounded by a panelled frame shaded to represent wood, containing small figures, in medallions, of the Evangelists and scenes from the Old Testament, and also the Virtues, Peace, and Justice. These small figures are in the same style as the Crucifixion picture, but the minuteness of their scale gives them a vividness and liveliness which do not carry over when the figures are larger. Other pages with historiated initials and marginal borders with scenes and decorative figures including some magnificent naturalistic birds[67] are in the finer technique of the border scenes on the Crucifixion page. It is possible that Siferwas worked better on a small scale, and this theory is borne out by the illuminations in the other signed manuscript, the Lovell Lectionary.

Before leaving the Crucifixion miniature of the Sherborne Missal, a further comparison between the background figures and the group of heads in the Chapter House paintings (Plate 156A) may be suggested. The types of faces and the various positions of the heads, and even the manner of accentuating the features by strong shading, are very close in the styles of the two pictures; in both are the monochrome angels with spread wings. If the Chapter House heads were not painted by Siferwas or from his designs, certainly they were done by someone working in a very similar style. Or it might be that Siferwas himself was influenced by the paintings which unquestionably have certain resemblances to

the Norwich Retable; the fantastic costumes worn by figures in the Sherborne Crucifixion also are related to those of the Norwich Retable. The only conclusion that can be drawn from these analogies is the distinction between this phase of English International style, for Siferwas seems certainly to have been an Englishman,[68] and the phase represented by the influence of the Dutch artist in the Carmelite Missal which will be found in the group of manuscripts illuminated by Herman Scheerre and his associates.

The second manuscript containing Siferwas's name illustrates both his large-scale painting and his miniature style. The Lovell Lectionary (Brit. Mus., Harl. MS. 7026) has lost many of its pages, but retains the full-page dedicatory picture on fol. 4 verso repre-senting Siferwas – his signature, Frater Johannes Siferwas, is at the bottom – presenting his book to his patron Lord Lovell, who is named in the inscription on the scroll at the left of the picture.[69] The faces, which look as though they were meant to be portraits, are painted with exaggerated attention to every detail, but the total effect is far from realistic. The eyes have the same bold protruding eyeballs and heavy lids as in the figures of the Sherborne Crucifixion, and the technique is wholly linear, with the modelling depending on the use of contrasting contours. The beauty of the drawing in Siferwas's style is again seen best in the smaller picture of the Coronation of the Virgin on the cover of the book which is represented in the miniature. Other pages in the Lectionary with miniatures (Plate 164B) and marginal borders and figures show this same fineness and delicacy of workmanship, but all do not seem to be by Siferwas himself, or else some were done with much less meticulous care. The marginal decoration includes very beautifully painted angels, animals, and grotesques in the best English decorative style. The borders, like those of the Sherborne Missal, contain a great many different kinds of motifs some of which seem to come from East Anglian sources while others are very close to the feathery sprays and twisted acanthus scrolls in the borders of the Dutch artist's style in the Carmelite Missal. The colouring of the Lectionary like that of the Sherborne Missal is rich and strong, and heavily shaded; a very fine ultramarine blue is used freely with tooled gold or diapered coloured grounds.

In a style similar to that of Siferwas but by a different artist are some of the miniatures illustrating the text of Marco Polo's *Li Livres du Graunt Caam* dating from *c.* 1400, which was added to an earlier manuscript of the Alexander Romance (Bod. Lib., MS. 264). On the opening page of the Marco Polo is a marvellously detailed panoramic view of Venice (fol. 218),[70] in which many of its well-known features are recognizable, as St Mark's Church with the four bronze horses, the Doge's Palace next to it, and the column with the lion of St Mark on the waterfront. The houses are medieval in their Gothic detail, but nearly all have stepped façades which were more typical of Flanders than of Italy. The shops and the street vendors, the galley ships and the small boats, the groups of well-dressed citizens and, in the lower right-hand corner, the rocky wilderness with lions and panthers, present a fascinating picture of Venice as the artist knew or imagined it at the turn of the fourteenth century.

Among other miniatures in Bod. 264 in the same style as the Venice picture is one (Plate 164A) containing the signature of the artist, written in gold letters across the bottom of the mantle of the Grand Khan: Johannes me fecit. At first thought this might seem to

refer to Johannes Siferwas, but the style of the two artists, while closely related, is not identical (cf. Plates 164A and B). Nor could the miniature be an early work of Siferwas because its date falls within the same years as the two signed Siferwas manuscripts. Johannes was apparently an eclectic painter perhaps of foreign (German or Low Country?) extraction who was first influenced by Siferwas and later by Herman Scheerre (see below). He may have been largely responsible for the best miniatures in a Sarum Hours[71] in Trinity College, Cambridge (MS. B.2.7), and for much of the work in the Hours of Elizabeth the Queen, in connexion with which he will be discussed further.

His early figure style (Plate 164A) is characterized by strongly marked facial features, gesturing hands, and a bizarre Oriental type of dress which, in the Marco Polo, may be explained by the nature of the subject illustrated. The same exaggeration of features and eccentricities of costume seem to have remained with him even later. His colouring is rather strong and often ugly, but there is a certain virility in his representations which animates them.

Out of the mingling of various foreign elements with the Italianate-English style established in the 1380s and 1390s, principally in London, there emerged after 1400 a fairly homogeneous new style. A considerable number of manuscripts are illuminated in this style, and on the grounds that three of them contain the name of Herman (one, his full name, Hermannus Scheerre with the words 'me fecit'), the whole group has been attributed to him and his associates. He may be the 'Herman lymnour' who appears twice in connexion with London wills in 1407.[72] He was active in England at least until 1414 and possibly longer there or on the Continent; his English atelier continued to produce manuscripts in the 'Herman style' long after his own hand is no longer recognizable. From his early association (through the wills) with persons designated as 'of Cologne', it could be inferred that he also may have come from that region, but no trace of his name has been found anywhere as yet.

The development of Herman's style can be traced mainly in relation to two manuscripts already discussed: the Carmelite Missal and the Annunciation in Roy. MS. 2 A.xviii, possibly also by the Dutch master. Two miniatures here attributed to Herman, however, show no sign of influence from either of these works and these may be the earliest examples of his style, which is probably of Continental origin.

These two early miniatures illustrate some medical treatises in a manuscript in Brussels (Bib. Roy., MS. 4862-9) which contains also the Carmelite Calendar compiled in 1386 by Nicholas of Lynn at the request of John of Gaunt, and the Treatise on the Astrolabe composed by Geoffrey Chaucer probably for his son, 'litel lowys', to whom it is addressed. The two illustrations are of the 'blood-letting man' and the 'zodiac man' (Plate 170C). The manuscript could be as early as late fourteenth century, on the evidence both of the Calendar and of the style of decoration on a third page at the beginning of the Astrolabe treatise[72a] (fol. 75). The figure style on fol. 67 (Plate 170C) is characterized by light modelling in brown and flesh tones with high-lights in white. The hair is golden with shading in dull red. The tiny figures of the Zodiac signs show the same delicacy and precision of technique as the main figure. The style is that of a painter rather than a miniaturist, for there are no sharp outlines, and the gentle nuances of shading set the

pictures apart from the brilliant but flat colouring common in contemporary miniatures.

Closest in style to the two Brussels miniatures is the large Crucifixion, now a separate leaf[73] (Plate 169), but certainly painted originally to face the *Te igitur* page in the Canon of some missal. At first glance it might seem to be the missing picture from the Canon of the Carmelite Missal, but its dimensions would hardly be adequate for the great size of this manuscript. Moreover there is no evidence of this style in any of the surviving miniatures in the Carmelite Missal. It is most likely, however, that this miniature (like the Crucifixion in the Lapworth Missal, Plate 168) copies the composition of the Carmelite picture, but in a very different style. If this is true, the Herman Crucifixion also would be an early work, that is, in the last years of the fourteenth century, and this date is supported by the type of decoration which, like that in the Lapworth miniature, is very close to the decorative style of the *Temporale* in the Carmelite Missal, particularly as to the motifs and colouring.

The manner of painting in the Crucifixion is very close to that of the Brussels miniatures. Characteristics common to both are: the modelling of the nude figure, the delicate brown and other pale colours used for the flesh, the pencilled features, the pale gold hair, and above all the painterly technique evident in the absence of strongly defined contours and sharp colours.[74] The dreamy expressions suggest a lyrical mood; the head of the Christ is intensely moving in its deep spirituality. The picture suggests a panel painting framed (except for the arms of the cross) by the decorative border.

This border differs in one important detail from that of the Lapworth Missal, namely in the ribbon and acanthus scrolls twisted around a rod used as filling for the frame, though similar interlaced knots and sprays issuing from them and filling the margin are found in both (cf. Plate 168). The presence of these winding scrolls indicates that Herman was familiar at this time not only with the Carmelite Missal but also with the Annunciation miniature (Plate 172) in the framework of which identical scrolls first appear, to be copied later in many other English manuscripts. The drapery in the Crucifixion, though more consciously patterned in the richness of its convolutions than that of the Annunciation, envelops the figures in a similar manner. However, there is no possible question of confusing the two styles: in the Annunciation the handling of figures and poses is firmer, especially in the technique of modelling the heads. In standing figures of the Crucifixion miniature the far eye is slightly higher and the heads are not foreshortened as are those in the Annunciation. The figures and draperies in the Herman miniature could well be the next stage in their evolution under the influence of the Dutch master whose convincing figure representations can be seen to such great advantage in a variety of miniatures in the Missal. The figures in the Crucifixion are certainly more carefully and skilfully painted than those in the Brussels manuscript, but this could be partly the result of the subject and importance of this particular picture, a consideration which appears always to have affected the quality of Herman's work. What seems clear is that this artist, who had already attained a sensitive style of painting in the Brussels miniatures, did not abandon it under the influence of the great Dutch master's more vigorous style, but profited by its stimulation.

Herman's style shows still stronger signs of development in the direction of influence

from the Annunciation in a number of miniatures representing saints contained in a small book of Hours and other religious texts, now in the Bodleian Library (MS. Lat. liturg. f.2) which can be dated after 1405 and before 1413. The basis for the dating is the representation in one of these miniatures[75] of the beheading of Richard le Scrope, Archbishop of York, which took place in 1405.

Perhaps the most beautiful of these pictures and the one which seems closest in feeling to the Brussels and Crucifixion miniatures is that of St Michael killing the dragon (fol. 143 verso; Plate 171C). The technique of the facial modelling is that of both the earlier miniatures; but here, perhaps, it is even softer and more painterly than formerly. The deepset eyes, the thin cheeks, the soft mass of yellow hair, the delicate tinting on cheek and lips – all can be accounted for in the earlier figures, but the technique has taken on a greater depth of colouring, delicate though it still is, and the modelling has acquired something of the enamel-like surface which results from the application of paint over paint, especially as to the use of white. The mantle in this miniature is fine ultramarine, the feathered leg that protrudes from it is red, the wings are madder pink, as is the background (which is patterned with the same motif in gold as is seen on the back of the Virgin's *prie-dieu* in the Annunciation). Indicative of a Dutch derivation in the border style are the small hair-line sprays with tiny elongated gold motifs usually in groups of three which are found also on many of the sprays attached to initials by the Dutch master in the Carmelite Missal (cf. Plate 167B). Other miniatures by Herman in the Bodleian manuscript are similarly framed with border sprays of this type.

Closest of all to the Annunciation, yet apparently not by the same hand, is the Virgin (of the Immaculate Conception?) on fol. 19 verso; and in the Ascension of Christ, two kneeling donors (fol. 2 verso) reflect the donor figures in the Annunciation. It is these two miniatures in the Bodleian manuscript which have constituted the principal stylistic basis for the attribution of the Annunciation to Herman. But precisely in these figures, close as they are, the differences in style are most clearly apparent. The Bodleian miniature style is lighter in technique, less elegant and exquisite in its modelling, and simpler, more direct, and much more spiritual in feeling. These subtle differences betray both Herman's indebtedness to the earlier master and his independence as an artist. The Bodleian miniatures are the last of his work to be attributed to the early period of his development (as here reconstructed) before the manuscript illuminated mainly by his own hand in which his full name first appears.

Indeed, it seems probable that it was about this time (that is, after 1405) that Herman became known in London as 'Herman lymnour', since in 1407 he witnessed the will of one Peter of Cologne who left all his goods to 'Brother Herman of Cologne, of the Order of Carmelites' (see note 72). This document has interesting implications besides the connexion it suggests with persons from Cologne. One of these was a Carmelite, and of the two early manuscripts attributed to Herman one has a Carmelite text and the other shows familiarity with the Carmelite Missal.

The identification of Herman as an illuminator in London (assuming that he is Herman Scheerre) is significant also because it implies that he was already (in 1407) established there, perhaps with a shop; for the manuscripts associated with him from this time on con-

tain work by one or more other illuminators working with him. The earliest of these manuscripts (judging from its style) is the unpretentious little book of Offices and Prayers (Add. MS. 16998) on fol. 37 of which appears a tiny miniature of St John the Evangelist (Plate 171A) containing the full name of the illuminator: 'Hermannus Scheerre me fecit' following a familiar Latin invocation. Other similar miniatures contain single figures, but some have crowded compositions with as many as six or more figures. A Crucifixion has not only the two thieves but also the Virgin, St John, Nicodemus, and several other figures within a space of less than four square inches. One of the best of these miniatures, in Herman's finest style, is the Vernicle (fol. 88; Plate 171B). Two others contain an Annunciation copying closely the composition in Roy. MS. 2 A. xviii, and a charming Madonna of Humility. Both of these subjects occur again, with variations, in another manuscript, Stowe 16 in the British Museum, almost certainly by Herman. (See below.)

The style, as illustrated in the 'signed' miniature and in the Vernicle (Plate 171A and B), is so similar to that of the manuscripts thus far described that there can be no doubt as to the identity of the hand. The technique is less detailed in the tiny miniatures, but the manner of painting the hair and flesh softly without outlines, together with the gentle mood, the heavy drapery, and the restrained gestures all are characteristic of the style of the early period. The quality of others of these small pictures varies somewhat, but it is difficult to determine whether these variations indicate the normal differences in one artist's work from day to day, or the hand of an assistant working closely under the supervision of the master of a shop.

Additional MS. 16998 is written in two columns, the miniatures filling the width of one. The decoration is very simple, with almost monotonous repetition of a very few trefoil or quatrefoil motifs. On the miniature of the Vernicle (which is the last in the manuscript), two sprays with tiny floweret motifs, pen-drawn with no colour, are attached, which are identical with some found on several pages of Bod. Lat. liturg. f.2 – a small detail adding further proof as to the identity of hands in the two manuscripts.

The small book of Hours (Stowe MS. 16) in which the two miniatures occur (the Annunciation and the Madonna of Humility) which are so similar in style to the signed Herman manuscript, has no signature or other indication, other than stylistic, relating it to Herman; but the attribution seems unquestionable and the date must be close to the signed work, before c. 1410. The illumination in Stowe 16 is unfinished, spaces being left for miniatures when the text was written. Later, some of these were filled, two of the subjects being the Crucifixion and the Vernicle possibly following (at a considerably later date) compositions from the early work of Herman. At any rate, both the two early miniatures (one in a square frame as in Add. MS. 16998) and the type of ornamental borders show that Stowe 16 cannot be far removed from the earlier Herman manuscript.

Two small miniatures illustrating a copy of John Gower's *Confessio Amantis* (Bod. MS. 294, fols 4 verso and 9) must have been painted in this early period.[76] The portraits of the 'lover' kneeling before his confessor (fol. 9) are in Herman's most characteristically sensitive style and very close to the signed miniature in Add. 16998. The composition was copied in a different, more sophisticated style in another manuscript of the same text (Brit. Mus., Eg. MS. 1991; see note 86 below).

The border design in Stowe 16 is a link also between this manuscript and another recently identified Herman manuscript, the wonderfully fine illuminated psalter[77] now in the public library at Rennes (MS. 22). It is one of three Herman manuscripts which can be closely dated *c.* 1410–15, on the basis of internal evidence.[78]

The Rennes Psalter proves to be one of the most important of the whole Herman group, not only because of the richness and beauty of its illumination but because, as now appears, it was this manuscript that originally contained the Annunciation attributed by this writer to the Dutch artist of the Carmelite Missal. Its place among other preliminary miniatures in the Psalter, now likewise bound up with Roy. 2 A. xviii, can be determined on the basis of some fragments of text still in the Rennes Psalter.

In the Psalter itself six out of an original eight historiated initials remain, but one of these is so damaged that its style is unrecognizable. Of the other five, the *Beatus* initial in a full-page border (Plate 173) is almost certainly by Herman. Two other illuminators did two initials each. The first of these is very close to Herman and, in fact, copied his figure of David[79] from the *Beatus*; the other artist may have illuminated another psalter (Roy. 2 B.viii) known as the Psalter of Princess Joan.[80] The decorative borders of the later part of the Rennes Psalter are very close to those in the Bedford Hours (see below), but the style is clearly a development of that in the first part of the manuscript.

The *Beatus* initial (Plate 173) shows the delicate modelling and soft colouring of other Herman works, especially the small miniatures in Add. 16998. Again the quality of Herman's work is evident when compared with another David by his first assistant, which is almost identical in pose and setting but which lacks the fine sensitiveness of the Master.

The decoration of the *Beatus* page, which is the first in the psalter after the Calendar, is in the same style as that of the preliminary miniatures in this manuscript and in Roy. 2 A. xviii. All of these except the Annunciation are painted in a very different, and certainly foreign, style,[81] on separate pieces of vellum pasted on the pages ruled for them opposite the relevant text. The borders which surround these miniatures cover the joins (as also in Roy. 2 A. xviii). The identity of the style and the text hand with those of the Rennes Psalter itself is proof that the miniatures were placed there while the Psalter was in the making.

The Annunciation miniature (Plate 172) also has a border, but the motifs and also the delicacy of the sprays suggest that it was added to this picture slightly earlier than the others, before the Psalter itself was written. Also, the handwriting of the text on the other half of the double leaf on which is the Annunciation differs from that of the Psalter, and there seems little doubt that, all things considered, the conclusion suggested above that it was originally a separate unit, later incorporated into the Rennes Psalter, is correct.

As to the foreign artists (probably at least two in number) of the preliminary pictures, they painted miniatures for several other English manuscripts, notably for Bod. Lat. liturg. f. 2 discussed above as containing similar pages by Herman. The inclusion in two manuscripts associated with Herman of this same foreign style could be significant as pointing towards the source of Herman's style. But thus far no precise localization of the foreign style has appeared though it looks more Dutch than anything else.

Herman's part in the illumination of the Rennes Psalter seems to have been very small:

only one, the first and most important page with the *Beatus* initial. In the second of the three Herman atelier productions, very much the same thing occurs. This is the so-called Chichele Breviary (Lambeth Palace Library, MS. 69) owned by Archbishop Chichele (1413–43) but perhaps not made especially for him since his arms have been added to the first page. The Breviary could, therefore, date even from before 1413; the Calendar indicates that the manuscript was written before 1416.[82]

On folio 1 is an initial (Plate 170B) representing a bishop (archbishop?) receiving a book from one of a group of clerics; across the background is written: 'Si quis amat non laborat q(d) Herman'. This is part of the text which is on the *prie-dieu* of the Annunciation in the Royal manuscript. But the style of the miniature is typically Herman's: the sensitive rendering of the faces which show a remarkable variety of types and expressions; the characteristic pale technique with the use of brown on white for modelling, the soft painterly style without outlines and with pale colours. Tiny as it is (cf. Add. 16998), the detail is meticulously executed, with even more care than in the miniatures of the Additional manuscript. The border style is heavier and lusher, using more types of leaf and flower than the earlier borders, even those in the Rennes Psalter. But one might suppose that by this time the master was not concerned with the decorative work, since similar borders occur on other pages where the miniatures are obviously not by Herman.

At least one assistant's style is recognizable in some of these other initials. It is probably that of one of the 'learner' hands in the Carmelite Missal, the one who painted the Crucifixion in the Lapworth Missal (Plate 168) in or before 1398. Some other initials by a third hand are much closer to Herman's style, but it is impossible to be sure in these cases whether this miniaturist had a part in Herman's 'signed' manuscript or not. This illuminator might be the 'portraitist' of the small initials in the Bedford Psalter (see below).

The border decoration on many pages of the Chichele Breviary shows rich development of such motifs and design as are found in the latter parts of Stowe 16 and the Rennes Psalter, as well as in many parts of the so-called 'big Bible' (Roy. MS. 1 E. ix). This manuscript must have been the most ambitious undertaking of Herman's atelier up to this time. In size it almost equals the Carmelite Missal (which may have inspired its production) and in the amount of its illumination, though not in its fine quality and its beauty, it rivals the Missal. There is not a scrap of evidence now (though many pages show erasures) as to the person or persons for whom the Bible was made. Whoever it was, it was certainly not Richard II, since its date is patently later, probably not earlier than *c.* 1410.[83] Many hands worked both on the miniatures and on the borders. The text is written in two columns and there is decoration not only on almost every one of its pages but in both columns of many pages. The miniatures are in the form of historiated initials, but the picture has been given more importance than the decorative effect of the initial which is treated as a frame for the picture. The prologue to each of the Books of the Bible is introduced by a historiated initial containing the figure of St Jerome. Some of these are very fine; others are obviously derived or copied; a few may have been drawn by a master hand and coloured by an assistant. The text of each Book also is introduced by an historiated initial, containing an illustration of biblical characters or events. The decoration is completed by a great number of (mostly smaller) decorative initials marking the text divisions.

Only the first initial (fol. 2; Plate 170A) can be attributed with any assurance to Herman himself, even without the inscription of his name. The style of this miniature seems closer to that of the Crucifixion (especially as to the draperies) but the composition and even the type of figure used for St Jerome show some influence from the Dutch miniatures in the Carmelite Missal. The kneeling boy also can be matched in the Missal, although the style of both these figures is Herman's and not the Dutch artist's.

Evidence of the stylistic influence of the Missal on the Bible is found on the page following that containing the miniature attributed to Herman (fol. 3 verso; Plate 174A). The figures here are more broadly modelled than Herman's, the colouring is much stronger, and the drapery more voluminous than in Herman's style. This illuminator might be the 'learner' hand who copied the Crucifixion of the Lapworth Missal (Plate 168); he surely is the painter of the second and other subsequent initials in the Chichele Breviary. There are other initials by him in the Bible, as well as by other collaborators some of whom (especially in the later part of the Bible) may be fresh recruits from the Continent: texts in both French and Low German occur on the backgrounds of several of these.[83a] And there is at least one other illuminator who was greatly under Herman's influence. The Baptism (fol. 262 verso; Plate 174B) is very close to Herman's style, but in colouring and a certain feebleness of technique it does not seem quite a work of his own hands. Perhaps he drew this and other miniatures in a similar style and left the painting to others.

All in all, the Bible, unlike the Missal, must have been a melting pot of styles, foreign and native, as developed in the early fifteenth century. In the earlier part of the Bible the different artists' hands are still distinguishable if not always identifiable; but in the later part it becomes much more difficult and in some cases impossible to draw sharp distinctions because of the fusion of stylistic elements. This is the first manuscript in which this can be said to have taken place, and it did so, apparently, under the influence and direction of Herman.

Two of the recognizable collaborators on the Bible produced between them and without Herman the miniatures in the large Psalter[84] now in the National Library at Turin (MS. Cod.I. i.9). It contains the usual *Beatus* and other historiated initials marking the main divisions to the Psalms. The *Beatus* has been too badly damaged by fire to be attributed; but of the other initials one at least, containing the Trinity (Plate 175B), is almost certainly by the same painter as the initial on fol. 3 verso in the Bible (cf. Plate 174A). The figure types and heavy colouring in both miniatures stem from the Missal. Other initials in the Turin Psalter are by one of the 'new foreigners' in the Bible; his figures are flat with heavy features, yellow hair, and individualized expressions, sometimes coarse or comical. He seems to have painted all the initials of the psalter (in the Bible) and to have repeated some of the same ideas and compositions in the Turin Psalter.

It can serve no useful purpose to multiply examples of this borrowing, adapting, and fusing of styles; it is of the very essence of English International Style in manuscript illumination in the early fifteenth century. In its formulation the 'big Bible' played a very important if not the major part.

The *chef-d'œuvre* of the Herman atelier and, apparently, the latest example in which his own hand can be identified is the Bedford Psalter and Hours[85] (Brit. Mus., Add. MS. 42131).

Both in the quantity and in the quality of its illumination this manuscript is the finest that was produced in England in the mature 'New Style'. It dates from after 1414 when John, younger brother of Henry V, was created Duke of Bedford. His arms are incorporated in the original decoration on fol. 73, and his name occurs in line endings in the text itself. The absence of the feasts of Saints Chad, David, and Winifred from the Calendar indicates that the manuscript probably was written before 1416 (see note 82 above).

The illumination in the Bedford Psalter and Hours follows the usual pattern of large historiated initials introducing the principal text divisions, with smaller ones for the less important. An unusual and admirable feature of these smaller initials is the series of more than two hundred and eighty portrait (?) heads contained in them. These are of some variety in style but almost all are of the best workmanship and a few are amazingly fine.[85a] Some of them might be by Herman, but none occur on pages where his name is found in line endings: on fol. 124, 'herman your meke (?) servant'; and on fol. 232 verso, 'I am herman youre owne servant'. Such inscriptions (if, indeed, they really refer to Herman Scheerre, which because of their modest tone and position one might doubt) seem to indicate that Herman was at this time actually under the personal patronage of the Duke. But in any case, the Bedford Hours is quite clearly the product of his atelier.

The miniature which seems closest to Herman's own style is the Annunciation on fol. 7, at the beginning of the Hours (Plate 176). The composition has been derived (but not closely copied) from the Annunciation originally in the Rennes Psalter (cf. Plate 172). The grey stone of the architecture, the red and blue vaulting of the ceiling, the position both of the Virgin and of the Angel with the curling scroll between them, all reflect the earlier miniature. The green tiled floor with red spots is an innovation; but the use of green is much more prevalent in all the miniatures in this manuscript than in earlier ones. The technique of the faces is that of Bod. Lat. liturg. f. 2 (cf. Plate 171c) and, like that, shows influence of the delicate modelling in the Annunciation of Roy. 2 A. xviii. The two heads in the small initial on this page show a different technique (see below) and do not seem to be by Herman.

Four or five artists can be distinguished in the illuminations of the Bedford Hours, among whom there must certainly be some who were associated with Herman in other manuscripts produced in his atelier. But the general characteristics of the English style by this time have largely blurred the distinguishing traits of individual illuminators, as had begun to happen even in the latter part of the Bible. In addition to the new foreign influences introduced there, in the Bedford Hours, Franco-Flemish or perhaps Parisian influence may have affected the style, particularly as to the interest shown in landscape settings and the greater elegance and more stylish figure representations. Except in the series of heads in the small initials, this new sophistication, while adding to the beauty and brilliance of the effect as a whole, detracts somewhat from Herman's sensitive representations, which have now become more formal. This is obvious in a comparison with miniatures in the Carmelite Missal (Plate 167). Even the tiny miniatures in Herman's first signed work are more lively and individualized.

Certainly the most striking feature of the Bedford Psalter and Hours is the series of heads in the small initials which introduce prayers or verses of the Psalms. These are, for

the most part, by artists who painted the large initials, of whom there may have been three in the Hours and as many in the Psalter. The initials by the various hands are not all confined to the quires containing large miniatures by the same hand, though they tend to be more frequent there. Two of the best hands apart from Herman can be distinguished. They are (1) that of a painter, perhaps Johannes, who did the series of miniatures of the Passion, eight small scenes ending with a Christ in Judgement (fols. 12 verso–37); (2) an illuminator closely associated with Herman, perhaps even in Add. 16998, who painted the two heads on fol. 7 which contains also Herman's Annunciation (Plate 176), and the large miniature for the Vigils of the Dead on fol. 46. He almost certainly is also the artist of the portraits of Henry V and Hoccleve in Arundel 38 (Plate 175A). He was, perhaps, more interested in portraiture than was Herman and he may be recognizable in other manuscripts which contain portrait types.[86] The heads painted by this second artist towards the end of the Bedford Psalter develop into some of the finest examples of portrait-type painting known in English manuscripts of the fifteenth century. His technique is firmer and his colouring stronger than Herman's, and he was interested in individualized features and expressions. Although none of his portraits are certainly identifiable, a few strongly suggest specific persons, such as Henry V and Geoffrey Chaucer.

Typical of this portrait style is the miniature in Arundel 38 representing Hoccleve offering his book, *De Regimine Principum*, to the young Prince Henry[87] (Plate 175A). The date must be shortly before 1413, the year of his coronation. The figures are intended to be portraits; certainly they are distinguished in age, in complexion, in features, and even in expression. Henry is richly dressed in an ermine-lined blue gown with fashionable dagged sleeves hanging to the ground. A curious feature of the shading of the folds is the use of a golden yellow pigment which gives the effect of gilding; his girdle and coronet are gold. Hoccleve wears a madder pink gown with very high collar. His face is florid, in contrast to Henry's pale complexion; his hair is dark, Henry's golden brown; his mouth is firm with a bitter droop at the corners, Henry's is straight and thin-lipped.

The closest rival to the Bedford Psalter and Hours is the Hours of 'Elizabeth the Quene',[88] so called from an autograph inscription on fol. 22. This is Elizabeth of York who married Henry VII in 1486. The inscription has no significance, therefore, in dating the manuscript which appears stylistically to be nearly contemporary with the Bedford manuscript (c. 1415–20). It is puzzling to find, in comparing the two manuscripts, that there seems to be little relationship between the styles of the illumination. Like the Bedford book, the Hours of Elizabeth has large miniatures (instead of historiated initials) for the principal divisions of the text and small historiated initials for less important passages. It also has a long series of heads representing types, rather than individualized persons as in the Bedford. The general scheme of the Hours therefore corresponds to that of the Psalter, but there is only one link between them stylistically: the artist of the small Passion miniatures in the Bedford book (who was tentatively identified as Johannes) seems to have painted a similar series of large miniatures in the Elizabeth Hours (Plate 177). In this manuscript he appears to be the principal artist; an assistant working in a quite different style painted the series for the Hours of the Virgin. The two styles are easily distinguishable in most of the pictures but one or two (perhaps by a third hand) seem to have characteristics of both the others.

Johannes (if he is actually the main artist) models his faces strongly; they have large, bulging eyes and rather coarse features with accentuated cheekbones and heavy mouths. The compositions are not well adapted to the space, though background is an important feature, and this, together with strong light and shade, gives the settings a certain feeling of depth and solidity but also a sense of overcrowding and airlessness. The decoration of the frame of the miniature is a curious combination of the bands of rosettes found in early Herman miniatures (as in Bod. Lat. liturg. f.2) and the serrated scroll wrapped round a rod, which first appeared in the Annunciation of Roy. 2 A. xviii. The costumes, especially the headdresses, are often bizarre.

The second artist, who painted the miniatures in the Hours of the Virgin, paints feebler figures, especially the women, who are pale, almost anaemic, with lank yellow hair, high foreheads, and little pointed chins – typical late Gothic Madonna types enveloped in swirling Gothic draperies.

The two main styles suggest various antecedents. The Johannes style can be traced back to the Marco Polo (Bod. MS. 264) in which his name first appears (Plate 164A), but there is a good deal of Siferwas's style in it also, and apparently none of Herman's. Also, there is more than a superficial resemblance (in spite of a different composition) between a Crucifixion in the Hours of Elizabeth and the one in the Lapworth Missal (Plate 168), which suggests the possibility either that Johannes himself may have painted this earlier miniature, as the 'learner' under the Carmelite Missal master, or that, at least, he may have been influenced by that style. Johannes is only questionably identifiable among the Bible artists.

The other illuminator in the Elizabeth Hours is closer to Herman than to anyone else, but far removed from Herman's best collaborator. It is doubtful, though possible, that this artist worked in Herman's atelier.

The best explanation of the anomalous styles of the Hours of Elizabeth the Queen is that both artists were, even in their maturity, mainly eclectics and that their styles did not become fused with the main stream of development in English illumination under the influence of Herman, but retained something of the various borrowings from other styles with which they came in contact.[89]

It is inevitable to compare the Hours of Elizabeth the Queen and the Bedford Psalter as to style and quality. (Cf. Plates 176 and 177.) In the border decoration the two manuscripts show many points of similarity, especially as to the motifs. But the colouring in the Hours is much stronger and the sprays are overloaded in a manner not found in the Bedford decoration, where delicacy and good taste prevail.

But the greatest difference between the two is in the design of the page. In the Bedford Psalter the historiated initial enclosing a picture related in subject to the text combines text, illustration, and ornament in a well-balanced arrangement with no one outstanding feature. The historiated initial is superimposed on a square field on which the picture is painted. The border surrounding the text and the small initials within it also preserve this flatness. All the elements are harmoniously in balance.

In the Hours of Elizabeth the principle of the page design is different. The large rectangular framed picture constitutes the main feature of the page, overbalancing in importance

both the text and the decoration and having no integral relation to either. The picture is inserted into the page; the volume and depth suggested in it break through the flat surface and open up the space behind, as it were, thus destroying the evenness of the surface plane. Even the framework of the border, instead of lying flat on the page, stands away from it to allow the acanthus scroll to encircle it.

Of these two methods of decorating a text page, that of the Bedford Psalter conforms to the basic principles of book illumination, which require that a balance between the writing and illustrating of the text and its decoration be maintained without violating the two-dimensional flatness of the page. The Bedford Psalter, therefore, even apart from the superior quality of the work, takes precedence over the Hours of Elizabeth. Further exploitation of the picture page, with the consequent diminution in the amount of text on it and the introduction of naturalistic border motifs (often so roundly painted as to cast shadows) in the later fifteenth century, will put an end to the art of true manuscript illumination.

The portrait-type heads in the Bedford and Elizabeth Hours are not the only examples of this fine phase of fifteenth century English illumination. In fact, the same artist who painted the best of the Bedford heads may also have painted a very interesting group of almost recognizable people in the miniature which opens a copy of Petrus de Aureolis's *Compendium super Bibliam* (Brit. Mus., Roy. MS. 8 G. iii),[89a] written by Bishop Philip de Repington in 1422 and presented to Lincoln Cathedral. A bishop is shown preaching to a group of male listeners, who are dressed in fashionable costumes. The style is suggestive of the Bedford Hours, but the painting is stronger and brighter in colouring and seems closer to the tradition of the Dutch artist in the Carmelite Missal. This is probably the same artist who painted the miniature of Henry V and Hoccleve in Arundel 38 (cf. Plate 175A).

One more example of portraiture of this period is reproduced from a manuscript of Chaucer's *Troilus and Criseyde* (Camb., Corpus Christi Coll., MS. 61, fol. 1 verso; Plate 178). Chaucer is shown reading to a company of richly and fashionably dressed nobles who sit or stand in various attitudes of attention. Though the facial types and figures of individual listeners are varied, the impression the picture gives is that the artist was more interested in the setting and the panoply of the scene than in the possibilities it offered for portraiture.[90] The style of this miniature is brilliant and highly decorative. The gold tooled background against which a fairy-tale castle is silhouetted, with figures conversing in the open windows and angels fluttering on the topmost turrets, suggests the Calendar pages in the *Très Riches Heures* of the Duc de Berry.[91] The style seems too elegant and sophisticated for typical English work, but the loose sprays of the border decoration with their softly curling shaded leaf and flower motifs can be matched in other English work[92] of about 1400 and will be met again in manuscripts of the next period, which can be assigned to a specific centre, Bury St Edmunds (see below).

The preoccupation of the present chapter with manuscript illumination is neither a matter of chance nor choice, since it was in that medium that the principal developments took place. Panel painting had a much smaller rôle in England, if surviving examples represent the accomplishment of the period. For notable though the Wilton Diptych and the Norwich Retable are, as compared with the manuscripts, they contribute little to the

development of a more realistic painting style. Of stained glass also few examples have survived, and, though good of their kind, they are more interesting for the development of the design of the windows as a whole in relation to their tracery than for individual figures. Following the important innovations in colouring and design of stained-glass windows, which were introduced in the earlier part of the fourteenth century,[93] the later years have little to offer beyond further exploitation of the limited possibilities of composition within the rectangular panels formed by Perpendicular tracery.

Two examples of the best late fourteenth century glass are known to have been made in Oxford, where there is evidence of glass painting even earlier than this. The shop which produced the windows of the antechapel of New College, Oxford, also made and dispatched to Winchester[94] by cart the glass for the great east Jesse Tree window and the side windows of William of Wykeham's other foundation, Winchester College. The master of this shop was Thomas; his portrait with his name was included in one of the panels of the Winchester Jesse. The dates of the New College windows[95] are 1380–6; the Winchester College east window[96] can be dated c. 1393. The side windows in the Chapel were probably inserted not much later, because they were repaired[97] by Master Thomas in 1421–2.

New College as well as Winchester College had a Jesse window, but until recently it was believed to have been lost, having been replaced in the seventeenth century by a new window designed by William Peckitt. The old Jesse Tree window, it is recorded,[98] was given to Peckitt in part payment for his work. Peckitt came originally from York and he sent the old Jesse Tree glass back there; thus, eventually, some panels found their way into one of the windows in the south choir aisle of the Minster. Students of the glass have long been puzzled by the uncanny resemblance of these panels to the remains of the Winchester Jesse window (Plate 180A), but no explanation was forthcoming until a re-examination of the documents yielded this interesting and correct solution of the style of the York panels (Plate 180B). But the Winchester Jesse window had also suffered a disastrous fate. In the early nineteenth century it underwent a drastic 'restoration' which consisted in replacing all the old glass with copies, and – under what circumstances is not known – dispersing the old glass. For a hundred years the Winchester Jesse window was known only in this copy, but recently all the old fragments which could be collected in England were restored to the Chapel and are now placed in a large window in Thurbern's Chantry on the west wall of the College Chapel. The contrast between the rich and harmonious colouring of the old glass and that of its copy in the present east window of the Chapel is at once apparent.

Although the design of the New College Jesse window is not known in detail, the Winchester copy has preserved at least the design of its original. In the centre of the lowest tier was Jesse, the stem issuing from his side; in the centre branches were David, Solomon, the Virgin and Child, and at the top, a strange addition to the traditional design, a Crucifixion with Mary and John. In the two rows of vine-branch panels on either side of the centre were sixteen kings and two prophets; and in the outer panels on each side the remaining ten prophets. From the similarity of the single figures surviving from the New College Jesse window, it is likely that the design followed in general that of Winchester.

The style of the two figure panels is indeed very close (Plate 180, A and B). The short, thickset figures with large heads holding their identifying scrolls and standing within the same sharp-elbowed loops of the vine could have stood side by side in the same window without suggesting any stylistic discrepancy. The features of both figures are painted with the same soft but firm modelling, the hair is treated in the same roughened manner, the drapery is decorated with an almost identical ornamental pattern. The vine leaves and the stiff bunches of grapes, and even the scrollwork of the background are identical in the two panels. Certainly one need not assume that the glass was all painted by the same hand even in the same window; but the similarities in style in these panels indicate unmistakably one workshop, that is, the shop of Master Thomas.

Some of the old glass still remains in the antechapel at New College.[99] The figures which fill the six windows on each of two tiers include prophets and patriarchs, the Apostles and the Church Fathers, three Crucifixions and a group of holy women and penitents, all under elaborate architectural canopies against grounds powdered with the initials of their names. Under each figure is a scroll bearing the name and title. At the bottom of each window is a scroll containing the words: 'Orate pro Willelmo de Wyke-ham episcopo Wynton fundatore istius collegii'.

The figures in the windows of New College antechapel are taller than the Jesse Tree figures and better proportioned, with large heads and ample draperies. The faces are modelled with considerable understanding of features and expressions, and there is some variety in the types.

In Winchester College there were also large figures in the side windows. Three have survived and are now in the Victoria and Albert Museum (Plate 181A). They are similar in style to the Jesse figures but perhaps even more competently modelled as to the faces and, like the New College figures, better proportioned. The drawing of all the figures is extremely good and each figure is individually designed, without any apparent repetition of the same cartoon. The colouring in general is deep, rich, and varied, with a minimum of silver stain used, and that only for borders and ornamental patterns on draperies. The backgrounds are coloured, red and blue, and a considerable amount of white is used in the draperies.

The connexion of William Peckitt with York which resulted in the Oxford glass finding its way there was not the first instance of the possible influence of the Oxford shop on York glass. John Thornton of Coventry, glazier, contracted in 1405 to glaze the great east window of the Minster and to finish the work within three years.[100] Coventry is in the Midlands, not far from Oxford, and it is conjectured from the characteristics of the style in the York glass that John Thornton may have learned his craft from the Oxford glaziers. However that may be, the great east window at York was the first of a large number of fifteenth century windows in the Minster and in the many parish churches of York, which furnish some of the finest and most interesting examples of later English glass.

The design of the York east window (Plate 179) is impressive, as is the scheme of its subject matter. The window, like that of Winchester, is divided into two halves by a gallery. In the upper half, under three equal arches of three lights each, is an elaborate scheme of many-shaped tracery panels; the lower half again is divided by a transom into

two tiers, each of nine elongated panels with cusped heads. The tracery in the heads is Perpendicular, and there is a geometrical uniformity in the panels which is lacking in the flowing lines of Decorated tracery. On the other hand, the long unbroken lights below the tracery lend themselves admirably to a series of uniform panels, each one yard square, in which successive scenes of the Creation and Fall of Man and the Apocalyptic vision of his judgement and redemption unfold themselves with the continuity of a film strip. Above the gallery are twenty-seven scenes from Genesis and Exodus; in the lower half are eighty-one scenes from the Apocalypse and, in the lowest row of all, nine panels with figures of ecclesiastics and kings. Every panel is filled with coloured glass; the effect of the whole, therefore, is much more brilliant than that of the earlier east window at Gloucester.

The tracery panels contain half-length figures, of which the David (Plate 181B) may be compared with the Winchester and New College figures. The type of head is certainly very similar in proportions, in modelling, and in the treatment of the hair and beard. It would appear that the Oxford style of Master Thomas was carried over into York, where it flourished and spread, eventually to the Priory of Great Malvern, during the course of the fifteenth century.

Summary

The English International Style did not herald any Renaissance school of painting such as was in the making on the Continent, nor did it produce any great painters as in the Low Countries. The Wilton Diptych and the Westminster portrait of Richard are anonymous and unique of their kind in England. The 'New Style' in England at the beginning of the fifteenth century is confined to illumination and manifested itself both in the international character of the miniatures and in the rich new border ornament. Of the two illuminators whose names are known, Herman Scheerre was almost certainly a foreigner who brought new elements of style into England, and John Siferwas, who was English, apparently had contacts with Continental work either in England or on the Continent or both, which greatly affected his style. The source of the new miniature style and also of certain elements of the border decoration is identifiable in the work of the Dutch artist of the Carmelite Missal, whose name and specific origins are not known. The influence of his style was so marked, however, that there can be no doubt as to the recognition in England of his outstanding ability and of the new elements which he introduced. The fine crop of richly illuminated manuscripts by a variety of hands bears witness to the stimulus resulting from international artistic contacts on English soil; it also represents the last flowering of the art of illumination in England.

CHAPTER 8

THE END OF THE MIDDLE AGES

★

HISTORICAL BACKGROUND

FOREIGN AND CIVIL WARS

Henry VI, son of Henry V, crowned at Paris 1431; reigned (with regencies) 1422–61 (deposed) and 1470–1; married Margaret of Anjou 1445.

John, uncle of Henry VI, Duke of Bedford 1414–35; Regent of France 1422–35.

Humphrey, uncle of Henry VI, Duke of Gloucester 1414-47; married Jacqueline daughter of William, Count of Holland.

Battle of Castillon ended the Hundred Years War 1453.

Wars of the Roses between the Houses of Lancaster and York 1455–85.

Richard Neville, son-in-law of Richard Beauchamp, Earl of Warwick, 1439; 'Kingmaker' 1461–71.

Edward IV, oldest surviving son of Richard, 3rd Duke of York, King 1461–83; in exile in Flanders 1470–1; married Elizabeth Woodville 1464.

Edward V, son of Edward IV, King April–June 1483.

Richard III, youngest son of Richard, 3rd Duke of York, King 1483–5.

Battle of Bosworth 1485.

Henry VII, great-great-grandson of John of Gaunt, Duke of Lancaster, King 1485–1509; united Houses of Lancaster and York by marrying Elizabeth of York, daughter of Edward IV 1486; his reign marks the transition between the Middle Ages and the Renaissance; his elder son, Prince Arthur, married Catherine of Aragon 1501; died 1502.

★

DURING the last three-quarters of the fifteenth century, English art was markedly affected by two waves of direct Continental influence, both initiated mainly by political events. The first was French, and occurred during the period of the regency of John, Duke of Bedford, uncle of the infant Henry VI (born 1421), who, soon after the death of his father in 1422, fell heir also to the kingdom of France through his mother, daughter of King Charles VI. The English tried to press the claim, and the regency established in Paris was temporarily successful. During this time the Duke took advantage of his opportunities to acquire many treasures from the royal collections, including illuminated manuscripts;[1] he also employed Parisian illuminators to make books for him, such as the magnificent Bedford Missal[2] (Brit. Mus., Add. MS. 18850). French influence in illumination was not limited to work done in France, but French scribes and illuminators also came to England. The results of this French fashion are apparent in English illumination after 1425, in the

more conventionalized types of figures and the formal border decoration. However, by the second quarter of the fifteenth century, French work under Flemish influence had incorporated many features of naturalism in composition, such as landscape and spatial concepts, and the influence of these also is reflected in English work.[2a] A good example of the new mixture of French and English can be seen in the later illumination of the St Omer Psalter, which was finished for Humphrey, Duke of Gloucester (d. 1447), brother of the Duke of Bedford and of Henry V, and a famous bibliophile.

With the defeat and expulsion of the English from France, and the outbreak of the Wars of the Roses at home, the middle years of the century had little time or interest for the ordering or producing of art in England. They are very barren years, indeed, when the Franco-English style of illumination of the earlier part of the century dragged out a poor and on the whole undistinguished existence except for a few fine tinted drawings.

In other media, also, the middle years are lean, and the best representative of English art during this time is glass painting. Parish churches such as those of the dioceses of York and Norwich, chantry chapels such as Fromond's at Winchester and Beauchamp's at Warwick, and the Priory Church of Great Malvern (Worcs.) furnish the greatest amount of material for judging the style and the quality of English glass painting in the second half of the fifteenth century.

From the exile of Edward IV (1470–1), which was spent mostly in Bruges, came the second main stream of Continental influence on English art in the late fifteenth century; for Edward bought and ordered in Bruges manuscripts illuminated and painted in the highly realistic Flemish manner of the developed Northern Renaissance. It seems likely that English illuminators worked side by side with Flemish painters during this time, for there are many late fifteenth century manuscripts with Flemish miniatures and borders in the florid, rather coarse English manner. Certain it is that Flemish painters returned with Edward to England, and much work, both in manuscripts and in panels, and in painted glass[3] bears witness to their activities. If French influence was, on the whole, devitalizing in its effect on English work in the early part of the century – since the charm of English art ever depended on its originality and informality – Flemish realism of the end of the century was disastrous, for the English painter could neither assimilate it nor ignore it. With the advent of Flemish influence, therefore, English medieval painting came to an inglorious end.

The St Omer Psalter (Brit. Mus., Yates Thompson MS. 14), which is illustrated in plate 182A, has been described (see Chapter 6) as being in its earlier parts one of the finest and most typical examples of the mature East Anglian style. The circumstances which interrupted the illumination of the manuscript are not known, but it appears from the book itself that the decoration was only about half finished in the earlier part of the fourteenth century. At what date it came into the hands of Humphrey, Duke of Gloucester, is not known, but it was finished for him in the style of the second quarter of the fifteenth century. Folio 87 contains an historiated initial with the central bar of the letter E eliminated, except for its truncated ends, in order to give the whole space to the picture of David playing the bells. Compared with the fine historiated initials of similar subject matter painted in the thirteenth and fourteenth centuries (cf. Plate 122), there is little to

be said in praise of this curiously stiff, awkward figure seated precariously on a tilted bench in the foreground of a tiled floor, which shows no signs of foreshortening in the tiles or of recession into the background. The bells are hung awkwardly across the top of the initial, and the cramped position of David indicates only too clearly the artist's difficulty in achieving any spatial relationship between them. These problems in spatial composition had, it is true, been common to earlier artists, even in the late fourteenth century; in the miniatures of the Carmelite Missal and its successors, they had by no means been solved according to principles of true perspective. But the St Omer miniature, judging by the decorative style of the border and the technique of shading one colour with another, cannot be much earlier than the 1430s, and should display greater competence in handling space. The style of the figure of David is an odd combination of hard outline and bright colouring intended to suggest modelling. The features are strongly accentuated with dark lines and white high-lights; yet there is no effect of roundness in the contours or of softness in the flesh, and the hands are shapeless. The border which surrounds the text page contains some motifs found earlier in East Anglian manuscripts, as the little round liver- and heart-shaped leaves; but the tendency of the illuminator was not to introduce many small, delicate naturalistic motifs but to increase greatly the size of cabbage-leaf forms developed from or related to the acanthus leaf, and to fill the roundels with them and twine them around the bar of the border in a writhing pattern which is rich and heavy but not beautiful. These coarse flower-leaf forms[4] are painted either in monochrome colours – blue, madder pink, or green – or in these colours striped with lines, most often in yellow or gilt paint on green and on dark or bright red. The sprays are heavy with tendrils ending in green dots. The whole design is overloaded and ugly, and its coarse scale dwarfs the historiated initial. This style is conspicuously out of step with the fine earlier pages of East Anglian work in the same manuscript, particularly where, as on some of the repainted pages like fol. 29 verso, the earlier design shows clearly through the later overpainting.

There is another interesting feature in the decoration of the St Omer Psalter. Folios 152–67 in the latter part of the manuscript have borders which are completely French in style, and other pages before and after these are decorated in an English version of the French style: the French elements are the arrangement of the hair-line sprays in a formal border with even outside edges, and the use of many gold dots, sometimes tricked out with barbs drawn in black ink, and of tiny detached flowerets in pink and blue. The Calendar of the Psalter is decorated in this Franco-English style which is of Duke Humphrey's time.

The Franco-English mixture is documented not only by the elements of the style itself, but by internal evidence in other manuscripts. British Museum, Harl. MS. 4605, was written, according to the colophon, in London by a Frenchman and finished in 1434.[5] It is a copy of Christine de Pisan's *Le Livre des fays d'armes et de chevelrie* and contains at the beginnings of the four books miniatures in this curious, stiff, hybrid style. Folio 3 (Plate 182B), for example, if compared with the many similar portraits of the author found in French and Flemish copies of her books, demonstrates how far below Continental work this falls. The hard flat contour drawing and the feeble, patchy colouring of faces and hands and

the strong ugly shades of pink, green, blue, and fiery red are such as would hardly be found in so unharmonious a combination in French work. At the same time, an English artist of the period, if uninfluenced by French models, probably would have drawn the figures with much greater freedom and coloured them more delicately. Certainly the French-English mixture as illustrated in the St Omer Psalter and the Harleian Christine de Pisan has done the English style of the first quarter of the century no good.

Of different style but of exactly the same date is a most interesting manuscript of the *Metrical Life of St Edmund* by John Lydgate, which was written at Bury St Edmunds, where Lydgate was a monk, in 1433–4 (Brit. Mus., Harl. MS. 2278; Plate 183A). The pictures are framed miniatures, which, except for drawings, have always been infrequent in English illumination. The compositions are still lacking in perspective and show the high horizon characteristic of all late medieval pictures; but the figures themselves are arranged in groups which have some relation to the floor plan, tilted though this is, and it is noteworthy that outside the architectural enclosure, blue sky with floating white clouds can be seen. The figures in these miniatures in some respects remind us of the earlier miniature (Camb., Corpus Christi Coll., MS. 61; Plate 178), which shows characteristics of the Continental International Style,[6] especially in the somewhat bizarre form which this took in Burgundy; and the Lydgate pictures display the same interest in rich and fashionable costumes. The figures are short and stocky without any Gothic elegance, but they are modelled with considerable vigour; the faces are round, the flesh is soft, and the eyes are bright and lively with varied expressions. There are no sharp, hard contour lines visible. The style might be characterized as soft and 'painterly', in contrast to that of David in the St Omer Psalter (Plate 182A). The source of this soft style seems to be found in contemporary Dutch miniatures rather than in French; and it seems to have had some influence on a similar manner of painting figures with soft shadows, which is found in some of the York and Norwich glass of the second third of the fifteenth century.

The miniature reproduced in plate 183A is particularly interesting as depicting the presentation of the book by Lydgate and the monks of Bury to King Henry VI, for whom it was written. Another miniature (fol. 4 verso) commemorates a visit of the King to the shrine of St Edmund at Bury in 1433.

This same soft modelling and interest in the facial types in another technique appears in a copy of the *Desert of Religion*, of unknown provenance (Brit. Mus., Cott. MS. Faust. B.vi, Part 2; Plate 183B). This manuscript also is illustrated with miniatures, without borders, which are remarkable as examples of tinted drawing in a fully modelled technique. The figures, it is true, are often incorrectly drawn as to the proportions of the body, but the heads are magnificent. The bony contours of the cheeks, the well-drawn noses, eyes, and mouths, and most of all, the delicate gradations of shading on the flesh and the shadows on it are remarkably realistic. These characteristics stand out with increased vividness against the plain vellum background. The colours in the miniature are muted: white, soft grey, and mousy brown are the chief tints used on the faces, with only a touch of red wash on the lips and cheeks and of green in the landscape. It is an extraordinary style, like nothing known earlier in England;[7] but the tinted drawing technique itself is one in which the English artist had long been proficient, and in spite of the feeling that

there is Dutch influence in the soft modelling, the work is almost certainly English, since the style appears in other manuscripts of undisputed English provenance a little later in the century. The date of this manuscript would not seem to be earlier than the second quarter of the fifteenth century.

This tinted outline style producing vividly modelled heads may originate in Bury St Edmunds. Another fine miniature which seems to be a developed example of it (Brit. Mus., Harl. MS. 4826, fol. 1; Plate 184) has been inserted as the fly-leaf of a copy on paper of Lydgate's poem, *The Pilgrim*. The miniature shows the author presenting his book to Thomas Montacute, Earl of Salisbury, to whom the poem was dedicated. The figures, which are more competently drawn than in the Cotton Faustina manuscript, have some of the same extraordinary sensitiveness in the delineation of the faces. Almost no colour is used, only faint washes – pink on the cheeks, green in the landscape. The profiles are rounder and less bony in contour than are those of the Faustina manuscript, and the drapery folds are carefully drawn with soft curves and some shading and cross-hatching in pen strokes. The landscape is very simply suggested by a horizon line with trees and a few flowerets in the foreground. The date of the miniature, judging from the armour and the high-cut hair, cannot be much before the middle of the fifteenth century.

The relation of this style, whatever its provenance, to that of the miniatures in a manuscript[8] containing works by Thomas Chaundler (Camb., Trin. Coll., MS. R.14.5) is so close as to suggest that the artist was trained in the same atelier. Chaundler's manuscript can be dated closely, since he speaks of himself as Chancellor of Oxford, a position he held only between 1457 and 1461. The manuscript contains a series of fifteen full-page miniatures illustrating the earlier of the tracts in the book. The presentation picture (fol. 8 verso; Plate 185) shows Chaundler offering the book to Bishop Bekynton, to whom it was dedicated. The technique is tinted outline of very delicate workmanship which, though English, shows more clearly recognizable French or Flemish feeling than does Harl. 4826. The figures are drawn with a firm, sure line and the drapery folds and the shading on the faces are indicated with cross-hatching. Only the palest colour is used on the faces and hands, but the tiled floor is painted red and green and the fringe of the baldaquin and also the framework of the miniature show a little colour. There is more detail in the Chaundler miniatures than in Harl. 4826: the carved ornament of the Bishop's chair, the leaded windows, and the patterned walls and canopy have the crispness and clarity of an engraved line. The drapery is represented with folds that are deeper and more sharply turned at the corners than in Harl. 4826, and suggest sculptured draperies rather than linear surface patterns – a characteristic of French rather than of English drawing. Other miniatures in the Chaundler manuscript are of comparable quality, but the sky in those with landscape backgrounds has been tinted, with spotty blue clouds, and the trees have been painted untidily with green, perhaps by a later hand.

In much the same type of figure style, but certainly by a less skilled hand, are four miniatures, ascribed, without any actual evidence, to Chaundler himself, in another manuscript containing works by him (Oxford, New College, MS. 288). The most interesting of these are three drawings of New College, Winchester, and Wells, of which the first is thought to have been done from observation. The miniatures in both Chaundler

manuscripts represent English drawing style of the mid fifteenth century, under strong Continental influence from French or Franco-Flemish sources. They are to be distinguished from the purely Flemish drawings of the Beauchamp Pageants (see note 12 below) and possibly owe their Continental flavour more to French than to Flemish contacts.

An example of typically English painted style in manuscript illumination, dated[9] 1461 (Plate 186), shows that the earlier French-English mixture of stylistic elements has neither improved in quality nor developed any new features. A missal, now in two parts, made for Abingdon Abbey (Oxford, Bod., MS. Digby 227 and Trin. Coll., MS. 75) contains the usual full-page Crucifixion (fol. 113 verso) preceding the Canon of the Mass, painted in a style which is uninspired in drawing and ugly in colouring. The faces are stolid with solemn, heavy-lidded eyes, and the bodies are unmodelled under the draperies. The flat background is filled up with one thing and another – rays from the haloes, stars, and even old-fashioned arabesque patterns. The subject is really a Trinity, with God the Father above, and the Dove of the Spirit flying downward above the cross. The borders have the even outer edge seen in both of the earlier French-English manuscripts described above; the motifs are large and coarse, and the colouring is strong and ugly. The kneeling donor is probably Abbot William Asshenden (1436–69), whose arms presumably are those on the dexter shield, although, as Millar noted,[9a] they do not seem to be those usually borne by that family. Such donor portraits in religious settings are a common feature of fifteenth century painted glass. In this, the high period of Flemish portraiture, there is not much to be said for the Abingdon Missal. In England these middle years are indeed lean ones for the fine art of painting.

A decade later, in the 1470s, two manuscripts interesting for their new subject matter but using an old technique were almost certainly illustrated by English artists. One of these (Morgan Library, MS. 775), the *Ordinances of Chivalry*,[10] is illustrated with miniatures representing actual combats (fol. 2 verso; Plate 187) in which the knight, Sir John Astley, for whom the manuscript was written, took part. The pictures serve, therefore, as a record of events of which the artist may have been an eye-witness, and they have the authenticity of such a record, though the quality of the illustration is as mediocre as most other English work of the time. The second of the two manuscripts is a roll of arms, the so-called Warwick Roll, now in the College of Arms, London. It was drawn up and probably illustrated by one John Rous.[11] The opening picture in this Warwick Roll shows Rous writing and is usually described as a self-portrait of the author. Although it has the features of an individual, the drawing is rough and amateurish. An earlier and much finer Warwick Roll recently acquired by the British Museum[11a] was written in English by Rous in 1483 or 1484. It contains sixty-four well-drawn portraits by an English artist strongly influenced by Flemish drawing.[12]

Painting and Glass

In panel and wall painting and in painted glass, of which a considerable quantity from the second third of the century has survived in England, Continental influences are not so strong as in the manuscripts. Towards the end of the century, Flemish glass painters

working for Henry VII in King's College Chapel, Cambridge, revolutionized the traditional style of two-dimensional compositions for glass panels. The King's College glass is, therefore, not medieval in style, but Renaissance, as is most of the glass at Fairford.

In the mid fifteenth century, English windows were still made up of irregularly-shaped pieces of pot-metal and silver stained glass, but were no longer designed on the principle of the all-over pattern, or even on that of bands of colour and grisaille as in the first half of the fourteenth century, but to display the figure in clearly defined detail both of facial features, as in portraits, and of dress. The figures were represented either singly or in group compositions, with little if any background, and that little likely to introduce details of interior or exterior architecture or of landscape. Nevertheless, the design in English windows is flat, and there is no evidence of interest on the part of the painter-glazier in vanishing point perspective, correct foreshortening, or representations of three-dimensional form. This was true right through the century, until Flemish glass painting was introduced in the early sixteenth century.

In panel painting a similar situation holds, partly perhaps because fifteenth century panel painting is found principally in the rood screens which, being constructed with elaborate tracery framework, suggest an analogy in general design to the windows. Except for the screens or other panels which are thought to have constituted parts of church furniture, no certainly English panel painting of the later fifteenth century is known. As for wall paintings, the remarkable series in Eton College Chapel executed, according to documentary evidence, at least partly by English artists, presents a unique problem. Apart from these, English wall paintings of the later fifteenth century, though fairly numerous, as far as can be judged never reached a high level of execution. In subject matter, Dooms are repeated endlessly; the most frequently represented single saint is Christopher,[13] whose place opposite the south door of the church had long been established. The Doom regularly occupied the chancel arch, above the rood screen; in a unique instance at Wenhaston (Suffolk)[14] the Doom was painted on wooden boards fastened together and shaped to the chancel arch, and constituted the background for the rood, now lost, which was nailed to the boards.

An orderly presentation of the varied examples of fifteenth century English painting and glass in a stylistic sequence is difficult: the glass, except in a few instances, seems to reflect the styles of local schools, as at York and Norwich. The painted screens, a great number of which are found in East Anglia, although showing some degree of stylistic continuity, have little connexion with the style of the local glass. Nor is there any appreciable chronological development from the earlier to the later part of the century. In the absence of any better basis for grouping these works, therefore, a topographical arrangement has been followed. It is reasonable to begin with East Anglian work, as being greatest in amount, then proceed to London and the Midlands, and finish with York and Great Malvern which are linked stylistically in some unexplained way, though widely separated in distance. The choir stall paintings of Carlisle Cathedral of the end of the fifteenth century belong nowhere in contemporary relationships, but for subject matter and even for many of the compositions hark back to a Durham[15] manuscript of *c.* 1200 and furnish a striking example of the persistent traditional character of English medieval iconography.

Nothing is actually known about the provenance of the two wooden panels now in the Society of Antiquaries, London, painted with four scenes from the Life of St Etheldreda (Plate 188). The panels are now framed together, but could originally have formed doors, as of an aumbry. They are said to have belonged to Ely Cathedral[16] and may be dated c. 1425. The painting is in tempera and perhaps oil, on a gesso ground; the gilded background is decorated with patterns in relief. The subjects of the panels from left to right, beginning at the top, are: the marriage of Etheldreda; the Saint leaving her husband and retiring to a convent; the Saint superintending the building of the church at Ely; and either her interment or her translation. The panels measure 46½ by 21 inches each.

The style of the painting in certain respects is related to that of the Bury manuscript of Lydgate's *Life of St Edmund* (Harl. 2278; Plate 183A). The figures are of much the same proportions, with rounded foreheads and bright eyes. The costumes, with their full, pleated skirts and bands of embroidery, are somewhat like those of the Lydgate, and in some cases have the rather bizarre character which is found in costumes represented in Burgundian art of the period. The poses are oddly unstable and stiff, and the gestures are unnatural. There is a French hardness and precision in the drawing; but the modelling is done with paint as in Dutch miniatures, not with lines, and it would seem that Burgundy might furnish a likely source for the mixture of elements which influenced this style.[16a]

That the style is not foreign to contemporary East Anglian painting is obvious when the St Etheldreda panels are compared with two others containing four saints, which are known to have formed part of a rood screen in the church of St John Maddermarket,[17] Norwich, now in the Victoria and Albert Museum (Nos 23, 24-1894). These panels bear the device and initials of Ralf Segrym, the donor, who was mayor of Norwich in 1451. Thus they are among the earliest examples of this form of English painting and one of the very few screens which can be dated.

The saints in one panel (Plate 189) are Leonard and Agnes (or perhaps Catherine); in the other they are Apollonia and William of Norwich. The panels are of oak, each 3 feet 4 inches high and 2 feet 5½ inches wide. The tracery which would have framed the panels is missing, but the background patterns which filled the cusped heads are still visible.

The style of the figures is to be associated with a group of East Anglian screens distinguished by Constable as belonging to the coastal area and having possible contacts with the Netherlands. The best example of the style of the group is the screen at Hempstead in which, as he points out,[18] typical characteristics of the figures are the small cheeks, protuberant foreheads, and fully modelled drapery, all of which are found in the Maddermarket panels. Moreover, the presence of St Leonard, who also occurs on the Hempstead screen and on only four others, connects the Maddermarket panels with this East Anglian group. The shaded draperies contrast pleasingly with the plain red or green grounds sprinkled with gold motifs, and the screen when complete with its remaining panels and its tracery framework gilded and coloured must have been brilliant.

A rood screen *in situ*, in the church of Barton Turf, dated after 1480 and belonging, according to Constable, to a different group,[19] is illustrated by the two panels (Plate 190) with figures of angels representing two orders of the angelic hierarchy,[20] namely thrones,

holding a throne and scales, and archangels, dressed in armour, holding a mace, and standing within a castle. The backgrounds, of which little is seen behind the spread wings, are alternately red and green, and the costumes are usually complementary to the background. The haloes, feathers, and details of the mantles are gold. The figures are better proportioned and finer in drawing than those on the earlier panels, and this may be due to their later date. There is more careful modelling, especially of the figures and draperies, and more elegance and beauty in the design than in the Maddermarket panels. The rich tracery forms a canopy over the heads of the figures and a base under their feet. The contrast between the painted figures and the delicate carving of the woodwork is very effective.

A still later East Anglian screen of the finest quality is the one in Cawston Church, Norfolk. It consists of eight panels on each side of the chancel doors and contains pairs of apostles and saints. In the four panels of the doors themselves are the four Church Fathers. There are two distinct styles in the figure painting, both illustrated in plate 191. The Apostle Paul on the right is painted in a linear, stylized manner and stands in an awkward pose holding, without actually grasping, his sword and book. The figure is short and has a head too large for the body; there is no modelling of the form under the drapery. The Apostle Philip on the left stands easily in *contrapposto*, his body in profile, his head turned naturally and his gaze fixed on the spectator. The proportions of the head and body are good; the hair and face are softly modelled with gradations of light and shade, as is also the heavy drapery which is flung back over the shoulder. There seems little doubt of Flemish influence in this style, and it would appear that artists trained in two very different manners were working side by side on the same work. The date[21] of the Cawston screen can be ascertained from parish records as between 1490 and 1510.

Of about the same time, that is, just before the end of the fifteenth century, there was painted over the chancel arch in the little church of St Thomas of Canterbury at Salisbury, one of the largest Dooms[22] surviving in England (Plate 193). The exceptionally high space allowed for the inclusion of more detail than was usually introduced into such paintings, and this Doom must originally have been one of the most impressive of many examples of its kind in England.

In the upper part, under the flattened roof, is Christ in Judgement, seated on a rainbow and displaying the wounds, with the Virgin kneeling on his right and St John the Evangelist, holding a book, on his left. Below are the Apostles. On the spectator's left is the Resurrection of the Dead; on his right, Hell. In the lowest corners, left and right, are two saints, Osmund and a pilgrim, probably James the Greater. In the upper corners is an elaborate architectural representation of the Heavenly Jerusalem. The colours of the painting now are dull green, yellow, and red of various shades, with a little blue, as in the mantles of the Virgin and of some of the Apostles. Red is used freely, as usual, in the representation of Hell. The repainted condition of the Doom makes it difficult to determine its original style or to evaluate its quality, but it would appear to be essentially English in its decorative composition, the details being spread loosely over the surface with no attempt to render space except for the more or less formal shading of the architecture. The two large saints in the lower corners of the arch stand in representations of carved

and painted niches which suggest those of painted choir screens, as at Cawston. These figures show some evidence of Flemish influence in their more plastic rendering.

East Anglia in the latter half of the fifteenth century not only produced more and finer painted screens than any other part of England,[23] but it had a distinctive and apparently flourishing school of glass painting with its centre in Norwich.[24] The evidence for an identifiable local school, distinct in style from the glass produced elsewhere in England, rests on the peculiarly individual character of the glass in St Peter Mancroft at Norwich. At East Harling, south-west of Norwich and nearer to Bury St Edmunds, there is a quantity of glass very similar in style and undoubtedly from the same workshop. At Long Melford, south of Bury, in Suffolk, there are also considerable remains of fifteenth century glass, but the style here is both later and somewhat different. The characteristic figure style of the Norwich school suggests a possible Low Country derivation or at any rate foreign influence similar to that noticed already in the Bury manuscripts and in the St Etheldreda panels.

The glass now displayed in the east window of the chancel of St Peter Mancroft[25] at Norwich belongs to three periods, and undoubtedly has been collected there from windows elsewhere in the church which were glazed at different times. The subjects of the panels now in the great east window are the following: scenes from the Life of the Virgin, including both the Nativity Cycle and her later life, in a style which suggests a date of c. 1440; scenes from the life of St Peter, possibly originally in the east window since the church is dedicated to him, in a style of slightly later date, perhaps c. 1450; scenes from the Passion Cycle, and figures of saints and scenes from their lives, dating from c. 1480. Of the three periods, the two earlier ones are most characteristic of the Norwich style. The main features of the style are: well-proportioned figures set in architectural or landscape grounds, rather than against decorative patterned grounds; full, soft, well-rendered draperies; slight modelling of the bodies but great interest in the modelling of the heads, with attention to variety of position and expression. This last feature is especially prominent in the St Peter series. The painter's interest in literal detail in his representations is well illustrated in the Visitation panel (Plate 196A), where Elizabeth wears a maternity gown laced down the front, and carries over her arm a piece of scarlet cloth upon which, according to the legend,[26] she had been working when she heard of the Blessed Virgin's arrival. It is a charming, idyllic scene, full of homely interest rendered in a manner reminiscent of the miniature style in the Bury Lydgate of slightly earlier date.

In the East Harling glass, with some of the same subjects represented similarly but with variations in the style, the architecture shows patterned tiles in the foreground, and in the vaults overhead a peculiar stippling in black which is intended undoubtedly to suggest depth. The heavy draperies and the interest in faces observed in the Norwich glass appear also here. The donor portraits at East Harling[27] (Plate 196B) of the end of the century form a link with those at Long Melford,[28] which are almost all that is left of the large amount of glass formerly filling the Perpendicular windows there. The interest in painting the faces is most noticeable in these portraits, and both at East Harling and at Long Melford there are some splendid examples of portraiture.

At Oxford, where at the end of the fourteenth century Master Thomas and his associates

flourished so greatly under the patronage of William of Wykeham,[29] in the 1440s the art of glass painting was still in full swing. John Glazier is mentioned in connexion with executing the windows of the antechapel of All Souls College.[30] The glass of the four east windows dating from 1441–3 has survived, says Hutchinson, with less alteration than any other glass there. The four windows are designed on a very simple plan, with three lights each divided by a transom into two registers, thus providing panels for six figures each. The subjects are, in the upper rows, the twelve Apostles, and in the lower, twelve figures of holy women (Plate 195) standing on elaborate pedestals with tiled floors, under canopies which are architectural in form and are supported by slender piers. The style is clear-cut and uncomplicated by details, the figures standing out sharply against the red and blue patterned backgrounds; the colours of the saints' garments are counter-changed with those of the background. The style carries over the earlier Oxford tradition of well-proportioned figures, amply draped, and with no complexities of ornament or detail. In the tracery above the top row the lights are filled with angels, the two centre openings having seraphs standing on wheels.

The so-called Royal window,[31] south of the great west window of the antechapel, now contains glass which formerly filled the windows of the old library of All Souls College. Here again the design of the double register is used, but in each light of each register there are two figures instead of one, representing kings. Although many of these have been wholly or partially renewed, the few original figures which remain are of particular interest because of the possibility that they may be the work of the famous Westminster glass-painter, John Prudde.[32] Certainly the glass of the Royal window differs from that of the others in the design of the canopies, in the style of the figures, in the amount of ornamental detail, and in the use of colour and pattern in the backgrounds; but whether or not this is the glass mentioned as the work of Prudde, the king's glazier, no one can say with certainty.

The only known surviving examples of John Prudde's work which are documented are the remains of the magnificent glass windows in the Beauchamp Chapel in the Collegiate Church of St Mary at Warwick. These were provided by the will of Richard Beauchamp,[33] Earl of Warwick (d. 1439), and inserted between 1447 and 1450. The angels with music scrolls in the tracery[34] in the east window and four full-length figures of saints (Plate 194) are original panels still *in situ*; a panel with the donor, now misplaced in the central light, was probably originally elsewhere in this window. The glass, according to the contract,[35] was to be from 'beyond the seas and with no glass of England'; the colours were to be of the finest – blue, yellow, red, purple, crimson, and violet, and 'of white glasse, green glasse, and black glasse, he shall put in as little as shall be needful for the shewing and setting of the matters, images, and stories'. The cartoons for the designs were to be furnished to Prudde by the executors of the will, but these patterns were 'to be newly traced and pictured by another painter in rich colour, at the charges of the said glasier'.[36]

The two saints reproduced in Plate 194 are Thomas of Canterbury and Alban. Both are richly clothed, the one in pontifical robes, the other in white armour edged with gold, and a royal mantle lined with gold-patterned brocade and bordered with jewels. The

Archbishop's vestments are remarkable for the beauty of their ornament: the orphreys of the cope are embroidered with figures of prophets under canopies,[37] and have jewelled borders. These small figures are most beautifully rendered in painted coloured glass, and the jewels are tiny bits of glass set into the larger panels without leading. The backgrounds are red for Thomas and blue for Alban, and the quarries contain the chained bear and the ragged staff which are the armorial devices of the Beauchamps. The colour is indeed rich and brilliant and as little white, green, and black as possible actually is used, as stipulated in the contract. The faces are remarkably well delineated, with delicate line shading on the colourless glass. The fine contours of the faces, the well-proportioned figures, and the elegance and richness of the whole design support John Prudde's reputation as the most famous English glass-painter of his time.[38]

The series of monochrome paintings which occupy the north and south walls of the Chapel at Eton College are the most important remaining examples of fifteenth century wall painting in England. Their dates are known, 1479–80 to 1487–8, and the names of two painters, Gilbert, and William Baker, are mentioned in connexion with the work.[39] The names are English yet the style of the paintings seems to be more Continental than English.

The paintings are in two registers each six feet high separated by a two-foot border; the total length of the panels on each wall is about sixty-seven feet. Each tier is divided into eight panels five feet wide containing figure compositions representing the miracles of the Virgin,[40] separated from each other by single figures of female saints in the lower tiers and, in the upper, prophets standing on brackets under canopies. The technique is grisaille, that is, monochrome painting in tones of black and white on a red lead base which, now exposed in many places, gives the paintings a warm pinkish tinge. The painting is done in oils on a thin coating of gesso. The upper tier has almost entirely disappeared[40a] and the two centre panels of the lower tier on each side are replaced by copies. The lower tier paintings have deteriorated, but of those that remain, it is possible to judge that the style is not uniform and that at least two artists must have painted the pictures; one executing those on the south side, the other, those on the north.

Plate 192 illustrates both styles. The upper picture includes the sixth and part of the seventh panel from the east on the north side, with the single figures of two saints, Etheldreda left, and Elizabeth right. The subjects of the panels are the Miracle of the Candle and the Miracle of the Woman who took the image of the Christ Child from the Madonna as hostage for her captive son.

Plate 192B represents the second panel from the west on the south side, the Miracle of the Empress who healed the knight's brother, and the single figure of Dorothy with her basket of flowers on the pedestal at the left.

The styles in these two panels are strikingly different. The north side paintings are composed with a strong feeling for space in the composition: an empty foreground except for the saints in niches, and a middle ground with figures in an architectural setting which is so planned and executed as to set the background far back in shadow. On the back wall are windows cut off at the top by the arch, through which tiny figures may be seen outside. The groups are arranged on a diagonal leading into the far corner of the room.

The single figures stand on brackets which are represented as though seen from below, thus concealing the feet from the eye of the spectator; the canopies of the niches extend forward to correspond to the projection of the bracket, and the figure overlaps the colonnettes which flank the niche. The niche is thrown further into the background by deep shadows on one side. The spatial rendering is admirable – in the Flemish manner, depending upon the diagonal line of recession and the skilful placing of strong shadows and highlights. The figures are modelled, with draperies of heavy material arranged in rich patterns of deep folds, dark in the shadows, and white on the edges where the light catches them. The arrangement of the draperies of the kneeling woman in the Miracle of the Candle is strongly suggestive of similar figures in the paintings of Rogier van der Weyden, particularly those in grisaille representing carved figures. The composition, the poses, the setting, and the delicate modelling of faces and head-dresses are all those of Flemish painting of the second half of the fifteenth century, and it seems impossible that any artist but a Fleming could have shown himself so consummate a master in this technique.

The setting of the paintings on the south side is designed on the same scheme, with the panels set back by the architectural brackets and niches. But what a difference in the depth of the spatial rendering! The niche itself has no depth but is decorated with linear mouldings, ornamental colonnette capitals, and crocketed ogee-shaped gables with foliate finials – all in the best Tudor Gothic manner. The painting has suffered much damage and the background detail has almost disappeared, but it is evident from what remains that no such devices for representing depth in the setting have been used as in the other style. Although the figures are arranged on a shallow diagonal with the Empress at the point nearest the spectator in the exact centre of the group, there is no feeling that the other figures extend back into space. The poses are stiffer and more mannered than those on the other wall, the folds of the draperies are flatter and shallower, more superficially complex and less realistic in texture. The faces, however, are carefully rendered with attention to the differentiation of types, as the two lepers at the left who are distinguished from the healthy people at the right.

The technique of the two styles is very similar in the handling of the soft, muted tones of the grisaille, and the panels on opposite sides of the chapel, therefore, match reasonably well. It has been suggested that the drawing may be the work of a single artist, the master, but the styles seem too far removed from each other for this to be true. It is more likely that a Fleming and an Englishman competent in Flemish technique were responsible for the two styles. It may be assumed that the Englishman was the William Baker mentioned in the documents.

The similarity of the Eton College paintings to a series of wall paintings in the same technique in the Lady Chapel at Winchester Cathedral was pointed out by James,[41] who described the Winchester paintings as 'inspired' by the Eton pictures but not slavish copies of them. In style, the Winchester paintings are much closer to the Flemish master than to his presumed English collaborator.

The stained and painted glass of the later Middle Ages tells a similar story of English style, which was first influenced and finally superseded by Flemish work. The great St William window in the north choir transept of York Cathedral,[42] which can be

dated *c.* 1421, might belong in point of time to the preceding chapter; but the stylistic connexion between some of the figures in this window and those in the earliest windows at Great Malvern Priory Church makes the York window more suitable for discussion in relation to the latter part of the century. It seems likely that the glazing of the St William window, like that of the great east window of the York Minster choir, was supervised by John Thornton, who in 1410 was admitted a freeman in York and presumably established his shop there. Knowles[43] distinguishes four different styles of painting the faces, and conjectures that the enormous work was parcelled out to 'sub-contractors' in their own shops, possibly using cartoons furnished by the central shop run by John Thornton. Though it is difficult to see any striking connexion between the styles of the St William glass and that of the great east window, there is a general continuity between the work of Thornton and the later York windows (Plate 197).

The St William window is divided into four sections by three transoms; three of the sections consist of twenty-five panels each, and one of thirty, all with scenes from the life, translation, and miracles of the Saint. Across the bottom of the window are panels containing donors, members of the Ros family. There is some discrepancy in the sizes of the division of the window by the transoms, and Knowles offers the hypothesis that the St William window originally consisted of two separate windows, each of fifty panels, one in the north, and the other in the south choir transept, one containing scenes from the life, the other scenes from the miracles of St William. The incorporation of the two windows into one, he further suggests,[44] may have occurred when the St Cuthbert window, now in the south choir transept, was given about 1440. The windows now measure approximately the same in height, about 75 feet, and have a similar composition in panels, though the St Cuthbert style seems to be unrelated and is far inferior to that of the earlier St William window.

The style of the figures in some of the panels is extraordinarily fine (Plate 197A). The head in the detail of the Miracle of St William is well proportioned, the hair and beard are painted in a soft mass, the eyes are carefully delineated as to eyeballs and lids, the nostrils and lips are rounded. The heads are better than the bodies, the hands and feet in particular being clumsily drawn. Only details necessary for the representation of the scene are included, as the utensils on the bedside stand; the background behind the bed and the furnishings is decorated with an arabesque pattern of acanthus foliage; this is alternately blue and red in successive panels.

The three lights in the east window at All Saints, North Street, York,[45] are some twenty to twenty-five years later than the St William window, and the figure painting is much broader and less linear. St Christopher from one of the upper panels (Plate 197B) has a large, modelled head with soft, bushy hair and beard similar in type to the figure from the St William window. In spite of the difference in date and the better drawing in the St Christopher, there is considerable similarity to the St William. This is probably due not to any likelihood that the same craftsmen worked on the two windows, but that the figure tradition established by John Thornton in the east window of York Minster, either by means of cartoons or by a continuity in shopwork style, was carried over into other York glass. The coloured background with the running acanthus pattern is very close

to that in the St William panels, and the elaborate buttresses, which are also present in the St William glass, dividing one panel from the other, are retained in the All Saints windows. But the feature of niches sheltering small figures of prophets of the same large-headed type as the principal figures is an innovation. The background of the Christopher panel is red; the Saint and the Christ Child both are clothed in white, patterned and bordered with gold. The colouring is not rich, but the contrast between figures and background gives to the painted figures some plasticity as in the panels of rood screens.

The other two lights of the east window of All Saints Church contain figures of St Anne teaching the Virgin, in the centre, against a blue ground, and John the Baptist, in the north light, wearing a gold-coloured camel's hair garment and a blue mantle, against a red ground corresponding to that of Christopher on the south side. All three lights have undergone considerable restoration, especially in the tracery and in the donor portraits in the lower parts of the window.

The stylistic connexion between the St William window and other windows in York churches can be explained more easily than can the relation between these and the style of the earlier windows in the Priory Church at Great Malvern, which has often been noticed but never accounted for. It may be merely the influence of the important York school of glass painting that reached as far afield as Malvern; but some unknown, more specific basis for a stylistic connexion between these two places seems likely.

The windows in the Priory Church at Great Malvern are in themselves an extraordinary phenomenon, not only because so much of the original glass has survived, though much moved about, but because of the fact that the glass represents more than half a century of uninterrupted development in style. The chronology of the original windows, as given by Rushforth,[46] is as follows:

> Choir: east window and the adjacent clerestory windows, north side, with scenes from the Incarnation and the Passion, c. 1430–40 (Plate 198); remaining clerestory windows, c. 1460–70 (Plate 199).
> Nave, originally the south clerestory, the north aisle, the west window, 1480–90.
> North transept, north window, Magnificat window, 1501 (Plate 200).

Except in the choir, the greater part of the windows were inserted within the period when Richard Dene was Prior of Malvern (1457–91), and Rushforth suggests[47] that the scheme of the nave windows may be due to him, and that, since they have characteristics in common, they may represent work contracted for with a firm of glaziers. The subject of the nave windows was a concordance of Old and New Testament scenes.[48]

The finest glass in the church is found in the choir and in the Magnificat window of the north transept.

The east window originally contained twenty-four scenes from the Passion cycle, ending with Pentecost, besides the twelve Apostles, saints, and other subjects in the tracery lights. Many of the scenes are lost, badly damaged, or entirely reconstructed, but one of the few best preserved is the Last Supper (Plate 198), which shows in comparison with the detail from the St William window (Plate 197A) unmistakable similarities in the style of the figure painting: the meticulous painting of the eyes, especially the eyeballs,

the modelling of nose and lips, and the soft mass of hair and beard. The background has the same acanthus scroll pattern against a strongly coloured ground. But there are similarities also with the St Christopher in All Saints, York: the curving line at the corner of the eye, the oddly conventionalized drawing of the ear, and the richly patterned materials of the garments. The corkscrew curls of John in the Last Supper at Malvern resemble those of the Christ Child in the St Christopher panel, and the barred pattern of the table-cloth is like, though not identical with, that of the Christ Child's gown. The drapery technique seems to fall between the linear treatment of the St William window and the shaded technique of the All Saints panels, but is perhaps closer to the latter. On the grounds of these stylistic features, the date 1430–40 is very acceptable, and if Rushforth is correct in recognizing the arms of Beauchamp and Despenser, this date would be further supported, for Richard Beauchamp, Earl of Warwick, and Isabella Despenser his wife both died in 1439, and the window may have commemorated them.[49]

Of the surviving clerestory windows in the choir, the most interesting is the so-called Founders' window of c. 1460–70, containing, under canopies, figures of the founders of the Priory. Plate 199 reproduces a panel with St Wulfstan, the last of the Saxon Bishops of Worcester, blessing Aldwin who holds a document bearing the great seal of the Priory. The style is clearly related to that of the east window but is less modelled and more linear in the contours and features of the heads and in the folds of the drapery. The figure is drawn on a larger scale, as is usual in clerestory windows, and the glass in these panels is better preserved than any other glass in the church.

The windows of latest date at Malvern are those of the north transept, of which the north window was glazed to commemorate the marriage of Prince Arthur, eldest son of Henry VII, to Catherine of Aragon in November 1501. The window still retains the kneeling figures of Arthur (Plate 200), his father, and three of the four knights originally there, with an inscription which asks for prayers for their 'good estate'. The window must have been made, therefore, before the death of Arthur in April 1502. It is called the Magnificat window from its subject, the Joys of Our Lady, which illustrate the verses of the Magnificat hymn in separate scenes in the main part of the window. The portrait of Prince Arthur reproduced in Plate 200 shows him in a coat of his blazon over armour, and wearing a coronet. He is kneeling before a *prie-dieu* on which is an open book, in a richly canopied recess. A choir of angels playing musical instruments surrounds the canopy. It is to be noted that they are not of the feathered type familiar in East Anglian art throughout the fifteenth century, but young women with curly hair and dressed in long white gowns.

The style of the glass in this window is not only later but different from that in the other windows. The figures are better modelled, the colours richer and deeper in tone, and the drawing is more careful, especially as to the modelling of the faces. The Magnificat window may be the work of the king's glazier at Westminster.

With the later windows at Malvern Priory the story of English style in glass painting comes to an end. The differences between the earlier and the later Malvern windows probably can be accounted for by the influence of the more plastic Flemish style of Bruges which, it has been pointed out, was introduced in the manuscripts and paintings of the

time of Edward IV.[50] Two other rich collections of stained glass, however, may be noted as an impressive postscript to the story of English medieval painting because of the rôle they play in marking the transition from late medieval style to that of the Renaissance in England. This glass is found in the parish church at Fairford (Glos.) and in the chapel of King's College, Cambridge.

The Fairford glass[51] is the earlier and dates from 1495 to 1505. There are twenty-eight windows in all, comprising a well-defined scheme of subject matter based, in general, on the Apostles' Creed. It begins in the first window west of the screen separating the Lady Chapel in the north choir aisle from the north aisle of the nave; the subjects of this first window are four Old Testament incidents representing types of the Incarnation of Our Lord: Eve Tempted in the Garden, Moses and the Burning Bush, Gideon and the Golden Fleece, and the Judgement of Solomon. In the Lady Chapel itself begins the series of events in the early life of the Virgin and of Christ, followed, in the great east window of the choir, by the Crucifixion and other scenes from the Passion Cycle. In the south choir aisle are the Appearances of Christ after the Resurrection, and the Ascension and Pentecost. The aisle windows contain the witnesses to the Faith – the Apostles on the south each with that text from the Creed which was traditionally attributed to him, and on the north, twelve prophets. The three west windows are filled with three Judgement pictures: the Judgement of Justice as represented by David and the Amalekite; the Last Judgement; and the Judgement of Truth or Mercy represented by the Judgement of Solomon. In the clerestory windows are figures of martyrs on the south side facing figures of persecutors of the Faith on the north. The scheme is not new, but the completeness and the systematic arrangement correspond to the popular late medieval literary compilations of similar material, such as the so-called *Biblia Pauperum*, or Poor Man's Bible.

The designs of the windows are of two types: single figures or, in a few instances, single scenes placed one to a window light under canopies of late Gothic Perpendicular design, such as were common in earlier English windows; and elaborate scenes without canopies spreading over two or more lights or even over the whole of the window. Of the canopy type of design the Old Testament scenes in the first window outside the Lady Chapel are striking examples. In spite of the canopies, which look incongruous in relation to the pictorial scenes beneath them, especially the first three which take place in a landscape setting, the compositions are rendered more freely and with more naturalistic detail than has been seen in any previous English work. The single figures in the aisle and clerestory lights also have taken on much more plasticity in the modelling and in the drapery, and stand with the heavy monumentality of Flemish figures.

More strikingly foreign to English style are the pictorial compositions which have no architectural canopies but spread freely over the window surface as though it were a canvas or a wall. Such are the two corresponding east windows in the Lady Chapel and in the Chapel of Corpus Christi, on the north and south sides of the choir respectively. In each case the central light contains the principal scene, the Assumption of the Virgin and the Transfiguration of Christ, while the two lights on each side are paired to receive a single scene with either a landscape background (as in the Flight into Egypt) or an architectural interior (as in the scene of Christ among the Doctors). The pictorial elements

in both scenes are rendered without regard to the divisions of the window and with an attention to detail in costume and setting which is strikingly different from the more formal compositions characteristic of Gothic window design. The figures also, dressed in rich materials cut in contemporary fashions, have a plasticity, indicated by heavy shading, and a bulk and solidity which are not found in English glass painting even of the late Middle Ages. Certainly the dominating style of the Fairford windows is not English but Flemish, though the survival of the older canopied designs with single figures would suggest that English glaziers might also to some extent have assisted in the work.

The glass that formerly filled the windows in Henry VII's Chapel at Westminster Abbey may have been similar to that at Fairford,[52] but unfortunately none of it has survived. The splendid array of windows in the nearly contemporary chapel at King's College, Cambridge, however, offers a connecting link between the Flemish pictorial style without Renaissance detail, as found at Fairford, and the full-fledged Renaissance style with a whole new crop of decorative motifs, which is known to have been produced at least in part by Low-Country artists.[53] On the ground of ample documentary evidence the glass in the King's College Chapel can be dated between 1515 and 1531.

As in the windows at Fairford and probably also in those formerly in Henry VII's Chapel at Westminster, the subjects of the King's College Chapel glass[54] also constitute a cycle: according to the contract of 1526 apparently, as Harrison suggests,[55] echoing an earlier contract, they were to represent 'the story of the olde lawe and of the newe lawe', that is, scenes from the Old Testament chosen for their significance in connexion with scenes from the New Testament, or the long-familiar theme of a concordance. The relationship of the paired scenes, one to the other, is indicated by 'messenger' figures bearing scrolls with texts.

The King's College Chapel windows can be divided into two main chronological groups: four earlier windows executed by the Netherlander Barnard Flower and his assistants between 1515 and 1517; and a later group of twenty-one, including the east window but not the west, executed between 1526 and 1531. Names of a number of glaziers working on the later group are known:[56] Galyon Hone, John Nicholson, and Francis Williamson ('Willem Zoen') were Netherlanders or Flemings, and Symond Symondes, who was associated with Williamson, was probably English.

All the windows in the King's College Chapel have marked Renaissance characteristics both in style and in motifs, including a wealth of decorative detail. The chief differences between the earlier style of the Flower school and that of the successive later glaziers are in the nature and amount of this detail, and in the heaviness or delicacy of the painting itself; there are also certain individual characteristics of the styles which do not concern this present survey. However, the importance of the King's College Chapel glass as a whole for an understanding of the early stages and the spread of Renaissance influence in England cannot be overlooked.

Summary

In the fifteenth century English pictorial art was wholly at the receiving end of Continental influences; Europe was too intoxicated with the exploitation of its newly found stylistic expression to be aware of the sporadic and, for the most part, mediocre phenomena which registered superficially the influence of the new trends in England. The interesting thing is that this influence, which appeared during the century in all the arts – illumination, wall and panel painting, and stained glass – came primarily, as we have seen, from the Low Countries. This can be explained partly by the political and economic relations between England and Flanders during this period, and partly by a kinship of artistic temperament and tradition which had been apparent even throughout the Middle Ages and which greatly facilitated the transfer of Flemish style with its new Renaissance elements to England. These elements, which are manifest chiefly in the greater interest in observed detail and in concepts of spatial and atmospheric reality, had been stimulated previously in Flanders by influence from Italian painting in the late fourteenth century and during the fifteenth had flowered brilliantly in the so-called Northern Renaissance in Flanders and Holland. The interest in realistically rendered detail and its organization in an essentially decorative compositional scheme was the particular phase of the new style which the English artist could understand best. The curious fact is, however, that though accepting the new style with enthusiasm, he did not (perhaps could not) reconcile its modelled technique with his own fundamentally linear tradition. The arts of illumination and glass painting – both essentially linear in their best phases and both, but especially the former, the English artist's *forte* – fell foul of the new realistic tendencies typical of Flemish miniatures in the early sixteenth century, which were no longer flat, as decorations of a text page should be, but opened up the page by inserting behind the border framework a picture conceived as a view through a window.[57] Similarly in stained glass, the flat design most suitable for the diffusion of light gave way to the figure composition in a spatial setting. With this concept of deep space the medieval English artist was not in sympathy, and when Flemish work of this type began to flood the market, the English illuminator and glass painter, being unwilling or unable to conform, could only retire from the scene. When next a vigorous painting style emerged in Britain, in the second third of the sixteenth century, two decisive factors had appeared to turn it into other channels: Hans Holbein had come to the court of Henry VIII, and the Reformation had swept away, almost overnight, a great part not only of existing medieval art but of the traditional subject matter upon which it had so richly drawn. Thus with the influx of the High Renaissance into England came new styles of painting and new subject matter which was mainly portraiture and themes taken from classical mythology. The story of this later phase of English art is told elsewhere.

EVALUATION

AT the conclusion of this survey of medieval painting in Britain it may be well to look back over the ground it has covered and attempt to summarize and evaluate the accomplishments of English artists in more than eight centuries.

The fact that stands out most clearly, perhaps, from the array of examples which form the basis of the survey is the predominance of illuminated manuscripts in the ratio of almost three to one over other forms of painting as illustrated in the plates. This proportion, astonishing as it may be, is essentially correct, in so far as our present knowledge of English painting in the Middle Ages is concerned. The reasons for this are not far to seek. Manuscripts are portable and in time of danger or disaster can easily be transported to places of safety, where painting *in situ* must remain to face the vicissitudes of time and fortune. Moreover, manuscripts of good quality (that is, primarily, those decorated with gold leaf and fine colours) were normally considered by their owners as part of their treasure, not shelved in their libraries. Apparently, not even fine liturgical books were used commonly, but were brought out only for special occasions. These circumstances have resulted in the survival in almost perfect condition of a large body of material which, in lieu of other forms of painting where these have perished, or supplemented by them in whatever state they have survived, furnish the main body of evidence upon which our knowledge of medieval painting depends.

In the case of English medieval painting, the manuscripts are of peculiar importance; for, as must have become evident from the survey of its monuments, the fundamental characteristics of English pictorial art in all its forms are not those of painting but of outline drawing, and the technique of manuscript illumination at its best is linear. English drawing, it is true, in its developed stages makes use of colour even for purposes of shading or for filling in whole areas of a composition. But this is not the technique of true painting, which is rather the application of pigments of different tones to build up surfaces so that eventually the original drawing is partially or wholly obscured. The English technique of coloured outline, whether delicately shaded or evenly washed over with flat or shaded tones, seldom loses sight of the contour line; it is this fundamental characteristic which makes it possible to judge the style of painting in other forms by that of manuscripts; for in what has survived of wall and panel painting and of stained glass and embroidery, a similar technique is almost invariably used. We can assume, therefore, even without a comparable number of examples of the other arts, that the linear character of manuscript illumination determined their style. There is ample evidence for this assumption within the pages of this book.

Nevertheless, in the course of tracing stylistic developments throughout the Middle Ages, the term 'monumental' has frequently been applied to certain types of figure painting, as, for instance, the Winchester Bible, and even more aptly, the early glass represented

by the Methuselah figure at Canterbury (Plate 95), and this term must now be explained in the light of the statements just made. 'Monumental' is used here to characterize one side in the recurrent swing of the pendulum between large-scale and small-scale painting or drawing. The monumental style therefore refers to a composition with few large figures nearly filling the space, thus leaving little, if any, room for decorative features. It also implies a figure type of imposing but approximately normal proportions, as contrasted with exaggeratedly tall or thin or distorted figures, such as were, in general, more often current in English figure painting and drawing. Thus there can be and is a monumental style in outline drawing, as witness some of the superb late tenth century miniatures such as the Crucifixion in the Harleian Psalter (Plate 30). The so-called small-scale style, in drawing or in painting, however, was much more to the English medieval artist's liking; it persists in one form or another, throughout every century, and it is upon this form that his greatest accomplishment was built. This is primarily the art of the illuminator.

On the technique of outline drawing in both of its forms rests the continuity of English painting in the Middle Ages, and this is true not only of figure compositions but of the decorative work as well. There are several kinds of line which have been distinguished in specific examples throughout this survey and which may now be summed up in relation to their effect on the development of English style as a whole.

Because the earliest examples of the art are primarily decorative, one must start with the use and effect of line in decoration. In Hiberno-Saxon manuscripts the line is firm, almost mechanically true and even, and it is used in wholly abstract designs. The decorative text pages of the early manuscripts as well as the entire pages of intricate linear ornament contain no representational elements and only an echo of symbolism in the occasional cross or the arrangement in a cross pattern. This harmony of technique and style is perfect in the early stages of the style; there is no discordant element to break it on the pages of the Book of Durrow; the simplicity of the colour scheme and the clarity of the linear patterns reign supreme.

But exclusively abstract patterns did not completely satisfy even the early artist of the Book of Durrow. There is a page of animal ornament (Plate 1) – animals they may be called by courtesy; for really they are only ribbons with heads, tails, and feet, and they are used in exactly the same manner as, but with more variety than, if the heads and appendages were amputated. But we must watch these little animals, for they will not always remain so tractable. In the early Hiberno-Saxon style they are a perfect complement to the abstract, linear patterns, and still the harmony is unbroken.

The introduction of the human form into this abstract style is one of the most interesting phenomena in the history of medieval art. For the temperament of the Celtic artist seems at this point to be distinguishable from that of his Anglo-Saxon contemporary in the manner of his reaction to this totally extraneous element which he finds he must, in the interests of illustrating his book, incorporate into his repertoire. The Irish artist promptly makes of the figure a new and fascinating pattern, by reducing it to an organization of lines. The Anglo-Saxon artist, faced with the same problem (though perhaps not entirely with the same models to follow), rather worriedly transfers his painted model into an outline drawing of it; if he had been less an artist he would probably have traced it,

as a child might do, and filled in the lines with colour. But there is evidence of analysis of the painted form and of considerable intelligence as well as skill in the selection of salient features to be included in his own picture. Thus the very earliest stages of English pictorial art incorporate the beginnings of its two fundamental and persistently enduring elements: decorative linear pattern and figure drawing in outline.

The decoration did not long remain abstract and simple in motifs. Soon foliage of the vine and acanthus types was introduced from Continental sources, and the acanthus especially was received eagerly by Winchester artists, whence the style spread rapidly elsewhere in England. At Canterbury, there seemed to be a preference for animals of a much livelier variety than the earlier writhing lacertines. By the end of the twelfth century both types of decoration had settled down happily in the text initials which became larger and more imposing as the size of the manuscripts increased. Still Canterbury artists retained their preference for the ribbon-like scrolls and prancing animals, varied now by human figures climbing about among them. Winchester artists, on the other hand, took their decoration more seriously; the acanthus leaves became larger and were more boldly painted with heavy colours, as in the Winchester Bible, and foliage pendants to the initials extended into the margins. It was a sort of second spring for the acanthus of the earlier Winchester style, and the coarse plant flourished mightily.

In the midst of this lush and verdant growth, suddenly the whole style withered away and the next thing noticeable, at the very end of the twelfth century, is a new style in the Beatus initial in Psalters which, in its dizzy convolutions of ribbon coils and its wizened little animals crushed within the strands, reminds one not only of the earlier Canterbury style, but of its ancestor, the Hiberno-Saxon; but the complete harmony of animal and abstract pattern in this new style is lacking. The next step was inevitable. The scrolls put out leaves and buds, and the animals, released from their uncomfortable confinement, began to run about not only inside the decoration but out of bounds, in the margins of the page. Here the harmony begins to be restored, and when during the course of the thirteenth century the initial foliage grows out so that it surrounds the page forming a border for the animals to play in, all the elements are again in perfect accord. This is the East Anglian period, during which the foliage motifs become recognizable as particular species, and not only are the animals amazingly drawn from nature, but introduced among them are new species of hybrid and monstrous types. Again the inevitable happened: the monsters grew in size and monstrosity, the leaves and flowers became gigantic, and the whole style suddenly blew itself out, with only a few East Anglian daisies and marigolds surviving and an occasional grotesque showing its sad little face on the pages of otherwise monotonously repetitive bar borders bearing odd spoon and liver-shaped forms of nondescript variety. But hope was on the way. The ubiquitous acanthus at the end of the fourteenth century again displays its showy head and long trailing leaf, and mingling with current forms, produces at least new patterns and richer colouring. Characteristic of this phase of decoration are showers of fine hair-line sprays with small gold and coloured motifs which are interspersed among the heavier branches. This is the end of the development of English manuscript decoration.

As the decorative style developed primarily out of the Celtic ornamental style, so

figure art traces a direct ancestry to Northumbrian, that is, Anglo-Saxon eighth-century manuscripts. The distinction of origins is unmistakable, but the reason for it is not clear: was it a matter of environment or of temperament? At any rate, whereas Celtic figures show an increasing tendency towards a *reductio ad absurdum*, Anglo-Saxon figures, though often badly understood, always are unmistakably human. We have seen, in the survey, examples of the two main types of figures which were evolved by Anglo-Saxon artists out of two Continental prototypes: the monumental type which flourished especially at Winchester, and the lively, dramatically rendered narrative type which so quickly made itself at home in Canterbury. The monumental type associates itself with the heavily painted acanthus ornament of the Winchester style, or else appears completely free of decoration, in single miniatures in outline technique, as in the Harley Psalter; the restless Canterbury type, appearing first in crowded narrative compositions, soon associated itself with the ornamental initials and the jumping animals. The mingling of figures and figure subjects with decorative motifs produced the form which suited most perfectly the English illuminator's taste and ideology: the historiated initial, born at Canterbury. But it was the monumental figure style which produced late twelfth century wall painting and stained glass.

With the replacement of the heavy acanthus initials by the fine-line ribbon-scroll letters at the beginning of the thirteenth century, the small-scale figure comes into its own. Initials, and related forms, medallions, were admirable places for composing a small but lively scene illustrating a story without violating the general ornamental effect. Designers of stained glass saw the possibilities of this style as combining a pleasing overall design for a panel with the lively interest and variety of a narrative. Thus manuscripts and stained glass drew very close together in this period, and again it was Canterbury which took the lead.

What new impulse produced the climax of the decorative style in East Anglian art is still to be determined. Though some of its elements seem to have affinities with contemporary styles in north France and Flanders, there is no basis for believing that the style, or any of its essentials, was imported. In its underlying principles, its love of ornament, of variety, of exciting narrative, of the bizarre, and, above all, its harmony of figures and decorative features, it can be accounted for wholly in earlier phases of English painting. It is, as a matter of fact, in all respects the most characteristically English phase of medieval painting. This is important to remember in evaluating English art; for the East Anglian is the second and last great period of its development, and it is comparable in the quality of its best workmanship, as in the harmony and perfection of its elements, to the best Hiberno-Saxon work, though totally different in style and ideology. The difference, of course, lies not only in the decoration but most of all in the figures, which show the strongest influence of Gothic figure style, perhaps directly from France, certainly from the enigmatic style of the Westminster Retable. Figures are tall and willowy with flowing draperies arranged in graceful curves; poses are strongly 'hip-shot'; gestures are mannered, and faces have lively, coy, or mischievous expressions. The delicately modelled faces and deeply shaded draperies of the Westminster panel survive only the early stages of the style; later, the faces are linear with a spot of colour. The figure style at its best suits admir-

ably the rich but delicate charm of the decoration and places the East Anglian style in a category by itself.

Only one more phase need be noted in the development of English medieval painting, and that was the result mainly of influence from abroad. But it found congenial soil in England. The interest in facial expression was apparent almost from the first figure paintings by English artists, even though the modelling of the features was of the simplest nature. The faces of early votive figures, such as the St Dunstan at the feet of Christ (Plate 22), and Matthew Paris at the feet of the Virgin (Plate 110), show expressions of humility and devotion. The increase in the number of individual figures in association with various religious themes led to the introduction of individuals for their own sake, and this led, of course, for purposes of recognition, to portraiture. But the panel portraits of the later Middle Ages, such as King Richard in the Wilton Diptych and the large picture in Westminster Abbey, are painted in a technique which is not unmixed with Italian or other Continental influence, so that for examples of purely English skill in portraiture, we must turn again to manuscripts. In first rank, in the number of pictures as well as in their life-likeness, is the Bedford Psalter which contains dozens of small heads within initial letters, many painted so discerningly and skilfully that they must be considered portraits: some are almost certainly identifiable. The Bedford book is the work of a number of illuminators; it is painted in part by Herman Scheerre himself and probably wholly under his direction. Out of the same atelier come the portraits reproduced in Plate 175A. The technique is linear, lightly coloured, and the artist's sensitiveness to his subject and his skill in depicting not so much what he sees as what he feels are evident. In view of the importance given to portrait painting in later English art under the stimulus of Holbein and others from abroad, is it too much to suggest that this sensitive treatment of the individual is also to be traced back to a continuity in the attitude of the English artist towards his subject?

For it must be remembered that his earliest experience in representations of free narrative was drawn from the lively illustrative scenes in the Utrecht Psalter, which he might have duplicated many times had his temperament been capable only of slavish copying. Instead, it is noteworthy that the model was re-born with each succeeding generation. The English medieval artist always seemed to need to express his individual reactions to whatever came to hand. This projection of his personality into the figure arts is what gives his work, certainly its variety and interest, but more than that, its meaning. It was therefore possible for Continental manuscripts to be imported and even copied, in a manner of speaking, but the result would not be merely a duplication of the model, but a re-vivified version. It might not express the original artist's intention exactly, but it would certainly be the English artist's interpretation of the underlying facts or ideas in the representation before him. It was this constant awareness of the idea behind his model or subject that imparts to English medieval painting its significance as an art in its own right: it was fundamentally and intensely alive and creative. This independence of spirit also accounts in great part for the ability of English artists to be exposed without succumbing to those foreign influences which were constantly arriving from across the Channel throughout the Middle Ages. Even in the face of the strongest French influence,

in the mid thirteenth century, when Paris was the hub of the art world and England even then was within easy reach of it, artists like Matthew Paris and William de Brailes, though showing evidence of knowledge of the wonderful new French style, quietly went their own way, using their own techniques and expressing their thoughts with characteristic independence. As long as English art remained sturdy and vigorous, it was safe from being stampeded by foreign styles. It is significant that in this same period of the climax of French international influence, it was English artists who painted in a variety of styles and with inimitable freshness and originality a long series of apocalypse pictures which are unsurpassed in medieval painting anywhere. Typically English too are the slightly earlier illustrated bestiaries with their marvellous renderings of tales about fabulous animals such as even their fertile imaginations would hardly have dreamed of without some stimulating model. This was grist for their mill, and their reaction to such eminently congenial material was not only magnificent drawing though often completely unnaturalistic painting, but the well-nigh inexhaustible stream of grotesques that poured out from the bestiary material into the borders of East Anglian manuscripts, and even into wall paintings and embroideries.

If there is no doubt about the vigour of English medieval style, what of the quality of its craftsmanship? In competition with the fine Paris style of the mid thirteenth century, English manuscripts are hopelessly lost. On this scale and within these more formal limitations, English work is less meticulous and exquisite, less strictly controlled by good taste in design as in subject matter, less uniform in quality, and, of course, it never reached the degree of diminutive size which the French pocket Bibles attained. It is probable that the very qualities that make English illumination interesting were responsible for the unevenness in their quality. For in Paris in the thirteenth century illuminators were trained and controlled by the guild system; in England even much later than the thirteenth century a great deal of work was still done in monasteries, either by monks or by lay illuminators who were brought in. As a matter of fact, we know very little about the training of English illuminators, but it would seem from the variations in their skill and manner of working that their training was far from systematic and may have been acquired largely by the method of trial and error. There is the interesting example of the early fourteenth century picture book (Plate 138) which contains an amazing series of illustrations drawn and painted in a manner which would have horrified a French illuminator of almost any period. They are certainly the work of some local genius who was an amateur in his craft.

This expression of individual skill, often very crude indeed, is most apparent in much of the surviving wall painting in England. It is true that in its present battered state it would be difficult to evaluate the style of any artist; but Peterborough was a very important centre of art in the high Middle Ages, and the paintings in the manor at Longthorpe just outside the town (which are fairly well preserved) are certainly not the work of a highly skilled and trained painter, interesting though they are in their subject matter and its interpretation. Of panel painting there remains so very little outside the fine Court pieces and the East Anglian panels (where, naturally, we could expect to find at least moderately well-trained artists) that it is difficult to judge whether local artists often tried

their hand at this kind of painting also. A few rather roughly painted chests, like one in Winchester Cathedral, would suggest that they did. The art of making stained-glass windows was, of course, necessarily too technical and difficult for amateurs; thus we find more artists showing evidences of training in such centres as Canterbury and York. Embroideries also show considerable similarity in the types of designs and figures, but in this art the technical skill which the designer might have shown in the original patterns could largely have vanished under the embroiderer's needle.

To sum up the picture of the accomplishment of English art in the Middle Ages, we can conclude that it demonstrates, in the variations of skill displayed, the same lack of uniformity that characterizes the interpretation of subject matter. But what is gain for the representational interest may be loss in the more formal and highly skilled technique. Only rarely in either France or in England does one find both in equal measure.

This summary of the characteristic traits of English style has not so far taken account of the Continental influences in the later periods which were in some degree acceptable and accepted by English medieval artists. Of these the most congenial came from Flanders and the Low Countries. Italian influence and even, apparently, Bohemian had a limited effect on the technique, but were never really understood nor wholly accepted. There may be a reason for this.

Partly it was a matter of temperament. The more forthright, robust character of Flemish art in the late thirteenth century, with its less formal design and less controlled taste, appealed more strongly to the English artist and, within limits, he took it to his heart. A small Book of Hours in the British Museum, illuminated in Maastricht *c.* 1300, could almost be mistaken for English work and, in fact, does show some affinities with East Anglian manuscripts in the humour of its historiated initials, the lustiness of its grotesques and even in some of the decorative motifs. And yet the similarities seem to be rather of kind than of the influence of the one on the other. Another fourteenth century manuscript, a finely and fully illustrated copy of the Alexander Romance, in the Bodleian Library, written in Bruges *c.* 1338, could also (except, perhaps, for its technique) have been painted by an English illuminator. These two examples will serve to illustrate the strong affinities between English and Flemish style and interpretation. It would be no wonder, therefore, if Flemish influence were eventually found to be influential in the formulation of the East Anglian style, and yet in its earlier and finer phases, this style can, as we have seen, be well established as stemming from the continuity of English work. In its later phases, however, when a strange exaggerated type of modelling of faces and draperies makes its appearance in the larger and coarser motifs, and humour goes beyond the limits of the fantastic and becomes outright crude and vulgar, then, if we evaluate Flemish traits correctly, this phase may have been introduced into England from some Low Country source, for rarely does English humour allow itself the licence of such forms.

In the late fourteenth century a much more clear-cut contact with Netherlandish art is supplied by the work of a Dutch artist who, through what means we do not know, found himself in London and joined a group who were engaged in illuminating the great Carmelite Missal. The style of this artist can be matched in other late fourteenth century

Netherlandish works, one of which was made for the Duke of Gelder, probably at Arnhem. So the style is authentically Dutch, and indeed contrasts strongly with that of his two collaborators on other pages. The interesting fact about this collaboration is that the Dutch style seems to have had no immediate effect on the other artists, but in slightly later miniatures its influence is unmistakably apparent. The Dutchman was much more of a painter, in the true sense of the term, than any English artist whose work we know, and the effect of his heavy modelling, especially in the faces, and his stronger colouring and brilliant rendering of compositions of figures in architectural settings set up a whole new concept in late medieval English illumination. The companion volume to the great Missal, an enormous Bible with a full complement of historiated initials, many of which follow closely the Dutch artist's style, are evidence of his influence on English work. This influence might have been still more effective had not another artist appeared upon the scene, of unknown but certainly Continental origins, whose technique approached even more closely that of the traditional linear style. Herman Scheerre (the name suggests a Low Country origin) was a magnificent painter in the sensitive manner which was part and parcel of the English artist's temperament; but his technique, delicate and linear though it is, is based not on the outline style, but on a soft surface modelling in browns on a pale base. This technique appealed to the English artist more than the heavy, built-up modelling of the Dutch Carmelite artist, and became, in fact, the inspiration of a whole group of illuminators who had evidently learned from him. These two instances of a willingness to accept and incorporate into their traditional style new elements which were congenial are typical both of the English artists' independence and of their ability to assimilate what would enrich without radically altering their own manner of working.

The reaction of English artists to Italian styles of painting in the later Middle Ages is another matter, but is likewise indicative of their reluctance to yield to influences which they did not understand or approve. The spread of Italian influence everywhere in Europe in the second half of the fourteenth century was affecting the various local styles in such a marked manner that many examples of the so-called International Style cannot be assigned with certainty to any place of origin. Italian techniques were, however, particularly applicable to panel and wall painting, and since this form of art was not produced to any extent in England, we would not expect to find many examples of panel paintings in the International Style there. The one outstanding example is the Wilton Diptych (Plates 160 and 161), which must be attributed to this style because it contains some elements of Italian and French technique which are not characteristic of English work; the composition and the mood, however, seem to be English. There may have been evidence of such a mixture of styles in the newly uncovered wall paintings in the Tower of London, but in their present fragmentary and damaged condition they do not seem to have affinities with the Wilton Diptych, either in figure types or in quality of colouring. The date is closer to the St Stephen's frescoes but the style appears to be less Italianate than these.

North Italian, or Lombard, influence has already been suggested as the source of these elements in the paintings from St Stephen's Chapel. It has also been pointed out that England had close political contacts with Lombardy in the third quarter of the century,

which might partly account for the introduction of Italian influence into England. A small piece of evidence of the personal contacts of one Englishman with Italian painting in Florence is furnished by the picture of a Knight of the Garter among the important foreground figures in the great fresco of the Church Triumphant in the Spanish Chapel in Sta Maria Novella in Florence. This man has been identified as one of the nobles who accompanied Lionel, Duke of Clarence, son of Edward III, on his journey to Lombardy on the occasion of his marriage in 1368 to an Italian princess. As an additional item in this connexion, Humphrey de Bohun, for whom some of the manuscripts showing strongest Italian influence were made, was one of the two men who made arrangements for this journey. There must have been a great many other visits of Englishmen to Italy and Italians to England, painters and illuminators among them. In fact, there is evidence of these contacts in English painting in such details as facial types and a kind of modelling in faces and draperies, and the curiously misunderstood back view of figures as shown in Plate 154A. These are only superficial features, it is true, and although they do occur in a group of manuscripts, they do not imply much more than awareness of the Italian fashion. Nor could it really be otherwise, considering the fundamental differences between the technique of Italian painting and that of English line.

One more foreign influence should be examined in the light of its acceptability by English artists in the late fourteenth century. There is much disagreement as to whether or not Bohemian artists came to England in the train of Anne of Bohemia at the time of her marriage to King Richard II. It must be admitted that there is no documentary evidence to support such a fact, but it will on the other hand be obvious to anyone who has studied the *Liber Regalis* (the Coronation Book of Kings, in Westminster Abbey, Plate 159) that it is painted in a style much more like that of Bohemian manuscripts than any of English origin. If it is the work of a Bohemian, it does not seem to have had much influence on English style, but an interesting sequel to its appearance in the *Liber Regalis* is its echo in a small group of miniatures in the Carmelite Missal. Whatever the source of this curious style may be, it seems to have been limited to these two examples, though traces of its influence, particularly in figure types, lingers in one or two other manuscripts made for Richard. The border decoration of the miniatures in the *Liber Regalis* is English and the book was probably made at Westminster. The decorative style of the 'Bohemian' miniatures in the Carmelite Missal has certain elements of East Anglian foliage, which could represent an echo of earlier East Anglian influences on Bohemian illumination.

All these various foreign contacts are indicated graphically in the Chart on pages 4–5 and discussed in the text; but it has seemed worth while to review them as a body because of the light they throw on the peculiar paradox of repudiation and acceptance by English artists of successive foreign influences to which they were exposed in the crucial period of the late Middle Ages. This determined attitude may have been both their weakness and their strength: certainly such examples of the International Style as the Broederlam altarpiece in Dijon illustrate what fine achievements became possible by the assimilation of Italian technique. Painting in the International Style never attained this high quality in England except in the Wilton Diptych, which had no successors.

What then is the utmost degree of accomplishment reached in English medieval

painting and how does it measure against contemporary Continental work? At two and only two specific times, it seems to this writer, was English pre-eminence incontestable in Europe. The first was in the late seventh and eighth centuries, when Hiberno-Saxon illumination was at its peak and, through monastic missionaries, was spreading over Europe to be incorporated almost everywhere in current and subsequent decorative styles. The second period of pre-eminence was in the late thirteenth and early fourteenth centuries when the East Anglian style in the full vigour of its growth poured forth its wealth of beauty and originality in manuscripts and in embroideries to all parts of Europe.

In the intervening centuries between these two high points, English painting, in an exchange with Continental influences, was perfecting a linear technique which was fundamental to it even at the outset, a technique whose task was to reconcile the abstract with the concrete, pure line with corporate form. The initial stimulus in this process was the providential appearance in England of the Utrecht Psalter to serve not as a model but as an inspiration. Successive stages in the perfection of the English linear technique do not stand out strongly against the background of European art which by the middle of the twelfth century had accomplished its fulfilment as dynamic line on both sides of the Channel. But whereas on the Continent this style almost immediately reached its ultimate expression in Gothic of the early years of the thirteenth century, English linear technique continued on its sober way (in the illustration of monumental psalters and the endless spinning out of pictorial narrative as in the apocalypses), affected only at moments during the first three-quarters of the century by the exquisite French-Gothic fashion and never for a moment competing with it.

And then, at the end of the century, the miracle happened. The homeliness of the English figure style suddenly blossomed out into a fairy-like grace and beauty, and the ornament which had retained much of the simplicity of twelfth century decoration, burst forth in full leaf and flower, covering the margins of manuscript pages with verdure in which bird and beast hovered or played. No wonder this amazing style startled Europe and charmed it: this was the second and final moment of triumph for English pictorial genius in the Middle Ages.

GLOSSARY

No claim is made as to either the completeness or the consistency of the terms included in this Glossary. The basis for selection has been solely their applicability to the present text.

Acanthus. Fleshy curling lobed leaf of a Greek plant, a favourite decorative motif especially in Roman art.

Addorsed. A term used in heraldry signifying figures placed back to back.

Animal interlace. Interlace (*q.v.*) formed of lacertines (*q.v.*) or other animal forms.

Antependium. See *Frontal.*

Arabesque (*medieval*). Ornamental pattern of stems and foliage in running curves or scrolls often including animals and birds within the coils. Cf. *Inhabited scroll.*

Baldacchino or baldaquin. A canopy over a seat or other place of honour.

Bar-branch. An ornamental motif in later medieval illumination consisting of a vertical or horizontal stem to which foliage is joined to form a marginal border. (*Below left.*)

Bar tracery. Decorative shapes given to stonemasonry in the head of a window or other opening to form a pattern. (*Above right.*)

Barbed quatrefoil. A four-lobed ornament having points between the lobes.

Benedictional. A liturgical service book containing episcopal benedictions for the great feasts of the Church year.

Book of Hours (Horae). A liturgical service book, used mainly for private devotions, containing the office in honour of the Virgin as recited in monasteries and churches after the Canonical Hours (*q.v.*) of the day. It often included also the Hours of the Holy Ghost and of the Holy Cross.

Breaks interlace. See *Stopped-knot interlace.*

Breviary. A liturgical service book containing Offices for the Canonical Hours (*q.v.*).

Buskin. A covering for the foot and leg reaching to the calf or to the knee.

C-scroll. Two convergent spirals. (*Below left.*)

Cabbage head motif (so-called). A coarse floral or foliate ornament typical of fifteenth century illuminated border design; probably a descendant of the acanthus (*q.v.*). (*Above right.*)

Cable pattern. A two-strand flattened twist.

Calendar (ecclesiastical). The days of the months designated in relation to the Kalends, Nones, and Ides of the Roman calendar. The feasts and saints' days celebrated locally were entered in the Calendars of liturgical manuscripts. See also *KL monogram.*

Calendar pictures. Illustrations of the twelve signs of the Zodiac (*q.v.*) and twelve labours or occupations suitable to the respective months.

Calligraphic style. A precise linear technique as developed in fine handwriting applied to decorative or pictorial art. Used particularly in connexion with Hiberno-Saxon manuscripts.

Camayeu or camaieu. Painting in monochrome, i.e. in tones of any single colour.

Canon Tables. A concordance of references to parallel passages occurring in two or more of the four gospels. See also *Eusebian Canon Tables.*

Canonical Hours. The eight monastic church services prescribed for the twenty-four-hour day. They were:

Matins	three nocturns said during the night
Lauds	said at dawn
Prime	said at 6 A.M.
Terce	said at 9 A.M.
Sext	said at noon
Nones	said at 3 P.M.
Vespers	said at 6 P.M.
Compline said at nightfall	

Champlevé. See *Enamel.*

Chasuble. A garment worn by the celebrant at Mass.

Cinquefoil. A five-lobed ornamental motif.

Cloisonné. See *Enamel.*

Codex Aureus. A manuscript book, usually the four gospels, written in gold.

Confronted. A term used in heraldry signifying figures placed face to face.

Cope. A bell-shaped outer garment worn by clergy during processions and at other important church functions.

Crested animal head. An animal head having an excrescence in the form of a curling lappet or ear or of an acanthus-type leaf form. Characteristic of South English and Mercian animal ornament.

Crockets. Projecting leaf ornaments placed on a frame or architectural member as an arch or gable. In the pictorial arts, used on frames of panel paintings and in representations of architectural detail.

Cross with interlace. Typical Celtic Christian stone monument decorated with a carved interlace pattern (*q.v.*).

Cross-hatching. Filling a space with two crossing systems of parallel lines in order to distinguish one space from another as to colour or tone.

Cruciform page. A decorative page in Hiberno-Saxon manuscripts, of which the central feature of the design is some form of cross.

Cusp. A projecting point formed by the meeting of two segmental curves in tracery. (*Below left.*)

Daisies (*East Anglian, so-called*). The common English daisy, a pink or white multi-petalled flower. In East Anglian ornament it was usually simplified to a rounded pinkish tip and a green calyx. (*Above right.*)

Dalmatic. A vestment worn by deacons, and (under their outer vestment) by bishops and certain other prelates when officiating at Mass.

Diagonal fret. A version of meander pattern (*q.v.*) running diagonally instead of vertically or horizontally.

Diaper work (*medieval*). Surface decoration composed of square or lozenge shapes which usually enclose small formal motifs.

Displayed. A term used in heraldry to describe an eagle or other bird represented with wings spread.

Dorsal (*altar*). A panel of material, often richly embroidered, hung against a wall behind an altar.

Easter Tables. Charts for the astronomical computations of the date of Easter.

Enamel, champlevé. A process of enamelling in which the ground of the metal is cut out to form the pattern and enamel is inserted in these hollows.

Enamel, cloisonné. A process of enamelling in which a flat metal surface is divided into compartments (cloisons) by the welding on to it of thin metal strips. The hollow cloisons are filled with enamel.

Eusebian Canon Tables. A concordance of references to parallel gospel passages compiled by Eusebius of Caesarea in the fourth century and commonly included in early medieval gospel books.

Finial. A carved ornament, usually resembling a conventionalized leaf or flower, used as a termination or finishing point of a gothic pinnacle, gable, or other architectural feature, or on frames as represented in pictorial art. (*Below left.*)

Fleuron. Decorative carved flower or leaf terminating a staff, a rod, or a sceptre. (*Above right.*)

Fresco painting. Mural painting executed on the fresh plaster, in which the pigments, suspended in a lime medium, bind with the plaster.

Frontal (altar). A decorative panel of rich cloth or embroidery, or of painted wood or precious metal and jewels, covering the front of an altar.

Gesso. A mixture of plaster of Paris and glue to form a hard smooth surface over wood, for use in panel painting.

Glossed text. Text which has been annotated with sources or parallel passages; for example, glossed epistles or gospels.

Gospel lectionary. Gospel book arranged according to liturgical order.

Granulation. Ornament in metalwork, consisting of tiny beads soldered to the surface.

Greek cross. Plain cross with four equal limbs, sometimes placed within a circle, as on early Irish monuments.

Grisaille. Painting done only with black, white, and the greys resulting from mixing them. Cf. *Camayeu.*

Grotesques. Systems of ornament representing fantastic subjects or extravagant figures and fanciful animals.

Guilloche. An ornamental pattern consisting of a loose, continuous twist or interlace, enclosing a series of equidistant circles.

Hatching. A system of parallel lines used to suggest tone or colour. See also *Cross-hatching.*

Historiated initial. Initial letter at the beginning of an important text passage, enclosing a picture which illustrates or refers to the text it introduces.

Horae or Hours. See *Book of Hours.*

Inhabited scroll. An arabesque pattern with birds or animals among the branches.

Interlace. A general system of ornament consisting of lines or bands which pass over and under each other, like the threads in lace.

Key. See *Meander.*

KL monogram. A combination of the letters K and L from the Latin *Kalendae*, which stand at the beginning of each month in an ecclesiastical calendar.

Lacertine. A very elongated biped or quadruped with an eel-like body. The heads vary in type but usually have ears and a biting snout.

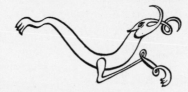

Lappets. Soft, curved ears found on many medieval animals.

Line endings or fillings. Ornament placed in the empty spaces left at the ends of lines which the writing does not completely fill.

Lodged. A term used in heraldry to describe an animal in repose, as the White Hart in the badge of Richard II.

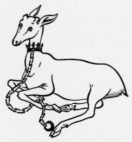

Lozenge. A diamond shape used in diaper or other ornamental design usually containing a motif.

Mandorla. The almond-shaped glory which surrounds Christ, the Virgin, or (rarely) saints ascending to Heaven.

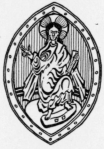

Maniple. A band of embroidery worn by priests over the left hand or arm.

Mask (animal). A stylized animal head used as a decorative motif in classical art and carried over into Carolingian and later ornament.

Meander: also Key or Greek Key. A geometrical pattern formed by broken lines at right angles to one another.

Millefiori glass. A kind of mosaic glass used for mounts in metalwork. It was made by grouping several rods of different-coloured glass into a simple pattern, fusing them, and cutting the bundle crosswise so as to display the pattern. The technique was Roman, but it was used also by the Irish in the Late Celtic period.

Missal. A liturgical service book containing the texts and ceremonial for Masses for all the Sundays and for the various feast days throughout the whole year.

Mitre. A liturgical head-dress worn by high ecclesiastics.

Niello. A process of incising in metal and filling the incised lines with a black compound which melts at a high temperature. When polished, the design appears as a black incrustation on the polished metal plate.

Ogee arch. An arch inscribed by means of four centres so as to be alternately concave and convex.

Orphreys. Decorative bands, usually embroidered, on ecclesiastical vestments.

Pelta. A classical ornamental motif formed by two converging curves joined by another line. The ancestor of the trumpet pattern (*q.v.*).

Phylactery. In medieval art, a long narrow band held or issuing from the mouth of a figure, intended to be inscribed with a text identifying the person or showing what he is saying.

Plaitwork. See *Interlace.*

Plate tracery. Pattern formed by piercing the solid masonry in the head of a window or other opening.

Pontifical. A liturgical book containing offices to be celebrated by bishops or higher ecclesiastics.

Powdered (heraldic semé). Decorated with a number of small motifs scattered over a surface.

Psalter. A service book containing the psalms.

Quarried glass. Window panels divided into squares or diamonds, each containing an ornamental or heraldic motif.

Quatrefoil. Four-lobed ornamental form. Cf. *Barbed quatrefoil.*

Reredos. Cf. *Retable.* In the Middle Ages the two terms were interchangeable.

Reserved edges. Spaces left around a painted ornament exposing the vellum of a manuscript page. In Hiberno-Saxon decoration the reserved edges aid in clarifying a complicated pattern of spirals or interlace.

Retable. A framed panel, usually of painted wood or precious metal, standing on or slightly above the rear edge of the altar.

Ribbon pattern. Sometimes used to describe plaitwork or strapwork; any flat ribbon-like ornament.

Rood. Cross or Crucifix.

Rood screen. See *Screen.*

Rosette. An ornament fitting into a circle and having six or more lobes or petals.

Roundel. A circular medallion containing ornaments or figures.

S-chain. An ornamental calligraphic pattern consisting of a series of connected S's, used to fill the space between large initials and smaller text letters in some early Hiberno-Saxon manuscripts.

Sacramentary. A liturgical service book containing the ritual for administering the sacrament; it is the predecessor of the much more complete missal *(q.v.).*

Sarum use. A form of liturgical use established by the thirteenth century at Salisbury (Sarum) and later adopted for use in English non-monastic churches.

Screen, parclose. The screen partially enclosing the choir and separating it from the remainder of the church.

Screen, rood. A screen between the choir and the nave of a church on the top of which was placed the rood or cross.

Scroll. See *Spiral.*

Seraph. The highest of the nine orders of angels. (For the other eight orders, see p. 250, note 20.) Seraphs were usually represented with six wings adorned with human eyes.

Serrated cabbage leaf (so-called). An East Anglian decorative motif probably derived from the acanthus *(q.v.),* greatly elongated to form a graceful ribbon-like form with serrated edges.

Service books, liturgical. See *Benedictional, Book of Hours, Breviary, Gospel Lectionary, Missal, Pontifical, Psalter, Sacramentary,* and *Troper.*

Spandrel. The triangular space between two adjoining arches.

Spiral (Celtic). A pattern formed by a line revolving in a curve about a central point. See *C-scroll.*

Stepped patterns. Right-angled geometric patterns progressing in steps.

Stippled gold ground. Background of gold leaf on a miniature or painting which is decorated with patterns formed by a number of small dots punched on the surface with a pointed tool. Also called tooled. To be distinguished from stamped ground, where the motifs are pressed in with a die.

Stole. A narrow strip of material, often embroidered, worn by clerics around the neck, as a part of their ecclesiastical vestments (*q.v.*).

Stopped-knot interlace. The typically Celtic form of interlace, the strands being doubled back at intervals to form knots. Also called the breaks interlace.

Strapwork. A form of ornament consisting of bands or fillets interlaced or intertwined; a later offshoot of the Celtic interlace. (*Below left.*)

Terminal heads. Animal or human heads without bodies which are often attached to initial letters or other decorative forms as terminations. (*Above right.*)

Tetramorph. The union of the four symbols of the Evangelists – the angel, lion, ox, and eagle – into one figure.

Tooled ground. See *Stippled gold ground.*

Tracery. See *Bar tracery* and *Plate tracery.*

Trefoil. A three-lobed ornament.

Trefoiled arch. An arch shaped into three lobes.

Troper. A liturgical service book containing the musical interpolations or tropes.

Trumpet pattern. Two whorls (*q.v.*) joined across the open side by a curved line.

Twist. See *Cable pattern.*

Vair. Fur obtained from a variety of squirrel with grey back and white belly, used commonly in the Middle Ages for lining and trimming garments.

Vellum. Calf and other animal skins dressed and polished for use as writing material.

Vernicle. A term for the *Vera Icon* or true image of Christ's face traditionally impressed upon the *Sudarium* or cloth presented to him by St Veronica on the road to Calvary.

Vestments. The robes worn by the clergy in the celebration of Mass and other church services and functions. See also *Chasuble*, *Cope*, and *Dalmatic.*

Vine scroll. Running arabesque pattern of grape or other vine stems with leaves and fruit.

Whorl. An elaboration of the spiral in which several lines curve in the same direction around a single centre.

Zodiac signs. Names of the constellations in the order of their ascendancy during successive months of the astronomical year:

January	Aquarius (Water Carrier)
February	Pisces (Fishes)
March	Aries (Ram)
April	Taurus (Bull)
May	Gemini (Twins)
June	Cancer (Crab)
July	Leo (Lion)
August	Virgo (Virgin)
September	Libra (Scales)
October	Scorpio (Scorpion)
November	Sagittarius (Archer)
December	Capricornus (Goat)

NOTES

CHAPTER I

10 1. This term is intended to suggest the twofold character of the art of this period. An alternative designation could be Anglo-Irish. There is not necessarily in either term any indication of precedence of one element over the other.

11 2. It still belonged in the seventeenth century to the monastery of Durrow (Co. Offaly) which was founded by St Columba c. 553. On fol. 12 verso there are two colophons, one of which states that the book was written in twelve days by Columba in memory of the holy priest, Patrick.

A very recent (1960) publication of the Book of Durrow in facsimile by Luce, Simms, Meyer, and Bieler reviews all the evidence concerning the sources of its style and the place of its origin. Luce favours the theory that it was written and illuminated at the monastery of Durrow about the mid seventh century but he concludes: '...wherever the book may have been written it has a thoroughly Irish background' (II, 94).

3. The symbols of the Evangelists are the four Beasts described in Ezekiel 1 and Revelation 4; they were assigned authoritatively to the authors of the four Gospels by St Jerome in the fifth century as follows: Matthew – winged man (angel); Mark – winged lion; Luke – winged bull; John – eagle.

4. These tables are a concordance of references to corresponding passages in the different Gospels, compiled by a monk, Eusebius of Caesarea, in the early fourth century.

5. The manuscript has recently been rebound, and some of the leaves which previously were misplaced have been restored to their original positions. All the pages have been renumbered.

6. Henry (*Irish Art*, 67 ff.) explains this inconsistency by assuming that the symbols were added after the text was written, in Ireland, from a different manuscript which preserved the order of an older version of the Gospels than the Vulgate, which is the form of the text. Luce is of the opinion that the inconsistency does not indicate that text and pictures were produced in different places or at different times. It does show that wherever the book was made two alternative texts were known: the so-called Old Latin version (with Mark and John interchanged) and the Vulgate of St Jerome. See Durrow facsimile, II, 7 f.

7. Similar patterns are found in the millefiori glass used on later Irish metalwork (e.g. the Tara Brooch and Ardagh Chalice). Henry, *op. cit.*, 118 ff. Plates 45-7. The symbol of Matthew in the Book of Durrow has been likened to a figure on the handle of a bronze vessel found at Moklebust, Norway, probably insular in origin. See Doran, 'The Enamelling and Metallesque Origin of the Ornament in the Book of Durrow', 143. Two noticeable differences, however, are the wig-like hair and the position of the feet, both suggesting Egyptian figures. The Matthew and the Luke symbols on the page containing all four symbols (fol. 2) also show these Egyptian traits particularly well. For Coptic influence on the symbols see Hovey, 'Sources of the Irish Illuminative Art', 105 ff.

8. Similar but more elaborate text pages occur p. 12 also in the later manuscripts (see Plates 5 and 13).

9. See Åberg, *Occident and Orient*, 15-129, which, previous to the publication of the facsimile, contained the clearest and most complete summary of the various theories held by scholars. The most important new evidence on sources for the Irish origin of the style has resulted from more recent excavations in Ireland, especially at Lagore crannog, in which metal objects going back to the end of the seventh or early eighth century show that some of the ornamental designs used in the Book of Durrow were produced in Ireland at the same time. For reproductions see Durrow facsimile, II, plates II and III. A summary of the evidence as to date is given, *op. cit.*, 45-66.

10. Parts 2 and 3 of Åberg's study deal with ornamental motifs and compositions, chiefly the interlace, of Lombard Italy and the Merovingian kingdoms. For the animal ornament of Durrow and related manuscripts see the monumental study by Bernhard Salin, *Die altgermanische Tierornamentik. Typologische Studie über germanische Metallgegenstände aus dem IV. bis IX. Jahrh. nebst einer Studie über irische Ornamentik, übersetzt von J. Mestorf*. 2. Aufl. (Stockholm, 1935). On Continental sources of English ornament in the pre-Norman period as a whole, see Brøndsted, *Early English Ornament*.

11. See P. W. Joyce, *A Social History of Ancient Ireland*, 2nd ed. (London, 1913), I, 410 ff. Bede in his *Ecclesiastical History* remarks on the reception of English scholars in Irish monasteries (Book III, Chapter 27. Trans. A. M. Sellar (London, 1907), 204.)

p. 12 12. See H. J. Lawlor and W. M. Lindsay, 'The Cathach of St Columba', *Proc. Royal Irish Acad.*, XXXIII (1916), 241–331 and plate 33. A Cathach was a book which was carried before an army going into battle, in the hope of bringing victory.

13. According to legend, St Columba copied the Psalter without permission from one borrowed from St Finnian and a dispute ensued which culminated in the Battle of Cul Dremhne in 561 and led to the exile of St Columba from Ireland and therefore, indirectly, to the founding in 563 of the monastery at Iona. For a colourful account of the copying episode and its dire results, see Manus O'Donnell, *Life of Columcille*, paras 167–201. Trans. A. O'Kelleher and G. Schoepperle, *Betha Colaim Chille* (Urbana, 1919), 177–201. The story is told in briefer form by D. Chrétien, *The Battle Book of the O'Donnells* (Berkeley, Cal., 1935). The early dating of the Psalter is accepted by Lowe on paleographical grounds: F. A. Lowe, *Codices Latini Antiquiores* (Oxford, 1934 *et seq.*), II, No. 173, 41. Lindsay, *op. cit.*, 402, says: 'There is no known reason to prevent the script of the Cathach from being as old as St Columba's time.'

p. 13 14. See Nordenfalk, 'Before the Book of Durrow', figures 7, 8, 12, 14, 15, and 17. See also Kendrick, Lindisfarne facsimile, II, plate 18.

15. Cf. Nordenfalk, *op. cit.*, figures 9–11 and 13.

16. Some of these objects are reproduced in colour in Kendrick, Lindisfarne facsimile, II, plate 17. See also *The Sutton Hoo Ship-Burial: a Provisional Guide* (British Museum, 5th impression, 1956).

17. Cf. also the interlace on seventh century Northumbrian high crosses, as Ruthwell and Bewcastle. Saxl and Wittkower, *British Art and the Mediterranean*, 15–18. It occurs also on an early Irish slab at Fahan Mura (Donegal), probably of the second half of the seventh century. See Françoise Henry, *La Sculpture irlandaise* (Paris, 1933), 15 ff., plates 14 and 15. For an analysis of the Celtic version of the interlace known as the breaks or knot type, see Allen, *Celtic Art in Pagan and Christian Times*, 257–78. Lethaby believes the source of the knotted and plaited work may be Coptic. See W. R. Lethaby, 'The Origin of Knotted Ornamentation', *Burl. Mag.*, x (1907), 256. For the most recent study of the development of the interlace, see G. Haseloff, 'Fragments of a Hanging-Bowl from Bekesbourne, Kent ...', *Medieval Archaeology*, II (1958), 88 ff.

18. Even closer and almost identical with the Durrow animals are those on the Crundale sword pommel, dated first half of the seventh century, by Salin, *op. cit.*, 328 ff., and also by Baldwin Brown, *The Arts in Early England*, v, 385. The design of the Crundale pommel is compared with the Durrow animal design in the *Sutton Hoo Provisional Guide*, figure 15. On the Crundale pommel, see British Museum, *Guide to Anglo-Saxon Antiquities* (London, 1923), 11, figure 6.

19. The arrangement of these spirals varies somewhat from that in Durrow. Even closer in design is a hanging bowl escutcheon from Hitchin now in the Victoria and Albert Museum. See Françoise Henry, 'Hanging Bowls', *Jnl Roy. Soc. Antiq. Ireland*, LXVI (1936), 209–46, especially plate XXXII. In her more recent book, Mlle Henry maintains her earlier conviction that these bowls were made in Ireland, though nearly all were found in Saxon graves. See Henry, *Irish Art*, 36 ff., especially 37, n. 1. Kendrick, on the other hand, stoutly maintains the British origin of these bowls. *Anglo-Saxon Art*, 51 ff.

20. *Sutton Hoo Provisional Guide*, plates 18 and 20.

21. Two are reproduced in the *Provisional Guide*, plate 15, b and c. Closer to the cross with interlace, as on fols 1 verso and 2, is the Fahan Mura slab (see note 17 above).

22. One of the clearest statements of this idea that Celtic illuminative style was the result of Irish calligraphic skill and the development of Anglo-Saxon metalwork is found in an article by Clapham, 'Notes on the Origins of Hiberno-Saxon Art'. He says in part: 'No one doubts ... that the learned Irish missionaries brought with them proficient scribes and that the Northumbrian scribes were trained in turn by them' ... 'In any case all the available evidence goes to show that the Irish came to Northumbria without any form of Celtic art-expression and left it capable of producing the highest forms of Irish Christian art', pp. 56 and 57.

23. Recent support for the theory of Irish origin of the bowls has been given by Haseloff, discussing some fragments of one found at Bekesbourne in Kent (*op. cit.*, 72–103). He concludes, however, that it is impossible to say whether these bowls were made in Ireland or by Irish craftsmen in Britain. This is really the heart of the whole problem of the origin of Hiberno-Saxon ornament.

24. This manuscript is sometimes called the Durham Book from the fact that it was preserved in St Cuthbert's shrine there from the late tenth to the twelfth century. The evidence of authorship is given in a tenth century colophon which, because of its late date, has been suspect. The grounds for accepting it are, as Bruun remarks, that if the writer were inventing his facts he would probably have attributed the writing of so sumptuous a manuscript to a better known person than Eadfrith, perhaps St Aidan

the founder of Lindisfarne. Bruun, *Celtic Illuminated Manuscripts*, 49 ff. Millar (*Lindisfarne Gospels*, 4) finds no reason for rejecting or even questioning the facts in the colophon. On the acceptability of the colophon, see also Baldwin Brown, *op. cit.*, 334 ff.

In the Lindisfarne facsimile T. J. Brown fixes a closer date for the writing and illuminating of the Gospels: between 687 (date of the death of St Cuthbert, to whom the manuscript was dedicated) and 698, when Eadfrith became Bishop of Lindisfarne and therefore (it is assumed) would have had less time for the work. *Op. cit.*, 16.

25. A bird of prey constitutes one of the fittings of the shield in the Sutton Hoo treasure. See *Provisional Guide*, Plate 4C. Bird heads also occur on the gold buckle and on the purse mounting in the same.

26. Reproduced by Millar in colours which represent fairly accurately the original, as the frontispiece to his monograph. Also in the Lindisfarne facsimile. All the opening decorative and text pages, the Evangelists, and the Canon Tables are excellently reproduced in colour in this monumental publication, as are also the two miniatures in the related *Codex Amiatinus* (plates 21 and 24 of vol. II).

27. On other folios this is not always true. Cf. fol. 95 (Plate 5) where the knotted interlace in both initial and border is painted over in solid blocks with considerable loss of delicacy and brilliance.

28. The most noticeable of these symmetrical elements are the C-scrolls of the ribbons in groups of four within the cross. C-scrolls are also used in the trumpet patterns in Durrow, but with less perfect symmetry.

29. So also the other symbols, with the possible significance of suggesting the source of the Evangelist's inspiration.

The meaning of the head peeping from behind the curtain is not clear. In the earliest surviving picture of a seated Evangelist (a sixth-century Gospel Book now in the Cathedral of Rossano, Calabria) a female figure, usually interpreted as an allegorical representation of Divine Wisdom, is holding out a book to the Evangelist Mark in a similar manner as in Lindisfarne. Reproduced A. Muñoz, *Il codice purpureo di Rossano* (Rome, 1907), plate XV. It seems possible that the Matthew miniature may be following such a prototype. For another explanation of its source in an ivory panel carved with the legend of St Mark (now in the Museo Archeologico, Milan), see Carl Nordenfalk, 'Eastern Style Elements in the Book of Lindisfarne', *Acta Archaeologica*, XIII (1942),

161. Bruce-Mitford (Lindisfarne facsimile, 162 ff.) explains the third figure as representing Christ, 'the earliest surviving iconographical record of the special association of Christ with Matthew'. It was copied he thinks from a sixth century original brought to Wearmouth–Jarrow from South Italy. See note 31.

30. Florence, Biblioteca Laurenziana, MS. Amiatinus 1, *c.* 700. Presented at the close of the ninth century to the Monastery of Monte Amiata, near Siena. It was one of three manuscripts ordered to be written by Ceolfrid, Abbot of Jarrow, 690–716, and was the one chosen by him for presentation to the Pope in Rome.

31. Burkitt describes the text of the *Codex Amiatinus* as perhaps that approved by Cassiodorus for his monks at Vivarium in South Italy. F. C. Burkitt, 'Kells, Durrow and Lindisfarne', *Antiquity*, IX (1935), 34. According to Burkitt, the Lindisfarne text was not copied from *Amiatinus* but, like *Amiatinus*, from a parent manuscript brought from South Italy, of which Durham A.II.17 has preserved nine leaves. *Op. cit.*, 36. The whole problem of the sources of the *Amiatinus* Ezra and the Lindisfarne Evangelists is fully dealt with by Bruce-Mitford in the Lindisfarne facsimile, II, 142–73, with a summary on 172 f.

32. On fol. 796 verso of the *Codex Amiatinus* is a Majesty in a poor linear style which also was copied perhaps from some Continental miniature of this subject. (Reproduced Kendrick, *Anglo-Saxon Art*, plate XLII.)

The other three Evangelist pictures in Lindisfarne have no relation to the Matthew, and it is conjectured that they were derived from lost prototypes which may be represented in two surviving pictures out of four originally in a Gospel Book in Copenhagen (Gl. Kgl. Saml. 10 2°). This manuscript is dated *c.* 975–80 and the style is Winchester (see Chapters 2 and 3). The Copenhagen Evangelists have always been thought to be copies of the Lindisfarne miniatures. Reproduced Lindisfarne facsimile, II, plates 22d and 23a; discussed 149 ff.

33. Reproduced E. Heinrich Zimmermann, *Vorkarolingische Miniaturen* (Berlin, 1911), plate 221. See also pp. 124 ff. and 259 ff. Folios 103–11 are a fragment of an earlier Gospels. See note 31 above.

34. The animal head is the long-nosed biting type as in Durrow (Plate 1). An interesting feature which perhaps points to the intermediate chronological position of this manuscript between Durrow and Lindisfarne is the bird heads in the whorls which could easily have developed out of the Durrow

geometric whorl, as on fol. 3 verso (Plate 3D). A similar bird head with biting beak joined to a body with wings, constitutes one of the characteristic motifs of Lindisfarne, as on fol. 26 verso (Plate 4). Cf. also Millar, *op. cit.*, 22.

p. 16 35. The cloisonné-like treatment of the feathers and the staring faces are close to the St Matthew symbol of Durrow, but the striped draperies suggest the Chad Evangelists. See below.

36. Perhaps written in Wales; it was in the church at Llandaff in the early eighth century and at Lichfield from the tenth century. Lowe, *op. cit.*, No. 159. Page 5 is reproduced in Zimmermann, plate 245b.

p. 17 37. Notably St Gall MS. 51, the Book of Kells, and others.

38. Paris, Bib. Nat. MS. lat. 9389. The Abbey of Echternach was founded in 698 by Willibrord, the second English missionary to Friesland. He was of English birth but educated in Ireland. The manuscript is clearly the work of a Hiberno-Saxon scribe and illuminator, and shows no evidence of Continental influence. Masai, *Essai*, 133, dates this manuscript between Durrow and Lindisfarne, i.e., *c.* 710; Nordenfalk places it shortly after Durrow, i.e. before or about 700. Carl Nordenfalk, 'On the Age of the Earliest Echternach Manuscripts', *Acta Archaeologica*, III (1932), 57–62.

39. Page 219 of the Lichfield Gospels contains all four symbols (reproduced Zimmermann, plate 245a). The calf, symbol of Luke, is exactly as in the Evangelist portrait but turned sidewise as though standing on its hind legs. The other Echternach symbols are reproduced *op. cit.*, plates 255b and 256. The lion is reproduced in colour in Grabar and Nordenfalk (1957), 112.

40. Bede, *op. cit.*, Book IV, Chapter XVIII, 257 ff., and n. 3.

p. 18 41. Folio 81 verso, reproduced Zimmermann, plate 247.

42. In Northumbrian sculpture of the seventh to eighth century, such figure types are even more strikingly rendered. Especially the Ruthwell Cross (early seventh century) shows the influence of figure art such as that brought in by Benedict Biscop. See Kendrick, *Anglo-Saxon Art*, 119 ff., on this 'Anglo-Saxon Renaissance'. Another suggestion as to the origin of the figures on the Ruthwell Cross and also of the Evangelists of Northumbrian manuscripts is the influence of Romano-British sculpture. Fritz Saxl, 'The Ruthwell Cross', *Jnl Warb. and Court. Insts*, VI (1943), 1–19.

43. Camb., Corpus Christi Coll., MS. 286, still dated by most recent writers in the sixth century, probably not earlier than the latter half of the century. A recent study of this manuscript with many plates (some in colour) has been published by F. Wormald, *The Miniatures in the Gospels of St Augustine* (Cambridge, 1954). The manuscript contains two miniatures: fol. 125, twelve gospel pictures from the Passion of Our Lord; fol. 129, the Evangelist Luke seated under an arch containing his symbol, and flanked by a series of six gospel scenes on each side. The technique though linear is based on antique representational style such as is found in early Christian manuscripts, like the Rossano Gospels of the sixth century. Cf. A. C. Haseloff, Review of Muñoz, *Il codice purpureo di Rossano ...*, *L'Arte*, X (1907), 468.

44. This technique certainly does not come from St Augustine's Gospels, however early this may be dated, though some details of the David miniature resemble it, e.g., the rendering of the throne and cushion, the arch filled with decorative patterns and the plant motifs on each side of the arch. In place of the gospel scenes between the columns flanking the throne, the Psalter miniature uses a flat panel of decoration bordered by plain bands. All sense of space has of course been lost in the Psalter, as in the Gospels.

45. Traced by Brøndsted to Merovingian manuscripts, *op. cit.*, 100 ff.

46. A book cover of the seventh century at Stonyhurst College has as a central motif a similar type of acanthus spray stylized and much simplified. Reproduced Kendrick, *Anglo-Saxon Art*, plate XLIII, figure 1. The plant ornament on the Ruthwell and Bewcastle Crosses is the vine used in a running scroll pattern and was probably introduced from the Near East. See Brøndsted, *op. cit.*, 35–42.

47. In Carolingian manuscripts, the Sacramentary of Drogo is probably the earliest example, dated mid ninth century. On the schools of Carolingian illumination see Adolph Goldschmidt, *German Illumination*, I (New York, 1928), and Amédée Boinet, *La Miniature carolingienne* (Paris, 1913).

48. MS. A. 135. According to an inscription on fol. 11, it was bought by the ealdorman Ælfred from some pagans, who almost certainly had stolen it, and presented by him to St Augustine's Abbey, Canterbury. Brøndsted says *c.* 775, on the basis of vine patterns and early Carolingian ribbon; *op. cit.*, 123.

49. Reproduced in colour by Grabar and Nordenfalk *op. cit.*, 123. Only one other Evangelist minia-

ture survives, John on fol. 150 verso (reproduced Zimmermann, plate 283). There are four leaves of Canon Tables under arches (fols 5–8); on fol. 6, busts of the four Evangelists appear in the two capitals and bases of the columns (*op. cit.*, plate 280).

50. Perhaps part of a Bible of St Gregory. See M. R. James, *Anc. Lib. Cant. and Dover*, LXV.

51. Zimmermann, plate 290.

52. *Op. cit.*, plate 292c.

53. It has been suggested that this leaf and fol. 30 with a full-page miniature of Mark framed by an acanthus border both may be late ninth-tenth century additions, Sir George Warner and J. P. Gilson, *Cat. of Western MSS in the Old Royal and King's Collns* (London, 1921). Kendrick, however, dates the whole manuscript tentatively to the time of Archbishop Wulfred (805–32) but attributes it to Mercia, *Anglo-Saxon Art*, 162. Carolingian influence in the figure of the Evangelist is evident. For the relation of this manuscript to the Book of Cerne, see below, p. 25.

54. Kendrick calls this manuscript Mercian also, *op. cit.*, 168.

55. Other Evangelists are reproduced by Zimmermann, *op. cit.*, plates 297, 299, and 300.

56. Saxl compares the St John with the portrait of Virgil in Vat. MS. lat. 3867, Saxl and Wittkower, *op. cit.*, plate 6, e and f, and page 19.

57. According to Zimmermann, 101 ff., the manuscript is not found in the earliest St Gall catalogue, *op. cit.*, 240.

58. Page 6 of the manuscript; reproduced *op. cit.*, plate 187a. See also Duft and Meyer, *Irish Miniatures in St Gall*, with good colour reproductions of this page (plate III) and many others.

59. Zimmermann, pages 2, 128, 208; reproduced *op. cit.*, plates 189 and 191a. Duft and Meyer, plates V, VII, and XI.

60. Paris, Bib. Nat., MS. Nouv. Acq. 1203; reproduced Goldschmidt, *op. cit.*, plate 25. It is interesting to note bands of knotted interlace in the border of the page, very similar to those on the St Gall manuscript page.

61. Reproduced Zimmermann, plate 188. Also Duft and Meyer, plates XIII and XIV.

62. Henry, *Irish Art*, 149. Zimmermann dates it much earlier, in the beginning of the eighth century, *op. cit.*, 234. Masai dates it late eighth century, *op. cit.*, 133. Kendrick dates it by implication *c.* 800, *Anglo-Saxon Art*, 147. The most precise stylistic and iconographic evidence for dating the Book of Kells is

given by Friend, 'The Canon Tables of the Book of Kells'. Friend places the greater part of the illumination between the years *c.* 795 and 806 (*op. cit.*, 639). He explains the beast Canon pages as copies from a Carolingian model of the Ada School, which was perhaps also copied by the artist of the Carolingian manuscript Harl. 2788 in the British Museum. Luce (Durrow facsimile, II, 43 ff. and footnote 127) finds no basis for assuming that the Book of Kells was begun at Iona. The unfinished state of the Canon Tables may have been a feature of the exemplar from which they were copied.

63. Henry distinguishes at least four, *Irish Art*, 144 ff.

64. The original is not generally available for examination but a facsimile of the manuscript has been published: Alton and Meyer, *Codex Cenannensis, The Book of Kells*, with many colour plates and a text volume containing a study of the ornament (III, 27–52). Many pages are reproduced by Robinson, *Celtic Illuminative Art*, plates XI–LI. See also Sullivan, *The Book of Kells*.

65. For a detailed discussion of this important motif in English ornament see Brøndsted, *op. cit.* Two examples of the Kells vine scroll are reproduced *op. cit.*, figure 71.

66. Bruun describes this and other like motifs as phyllomorphic innovations in Kells, *op. cit.*, 21 ff. Robinson identifies these trilobed forms as 'pendent bells attached to the flabellum, similar to those in use in the Coptic Church for protecting the Eucharistic elements', *op. cit.*, plate XIII. As used on plate 6B of this book they certainly are meant to be the flowers or fruit of a growing vine.

67. Cf. Friend, *op. cit.*, plates XX and XXI.

68. Reproduced in colour, Alton and Meyer, *op. cit.*

69. See *The Rabula Gospels*, facsimile edition of the miniatures of the Syrian Manuscript Plut. 1, 56 in the Medicean-Laurentian Library, ed. and commented by C. Cecchelli, G. Furlani, and Mario Salmi (Olten and Lausanne, 1959). The Betrayal of Christ is on fol. 12 and is reproduced in colour.

70. Alton and Meyer, *op. cit.*, reproduction in colour.

71. Josef Strzygowski, 'Das Etschmiadzin-evangeliar', *Byzantinische Denkmäler*, I (Vienna, 1891), plate IV. For an interesting suggestion of the Egyptian Isis and Horus as a prototype, see H. Rosenau, *Burl. Mag.* LXXXIII (1943), 228–31.

71a. The first three letters (chi rho iota) of the word Christi spelt in Greek, from which the page is called the Chi Rho page. See also Plate 12.

p. 22

p. 23

p. 24 72. Robinson suggests that this little scene may be an allusion to unworthy receivers of the Eucharist and the impending judgement awaiting them, *op. cit.*, plate XL.

73. See Henry, *Irish Art*, 150–3, with bibliography and references to reproductions.

74. Kendrick, *Anglo-Saxon Art*, 147.

75. The other three Evangelists, fols 50 verso, 79 verso, and 124 verso (Zimmermann, plates 313b and 314) have heads of the same type, and similar poses. Only the Matthew page has been completed with the patterned border. Zimmermann places this manuscript in the South English group, *op. cit.*, 140 ff.

p. 25 76. *Anglo-Saxon Art*, 165.

77. Herbert, *Illuminated Manuscripts*, 85, identifies Ethelwald as the Bishop of Lindisfarne (724–40). Zimmermann (*op. cit.*, 295) says there was a Bishop Ethelwald in Cerne in the eighth century. It is not known when the manuscript was at Cerne Abbey (Dorsetshire). See also Kuypers, *The Book of Cerne*, pp. xii–xiv.

78. The pen drawing of the ox in the margin is a late copy by an even less expert artist.

79. Kendrick, *op. cit.*, plate 68.

80. Zimmermann, plate 293.

CHAPTER 2

p. 28 1. See *Liber Vitae: Register and Martyrology of New Minster and Hyde Abbey*, ed. by Walter de Gray Birch. Hampshire Record Soc. (London, Winchester, 1892), p. ix and n. 4. For the most recent study of the life of Grimbald see Philip Grierson, 'Grimbald of St Bertin's', in *English Historical Review*, LV (1940), 529–61.

p. 29 2. See Ker, *The Pastoral Care* (facsimile).

3. Especially fol. 43 (reproduced Zimmermann, *op. cit.*, plate 293) which differs from other more Celtic decorative forms as on fol. 32 (reproduced on the same plate).

4. Two other examples of the animal style are found in the Durham Ritual (Durham Cath. Lib., MS. A.iv.19) late-ninth or early-tenth century, and Bod. MS. Auct. F.4.32. Initials from both manuscripts are reproduced in Plates II and III of Wormald's excellent study, 'Decorated Initials in English Manuscripts'. (The initial from MS. Auct. F.4.32 is labelled in error MS. Hatton 60.) See also *New Pal. Soc.* I, plate 82. To this manuscript, the fine drawing of

Christ and St Dunstan was added later (see p. 32).

The development of decorated initials in English manuscripts cannot be pursued in detail here. In addition to the article just cited, a good discussion will be found in Kendrick's *Late Saxon and Viking Art*. One other early manuscript should be mentioned, however, in connexion with the survival of the South English-Mercian animal ornament, that is, Royal MS. 5 F. iii in the British Museum, a copy of Aldhelm's *De Laude Virginitatis*. The initials (see Wormald, 'Decorated Initials', plate IIIc), though related to the two Bodleian manuscripts mentioned above, show evidence of Continental influence, perhaps of the School of Metz, as in the Sacramentary of Drogo (Boinet, *La Miniature carolingienne*, plates 86–90). This same Continental source will be referred to again later on in this chapter.

5. A new thesis on the rôle played by this Anglo-Saxon decoration in the development of Scandinavian style of the eleventh century (the so-called Ringerike style) has recently been presented with many illustrations in an important study by Wilhelm Holmquist, 'Viking Art in the Eleventh Century', *Acta Archaeologica*, XXII (1951). This article will be referred to further in reference to particular English manuscripts of this period.

6. Reproduced and discussed in a booklet, entitled *The Alfred and Minster Lovell Jewels*, published by the Department of Antiquities, Ashmolean Museum, Oxford, 1948; see also Kendrick, *Anglo-Saxon Art*, 216 ff. and plate 101. The association of the jewel with Alfred is still controversial.

7. And therefore closer in date to the Chad Evangelist? On the possible Continental source of the enamel, see Saxl and Wittkower, *op. cit.*, 19, figures a and c. On a possible Coptic source for the two flowering rods, see O. M. Dalton, 'A Note on the Alfred Jewel', *Proc. Soc. Antiq.*, 2nd series, XX (1904), 71 ff.

8. Particularly the silver mounts for a drinking horn from the treasure deposited c. 875 at Trewhiddle, Cornwall. Kendrick, *Anglo-Saxon Art*, 185, plate 78. Brøndsted discusses the style in detail and reproduces many more examples, *op. cit.*, 127 ff. and 149 ff. For the most recent study of this material see David M. Wilson and C. E. Blunt, 'The Trewhiddle Hoard', *Archaeologia*, XCVIII (1961), 75–122, with many illustrations.

9. As on the mounts from the great shield. *Provisional Guide*, plate IV.

10. Brøndsted calls it vine, but the stylized curling leaves rather suggest the acanthus.

11. Inscriptions embroidered on the ends of both vestments record the fact that Ælfleda (second wife of King Edward the Elder, son and successor of Alfred) ordered them for Frithestan, Bishop of Winchester (909–31). Ælfleda died in 916, hence the work must have been begun and perhaps was finished between 909 and 916. For a description and complete reproduction of the embroideries, see Baldwin Brown and Christie, 'St Cuthbert's Stole and Maniple at Durham'. An exhaustive study of the embroideries with illustrations (two in colour) and much comparative material is included in Battiscombe, *The Relics of St Cuthbert*, 375 ff. The technique is discussed by Elizabeth Plenderleith; the iconography and style by Christopher Hohler and R. Freyhan.

12. Cf. the First Bible of Charles the Bald, Paris, Bib. Nat., MS. lat. 1, fol. 192 verso – a prophet standing on conventional clouds or rocky ground, holding a scroll. Reproduced Wilhelm Koehler, *Die karolingischen Miniaturen: Tours* (Berlin, 1930), plate 87b.

13. Cf. also Saxl and Wittkower, *op. cit.*, 19, n. 8, where a figure of Christ from MS. gr. 510 in the Bibliothèque Nationale, Paris, is compared with a prophet on the stole. Freyhan sees no Carolingian influence in the figures (therein disagreeing with Kendrick, *Anglo-Saxon Art*, 218) but finds the closest parallels to the prophets on the embroideries in the late ninth century group of manuscripts 'around the Paris Codex' (i.e. Bib. Nat., cod. gr. 510) and the Vatican *Indicopleustes* (Vat. cod. gr. 699). *Relics of St Cuthbert*, 423.

14. Especially those of the School of Tours: First Bible of Charles the Bald (Paris, Bib. Nat., MS. lat. 1), fols 327, 327 verso, and 387 (Koehler, plates 83, 84, and 87e). Here also Freyhan (*op. cit.*) differs. He finds that the ornament (which he describes as a tree-like motif) is derived from Sassanian sources and developed in Byzantine textiles in the ninth century. In the opinion of the present writer there is no reason why these sources need be mutually exclusive in respect to both figures and ornament in the embroideries. The further development of this decorative style at Winchester in the late tenth century is traced by Freyhan (423–32), thus strengthening the assumption that the embroideries were made there. On Anglo-Saxon vine scroll ornament, see E. Kitzinger, in *Antiquity*, x (1936), 61 ff.

15. The technique is described in detail by Mrs Christie in the article cited in note 11 above.

16. Durham Cath. Lib., MS. A.iv.19. Mynors, *Durham Cath. MSS.*, 25; Wormald, 'Decorated Initials', plate IIc.

17. One of the best is reproduced, *op. cit.*, plate IId. The colours are red, yellow, and blue.

18. *Op. cit.*, 116. The P is reproduced on plate IV, a. The motifs consist of short acanthus leaves arranged horizontally within the loop of the letter, and a vine with grapes running vertically in the upright shaft. Holmquist, *op. cit.*, 29 and figure 25.

19. The book was afterwards given by Æthelstan to Christ Church, Canterbury (James, *Anc. Lib. Cant. and Dover*, xxv) and is now in the British Museum, Cott. MS. Tib. A.ii. The Evangelist Mark (fol. 74 verso) and some ornamental text are reproduced in colour by J. O. Westwood, *Paleographia Sacra Pictoria* (London, 1843–5), plate preceding p. 99. The style of three of the miniatures (Mark, Luke, and John) is that of the Reims School, but the manuscript was written for use in the Abbey of Lobbes in the diocese of Liège. J. A. Robinson, *The Times of St Dunstan* (Oxford, 1923), 60. p. 31

The belief that this manuscript was one of two books on which Anglo-Saxon kings took oath at their coronation has recently been shown by Wormald to be without foundation. See 'The So-Called Coronation Oath-Books of the Kings of England', *Essays in Honor of Georg Swarzenski* (Chicago, 1952), 233 ff.

20. See Wormald, 'Decorated Initials', 115. The ornament consists solely of animal heads and interlace, no acanthus; the initials were apparently unaffected by the Franco-Saxon initials in the Continental part of the book.

21. According to a sixteenth-century inscription. See Millar, *Eng. Illum. MSS I (X to XIII Century)*, 2.

22. Cf. Christ in Majesty in the Godescalc Gospels, the earliest of the Ada group. Goldschmidt, *German Illum.*, I, plate 25.

23. James, *Anc. Lib. Cant. and Dover*, 529.

24. Cf. Vienna, Nationalbib., Cod. 652 (theo. 39), a copy of Rabanus Maurus with a miniature showing the presentation of the book to Gregory as in Trin. Coll. MS. B.16.3. The Vienna manuscript came from St Stephen's monastery, Fulda, and dates from between 831 and 840. Goldschmidt, *German Illum.*, I, No. 55A.

25. The text is composite and was written partly on the Continent, partly in Wales. See Hunt, *St Dunstan's Classbook*.

26. Dunstan is garbed as a monk and not as a prelate, and this may (but need not) indicate a date p. 32

before 959 when he became Archbishop of Canterbury. A later inscription above the drawing attributes both picture and writing to Dunstan's own hand. There is no basis for this attribution. Hunt (*op. cit.*, vii) says: '... the drawing, the text, and the scripts are consistent with a date in the life of St Dunstan'.

p. 32 27. It needs hardly to be explained that artists of this period show no evidence of working from living models, even in so-called portraits.

28. See Saxl and Wittkower, *op. cit.*, plate 20, No. 8. See also Wormald, *Eng. Drawings*, No. 46.

29. See *New Pal. Soc.*, Series I, plate III; Wormald (*Eng. Drawings*, No. 54) dates the manuscript 992–5. Leroquais dates it between 960 and 998. *Les Pontificaux Manuscrits des bibliothèques publiques de France* (Paris, 1937), No. 93.

30. Kendrick (*Late Saxon Art*, 45) notes the closeness of the drapery to that of a tenth century ivory Christ on the Cross in the Victoria and Albert Museum, thought to be Winchester work. Reproduced, M. H. Longhurst, *English Ivories* (London, 1926), frontispiece in colour. One notable difference between the three miniatures and the ivory is the succession of pointed folds below the waist in the manuscript.

31. There is a striking similarity between these angels and two carved angels in the Saxon church at Bradford on Avon, which are dated by Kendrick *c.* 950; *Late Saxon Art*, 220 and plate 103. Kendrick calls them 'exercises in a new linear style of such an airy lightness and grace that we know them to be connected with the figure drawings on the Cuthbert stole and in later manuscripts of the developed Winchester style'. The carved angels are even closer in drawing and in conception to those in the Paris Crucifixion. In this connexion the stylistic relationship between Mary and John of the Crucifixion and the figures of the Cuthbert stole and maniple (plate 18) cannot be mistaken. However, in the drawings the drapery patterns, especially the edges, are lighter and richer than in the vestments, and their relation to the body is more marked as in the sculptured angels.

p. 33 32. For reproductions, see Wormald, 'Decorated Initials', plate IV. He describes these initials as portions of inhabited acanthus scrolls as found in Cambridge, Corpus Christi MS. 183, 'snipped off' and twisted into initial form. See *New Pal. Soc.*, second ser. (1913–30), No. 62. A sister manuscript in respect to the designs of the initials, which are uncoloured, is the Helmingham Hall *Orosius*, now Brit. Mus.,

Add. 47967. A facsimile edited by Alistair Campbell forms volume three of the series Early English Manuscripts in Facsimile (1953).

33. Kendrick, *Late Saxon Art*, 35; Wormald, 'Decorated Initials', 110. The calendar was added after Dunstan's death (988) as is shown by the inclusion of his feast. This calendar has been identified as of Glastonbury origin, with Canterbury modifications. See Abbot F. A. Gasquet, and Edmund Bishop, *The Bosworth Psalter* (London, 1908). On the relation of the initial style to the Scandinavian Jellinge stone, see Holmquist, *op. cit.*, 7 f. and figures 4–5.

34. On the dating, text, and other details, see p. Warren, *The Leofric Missal*. See also Madan, *Summary Cat.*, No. 2675.

35. Wormald, *Eng. Drawings*, No. 49.

36. The Reims style came to Canterbury via the Utrecht Psalter, probably in the very late tenth century, but there is no known connexion between the Leofric Missal and Canterbury. Its style, therefore, may have come from parallel Continental sources affected by the Reims style.

37. G. F. Warner, *Illum. MSS in the British Museum*, plates 7 and 8. Both initial and Crucifixion are reproduced in colour. See also Holmquist, *op. cit.*, figures 12–15.

38. The evidence is the very rare division of Psalm 77 at verse 44, which occurs in only three other psalters between 950 and 1100, all of which are Winchester books. See C. and K. Sisam, *The Salisbury Psalter*, Early English Text Society (Oxford, 1959), 5, n. 3. Evidence presented earlier for a Ramsey Abbey provenance is now questioned. See Niver, 'The Psalter in the British Museum, Harley 2904'.

39. Another miniature very similar in style to the p. Crucifixion, representing Christ between St Gregory and St Benedict, is now inserted in a book of sermons by St Gregory, MS. 175 in the Bibl. Mun. at Orléans. The manuscript was written at Fleury but the miniature may have been produced at Winchester or Ramsey. At any rate, no miniature of comparable style or quality survives from Fleury. Reproduced in Rickert, *La miniatura inglese*, I, plate 15.

40. Wormald is now of the opinion that this p. manuscript may be later than 966, or any time before Æthelwold's death in 984. Its form and wording seem to be more those of a commemoratory document than a genuine royal diploma. This view was put forward by Wormald at the Art Historical Con-

gress held in New York in 1961. It has not yet appeared in print.

41. Formerly at Chatsworth, now Brit. Mus., Add. MS. 49598. A monograph on this manuscript was published for the Roxburghe Club by Warner and Wilson, *The Benedictional of Saint Æthelwold*. The text and drawings of all the miniatures were published by Gage, 'St Æthelwold's Benedictional'. The manuscript is treated in all discussions of early English illumination. See especially Homburger, *Die Anfänge der Malschule von Winchester im X. Jahrhundert*. In a recent publication on the Benedictional Wormald reproduces eight miniatures in colour. He discovered some strips of vellum in the binding containing part of a list of Hyde Abbey relics which attest possession of the Benedictional by Winchester. He also determined the number and subjects of the miniatures now missing in the Benedictional.

42. Homburger, *op. cit.*, 10 ff.

37 43. Such as the Gospels from Lorsch, miniatures from which were copied in a Reichenau manuscript shortly before 969 (Sacramentary of Gero, Darmstadt Landesbib., Cod. 1948). Reproduced Goldschmidt, *German Illum.*, II, plates 17 and 18. A similar Carolingian prototype may have been present at Winchester.

44. The curious 'padded' fold at the hem of the Virgin's gown (seen also on fols 51 verso and 64 verso of the Benedictional) is found in another Reichenau style manuscript, the single leaf of a *Registrum Gregorii* (Chantilly, Musée Condé). Reproduced, *op. cit.*, plate 8; this manuscript was made at Trèves in 983. Other Reichenau manuscripts use the acanthus frame border also, as the Gospels of Poussay (Paris, Bib. Nat., MS. lat. 10514), of the last quarter of the tenth century. Reproduced, *op. cit.*, plate 22.

38 45. Tolhurst, 'Two Anglo-Saxon Manuscripts of the Winchester School', 41 ff.

46. On the grounds of liturgical evidence. See H. A. Wilson, *The Benedictional of Archbishop Robert*, Henry Bradshaw Society, XXIV (London, 1903).

47. A seventeenth century inscription records the ownership of the Rouen manuscript by Robert, Archbishop. There is still some controversy as to whether this was Robert, Archbishop of Rouen (990–1037), or Robert of Jumièges, Archbishop of Canterbury (1051–2), who owned the Missal (Rouen Y.6). On stylistic grounds, it hardly seems possible that the Rouen Benedictional can be far removed in origin from the Æthelwold manuscript. Leroquais notes that the manuscript definitely was made for Winchester and not for Rouen, and that probably it was given by Robert of Jumièges together with the Missal to the Cathedral of Rouen. *Les Pontificaux Manuscrits (op. cit.)*, No. 189.

48. The evidence, according to Millar (*op. cit.*, 74) is twofold: the manuscript was given to Trinity College by Thomas Nevile, Dean of Canterbury, among many others which came from Canterbury; and the initial I (fol. 59 verso, reproduced plate 15) is of a type not found in Winchester books, but common to Canterbury. Kendrick also assigns the Gospels to Canterbury: *Late Saxon Art*, 16.

The Winchester style of miniature and border may have been introduced into Canterbury during the archbishopric of Æthelgar who was Abbot of New Minster 965–77 and succeeded Dunstan as Archbishop of Canterbury in 989. See Millar, *op. cit.*, 75.

49. That is, a decorative initial letter containing p. 39 a figure subject, as distinguished from decorative human and animal figures without iconographic meaning. The historiated initial was a fundamental feature of English illumination even as late as the fifteenth century (see Chapter 8). The earliest known examples are found in the Canterbury Psalter, Cott. MS. Vesp. A.i.

50. Tolhurst, *op. cit.*, 27–41. Evidence for the dating is the absence of the mass for St Alphege who was martyred in 1012 and in 1023 was translated at Canterbury. Earlier it had been assigned to Peterborough on the basis of the calendar. See Atkins, 'An Investigation of Two Anglo-Saxon Calendars'. For the text of the Missal, see H. A. Wilson, *The Missal of Robert of Jumièges*, Henry Bradshaw Society, XI (London, 1896).

51. For reproduction in colour, see Rickert, *op. cit.*, I, plate II. Homburger, *op. cit.*, 68, suggests the possibility of a translation from painting to linear technique which parallels that in the Utrecht Psalter but is independent of its influence. Cf. on this point, Saxl and Wittkower, *op. cit.*, 30 ff., illustrating this stylistic translation from the Carolingian MS. Harl. 647 into the English MS. Harl. 2506 containing the same text. See below, note 59. Harl. MS. 2506 is comparable in quality and in technique to Harl. 2904 and could be by the same artist.

52. The evidence, which rests mainly on the inclusion in the manuscript of a copy of a charter connected with Reculver Monastery, near Canterbury, which was dissolved in 949, is discussed by Walter de Gray Birch, *The Utrecht Psalter* (London, 1876). The Utrecht Psalter is reproduced in facsimile by E. T. De Wald (Princeton University

Press, n.d.). The manuscript is fully treated in every study of Carolingian illumination. For its relation to the English copies, see Birch, *op. cit.*, chapter III.

p. 40 53. Millar, *op. cit.*, plate 22; see also Wormald, *Eng. Drawings*, No. 34.

54. Cf. De Wald, plate VI.

55. Reproduction in colour, Rickert, *op. cit.*, I, plate I.

56. Compare fol. 56 verso (Plate 33) and fol. 64 verso of the Utrecht Psalter: reproduced De Wald, *op. cit.*, plate CI.

57. A study of the variations of style in the Utrecht Psalter itself (which certainly is not all by the same hand) is beyond the scope of this book, but two points should be noted. The Anglo-Saxon artists of Harl. 603 who copied the model most closely (fols 1–27 verso and 50–7) reflect differences in style in the originals (cf. fol. 4, plate 32 and fol. 21, and De Wald, plates VI and XXXIV). And secondly, certain miniatures in the Utrecht Psalter have been partially retouched in a style very suggestive of the Anglo-Saxon copy. E.g. fol. 24 (De Wald, plate XXXVIII). This kind of sharpening of the line is different from the shading in ink done in whole sections of the Utrecht Psalter (as fols 30–4) which De Wald notes. The shaded retouching is in the style of the Reims School. Some of the linear retouching may have been done by the Anglo-Saxon copyist, and may explain the almost unbelievably close correspondence between the original and the copy.

58. Manuscript Jul. A.vi was in Durham in the fifteenth century: Mynors, *op. cit.*, No. 21. Herbert thought this manuscript was copied from a French original in Northumberland. Herbert, *op. cit.*, 114. Many miniatures in the Utrecht Psalter, as in Harl. 603, however, contain similar occupational scenes, and as far as subject goes, the scenes illustrating the calendar could have been derived from this source. Cf. Wormald, *Eng. Drawings*, plate 2. No earlier 'occupational' calendar is known in England.

59. The main part of the text and its illustrations including the calendar pictures were copied from a Carolingian manuscript of Cicero's *Aratus* (Harl. 647 in the British Museum). The calendar of Tib. B.v. has affinities with that of Winchester, and Saxl thought the illustrations were painted in Wessex (cf. Saxl and Wittkower, *op. cit.*, 30). According to Ker, the text was 'written in some important centre, perhaps Winchester, since Swithin is the only name in capitals in the list of Bishops'. N. R. Ker, *Catalogue of Manuscripts containing Anglo-Saxon* (Oxford,

1957), No. 193. The prototype is known to have been in Canterbury from the late tenth century. Harl. 2506 is another copy of the same work with illustrations in the fine monumental style of Harl. 2904.

60. A psalter written in two columns, in Latin p. 4 and Anglo-Saxon (Paris, Bib. Nat., MS. lat. 8824), has the spaces at the ends of the Latin verses on fols 1–6 filled in with thirteen small drawings illustrating the text. They were evidently done by the scribe while writing. The style is that of the Utrecht Psalter, but there is evidence (in missing pages) that there were originally also eight full-page miniatures, probably with borders. A stub of a leaf between folios numbered 26 and 27 shows a minute fragment of Winchester decoration. The date is given by Wormald as between 1023 and 1050. See Colgrave, *The Paris Psalter*, 15. This manuscript once belonged to the Duc de Berry (cf. fol. 186). There is no internal evidence of provenance, but Sisam (*op. cit.*, 48) calls it south-western. For a discussion of the manuscript see also V. Leroquais, *Les Psautiers manuscrits latins des bibliothèques publiques de France* (Macon, 1940–1), No. 323.

61. James (*Anc. Lib. Cant. and Dover*, p. lxxxiv) identified it with a Genesis in English listed as No. 95 in the Medieval Catalogue of St Augustine's (fol. 3, col. 2), *op. cit.*, 201. Millar, *op. cit.*, 80, and Kendrick, *Late Saxon Art*, 24, accept the St Augustine provenance.

62. Fol. 114 verso is reproduced in colour, Grabar and Nordenfalk, *op. cit.*, 181.

63. Homburger, *op. cit.*, 70, n. 1, questions the Winchester origin of this manuscript on the grounds that the letter from Fulk, Archbishop of Reims, recommending the monk Grimbald to King Alfred (which connects the manuscript with Grimbald's name) is a late eleventh century copy and therefore was inserted later. See also Grierson, *op. cit.*, 547 f. The style of the manuscript is certainly right for Winchester and Wormald does not question its provenance, though its date (*c.* 1020) makes it too late for Grimbald, who came to Winchester as early as 893 and died there in 901.

64. The head and symbol of Matthew are repro- p. duced by Kendrick, *Late Saxon Art*, plate VII; the text page, plate VI. The Mark picture is missing and perhaps was never included, since the text of Matthew ends on fol. 45 and that of Mark begins on the verso of this same leaf.

65. A very similar figure is found in the initial Q (fol. 70) of Royal MS. 1 D. ix decorated at Canterbury

in Winchester style. See plate 28B. The angels, however, and the Majesty figures seem to be inspired by Vesp. A.viii; the three similar figures of the Trinity are found in the Dunstan pontifical (Paris, MS. Lat. 943).

66. A gospel book of *c.*1000 in the library of York Minster has three surviving Evangelist pictures which are close in style to those in the Grimbald Gospels. Its place of origin is unknown. See J. P. Gilson, *Description of the Saxon Manuscript of the Four Gospels in the Library of York Minster* (York, 1925). The Evangelist Mark is reproduced in colour, Oakeshott, *op. cit.*, plate 16. See also Wormald, 'The Survival of Anglo-Saxon Illumination', 3 ff.; he dates it late tenth century.

67. See W. de Gray Birch, 'On Two Anglo-Saxon Manuscripts', *Roy. Soc. of Lit. Trans.*, Series II, xi (1878), 463–512.

68. The Last Judgement on fols 6 verso–7 seems to be more in the Utrecht style. Millar, *op. cit.*, plate 25b (fol. 7). See also Wormald, *Eng. Drawings*, No. 33, and plate 16.

69. Millar (*op. cit.*, 19) notes this as their first appearance in English manuscripts. On the iconography of the Trinity with the Virgin and Child, (fol. 75 verso) see Kantorowicz, 'The "Quinity" of Winchester'.

70. *Pal. Soc.*, Series II, plate 191. Wormald, *Eng. Drawings*, No. 43, dates it late tenth century. The manuscript belonged, as indicated by a pressmark, to Waltham Abbey at one time.

71. *Proc. Camb. Antiq. Soc.*, VII (1888–91), 51–7, plates X and XI. For a complete study of all the Prudentius manuscripts, see Richard Stettiner, *Die illustrierten Prudentiushandschriften* (Berlin, 1895; Plates, 1905).

72. See dedicatory verses on fol. 2 verso of the manuscript. Wormald, *Eng. Drawings*, No. 4. Goldschmidt called the drawings of Faith and Charity in this manuscript some of 'the most charming drawings mediaeval art has produced'. Adolf Goldschmidt, 'English Influence on Mediaeval Art', *Med. Studies*, II, 719.

73. Reproduced, Millar, *op. cit.*, plate 26; Brit. Mus., *Reproductions from Illuminated Manuscripts*, I, plate VII; *Pal. Soc.*, Series I, plate 190. See also H. P. Mitchell, 'Flotsam of Later Anglo-Saxon Art', *Burl. Mag.*, XLIII (1923), 104–17.

74. Herbert, however, considered it earlier, i.e. late tenth century; *op. cit.*, 111. Wormald also dates it 'late tenth century with later additions', *Eng. Drawings*, No. 24, plate 6a.

75. M. R. James, *On the Abbey of St Edmund at Bury* (Cambridge, 1895), 71. Wormald has expressed his opinion verbally that this manuscript is very early and that it certainly was imported to Bury St Edmunds.

76. See Warner, *Illum. MSS*, where the miniatures are described in detail and the *Beatus* page is reproduced in colour (plate 10). See also Wormald, *Eng. Drawings*, No. 26, plate 22. Sisam attributes the Psalter to Christ Church, before 1050 (?). *Op. cit.*, 48.

77. According to a note in the Easter Calendar. See *New Pal. Soc.*, Series II, plates 166–8. Wormald, *Eng. Drawings*, No. 56 (with bibliography), and plates 26–8.

78. Reproduced *New Pal. Soc.*, Series II, plate 166.

79. All the miniatures are reproduced by Henry Ellis, 'An Account of Cædmon's Metrical Paraphrase', *Archaeologia*, XXIV (1832), 329–40, plates lii–civ. See also Charles Kennedy, *The Cædmon Poems* (Princeton, 1916): English translation with introduction by C. R. Morey, and plates much reduced in size. For the latest and best reproduction, see Gollancz, *The Cædmon Manuscript*, a facsimile of the manuscript with a fine colour plate of page 84 as the frontispiece. Gollancz ascribes only Book I (Genesis) without the interpolations to Cædmon. *Op. cit.*, cvi.

80. Millar, *op. cit.*, 76, dates it *c.* 1000 and accepts James's identification of the manuscript as No. 304 in the Medieval Cat. of Christ Church, Cant.: James, *Anc. Lib. Cant. and Dover*, pp. lxxxviii and 51. Herbert, *op. cit.*, 118, dates it *c.* 1035 and gives Winchester as its provenance on the grounds of the portrait of Ælfwin on fol. 2, whom he identified as Abbot of New Minster 1035–57. Kendrick, *Late Saxon Art*, 104 ff., and Wormald, 'Decorated Initials', 121, date the manuscript in the second quarter of the eleventh century on the grounds of its containing Scandinavian Ringerike ornament combined with Winchester acanthus motifs.

The important study by Holmquist (see note 5 above) of the English origins of the Ringerike style, if accepted, would invalidate Scandinavian influence as a basis for dating the Cædmon late, since English manuscripts as early as the late tenth century are cited as containing ornament of the same type. Camb. Univ. Lib. MS. Ff. 1. 23 is, he says, the manuscript which furnishes 'a whole sample card of the gradual evolution of the south of England acanthus into what has hitherto been called the Ringerike style, i.e. the foliate motif of the style' (*op. cit.* 15 f., figures 9, 11, 17, 20–2). The Cambridge manuscript

p. 44

p. 45

is an early eleventh century manuscript probably 'copied more or less freely from other and better models' (*ibid.*).

Gollancz, *op. cit.*, vii ff., points out, in support of the Winchester origins of the Cædmon, a manuscript which he finds similar in style, having Winchester connexions: Rouen, Bib. Pub., MS. A.27 (368), the Llanalet Pontifical. The Rouen manuscript was noted and two illustrations of it were published by John Gage, 'The Anglo-Saxon Ceremonial of the Dedication and Consecration of Churches, illustrated from a Pontifical in the Public Library at Rouen', *Archaeologia*, xxv (1834), 235–74. See also Talbot Rice, *English Art*, plate 70a. Wormald finds no connexion between the style of the Rouen manuscript and the Cædmon and has recently expressed his opinion privately that 'the whole thing is probably a Canterbury production'. The Winchester connexion really rests on rather shaky evidence, namely the fact that there was an illuminator named Ælfwin there at about the right time. Stylistically, all the Cædmon drawings might very well be Canterbury work.

p. 45 81. Both the Vivian and the Moutier-Grandval Bibles contain similar bands of continuous narrative. See Koehler, *op. cit.*, plates 50, 69, 70, and 74.

82. Wormald says that this second artist's style 'appears to be a derivative' of that of the Leofric Missal and the Malmesbury *Prudentius* (Plate 38B). The similarities are chiefly in the drapery with its ropy folds and pleated edges, in the survival of a certain 'classical' solidity of figure forms, and in the persistent profiles. The Cædmon is certainly later, however, and much less fine in quality than the Corpus Christi College *Prudentius*.

CHAPTER 3

p. 47 1. Wormald, 'The Survival of Anglo-Saxon Illumination', 127–45.

2. Dodwell, *The Canterbury School of Illumination*.

p. 48 3. Dodwell, *op. cit.*, 6 f. For a list of the Christ Church manuscripts, see Appendix 4, 120 ff. See also Ker, *English Manuscripts after the Conquest*, 25 ff.

4. Sir Frank Stenton (ed.), *The Bayeux Tapestry*. Complete reproduction in black and white, with thirteen colour plates of details in actual size. The chapter on Style and Design is by Wormald. See also Sir Eric Maclagan, *The Bayeux Tapestry*: complete reproduction with eight plates in colour and introductory text with a summary of the evidence for its provenance and a bibliography.

4a. Dodwell, *op. cit.*, plate 2a, b.

5. F. Wormald, 'Two Anglo-Saxon Miniatures Compared', *Brit. Mus. Quart.*, IX, no. 4 (1935), 113–15. See also Wormald, *Eng. Drawings*, 45 ff.

5a. Dodwell, *op. cit.*, plate 3a, b.

6. Dodwell, *op. cit.*, 24 f.

7. Wormald attributes these folios (58–73) to his Hands E and F of the second quarter of the eleventh century. There seems to be little difference in style between these and the sketch on fol. 17 verso.

8. Boinet, *op. cit.*, plates LXXXVI–XC. p.

9. Cf. MSS Tib. C.ii and Roy. I E. vi. An assortment is reproduced by Kendrick, *Late Saxon Art*, figure 1, and their survival in the tenth century manuscripts is discussed *op. cit.*, 30 ff.

10. Reproduced *op. cit.*, plate XXVIII 2, and discussed, 31 ff.

11. Wormald, 'Survival', 136. The saints' lives are grouped according to the months in which their feasts occur. Three initials are reproduced, Dodwell, *op. cit.*, plates 16b, 35a and b.

12. Kendrick, *Late Saxon Art*, 35 ff. and plate XXXI. P Dodwell, *op. cit.*, plates 15, 16, 21a, 35c.

13. Guido Biagi, *Reproductions from Illuminated* P *MSS in the R. Medicean Laurentian Library* (Florence, 1914). *New Pal. Soc.*, Series 1, plates 138–9 (fols 1 verso, 2 verso, and 5 reproduced).

14. Dodwell, *op. cit.*, 28.

15. Reproduced Dodwell, *op. cit.*, plates 13a, 17a, 17d, 18c.

16. Niver, 'The Psalter in the British Museum, P Harley 2904', 684. The Litany indicates a date after 1031. Madan dated Douce MS. 296 before 1036 and suggested Ely for its provenance, *Summary Cat.*, No. 21870. The B of the *Beatus* in Douce 296 (fol. 9) is a thinly painted linear version of the one in the Benedictional of Æthelwold. Swarzenski finds a stylistic relationship between Douce 296 and the Anhalt Morgan Evangelists: in both there are certain Reims characteristics. 'The Anhalt Morgan Gospels', *Art Bulletin*, XXXI (1949). See note 21 below.

17. Morgan 709 has had an exceptionally interesting history. It was procured for Judith of Flanders, wife of Tostig, perhaps by Tostig's uncle Ælfwius who was Abbot of New Minster from *c.* 1063 to the Norman invasion, in which he and twelve of his monks disguised as soldiers fought and lost their lives. Judith carried the Gospel Book with her when she fled to the Continent with her husband. Later, after his death, when she married Guelph IV and

founded (1094) the Benedictine monastery of Weingarten on Lake Constance, the Morgan Gospels were among her gifts to the monks there. Thus it happened that a Winchester manuscript of the middle of the eleventh century helped to set the style which developed into the magnificent Weingarten illumination of the late twelfth century. See Hanns Swarzenski, *The Berthold Missal* (New York, 1943), 1 ff. and 8 ff.

18. D. Maurus Inguanez, *Codicum Cassinesium Manuscriptorum Catalogus* (Monte Cassino, 1940–1).

19. Reproduced Harrsen, 'The Countess Judith', figure 2.

20. Facsimile published by Forbes-Leith, *The Gospel Book of St Margaret*.

21. This influence may have come to England from St-Bertin at St-Omer through connexions with this monastery under Abbot Bovo (d. 1065) whose pupil Foulkard came to Thorney Abbey. The connexions between Winchester and St-Bertin and also St-Vaast at Arras in the late tenth and early eleventh centuries are known to have been close, and it is possible that the 'Reims' characteristics were introduced into Winchester in a return of Continental influence. Swarzenski has suggested some of these connexions in his study of the Anhalt Gospels.

22. All the illustrations are reproduced and described by Wormald, 'An Eleventh Century Psalter'. Some interesting iconographical and liturgical details are pointed out in this excellent article.

23. The type of the composition is represented in the First Bible of Charles the Bald (Paris, Bib. Nat., MS. lat. 1) and the Golden Gospels of St Gall (reproduced Goldschmidt, *German Illum.*, 1, plate 68A). For the technique, cf. also the St Augustine Psalter (Brit. Mus., Cott. MS. Vesp. A.i, Plate 10B), Harl. MS. 647, and its copy Tib. B.V (Plate 34B).

24. A similar contour line painted in green is used in the New Minster MS., Brit. Mus., Cott. Titus D. xxvii (Plate 37B).

25. Wormald, 'Survival', 131, n. 2. On the provenance see Sisam, *op. cit.*, 48.

26. Homburger says they are by the same artist, but there is clearly a great difference in the dynamic quality of the outline; *op. cit.*, 68.

27. Reproduced in colour, Brit. Mus., *Schools of Illumination*, 1, plate 16. Dodwell (*op. cit.*, 118 f.) places it with the second Crucifixion (fol. 52 verso) and the decoration on fol. 53, as post-Conquest additions to the Psalter.

28. It could be East German (Ottonian): cf. Sacramentary from Regensburg, 1102–14, Munich, Staatsbib. Cod. lat. 4456 (Clm. 60), fol. 15. Reproduced Goldschmidt, *German Illum.*, II, plate 75.

29. Swarzenski suggests Flemish influence, as Lüttich; 'Der Stil der Bibel Carilefs von Durham', *Form und Inhalt, Festschrift für Otto Schmitt* (Stuttgart, 1950), 91.

30. Millar, *op. cit.*, 22 and 81.

31. Containing the 'tropi' or musical interpolations in the liturgy. p. 56

32. *Op. cit.*; Homburger, *op. cit.*, 6. It may be the troper given by Bishop Leofric to Exeter in the eleventh century. See W. H. Frere, *The Winchester Troper*, Henry Bradshaw Society, VIII (London, 1894), xxx and 99 ff. Two miniatures in this same style are found in a gospel book, made for Bishop Leofric while he was in exile. Swarzenski, *op. cit.*, 91. See also R. Schilling, 'Two Unknown Flemish Miniatures of the Eleventh Century', *Burl. Mag.*, XC (1948), 315 ff.

33. Mynors, *Durham Cathedral Manuscripts*, Nos 30–45. Folio 1 of Vol. II of the great Bible (MS. A.ii. 4) contains a contemporary list of all the manuscripts given by Bishop Carilef. See also Dodwell, *op. cit.*, 115 ff.

34. He was accused of having supported the conspiracy of Odo, Bishop of Bayeux, against William the Conqueror.

35. Pächt, 'Hugo Pictor', 98. p. 57

36. A nun and follower of St Jerome, to whom he dedicated the commentary on Isaiah.

37. Swarzenski groups these miniatures and also the historiated initials on fols vi verso and 2, with two miniatures in a gospel book, made for Bishop Leofric of Exeter, and ascribes both to 'the well-known Lüttich workshop which was also active at St-Omer in the third quarter of the century'; *op. cit.*, 91. On the miniature of the Leofric Gospels, see note 32 above.

38. Those closest in style to the Carilef manuscripts p. 58 are Rouen, Bib. Pub., MS. A.85, made for St-Ouen, and Bayeux Cathedral, MSS 57 and 58. Swarzenski, *op. cit.*, 94 ff. See also Boase, *Eng. Art 1100–1216*, plates 4 and 5, and Dodwell, plate 72b.

39. Kendrick, *Late Saxon Art*, 130. p. 59

40. *Op. cit.*, 128–31; Wormald (Stenton), *op. cit.*, 29; Maclagan, *op. cit.*, 18 ff. Professor Loomis considers the tapestry to be Anglo-Saxon. *Art Bull.*, VI (1923–4).

41. Wormald notes that Odo was Earl of Kent by

1067, and thinks Canterbury a likely centre for the production of the tapestry. *Op. cit.*, 34.

p. 59 42. Lethaby once made the interesting suggestion that the aim of the Bayeux Tapestry was to show the fulfilment of God's judgement on Harold's violated oath. W. R. Lethaby, 'The Perjury at Bayeux', *Archaeol. Jnl*, LXXIV (1917), 136–8. Cf. Wormald, *op. cit.*, 33 f.

43. Pächt finds that the colour scheme is similar to that of Norman painting, with the predominance of certain greens and reds, and that the architecture is represented much as in Norman miniatures. Pächt, while agreeing with Wormald on the similarity of details in English manuscripts such as Ælfric's *Pentateuch*, 'Cædmon's' *Paraphrase*, and the *Psychomachia*, calls these agreements in the 'vocabulary' of style, and points out the essential differences in story-telling method used in the manuscripts (which have a classical origin) and the 'specifically and genuinely medieval' continuous narrative of the Bayeux Tapestry. *The Rise of Pictorial Narrative in Twelfth Century England*, 9 f. On this point compare plates 35, 44, and 38b with 47.

CHAPTER 4

p. 61 1. Saxl and Wittkower, *op. cit.*, 24.

2. *Op. cit.*

3. Dom David Knowles, *The Religious Houses of Medieval England* (London, 1940), 27 f.

p. 62 4. See Buchtal, *Miniature Painting in the Latin Kingdom of Jerusalem* (Oxford, 1957). For Byzantine influence via Italy see Dodwell, *op. cit.*, 39 and Pächt, *The St Albans Psalter*, 119 f.

A Cistercian manuscript discussed by Boase, *Eng. Art*, and reproduced (plate 50a) is a charter granted in 1159 by Malcolm IV to the Abbey of Kelso, now deposited in the National Library of Scotland. The only illumination is a historiated initial in a style which (judging from the reproduction) somewhat resembles that of the Winchester Psalter (Cotton MS. Nero C. iv, see below).

The effect of Cistercian influence on English architecture was very marked, but since decoration in general was frowned on in Cistercian houses, pictorial art was little affected, except perhaps by the intensification of monastic fervour which so many new religious foundations would foster. However, Cistercian influence was reflected in the use of grisaille glass in windows, as in the Five Sisters in York Minster. See Chapter 5. An English Cistercian monk known as 'Pictor in Carmine' compiled an elaborate series of descriptions of subjects for painting. See Chapter 5, note 119.

5. Saxl and Wittkower, *op. cit.*, 24.

6. *English Romanesque Illumination* (Bodleian Picture Books 1), No. 7. On the Bestiary in general, see below, p. 87 f.

7. Harl. MS. 647. See Chapter 2, note 59. A tendency noticeable in Bod. MS. 247 to interlace the branches of trees and make curls of the ground has parallels in eleventh century manuscripts, such as the Ælfric Pentateuch and the Cædmon manuscript (*q.v.*), and is probably to be accounted for by Hiberno-Saxon heritage.

8. Dodwell, *op. cit.*, 34

9. The manuscript was formerly owned by A. Chester Beatty and is fully described by Eric Millar in the *Catalogue of the Library of A. Chester Beatty*, I (Western Manuscripts) (Oxford, 1927), No. 19. Millar suggests (74, n. 1) the Blois Gospels, the Ebbo Gospels, and the Bible of St Paul-outside-the-Walls as representing the style of the prototype. The technique of the Morgan manuscript, however, is less impressionistic and more solid than any of these.

10. Fritz Saxl, 'Beiträge zu einer Geschichte der Planetendarstellungen im Orient und im Okzident', *Der Islam*, III (1912), 151–77; Erwin Panofsky, 'Dürers Stellung zur Antike', *Wiener Jahrbuch für Kunstgeschichte*, I (1921–2), 43–92; cf. also Dimitri Tselos, *Art Bull.*, XXXIV (1952), 257–77.

11. See Millar, *Catalogue of the Library of A. Chester Beatty*, coloured frontispiece to volume of plates (fol. 24 verso, Mark).

12. C. de Ricci, *Census of Medieval and Renaissance Manuscripts in the United States and Canada*, II, No. 777; Morgan Library, *Catalogue of an Exhibition of Illuminated Manuscripts*, 1934, 17, No. 29, plate 28.

13. Pächt, *The Rise of Pictorial Narrative*, 13. p.

14. In his discussion of the miniatures in this manuscript, Pächt suggests as a source of some of the iconography an earlier Northumbrian picture cycle illustrating the life of St Benedict. *Op. cit.*, 18.

15. Mynors, *op. cit.*, No. 57, plates 36 and 37.

16. Brit. Mus., *Schools of Illumination*, Part II, 6.

17. Wormald, 'Survival', plate 7. p.

18. *Op. cit.*, 141, n. 2.

19. This manuscript is very important in relation to the style of the Winchester Psalter and Bible. Cf. Plates 80, 82, 83, and 84.

20. Such as the Hitda Codex, Darmstadt, Landesbib. Cod. 1640; Goldschmidt, *German Illum.*, II,

plate 86; Hans Jantzen, *Ottonische Kunst* (Munich, 1948), plates 64–7.

21. In Goldschmidt's publication, *Der Albani-psalter* (1895), the artist of the miniatures is christened the Alexis Master. A recent (1960) thorough study of the manuscript has been published by Pächt, Dodwell, and Wormald with one colour plate and reproductions of all the illuminations and much other material for comparison. The consensus of this study is that the Psalter was brought together with a Life of St Alexis for Cristina, anchoress of Markyate, and later prioress of a convent there. The early date rests on the addition in the Calendar of the obit of Roger the hermit, Cristina's patron, who died in 1121 or 1122. *Op. cit.* 5 and 278 ff.

22. It is possible, indeed, to imagine the development of this style from that of the St Albans *Psychomachia* (Plate 59A) combined with the new painting technique of the Alexis Master in the Psalter.

23. Saxl and Wittkower, *op. cit.*, 26; the authors compare the Temptation of Christ with the somewhat later mosaic of the same subject in St Mark's, Venice.

24. This scene, the Expulsion from Paradise, is one of the examples discussed by Pächt as to both the source of the iconography and the new concept of movement of figures in the scene (*The Rise of Pictorial Narrative*, 26 f.). His conclusion (p. 58) is that 'what stimulated the artist's imagination ... was not visual experience ...' but a 'creative impulse [which] seems to have come from the talking world'. And again, 'an enactment of spoken narrative in visual form ...'.

25. Swarzenski, *The Berthold Missal*, 47 and figure 63. See also Pächt, 'The Illustrations of St Anselm's Prayers and Meditations', *Jnl Warb. Court. Insts*, XIX (1956), 74 ff. See also *The St Albans Psalter*, 156 and elsewhere.

25a. Pächt discusses in detail (172 ff.) the interesting and controversial question of possible Danish influence on the Alexis Master through the activities of Anketil, the famous metalworker who designed the shrine of St Alban, as a designer of coins in Denmark. A seal of Binham Priory (Norfolk), a cell of St Albans, clearly exhibits the style of the Alexis Master (176 and n. 3). He concludes: 'Those still reluctant to identify the Alexis Master with Anketil must, therefore, face the difficult assumption that there were at the crucial time in St Albans two artists of outstanding merits and equal skill practising the same style'.

26. Slight but significant evidence of this style is found on pages of the St Albans Psalter where the border includes animals delicately etched in white line. Similar motifs are used in borders of some of the Reichenau manuscripts.

27. Swarzenski, 'Der Stil der Bibel Carilefs von Durham', 94.

28. On the grounds of an included letter referring to Henry I, who died in 1135. *New Pal. Soc.*, Series I, plates 113–15.

29. M. R. James, *Descriptive Catalogue of the* p. 67 *Manuscripts in Pembroke College* (Cambridge, 1905).

30. Dodwell, *Canterbury Illumination*, 46, dates both text and miniatures mid twelfth century. Pächt (*St Albans Psalter*, 75, n. 1) sees no connexion between miniatures and historiated initials; the latter he finds are pure Bury style. The miniatures he describes as 'work of a pupil of the Alexis Master' (76, n. 1) but not (by inference) the artist of the Life of St Edmund, which he attributes to the Alexis Master himself.

31. See James, 'Four Leaves of an English Psalter'.

32. For comparative tables of this series with p. 68 other nearly contemporary cycles, see *op. cit.*, 3–23.

33. Dodwell, *op. cit.*, 99 ff., proposes that they originally prefaced the Eadwine Psalter (see below). The styles would thus form a bridge between St Albans and Canterbury in the mid twelfth century. On the relationship between the four Bible-picture leaves and similar leaves in the Gospels of St Augustine, see F. Wormald, *The Miniatures in St Augustine's Gospels* (Cambridge, 1954), 12 f.

34. Mary Ann Farley and F. Wormald, 'Three p. 69 Related English Romanesque Manuscripts', *Art Bull.*, XX (1940), 157–61.

35. *Op. cit.*, 158.

36. In later psalters these subjects are often included among the preliminary miniatures. See Chapter 5.

37. Again, the Hitda Codex, of the Cologne School. See note 20 above.

38. Farley and Wormald, *op. cit.*, figures 1 and 2.

39. Direct contact with the St Albans Psalter is p. 70 attested by the insertion of an initial to Psalm 105 (p. 285) painted on a separate piece of vellum and pasted in. The date is later (mid twelfth century) and the style is close to that of Lansdowne MS. 383. Pächt, *St Albans Psalter*, 163 and plate 72b.

40. M. R. James, *Cat. of the MSS in Corpus Christi Coll. Lib.* (Cambridge, 1909), MS. 2. See also James, *On the Abbey of St Edmund at Bury*

(Cambridge, 1895), 7. The Cambridge manuscript is the first volume only of the Bible, as far as the Book of Job.

p. 71 41. Otto Demus, *The Mosaics of Norman Sicily* (London, 1950), 25–58, plates 16–18. See also Dodwell, *op. cit.*, 81 ff.

42. Millar, *op. cit.*, 31.

43. A facsimile of the Eadwine Psalter with his portrait reproduced in colour was published with an introduction by M. R. James, *The Canterbury Psalter*. The date of the manuscript can be closely determined between 1146–7 (the date of the recorded appearance of a comet which is referred to in a drawing on fol. 10) and 1170, the date of the death of Thomas Becket who is not included in the Calendar. A detailed plan of Christ Church monastery on fols 284 verso–285 certainly localizes the manuscript there. See also Dodwell, *op. cit.*, chapter IV. An analysis of the style is given on 44 f.

44. That is, it contains in three parallel columns the three versions of the text, Hebrew, Roman, and Gallican.

p. 72 45. But not, as far as any evidence shows, a self-portrait, since Eadwine was only the scribe of the manuscript and his efforts at drawing do not seem to show much ability. See below and note 47.

p. 73 46. So-called because it bears the pressmark of the Priory of St Martin at Dover, which was a dependent cell of Christ Church, Canterbury. See Dodwell, *op. cit.*, chapter V; for the iconography, chapter VII.

47. For example, fol. 144 of Trin. Coll. MS. R.17.1 and fol. 106 of Corpus Christi Coll. MS. 3.

48. This was James's interpretation, *Cat. of MSS in Corpus Christi Coll. Lib.*, I. A similar representation occurs in the Floreffe Bible (Brit. Mus., Add. MS. 17738, fol. 187), at the beginning of the gospel of Luke, as in the Dover Bible. The subject is elucidated by Dodwell, *op. cit.*, 87 f., as a 'typological scene in which the sacrifice of the calf in the Old Testament anticipates the sacrifice of the Son of Man in the New'.

p. 74 49. As also in Aquitaine, that part of France with which relations were particularly close during the middle decades of the century.

50. Tristram, *English Medieval Wall Painting*, I, 15 ff. Reproduced, Boase, *op. cit.*, plate 25.

51. This incident, related in Acts 28, is rarely depicted. It occurred shortly after Paul landed on Malta: he was building a fire with sticks when a viper attacked his hand.

52. Tristram, *op. cit.*, 21 ff. From surviving fragments of decoration on the stringcourse and window splay it would seem that originally the whole chapel was painted.

53. Saxl compares the Canterbury Paul with Paul p. in the scene of his conversion in the Cappella Palatina, Palermo. Saxl and Wittkower, *op. cit.*, No. 26, figures 1 and 2.

54. It may be remembered that Lewes Priory, a daughter of Cluny, was only a few miles from Canterbury. On painting connected with Lewes, see Baker, 'Lewes Priory and the Early Group of Wall Paintings in Sussex'. Little survives of Continental Cluniac painting, but its quality can be judged from the frescoes in St Hugh's Chapel, Berzé-la-Ville (Saône-et-Loire), dating from *c.* 1100. Joan Evans, *Cluniac Art of the Romanesque Period* (Cambridge, 1950), figures 21–4, 186, and 187.

55. Tristram, *op. cit.*, 20. For a description of Lambeth 3, see below.

56. *Op. cit.*, 27–36. The paintings are described and many are reproduced, plates 28–43. See also *Twelfth Century Paintings at Hardham and Clayton* with introduction by Clive Bell.

57. Tristram, *op. cit.*, 33. They may be compared also with the earlier Ælfric Pentateuch pictures (Plate 35).

58. On the façade of the Church of Ste-Foy. p. Reproduced Arthur Gardner, *Medieval Sculpture in France* (Cambridge, 1931), figure 57.

59. *Twelfth Century Paintings*, plate 35.

60. See Henri Focillon, *Peintures romanes des églises de France* (Paris, 1938), 19–34, plates 1–39, especially some of the Old Testament pictures of the nave, as plates 6–23.

61. There are other wall paintings, or traces of them, in Sussex. At Coombe the walls of the tiny church were apparently covered with paintings which were uncovered by Mr E. Clive Rouse. The subjects include scenes from the Infancy Cycle, Christ giving the key to St Peter and the book to St Paul, and a remarkable grotesque caryatid crouching in the soffit of the chancel arch. The style seems to be closer to Hardham than to Clayton; the paintings are probably early twelfth century.

62. See Émile Mâle, *L'Art religieux du XII^e siècle en France* (Paris, 1928), 378.

63. How much wall painting has been destroyed p. or is still hidden under plaster is, of course, impossible to guess. The discoveries of recent years suggest that more examples may yet come to light.

64. The second volume, sadly mutilated by having almost all the initials cut out, was identified by Millar in the Museum at Maidstone. Millar, *op. cit.*, 32. Lambeth Palace MS. 4, which once was considered to be the second volume, is described by Millar as copied from the same prototype as the Maidstone manuscript. On this and related matters of style and ownership of Lambeth 3, see Dodwell, *op. cit.*, Chapter V, 48 ff. A fine colour plate of the Genesis initial (fol. 6 verso) and many other illustrations are given. See also *The Great Lambeth Bible* by the same author, with colour plates.

65. Reproduced, Gardner, *op. cit.*, figure 52. Since this sculpture dates from well before the middle of the twelfth century, it would seem that it might have influenced this style of painting; but on the other hand, there is much that is Byzantine in both the sculpture of Aquitaine and in the Lambeth Bible, and the most likely explanation seems to be a common Byzantine source, modified in both cases by the twelfth century propensity for powerful linear pattern.

66. A small champlevé enamel plaque in the Victoria and Albert Museum has a Last Judgement in precisely this style; reproduced in a small booklet, entitled *Romanesque Art* (Victoria and Albert Museum, 1950), plate 21. The Last Judgement plaque is compared with miniatures from the Winchester Bible by H. P. Mitchell in *Burl. Mag.*, XLVII (1925), 163.

67. See A. Boinet, 'L'Atelier de miniaturistes de Liessies au XIIe siècle', *La Bibliofilia* (1948), 149–61; J. Leclercq, 'Les Manuscrits de l'abbaye de Liessies (Hainaut)', *Scriptorium*, VI (1952), 52–62. Two leaves from the Gospel Lectionary (formerly Metz, Bibliothèque Municipale, MS. 1151) are reproduced. Dodwell, *op. cit.*, 55 ff., discusses these miniatures and reproduces two in plates 52b and 30b.

68. Wormald dates the drawing in the second half of the twelfth century; see 'A Romanesque Drawing at Oxford', *Antiq. Jnl*, XII (1942), 17–21.

68a. A pressmark in the manuscript has been identified by Ker as that of the Benedictine abbey at Eynsham (Oxon), indicating its ownership though not necessarily its production there. See *Bodleian Library Record*, 5, No. 4 (Oct. 1955), 173.

69. L. W. Jones and C. R. Morey, *The Miniatures of the Manuscripts of Terence* (Princeton, 1931), 68–93.

70. Hand A is the so-called Master of the Apocrypha Drawings, Hand B the Master of the Leaping Figures (see below). *Op. cit.*, 70 and 92–3.

71. The addition of the feast of the Dedication of the church of Shaftesbury indicates that it was given to Shaftesbury Abbey probably soon after its completion. Cf. Lansd. MS. 383 above, which was made for the same abbey.

72. Herbert, *op. cit.*, 137.

73. No facsimile of the manuscript has been published but a small book by Oakeshott, *The Artists of the Winchester Bible*, distinguishes the various hands, names them from their principal characteristic miniatures, and reproduces many details of the illumination.

74. Millar, *op. cit.*, 34. The record is found in *Magna Vita S. Hugonis*, cap. xiii.

75. One of these has been found and restored to its original place on fol. 203 verso, in vol. II, as bound at present.

76. Oakeshott, *op. cit.*, 18 ff.

77. *Op. cit.*, 5 ff. Two details are reproduced, Oakeshott, *The Sequence of English Medieval Art*, plates 27 and 28.

78. Oakeshott attributes this miniature to the Master of the Leaping Figures (*Artists of the Winchester Bible*, plates VII, VIII), but the figure seems too monumental in proportions and too quiet in mood for this master's style. King Antiochus is reproduced, *op. cit.*, plate XII.

79. The verso of the leaf contains scenes from the life of Samuel, certainly not by the same hand.

80. Perhaps even in other arts too. The fine Warwick (or Balfour) ciborium in the Victoria and Albert Museum has engraved figures so close to the drawing of the Morgan Master's figures as to suggest his hand in the design. Cf. especially the figure of Abraham in the Sacrifice of Isaac. See also the Sigena frescoes (Plates 87 and 92B).

81. Reproduced, Oakeshott, *Artists of the Winchester Bible*, plate XXXVIII. It is the preliminary drawing for a painted initial.

82. A copy of the glossed Pauline Epistles in the Bodleian Library (MS. Auct. D.i.13) dated mid twelfth century may be an early work by this master. See *English Romanesque Illumination*, No. 16. The faces in this miniature even resemble the masks in the Terence miniatures.

83. Cf. fol. 169. The Pantocrator and a similar figure by the Genesis Master (Plate 84A) both suggest direct influence from the Pantocrator in Italo-Byzantine apse mosaics, as at Cefalù; yet it is possible that the Morgan Master derived his type from the Genesis Master, rendering it in his own incomparable style.

p. 80
p. 81
p. 83
p. 84

p. 84 84. A miniature of the Evangelist Mark and two historiated initials are reproduced, *English Romanesque Illumination*, plates 19 and 20.

85. *Op. cit.*, plates 12 and 17–18.

86. *Op. cit.*, 4.

87. Boase, *op. cit.*, 179 f. MS. Auct. E. infra was given to the Bodleian Library by a Warden of New College, Oxford, who was also a Canon of Winchester.

88. W. W. S. Cook and J. G. Ricart, *Ars Hispaniae*, VI (1950), with many excellent reproductions.

89. Pächt, 'A Cycle of English Frescoes in Spain'. Pächt notes (p. 169) a striking example of English iconography in the detail of the 'bernacle goose' represented, he says, in the scene of Moses receiving the Tables of the Law (figure 3). This subject was described by Giraldus Cambrensis in writing of his visit to Ireland in 1185–6 and it immediately appeared in an English Bestiary (figure 4).

p. 85 89a. Dodwell, *op. cit.*, 99, finds the wall paintings 'remarkably like' the illumination of Bib. Nat., MS. lat. 8846, the third copy of the Utrecht Psalter, made at Canterbury between 1170 and 1200 (see Chapter 5). 'The foliage', he says, 'and even the iconography ... derive from the Paris Psalter.'

89b. Reproduced and described by Yves Bonnefoy, *Peintures murales de la France gothique* (Paris, 1954).

p. 86 90. Boase, *The York Psalter*, says 'north of England'. Most of the text in this brief monograph is concerned with the origins of the iconography in the three miniatures illustrating the Death, Burial, and Assumption of the Virgin. The final scene, in which the Virgin wrapped in a shroud is borne to heaven by angels, is the earliest representation (says Boase) of the actual assumption of the body of the Virgin. Reproduced in colour, plate 6. No prototype or successor is known for this manner of representing the Assumption. *Op. cit.*, 8–14.

90a. This shows up better in the colour. Reproduced, *op. cit.*, plate 8.

91. See M. Mackeprang, J. L. Herberg, and A. Jansen, *Latin Manuscripts in Danish Collections* (Copenhagen, 1921), 32–42 and plates XLVIII–LX. All the miniatures are reproduced and many of the initials. The text includes an analysis of the hands responsible for the illumination. Cf. Rickert, *La miniatura inglese*, I, plates 52 and 53.

p. 87 92. Mynors, *op. cit.*, no. 147, plate 53.

93. James, *The Bestiary*.

94. *Op. cit.*, Suppl. plate 2. See above p. 62.

95. *Op. cit.*; a facsimile of this manuscript is included. p.

96. See G. C. Druce, 'Mediaeval Bestiaries', *Jnl Brit. Archaeol. Assn*, New series, XXV (1919–20), 52.

97. See Alexandra Konstantinowa, 'Ein englisches Bestiar', *Kunstwissenschaftliche Studien*, IV (Berlin, 1929).

98. James, *The Bestiary*, 55–9. See also James, 'The Bestiary in the University Library', *Aberdeen Univ. Bull.*, No. 36 (Jan., 1928).

CHAPTER 5

1. The similarity between the Ingeburg Psalter p. (Chantilly, Musée Condé, MS. 1695) and the Westminster Psalter (Brit. Mus., Roy. MS. 2 A. xxii) has long been noted. It still is not established whether this fine manuscript was made in France or in England. But see a recent study of the history and provenance of the manuscript by J. Guignard, 'Le Psautier d'Ingeburg', *Art de France*, I (1961). For reproductions of the Ingeburg Psalter see J. Meurgey *Les Principaux Manuscrits du Musée Condé* (Paris, 1930), plates X–XIII. Another psalter illuminated in 'Channel' style belonged to St Louis and is now in Leyden, MS. Lat. 76A in the Bib. de l'Université. Henri Omont, *Psautier de S. Louis* (Leyden, 1902). It has an English calendar with indications of York use and an obit, in the calendar hand, of Geoffrey Plantagenet, Archbishop of York 1191–1212. The style is not very good. See Boase, *Eng. Art*, 281.

2. There is no signed work by these painters, of p. course, but payments to them indicate that they were employed as masters in work known to be in progress at that time. (See below.)

3. This is not necessarily the same as localizing the origin of the style, since artists, even monks, did not remain stationary.

4. The evidence for St Albans ownership of Trin. p. Coll. MSS B.5.3 and O.5.8 is, in both cases, an inscription on a fly-leaf, 'Hic est liber S. Albani', in an early hand.

5. The subjects are: the Annunciation, the Visitation, the Madonna and Child, Christ in Majesty, and David as Musician.

6. A Psalter and Hours in Paris (Bib. Nat., MS. lat. 10433) made for a Benedictine abbey (V. Leroquais, *Les Livres d'heures manuscrits de la Bibliothèque Nationale*, Paris, 1927, No. 148) before 1173 has been identified by Boase (*op. cit.*, 286) as certainly

for Westminster use. It has two full-page miniatures (fol. 1, Crucifixion, and fol. 9, Christ in Judgement) and fine historiated initials on gold ground. The style seems close to late Winchester work, and it is perhaps another link between Winchester and St Albans.

7. James, 'The Drawings of Matthew Paris', 24–6, plates XXVII–XXIX. The five coloured pen drawings in Matthew Paris style on the end fly-leaves may have been inspired in part by the preliminary leaves in Roy. MS. 2 A. xxii, which could have been seen by the later artist either at St Albans or at Westminster. The difference in date between the drawings and the preliminary leaves must be about half a century.

93 8. Millar, *Eng. Illum.*, I, 46, plate 67: 'almost certainly executed at Canterbury'. This manuscript was finished by an Italian artist probably in Catalonia. See Millard Meiss, *Journal of the Walters Art Gallery*, IV (1941), 73 ff.

9. See Dodwell, *op. cit.*, 98 ff. and plates 66 and 67. Facsimile published by Omont, *Psautier illustré.*

94 10. Millar, *op. cit.*, 36. See also *Bull. de la S.F.R.M.P.*, V (1921), 21 ff., plates IV–VIII.

11. Swarzenski, *The Berthold Missal*, 47, n. 80.

12. Seymour de Ricci, *Census*, II, 1503. The manuscript is from the collection of the Marquess of Lothian (1932) and was given to the Morgan Library in 1935.

13. The explanation of this practice, which was common in English manuscripts from *c.* 1200, is not known for certain. It might be interpreted as meaning that miniatures produced in lay or monastic centres were sold or given out for insertion at appropriate places in the text of a Bible or other familiar book. However, no such centre of production has been stylistically recognized. Some of the miniatures of the Lothian Bible are missing, having been removed, and others which remain crowd the spaces left for them in the text, partly overlapping it. An example of a similar practice of inserting miniatures is found in Brit. Mus., Add. MS. 39943 (see below). The explanation may be (as Cockerell once suggested) the wish to finish a manuscript quickly, the unimportant miniatures being painted on separate pieces of vellum at the same time as the text was written or decorated. There also may be something in the idea of choosing softer, finer vellum, more suitable for the small-scale miniatures than the rougher quality generally used in large English manuscripts.

14. In an unpublished study of the manuscript John Plummer of the Morgan Library points out the dependence of the text on that of earlier Bibles and gospel books written at St Albans under Abbots Symon (1167–83) and Warin (1183–95). The date of the Morgan Bible according to Plummer is not earlier than the first decade of the thirteenth century, the St Albans manuscript closest to it in date being Camb., Trin. Coll., B. 5.3, which, however, as he notes, has miniatures in a very different style (Plate 92A).

15. The Canterbury glass has been fully published by the Friends of Canterbury Cathedral, *The Ancient Glass of Canterbury*, with text by Bernard Rackham.

16. Cf. an early twelfth century copy of Bede's p. 95 Life of St Cuthbert probably made there (Oxford, Univ. Coll., MS. 165, Plate 59B). The Additional manuscript miniatures are reproduced in *The Life of St Cuthbert*, edited by W. Forbes-Leith (London, 1888). This manuscript, which was formerly in the Yates Thompson Collection, is described in *A Descriptive Catalogue of Fifty MSS. from the Collection of Henry Yates Thompson*, Third Series, No. LXXXIV; see also plates V–XV in *Illustrations from 100 MSS. in the Library of H. Y. T.* (London, 1914).

17. For a complete reproduction, see Warner, *The Guthlac Roll.*

18. *Durham Catalogue* of 1416, published by the Surtees Society (Durham, 1838), 107.

19. See Harrison, *The Painted Glass of York*, 110–18. Only one subject in the window shows close resemblances in treatment to the corresponding miniature, but this is not surprising since the window is so much later. See Chapter 8.

20. Colgrave, 'The St Cuthbert Paintings on the Carlisle Cathedral Stalls', 17–21.

21. The practice of pasting in miniatures painted on separate pieces of vellum which was observed in Morgan MS. 791 was responsible for the loss of the remainder.

22. The full-length standing figure of a bishop, p. 96 identified as Cuthbert, painted on the south jamb of the recess of the inner north aisle of the Galilee Chapel at Durham Cathedral, built by Bishop Pudsey *c.* 1175, is reproduced in colour and discussed by Audrey Baker in Battiscombe, *Relics of St Cuthbert*, 528–30.

23. Such as the late twelfth century ciboria (two in the Victoria and Albert Museum and one in the Morgan Library) and a casket, all with roundels containing figure subjects. See Chamot, *English Medieval Enamels*, plates 4–8.

23a. For the earliest formulation of this scheme see the Lansdowne Psalter, p. 69.

p. 96 24. Preliminary series of Bible pictures had become established features of psalter illustration in the twelfth century. One such series now existing unattached to any text is MS. III.3.21 in Emmanuel College, Cambridge, of *c*. 1200. Another elaborate series of 40 leaves precedes the psalter of *c*. 1200 in the Morgan Library (MS. 43, the Huntingfield Psalter, see note 29 below).

25. On the early calendar illustration see J. C. Webster, *The Labors of the Months in Antique and Mediaeval Art to the End of the Twelfth Century* (Evanston and Chicago, 1938).

p. 97 26. Reproduced Brit. Mus., *Reproductions from Illum. MSS*, I, plate X. As forerunners of this decorative style cf. Bod. MS. 752, *English Romanesque Illumination*, plate 22. The style suggests a reversion to Celtic initials but may have appeared under Norman influence, perhaps at Canterbury where the lively little animals had long been at home. Two fine Canterbury manuscripts decorated only with initials of this type are Bod. MS. Auct. E. infra 6 (reproduced *op. cit.*, plate 21) and Cambridge, Trin. Coll., MS. B.5.4 – two parts of a glossed psalter by Herbert of Bosham.

27. Uncoloured reproductions of these pages do not give any hint of their beauty. A fair coloured reproduction of the *Beatus* page (fol. 19) of Ar. 157 is found in *Schools of Illumination*, II, plate 8.

28. About 1145. Two late twelfth century medallions with Jesse and Daniel probably from a Jesse window have survived at York.

29. This manuscript is one of the most interesting and most lavishly illuminated of the late twelfth century psalters, but, alas, now badly damaged by water and with most of the blue of the backgrounds removed. An obit inserted in the Calendar for Roger de Huntingfield (d. 1204) connects the manuscript with Mendham Priory, Suffolk, founded by his father William in 1140. The text was apparently written in the last decade of the twelfth century and the original Calendar suggests Norfolk or Lincolnshire. Thompson, 'The Huntingfield Psalter' (*Proc. Soc. Antiq.*, XVI (1895-7), 219-20), thought the workmanship was not English and suggested the German border of Flanders as a possible source of the style. Both the Imola and the Huntingfield *Beatus* miniatures are reproduced in Rickert, *La miniatura inglese*, plate I (in colour) and plate I. A miniature with a Jesse Tree in which the unusual scene of the Nativity occupies the central medallion is on fol. 121 of the Munich Psalter. This would seem to be an intermediary step between the design of a Jesse window and that of the *Beatus*.

30. On the divisions of the psalter see Wormald, 'An English Eleventh Century Psalter', 2.

30a. See G. Haseloff, *Die Psalterillustration*.

31. *Beatus* page reproduced Georg Leidinger, p. *Meisterwerke der Buchmalerei* (Munich, 1920), plate 19; see also *Orbis Pictus*, 8 (Miniatures du Moyen-Âge, Lausanne, 1950), plate 17 (both in colour).

32. Herbert, 'A Psalter in the British Museum (Roy. MS. I D. X)'. On fol. 2 there is a vernicle in Matthew Paris style similar to that on fol. 221 verso of Roy. MS. 2 A. xxii. See below under Matthew Paris. A vernicle painted in a similar style also occurs on the first leaf of Arundel 157 with a partly legible inscription which begins: 'Ceste teste fait ...'.

33. Arundel 157 has the rare feast of St Frideswide (May 15). On the Oxford calendar, see C. Wordsworth, 'The Ancient Kalendar of the University of Oxford', *Oxford Historical Society*, XIV (1904). For this and other local liturgical evidence in the calendars I am indebted to Mr D. H. Turner of the British Museum.

34. Evidence for the dating comes from a short chronicle preceding the Psalter containing obits of the royal family. The latest entry is 1204 (death of Eleanor of Aquitaine); the next entry would be King John (d. 1216). R. Galli, *Un prezioso salterio*. See also Haseloff, *op. cit.*

35. For a discussion of this manuscript and St John's MS. D.6 see Bloch, 'Bemerkungen zu zwei Psalterien'.

36. See Boase, *op. cit.*, 283 f. p.

37. The folios and subjects are as follows: fol. 17, p. full-page miniature of the burial of Thomas Becket; fol. 32, a similar miniature, of the martyrdom of Thomas, perhaps the earliest known miniature of this subject; fol. 68, Sacrifice of Abraham; fol. 118, several saints; fol. 129, Peter walking on the water, and Christ and the Disciples. The style is very different from that of the rest of the manuscript and both in colouring and in technique does not look English.

38. Bloch, *op. cit.*, figures 2 and 4. p.

39. John Plummer, *Manuscripts from the William S. Glazier Collection* (New York, 1959), cat. no. 17, p. 15. Two miniatures are reproduced in colour, plates 1, 3.

40. See Wormald, 'Note on the Glazier Psalter', *Jnl Warb. Court. Insts*, XXIII (1960), 307; see also Meyer Schapiro, *ibid.*, 179–89.

41. The Translation of St Thomas of Canterbury p. which occurred in 1220 is entered in the original hand of the Calendar.

42. Reproduced, Millar, *op. cit.*, plate 69.

43. *Op. cit.*, plates 71, 72.

44. The medallions in thirteenth century glass were joined together by the iron armature which constituted the skeleton for the window. The designs composed by medallions in French windows tended to emphasize the central panels, on the axis of the light. In English windows the designs tended to be less closely integrated and the emphasis in them was spread more evenly over the whole of the window space. This is evident if one compares medallion windows at Chartres with those at Canterbury.

As to origins of the English glass, it is customary to attribute all good thirteenth century stained glass to France. Although there were close contacts between Canterbury and French art in this as in previous periods, the consensus now seems to be that the Canterbury windows, like those of York and Lincoln, are English in design and workmanship and in iconography. The glass itself, however, may have been imported from the Continent, since there is no record of the making of pot-metal glass in England, and in later times the best glass used in England was known to have been Continental (see Chapter 8). For a sensible discussion of the pros and cons for French origins of English glass, see Lafond, 'The Stained Glass Decoration of Lincoln Cathedral'.

45. Owned by Robert de Bello, Abbot of St Augustine's, Canterbury (1224–53).

46. The French pocket Bibles written in tiny script on the thinnest possible vellum are well known. English manuscripts never attained their minute scale or their fineness of workmanship.

47. Another miniature in Roy. MS. 1 D. i (fol. 1) has an unusual if not unique representation of the four Orders of Friars in the margins, two of each Order standing on pillars in the corners of the page. Most interesting are the Carmelites who are shown in their striped cloaks which were worn only until 1287 when they were changed to white as still worn. See *Speculum Carmelitarum*, vol. I, part II, 152. This detail unfortunately indicates only a date *ante quem* for the making of this manuscript.

48. Known as the Cuerdon Psalter from the late owners, R. Townley Parker and R. A. Tatham of Cuerdon Hall. See Morgan Library, *Exhib. of Illum. MSS* (1934), No. 41, 22–3, plate 40.

49. See Cockerell, *The Work of W. de Brailes*. On the identity of de Brailes (or de Brailles) see Graham Pollard, *Bod. Libr. Record*, 5, No. 4 (October 1955), 203–9. The author cautiously concludes that it is 'all but certain' that William de Brailes the Oxford resident was the illuminator W. de Brailes.

50. The subjects of the other five are: Fall of the Angels, six scenes from Genesis, Wheel of Fortune with story of Theophalus (a rose window design), Christ in Majesty and David Harping, Tree of Jessse.

51. Present whereabouts of the latter two manuscripts are unknown.

52. Swarzenski, 'Unknown Bible Pictures by W. de Brailes'. The dimensions of the leaves are approximately the same but both have been trimmed. There is no conclusive evidence on this point.

53. Millar, 'Additional Miniatures by W. de Brailes'.

54. Described and reproduced by J. and J. Leighton, *Catalogue of Manuscripts mostly illuminated* (1912), No. 27.

55. In support of this idea, the New College Psalter displays the practice already noted in earlier manuscripts, of miniatures painted on separate pieces of vellum and pasted on the text pages.

56. Swarzenski, *op. cit.*, 63. p. 105

57. Reproduced and discussed, James and Tristram, 'Medieval Wall Paintings at Christ Church, Oxford', *Walpole Soc.*, VI (1927–8), 1–8. See also Tristram, *English Painting*, II, plates 83–92. Cf. Brieger, note 92 below.

58. Published in facsimile by Millar, *The Rutland Psalter*.

59. B.F.A. Club, *Exhib. of Illum. MSS*, Nos. 41–2. On the whole group see Hollaender, 'The Sarum Illuminator and His School', 230–62.

60. From the presence of St Melor in the Litany and Calendar, it was suggested that the manuscript was written for the Abbey of Amesbury, perhaps for the nun who is kneeling in the miniature on fol. 4. There is no real evidence for this assumption.

61. *Brit. Mus. Quart.*, XI (1936–7). The con- p. 106 nexion of the Psalter with Evesham is established by the Calendar entry on Nov. 13: 'Dedicatio ecclesie euesamensis'. The manuscript was purchased for the Museum in 1936 by the National Art Collections Fund. The fine *Beatus* page is reproduced in a *Diary* for 1954 issued currently by this foundation.

62. For a discussion of this style, see p. 111. p. 107

63. Prayers at the end of the litany (fol. 206) show that this manuscript was written for the Abbess of Wilton Abbey. B.F.A. Club, *Exhib. of Illum. MSS Cat.*, No. 42, plate 40. See also *Bull. de la S.F.R.M.P.*, IV (1914–20), 55, plates LIII–LV.

p. 107 64. Rickert, *op. cit.*, plate 11.

65. M. R. James, *A Descriptive Catalogue of the Latin Manuscripts in the John Rylands Library at Manchester*, 1 (Manchester, 1921), No. 24, 73–5, plates 51–7.

66. Perhaps Henry of Chichester. Hollaender, *op. cit.*, 232 ff.

67. Tristram, *op. cit.*, II, 302–3. Tristram's copy of the painting is reproduced in colour as the frontispiece.

68. Some medallion paintings in the vaulting of the choir, transepts, and sanctuary at Salisbury Cathedral may also be related to the style of the Chichester roundel. The Salisbury roundels which are still visible (though repainted) contain Calendar subjects surrounded by very beautiful scroll foliage, in part original. The colouring is delicate, as in the Chichester roundel, and is suggestive of manuscript painting. See Tristram, *op. cit.*, II, plates 65 and 66 and suppl. plate 31. See also Borenius, 'The Cycle of Images', 44.

All the paintings in the Salisbury vaults were copied by Jacob Schnebbelie for the Society of Antiquaries in 1789, a year before the vaults were whitewashed. Subsequently these copies were lost, although the sketches for them still existed. Only recently Dr Frank Horlbeck discovered the Schnebbelie paintings in the Bodleian Library (Gough Maps XXXII, s.c. 17529), and from these he has reconstructed the whole scheme of the paintings which constituted a *Coelum*, with a Majesty, apostles, evangelists, prophets, and the heavenly host of angels – all in roundels. The Calendar scenes formed part of this scheme. The eastern transept vaults are still covered with whitewash, and it is Dr Horlbeck's hope that this will be removed and the original paintings revealed. See *Archaeological Journal*, CXVII (June, 1962).

69. Interestingly enough, it is this manuscript which furnishes concrete evidence that the group can be attributed to Salisbury. According to a colophon, the Bible of William de Hales was written in 1254 for Thomas de la Wile on the occasion of his appointment as Master of the Salisbury schools. It is unlikely that the manuscript was produced elsewhere than in the scriptorium of the fine new cathedral which was in the last stages of completion. See Millar, *Bull. de la S.F.R.M.P.*, IV (1914–20), 62.

p. 108 70. *A Thirteenth Century York Psalter.* Only two other York manuscripts of this date are known: the Psalter of Simon of Meopham in Sion College Library and a Bible formerly in the collection of Sir Sydney Cockerell. Stylistically they resemble each other, but have no relation to Millar's manuscript. See B.F.A. Club, *Exhib. Illum. MSS*, 44.

71. Reproduced Rickert, *op. cit.*, plate 22.

72. Professor Wormald first called my attention to these drawings, which have not yet been published.

73. A thorough study of Matthew Paris in all these capacities has been published recently by Richard Vaughan as vol. 6 of the *Cambridge Studies in Medieval Life and Thought* (1958).

74. See James, 'The Drawings of Matthew Paris', with many reproductions.

75. The attribution of these heads to Matthew Paris himself is to my mind the most questionable of those here listed. The technique is clearly related to that of painting, and they may represent either sketches from wall paintings or cartoons for them, in which case one is reminded of the many wall paintings at St Albans itself. For a discussion of these paintings and of the heads at Windsor which may be related to Paris's work, see below. In this connexion it is to be remembered that a painting of St Peter, now in the Oslo Museum, Norway, is attributed to Matthew Paris. See Andreas Lindblom, *La Peinture en Suède et en Norvège* (Stockholm, 1916). James accepts this attribution (*op. cit.*, 3), as Vaughan does also. The painting as reproduced appears to be so damaged that no fresh study of it is possible.

This is not the place to discuss in detail Vaughan's attributions to Matthew Paris's own hand. These seem to be based on the kind of mechanical evidence useful for identifying handwriting but unreliable for distinguishing the qualities of an artist from a collaborator or copyist. As for the marginal sketches in Corpus Christi Coll. 26 and 16, as far as they are visible under or without the disfiguring 'inking over', they represent some of Paris's most spirited work. So also the drawings but not most of the painting in the 'Lives of SS. Alban and Amphibalus'. Apropos of this manuscript, if it is as early as Vaughan believes ('... third or even second decade of the thirteenth century', p. 177), why should Paris have needed 'instruction' at the beginning of his (later) *Chronica Majora* (cf. *op. cit.*, 223 f.)?

75a. Wormald, 'More Matthew Paris Drawings'. p.

76. In addition to Walter of Colchester's brother Simon, his nephew Richard (Tristram, II, 318) is mentioned. It may be worth noting that, as Tristram remarks, St Albans supplied painters for Westminster (*op. cit.*, 329). The St Albans paintings are described and reproduced by Tristram, 325–30, plates

161–7. See also W. Page, 'The St Albans School of Painting', *Archaeologia*, LVIII (1902), 275–92.

77. Discussed under the Westminster or Court style, plate 114B.

78. James, *La Estoire de Seint Aedward le Rei*.

79. Compare the head of Christ on fol. 221 verso and a similar one on fol. 2 of Arundel MS. 157, with the Vernicle on fol. 49 verso in Corpus Christi Coll. MS. 16: *Walpole Society*, XIV (1925–6), plate XXIX, for reproductions of fols 49 verso and 221 verso.

80. In plate 111B, compare the seated figure in the centre with the standing figure on the right. Even in the centre figure, it is not only the deep pockets that are shaded with colour.

81. James attributes fols 1–4 of this manuscript to M. Paris, but the pictures do not seem to the present writer to show the grasp of figure modelling which is typical of him. On Brother William see A. G. Little, *Franciscan History and Legend in English Mediaeval Art* (Manchester Univ. Press, 1937), 37.

82. See Delisle and Meyer, *L'Apocalypse en français*.

83. The English illuminated apocalypses were grouped by him in the introduction to *The Apocalypse in Latin: MS. 10 in the Collection of C. W. Dyson Perrins*. His grouping is as follows: St Albans – Paris, Bib. Nat., fr. 403, Bod. Auct. D.4.17, Morgan 524, Brit. Mus., Add. 35166, Dyson Perrins 10; Canterbury – Add. 42555, Lambeth 209, Douce 180; Westminster – Trin. Coll. B.10.2; Peterborough District – Bod. Canon. Bibl. 62, Camb., Magdalene Coll. 5, Bod., Tanner 184. In his book *The Dublin Apocalypse*, James suggests Peterborough as the most likely provenance for Trin. Coll. MS. K.4.31 since it is related textually to his Peterborough group.

83a. 'Joachism and the English Apocalypses.' The title is somewhat misleading since the substance of the article deals with the history, iconography, and style of the manuscripts.

83b. *Op. cit.*, 218.

84. James, *The Trinity College Apocalypse*. The provenance is still controversial: James was inclined to assign it to St Albans (Cockerell dissenting), and Lindblom thought it to be an early work of Matthew Paris himself. In his work on the Dyson Perrins Apocalypse, James still favoured a St Albans attribution for the Trinity College manuscript, *op. cit.*, 33. But see Freyhan, *op. cit.*, 226 f.

85. *New Pal. Soc.*, Series I, plates 38 and 39 (fols 14 and 15 verso).

86. Freyhan suggests the artist of the first four

miniatures in *La Estoire de Seint Aedward le Rei* (Camb., University Library, MS. Ee. 3.59). *Op. cit.*, plate 55a, b.

87. Sold to Kraus in the second Dyson Perrins sale.

88. See Eric Millar, 'Les Principaux MSS à peinture du Lambeth Palace à Londres', *Bull. de la S.F.R.M.P.*, VIII (1924).

89. Perhaps the earliest member of the group. The Abingdon Apocalypse is dated before 1263, but is much repainted. See *Brit. Mus. Quart.*, VI (1931–2), 71–3.

90. Reproduced in facsimile by James, *The Apocalypse in Latin and French*, Bodleian MS. Douce 180. See also Coxe, *The Apocalypse of St John*, and Hassall, *The Douce Apocalypse*.

91. Several later apocalypse manuscripts are attributed by James to the district of Peterborough (see note 83 above) and may be related in style to some East Anglian psalters (see Chapter 6); one dating from the late fourteenth century (Camb., Trin. Coll., MS. B.10.2) will be referred to in Chapter 7. p. 113

92. *Brit. Mus. Quart.*, XXIII, no. 2, 27 ff., with coloured reproduction of one of the preliminary miniatures.

It should be recalled that as long ago as 1895 Sir E. M. Thompson in describing this psalter (then still in the College of St Mary at Oscott, Birmingham) said it is 'written in a graceful but not English hand' and that the character of the pictures appeared to be that of the French side of Flanders. He quoted from the manuscript a couplet in French giving the name of the scribe as William. *Proc. of Antiq. Soc.*, 16 (1895–7), 221. Saunders, *English Illumination*, 67 f., notes the relation of the Oscott Psalter apostles to the Retable. On the other hand Brieger finds them close to the Chapter House frescoes at Christ Church, Oxford. Brieger, *op. cit.*, 180 f. With this latter opinion the present writer does not agree.

93. Two manuscripts of the third quarter of the thirteenth century should be mentioned in relation to the Oscott. One of these, the so-called Salvin Hours (Brit. Mus. Add. 48985 from the Chester Beatty Collection) can be dated after 1262. p. 114

It is illuminated by at least two hands, one of which painted historiated initials having faces modelled in the technique of some of the apostles in the Oscott Psalter (e.g., fols 32 verso, 35, 37 verso). The Salvin Hours has rubrics and also, apparently, directions to the illuminator written in French (e.g., fols 74, 84).

The second of the two, the Huth Psalter (Brit.

Mus. Add. 38116), has a fine Jesse Tree *Beatus* and some preliminary miniatures of the life of Christ on very stiff vellum painted in a much better style than the calendar roundels and psalter initials. On fol. 119, a leaf inserted between two gatherings, are a Trinity and a Coronation of the Virgin. On fol. 60 portions of the border remain around a space where an initial which was pasted in is now missing. It would seem that the illuminator was a 'learning hand', following the style of 'imported' miniatures inserted in the manuscript.

p. 114 94. A complete photographic reproduction of this manuscript is available for study in the British Museum: Facsimile 560 (1).

95. Tristram, *op. cit.*, II, *Catalogue*, 497 ff. See also Borenius, 'The Cycle of Images in the Palaces and Castles of Henry III', 40–50.

96. Tristram, II, 611–17, plates 28–42. Some of the painting, as that in the Chapel of the Holy Sepulchre, replaced late twelfth century painting now visible only in a few places.

p. 115 97. *Op. cit.*, 171 f.

98. *Op. cit.*, 168–71, plates 44–50.

99. *Op. cit.*, 94. The documents relating to William and others of the King's painters are given and interpreted by Tristram here and elsewhere in the book.

100. Copies of the paintings were made in 1819–20 by C. A. Stothard and are in the library of the Society of Antiquaries, London. Society of Antiquaries, *Vetusta Monumenta*, VI (London, 1885); coloured plates with text by John Gage Rokewode citing records concerning painters. Some of the copies have been reproduced photographically by Tristram, *op. cit.*, suppl. plate 13; water colour copies and details by him, plates 16–25. The most accurate copy as regards representation of the style is, according to Wormald, the measured drawing of the Coronation of Edward the Confessor by Edward Croker now in the Victoria and Albert Museum. A detail of this is reproduced by Wormald, 'Paintings in Westminster Abbey', plate 7.

101. Tristram, *op. cit.*, 562–4. The Retable is reproduced in suppl. plates 1–6.

102. The panel, according to Vertue who first found it, was 'partly defaced after the reformation manner', and later served as the top of a large press containing funeral effigies in the Abbey. George Vertue, *Notebooks* (1713–21), *Walpole Soc.*, XVIII (1929–30), 157. Additional damage to the Retable occurred later.

103. Wormald, *op. cit.*, 170 ff.

104. Tristram makes out a case for the use of the panel not as a retable but as one side of the 'coperculum' or wooden cover of the shrine of the Confessor. The date might still be about the time of the restoration of the shrine itself, before the translation of St Edward's relics in 1269. *Op. cit.*, 144–8.

105. The iconography is unusual. Wormald explains the palm branches as possibly signifying the martyr's triumph in relation to Christ's. *Op. cit.*, 169.

106. It is probable that there was a corresponding figure of Paul on the right side, but no evidence survives.

107. Antonio Muñoz, *Roma di Dante* (Milan, Rome, 1921), 265 ff.

108. *Op. cit.*, 268, 269.

109. For an interesting study of architectural detail of the English Court School, see J. M. Hastings, 'The Court Style', in *Architectural Review*, CV (1949). Hastings finds that although French influence in the gabled arch and other details is unquestionable, English parallel variants in its use are distinguishable. He cites the Retable framework as an example.

110. See Walter W. S. Cook, 'Stucco Altar-Frontals of Catalonia', *Art Studies* (1923).

111. J. G. Noppen, 'Westminster Paintings and Master Peter', *Burl. Mag.*, XCI (1949). References to the original documents are cited.

112. The chevet, transepts, and crossing were dedicated in 1269 and probably also the Chapel of St Faith. It has been proposed that the painting in the transept is earlier than this, immediately after the completion of the chapter house in 1253. See J. C. Noppen, *op. cit.* Lethaby's dating of 1270–5 for St Faith (*Burl. Mag.*, XXIX, 1916) has been quoted by Wormald, 'Paintings in Westminster Abbey', 166. St Faith is reproduced, Tristram, II, suppl. plate 12.

113. Reproduced, Tristram, II, plates 11 and 12.

114. Laurence Tanner, *Unknown Westminster Abbey* (London, 1948), 13.

115. Tristram includes records of some of these furnishings, II, 78 ff.

116. Some of the fragments are in the British Museum, others in the Victoria and Albert Museum, and the remainder in the Chapter House of Worcester Cathedral.

117. Christie, *English Medieval Embroidery*, No. 44, 78–9.

118. See Lethaby, 'The Romance Tiles of Chertsey Abbey', and 'The Westminster and Chertsey Tiles and Romance Paintings'.

119. In this connexion the remarkable treatise known as *Pictor in Carmine* should be remembered. This is a literary work compiled by an English Cistercian monk, containing the largest known collection of types and antitypes intended, as stated in the preface, for the guidance of painters, 'to supplement the faults of excessive levity by providing a supply of more excellent quality'. James, 'Pictor in Carmine', *Archaeologia*, xciv (1951), 141–66. This paper was published posthumously, with the assistance of Eric G. Millar.

CHAPTER 6

1. Both these terms have now become generic. Though the East Anglian manuscripts were largely produced in East Anglia (i.e. Norfolk and Suffolk), some examples of the style seem to have originated in other parts of England. The *opus anglicanum* (English work) in embroidery has not been localized anywhere; the name of a needlewoman, Mabel of Bury St Edmunds, mentioned frequently in the records between 1239 and 1244 as working for Henry III at Westminster, suggests an East Anglian connexion. See Christie, *English Medieval Embroidery*, 2, and Appendix I, 33–4.

2. See Millar, ii, 24. On this question of the effect of the Black Death on the production of art, see Joan Evans, *English Art 1307–1461*, 74 ff.

3. Dom David Knowles, *Religious Houses of Medieval England* (London, 1940), 54.

4. The East Anglian style spread to the Continent but it also was affected by Continental, particularly French, influence even in England. See Georg Graf Vitzthum, *Die Pariser Miniaturmalerei* (Leipzig, 1907), 68–87.

5. Known also as the Tenison Psalter because of its later ownership by Archbishop Tenison (d. 1715). Saunders ascribed the Tenison Psalter to the Court School. *Eng. Illum.*, i, 67. For the influence of the Westminster Retable on this and other late thirteenth century psalters, see Chapter 5.

6. The remainder of the Psalter and the Calendar containing obits of the mother, wife, and daughters of Edward I, were finished apparently for Elizabeth, Alfonso's sister, who married first John, Count of Holland, and later Humphrey de Bohun, Earl of Hereford. Prefixed to the Psalter are three leaves containing tiny miniatures of saints and scenes from the Passion, framed with borders containing the Bohun arms. The Bohun connexion is worth noting in view of the important group of fine illuminated manuscripts, some with strong East Anglian characteristics, made for members of the Bohun family in the third quarter of the fourteenth century. (See below, pp. 149 f.)

7. Millar, ii, 63–4, 101–2.

8. *Op. cit.*, 63. See note 12 below.

9. The manuscript seems to have been presented to Ashridge Priory (see inscription on fol. 1) by Edmund, Earl of Cornwall (d. 1300), who founded the Priory c. 1283. Edmund's arms occur on fol. 234. Reproduced, *op. cit.*, plate 95.

10. *Op. cit.*, 63.

11. Both pages (fols 1 verso–2) are reproduced, *op. cit.*, plate 99.

12. Cockerell, B.F.A. Club, *Exhib. Illum. MSS*, 22, says of Morgan MS. 102: 'It is unquestionably English, but there is something that suggests Parisian influence in the figures'. It is now generally agreed that the roots of the East Anglian figure style are to be found in the Westminster Retable. For marginal ornament and grotesque and other scenes, Canterbury manuscripts and the Rutland Psalter furnish precedents. See Chapter 5.

13. See James, *A Peterborough Psalter and Bestiary*, 34 ff.; see also Van den Gheyn, *Le Psautier de Peterborough*. The manuscript was given by Abbot Godfrey de Croyland (1299–1321) to the French nephew of Pope John XXII.

In the spirit of the initials and marginal decorations of the Peterborough Psalter and the first part of the de Lisle Psalter (Arundel 83) are the full page miniatures and initials in a Book of Hours, MS. G.50 in the Glazier Collection, New York. Some later work in the manuscript also connects it with the latter part of Arundel 83, as does a fourteenth century inscription. See John Plummer, *Manuscripts from the William Glazier Collection* (New York, 1959), No. 27, plates 4, 21.

14. *Op. cit.*, 34; see also James, 'On the Paintings formerly in the Choir at Peterborough', *Proc. Camb. Antiq. Soc.*, ix (1897), 178–94.

15. This is an early example of the so-called 'babewyns' which were so popular in the fourteenth century. See Evans, *op. cit.*, 38–44. Their invasion of the pages of liturgical manuscripts, whether made for clerics or laymen, is one of the most startling features of later medieval art.

16. Cockerell, *The Gorleston Psalter*, 1 ff.

p. 125 17. James, *A Peterborough Psalter*, 13 and 15 ff.

18. The dedication of the church of Norwich is in the original hand in the Calendar.

19. A psalter which is almost certainly from Peterborough (Cambridge, Univ. Lib., MS. DD.iv.17) is so close in style to Cambridge, Corpus Christi 53, as to suggest the same hand. Many of the compositions of the preliminary Bible pictures are the same. The technique of MS. DD.iv.17, however, is a little less fine and the figures are less firmly drawn. It is possible that another artist was copying at Peterborough as closely as he could the pictures in MS. 53, which, whether made there or not, was certainly taken there. There is more evidence of another sort of the influence of MS. 53 and also of DD.iv.17. A small silver pyx recently acquired by the Victoria and Albert Museum has on the outside of the lid an engraved figure of the Virgin and Child with a flower which is identical in design with this subject as represented in both Cambridge, Corpus Christi 53 (Plate 126) and DD.iv.17: the drapery seems to follow the arrangement in the Corpus Psalter, while the position of the Child is closer to that in DD.iv.17. The engraving is rather rough and there are traces of enamel still to be seen in the grooves. On the inside of the lid of the pyx is another subject which is obviously copied from MS. DD.iv.17: a Nativity. The connexion of the pyx with the University Library Psalter is not only stylistic but genealogical. See Charles Oman, 'The Swinburne Pyx', *Burl. Mag.*, XCII (1950), 337–41. Francis Wormald was the first to notice the stylistic relation between the pictures on the pyx and those in the manuscripts. Still another Peterborough Psalter with preliminary pictures in much the same style is Bod. MS. Barlow 22. See Millar, II, plates 22 and 23.

20. James, *A Peterborough Psalter*, 18.

p. 126 21. *Ibid.*

22. See Robert Eisler, *Die illuminierten Handschriften in Kärnten*. Beschreibendes Verzeichnis der illuminierten Handschriften in Österreich, III (Vienna, 1907), No. 42, 83–9.

p. 127 23. Warner, *Queen Mary's Psalter*. The manuscript received this name from the fact that during her reign it was confiscated by English port authorities as it was about to be sent abroad, and was subsequently presented to her.

24. Millar, II, 13.

25. These marginal scenes and the general restraint in decorative elements suggest French influence in the style of Queen Mary's Psalter.

p. 128 26. Warner, *Descriptive Catalogue of Illuminated Manuscripts in the Library of C. W. Dyson Perrins* (Oxford, 1920), 57–9, plates XXI and XXII. This manuscript is now G. 53 in the Glazier Collection. See Plummer, *op. cit.*, No. 26, plate 23.

27. Cockerell dated it *c.* 1300; see B.F.A. Club, *Exhib. Illum. MSS*, 24, No. 50, plate 47.

28. A manuscript (*La Somme le roi*) in Cambridge (St John's College, MS. S.30) has a series of very fine historiated initials perhaps by the artist of Queen Mary's Psalter. See James, *Cat. of St John's Coll. Lib.*, No. 256. An Apocalypse in French bound with a copy of a French poem, 'La Lumiere as Lais' (Brit. Mus., Roy. MS. 15 D. ii), has miniatures and historiated initials close to Queen Mary's Psalter style but probably not by the same hand. This manuscript used to be attributed to Greenfield Nunnery (Lincs.). See Egbert, *The Tickhill Psalter and Related MSS*, 95–7.

29. For a general discussion of this second phase of East Anglian style see Cockerell, *The Gorleston Psalter*, 1–5.

30. *Summary Cat.*, V (1905), xxii–xxvii, a thorough examination of this manuscript and its history. See also Cockerell and James, *Two East Anglian Psalters*.

31. Reproduced Millar, II, plate 1. p.

32. Pächt, 'A Giottesque Episode in English Mediaeval Art', 54 ff. A carved figure of a trumpeter from a sarcophagus (reproduced, plate 15c) might be the model for the Ormesby trumpeter. This whole study of Italian influence on East Anglian and later English painting is most interesting and illuminating.

33. Cockerell, *The Gorleston Psalter*.

34. Reproduced, Millar, II, plate 14. See Pächt, p. *op. cit.*, plate 14, for Italian sources of this style.

35. This is the Italianate 'modelled' style, described as 'Trecentesque' by Pächt, *op. cit.*, 51 ff. The stylistic history of the East Anglian phenomenon as a whole is still to be written, but Dr Pächt's article makes a promising beginning.

36. James, *The Dublin Apocalypse*. Two other manuscripts are related by James to the style: Bod. Ashmole MS. 1523 (the Bromholm Psalter) and Cambridge, Emmanuel Coll., MS. 112 (Gregory, *Moralia*).

37. The Vaux Psalter. See Eric Millar, 'Les Princi- p. paux MSS à peinture du Lambeth Palace à Londres', *Bull. de la S.F.R.M.P.*, VIII (1924).

38. Egbert, *op. cit.*, 5. The other manuscripts of this group are also discussed.

39. *Op. cit.*, 16–18.

40. *Op. cit.*, plates 87 and 88.

41. *Op. cit.*, 90 ff.

42. See *A Descriptive Catalogue of the Second Series of Fifty Manuscripts (Nos 51 to 100) in the Collection of Henry Yates Thompson* (Cambridge, 1902), MS. 58, 74–82. See also *Facsimiles in Photogravure of Six Pages from a Psalter* ... (London, 1900). It was numbered Add. 39810 but has recently been changed to Yates Thompson 14.

43. On the fifteenth century additions, see Chapter 8.

44. Millar, II, plates 8–13; Warner, *Illum. MSS*, plate 31. The first psalter (fols 1–116 verso) was probably made for Sir William Howard of East Winch, near Lynn, Norfolk (d. 1308), or for his wife Alice de Fitton. At the end of the second Calendar is a note that Robert de Lisle gave this second psalter to his daughter Audere on 25 Nov. 1339.

45. On the relation of this miniature to a French manuscript, see R. Freyhan, 'English Influences on Parisian Painting of about 1300', *Burl. Mag.*, LIV (1929). But could the influence be reversed, that is, Paris on English?

Closely related to the style of the artist of the 'Three Living' is a single leaf belonging to the Staatliches Museum, Berlin (K.I.672), containing a superb painting of St Michael killing the Dragon. Reproduced, Oakeshott, *Sequence of English Medieval Art*, plate 35, opposite a coloured reproduction of the Three Living and the Three Dead from Ar. 83. The St Michael miniature was first published as East Anglian, by M. H. Bernath, 'An East Anglian Primitive in Germany', *Burl. Mag.*, LII (1928).

In the Archivio Capitolare of the cathedral at Velletri are three pieces of vellum originally sewn together to form a rotulus about two metres long and 26 cm. high. They contain a series of twelve scenes from the Passion, each under a foiled arch in the spandrels of which are medallions with busts of prophets and apostles. The design suggests that the paintings were intended as patterns, though they are in full colour; the proportions of the rotulus would hardly be suitable for a wall decoration. The suggestion which comes first to mind is that they might be patterns for that type of embroidered vestment which is designed with the figures under canopies or architectural frames, as the Bologna cope (Plate 141). But they might have served as cartoons for wall paintings, as at Chalgrove (see pp. 140 f). The style of the figures in the rotulus is clearly East Anglian of *c.* 1300, closest to the first artist of the second part of Brit. Mus., Arundel 83 (cf. Plate 134B). The rotulus is reproduced in detail and discussed by G. de Francovich, 'Miniature inglesi a Velletri', *Bollettino d'Arte*, Anno X, Ser. 1 (1930).

46. This is the time when Italian influence was very strongly felt in French miniatures of the Pucelle atelier. Cf. L. Delisle, *Les Heures dites de Jean Pucelle* (Paris, 1910). On Pucelle see Kathleen Morand, *Jean Pucelle* (Oxford, 1962).

47. E. G. Millar, *The Luttrell Psalter*.

48. *Op. cit.*, plates 115–16 (fols 181 verso–182).

49. *Op. cit.*, 5.

50. Reproduced in colour, *op. cit.*, frontispiece. **p. 134** Geoffrey (d. 1345) and his wife Agnes (d. 1340) and their daughter are represented. There is an inscription above the picture: 'Dominus Galfridus Louterell me fieri fecit'. In the Calendar several later obits are inserted including one (fol. 1, 17 January 1372) of Humphrey de Bohun (see Chapter 7).

51. H. D. Traill and J. S. Mann, *Social England*, II (London, 1902); J. R. Green, *A Short History of the English People*, II (London, 1908); George M. Trevelyan, *An Illustrated English Social History*, I (London, 1949), and others.

52. A series of these has been reproduced in colour on post cards which are for sale at the British Museum.

53. As, for example, the Bury Psalter now in the Vatican Library; see above, pp. 44 f.

54. *Catalogue of Yates Thompson MSS*, Second Series, No. 57, 50–74, and *Illustrations from One Hundred MSS. in the Library of H. Y. Thompson* (London, 1914), plate LI. Pächt cites this as being the only English manuscript for the illumination of which Pucelle's style could have been the model, *op. cit.*, 53, n. 3.

55. A late fifteenth century inscription is found on fol. 1: Liber domus sancti Bartholomei in Smythfylde. The source of the illustration in this manuscript is suggested by Pächt to be Bolognese manuscripts, *op. cit.*, 55 ff.

56. James, *The Treatise of Walter de Milemete*. **p. 135**

57. *Op. cit.*, xxi–xxiv.

58. James, 'An English Bible-picture Book of the 14th Century (Holkham MS. 666)'. See also Léon Dorez, *Les Manuscrits à peinture de la bibliothèque de Lord Leicester* (Paris, 1908). A facsimile with some colour plates and text by Hassall was published in 1954.

59. James, 'An English Bible-picture Book', 3.

p. 136 60. Christie, *English Medieval Embroidery*, 7–9.

61. *Op. cit.*, 89–94, plates XLII–XLV; see also W. R. Lethaby, 'English Primitives: The Ascoli Piceno Cope and London Artists', *Burl. Mag.*, LIV (1929), 304–8.

62. Christie, *op. cit.*, 94–6, plates XLVI–XLIX.

63. *Op. cit.*, 142–8, plates XCV–C.

64. *Op. cit.*, 112–14, plates LXIII–LXIV.

65. *Op. cit.*, 139–40, plates XCI–XCII, and 152–5, plates CVI–CVII.

66. *Op. cit.*, 159–61, plates CXII–CXIII.

p. 137 67. The shape of these medallions is the same as those of the Westminster Retable.

68. *Op. cit.*, 176–8, plates CXXXVII–CXXXVIII.

69. The name 'Johannis de Thaneto' is inscribed on a silver frieze above the arch. His name is mentioned three times in a Canterbury Cathedral inventory of 1315. Christie, *op. cit.*, 134, plate LXXXVI (colour).

69a. An interesting stylistic comparison can be made between this embroidery and the central panel of the Westminster Retable. The half-century difference in date marks the change from high Gothic grace and simplicity of linear design to the richer detail and fussiness of fourteenth century Gothic. This is particularly apparent in the drapery of this figure and in the detail of the arch.

70. *Op. cit.*, 178–83, plates CXXXIX–CXLII.

71. *Op. cit.*, 167–71, plates CXXV–CXXIX.

72. *Op. cit.*, 172–5, plates CXXXI–CXXXIV.

73. *Op. cit.*, 161–4, plates CXIV–CXIX.

74. Few examples of non-ecclesiastical embroideries have survived from this period. *Op. cit.*, 6.

75. *Op. cit.*, 21–7.

p. 138 76. *Op. cit.*, 17–19.

p. 139 77. W. W. Lillie, 'A Medieval Retable at Thornham Parva'. It was clearly made for some Dominican house, since Saints Dominic and Peter Martyr are represented in the two end panels.

78. Borenius and Tristram, *op. cit.*, 19–20. The inside of the lid of a chest at Newport (Essex) is painted with a Crucifixion and saints, dating from the early fourteenth century. See Roy. Acad. Arts *Exhib. Brit. Prim. Paintings*, *Cat.* No. 10, plate VI. See also R.C.H.M.: *Essex*, I (1916) 200.

79. Reproduced, Millar, II, plate 12.

80. W. R. Lethaby, 'London and Westminster Painters', *Walpole Soc.*, I (1911–12), 69–75.

81. Borenius and Tristram, *op. cit.*, 18.

82. Wormald, 'Paintings in Westminster Abbey', 175. Professor Wormald compares the style of the kings of the Sedilia with that of the Three Kings in Arundel MS. 83 (Plate 134B). East Anglian painters were working with Master Thomas. Two names mentioned are John of Jernemuto (Yarmouth) and John of Norfolk. *Op. cit.*, 176.

83. A mid fourteenth century panel with this same subject was discovered by Tristram in the possession of V. W. York at Forthampton Court, near Tewkesbury. See *Burl. Mag.*, LXXXIII (1943), 160–5.

84. For Croughton see Borenius and Tristram, *op. cit.*, 20–2, plates 50–2; also Tristram and James, 'Wall-Paintings in Croughton Church, Northamptonshire'. For Chalgrove see W. Burges, 'On Mural Paintings in Chalgrove Church, Oxfordshire', *Archaeologia*, XXXVIII (1860), 431–8.

85. See E. Clive Rouse, *Illustrated London News* (29 Dec. 1951), 1074–5.

86. E. Clive Rouse, *Country Life* (4 April 1947), 604–8.

87. Cf. Chapter 5.

88. Borenius and Tristram, *op. cit.*, 20.

89. The same subject occurs in other wall paintings of about the same time, for example, in the church at Tarrant Crawford (Wilts.) and others. See Williams, 'Mural Paintings of the Three Living and the Three Dead in England', *Jnl Brit. Archaeol. Soc.*, 3rd series, VII (1942), 31–40.

90. E. Clive Rouse, *Illustrated London News* (29 Dec. 1951), 1075.

91. Tristram, I, 58–9.

92. Woodforde, *Stained Glass in Somerset*.

92a. St Catherine. Reproduced in colour, Baker, *op. cit.*, plate xii. See also Eaton Bishop, St Michael, *op. cit.*, plate xiii (colour), and Virgin and Child, plate 28.

93. For coloured reproductions, see Harrison, *The Stained Glass of York Minster*.

94. Knowles, *The York School of Glass-Painting*, 3.

95. It is true that the figure compositions within thirteenth century medallions were placed under an architectural framework as at Canterbury. The change consists in the elimination of the medallion design and the further development of the canopy.

96. Peter de Dene became Canon of York in 1308. His adherence to Thomas of Lancaster caused him to retire hastily, after the latter's execution in 1322, to Canterbury. The window is not earlier than

1308 and surely not later than 1320. See Charles Winston and W. S. Walford, 'On an Heraldic Window in the North Aisle of the Nave of York Minster', *Archaeol. Jnl*, XVII (1860), 22–34; 133–48.

97. Richard Tunnoc, bell-founder, died in 1330. Knowles, *op. cit.*, plate XXI.

98. F. Harrison, *The Painted Glass of York*, 50. The same kind of naturalistic motifs are found in the glass of Wells Cathedral; cf. Woodforde, *Stained Glass in Somerset*, plate VIII. Knowles notes with surprise and without explanation the influence of Wells style on the glass of the parish church of St Denys at York (Knowles, *op. cit.*, 112 ff.). The so-called 'Golden Window' in the Lady Chapel at Wells was named from the extraordinary combination of yellowish tones (pot-metal and silver stain glass) with olive greens, harmonized in the Jesse Tree of the east window. The earliest of the windows in the north aisle of the church of St Denys exhibits this same colour harmony.

44 99. Rushforth, 'The Glass in the Quire Clerestory of Tewkesbury Abbey'. One of the knights is reproduced in colour, Baker, *op. cit.*, plate xiv.

100. Rushforth, 'The Great East Window of Gloucester Cathedral'.

CHAPTER 7

47 1. The mixture of Gothic and Italian painted figure styles which took place in the fourteenth century in various parts of Europe. On the International Style in general, see Raimond van Marle, *The Development of the Italian Schools of Painting*, VII (The Hague, 1926), 1–63. See also the introductions to the catalogue of an exhibition at the Kunsthistorisches Museum in Vienna in 1962: *Europäische Kunst um 1400*.

2. *English Art 1307–1461.*

3. On the influence of the East Anglian style in Germany, see Robert Freyhan, *Die Illustrationen zum Casseler Willehalm-Codex. Ein Beispiel englischen Einflusses in der rheinischen Malerei des XIV. Jahrhunderts* (Marburg, 1927). On the influence of East Anglian manuscripts on Bohemian illumination, see Jan Květ, *Iluminované Rukopisy Královny Rejčky* [The Illuminated Manuscripts of Queen Rejčka. A Contribution to the History of Czech Manuscript Painting in the fourteenth Century.] (Prague, 1931). The text is in Czech but includes a number of good plates for comparison of East Anglian and Czech border motifs.

4. In this connexion it may be recalled that some East Anglian manuscripts, such as the Ormesby Psalter (Plate 130), themselves show evidence of contacts with Italian painting in the first part of the fourteenth century. This occurs chiefly in certain figure types and poses rather than in technique and composition. Cf. Pächt, 'A Giottesque Episode'.

5. Stephen Beissel, *Vaticanische Miniaturen* (Freiburg i.B., 1893), 41–2, plate XXIIIA.

6. Wormald, 'The Fitzwarin Psalter and its Allies', 71–9. p. 148

7. James, *Catalogue of the Manuscripts in the Fitzwilliam Museum*, 100, gives evidence for the date and ownership, as well as a description of the miniatures in detail. See also Wormald, *op. cit.*, 73 and 79, plate 25C.

8. A detailed analysis of Italian, specifically of Giottesque influence, on English linear tradition is given by Pächt, *op. cit.*, 68 ff., in supporting the attribution of the Egerton Genesis to an English artist.

9. See Millar, 'The Egerton Genesis and the M. R. p. 149 James Memorial Manuscript', 1–5. A manuscript in Oxford discovered by Pächt (Bod. MS. Rawl. 185, dated before 1374) is very close in style to Add. MS. 44949 and may be partly by the same hand. Another manuscript illuminated in a mixed style (Brit. Mus., Egerton MS. 1894, the Egerton Genesis) seems to this writer not to be English in its style but rather a French-Italian mixture, since the technique is grisaille, which is found in many French manuscripts of the third quarter of the fourteenth century but in no known English ones of this time. James, *Illustrations of the Book of Genesis ... Egerton* 1894, believed the manuscript to be English, as does Millar. Pächt, as noted above, presents a well-reasoned and almost convincing case for an English origin, but the technique in its sculpturesque clarity seems more French than English.

10. James and Millar, *The Bohun Manuscripts*. The manuscripts included are: Oxford, Exeter Coll., MS. 47; Oxford, Bod. MS. Auct. D.4.4; Vienna, Nationalbib., Cod. 1826*; Copenhagen, Royal Library, Thott MS. 547; and Riches Coll. (now in the Fitzwilliam Museum, Cambridge). The Psalter in Edinburgh, National Lib., MS. Adv. 18.6.5, made for Eleanor de Bohun (d. 1399) was not included. Since the monograph appeared, two more manuscripts containing Bohun arms have been discovered: Brit. Mus., Roy. MS. 20 D. iv, a French text of *Lancelot du lac* with two earlier French miniatures painted over in the 'Bohun style', with Bohun arms added (Rickert, *Carmelite Missal*, plate

xlc); and Brit. Mus., Eg. MS. 3277, bought by the British Museum in 1943 (see plate 153A).

p. 149 11. For illustrations and discussion of this infiltration of Italian style into Vienna MS. 1826★, see Rickert, *Carmelite Missal*, 74 ff., and plate XL, a and b.

12. For example, Exeter Coll., MS. 47, also made for Humphrey de Bohun. James and Millar, *op. cit.*, plates I–XXII.

13. For example, Bod. MS. Auct. D.4.4, and Copenhagen, Thott MS. 547. *Op. cit.*, plates XXIII–XXXVIII and LVII–LXI.

14. His name occurs in the same series of memorials as in three other Bohun manuscripts: Exeter MS. 47, Bod. Auct. D.4.4, and Vienna MS. 1826★.

15. The north Italian-English mixture of styles occurs also in a Book of Hours in Munich (Staatsbib. Cod. Lat. 23215) illuminated for Blanche of Savoy (d. 1387) by Giovanni da Como, *c.* 1378. In this case it would appear that an English illuminator was working in Italy.

p. 150 16. The paintings were in two registers of four scenes each on the north and the south walls of the chapel, under the windows. The subjects were the stories of Job (north side) and Tobit (south side). See Brit. Mus., *Guide to an Exhibition of English Art*.

17. It is significant in this connexion to note that in the will of Hugh Payntour (1361), presumably Master Hugh of St Albans, is mentioned 'unam tabulam de VI peces de Lumbardy' which had cost £20. See W. R. Lethaby, 'London and Westminster Painters', *Walpole Soc.*, I (1911–12), 71.

18. An interesting sidelight is thrown on the painting in St Stephen's Chapel by a document of 1350 which appoints John Athelard, glazier and painter, to obtain painters for St Stephen's. Athelard himself continued to work at St Stephen's as a painter, possibly on cartoons for the windows. Salzman, 'The Glazing of St Stephen's Chapel, Westminster, 1351–2', 16.

p. 151 19. The paintings from the Chapel representing King Edward III and Philippa with their children, now entirely destroyed, are known only through copies made by Robert Smirke, now in the Society of Antiquaries, London. They seem to be earlier and much less Italianate in style. Reproduced, Evans, *op. cit.*, plate 27.

20. Waller, 'On the Paintings in the Chapter House, Westminster'. See also Noppen, 'The Westminster Apocalypse'. The wording of the document is 'fieri fecit' (caused to be made) which precludes the assumption that Brother John was the painter.

21. Oddly enough these paintings have not yet been published. The room is not usually open because it is part of a private apartment in the Tower. It was shown by courtesy of the Ministry of Public Building and Works.

22. The expenses for making the Missal are listed in the Abbot's Treasurer's Roll for that year. See J. A. Robinson and M. R. James, *The Manuscripts of Westminster Abbey* (London, 1909), 7 ff. Items of interest are payments for board and lodging of Thomas Preston while writing a missal and payment of ten shillings for painting the Crucifixion. No painter is named, but a possibility is Thomas Rolfe, a London 'lumynor', who is mentioned as illuminating another missal for Westminster Abbey. See Rickert, *Carmelite Missal*, 76, note 1.

23. Reproduced, Beauchamp, *Liber Regalis*. p.

24. Scharf (see note 43), 78, calls attention to the 'predominance of blue in contact with gold, and the strong deep shadows on the faces' in the *Liber Regalis* as showing 'much affinity to the Wilton House Diptych'.

25. The best period of Bohemian illumination was somewhat earlier in the fourteenth century and is found in a group of manuscripts made for Johann von Neumarkt. See Max Dvořák, 'Die Illuminatoren des Johann von Neumarkt', *Jahrbuch der Kunsthist. Sammlgn des allerhöchsten Kaiserhauses*, XXII (1901), 35–126. Later Bohemian manuscripts made for Wenzel, brother of Anne, have some of the exaggerated features found in the *Liber Regalis*. See Julius von Schlosser, 'Die Bilderhandschriften Königs Wenzel I', *op. cit.*, XIV (1893), 214–319.

Particularly close to the border style of the Trinity miniature is that of the latest of this group, the Gospels of Johann von Troppau in Vienna (Nationalbib. MS. 1182). Ten full pages from this manuscript are magnificently reproduced in colour by Ernst Trenkler, *Das Evangeliar des Johannes von Troppau* (Vienna, 1948).

26. Reproduced, Rickert, *Carmelite Missal*, plate p. XLd.

27. *Op. cit.*, plate XLVb.

27a. Reproduced, Wormald, 'The Wilton Diptych', plate 28a.

28. Both are reproduced, Rickert, *op. cit.*, plates XLII and XLIII.

29. In France the first (Italianate) phase was developed in painting under the influence of Simone Martini at Avignon, and later in the century, in miniatures by Jacquemart d'Hesdin.

30. The circumstances which caused painting in this part of Europe to differ so markedly from that of the Île-de-France in the later Middle Ages are still unclear. It may be that the longer survival of Romanesque style which was not superseded by Gothic, as in France, was partly responsible. Romanesque style revivified by later Italian influence could have produced the strong, often crude and ugly figure types and heavily modelled faces which characterize Dutch painting in the late fourteenth century. See Rickert, *op. cit.*, 83 ff. and plates XLVI–XLIX.

31. Many new documents have recently been discovered and published. See Gorissen, F., 'Jan Maelwael und die Brüder Limburg', *Vereeniging tot beoefening van Geldersche geschiedenis, oudheidkunde en recht, Bijdragen en mededelingen*, deel LIV (1954). See also Rickert, review of this article, *Art Bulletin*, XXXIX (1957).

32. Evidence for the earlier date rests on the absence from the Missal of three feasts introduced into the Carmelite rite in 1393: the Visitation, the Presentation of the Virgin, and St Mary of the Snows. The terminal date is fixed by the Crucifixion in the Lapworth Missal (presented in 1398), which copies the style of the Dutch master. See below.

33. It measured originally at least 25¼ ins. by 16¾ ins. and the margins had been trimmed considerably. The process of reconstructing the Missal is described by Rickert, *Carmelite Missal*, 116–37. Its early history (before it was cut up to make scrapbooks *c.* 1834) is unknown.

34. For evidence that the Missal is Carmelite, see *op. cit.*, chapter 1.

154 35. For an explanation, see *op. cit.*, 50.

155 36. *Op. cit.*, 105. Other miniatures containing equally interesting scenes by this artist are the Assumption of the Virgin (plate XV) and the Decollation of the Baptist (plate XVIB). Both Carmelites and donors occur in these and other miniatures in this style.

37. Especially the panel with the Annunciation on the back of the left wing of the great carved altarpiece made for the Chartreuse de Champmol near Dijon. The painter was Melchior Broederlam of Ypres and the panels were finished in 1399. Reproduced Erwin Panofsky, *Early Netherlandish Painting* (Cambridge, Mass., 1953), plate 50.

38. The characteristics typical of the painting in the 'foreign' miniatures of the Carmelite Missal are found, though in a less fully developed form, in certain miniatures in a book of heraldic poems, illustrated with many coats of arms and two miniatures, known as the Gelder *Wapenboek* (Brussels, Bib.

Roy., MS. 15652–6), compiled and illuminated at the court of the duke of Gelder between 1372 and 1393. Similar characteristics are found also in some cruder miniatures of another manuscript (Brit. Mus., Roy. MS. 20 D.v) written in Dutch between *c.* 1375 and 1400. Both these manuscripts are early enough to be attributable to the artist of the Carmelite Missal. Political connexions between Gelder and England in the reign of Richard II were close and Duke William IV of Gelder with a retinue including two heralds paid a visit to England in 1390. This could have been the occasion for the Dutch artist of the Missal to come also.

39. See Rickert, 'The So-called Beaufort Hours', 238. p. 156

40. *Op. cit.*, 242.

41. Both panels reproduced Panofsky, *op. cit.*, plates 50–1. p. 157

42. Another Gelder artist, Jan Maelwael, then court painter to the Duke of Burgundy, Philippe le Hardi, was one of the judges of the panels before they were paid for. Chrétien Dehaisnes, *Documents et extraits divers dans la Flandre, l'Artois et le Hainaut* (Lille, 1886), I, 720, note 1.

43. The principal earlier discussions of the Wilton Diptych are the following: G. Scharf, *Description of the Wilton House Diptych* (London, 1882); W. G. Constable, 'The Date and Nationality of the Wilton Diptych', *Burl. Mag.*, LV (1929), 36–45; Sir Martin Conway, 'The Wilton Diptych', *op. cit.*, 209–12; M. V. Clarke, 'The Wilton Diptych', *op. cit.*, LVIII (1931), 283–94; T. Bodkin, *The Wilton Diptych*, Gallery Books, No. 16 (London, n.d.). For the latest articles see Bibliography.

44. The gesso can be seen clearly on the back of the right panel where it has been badly damaged. p. 158

45. Brussels, Bib. Roy., MS. 11060–1. Reproduced Panofsky, *op. cit.*, plate 17. p. 159

46. See Harvey, 'The Wilton Diptych'. In a lengthy re-examination the author of this article weighs all the evidence and hypotheses to date and presents some new documentary material not related directly to the Diptych by which he seeks to establish the meaning of the painting and the occasion for which it was produced. His conclusion is that 'it symbolized his (Richard's) rededication to the cause of the English royal prerogative as the instrument of God on earth; and his foundation of a brotherhood leagued with him to achieve this end' (p. 24). Harvey dates the Diptych between the summer of 1394 and the autumn of 1395, 'shortly before he grew a beard'. p. 160

The dating now seems to the present writer acceptable, but the occasion for it, however ingeniously constructed, is not convincing. It would seem more likely to be connected with negotiations for Richard's second marriage.

p. 160 46a. Wormald has suggested that the Diptych was a memorial picture representing the reception of Richard in heaven and that its occasion possibly was the removal of the King's body from King's Langley to Westminster in 1413 ('The Wilton Diptych'). The heraldry, he concludes, makes a date earlier than 1396 impossible. For the style of the left panel even this date seems too late, and for the right panel 1413 also seems rather late. So the problem still rests unresolved.

47. Roy. Acad. Arts, *Exhib. Brit. Prim. Paintings, Cat.* No. 30. Borenius found that 'the picture seems to offer such close parallels to the paintings of St Stephen's Chapel as to make it seem much more natural to look upon it as a work of the same school'. 'English Primitives', *Proc. Brit. Acad.*, XI (1924–5), 82. The portrait is of course much later.

48. The background, which is now plain gold, was originally decorated in some manner, probably with a tooled pattern, glimpses of which can still be seen through the openings in the tracery of the throne. At the time of the restoration there was, however, a gilt gesso pattern similar to that of the canopy or tester of the tomb of Richard and Anne in the Westminster Choir. This gesso ground was removed, but there does not seem to be complete agreement as to whether it was original or a later addition.

49. In the south choir aisle of the Abbey. The tomb was ordered in 1395, soon after the death of Anne in 1394. The contract for the work still exists and is published in Rymer's *Foedera*, VII (1709), 795–6. The master mason who designed it was Henry Yevele, for an account of whose life and work see John Harvey, *Henry Yevele* (London, 1944).

p. 161 50. The portrait has been attributed to Beauneveu but seems to show no close resemblance to the work of this painter. See S. C. Cockerell, 'André Beauneveu and the Portrait of Richard II at Westminster Abbey', *Burl. Mag.*, X (1906), 126–7.

51. Two late fourteenth century examples may be cited: the so-called Jerzen Epitaph and the Dubečeker Altarpiece, both in Prague. Reproduced, Alfred Stange, *Deutsche Malerei der Gotik*, II (Berlin, 1936), plates 69–71; discussed 59 ff., 62 ff., and 65 ff.

52. *Op. cit.*, 132 ff.

53. Borenius and Tristram, *op. cit.*, 26.

54. Roy. Acad. Arts, *Exhib. Brit. Prim. Paintings, Cat.* No. 32. See also St John Hope, 'On a Painted Table or Reredos of the Fourteenth Century in the Cathedral Church of Norwich'. The boards comprising the Altarpiece run lengthwise. Only four of a probable five remain, the top one having been broken away, perhaps when it was used, with the painted side down, as a table. At the same time the holes in the four corners were made for table legs. The upper part of the centre panel with the Crucifixion is cut off by the loss of the top board. It is not known what may have filled this space in the other panels. The name of a 'peynter', Thomas de Ocle, who was admitted a freeman of Norwich in 1386–8, has been suggested as the artist. There is no evidence for this attribution. The painting has recently been restored and placed as a reredos in the Chapel of St Luke in the Cathedral.

55. St John Hope, *op. cit.* See also Waller, 'On p. the Retable in Norwich Cathedral and Paintings in St Michael-at-Plea'. Waller says the Retable is Italian.

56. Meister Bertram again comes to mind, rather in connexion with the figure types than with general style. Hanseatic influences on Norwich art would by no means be impossible. On the spread of Hanseatic art, see Stange, *op. cit.*, III, 196 ff. See also note 60.

57. Reproduced, Roy. Acad. Arts, *Exhib. Brit. Prim. Paintings, Cat.* Nos 33, 34, plate xxa. The panels have been reassembled and are now in Norwich Cathedral.

58. The painting has been much discussed. For a reproduction and bibliography, see *Catalogue of the Lee Collection* (revised 1962). The present author is not prepared to defend what is given here merely as a general opinion of the style.

59. The varnish and the dirt that had accumulated on it have now been removed and the surviving panels are more clearly visible.

60. Noppen, 'The Westminster Apocalypse', 159, thinks the paintings show strong German influence, as of the School of Meister Bertram. On this point, see Alexander Dorner, 'Ein Schüler des Meisters Bertram in England', *Jahrbuch der Preuss. Kunstsammlungen*, 58 (1937), 40 ff.

61. Noppen suggested that the model for the paintings was a late fourteenth century manuscript of the Apocalypse in Cambridge, Trinity College, MS. B.10.2. See 'The Westminster Apocalypse and its Source', 146–59. The manuscript was attributed

by James to Westminster (see Chapter 5, note 83) but the style is almost identical with that of a late fourteenth century St Albans manuscript (Brit. Mus., Cott. MS. Nero D.VII) containing portraits of benefactors of that abbey. Certainly the compositions of the first fifteen scenes of the Chapter House apocalypse paintings follow very closely those of the manuscript. Some pages are reproduced, *op. cit.*

At the end of the Cambridge manuscript are six leaves with some very fine tinted drawings of the life of St Edward, also of the very late fourteenth century, which in style and even in quality reflect the miniature of the Emperor Charles and the seven electors in the Gelder *Wapenboek*, which is attributed by this writer to the Dutch Master of the Carmelite Missal. See Rickert, *Carmelite Missal*, 83 f. and plate XLVII. (Cf. note 38 above.) The St Edward drawings were probably used for the sculptured reliefs of the same subject in the Confessor's Chapel at Westminster.

163 62. Borenius, 'An English Painted Ceiling of the Late Fourteenth Century'; see also Preston, 'The Fourteenth Century Painted Ceiling at St Helen's Church, Abingdon'.

63. Borenius, *op. cit.*, 276, found that some of the kings resembled the portrait of Richard II at Westminster. As far as can be judged from their present state, the quality of even the better Abingdon figures is greatly inferior to that of the Richard portrait.

64. A manuscript which is undated (Brit. Mus., Roy. MS. 20 D. v) not only shows strong influence of this style in the miniatures, but copies some of the Dutch artist's compositions in the Carmelite Missal. Rickert, *op. cit.*, 93, plate LIIIa.

65. Joint patrons of the Sherborne Missal were Richard Mitford, Bishop of Salisbury (1395–1407) and Robert Bruynyng, Abbot of Sherborne (1385–1415), who are represented frequently in pictures in this manuscript.

66. Herbert, *The Sherborne Missal*.

164 67. These occur most abundantly and with most precise ornithological intention between pages 363 and 393. Many are not only drawn and painted so accurately as to be recognizable, but in many cases are even labelled with their English names. A number are reproduced in the coloured frontispiece of Herbert's monograph. A fourteenth century sketch book (MS. 1916 in the Pepysian Library, Magdalene College, Cambridge) contains a whole page of such birds, some of which may be identified in the Sherborne Missal. See James, 'An English Medieval Sketchbook'.

68. Siferwas appears twice in documentary records. On 19 May 1380, F. John Cyfrewas, Friars Preachers, Guildford, was ordained acolyte at Farnham by the Bishop of Winchester (*Wykeham's Register*, ed. T. F. Kirby, *Hampshire Record Soc.*, 1 (1896), 296; 'Johannes Sifirwas, frater ordinis predicatorum' is named as the recipient of a pair of jet praying beads in the will of the widow Joan Elveden dated 4 Sept. 1421 (*Central Probate Registry*, Somerset House, P.P.C. Marche, fol. 52). These documents are quoted by Herbert, *op. cit.* p. 165

69. Reproduced in colour as frontispiece to Millar, II.

70. Reproduced, Rickert, *Painting in Britain* (1954), plate 157. See also Millar, II, plate 86.

71. Reproduced, Millar, II, plates 92, 93; Rickert, p. 166 *La miniatura inglese*, II, plate 55.

72. See Rickert, 'Herman the Illuminator', *Burl. Mag.*, LXI (1935), 39 ff.

72a. See H. Michel, 'Les Manuscrits astronomiques de la Bibliothèque Royale', *Ciel et Terre*, LXV (1949).

73. This leaf, now owned by Mr A. Wyndham p. 167 Payne of Sidmouth, was evidently exposed for many years to the light which has faded some of the colours. Rusted holes around the edges of the leaf indicate that it was tacked to a panel and framed as a picture. Its present size is $14\frac{3}{4}$ by $10\frac{1}{4}$ inches, but the margins have been trimmed close to the border decoration.

74. The original colour of the shading of the folds could have disappeared, since the surface of the miniature is so greatly damaged; but there is a possibility that the painting was never finished. The background probably was originally a soft madder red, now faded to dull yellow. The diagonal lines forming the diaper and some of the patterns in the lozenges were in gilt paint, as is shown by particles still visible here and there.

75. On fol. 146 verso; on fol. 147 is the Office for p. 168 him which was in use only till the death of Henry IV in 1413. The manuscript was perhaps intended for a York patron. See Kuhn, 'Herman Scheerre'.

76. This manuscript and two other copies of the p. 169 same text were discovered in the Bodleian Library by Mrs Gereth M. Spriggs, to whom I am grateful for knowledge of them. They are numbered: Bodley 294, 693, and 902. All have miniatures in the Herman style but only those in MS. 294, in the opinion of this writer, are by Herman himself. The manuscripts will be published by Mrs Spriggs in a forthcoming issue of the *Bodleian Library Record*.

Other miniatures attributed recently to Herman but not, it would seem, by his own hand, are found in two Books of Hours in Austrian monasteries. See Gerhard Schmidt, 'Two Unknown English Horae from the Fifteenth Century', *Burl. Mag.*, CIII (1961), 47 ff.

p. 170 77. First published by Leroquais, *Les Psautiers manuscrits latins des bibliothèques publiques de France* (Macon, 1940-1), II, 176-81, and III, plates 128-30. Rickert, 'The So-called Beaufort Hours', 242 f.

78. A notation on fol. 16 verso recording the Battle of Agincourt (1415) in a slightly later script gives a date *ante quem*.

79. *Op. cit.*, plate 10. He may have been the illuminator of MS. Gough liturg. 6 in the Bodleian Library. See note 86.

80. Rickert, *op. cit.*, plate 11. The Psalter of Princess Joan copied in almost every detail the compositions of the Rennes initials.

81. The name of Master of the Beaufort Hours or the Beaufort Master was given to the miniaturist of the series of preliminary miniatures in Roy. 2 A. xviii by Kuhn, *op. cit.* In view of the later study of this manuscript (see note 77 above) the name is perhaps less suitable but nevertheless probably will cling to this foreign style until further research identifies it.

p. 171 82. Evidence is based on the absence of offices for Saints David, Winifred, Chad, and John of Beverley, all ordered by Archbishop Chichele himself in 1416. *New Pal. Soc.*, Series II, plate 131. See also Millar, 'Les Principaux Manuscrits du Lambeth Palace', *Bull. de S.F.R.M.P.*, VIII (1924).

83. All traces of some former inscriptions on the end fly-leaves have been so completely removed that nothing shows even under ultra-violet ray. Nothing at all is known, therefore, about its ownership or history. No donors and no coats of arms are represented anywhere in the manuscript. The dating is based wholly on stylistic considerations.

p. 172 83a. See Rickert, *Carmelite Missal*, 96, note 2.

84. See Carta, Cipolla, e Frati, 'Inventario dei codici superstiti greci e latini antichi della Biblioteca Nazionale di Torino', 1904 (no. 163), 457 (*Rivista di Filologia e d'Istruzione Classica*).

85. This magnificent manuscript has never been completely published. A very brief study by D. H. Turner has appeared recently in *Apollo* (June 1962) with a colour reproduction of the historiated initial on fol. 109, which was perhaps painted by Herman.

85a. Several are reproduced, Turner, *op. cit.*, p. figures 2-9.

86. For example, a miniature in a copy of Gower's p. *Confessio Amantis* (Brit. Mus., Eg. MS. 1991) which seems to be copied from Herman's original(?) illustration in Bod. MS. 294, fol. 9, and also a miniature of St Augustine preaching on fol. 1 of a manuscript from Charterhouse (London), MS. 433 (432) in Gonville and Caius College, Cambridge. Both of these miniatures attest the closeness of his style to that of Herman with whom he may have collaborated earlier in Add. MS. 16998. On the background of the St Augustine miniature is the inscription used by Herman on fol. 37 of Add. 16998 with, at the end, a name which may be read (doubtfully) as Bektle. This same miniaturist may have done most of the illustrations in Bod. MS. Gough liturg. 6.

87. An interesting situation arises from the inclusion in a later(?) copy of this same work (Brit. Mus., Harl. MS. 4866) of a portrait of Geoffrey Chaucer (see Rickert, *Painting in Britain* (1954), plate 169B). A similar picture could be assumed to have been on a corresponding leaf in Arundel 38, now torn out. The Chaucer portrait is doubtfully by Herman but does not seem to be by his collaborator either, and one wonders whether a presentation miniature with this same composition by the artist of the surviving Chaucer portrait (Herman?) may have been present originally at the beginning of Harl. MS. 4866.

88. Brit. Mus., Add. MS. 50001. This manuscript, one of the gems of the Dyson Perrins Collection, was bought by the British Museum in 1958, after Mr Perrins's death. See Warner, *Descriptive Catalogue of Illuminated Manuscripts in the Library of C. W. Dyson Perrins, D.C.L., F.S.A.* (1920), ix; Millar, *op. cit.*, II, plates 88-90; *British Museum Quarterly*, XXIII; Turner, *op. cit.*, 270 f.

89. A Psalter and Hours of Sarum used in the p. Bodleian Library (Rawl. liturg. d.1), with a long series of large and small miniatures seems to form a stylistic link between the Bedford Hours and those of Elizabeth.

89a. Reproduced, *Catalogue of Royal Manuscripts* p. (1921), plate 62.

90. The portrait element has sufficiently impressed one scholar, however, to lure her into compiling from this miniature a complete roster of 'fourteenth century celebrities'. See Margaret Galway, 'The "Troilus" Frontispiece', *Mod. Lang. Review*, XLIV (April, 1949).

91. In the Musée Condé at Chantilly. See Comte Paul Durrieu, *Les Très Riches Heures du duc de Berry*

(Paris, 1903). Wormald compares this style with that of wall painting in the Torre dell'Aquila, Trento. 'The Wilton Diptych', 195 and plate 30b.

92. For example, a psalter made for the Abbey of Bury St Edmunds, now in the Grammar School at Bury.

93. See Chapter 6, 143 ff.

94. Le Couteur, *Ancient Glass in Winchester*, 63, quotes an entry from Wykeham's household accounts covering expenses for cartage; the date is 1393.

95. New College was founded in 1380, and in 1386, when it was occupied, '... it may be assumed that the windows of the chapel and hall were wholly glazed ...', Christopher Woodforde, *The Stained Glass of New College, Oxford*, 1.

96. Because there are no other payments after 1393, Le Couteur assumes that the glass was all in place in 1394 when the College was handed over by Wykeham, *op. cit.*, 63.

97. *Op. cit.*, 117, quoting entry of payment.

98. For documents referring to this transaction and to the cost of transporting the Jesse glass to York, see Woodforde, *op. cit.*, 20 ff.

99. Many of these figures are reproduced, Woodforde, *op. cit.*, plates I–XI and coloured frontispiece.

100. Harrison, *The Painted Glass of York*, 129.

CHAPTER 8

1. French influence on English art in this period perhaps dates from the purchase of the Library of the Louvre by John, Duke of Bedford in 1425. In 1427 a magnificent Livy manuscript (now Paris, Bib. Ste-Geneviève, MS. fr. 1.1) was sent by Bedford to his brother Humphrey, Duke of Gloucester. Leopold Delisle, *Le Cabinet des manuscrits de la Bib. Nat.*, I (Paris, 1866), 52 n. 6.

2. Warner, *Illum. MSS*, plate 47.

2a. English illumination of the Herman atelier, however, continued in such manuscripts as the Hours made for Margaret de Beauchamp of Bletsoe (Brit. Mus., Roy. 2 A. xviii) probably in the 1430s, and in the slightly later Warwick Hours formerly MS. 12 in the Dyson Perrins Collection, now Morgan MS. 893. Two slightly earlier illuminated manuscripts in the Herman style were made for Syon Monastery: Bod. Libr. Auct. D.4 (an ordinal and psalter) and Karlsruhe, Landesbibliotek, St Georgen 12 (a *Sanctilogium*), both in the late 1420s. For knowledge and reproductions of this last manuscript I am indebted to Dr Ellen Beer of the University of Berne.

3. For example, the stained glass at Fairford (Glos.) and King's College Chapel, Cambridge. The panel portraits of kings in the Society of Antiquaries, London, seem to be more Flemish in style than English, as is also the martyrdom of St Erasmus in the same collection. For a suggestion that the St Erasmus might be English (perhaps Canterbury) see Sir Martin Conway, *Burl. Mag.*, XCI (1943), 129 ff.

4. See M. Rickert, 'Illumination of the Chaucer p. 182 Manuscripts', John M. Manly and Edith Rickert, *The Text of the Canterbury Tales*, I (1940), 561–605, with illustrations.

5. The colophon reads in part, 'un pater noster et un Ave Maria per mosseu Pey (or Rey?) de la fita, qui a escrivt a quest livre en l'an de nre sengr mil CCCCXXXIIIIo Et fut feit a londres a XV de May'.

6. Similar in figure style but French in decoration p. 183 is the very beautiful Psalter of Henry VI, Brit. Mus., Cott. Dom. A.xvii. Warner, *Illum. MSS*, plate 48.

7. Another manuscript in this style but slightly less fine in quality is Cambridge, Trin. Coll., MS. B.10.12, the *Meditations of Pseudo Bonaventura*. The heads are magnificent in these miniatures but the bodies are usually underdeveloped and misshapen. More colour is used in this manuscript than in the Cotton Faustina, especially for backgrounds.

8. Both this and Chaundler's other manuscript p. 184 are discussed in the Roxburghe Club monograph by James, *The Chaundler Manuscripts*.

9. On fol. 270 verso of the Bodleian volume is a p. 185 colophon containing the date: '... annus millenus quadringenus tibi notus et sexagenus tunc ecce repletus.'

9a. Millar, II, 77.

10. See Viscount Dillon, 'On a MS. Collection of Ordinances of Chivalry of the Fifteenth Century belonging to Lord Hastings'.

11. Archibald Russell, 'The Rous Roll', *Burl. Mag.* XXX (1917), 23–31. Rous was attached throughout his life to the great Beauchamp family of Warwick and as a priest from *c.* 1445 held the chantry at Guy's Cliff founded by Richard Beauchamp (d. 1439). He wrote a number of books on the history of Warwick, of Guy's Cliff, and of the Warwick family.

11a. Additional MS. 48976. It is 24 feet long and 13½ inches wide. The figure drawings in the new

Rous Roll, good as they are, show little individuality, although armour and costume conform in some degree to the period in which the persons lived. The Roll was published in 1859 by William Courthope, Somerset Herald. See C. R. Wright, *Brit. Mus. Quart.*, xx, 77–81.

p. 185 12. Particularly as seen in a historical-genealogical manuscript written for the Beauchamps (Brit. Mus., Cott. MS. Jul. E.iv, art. 6). The artist was undoubtedly Flemish, and it would be impossible to mistake and useless to deny the enormous difference in the fineness of the drawing and the skill in rendering figures, singly or in groups, and spatial compositions in this manuscript. For reproductions see Sir Edward Thompson, 'The Pageants of Richard Beauchamp, Earl of Warwick, Commonly Called the Warwick MS.', *Burl. Mag.*, I (1903), 151–64; also Viscount Dillon and W. H. St John Hope, *Pageant of the Birth, Life and Death of Richard Beauchamp, Earl of Warwick* (London, 1914).

p. 186 13. Cf. H. C. Whaite, *St Christopher in English Mediaeval Wall Painting* (London, 1929).

14. Charles Keyser, 'On a Panel Painting of the Doom Discovered in 1892, in Wenhaston Church, Suffolk', *Archaeologia*, LIV (1895), 119–30.

15. See Colgrave, 'The St Cuthbert Paintings on the Carlisle Cathedral Stalls'. On the Durham manuscript see pp. 95 f. above.

p. 187 16. Roy. Acad. Arts, *Exhib. of Brit. Prim. Paintings, Cat.* No. 38, plate XXII. A recent re-examination of the backs of the panels furnished no evidence as to their original use.

16a. A tiny missal and psalter of *c.* 1433 (Bod. Libr., Douce MS. 18) is illuminated partly in a style similar to that of Harl. 2278 suggesting a French-English mixture, and partly in a style derived from that of the Hours of Elizabeth the Queen. (See Chapter 7.)

17. Victoria and Albert Museum, *Catalogue of English Furniture and Woodwork*, 2nd edition (1929). The figures have been much repainted.

18. Constable, 'Some East Anglian Rood Screen Paintings', 211–20, figures IX–X.

19. *Ibid.*, Constable suggests that the Barton Turf screen may have influenced the celebrated Ranworth screen which he dates somewhat later.

20. The medieval hierarchy of the angels consisted of nine orders: Seraphim, Cherubim, Thrones, Dominations, Virtues, Powers, Principalities, Archangels, Angels. Barton Turf contains the finest surviving representations of the hierarchy.

21. *Op. cit.*, 290 ff. See also E. F. Strange, 'The Rood Screen of Cawston Church', *Walpole Soc.*, II (1912–13), 81–7, with coloured reproductions.

22. The reason for its size is that *c.* 1460–70 the present carved roof was added to the nave, the height of which was considerably raised at that time. The painting was coated with whitewash after the Reformation and only uncovered in 1819 when it was extensively 'restored' by Clayton and Bell. See Hollaender, 'The Doom Painting of St Thomas of Canterbury, Salisbury'.

23. Painted screens may be found in numbers also in the South Midlands, Devon and Cornwall, and Somerset. On the South Midlands screens see W. W. Lillie, *Jnl Brit. Archaeol. Assn*, 3rd series, IX (1944), 33–47. On the Devonshire screens see John Stabb, *Some Old Devon Churches*, I (London, 1908). One particularly fine example is at Ashton (South Devon), dating from the late fifteenth century. Reproduced, N. Pevsner, *The Buildings of England, South Devon* (London, 1952), plate 38A. The screens in South Devon and Cornwall are particularly rich in carving; the painted panels are usually found in the lower part of the screens.

24. Woodforde, *The Norwich School of Glass Painting in the Fifteenth Century*.

25. *Op. cit.*, 16–42.

26. *Op. cit.*, 24, and footnote 3.

27. *Op. cit.*, 42–55. See also Baker, *Stained Glass*, colour plates III and XXIV.

28. *Op. cit.*, 74–127.

29. See Chapter 7.

30. Hutchinson, *Mediaeval Glass at All Souls College*.

31. *Op. cit.*, 17 ff.

32. *Op. cit.*, 37 ff. See also below.

33. Philip B. Chatwin, 'Recent Discoveries in the Beauchamp Chapel, Warwick', *Birmingham Archaeol. Soc.*, LIII (1928), 145–66.

34. See William Bentley, 'Notes on the Musical Instruments Figured in the Windows of the Beauchamp Chapel, St Mary's, Warwick', *op. cit.*, 167–172. See also Charles F. Hardy, 'On the Music in the Painted Glass of the Windows of the Beauchamp Chapel at Warwick', *Archaeologia*, LXI (1909), 583–614.

35. The contract, which was first printed in Dugdale's *Antiquities of Warwickshire*, II (edition of 1656), is quoted by Le Couteur, *Ancient Glass in Winchester*, 104.

36. The patterns on paper referred to here may be the 'patrons otherwyse called A vidimus' mentioned in two of the contracts for the King's College glass. See note 55 below. On the meaning of the term 'vidimus', see further A. Van der Boom, *Burl. Mag.*, XCI (1949), 114.

37. Similar figures under canopies commonly appear in fifteenth century embroidered orphreys which adorn vestments of rich materials, usually velvet. A number of examples can be seen in the Victoria and Albert Museum, London, notably the nearly contemporary Warwick Chasuble (No. 402–1907) bearing the arms of Henry de Beauchamp, Duke of Warwick (d. 1445). The ground of the vestment was usually *semé* with angels or seraphs on wheels, and heraldic emblems of the persons for whom they were made. Though rich in materials, fifteenth century vestments, in general, display workmanship in the embroideries which is far inferior to that of the earlier century.

38. Hutchinson, *op. cit.*, 38.

39. James and Tristram, 'Wall Paintings in Eton College Chapel and in the Lady Chapel of Winchester Cathedral'. Earlier publications of the paintings, particularly reproductions of the missing subjects shown in the Essex drawings of them, are listed here.

40. On the sources of the subject matter, see *op. cit.*, 19–36.

40a. The tragic story of the destruction of some of these paintings is told by James, *op. cit.* The surviving portions were in process of being cleaned and restored when last visited (October 1962).

41. *Op. cit.*, 37 ff.

42. J. A. Knowles, 'Technical Notes on the St William Window in York Minster', *Jnl Brit. Soc. Master Glass-Painters*, X, No. 3 (1950), 118–131. The window was apparently given as a memorial to John, 8th Lord Ros (d. 1421), by his wife Margaret Despenser (distant cousin of Isabella Despenser, Countess of Warwick) who remarried in 1423. See Rushforth, *Mediaeval Christian Imagery*, 52.

43. *Op. cit.*, 122–4.

44. *Op. cit.*, 118 ff.

45. See P. J. Shaw, *An Old York Church: All Hallows in North Street* (York, 1908). In Chapter 3, 'Stained Glass Windows', by Charles P. D. Maclagan, these panels are reproduced in colour plates. The window is here dated *c.* 1440.

46. Rushforth, *op. cit.*, 1–3.

47. *Ibid.*

48. The glass that remains of the New Testament series is now collected in the north nave aisle, the second window from the east. The remains of the Old Testament series are now in the south choir aisle (St Anna's Chapel). For a detailed listing of the subjects of all the original Malvern glass and its present location, see Hamand, *The Ancient Windows of Great Malvern Priory Church*.

49. This is the Richard Beauchamp, Earl of Warwick, for whom the Beauchamp Chapel in St Mary's, Warwick, was built. See p. 190 above.

50. Moreover, as early as 1449 a Fleming named John Utynam was employed by the King to 'make glass of all colours for the windows of Eton College and the College of St Mary and St Nicholas, Cambridge'. The document further states that 'because the said art' (of making glass) 'has never been used in England and John intends to instruct divers lieges of the king in many other arts never used in the realm beside the said art of making glass', provision is therefore made for a penalty to be imposed on any person who practises the art unlawfully. Public Record Office, *Calendar of Patent Rolls, 27 Henry VI*, part II, 255. In 1449–50 John Prudde, the King's glazier, was making 'storied glass' for the windows of Eton College Hall. Accounts *Empcio vitri* (1449–1450), printed in Willis and Clark, *Architectural History of the University of Cambridge*, I (Cambridge, 1886), 403.

51. For a detailed description of the windows, see Oscar G. Farmer, *Fairford Church and its Stained Glass Windows*, 5th edition (1938).

52. The manor of Fairford belonged to Henry VII and it might be expected that the King's glaziers would be responsible for both sets of windows.

53. Mr Kenneth Harrison, in the most recent publication on the King's College Chapel windows, has made out a very good case for the precedence of Flemish over Italian influence in the introduction of the full-fledged Renaissance style in England. *The Windows of King's College Chapel* (Cambridge, 1952), 19–35.

54. For a description of the subjects of the windows, see M. R. James, *A Guide to the Windows at King's College Chapel, Cambridge*, 3rd edition (revised) (Cambridge, 1951).

55. Harrison, *op. cit.*, 60. The contract is printed in full in Willis and Clark, *op. cit.*, I, 615 ff.

56. Harrison, *op. cit.*, 4 ff. See also the 'Tabular Summary' of windows attributed to the various glaziers on pp. 78–80.

57. See Otto Pächt, *The Master of Mary of Burgundy* (London, 1948), 25 ff.

BIBLIOGRAPHY

I

ENGLISH ART

GENERAL

BATTISCOMBE, C. F. (ed.). *The Relics of St Cuthbert*. Oxford. 1956.

BOASE, T. S. R. *English Art, 1100–1216*. Oxford, 1953. (Vol. III of The Oxford History of English Art.)

BRIEGER, P. *English Art, 1216–1307*. Oxford, 1957. (Vol. IV of The Oxford History of English Art.)

British Museum. *Guide to an Exhibition of English Art*. London, 1934.

EVANS, Joan. *English Art, 1307–1461*. Oxford, 1949. (Vol. V of The Oxford History of English Art.)

HARVEY, J. H. *Gothic England, a Survey of National Culture 1300–1550*. 2nd edition revised. London, 1948.

READ, Herbert. 'English Art', *Burlington Magazine*, LXIII (1933).

RICE, David Talbot. *English Art, 871–1100*. Oxford, 1952. (Vol. II of The Oxford History of English Art.)

SAUNDERS, O. E. *A History of English Art in the Middle Ages*. Oxford, 1932.

SAXL, Fritz, and WITTKOWER, Rudolf. *British Art and the Mediterranean*. Oxford, 1948.

Victoria and Albert Museum. *Exhibition of English Medieval Art, 1930* (Catalogue). London, 1930. 2nd edition, 1933.

PAINTING AND ILLUMINATION

BIRCH, Walter de Gray. *Early Drawings and Illuminations*. London, 1879.
Particular emphasis on subject matter.

Bodleian Library. *English Illumination of the Thirteenth and Fourteenth Centuries*. Bodleian Picture Books, 10. Oxford, 1954.

BORENIUS, T., and TRISTRAM, E. W. *English Medieval Painting*. Florence and Paris, 1927.

British Museum. *Reproductions from Illuminated Manuscripts*. Series I–IV. London, 1923–8.

British Museum. *Schools of Illumination*. Parts I–IV, English. London, 1914–22.

Burlington Fine Arts Club. *Exhibition of Illuminated Manuscripts*. London, 1908.

DODWELL, C. R. *The Canterbury School of Illumination*. Cambridge, 1954.

FRY, Roger E. 'English Illuminated Manuscripts at the Burlington Fine Arts Club', *Burlington Magazine*, XIII (1908).

GRABAR, André, and NORDENFALK, Carl. *Early Medieval Painting from the Fourth to the Eleventh Century*. New York, 1957.

GRABAR, André, and NORDENFALK, Carl. *Romanesque Painting from the Eleventh to the Thirteenth Century*. New York, 1958.

HARRISON, F. *Treasures of Illumination: English Manuscripts of the Fourteenth Century (c. 1250–1400)*. London and New York, 1937.

HERBERT, J. A. *Illuminated Manuscripts*. London, 1911.
Chapters iv, vi, vii, x, xii, and xiii deal mainly with English Manuscripts.

JAMES, M. R. 'On Fine Art as Applied to the Illustration of the Bible in the Ninth and Five Following Centuries, Exemplified Chiefly by Cambridge Manuscripts', *Proceedings of the Cambridge Antiquarian Society*, VII (1888–91).

JAMES, M. R. 'Primitive Painting', *British Painting*, by C. H. Collins Baker. London, 1933.

KENDON, F. *Mural Paintings in English Churches during the Middle Ages*. London, 1923.

MILLAR, Eric G. *English Illuminated Manuscripts from the Xth to the XIIIth Century*. Paris and Brussels, 1926.

MILLAR, Eric G. *English Illuminated Manuscripts of the XIVth and XVth Centuries*. Paris and Brussels, 1928.

MILLAR, Eric G. 'Fresh Materials for the Study of English Illumination', *Studies in Art and Literature for Belle Da Costa Greene*. Princeton, 1954.

MYNORS, R. A. B. *Durham Cathedral Manuscripts to the End of the Twelfth Century*. Oxford, 1939.

OAKESHOTT, Walter. *The Sequence of English Medieval Art*. London, 1950.

RICKERT, Margaret. *La miniatura inglese*. 2 vols. Milan, 1959–61.

Royal Academy of Arts. *Exhibition of British Primitive Paintings, 1923* (Catalogue). Oxford, 1924.

SAUNDERS, O. E. *English Illumination*. Florence and Paris [1928].

THOMPSON, D. V. *The Materials of Mediaeval Painting*. London, 1936.

THOMPSON, Sir Edward Maunde. *English Illuminated Manuscripts*. London, 1895–6.

THOMPSON, Sir Edward Maunde. 'Notes on the Illuminated Manuscripts in the Exhibition of English Medieval Painting', *Proceedings of the Society of Antiquaries of London*, 2nd series, XVI (1895–7).

TRISTRAM, E. W. *English Medieval Wall Painting*. I, *The Twelfth Century*. Oxford, 1944. II, *The Thirteenth Century*. Oxford, 1950. III, *The Fourteenth Century*. Oxford, 1955.

WARNER, George F. *Illuminated Manuscripts in the British Museum*. London, 1903.

WORMALD, Francis. 'Decorated Initials in English MSS from A.D. 900 to 1100', *Archaeologia*, XCI (1945).

WORMALD, Francis. *English Drawings of the Tenth and Eleventh Centuries*. London, 1952.

WORRINGER, Wilhelm. *Ueber den Einfluss der angelsächsischen Buchmalerei auf die frühmittelalterliche Monumentalplastik des Kontinents*. Halle, 1931.

STAINED GLASS

BAKER, John. *English Stained Glass*. London, 1960.

DRAKE, M. *A History of English Glass Painting*. London, 1912.

HARRISON, F. *Stained Glass of York Minster*. London, 1937.

HARRISON, F. *The Painted Glass of York*. London, 1927.

KNOWLES, J. A. *Essays in the History of the York School of Glass-Painting*. London, 1936.

LE COUTEUR, J. D. *English Mediaeval Painted Glass*. New York, 1926.

NELSON, P. *Ancient Painted Glass in England, 1170–1500*. London, 1913.

READ, Herbert. *English Stained Glass*. London, 1926.

WOODFORDE, Christopher. *Stained Glass in Somerset, 1250–1830*. Oxford, 1947.

EMBROIDERY

Burlington Fine Arts Club. *Exhibition of English Embroidery* (Catalogue). London, 1905.

CHRISTIE, A. G. I. *English Mediaeval Embroidery*. Oxford, 1938.

FARCY, L. de. *La Broderie du XIe siècle jusqu'à nos jours*. Angers, 1890. 1st Suppl. 1900. 2nd Suppl. 1919.

KENDRICK, A. F. *English Embroidery*. London, 1913.

Victoria and Albert Museum. *Catalogue of English Ecclesiastical Embroideries*. London, 1930.

ENAMELS

CHAMOT, Mary. *English Mediaeval Enamels*. London, 1930.

II

CHAPTER I

GENERAL

ÅBERG, Nils. 'The Occident and the Orient in the Art of the Seventh Century, the British Isles', *Kungl. Vitterhets, Historie och Antikvitets Akademiens Handlingar del. 56: 1*. Stockholm, 1943. The study is written in English.

ALLEN, J. Romilly. *Celtic Art in Pagan and Christian Times*. 2nd edition. London, 1912.

BRØNDSTED, J. *Early English Ornament, the sources, development and relation to foreign styles of Pre-Norman ornamental art in England*. Translated from the Danish manuscript by A. F. Major. London and Copenhagen, 1924.

BROWN, G. Baldwin. *The Arts in Early England*. Vol. V. London, 1921.

BRUUN, J. A. *An Enquiry into the Art of the Illuminated Manuscripts of the Middle Ages*. Part I, *Celtic Illuminated Manuscripts*. Stockholm, 1897.

CLAPHAM, A. W. 'Notes on the Origins of Hiberno-Saxon Art', *Antiquity*, VIII (1934).

HENRY, Françoise. *Early Christian Irish Art*. Dublin, 1954.

HENRY, Françoise. *Irish Art in the Early Christian Period*. 2nd edition. London, 1947.

HOVEY, W. R. 'Sources of the Irish Illuminative Art', *Art Studies*, VI (1928).

KENDRICK, T. D. *Anglo-Saxon Art to A.D. 900*. London, 1938.

MASAI, F. *Essai sur les origines de la miniature dite irlandaise*. Brussels, 1947.

MICHELI, Geneviève L. *L'Enluminure du haut moyen-âge et les influences irlandaises*. Brussels, 1939.

NORDENFALK, Carl. 'Before the Book of Durrow', *Acta Archaeologica*, XVIII (1947).

ROBINSON, S. F. H. *Celtic Illuminative Art*. Dublin, 1908.

WESTWOOD, J. O. *Facsimiles of the Miniatures and Ornaments of Anglo-Saxon and Irish Manuscripts*. London, 1868.

MANUSCRIPTS

ABBOT, T. K. *Celtic Ornaments from the Book of Kells*. Dublin, 1895.

ALTON, E. H., and MEYER, Peter. *Evangeliorum Quattuor Codex Cenannensis. The Book of Kells*. Berne, 1950.
Vol. III (text), 1951.

DORAN, Joseph M. 'The Enamelling and Metallesque Origin of the Ornament of the Book of Durrow', *Burlington Magazine*, XIII (1908).

DUFT, Johannes, and MEYER, Peter. *The Irish Miniatures in the Abbey Library of St Gall*. Olten, 1954.

FRIEND, A. M. 'The Canon Tables of the Book of Kells.' *Medieval Studies in Memory of A. Kingsley Porter*, ed. W. R. W. Koehler, II. Cambridge, Mass., 1939.

KENDRICK, Sir T. D., BROWN, T. J., BRUCE-MITFORD, R. L. S., and others. *Evangeliorum Quattuor Codex Lindisfarnensis*. Olten, 1956.

KUYPERS, A. B. *The Book of Cerne*. Cambridge, 1902.

LUCE, A. A., SIMMS, G. O., MEYER, P., and BIELER, L. *Evangeliorum Quattuor Codex Durnachensis*. Olten, 1960.

MILLAR, Eric G. *The Lindisfarne Gospels*. London, 1923.

SULLIVAN, Edward. *The Book of Kells*. 2nd edition. London, 1920.

CHAPTER 2

GENERAL

HOMBURGER, Otto. *Die Anfänge der Malschule von Winchester im X. Jahrhundert*. Studien über Christliche Denkmäler. Leipzig, 1912.

KANTOROWICZ, E. H. 'The Quinity of Winchester', *Art Bulletin*, XXIX (1947).

KENDRICK, T. D. *Late Saxon and Viking Art*. London, 1949.

ROBINSON, J. A. *The Times of St Dunstan*. Oxford, 1923.

MANUSCRIPTS

ATKINS, Sir Ivor. 'An Investigation of Two Anglo-Saxon Calendars: the Missal of Robert of Jumièges and Saint Wulfstan's Homiliary', *Archaeologia*, LXXVIII (1928).

CAMPBELL, Alistair. *The Tollmache (Helmingham Hall) Orosius*. Early English Manuscripts in Facsimile, 3. Copenhagen, 1953.

COLGRAVE, Bertram. *The Paris Psalter*. (Bibl. Nat., MS. lat. 8824.) Early English Manuscripts in Facsimile, 8. Copenhagen, 1958.

GAGE, John. 'A Dissertation on St Æthelwold's Benedictional', *Archaeologia*, XXIV (1832).

GASQUET, F. A., and BISHOP, E. *The Bosworth Psalter*. London, 1908.

GOLLANCZ, Sir Israel. *The Cædmon Manuscript*. London, 1927.

HUNT, R. W. *Saint Dunstan's Classbook, Bod. Auct. F.4.32, from Glastonbury*. Umbrae Codicum Occidentalium, IV. Amsterdam, 1961.

KER, N. R. *The Pastoral Care. Hatton MS. 20*. Early English Manuscripts in Facsimile, 6. Copenhagen, 1956.

NIVER, Charles. 'The Psalter in the British Museum, Harley 2904', *Medieval Studies in Memory of A. Kingsley Porter*, ed. W. R. W. Koehler, II. Cambridge, Mass., 1939.

TOLHURST, J. B. L. 'An Examination of Two Anglo-Saxon Manuscripts of the Winchester School: the Missal of Robert of Jumièges and the Benedictional of Saint Æthelwold', *Archaeologia*, LXXXIII (1933).

WARNER, G. F., and WILSON, H. A. *The Benedictional of Saint Æthelwold, Bishop of Winchester 963–984*. Roxburghe Club, Oxford, 1910.

WARREN, F. E. *The Leofric Missal*. Oxford, 1883.

WORMALD, Francis. *The Benedictional of St Ethelwold*. London, 1959.

EMBROIDERY

BROWN, G. Baldwin, and CHRISTIE, Mrs Archibald. 'St Cuthbert's Stole and Maniple at Durham', *Burlington Magazine*, XXIII (1913).

CHAPTER 3

GENERAL

HARRSEN, Meta. 'The Countess Judith of Flanders and the Library of Weingarten Abbey', *Papers of the Bibliographical Society of America*, XXIV, Part I (1930).

KER, N. R. *English Manuscripts in the Century after the Norman Conquest*. Oxford, 1960.

PÄCHT, Otto. 'Hugo Pictor', *Bodleian Library Record*, III, No. 30 (1950).

BIBLIOGRAPHY

WORMALD, Francis. 'The Survival of Anglo-Saxon Illumination after the Norman Conquest', *Proceedings of the British Academy*, XXX (1944).

MANUSCRIPTS

FORBES-LEITH, W. *The Gospel Book of St Margaret.* Edinburgh, 1896.

WORMALD, Francis. 'An English Eleventh Century Psalter with Pictures. British Museum, Cotton MS. Tiberius C.VI', *Walpole Society*, XXXVIII (1960–2).

BAYEUX TAPESTRY

BELLOC, Hilaire. *The Book of the Bayeux Tapestry.* London, 1914.

LEVÉ, A. *La Tapisserie de la reine Mathilde dite la tapisserie de Bayeux.* Paris, 1919.

LOOMIS, Roger S. 'The Origin and Date of the Bayeux Embroidery', *Art Bulletin*, VI (1923–4).

MACLAGAN, Eric. *The Bayeux Tapestry.* London, 1949.

STENTON, Sir Frank (ed.). *The Bayeux Tapestry.* London, 1957.

Victoria and Albert Museum. *Guide to the Bayeux Tapestry.* 3rd edition. London, 1931.

CHAPTER 4
GENERAL

BAKER, Audrey. 'Lewes Priory and the Early Group of Wall Paintings in Sussex', *Walpole Society*, XXXI (1942–3). Published 1946.

Bodleian Library. *English Romanesque Illumination.* Bodleian Picture Books, 1. Oxford, 1951.

PÄCHT, Otto. *The Rise of Pictorial Narrative in Twelfth Century England.* Oxford, 1962.

WORMALD, Francis. 'The Development of English Illumination in the Twelfth Century', *Journal of the British Archaeological Association.* 3rd Series, VIII (1943).

MANUSCRIPTS

BOASE, T. S. R. *The York Psalter.* London, 1962.

DODWELL, C. R. *The Great Lambeth Bible.* London, 1959.

GOLDSCHMIDT, Adolf. *Der Albanipsalter in Hildesheim und seine Beziehung zur symbolischen Kirchenskulptur des XII. Jahrhunderts.* Berlin, 1895.

JAMES, M. R. 'Four Leaves of an English 12th Century Psalter and an English Picture-Book of the Late 13th Century', *Walpole Society*, XXV (1936–7).

JAMES, M. R. *The Canterbury Psalter.* London, 1935.

OAKESHOTT, Walter. *The Artists of the Winchester Bible.* London, 1945.

PÄCHT, O., DODWELL, C. R., and WORMALD, F. *The St Albans Psalter.* London, 1960.

PAINTING

BELL, Clive. *Twelfth Century Paintings at Hardham and Clayton.* Introduction by Clive Bell. Lewes (Sussex), 1947.

PÄCHT, Otto. 'A Cycle of English Frescoes in Spain', *Burlington Magazine*, CIII (1961).

CHAPTER 5
GENERAL

BORENIUS, T. 'The Cycle of Images in the Palaces and Castles of Henry III', *Journal of the Warburg and Courtauld Institutes*, VI (1943).

FREYHAN, R. 'Joachism and the English Apocalypse', *Journal of the Warburg and Courtauld Institutes*, XVIII (1955).

HASELOFF, G. *Die Psalterillustration im 13. Jahrhundert.* Kiel, 1938.

HOLLAENDER, Albert. 'The Sarum Illuminator and His School', *Wiltshire Archaeological and Natural History Magazine*, L (1943).

KURTH, B. 'Matthew Paris and Villard de Honnecourt', *Burlington Magazine*, LXXXI (1942).

VAUGHAN, Richard. *Matthew Paris.* Cambridge, 1958.

MANUSCRIPTS

BLOCH, P. 'Bemerkungen zu zwei Psalterien in Berlin und Cambridge', *Berliner Museen*, Neue Folge, IX. Jahrgang, Heft 1 (1959).

COCKERELL, S. C. *The Work of W. de Brailes.* Roxburghe Club, Cambridge, 1930.

COXE, H. O. *The Apocalypse of St John the Divine* (Bod. MS. Auct. D.4.17). Roxburghe Club, London, 1876.

DELISLE, L., and MEYER, P. (eds.). *L'Apocalypse en français au XIIIᵉ siècle.* (Bib. Nat. fr. 403.) Paris, 1901.

GALLI, A. *Un prezioso salterio della Biblioteca Comunale d'Imola*. Rome, 1941.

HASSALL, A. G. and W. O. *The Douce Apocalypse.* London, 1961.

HERBERT, J. A. 'A Psalter in the British Museum' (Roy. MS. 1 D.x), *Walpole Society*, III (1913–1914).

IVES, Samuel, and LEHMANN-HAUPT, Helmut. *An English Thirteenth Century Bestiary.* New York, 1942.

JAMES, M. R. *The Apocalypse in Latin and French* (Bod. MS. Douce 180). Roxburghe Club, Oxford, 1922.

JAMES, M. R. *The Apocalypse in Latin* (MS. 10 in the collection of C. W. Dyson Perrins, F.S.A.). Oxford, 1927.

JAMES, M. R. *The Bestiary* (Camb. Univ. Lib. MS. Ii.4.26). Roxburghe Club, Oxford, 1928.

JAMES, M. R. 'The Drawings of Matthew Paris', *Walpole Society*, XIV (1925–6).

JAMES, M. R. *La Estoire de Seint Ædward le Rei* (Camb. Univ. Lib. MS. Ee. 3.59). Roxburghe Club, Oxford, 1920.

JAMES, M. R. *The Trinity College Apocalypse.* (Camb. Trin. Coll. MS. R.16.2). Roxburghe Club, London, 1909.

MILLAR, Eric G. 'Additional Miniatures by W. de Brailes', *Journal of the Walters Art Gallery*, II (1939).

MILLAR, Eric G. *A Thirteenth Century York Psalter.* Roxburghe Club, London, 1952.

MILLAR, Eric G. *The Rutland Psalter.* Roxburghe Club, Oxford, 1937.

OMONT, Henri. Psautier illustré (Bib. Nat. MS. lat. 8846), Paris, n.d.

SWARZENSKI, Hanns. 'Unknown Bible Pictures by W. de Brailes', *Journal of the Walters Art Gallery*, I (1938).

WARNER, Sir George. *The Guthlac Roll.* Roxburghe Club, Oxford, 1928.

WORMALD, Francis. 'More Matthew Paris Drawings', *Walpole Society*, XXXI (1942–3).

PAINTING

HORLBECK, F. R. 'The Vault Paintings of Salisbury Cathedral', *Archaeological Journal*, CXVII (1962).

JAMES, M. R., and TRISTRAM, E. W. 'Medieval Wall Paintings at Christ Church, Oxford', *Walpole Society*, XVI (1927–8).

LETHABY, W. R. 'Medieval Paintings at Westminster', *Proceedings of the British Academy*, XIII (1927).

WORMALD, Francis. 'Paintings in Westminster Abbey and Contemporary Paintings', *Proceedings of the British Academy*, XXXV (1949).

STAINED GLASS

LAFOND, Jean. 'The Stained Glass Decoration of Lincoln Cathedral in the Thirteenth Century', *Archaeological Journal*, CIII (1946).

RACKHAM, Bernard. *The Ancient Glass of Canterbury Cathedral.* London, 1949.

TILES

LETHABY, W. R. 'English Primitives – IV "The Westminster and Chertsey Tiles and Romance Paintings"', *Burlington Magazine*, XXX (1917).

LETHABY, W. R. 'The Romance Tiles of Chertsey Abbey', *Walpole Society*, II (1912–13).

CHAPTER 6

GENERAL

PÄCHT, Otto. 'A Giottesque Episode in English Medieval Art', *Journal of the Warburg and Courtauld Institutes*, VI (1943).

WILLIAMS, E. Carlton. 'Mural Paintings of the Three Living and the Three Dead in England', *Journal of the British Archaeological Association*. 3rd series, VII (1942).

MANUSCRIPTS

COCKERELL, S. C. *The Gorleston Psalter.* London, 1907.

COCKERELL, S. C., and JAMES, M. R. *Two East Anglian Psalters at the Bodleian Library, Oxford.* Roxburghe Club, Oxford, 1926.

EGBERT, D. D. *The Tickhill Psalter and Related Manuscripts.* New York, 1940.

GHEYN, J. van den. *Le Psautier de Peterborough.* Brussels [1905]. Le Musée des Enluminures, fasc. 2, 3.

HASSALL, W. O. *The Holkham Bible Picture Book.* London, 1954.

JAMES, M. R. 'An English Bible-picture Book of the Fourteenth Century (Holkham MS. 666)', *Walpole Society*, XI (1922–3).

JAMES, M. R. *The Dublin Apocalypse.* Roxburghe Club, Cambridge, 1932.

JAMES, M. R. *A Peterborough Psalter and Bestiary of the Fourteenth Century.* Roxburghe Club, Oxford, 1921.

JAMES, M. R. *The Treatise ... De nobilitatibus, sapientibus et prudentiis regum.* Roxburghe Club, London, 1913.

MILLAR, Eric G. *The Luttrell Psalter.* London, 1932.

WARNER, Sir George. *Queen Mary's Psalter.* London, 1912.

PAINTING

LILLIE, W. W. 'A Medieval Retable at Thornham Parva', *Burlington Magazine*, LXIII (1933).

LILLIE, W. W. 'The Retable at Thornham Parva', *Proceedings of the Suffolk Institute of Archaeology and Natural History*, XXI (1933).

TRISTRAM, E. W., and JAMES, M. R. 'Wall-Paintings in Croughton Church, Northamptonshire', *Archaeologia*, LXXVI (1927).

STAINED GLASS

RUSHFORTH, G. MacN. 'The Great East Window of Gloucester Cathedral.' *Bristol and Gloucestershire Archaeological Society, Transactions.* XLIV (1922).

RUSHFORTH, G. MacN. 'The Glass in the Quire Clerestory of Tewkesbury Abbey.' *Bristol and Gloucestershire Archaeological Society, Transactions.* XLVI (1924).

CHAPTER 7

GENERAL

KUHN, Charles. 'Herman Scheerre and English Illumination of the Early Fifteenth Century', *Art Bulletin*, XXII (1940).

SHAW, W. A. 'The Early English School of Portraiture', *Burlington Magazine*, LXV (1934).

MANUSCRIPTS

BEAUCHAMP, Earl. *Liber Regalis.* Roxburghe Club, London, 1870.

HERBERT, J. A. *The Sherborne Missal.* Roxburghe Club, Oxford, 1920.

JAMES, M. R., *Illustrations of the Book of Genesis.* Roxburghe Club, Oxford, 1921.

JAMES, M. R. 'An English Medieval Sketchbook, No. 1916 in the Pepysian Library, Magdalene College, Cambridge,' *Walpole Society*, XIII (1924–1925).

JAMES, M. R., and MILLAR, E. G. *The Bohun Manuscripts.* Roxburghe Club, Oxford, 1936.

MILLAR, Eric G. 'The Egerton Genesis and the M. R. James Memorial MS.', *Archaeologia*, LXXXVII (1937).

RICKERT, Margaret. *The Reconstructed Carmelite Missal.* London, 1952.

RICKERT, Margaret. 'The So-Called Beaufort Hours and York Psalter', *Burlington Magazine*, CIV (1962).

WORMALD, Francis. 'The Fitzwarin Psalter and its Allies', *Journal of the Warburg and Courtauld Institutes*, VI (1943).

PAINTING

BORENIUS, T. 'An English Painted Ceiling of the Late Fourteenth Century', *Burlington Magazine*, LXVIII (1936).

EVANS, Joan. 'The Wilton Diptych Reconsidered', *Archaeological Journal*, CV (1950).

HARVEY, John. 'The Wilton Diptych – a Re-examination', *Archaeologia*, XCVIII (1961).

HOPE, W. H. St John. 'On a Painted Table or Reredos of the Fourteenth Century in the Cathedral Church of Norwich', *Norfolk Archaeology*, XIII (1898).

NOPPEN, J. G. 'The Westminster Apocalypse and its Source', *Burlington Magazine*, LXI (1932).

PRESTON, Arthur. 'The Fourteenth Century Painted Ceiling at St Helen's Church, Abingdon', *Berkshire Archaeological Journal*, XL (1936).

TRISTRAM, E. W. 'The Wilton Diptych', *The Month*, New Series, I, No. 6 (1949).

WALLER, J. G. 'On the Paintings in the Chapter House, Westminster', *London and Middlesex Archaeological Society, Transactions*, IV (1875).

WALLER, J. G. 'On the Retable in Norwich Cathedral and Paintings in St Michael-at-Plea', *Norfolk Archaeology*, XIII (1898).

WORMALD, Francis. 'The Wilton Diptych', *Journal of the Warburg and Courtauld Institutes*, XVII (1954).

STAINED GLASS

LE COUTEUR, J. D. *Ancient Glass in Winchester.* Winchester, 1920.

SALZMAN, L. F. 'The Glazing of St Stephen's Chapel, Westminster, in 1351–2', *Journal of the British Society of Master Glass-Painters*, I, No. 4 (1926).

WOODFORDE, Christopher. 'English Stained Glass and Glass-painters in the Fourteenth Century', *Proceedings of the British Academy*, XXV (1939).

WOODFORDE, Christopher. *The Stained Glass of New College, Oxford*. London, 1951.

CHAPTER 8

GENERAL

CONSTABLE, W. G. 'Some East Anglian Rood Screen Paintings', *Connoisseur*, LXXXIV (1929).

WOODFORDE, Christopher. *The Norwich School of Glass Painting in the Fifteenth Century*. London, 1950.

MANUSCRIPTS

DILLON, Harold Arthur, Viscount. 'On a Manuscript Collection of Ordinances of Chivalry of the Fifteenth Century belonging to Lord Hastings', *Archaeologia*, LVII (1900).

JAMES, M. R. *The Chaundler Manuscripts*. Roxburghe Club, London, 1916.

PAINTING

COLGRAVE, Bertram. 'The St Cuthbert Paintings on the Carlisle Cathedral Stalls', *Burlington Magazine*, LXXIII (1938).

HOLLAENDER, Albert. 'The Doom Painting of St Thomas of Canterbury, Salisbury', *Wiltshire Archaeological and Natural History Magazine*, L (1944).

JAMES, M. R., and TRISTRAM, E. W. 'The Wall Paintings in Eton College Chapel and in the Lady Chapel of Winchester Cathedral', *Walpole Society*, XVII (1928–9).

STAINED GLASS

HAMAND, L. A. *The Ancient Windows of Great Malvern Priory Church*. St Albans, 1947.

HUTCHINSON, F. E. *Medieval Glass at All Souls College*. London, 1949.

RUSHFORTH, G. MacN. *Mediaeval Christian Imagery*. Oxford, 1936.
 Malvern Priory glass.

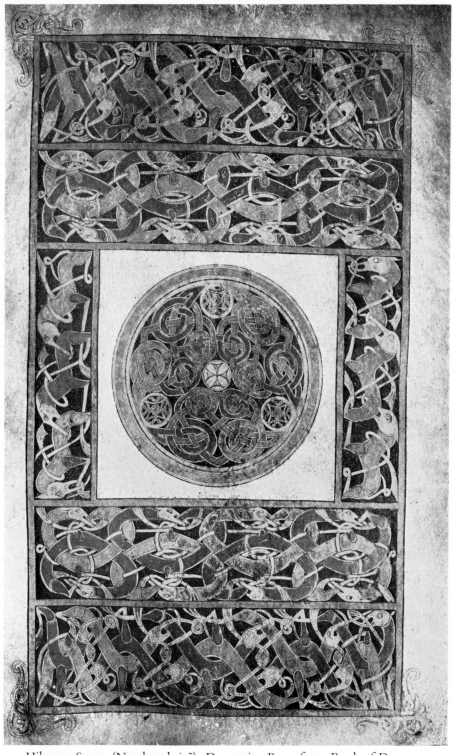

Hiberno–Saxon (Northumbria?): Decorative Page, from Book of Durrow. Seventh century (second half). 9⅝ by 6⅛ in. *Trinity College, Dublin*

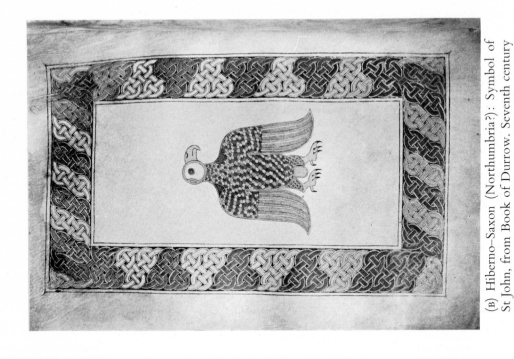

(B) Hiberno–Saxon (Northumbria?): Symbol of St John, from Book of Durrow. Seventh century (second half). 9⅝ by 6⅛ in. *Trinity College, Dublin*

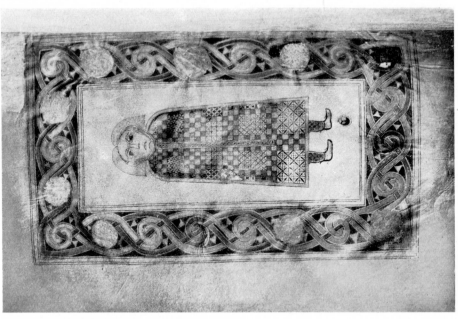

(A) Hiberno–Saxon (Northumbria?): Symbol of St Matthew, from Book of Durrow. Seventh century (second half). 9⅝ by 6⅛ in. *Trinity College, Dublin*

(A) Anglo–Saxon: Great Buckle, Sutton Hoo Treasure. Seventh century (first half). 5¼ by 2⅛ in. *Department of Medieval Antiquities, British Museum*

(B) Anglo–Saxon: Hanging Bowl Escutcheon. Sutton Hoo Treasure. Seventh century (first half). 2⅝ in. diameter. *Dept. of Medieval Antiquities, Brit. Mus.*

(C) Anglo–Saxon: Gold Clasp, Sutton Hoo Treasure. Seventh century (first half). 2¼ by 2⅛ in. *Department of Medieval Antiquities, British Museum*

(D) Hiberno–Saxon (Northumbria?): Decorative Page, from Book of Durrow. Seventh century (second half). Detail approx. actual size. *Trinity Coll., Dublin*

3

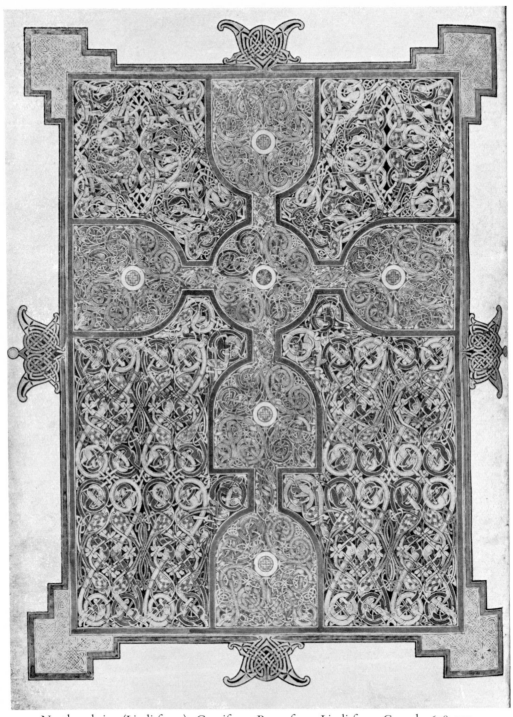

Northumbrian (Lindisfarne): Cruciform Page, from Lindisfarne Gospels. 698–721.
13½ by 9¾ in. *British Museum*

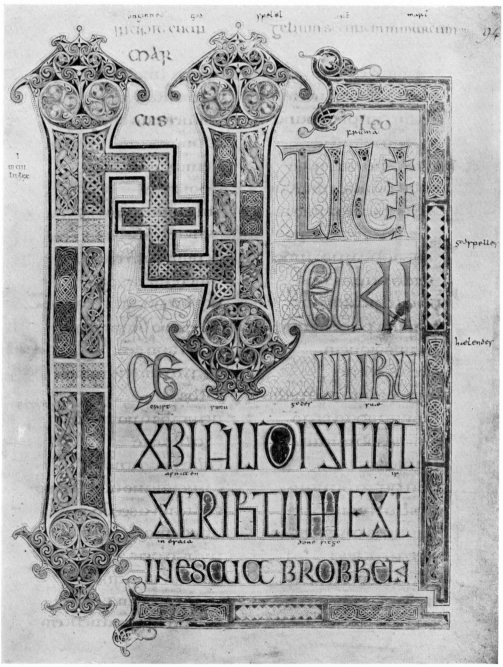

Northumbrian (Lindisfarne): Text Page, from Lindisfarne Gospels. 698–721.
13½ by 9¾ in. *British Museum*

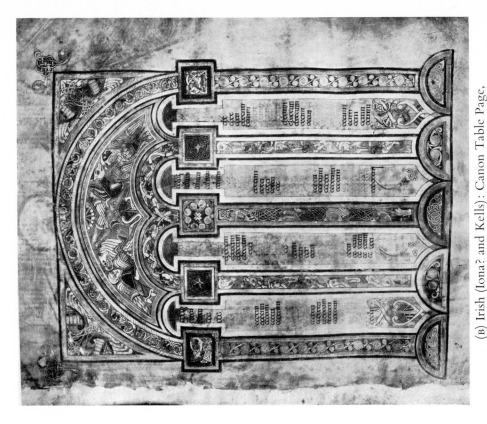

(B) Irish (Iona? and Kells): Canon Table Page, from Book of Kells. 760–820. 13 by 9½ in. *Trinity College, Dublin*

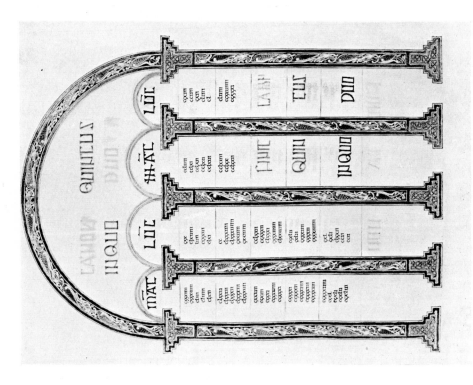

(A) Northumbrian (Lindisfarne): Canon Table Page, from Lindisfarne Gospels. 698–721. 13½ by 9¾ in. *British Museum*

6

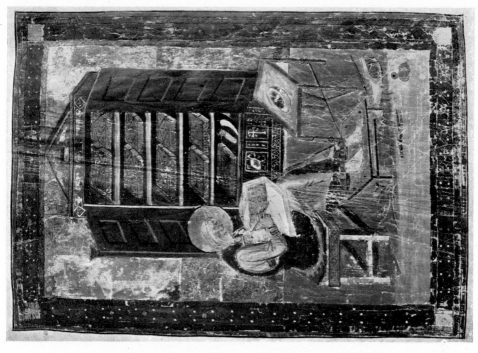

(B) South Italian (?): The Scribe Ezra, prefixed to Northumbrian Bible. Late sixth century. 19⅞ by 13 in. *Biblioteca Medicea Laurenziana, Florence*

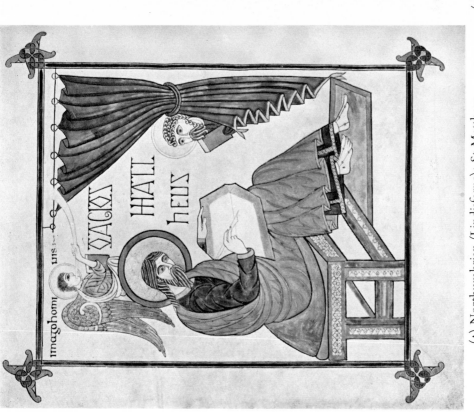

(A) Northumbrian (Lindisfarne): St Matthew, from Lindisfarne Gospels. 698–721. 13½ by 9¾ in. *British Museum*

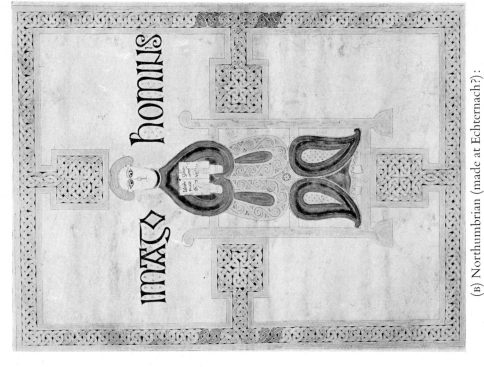

(B) Northumbrian (made at Echternach?):
St Matthew, from Echternach Gospels. Early eighth century.
Miniature $10\frac{1}{4}$ by $7\frac{5}{8}$ in. *Bibliothèque Nationale, Paris*

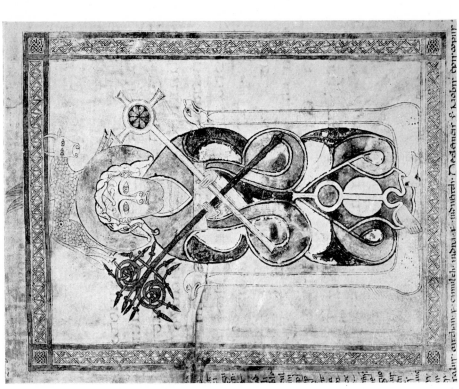

(A) Irish (Northumbria?):
St Luke, from Gospel Book of Chad. Late seventh or early eighth
century. Miniature $9\frac{3}{4}$ by $7\frac{1}{4}$ in. *Cathedral Library, Lichfield*

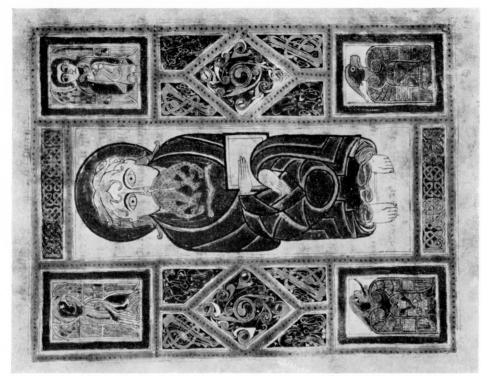

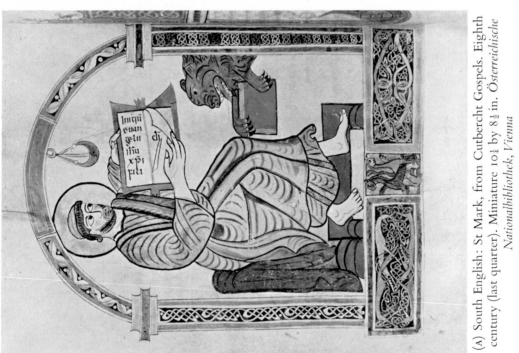

(A) South English: St Mark, from Cutbercht Gospels. Eighth century (last quarter). Miniature 10¼ by 8½ in. Österreichische Nationalbibliothek, Vienna

(B) Irish: St Mark, from Gospels. c.750–60. Miniature 9¼ by 7 in. Stiftsbibliothek, St Gall

9

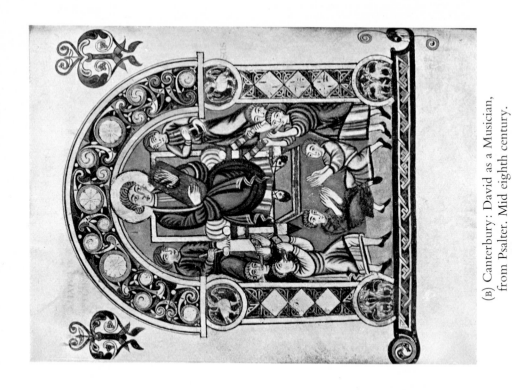

(B) Canterbury: David as a Musician, from Psalter. Mid eighth century. 9¼ by 7 in. *British Museum*

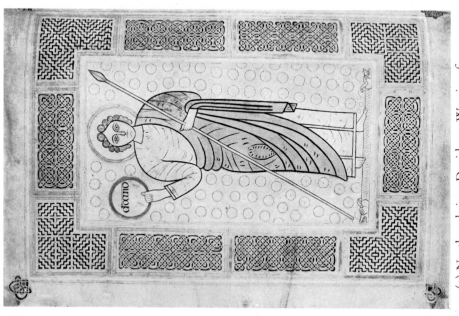

(A) Northumbrian: David as a Warrior, from Cassiodorus, *Commentary on Psalms. c.725.* Miniature 14⅞ by 10¾ in. *Cathedral Library, Durham*

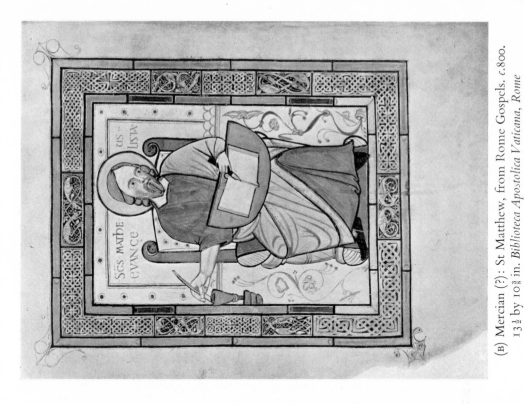

(B) Mercian (?): St Matthew, from Rome Gospels. c.800.
13½ by 10⅛ in. *Biblioteca Apostolica Vaticana, Rome*

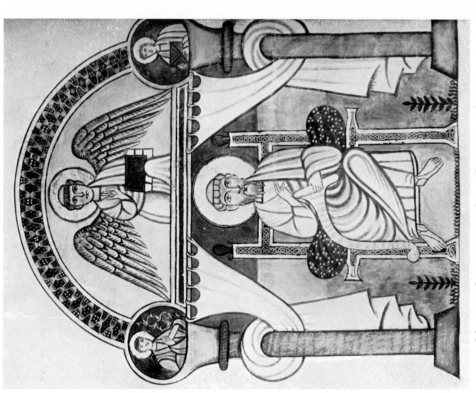

(A) Canterbury: St Matthew, from Gospels. c.760.
Miniature 12½ by 10⅛ in. *Royal Library, Stockholm*

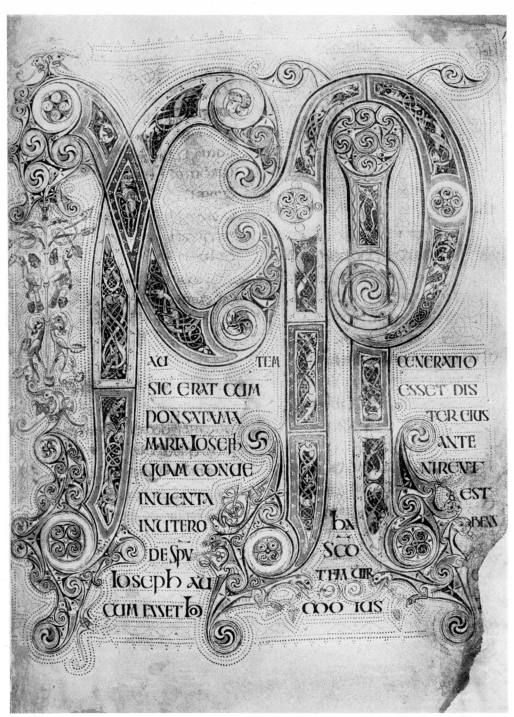

Mercian (?): XPI Page, from Rome Gospels. *c.*800. 13½ by 10⅜ in.
Biblioteca Apostolica Vaticana, Rome

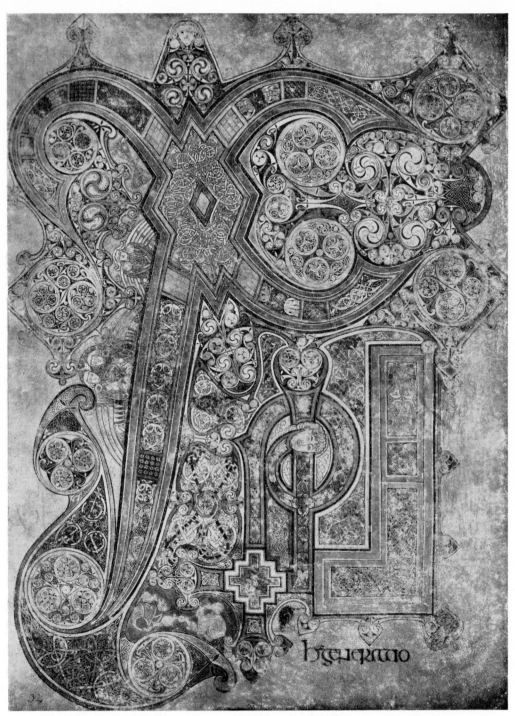

Irish (Iona? and Kells): XPI Page, from Book of Kells. 760–820. 13 by 9½ in.
Trinity College, Dublin

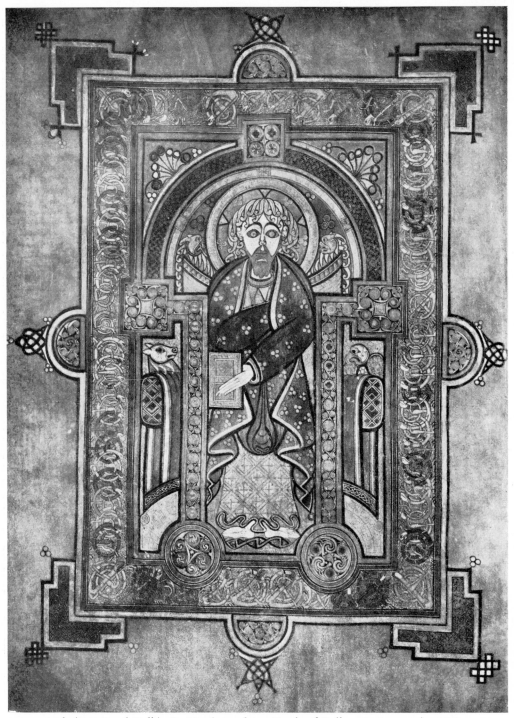

Irish (Iona? and Kells): St Matthew, from Book of Kells. 760–820. 13 by 9½ in.
Trinity College, Dublin

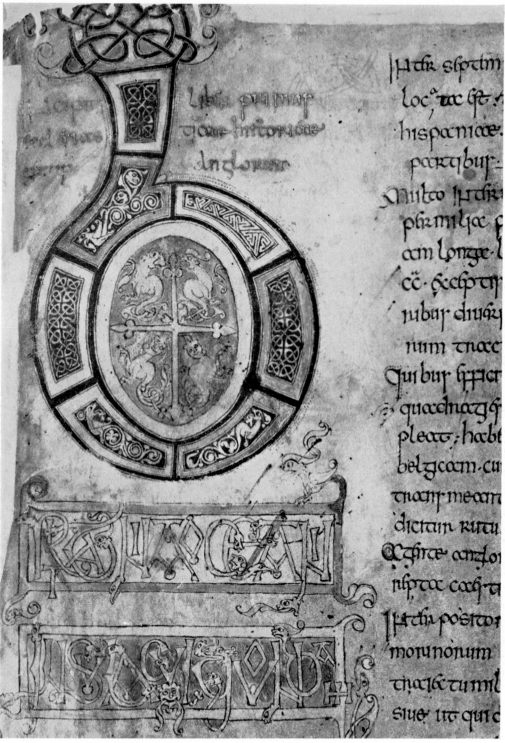

Canterbury: Decorative Text Page, from Bede, *Ecclesiastical History*. Late eighth century.
Detail approx. actual size. *British Museum*

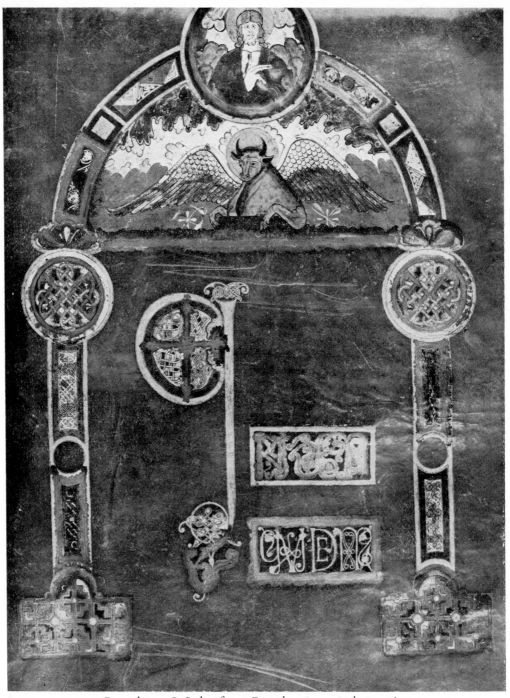

Canterbury: St Luke, from Gospels. *c*.800. 18½ by 13⅝ in.
British Museum

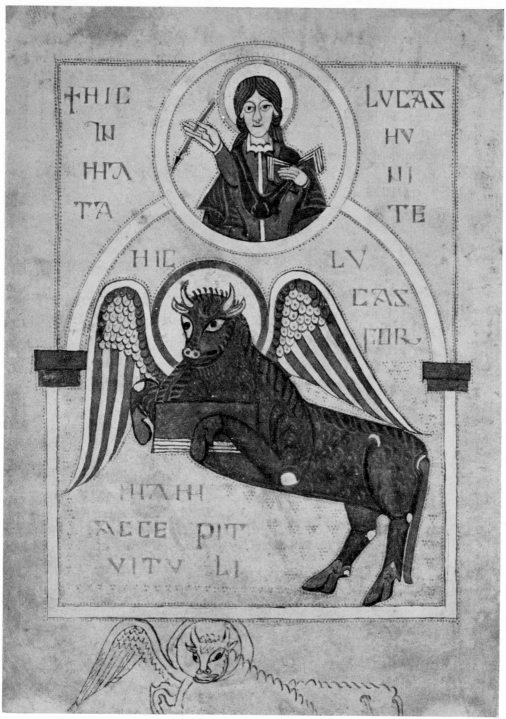

Mercian: St Luke, from Gospel Book of Cerne. 818–30 (?). 9⅛ by 7⅜ in.
University Library, Cambridge

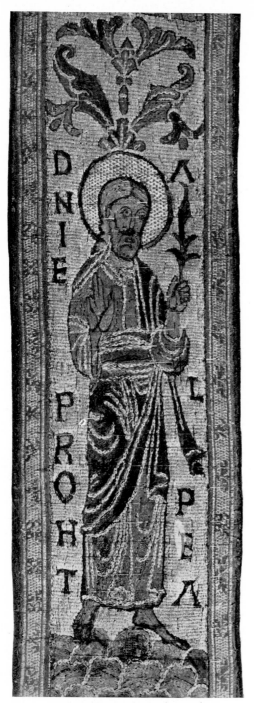

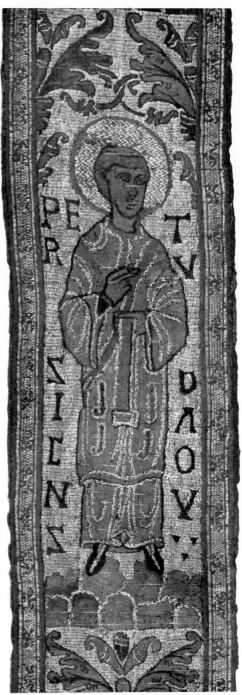

(A) Unknown (Winchester?):
Daniel, from Embroidered Stole. 909–16.
Detail actual size.
Cathedral Library, Durham

(B) Unknown (Winchester?):
Peter Deacon, from Embroidered Maniple.
909–16. Detail actual size.
Cathedral Library, Durham

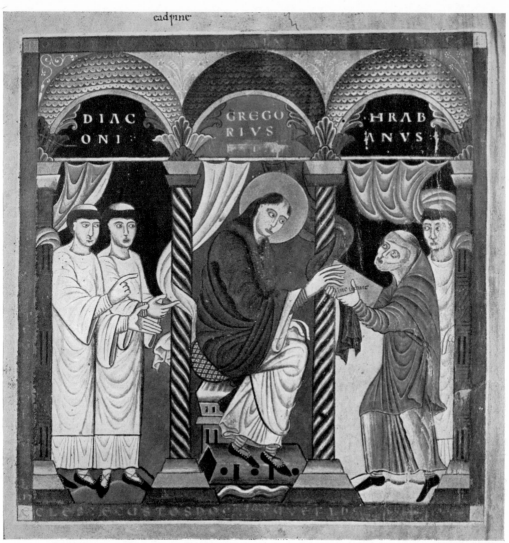

Unknown: Presentation of the Book to Pope Gregory, from Rabanus Maurus,
De Laude Crucis. Tenth century. 16½ by 13½ in. *Trinity College, Cambridge*

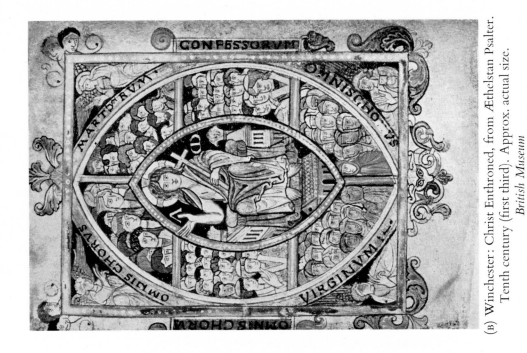

(B) Winchester: Christ Enthroned, from Æthelstan Psalter. Tenth century (first third). Approx. actual size. *British Museum*

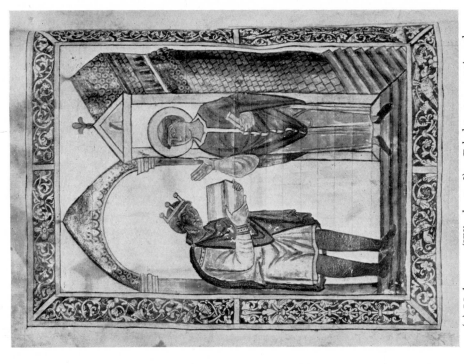

(A) Unknown (Winchester?): Æthelstan presenting the Book to St Cuthbert, from Bede, *Life of St Cuthbert. c.930.* 11½ by 7⅞ in. *Corpus Christi College, Cambridge*

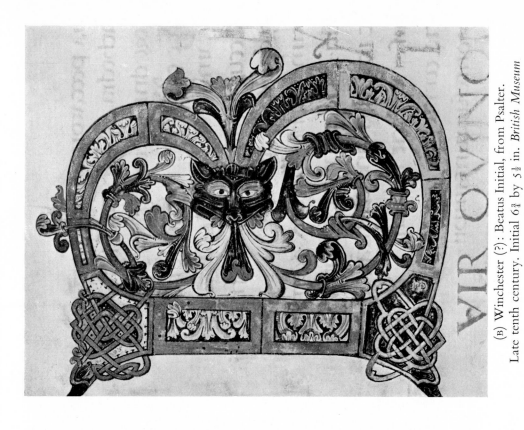

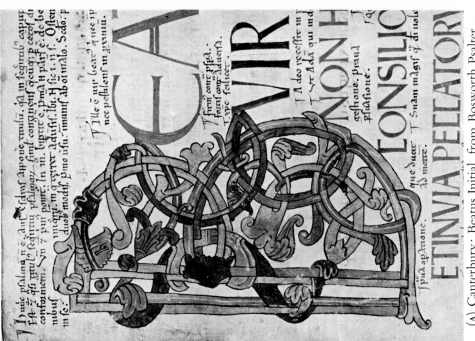

(B) Winchester (?): Beatus Initial, from Psalter.
Late tenth century. Initial 6¾ by 5½ in. *British Museum*

(A) Canterbury: Beatus Initial, from Bosworth Psalter.
Late tenth century. Initial 6¾ by 3⅞ in. *British Museum*

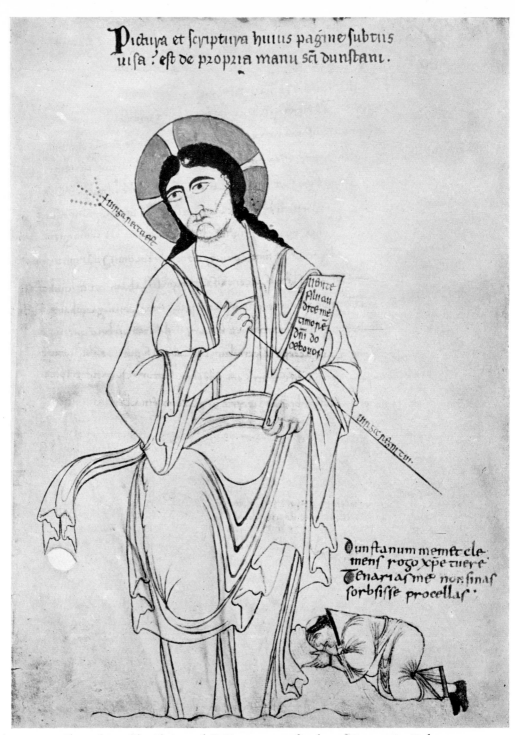

Glastonbury (?): Christ and St Dunstan, prefixed to a Composite Volume.
Mid tenth century. 9¾ by 7¼ in. *Bodleian Library, Oxford*

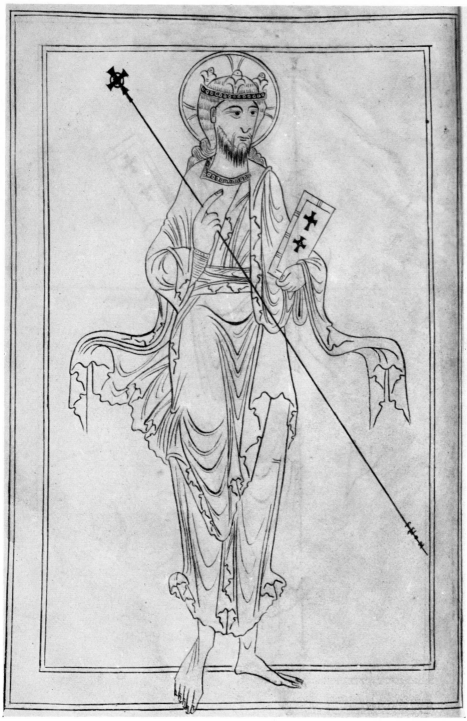

Canterbury or Sherborne Abbey?: God the Son, from Sherborne Pontifical. *c.992–5.*
12½ by 8 in. *Bibliothèque Nationale, Paris*

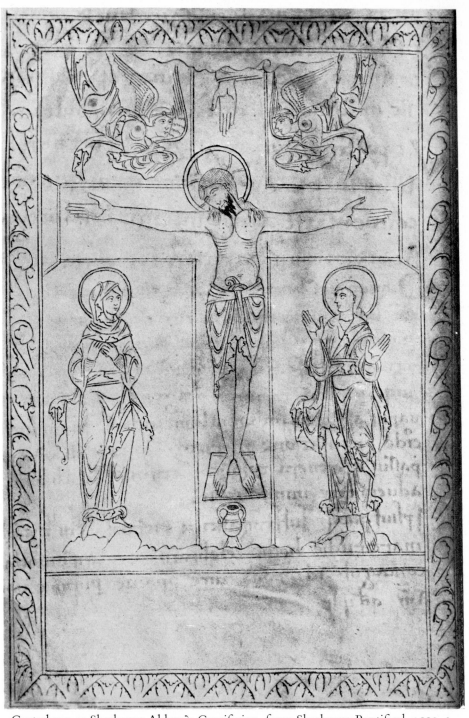

Canterbury or Sherborne Abbey?: Crucifixion, from Sherborne Pontifical. *c.992–5.*
12½ by 8 in. *Bibliothèque Nationale, Paris*

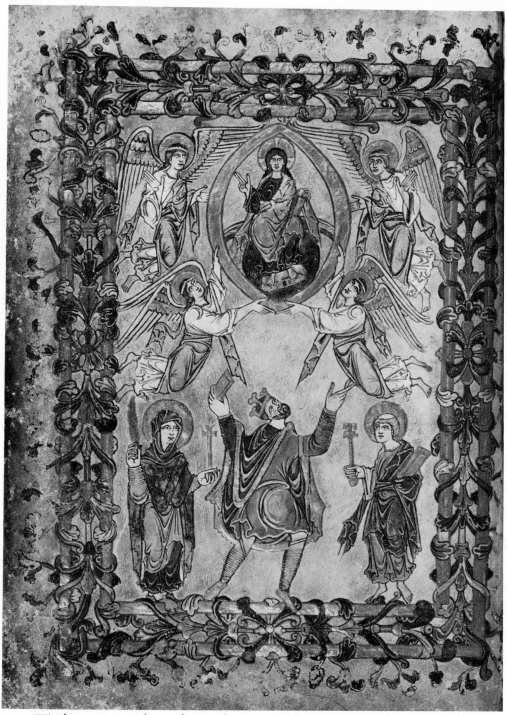

Winchester: King Edgar offering Charter to Christ, from New Minster 'Memorial'.
After 966. 8⅛ by 6¾ in. *British Museum*

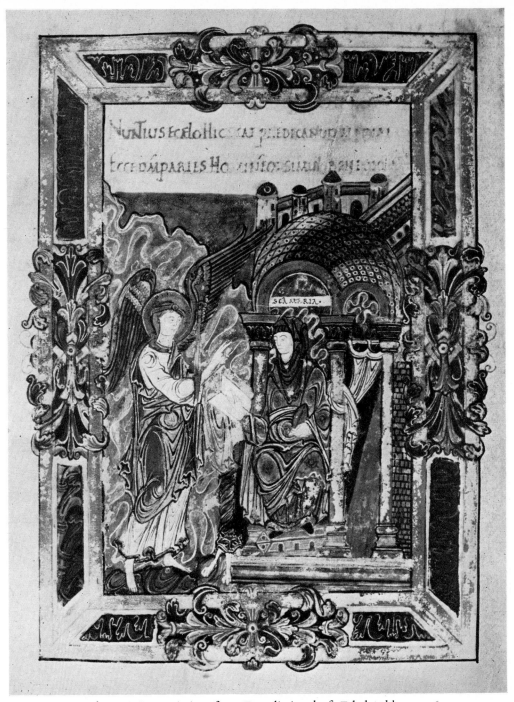

Winchester: Annunciation, from Benedictional of Æthelwold. *c.*975–80.
11½ by 8½ in. *British Museum*

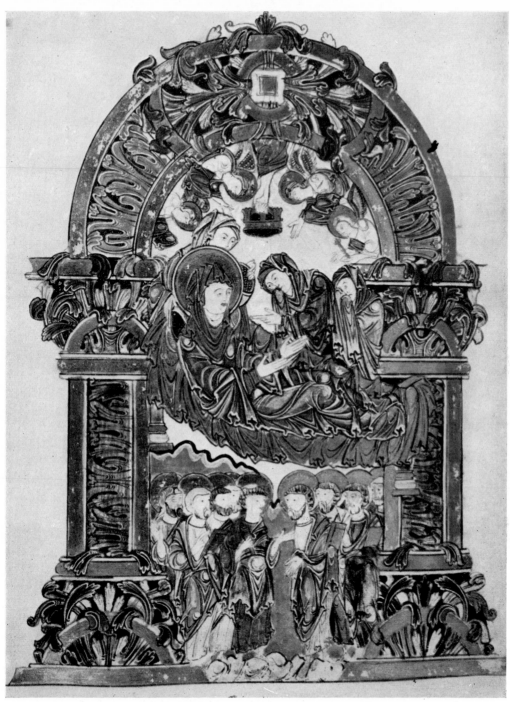

Winchester: Death of the Virgin, from Benedictional of Æthelwold. *c*.975–80.
11½ by 8½ in. *British Museum*

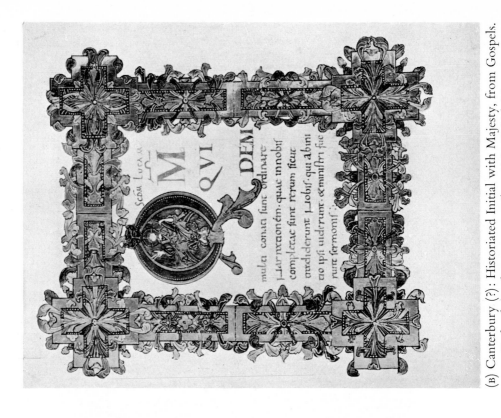

(B) Canterbury (?): Historiated Initial with Majesty, from Gospels.
Early eleventh century. 13¼ by 10¾ in. *British Museum*

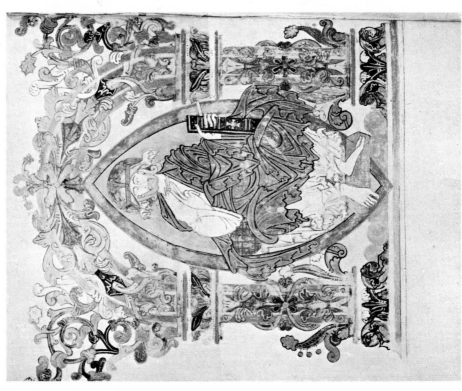

(A) Canterbury (?): Christ in Majesty, from Gospels.
Late tenth century. 12¾ by 9¼ in. *Trinity College, Cambridge*

28

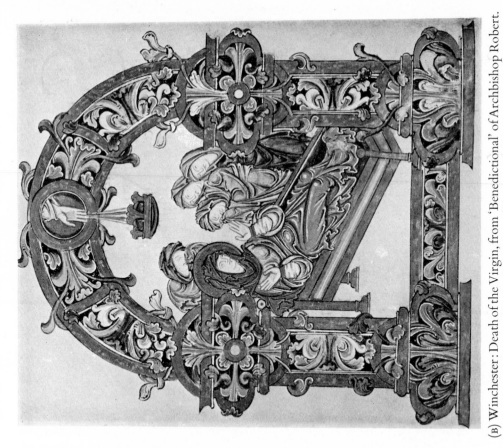

(A) Glastonbury: 'Vita', from Leofric Missal. Before 979. 8⅞ by 5⅞ in. *Bodleian Library, Oxford*

(B) Winchester: Death of the Virgin, from 'Benedictional' of Archbishop Robert. 990–1037 (?). 12⅝ by 9⅛ in. *Bibliothèque Publique, Rouen*

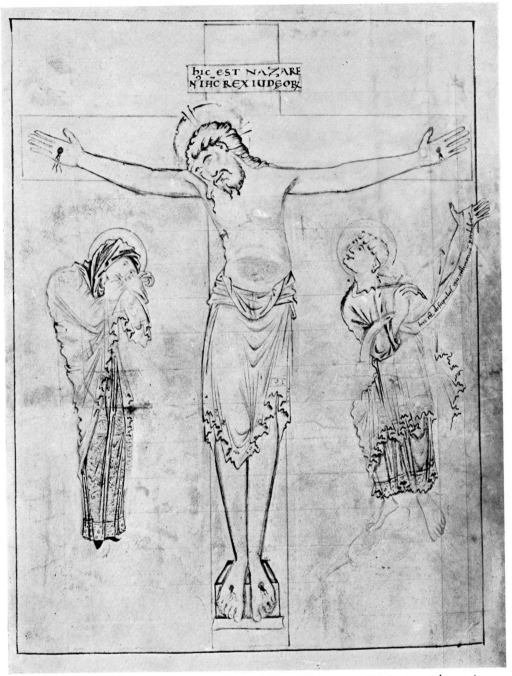

hɪc est naẓare
n iħc rex iudeorᷱ

Winchester (?): Crucifixion, from Psalter. Late tenth century. Miniature 9¼ by 7⅛ in.
British Museum

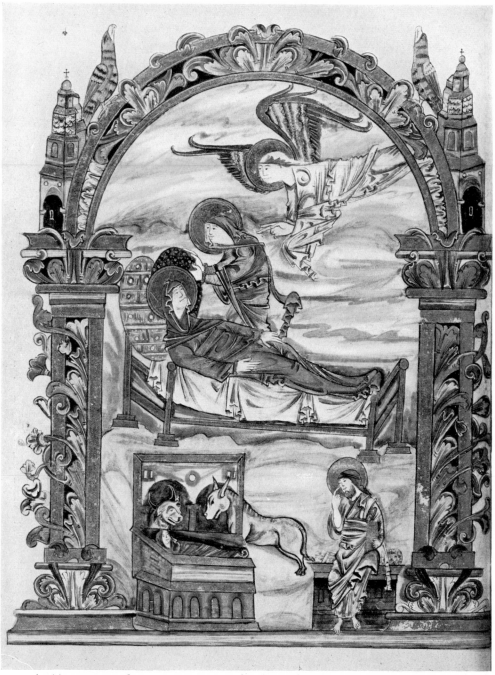

Ely (?): Nativity, from Sacramentary of Robert of Jumièges. 1006–23. 13¼ by 8¾ in.
Bibliothèque Publique, Rouen

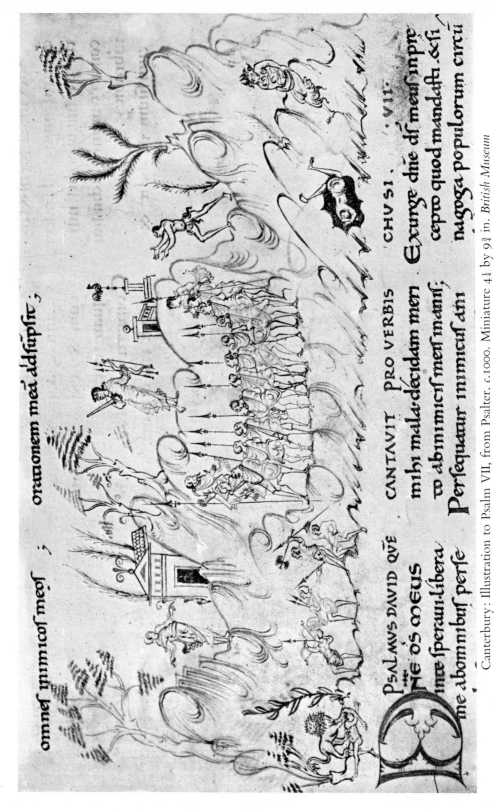

omnes inimicos meos ; orationem meam adsumpsit ;

PSALMVS DAVID QVE CANTAVIT PRO VERBIS CHVSI VII.
Dne ds meus mihi mala deridam meu Exurge dne ds meus in pre
inte speraui libera eo abinimicus meus inanis cepto quod mandasti & si
me abominibus perse Persequatur inimicus dm nagoga populorum circu

Canterbury: Illustration to Psalm VII, from Psalter. *c.*1000. Miniature 4¼ by 9¾ in. *British Museum*

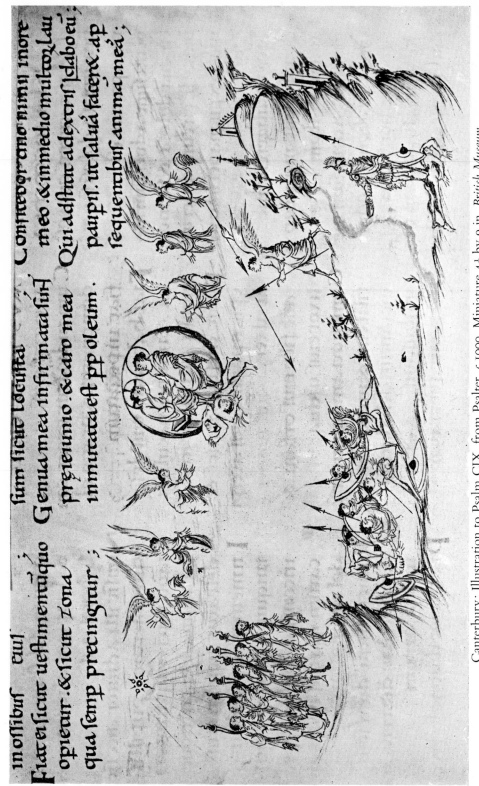

in ossibus euis sum sicut locusta Confixe sunt carnes mee inore
Factus sicut uestimentū quo Genua mea infirmata sunt meo. & inmedio muttoz lau
opietur. & sicut zona pre ieiunio. & caro mea Qui adstitit adextris ī dabo eū;
qua semp precingitur; inmutata est pp oleum. paupis. ut saluā faceret. ap
 sequentibus anima mea;

Canterbury: Illustration to Psalm CIX, from Psalter. c.1000. Miniature 4½ by 9 in. *British Museum*

33

(A) Canterbury (?): Ploughing, from Hymnal. Early eleventh century.
Miniature 1¼ by 4 in. *British Museum*

(B) Canterbury: Ploughing, from Astronomical Treatises. Early eleventh century.
Miniature 2¾ by 7⅝ in. *British Museum*

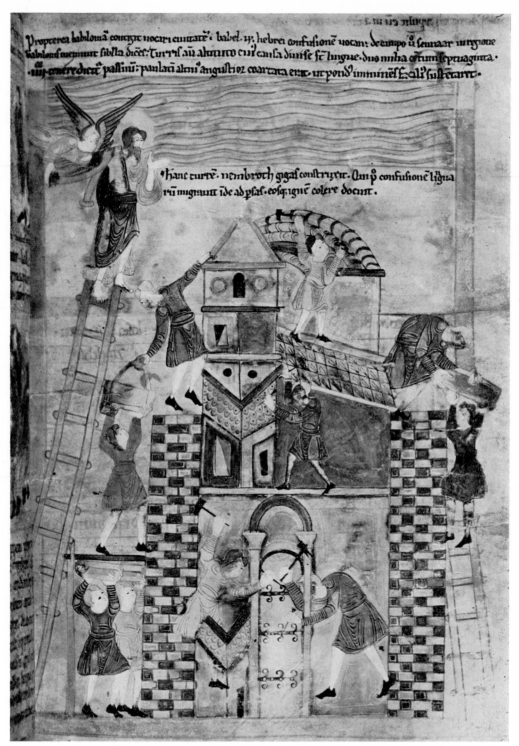

Canterbury: Building the Tower of Babel, from Ælfric, *Metrical Paraphrase of Pentateuch*.
Eleventh century (second quarter). 12⅞ by 8¾ in. *British Museum*

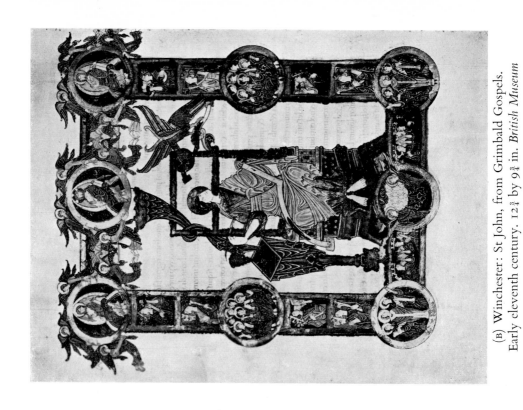

(B) Winchester: St John, from Grimbald Gospels.
Early eleventh century. 12¾ by 9¾ in. *British Museum*

(A) Winchester: St Luke, from Grimbald Gospels.
Early eleventh century. 12¾ by 9¾ in. *British Museum*

36

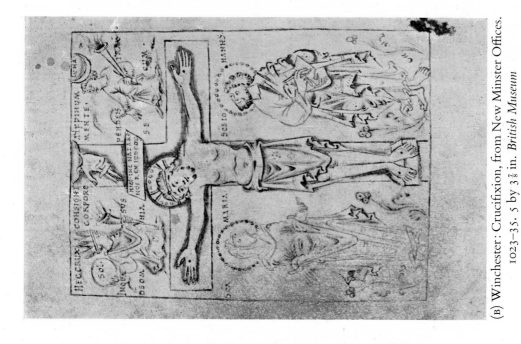

(B) Winchester: Crucifixion, from New Minster Offices. 1023–35. 5 by 3⅞ in. *British Museum*

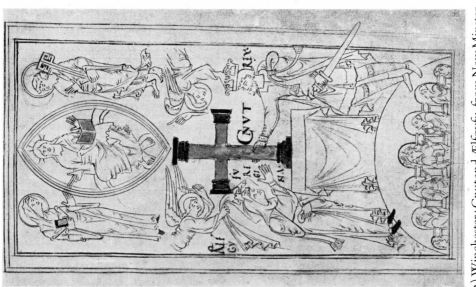

(A) Winchester: Cnut and Ælfgyfu, from New Minster Register. 1020–30. 10⅛ by 5¾ in. *British Museum*

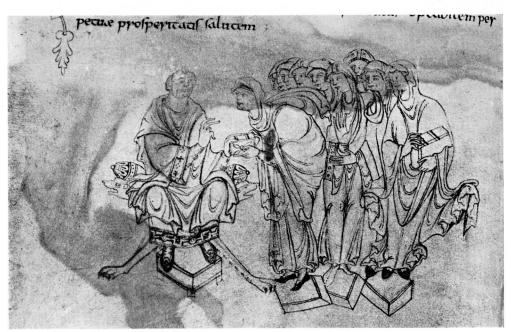

(A) Unknown: Aldhelm and Nuns of Barking, from Aldhelm, *De Virginitate*. Late tenth century. Miniature 3⅝ by 6¼ in. *Lambeth Palace Library, London*

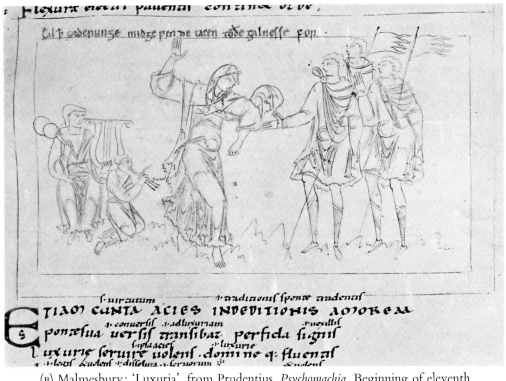

(B) Malmesbury: 'Luxuria', from Prudentius, *Psychomachia*. Beginning of eleventh century. Miniature 4¼ by 7⅝ in. *Corpus Christi College, Cambridge*

38

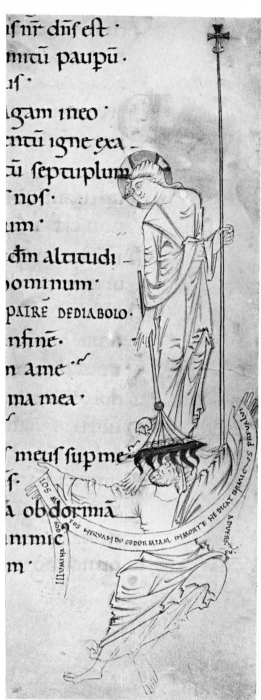

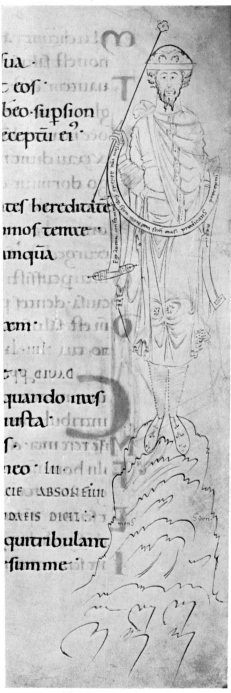

(A) Bury St Edmunds:
Christ Victorious, from Bury Psalter.
Eleventh century (second quarter).
Detail approx. 9 in. high.
Biblioteca Apostolica Vaticana, Rome

(B) Bury St Edmunds:
Psalmist on Mt Sion, from Bury Psalter.
Eleventh century (second quarter).
Detail approx. 9 in. high.
Biblioteca Apostolica Vaticana, Rome

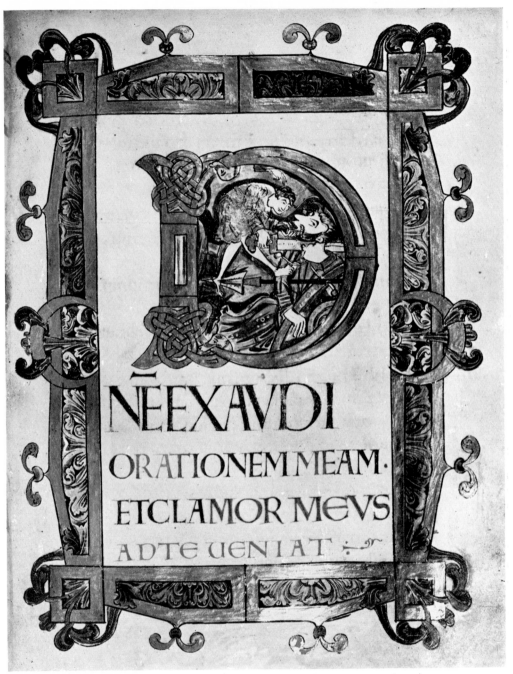

Canterbury: Historiated Initial with David and Goliath, from Psalter. *c*.1012–23.
11½ by 8½ in. *British Museum*

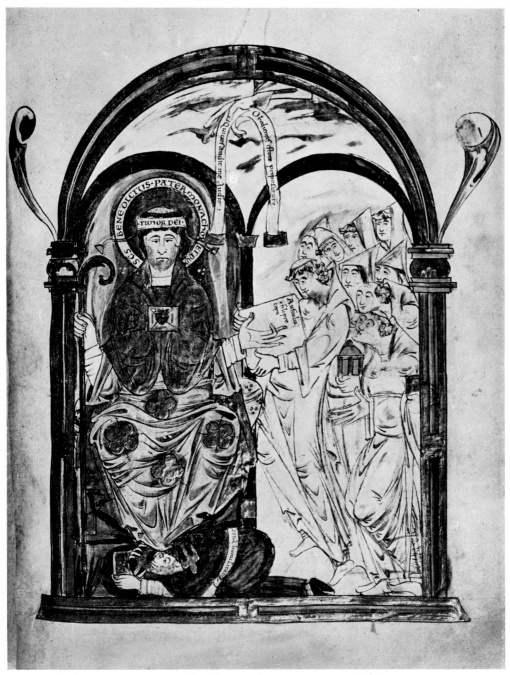

Canterbury: St Benedict and Monks of Canterbury, from Psalter. *c.*1012–23.
11½ by 8½ in. *British Museum*

41

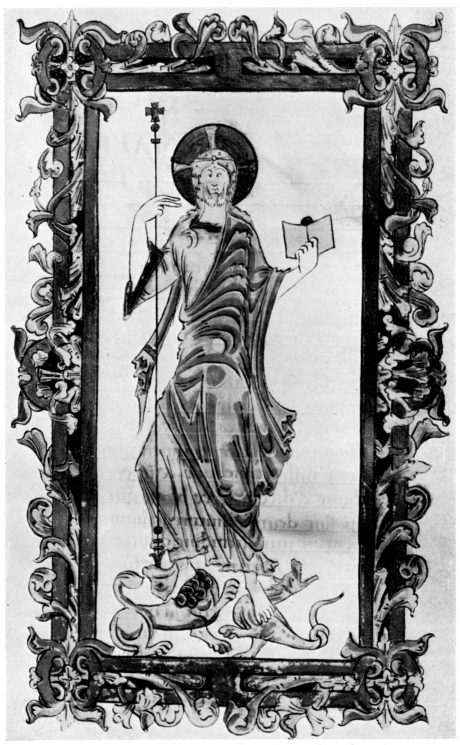

Croyland (?) or Ely (?): Christ Triumphant, from Psalter. Eleventh century
(third quarter). 10½ by 6½ in. *Bodleian Library, Oxford*

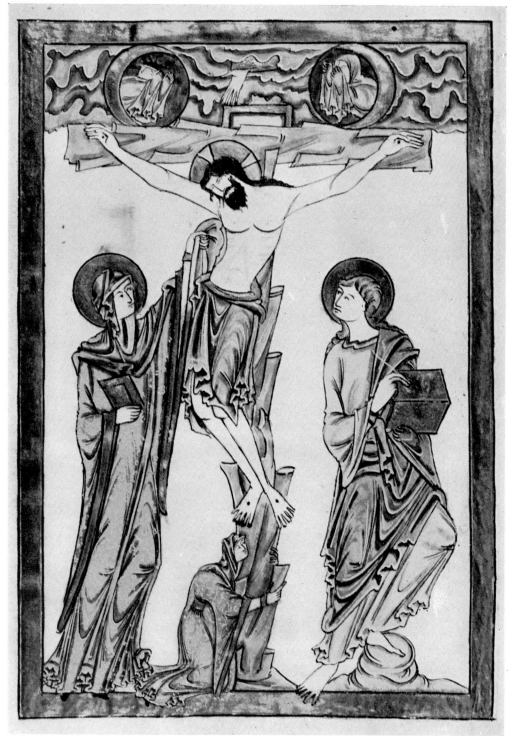

Winchester (?): Crucifixion, from Weingarten Gospels. Eleventh century (third quarter).
11½ by 7½ in. *Pierpont Morgan Library, New York*

43

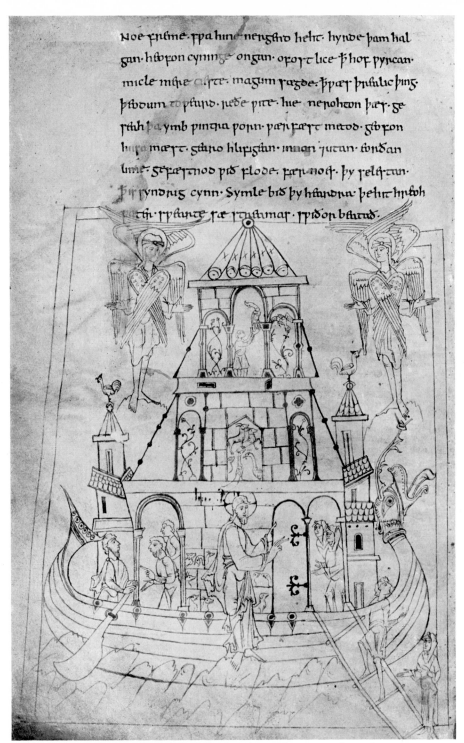

Canterbury (?): Noah's Ark, from 'Cædmon's' Poems. Eleventh century (second quarter). Miniature 9 by 7¾ in. *Bodleian Library, Oxford*

44

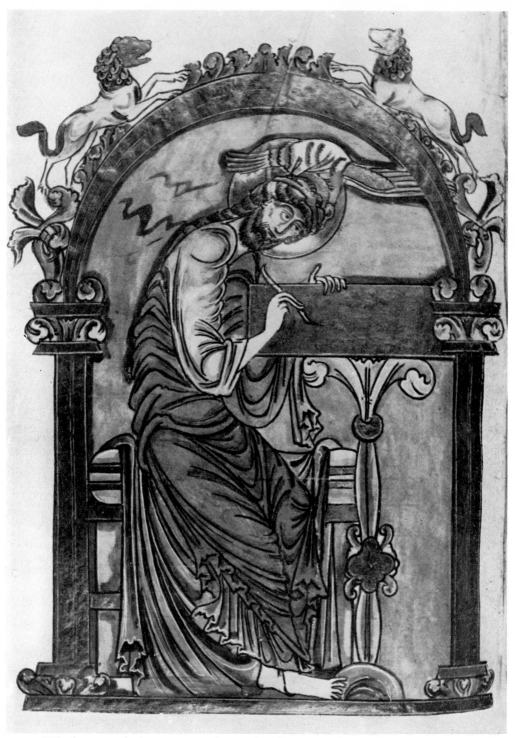

Winchester Style (Fen Country?): St John, from Gospels. *c.*1050–60. 10 by 6¾ in.
Monte Cassino Library

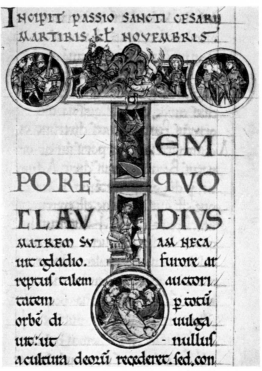

(A) Canterbury: Historiated Initial with Scenes
from the Life of St Cesarius, from Martyrology.
*c.*1100. Detail 4½ by 3¾ in. *British Museum*

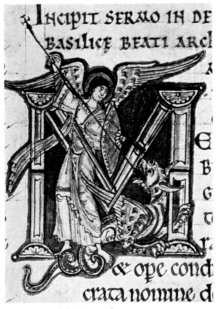

(B) Canterbury:
St Michael, from Martyrology. *c.*1100.
Initial 3¼ by 2½ in. *British Museum*

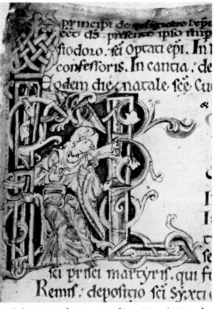

(C) Canterbury: Zodiac Sign 'Virgo',
from Martyrology. Twelfth century.
(first decade). 3½ by 3 in. *British Museum*

46

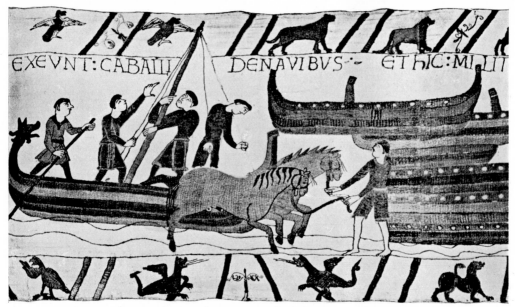

(A) Anglo–Norman: Landing Horses, from Bayeux Tapestry. *c*. 1073–83.
Detail 1 ft 9 in. by 2 ft 11 in. *Town Hall, Bayeux*

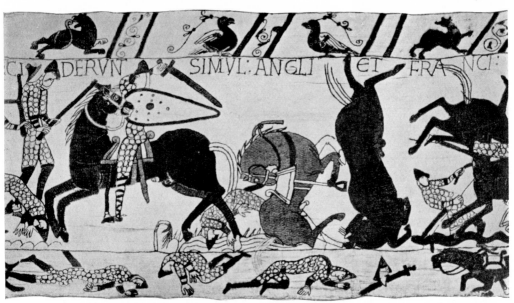

(B) Anglo–Norman: Battle of Hastings, from Bayeux Tapestry. *c*. 1073–83.
Detail 1 ft 9 in. by 2 ft 11 in. *Town Hall, Bayeux*

47

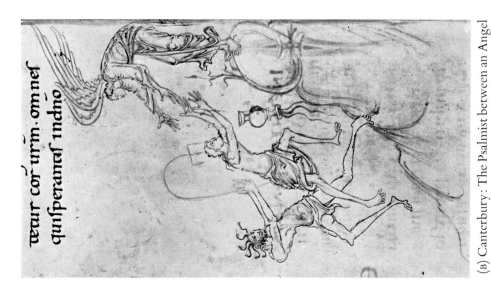

(B) Canterbury: The Psalmist between an Angel and a Devil, from Psalter. Eleventh century (second half). Detail 6¼ by 3½ in. *British Museum*

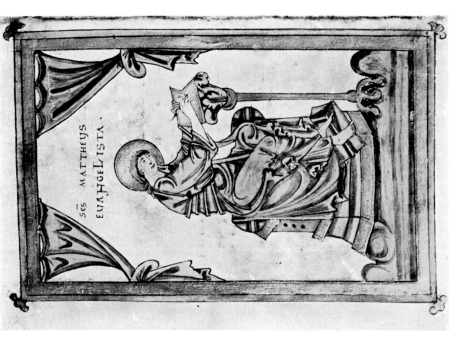

(A) Unknown: St Matthew, from Gospel Lectionary. Mid eleventh century. 6⅝ by 4⅜ in. *Bodleian Library, Oxford*

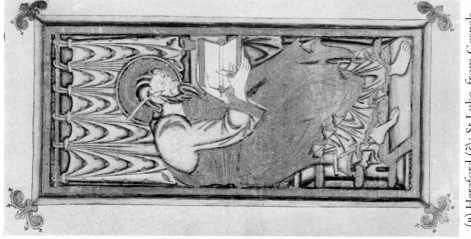

(B) Hereford (?): St Luke, from Gospels.
Mid eleventh century. 7¾ by 4 in.
Pembroke College, Cambridge

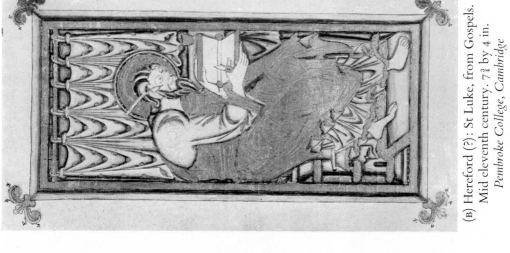

(A) Hereford (?): Scenes from Life of St Lawrence,
from Troper. Mid eleventh century. 6⅜ by 3⅝ in.
British Museum

49

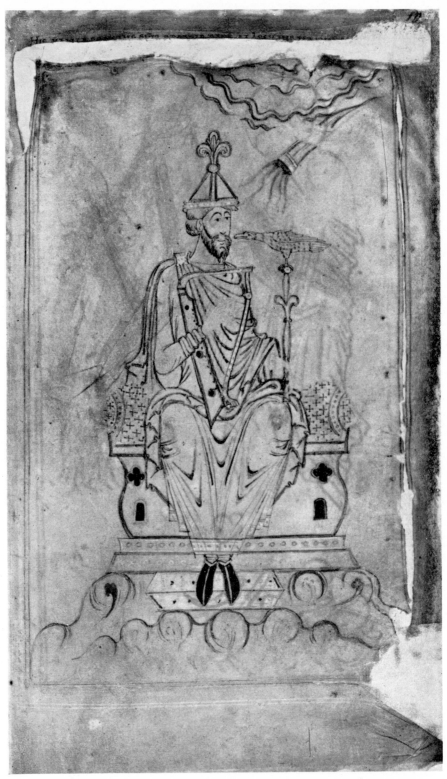

Winchester: David, from Psalter. *c.* 1050. 10 by 6 in. *British Museum*

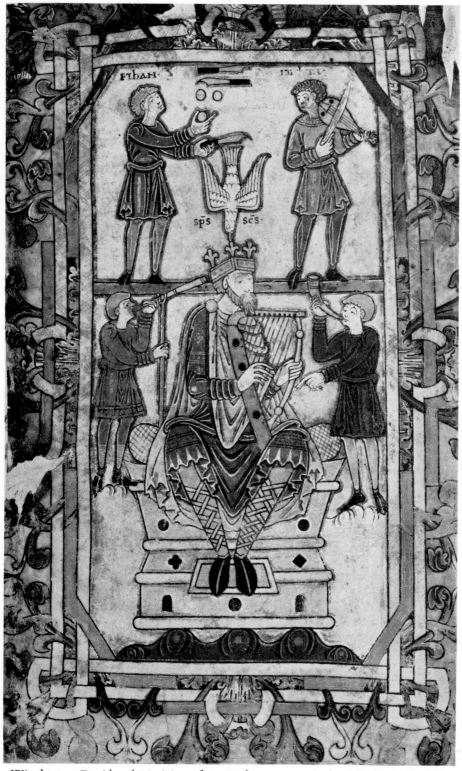

Winchester: David and Musicians, from Psalter. *c.* 1050. 10 by 6 in. *British Museum*

51

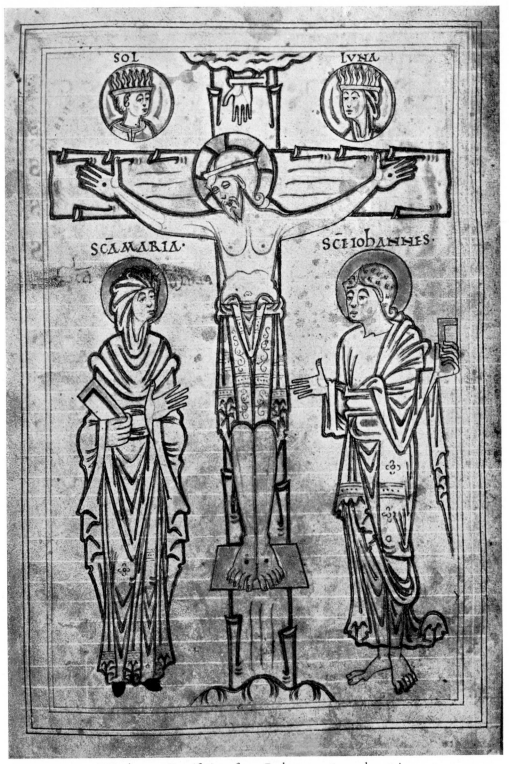

Winchester: Crucifixion, from Psalter. *c.* 1060. 12 by 7½ in.
British Museum

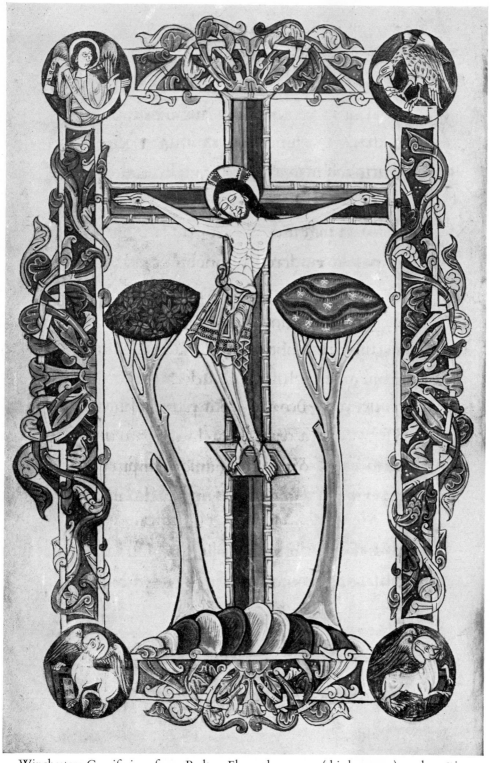

Winchester: Crucifixion, from Psalter. Eleventh century (third quarter). 12 by 7½ in.
British Museum

53

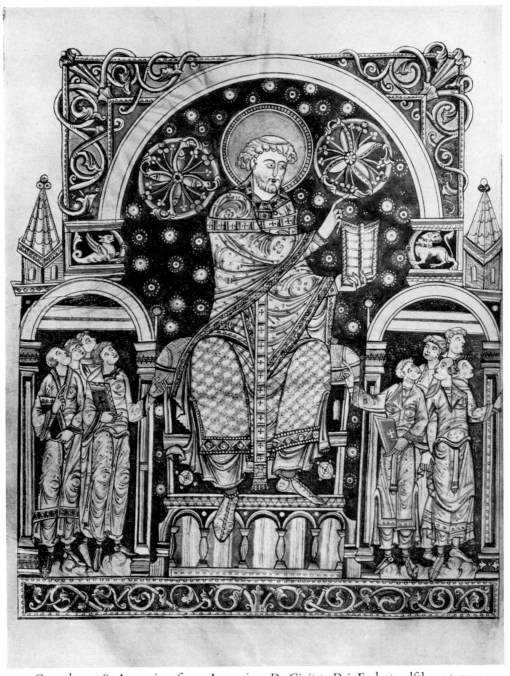

Canterbury: St Augustine, from Augustine, *De Civitate Dei*. Early twelfth century.
13¾ by 9⅞ in. *Biblioteca Medicea Laurenziana, Florence*

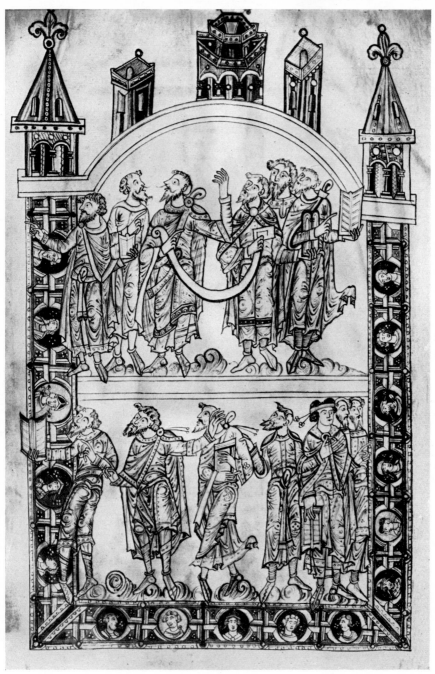

Canterbury: Clerics Discussing, from Augustine, *De Civitate Dei*. Early twelfth century. 13¾ by 9⅞ in. *Biblioteca Medicea Laurenziana, Florence*

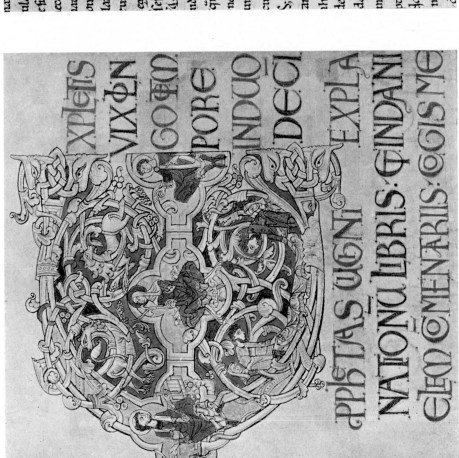

(A) Norman (?): Historiated Initial, from Jerome, *Commentary on Isaiah*. c. 1100. Initial 6 in. high. *Bodleian Library*, Oxford

(B) Durham (?): Initial with Robertus Benjamin, from Augustine, *Commentary on Psalms*. Before 1088. Initial 7⅞ in. high. *Cathedral Library*, *Durham*

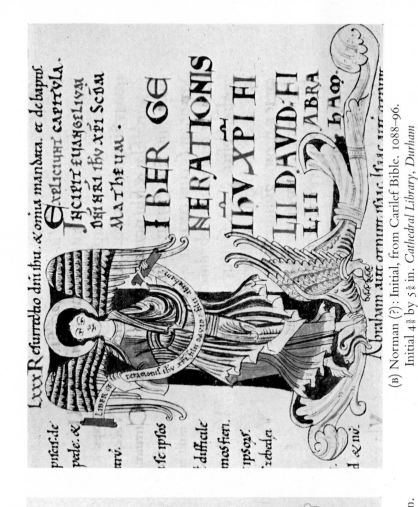

(A) Durham (?): Initial from Augustine, *Commentary on Psalms*. Before 1088. Initial 4½ by 4¼ in. *Cathedral Library, Durham*

(B) Norman (?): Initial, from Carilef Bible. 1088–96. Initial 4⅜ by 5⅝ in. *Cathedral Library, Durham*

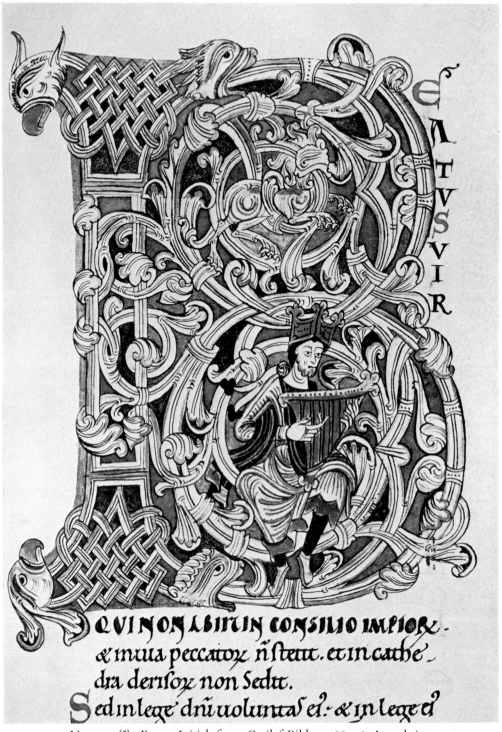

Norman (?): Beatus Initial, from Carilef Bible. 1088–96. Actual size.
Cathedral Library, Durham

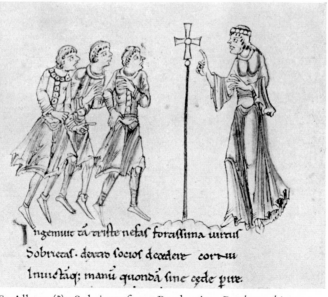

Ingemuit tã triste nefas fortissima uirtus
Sobrietas. dextro socios decedere cornu
Inuictamq; manú quondã sine cęde pite.

(A) St Albans (?): Sobriety, from Prudentius, *Psychomachia*.
Early twelfth century. Approx. actual size. *British Museum*

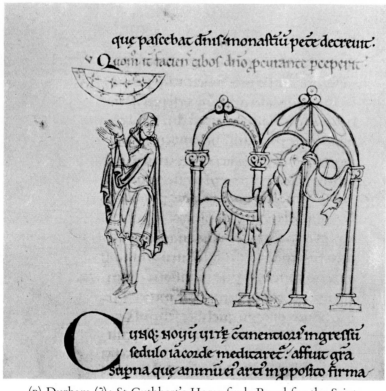

que pascebat dñs: monastiú pete decreuit.
Quoin te facien cibos dño peurante pceperit·

Cunq; noyij uirę ctanentiori ingressú
sedulo iã corde meditaret: affuit gra
stupna quę animú ei arcã inpposito firma

(B) Durham (?): St Cuthbert's Horse finds Bread for the Saint,
from Bede, *Life of St Cuthbert*. Early twelfth century.
Actual size. *University College, Oxford*

59

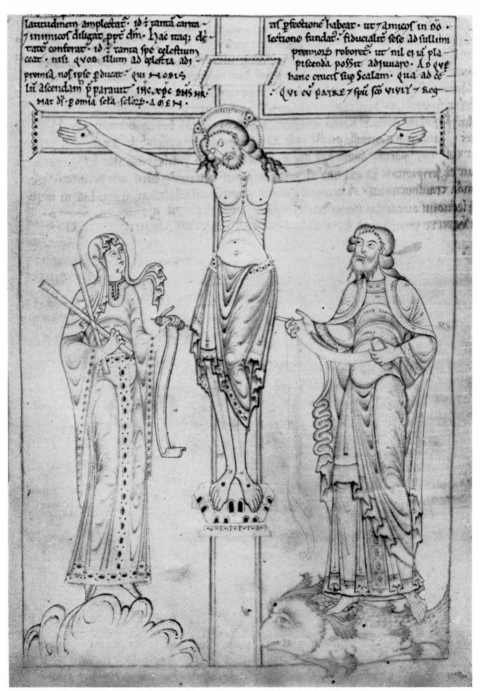

St Albans (?): Crucifixion, from Florence of Worcester's Chronicle. *c.* 1130.
Miniature approx. 8½ by 5¾ in. *Corpus Christi College, Oxford*

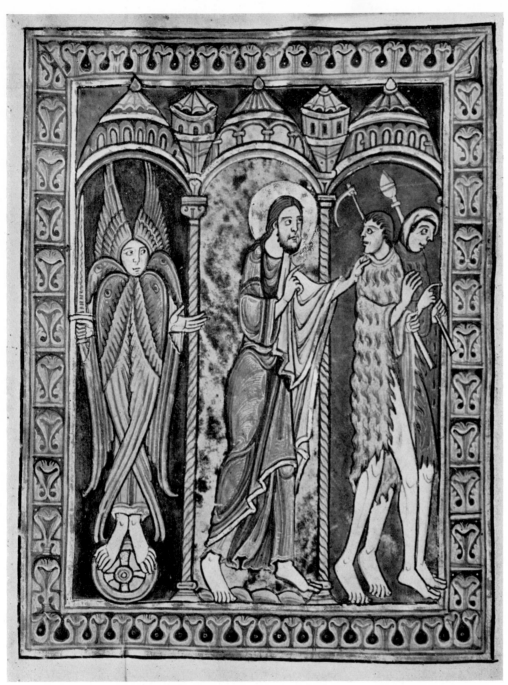

St Albans: Adam and Eve driven from Paradise, from Psalter. 1119–46. 10⅞ by 7¼ in.
Library of St Godehard, Hildesheim

61

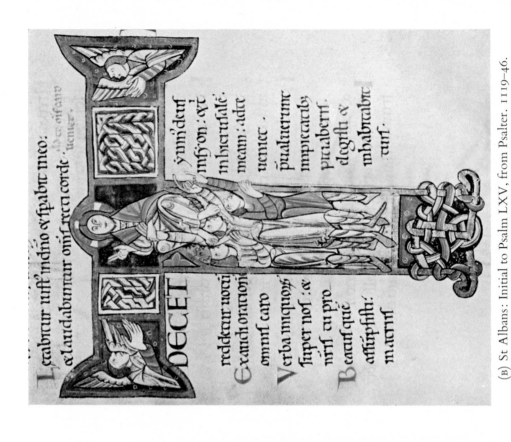

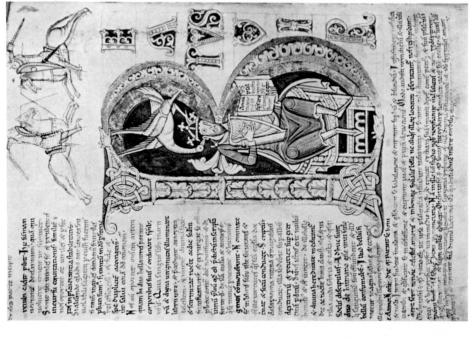

(A) St Albans: Beatus Page, from Psalter. 1119–46. 10⅞ by 7¼ in. *Library of St Godehard, Hildesheim*

(B) St Albans: Initial to Psalm LXV, from Psalter. 1119–46. Initial 7¼ in. high. *Library of St Godehard, Hildesheim*

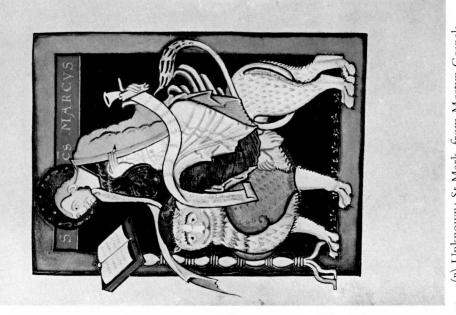

(B) Unknown: St Mark, from Mostyn Gospels. Early twelfth century. 10¾ by 6⅝ in. *Pierpont Morgan Library, New York*

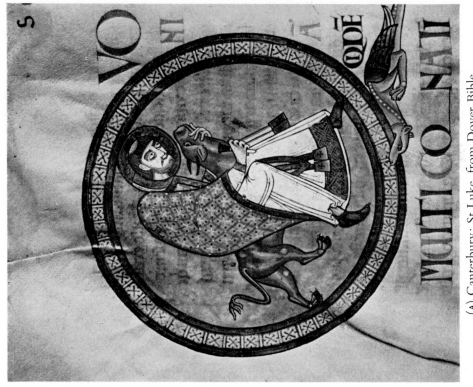

(A) Canterbury: St Luke, from Dover Bible. Twelfth century (third quarter). Initial 4¼ in. diameter. *Corpus Christi College, Cambridge*

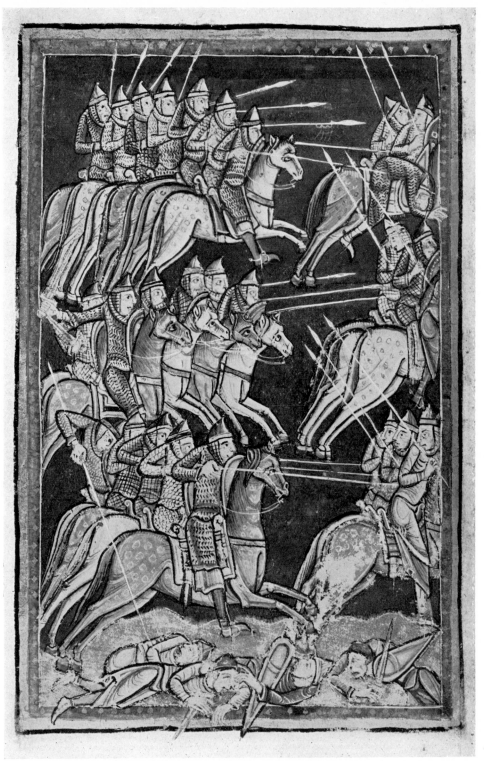

Bury St Edmunds: Fight with the Danes, from *Life of St Edmund*. 1125–50.
10¾ by 7¼ in. *Pierpont Morgan Library, New York*

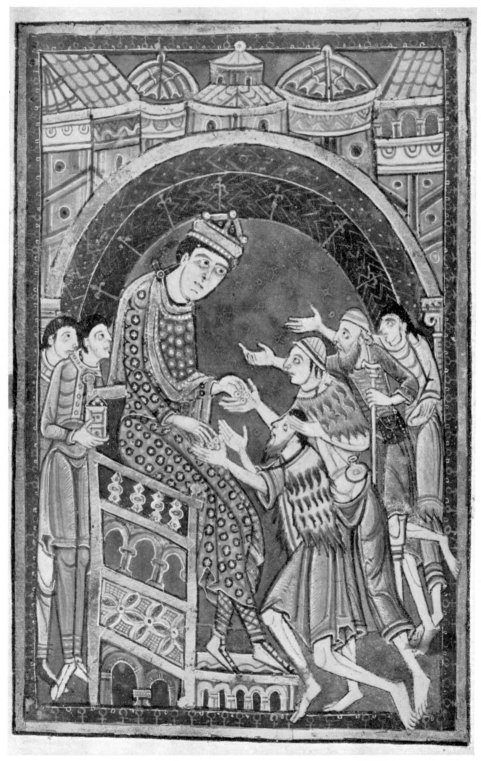

Bury St Edmunds: St Edmund feeding the Hungry, from *Life of St Edmund*.
1125–50. 10¾ by 7¼ in. *Pierpont Morgan Library, New York*

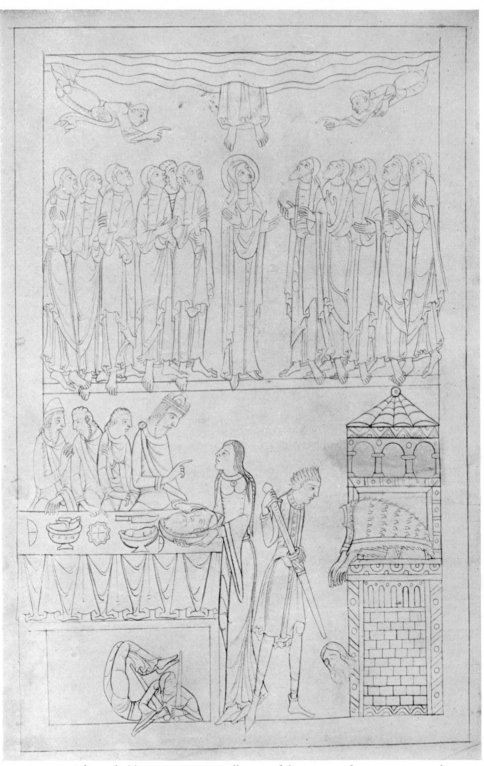

Bury St Edmunds (?): Ascension, Decollation of the Baptist, from Bury Gospels.
Mid twelfth century. 16¼ by 10¾ in. *Pembroke College, Cambridge*

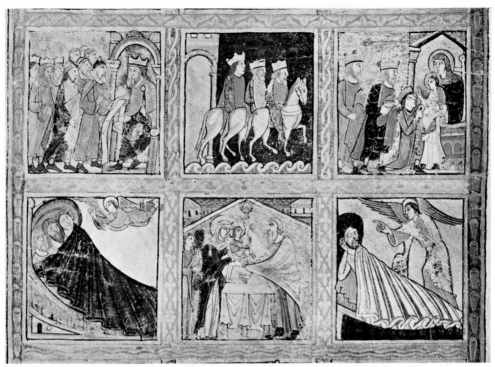

(A) Canterbury (?): Scenes from Infancy of Christ, from Bible Picture Leaf.
Mid twelfth century. Detail 7¾ by 11 in. *British Museum*

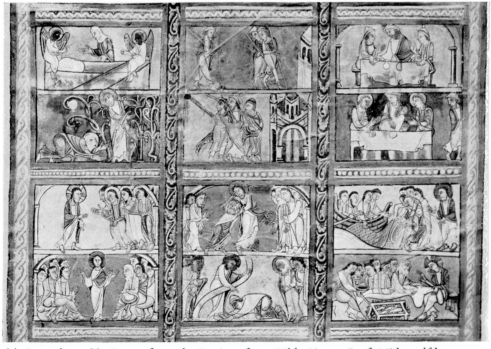

(B) Canterbury (?): Scenes from the Passion, from Bible Picture Leaf. Mid twelfth century.
Detail 7¾ by 11 in. *Victoria and Albert Museum, London*

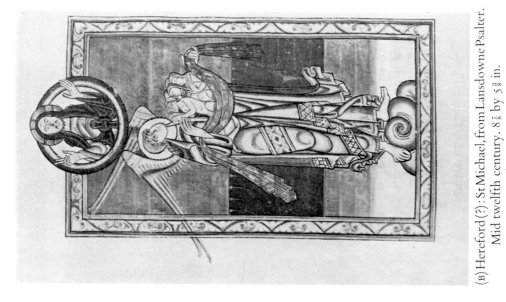

(B) Hereford (?): St Michael, from Lansdowne Psalter.
Mid twelfth century. 8⅞ by 5⅜ in.
British Museum

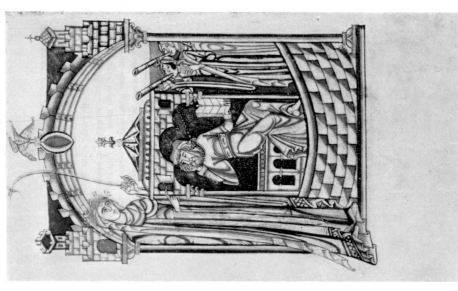

(A) Hereford (?) : Boethius in Prison, from Boethius,
De Consolatione Philosophiae. Twelfth century
(second quarter). 8 by 5 in. *Bodleian Library, Oxford*

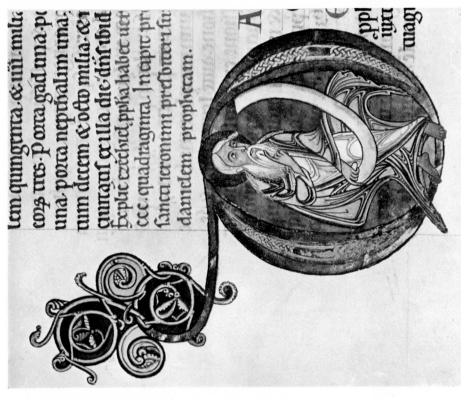

(A) Master Hugo: Prophet Amos, from Bury St Edmunds Bible. 1121–48. Initial approx. $3\frac{7}{8}$ by $3\frac{3}{4}$ in. *Corpus Christi College, Cambridge*

(B) Canterbury: Prophet Daniel, from Lambeth Bible. Twelfth century (second half). Initial $3\frac{1}{2}$ in. diameter. *Lambeth Palace Library, London*

69

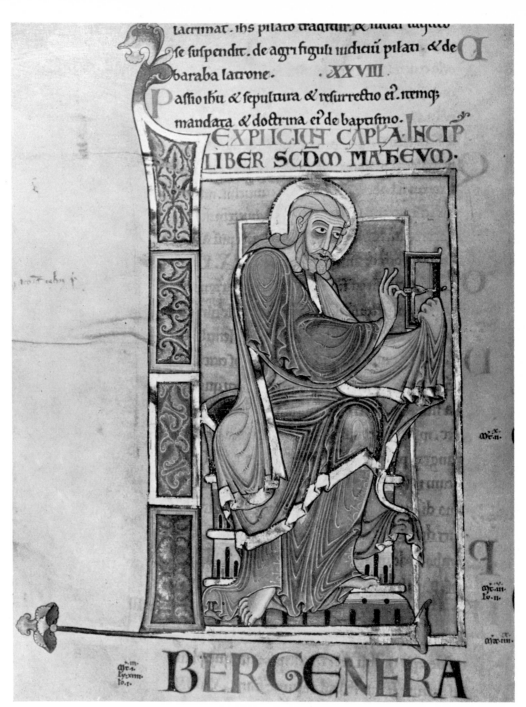

Canterbury: St Matthew, from Dover Bible. Mid twelfth century.
Initial 5½ by 4 in. *Corpus Christi College, Cambridge*

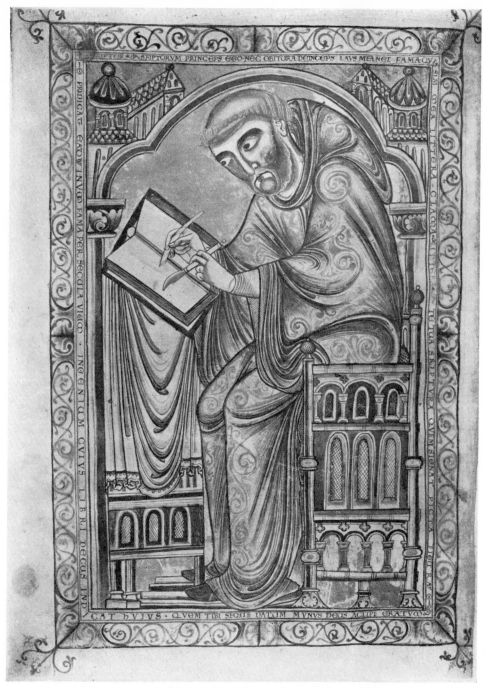

Canterbury: Portrait of the Scribe Eadwine, from Eadwine Psalter. *c.*1150.
18 by 13 in. *Trinity College, Cambridge*

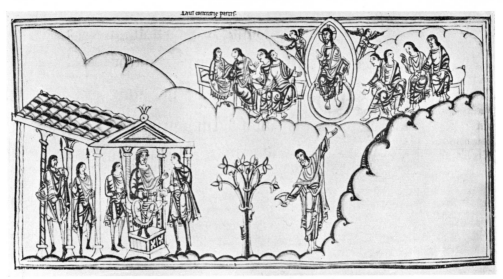

(A) Canterbury: Illustration for Psalm LI, from Eadwine Psalter. *c.*1150.
Miniature 5 by 11½ in. *Trinity College, Cambridge*

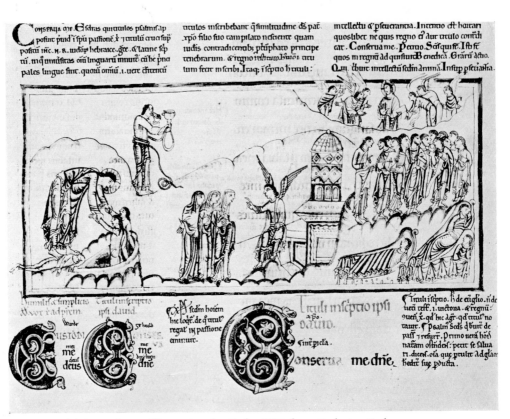

(B) Canterbury: Illustration for Psalm XV, from Eadwine Psalter. *c.*1150.
Miniature 5½ by 11½ in. *Trinity College, Cambridge*

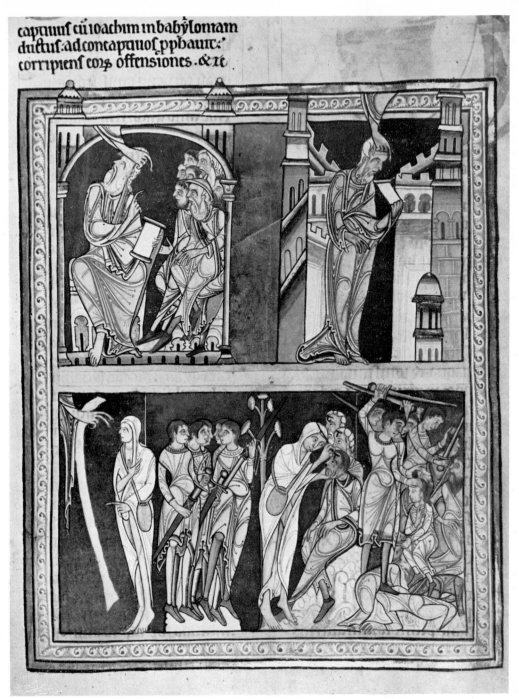

Canterbury: Moses and Israelites, from Lambeth Bible. Twelfth century (second half).
Miniature 10⅛ by 8⅝ in. *Lambeth Palace Library, London*

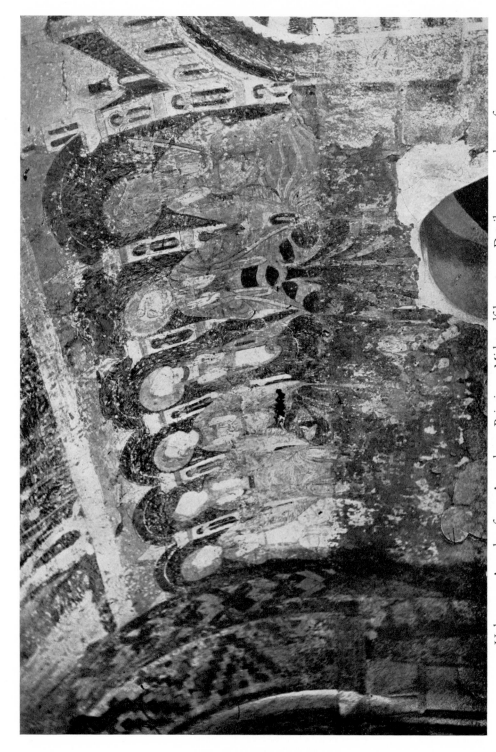

Unknown: Apostles, from Apocalypse Paintings. Mid twelfth century. Detail approx. 5 by 12 ft.
North Chancel Wall, Church of St Mary, Kempley, Gloucestershire

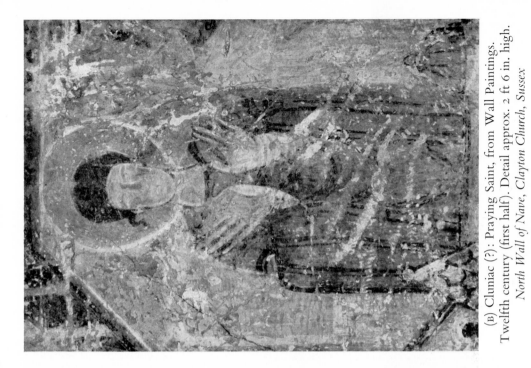

(B) Cluniac (?): Praying Saint, from Wall Paintings. Twelfth century (first half). Detail approx. 2 ft 6 in. high. *North Wall of Nave, Clayton Church, Sussex*

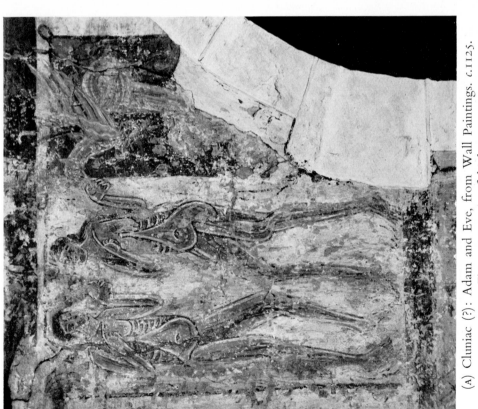

(A) Cluniac (?): Adam and Eve, from Wall Paintings. *c.* 1125. Figures approx. 4 ft high. *West Wall of Chancel, Hardham Church, Sussex*

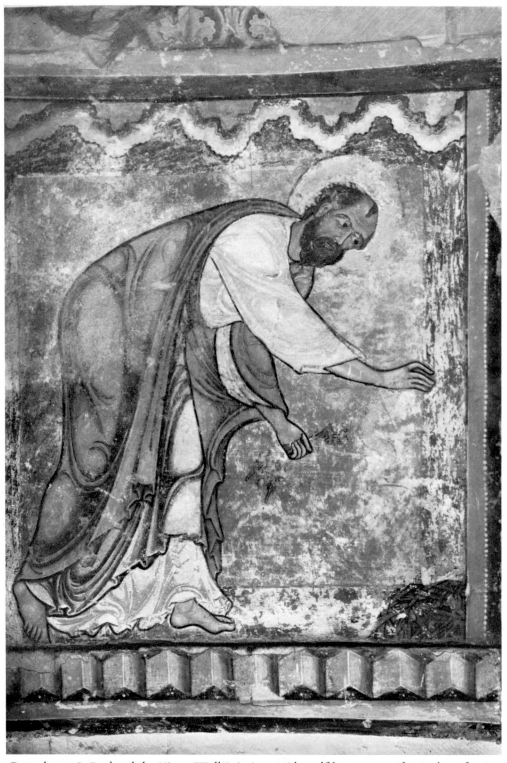

Canterbury: St Paul and the Viper, Wall Painting. Mid twelfth century. 5 ft 9 in. by 5 ft 6 in.
East Wall, St Anselm's Chapel, Canterbury Cathedral

Canterbury: St John and Two Angels, from Apocalypse. Wall Painting. *c.*1130.
Approx. half actual size. *Arch, St Gabriel's Chapel, Crypt, Canterbury Cathedral*

Ramsey Abbey (?): St John, from Bede, *Commentary on the Apocalypse*. Twelfth century (third quarter). 10⅛ by 7 in. *St John's College, Cambridge*

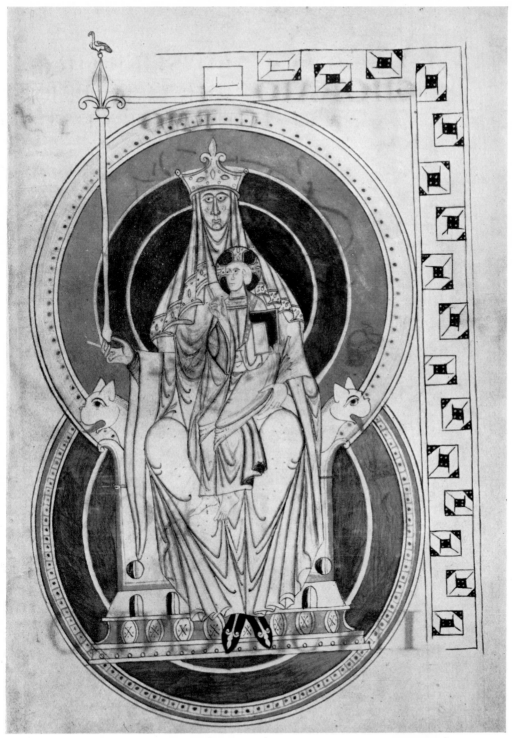

Unknown: Madonna and Child, prefixed to Augustine, *Commentary on Psalms*.
Twelfth century (second half). 10¾ by 6½ in. *Bodleian Library, Oxford*

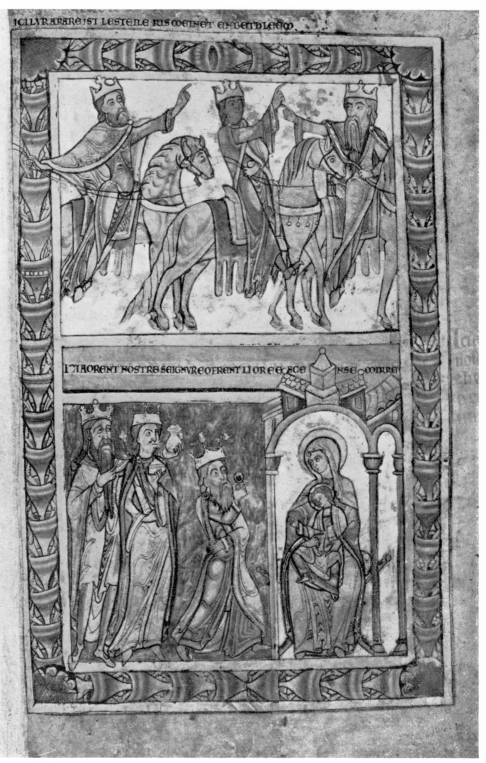

Winchester: Adoration of the Magi, from Psalter. 1150–60. 12¾ by 9 in.
British Museum

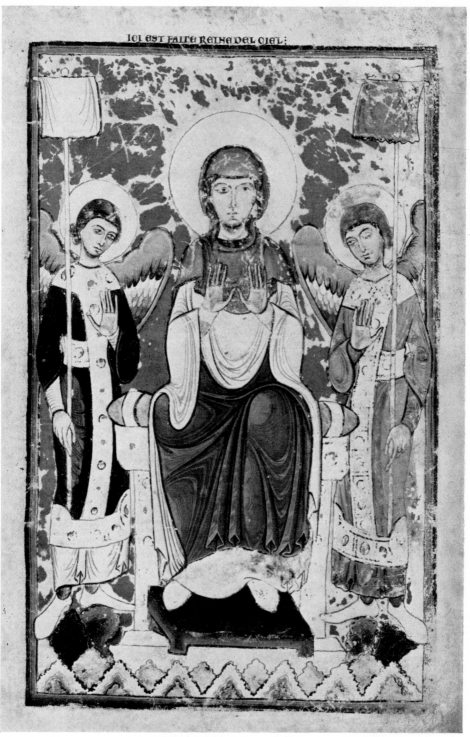

Italo–Byzantine (?): Virgin Enthroned, from Psalter. Twelfth century (third quarter).
12¾ by 9 in. *British Museum*

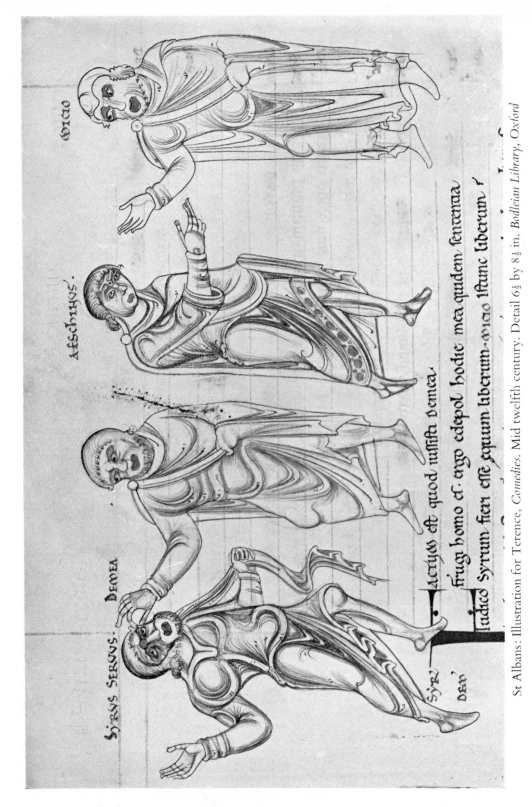

St Albans: Illustration for Terence, *Comedies*. Mid twelfth century. Detail 6½ by 8½ in. *Bodleian Library, Oxford*

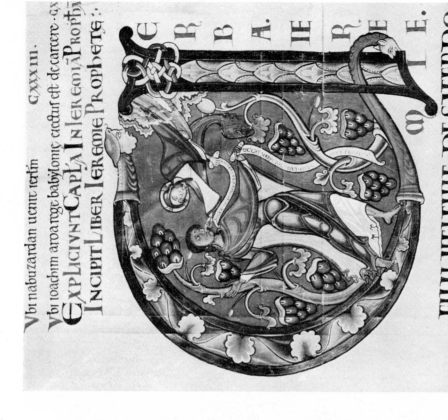

(A) Winchester: Initial for II Maccabees, from Bible. c.1160–70.
Initial 4¼ by 3½ in. *Cathedral Library, Winchester*

(B) Winchester: Initial for Jeremiah, from Bible. c.1160–70.
Initial 4⅜ by 5 in. *Cathedral Library, Winchester*

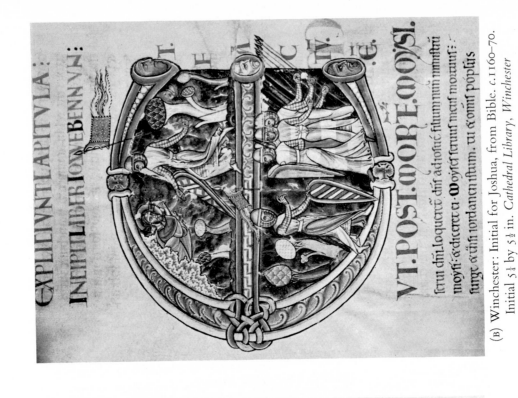

(A) Winchester: Initial for Zephaniah, from Bible. *c.*1160–70. Initial 4⅝ by 4½ in. *Cathedral Library, Winchester*

(B) Winchester: Initial for Joshua, from Bible. *c.*1160–70. Initial 5¼ by 5½ in. *Cathedral Library, Winchester*

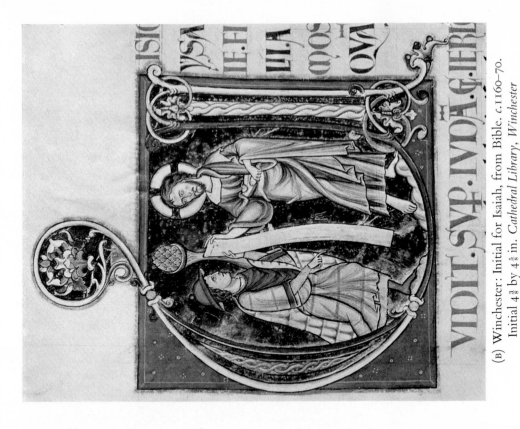

(B) Winchester: Initial for Isaiah, from Bible. *c.* 1160–70.
Initial 4¾ by 4⅝ in. *Cathedral Library, Winchester*

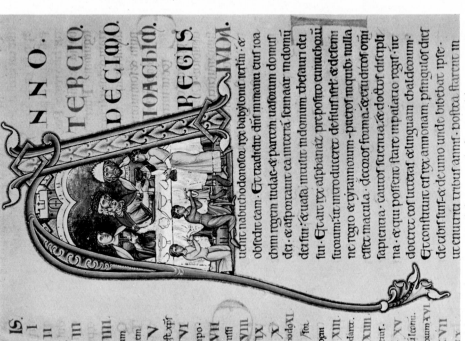

(A) Winchester: Initial for Daniel, from Bible. *c.* 1160–70.
Initial 4¾ by 4⅜ in. *Cathedral Library, Winchester*

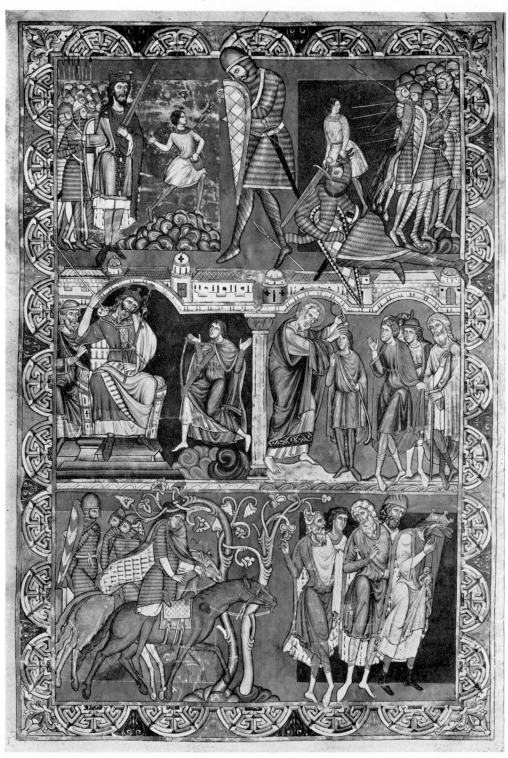

Winchester: Scenes from Life of David, from Bible Picture Leaf. Twelfth century
(third quarter). 22⅜ by 15¼ in. *Pierpont Morgan Library, New York*

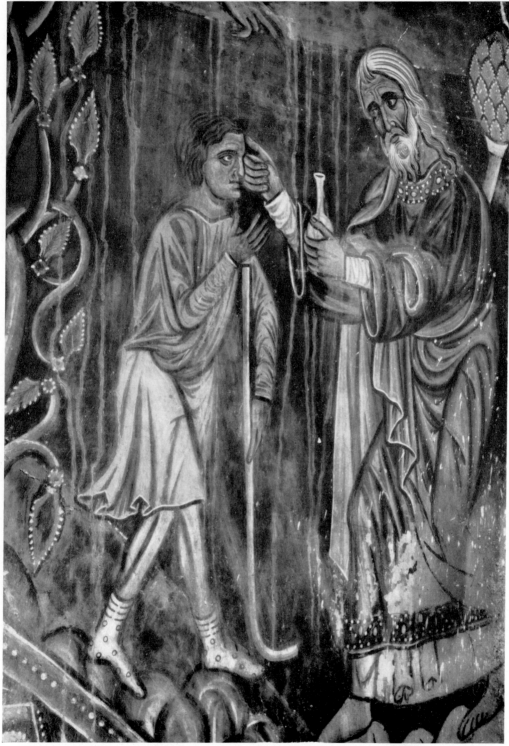

Winchester (Morgan?) Master: Anointing of David, Wall Painting. Twelfth century (last decade). Approx. actual size. *From Sigena (Huesca), Chapter House of Monastery. National Museum, Barcelona*

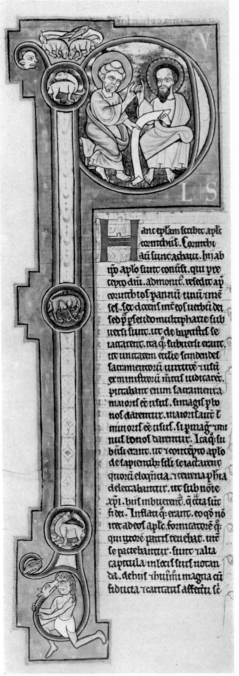

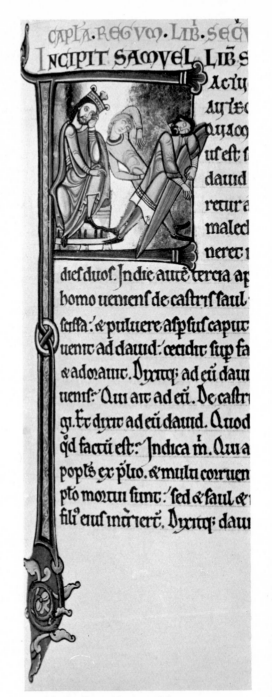

(A) Durham (?): Initial for Corinthians
from Pauline Epistles. 1153–95.
Detail 15 by 5¼ in.
Cathedral Library, Durham

(B) Durham (?): Initial for II Kings,
from Pudsey Bible. 1153–95.
Detail approx. 9 by 3 in.
Cathedral Library, Durham

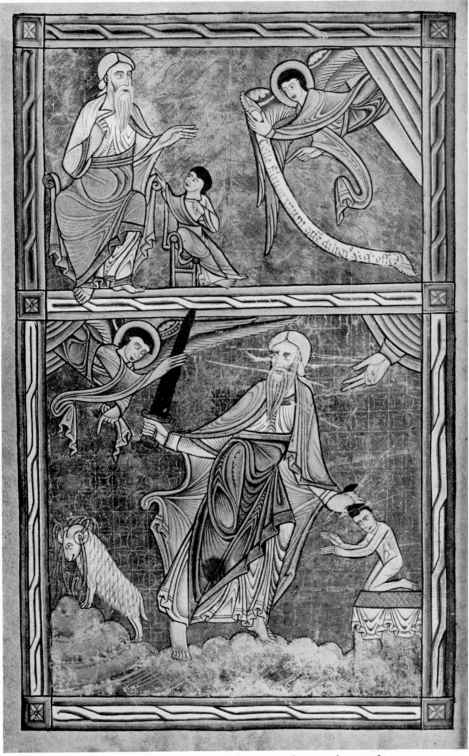

York (?): Sacrifice of Abraham, Bible Picture from Psalter. Before 1173.
11¾ by 7⅜ in. *Hunterian Museum, Glasgow*

89

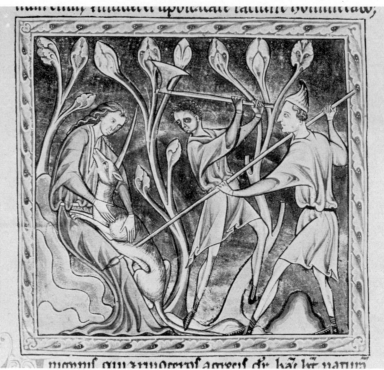

(A) Unknown: The Unicorn, from Bestiary. Late twelfth century.
Miniature 4⅛ by 4½ in. *Bodleian Library, Oxford*

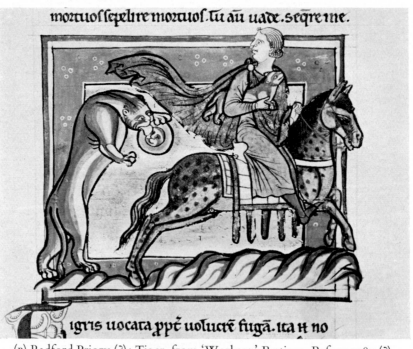

(B) Radford Priory (?): Tiger, from 'Worksop' Bestiary. Before 1187 (?).
Miniature 3½ by 4 in. *Pierpont Morgan Library, New York*

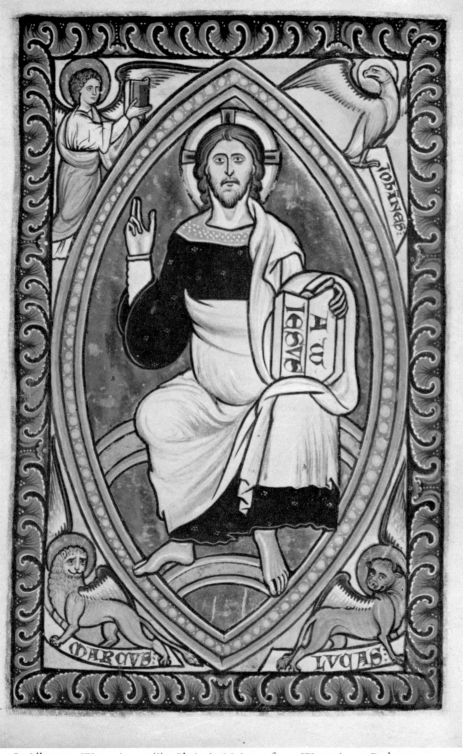

St Albans or Westminster (?): Christ in Majesty, from Westminster Psalter. *c.*1200.
9 by 6¼ in. *British Museum*

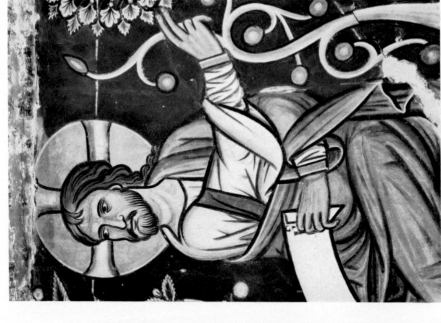

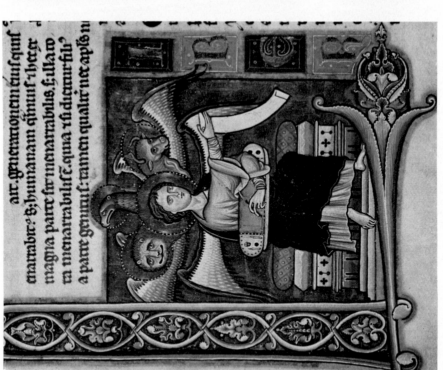

(A) St Albans: Symbol of St Matthew, from Glossed Gospels. c.1200. Approx. actual size. *Trinity College, Cambridge*

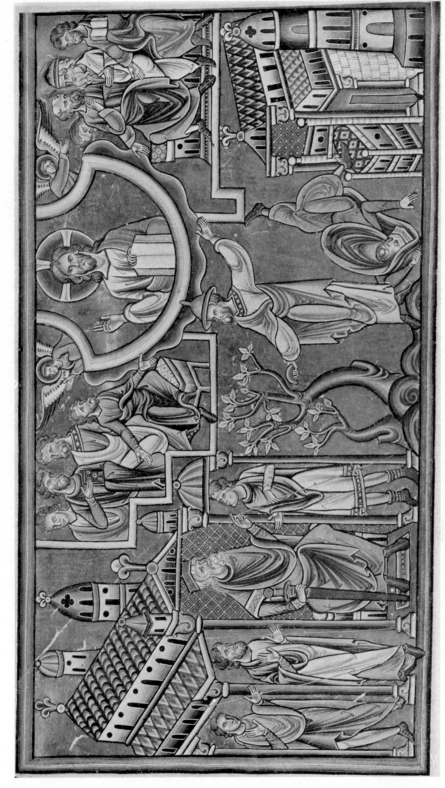

Canterbury: Illustration for Psalm LI, from Psalter. c.1200. Miniature 6⅜ by 11½ in. *Bibliothèque Nationale, Paris*

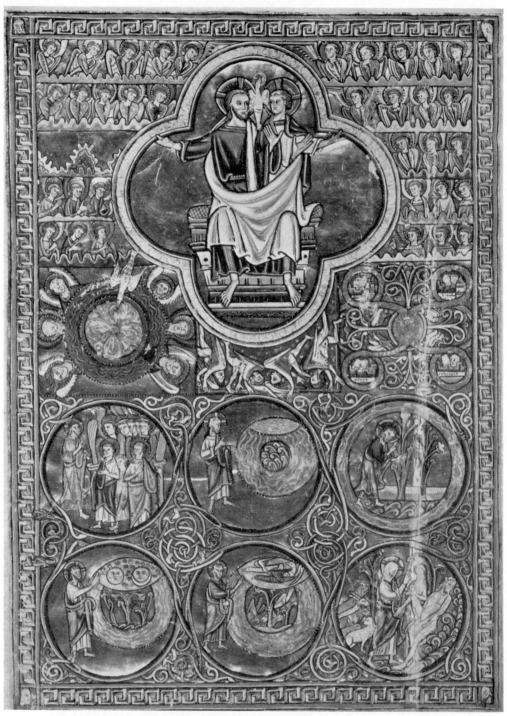

Canterbury (?): Trinity, from Lothian Bible. *c.*1210. 14 by 10 in.
Pierpont Morgan Library, New York

Canterbury: Methuselah, Panel from Stained Glass Window.
Late twelfth century. 5 ft by 2 ft 5 in.
Clerestory, South–west Transept, Canterbury Cathedral

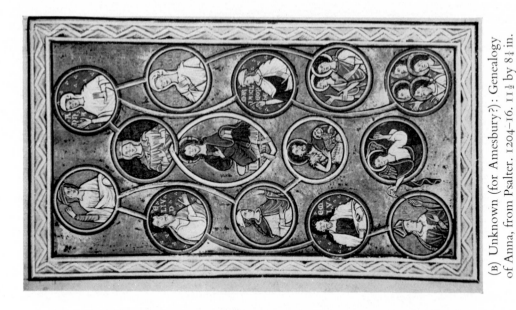

(B) Unknown (for Amesbury?): Genealogy of Anna, from Psalter. 1204–16. 11½ by 8¼ in.
Biblioteca Comunale, Imola

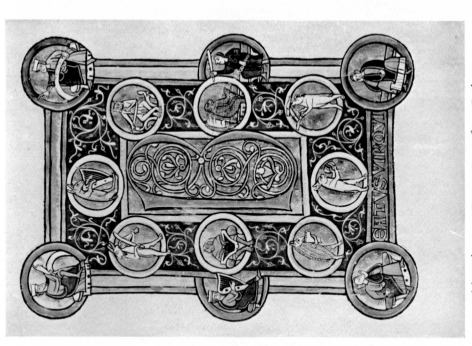

(A) Unknown: Beatus Page, from Psalter. Early thirteenth century. 12 by 8¾ in. *British Museum*

(B) Croyland Abbey: Guthlac receives the Tonsure, from *Life of St Guthlac*. c. 1200. 6 in. diameter. *British Museum*

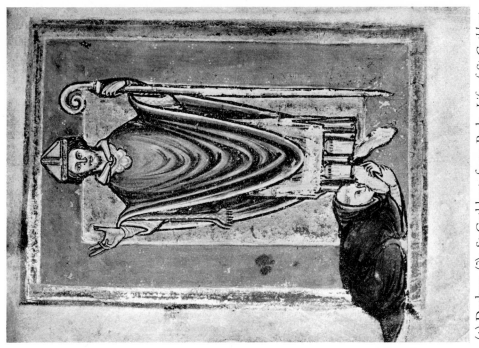

(A) Durham (?): St Cuthbert, from Bede, *Life of St Cuthbert*. c. 1200. 5⅜ by 3⅞ in. *British Museum*

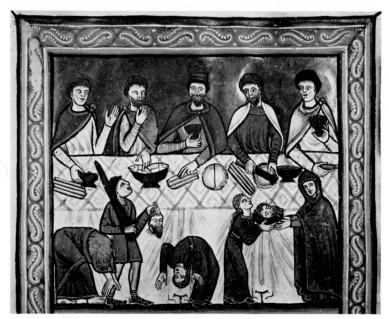

(A) Unknown (Oxford use?): Feast of Herod, from Psalter.
c. 1220. Detail 4 by 5⅛ in. *British Museum*

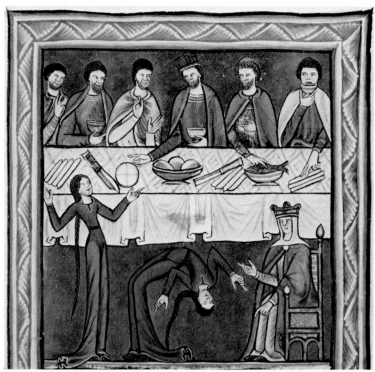

(B) Unknown (Gloucester use?): Feast of Herod, from Psalter.
Before 1222. Detail 4¼ by 4½ in. *Bayerische Staatsbibliothek, Munich*

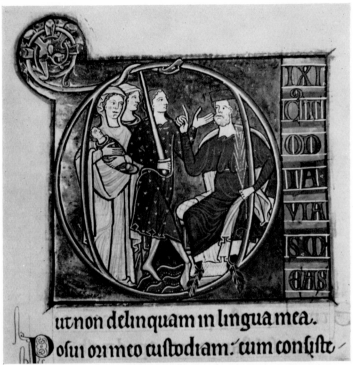

ut non delinquam in lingua mea.
Posui ori meo custodiam: cum consiste

(A) Unknown (for Amesbury?): Judgement of Solomon, from Psalter. 1204–16. Detail 3½ by 5 in. *Biblioteca Comunale, Imola*

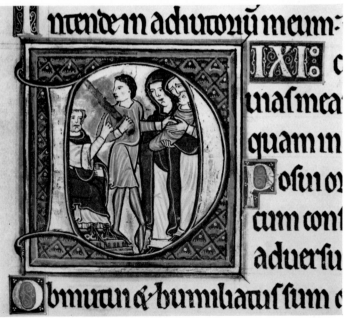

(B) Unknown: Judgement of Solomon, from Psalter. *c.* 1220. Miniature 2½ by 2½ in. *British Museum*

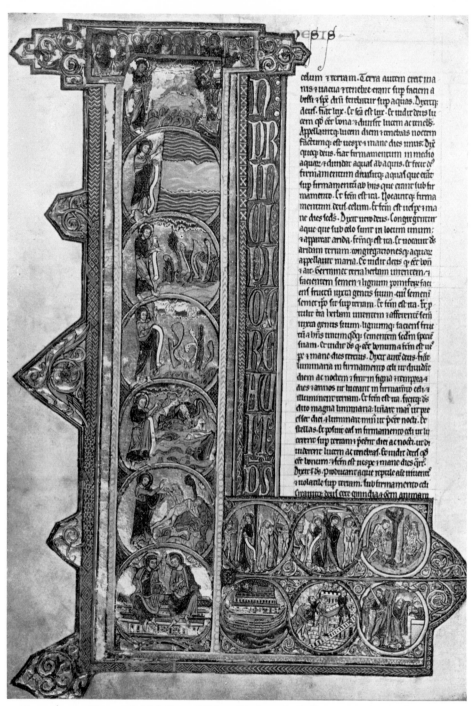

Canterbury: Genesis Initial, from Bible of Robert de Bello. 1224–53. 10⅞ by 7⅞ in.
British Museum

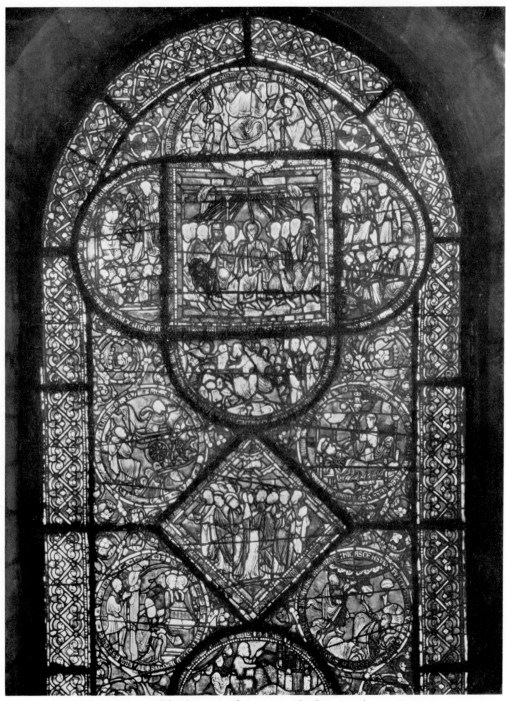

Canterbury: Biblical Scenes, from Stained Glass Window. *c.*1220.
Detail approx. 11 by 7 ft. *Corona, Canterbury Cathedral*

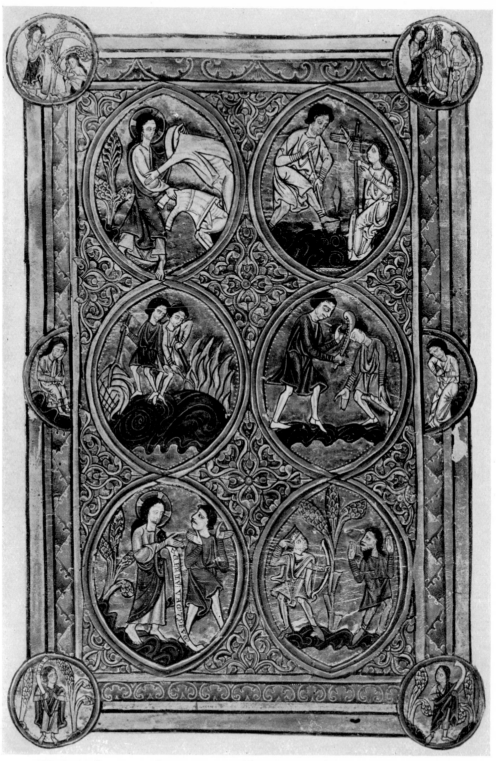

W. de Brailes: Scenes from Genesis, Bible Picture Leaf. *c.* 1230–60. 9⅞ by 6⅞ in.
Fitzwilliam Museum, Cambridge

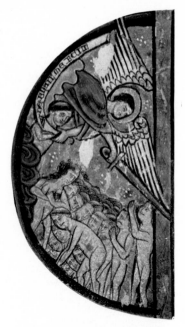

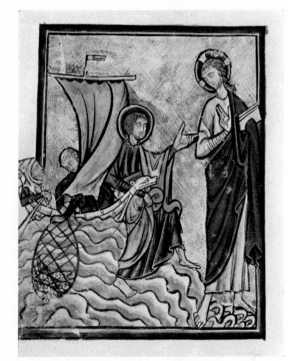

(A) W. de Brailes (signed):
Portrait of W. de Brailes, from Last
Judgement. *c.* 1230–60. Detail 1¼ in.
diameter. *Fitzwilliam Museum,
Cambridge. Reproduced by permission
of the Syndics*

(B) W. de Brailes: Christ walking on the Water,
from Bible Pictures. *c.* 1230–60. 5¼ by 3⅞ in.
Walters Art Gallery, Baltimore

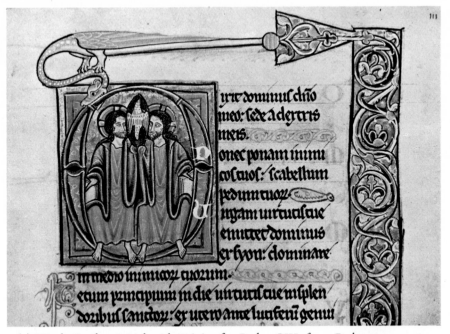

(c) W. de Brailes: Initial with Trinity for Psalm CIX, from Psalter. *c.* 1230–60.
Actual size. *Formerly Sir Sydney Cockerell, Kew, Richmond*

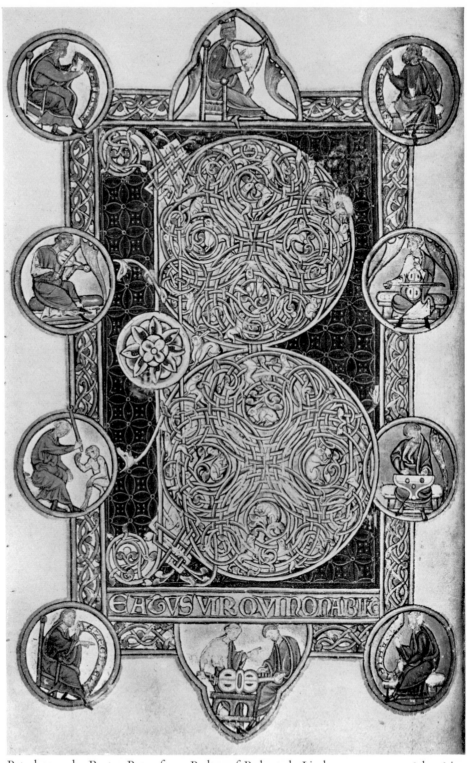

Peterborough: Beatus Page, from Psalter of Robert de Lindesey. 1214–22. 9½ by 6 in.
Society of Antiquaries, London

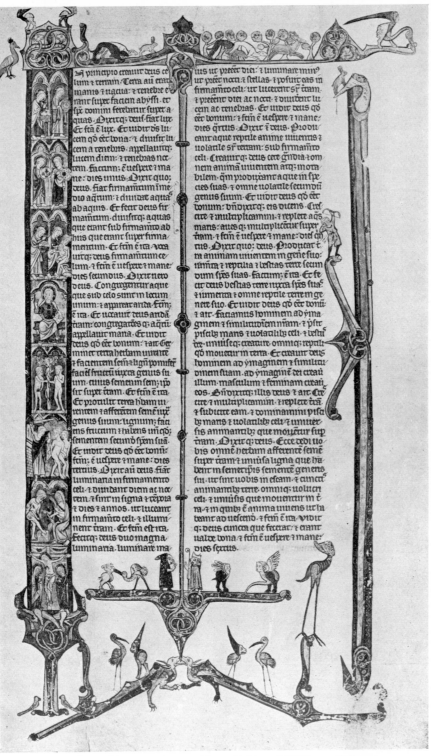

Canterbury (?): Genesis Page, from Bible of William of Devon.
c. mid thirteenth century. 12⅜ by 8 in. *British Museum*

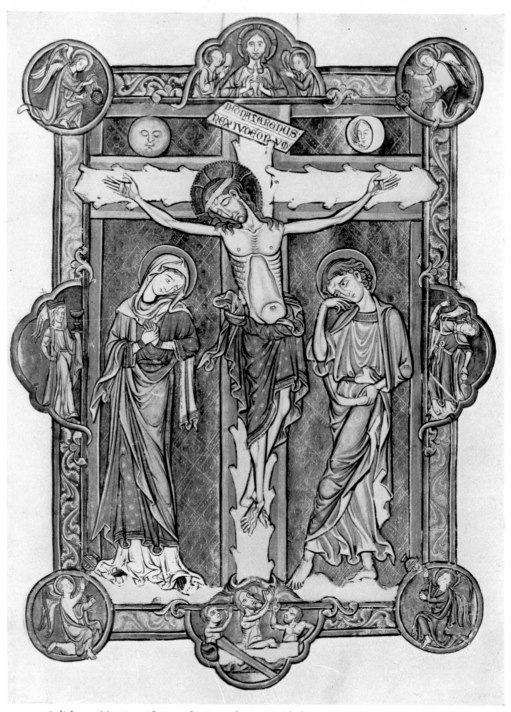

Salisbury (?): Crucifixion, from Psalter. *c.* mid thirteenth century. 12 by 8½ in.
All Souls College, Oxford

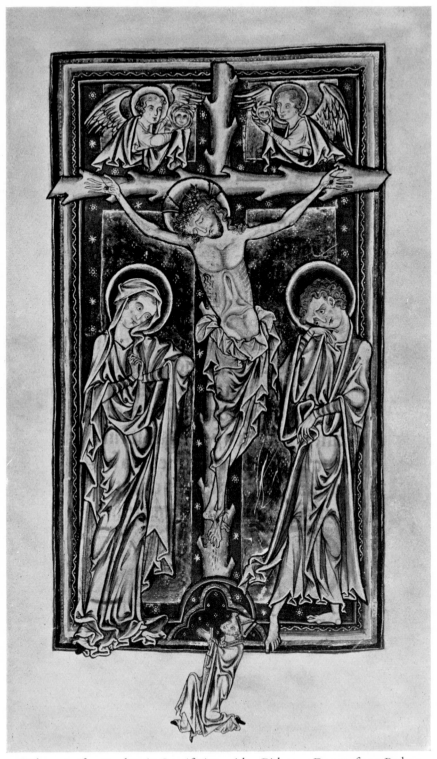

Unknown (for Evesham): Crucifixion with a Bishop as Donor, from Psalter.
Mid thirteenth century. 12⅜ by 8 in. *British Museum*

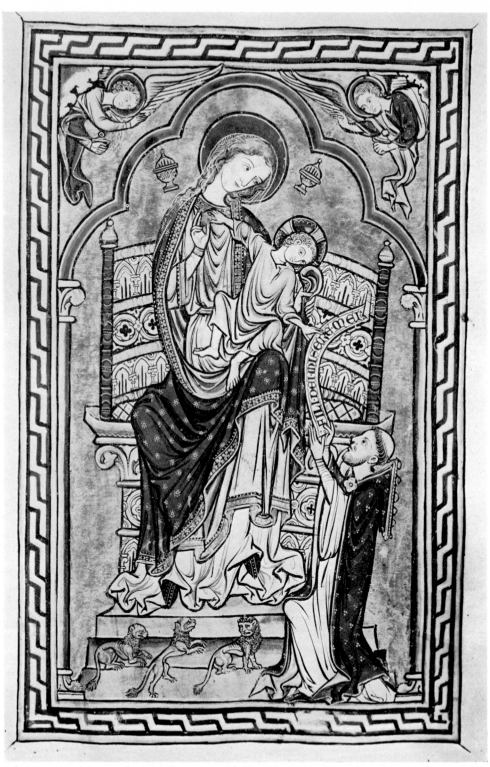

Salisbury (?): Virgin and Child, from Missal 'of Henry of Chichester'. Mid thirteenth century. 12½ by 8 in. *John Rylands Library, Manchester*

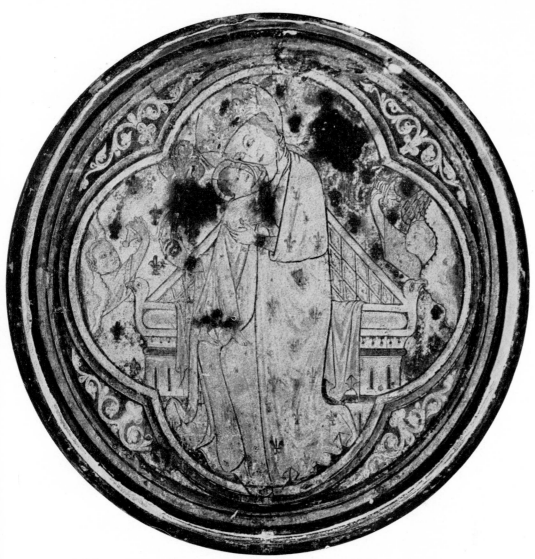

Salisbury (?): Virgin and Child, Painted Roundel. Mid thirteenth century.
2 ft 6 in. diameter. *Chapel of the Bishop's Palace, Chichester*

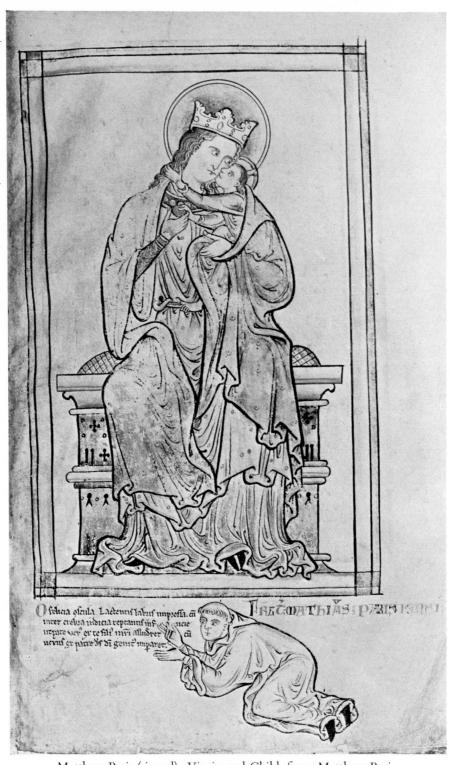

Matthew Paris (signed): Virgin and Child, from Matthew Paris,
Historia Anglorum. Before 1259. 14 by 9⅜ in. *British Museum*

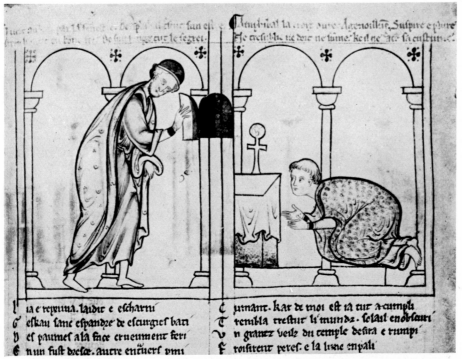

(A) Matthew Paris: Alban watching Amphibalus kneeling before the Cross,
from *Lives of Saints Alban and Amphibalus*. Mid thirteenth century.
Detail 4¼ by 6½ in. *Trinity College, Dublin*

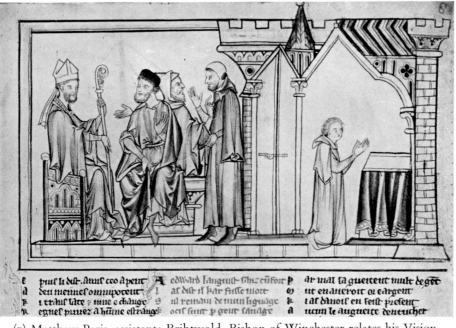

(B) Matthew Paris, assistant: Brihtwold, Bishop of Winchester relates his Vision,
the Young Edward praying, from *La Estoire de Seint Aedward le Rei*.
Thirteenth century (third quarter). Detail 5¼ by 7¾ in. *University Library, Cambridge*

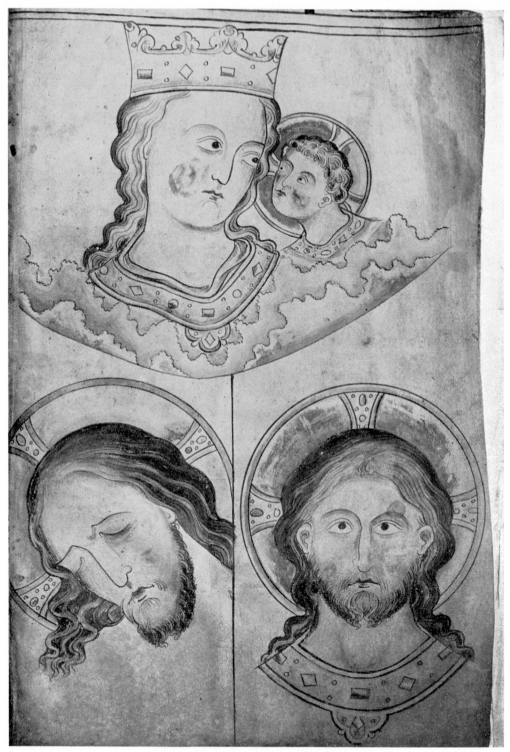

Matthew Paris: Heads of Christ and the Virgin, from Matthew Paris, *Chronica Maiora*.
Mid thirteenth century. 14¼ by 9⅝ in. *Corpus Christi College, Cambridge*

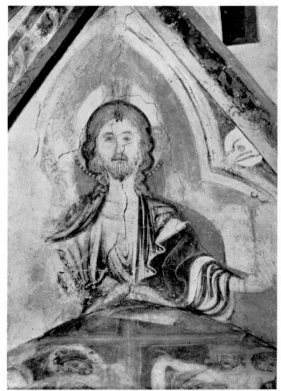

(A) Court Style (?): Majesty, Wall Painting. *c.* 1230.
Figure 3 ft 4 in. high. *Vault, Chapel of the
Holy Sepulchre, Winchester Cathedral*

(B) Court Style (?): Deposition, Wall Painting. *c.* 1230. Detail 4 ft 11 in.
by 7 ft 6 in. *East Wall, Chapel of the Holy Sepulchre, Winchester Cathedral*

(A) Matthew Paris: Head of Christ, from Matthew Paris,
Chronica Minora. Mid thirteenth century. Miniature 5¾ by 6 in.
Corpus Christi College, Cambridge

(B) Matthew Paris (?): Head of a King, Wall Painting.
Mid thirteenth century.
Over life-size. *Cloister, Windsor Castle*

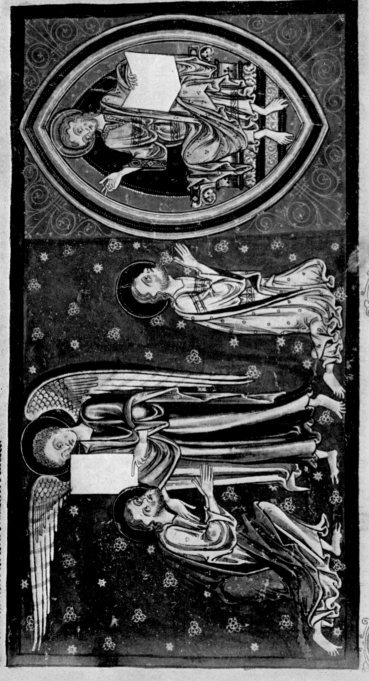

St Albans (?): St John and the Angel, from Apocalypse. c. 1250. Miniature 4½ by 8¼ in. *Trinity College, Cambridge*

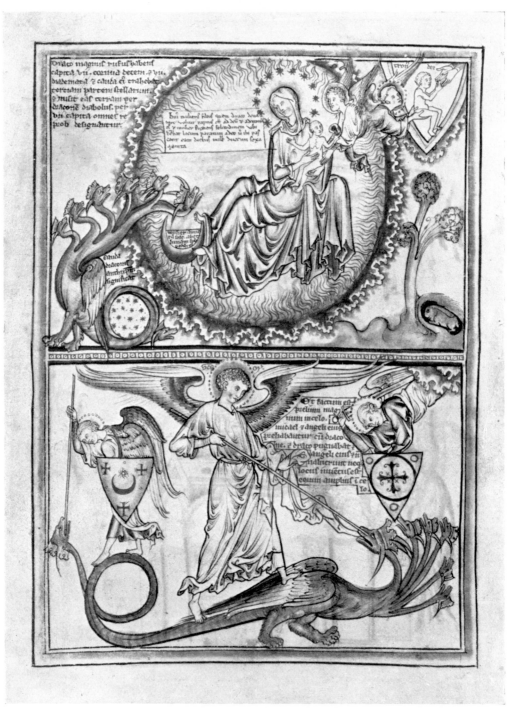

St Albans: The Apocalyptic Woman, St Michael and Dragon, from Apocalypse.
Mid thirteenth century. 10¾ by 7⅝ in. *Pierpont Morgan Library, New York*

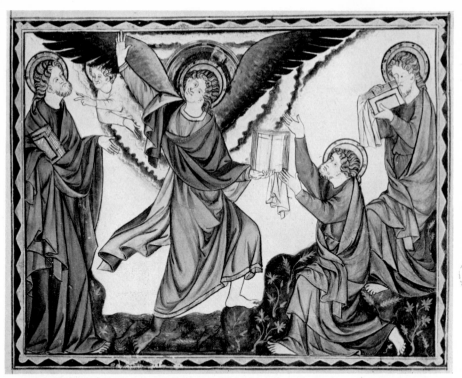

(A) Canterbury: St John and the Angel, from Apocalypse. *c.* 1270. Miniature
4½ by 5¾ in. *Bodleian Library, Oxford*

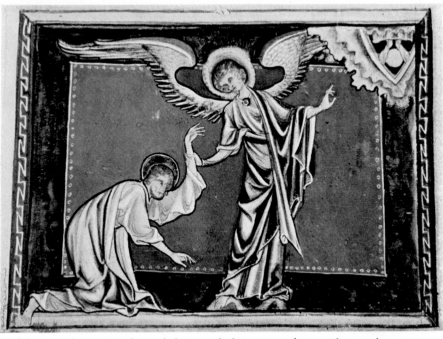

(B) Canterbury: St John and the Angel, from Apocalypse. Thirteenth century
(third quarter). Miniature 4½ by 6 in. *Lambeth Palace Library, London*

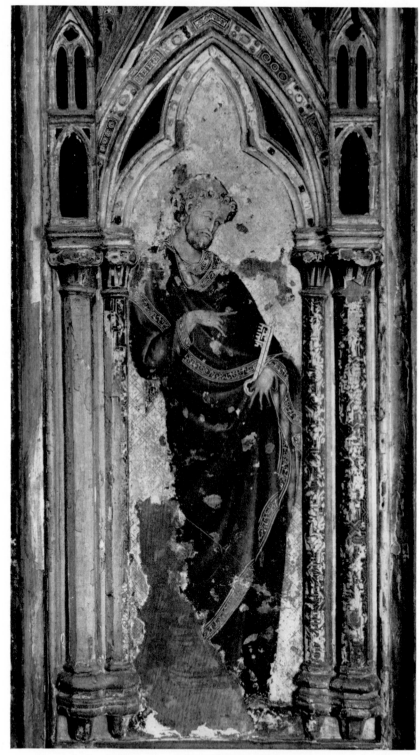

Court Style: St Peter, detail from Retable. Thirteenth century (third quarter). Figure approx. 19 by 6 in. *South Ambulatory, Westminster Abbey*

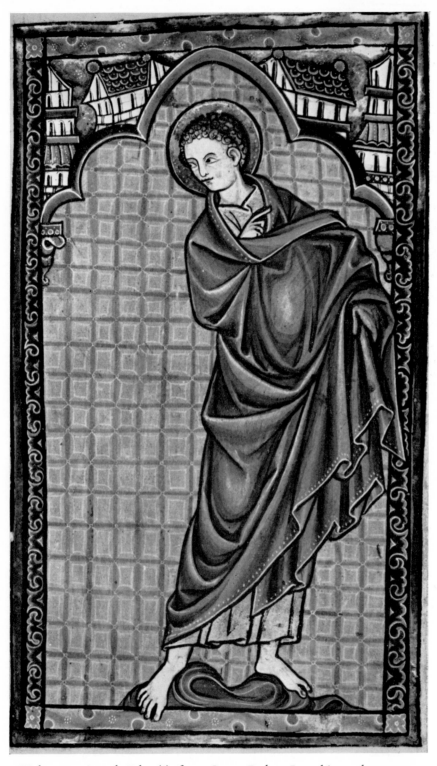

Unknown: Apostle John (?), from Oscott Psalter. Late thirteenth century. 11⅞ by 7⅝ in. *British Museum*

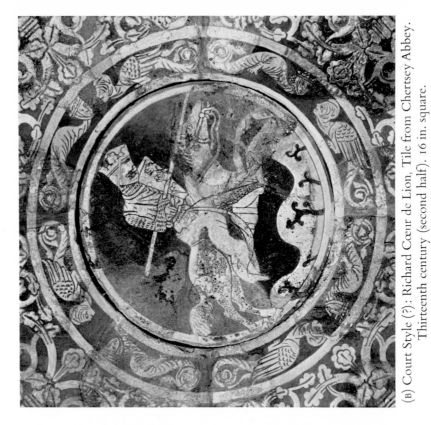

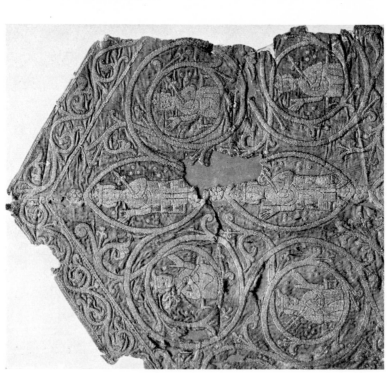

(B) Court Style (?): Richard Cœur de Lion, Tile from Chertsey Abbey.
Thirteenth century (second half). 16 in. square.
Edward VII Gallery, British Museum

(A) Worcester (?): Kings, from Fragment of
Worcester Embroideries. 1236–66. Detail $12\frac{7}{8}$ by $10\frac{1}{2}$ in.
Edward VII Gallery, British Museum

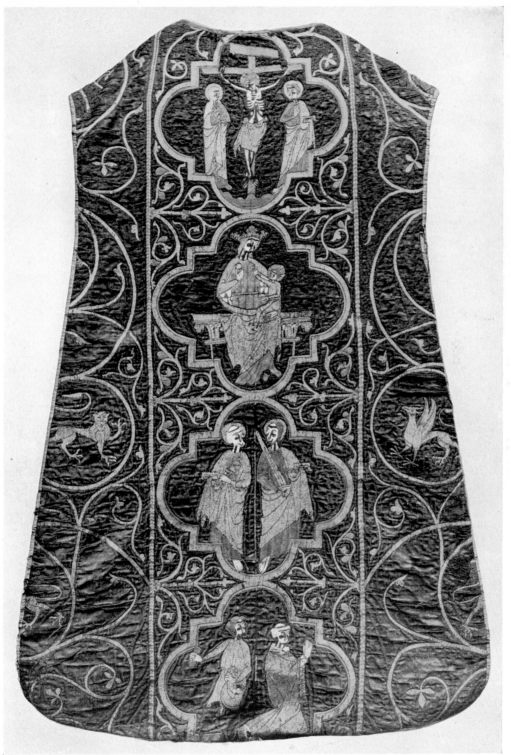

Unknown: Crucifixion, Madonna, Saints Peter and Paul, and Martyrdom of Stephen,
Clare Chasuble. Before 1284. 3 ft 3½ in. by 2 ft 8 in. *Victoria and Albert Museum, London*

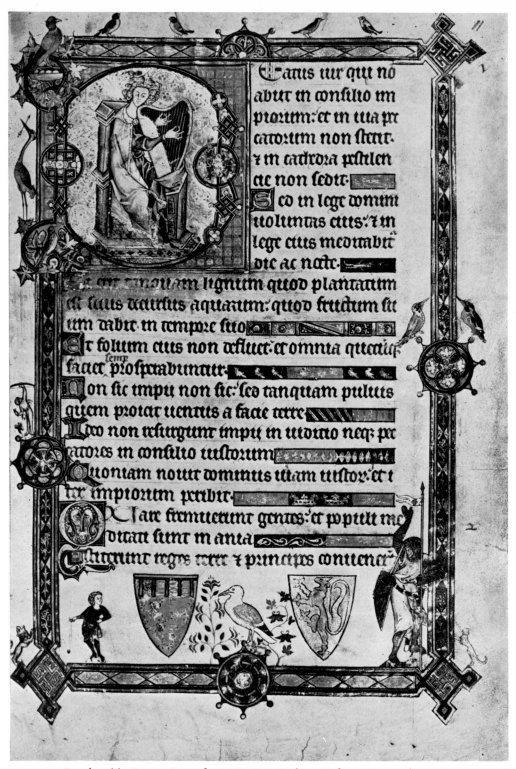

London (?): Beatus Page, from Tenison Psalter. Before 1284. 9½ by 6½ in.
British Museum

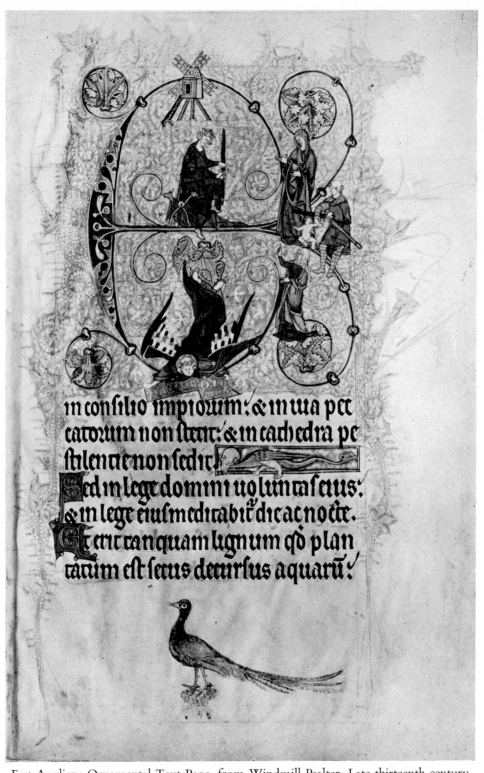

in confilio impiorum: & in uia pec
catorum non ftetit: & in cathedra pe
ftilentie non fedit. Sed in lege domini uoluntas eius:
& in lege eius meditabit dicac nocte.
Et erit tanquam lignum qd plan
tatum est secus decursus aquarū.

East Anglian: Ornamental Text Page, from Windmill Psalter. Late thirteenth century.
12⅝ by 8½ in. *Pierpont Morgan Library, New York*

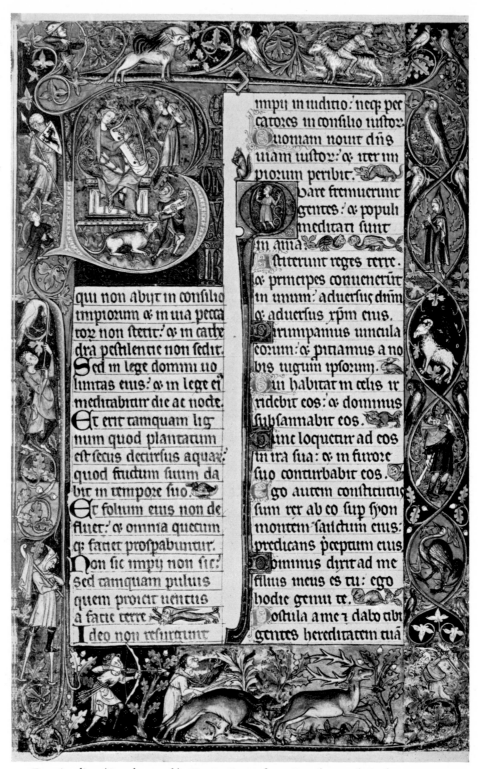

East Anglian (Peterborough): Beatus Page, from Peterborough Psalter. *c.* 1300.
11¾ by 7⅝ in. *Bibliothèque Royale, Brussels*

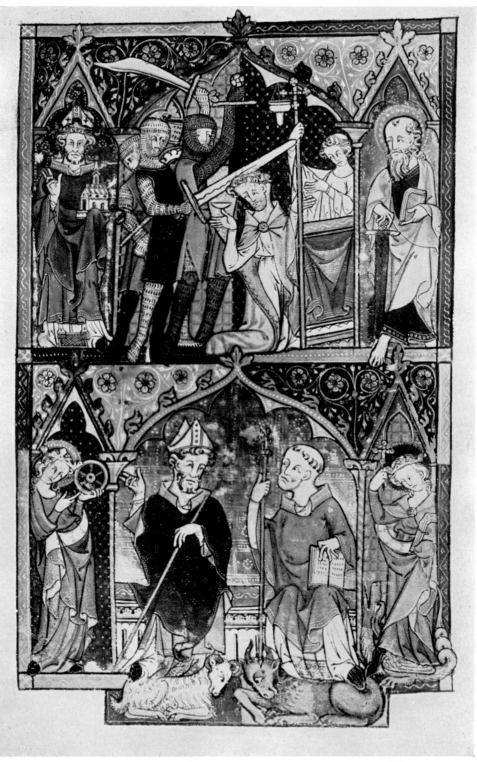

East Anglian (Ramsey Abbey): Martyrdom of St Thomas Becket, Bible Picture from a
Psalter. *c.* 1300. 10 by 6⅜ in. *Pierpont Morgan Library, New York*

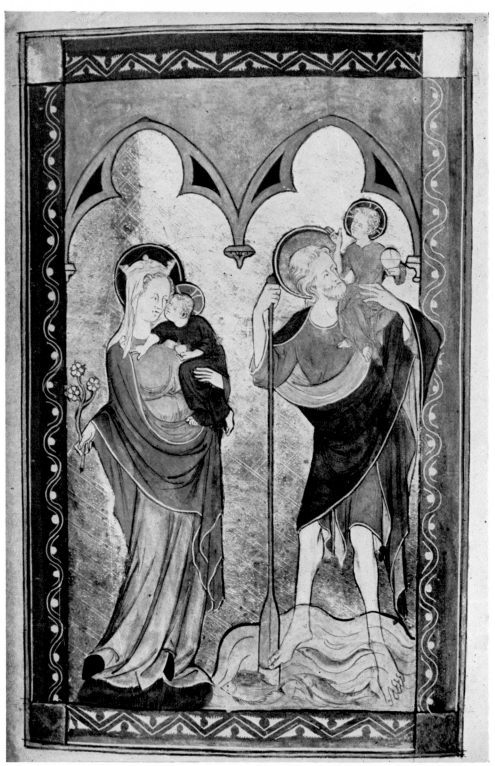

East Anglian (Peterborough or Norwich): Virgin and St Christopher, from Peterborough Psalter. Early fourteenth century. 13⅝ by 9¼ in. *Corpus Christi College, Cambridge*

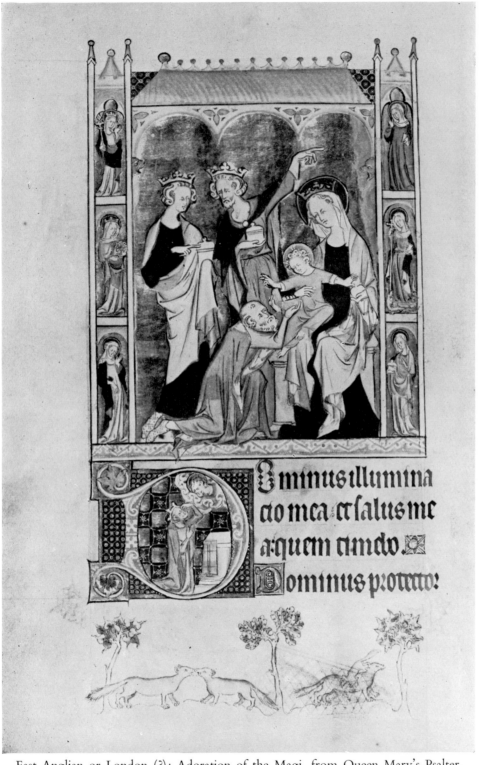

East Anglian or London (?): Adoration of the Magi, from Queen Mary's Psalter.
Early fourteenth century. 10⅞ by 6¾ in. *British Museum*

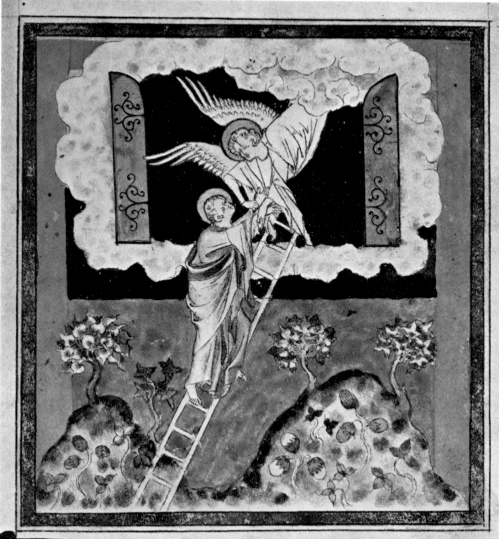

pres ceſt viſt ſeint Johan · Er eſtes vous le ocus ouert du ael ·
⁊ la voice primere qe il oi auſtome buſtne ſiy dit · voimoz
iceâ ioe vous monſtrai les choſes qe vendront viſt apres ceſte vie ⁊
rantoſt fu eu eſprite ·

East Anglian (Artist of Queen Mary's Psalter): St John and the Angel, from Apocalypse.
c. 1320–30. Miniature 5¼ by 5 in. *British Museum*

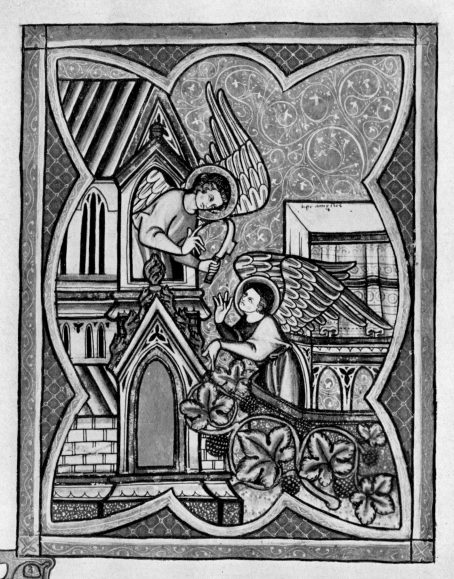

Et aluif angls exunt de templo qd; i celo huf t iix sal
te acuta et aluif angls exit de altan ej habet potestate sup
igne · et clamauit uoce magua ad eu ej habet falce acuta dices
mitte falce tua acuta et uindemia botruf uinee tre qui maruir
fut uue eius·

East Anglian (Gorleston?): Angel with the Sickle, from Apocalypse. Early fourteenth century.
14½ by 8⅛ in. *Trinity College, Dublin*

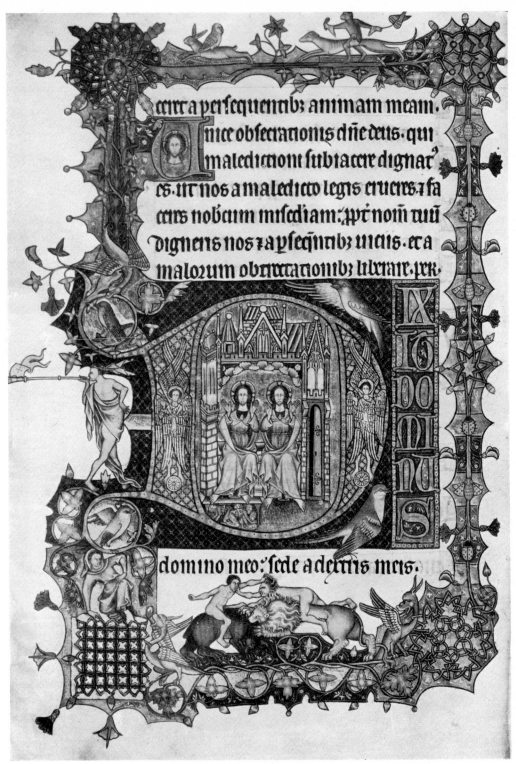

East Anglian (Norwich): Illustration to Psalm CIX, from Ormesby Psalter. *c.* 1310–25.
14⅞ by 10 in. *Bodleian Library, Oxford*

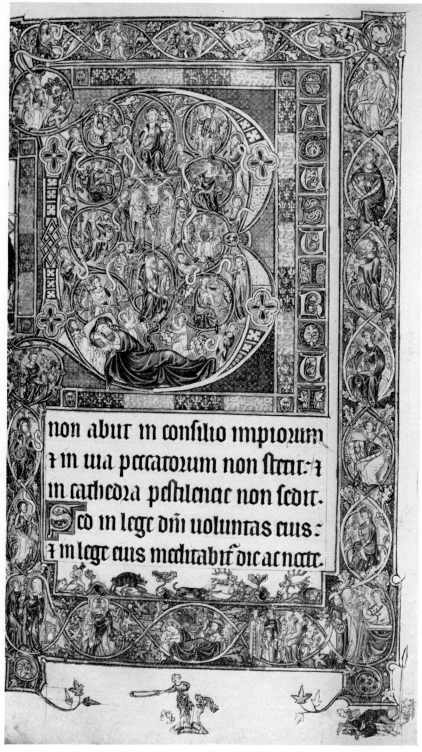

non abiit in confilio impiorum
⁊ in uia peccatorum non ſtetit: ⁊
in cathedra peſtilentie non ſedit.
Sed in lege dñi uoluntas eius:
⁊ in lege eius meditabit die ac nocte.

East Anglian (Gorleston?): *Beatus*, from Psalter. *c.* 1310–25. 14¾ by 9 in.
British Museum

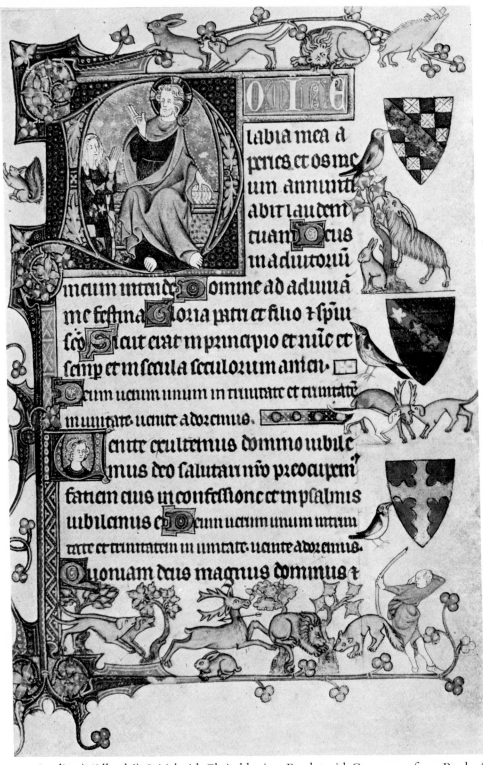

East Anglian (Midlands?): Initial with Christ blessing, Border with Grotesques, from Book of Hours. *c.* 1308. 9½ by 6 in. *Fitzwilliam Museum, Cambridge. Reproduced by permission of the Syndics*

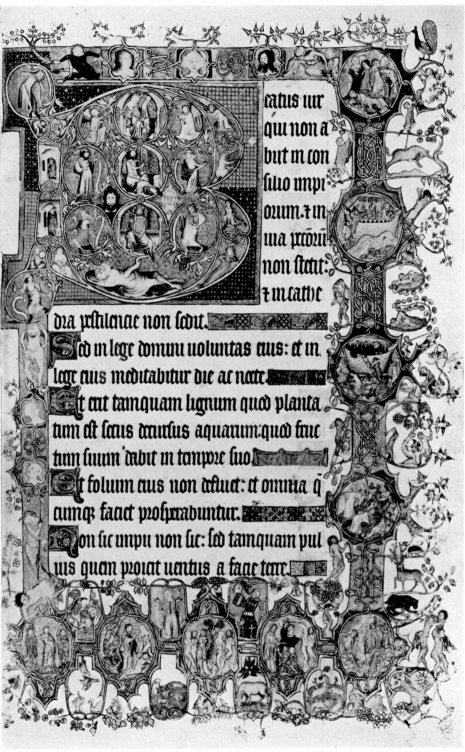

East Anglian: Beatus Page, from St Omer Psalter. *c.* 1330. 13⅛ by 8¼ in.
British Museum

(B) East Anglian: 'The Three Living', from Psalter of Robert de Lisle. Before 1339. Miniature 4⅝ by 3¼ in. *British Museum*

(A) East Anglian: Ascension, from Psalter of Robert de Lisle. Before 1339. Miniature 11 by 7¼ in. *British Museum*

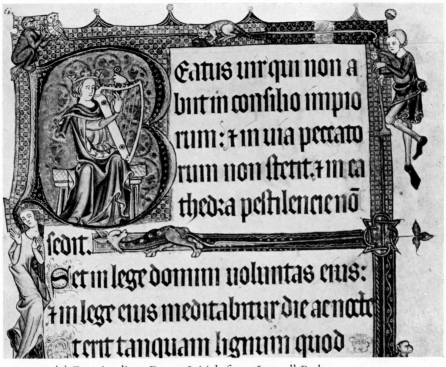

(A) East Anglian: Beatus Initial, from Luttrell Psalter. *c*.1340.
Detail 7⅜ by 9⅝ in. *British Museum*

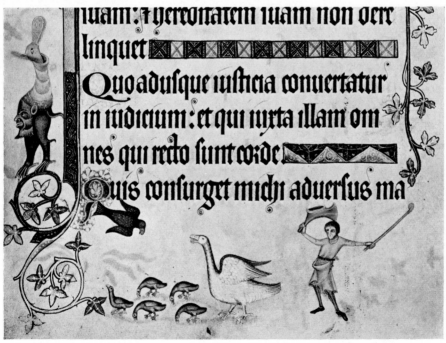

(B) East Anglian: Marginal Scene and Grotesque, from Luttrell Psalter. *c*.1340.
Detail 7 by 9⅝ in. *British Museum*

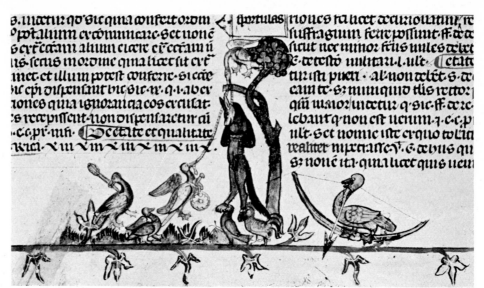

(A) London (St Bartholomew's, Smithfield?): Fox killed by Geese, from Smithfield Decretals. Mid fourteenth century or earlier. Detail 3⅜ by 5¾ in. *British Museum*

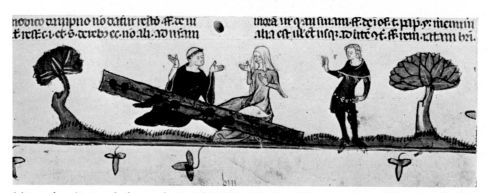

(B) London (St Bartholomew's, Smithfield?): Monk and Lady in Stocks, from Smithfield Decretals. Mid fourteenth century or earlier. Detail 2⅜ by 6⅝ in. *British Museum*

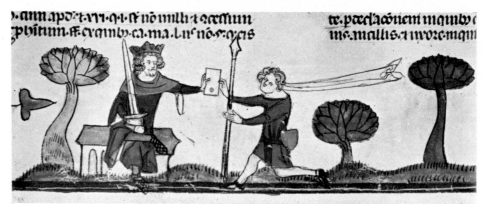

(C) London (St Bartholomew's, Smithfield?): The King's Messenger, from Smithfield Decretals. Mid fourteenth century or earlier. Detail 2¼ by 5⅝ in. *British Museum*

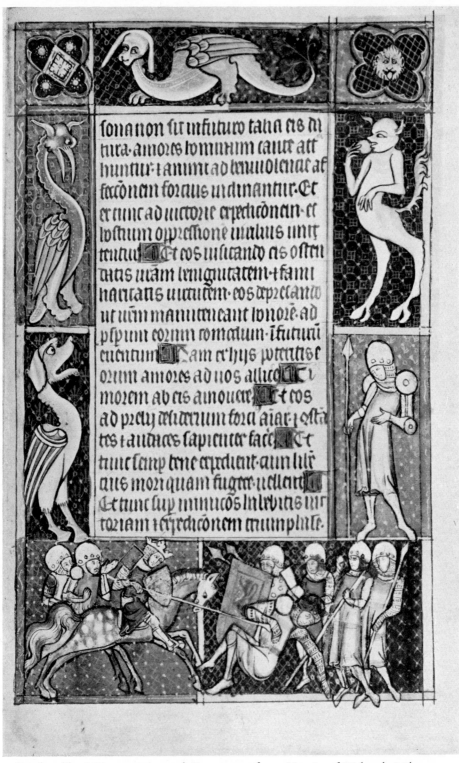

London (?): A Tournament and Grotesques, from *Treatise of Walter de Milemete*.
c. 1326–7. 9⅝ by 6¼ in. *Christ Church Library, Oxford*

137

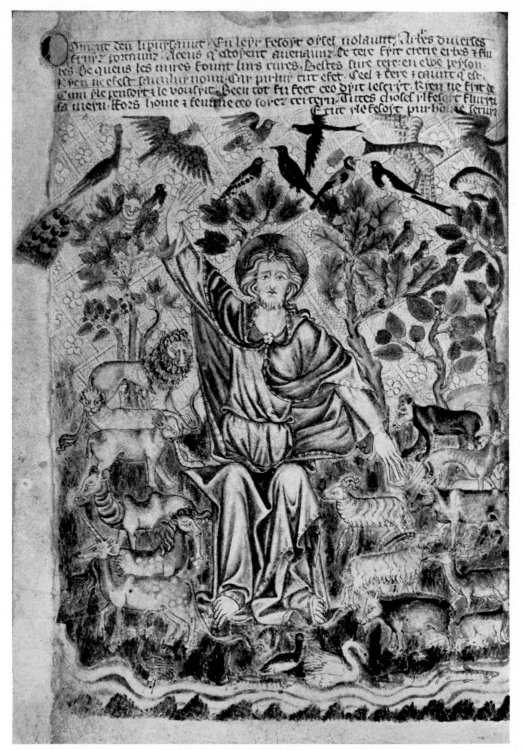

East Anglian (?): Creation of the Birds and Animals, from Holkham Bible Picture Book.
Fourteenth century (first half). 11¼ by 8¼ in. *British Museum*

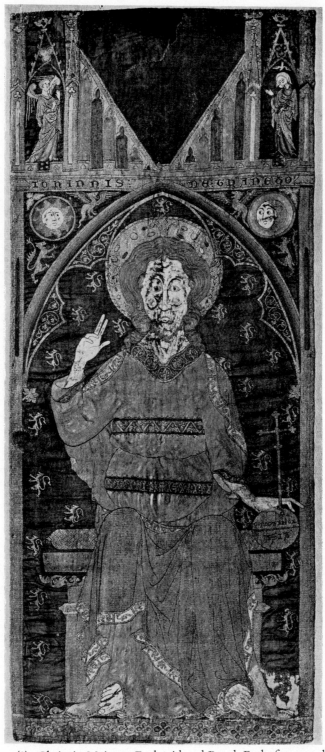

Canterbury (?): Christ in Majesty. Embroidered Panel. Early fourteenth century.
3 ft 3½ in. by 16½ in. *Victoria and Albert Museum, London*

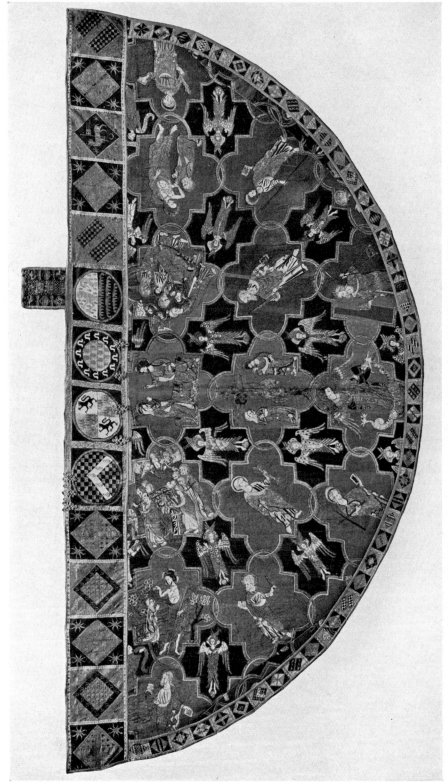

Unknown: The Syon Cope. *c.* 1300. 9 ft 8 in. by 4 ft 10 in. *Victoria and Albert Museum, London*

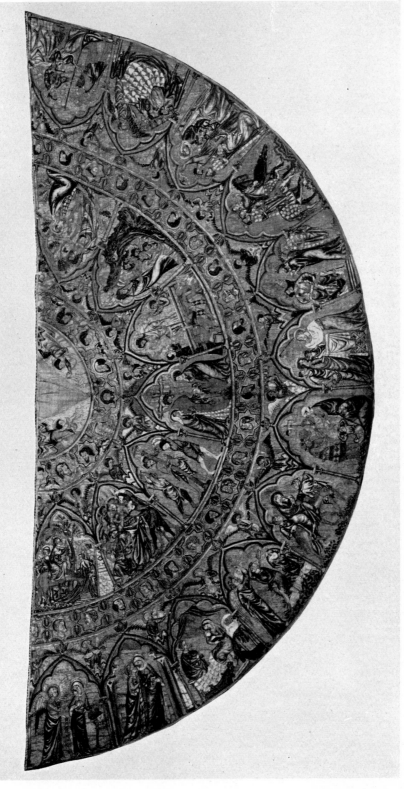

Unknown: Embroidered Cope. Early fourteenth century. 10 ft 7 in by 4 ft 10 in. *Museo Civico, Bologna*

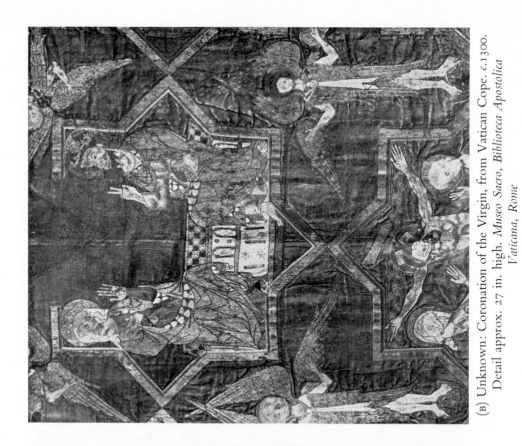

(B) Unknown: Coronation of the Virgin, from Vatican Cope. *c*.1300.
Detail approx. 27 in. high. *Museo Sacro, Biblioteca Apostolia
Vaticana, Rome*

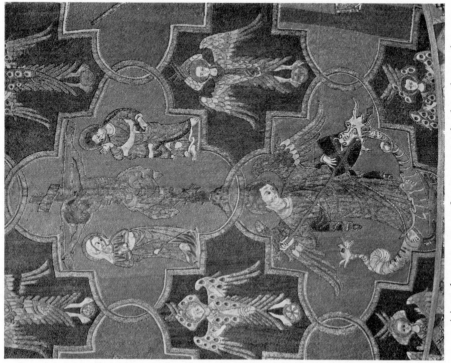

(A) Unknown: Crucifixion, St Michael, and Angels,
from Syon Cope. *c*.1300. Detail approx. 2 ft high.
Victoria and Albert Museum, London

Unknown: Scenes from the Life of the Virgin, from Embroidered Altar Dorsal. Fourteenth century (first quarter). Detail approx. $10\frac{1}{2}$ by 13 in. *Victoria and Albert Museum, London*

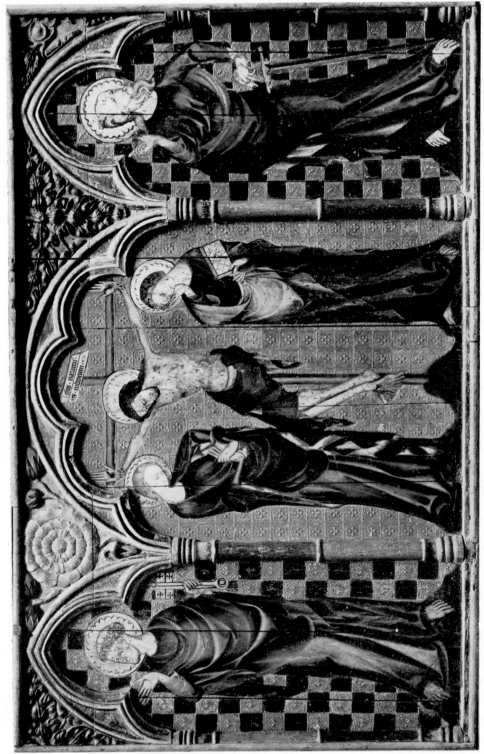

East Anglian (?): Crucifixion with Peter and Paul, Centre Panels of Painted Retable. Early fourteenth century. Detail 4 ft 6 in. by 3 ft. *Thornham Parva Church, Suffolk*

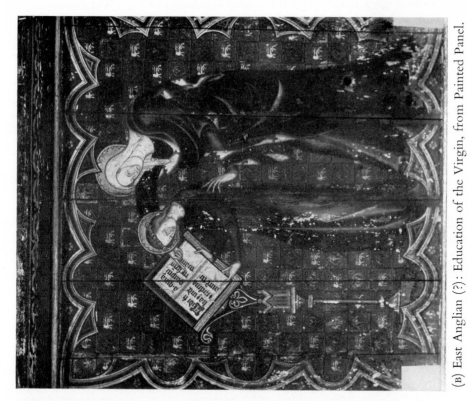

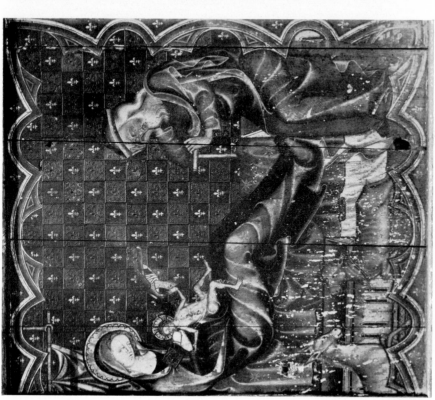

(A) East Anglian (?): Nativity of Christ, from Painted Panel. *c.* 1325–30. Detail approx. 3 ft square. *Musée de Cluny, Paris*

(B) East Anglian (?): Education of the Virgin, from Painted Panel. *c.* 1325–30. Detail approx. 3 ft square. *Musée de Cluny, Paris*

145

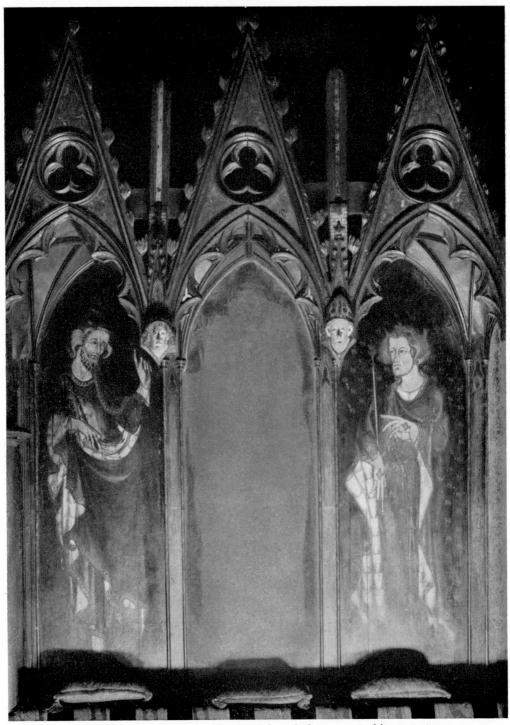

Court School (Master Thomas?): Two Unidentified Kings, Sedilia Paintings. *c*.1308.
Each panel 9 ft by 2 ft 8 in. *South Side of Choir, Westminster Abbey, London*

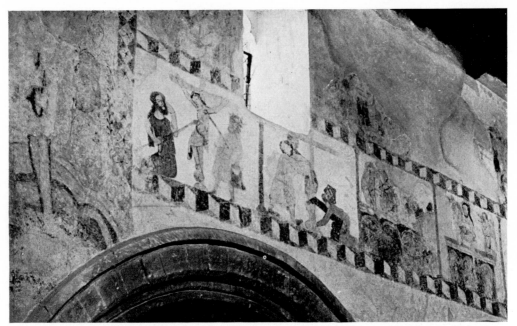

(A) Influence of Peterborough (?): Scenes from the Passion, Wall Paintings. Fourteenth century (second quarter). Approx. 22 ft long. *North Wall of Nave, Peakirk*

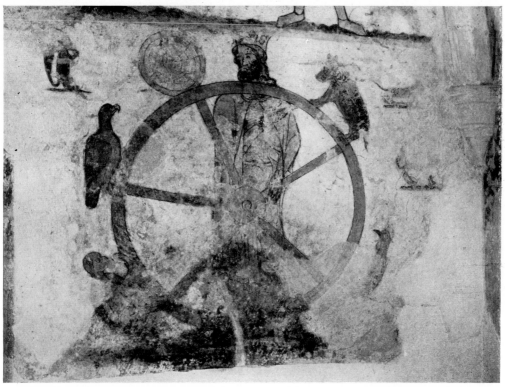

(B) Influence of Peterborough (?): Wheel of the Five Senses, from Wall Paintings. Fourteenth century (second quarter). Detail approx. 6 ft high. *East Wall, Tower, Longthorpe Manor*

York School: Peter de Dene Stained Glass Window. *c.* 1310. Detail approx. 16 by 10 ft.
North Aisle, York Minster

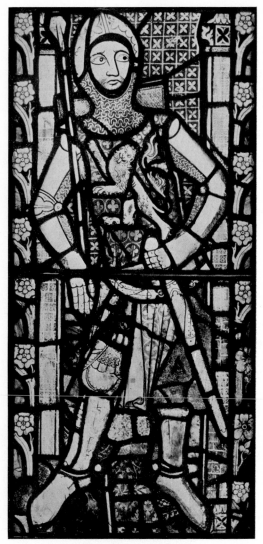

(A) Unknown:
St Peter, from Great East Window.
*c.*1349. Detail approx. 9 by 3 ft.
East Wall, Choir, Gloucester Cathedral

(B) Unknown:
Knight, from Clerestory Window.
*c.*1344. Detail approx. 4 ft high.
Choir, Tewkesbury Abbey

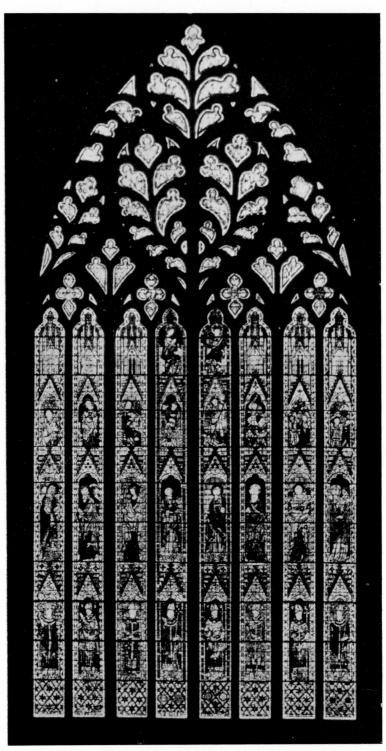

York School: Coronation of the Virgin, and other Subjects,
Stained Glass Window. *c.* 1338.
54 ft 3 in. by 25 ft 3 in. *West Wall, Nave, York Minster*

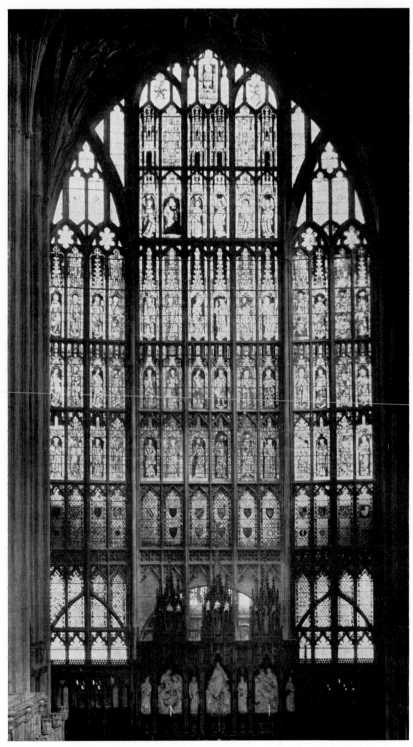

Unknown: Coronation of the Virgin, and other Subjects,
Great East Window. *c.* 1349.
78 by 38 ft. *East Wall, Choir, Gloucester Cathedral*

151

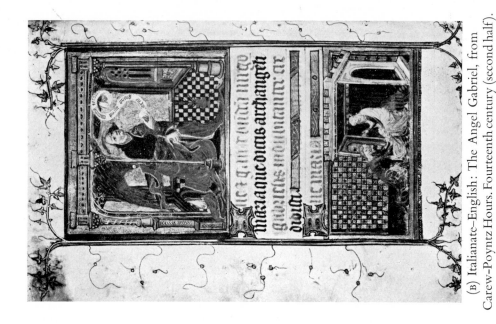

(A) Italianate–English: Creation, from Psalter. Fourteenth century (second half). 8⅜ by 4⅞ in. *Biblioteca Apostolica Vaticana, Rome*

(B) Italianate–English: The Angel Gabriel, from Carew–Poyntz Hours. Fourteenth century (second half). 7⅛ by 4⅝ in. *Fitzwilliam Museum, Cambridge. Reproduced by permission of the Syndics*

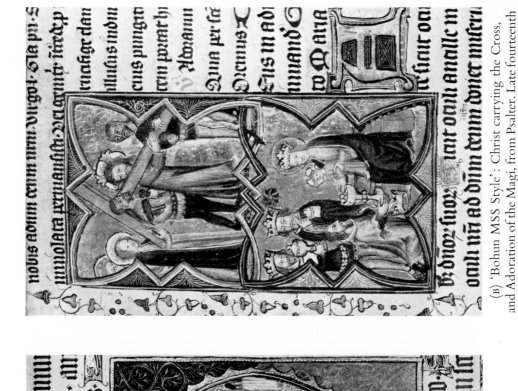

(A) 'Bohun MSS Style': Scenes from the Life of Christ, from a Bohun Psalter. *c.* 1370–80. Initial 4⅛ by 5¼ in. *British Museum*

(B) 'Bohun MSS Style': Christ carrying the Cross, and Adoration of the Magi, from Psalter. Late fourteenth century. Miniature 4⅞ by 2½ in. *British Museum*

(A) Italianate–English: Scenes from the Passion, from the
M. R. James Memorial Psalter. Late fourteenth century.
Miniature 4⅜ in. square. *British Museum*

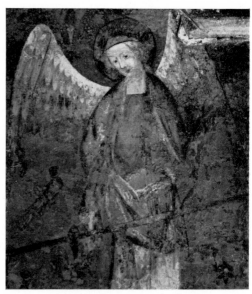

(B) Italianate–English: Head.
Detail of Wall Painting, from St Stephen's
Chapel. Fourteenth century (third quarter).
Head 2⅝ in. high. *British Museum*

(C) Court Style: St Michael.
Detail of Wall Painting. Fourteenth century
(last quarter). Wing spread 2 ft 6 in.
Byward Tower, Tower of London

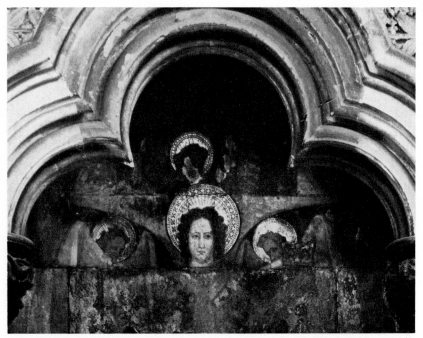

(A) Court School: Seraph from Last Judgement, Wall Painting.
Fourteenth century (third quarter). Detail approx. 4 ft wide.
Chapter House, Westminster Abbey, London

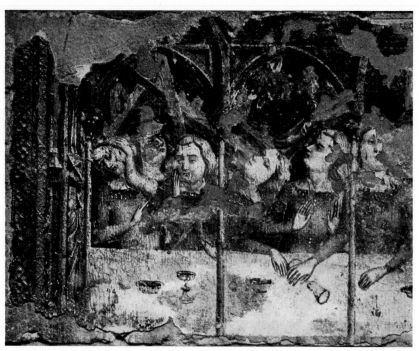

(B) Italianate–English: Story of Job, Wall Painting, from St Stephen's Chapel,
Westminster. Fourteenth century (third quarter).
Detail approx. 10¾ by 12¼ in. *King Edward VII Gallery, British Museum*

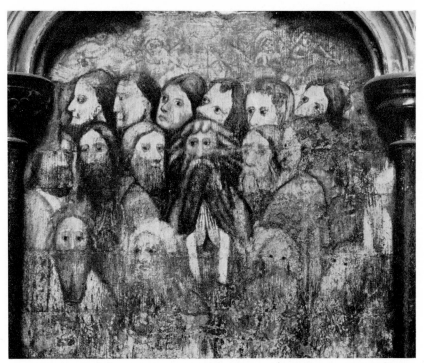

(A) Siferwas School (?): Group of Men from Last Judgement, Wall Painting.
Late fourteenth century. Detail approx. 4 ft square.
Chapter House, Westminster Abbey, London

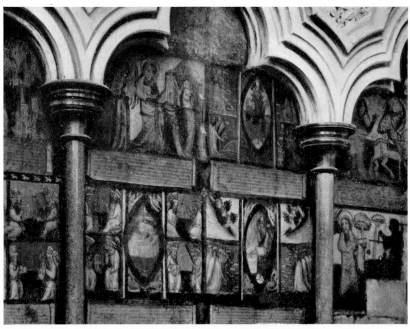

(B) Meister Bertram School (?): Apocalypse, Wall Painting. Before 1400.
Panels approx. 4 ft square. *Chapter House, Westminster Abbey, London*

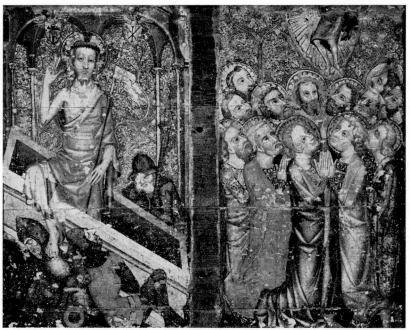

(A) East Anglian (?): Resurrection and Ascension, from Painted Retable.
Late fourteenth century. Detail approx. 2 ft 10½ in. by 3 ft 5 in.
Chapel of St Luke, Norwich Cathedral

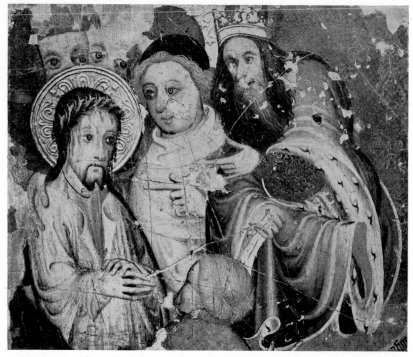

(B) East Anglian (?): Christ before Pilate, fragment from Painted Panel.
Late fourteenth century. Detail 12¾ by 11 in. *Fitzwilliam Museum, Cambridge.*
Reproduced by permission of the Syndics

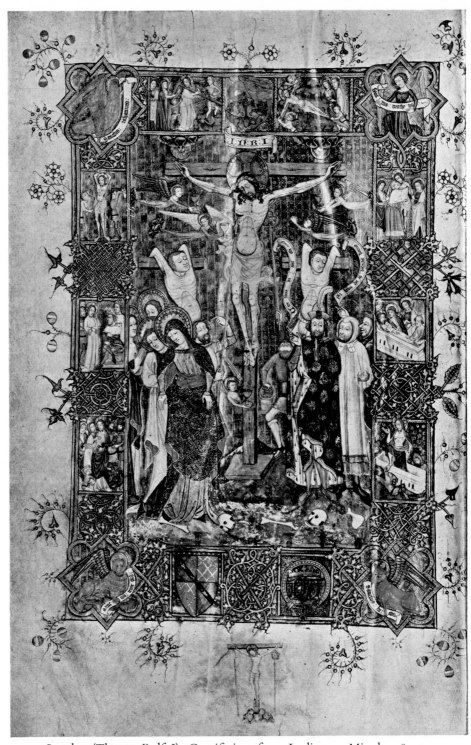

London (Thomas Rolfe?): Crucifixion, from Lytlington Missal. 1383–4.
20¾ by 14½ in. *Westminster Abbey Library, London*

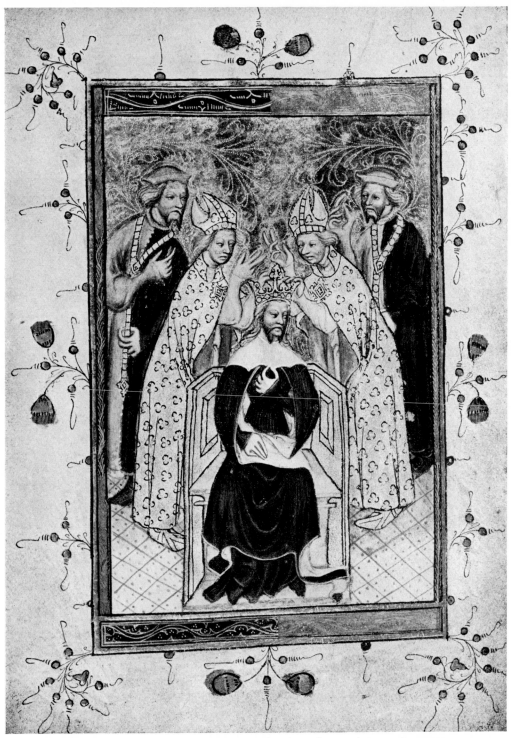

London (Westminster?): Coronation of a King, from *Liber Regalis. c.*1382.
10½ by 7 in. *Westminster Abbey Library, London*

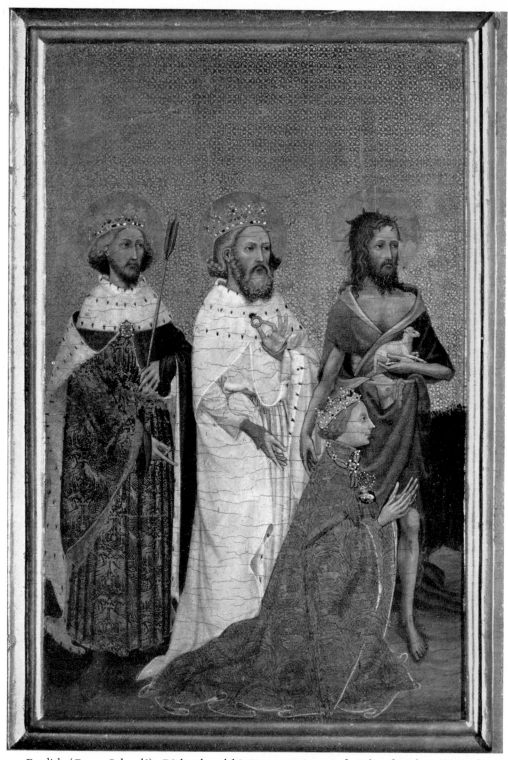

English (Court School?): Richard and his Patron Saints, Left Side of Wilton Diptych. 1380–95 (?). 14½ by 10½ in. *National Gallery, London*

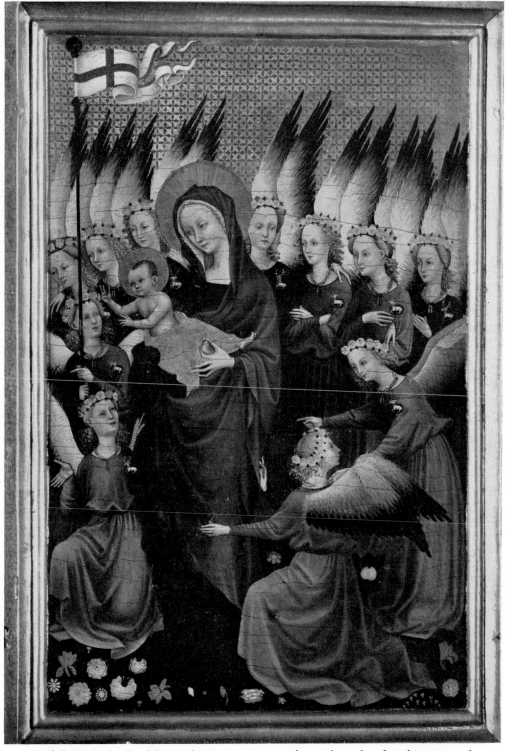

English (Court School?): Madonna among Angels, Right Side of Wilton Diptych.
1380–95 (?). 14½ by 10½ in. *National Gallery, London*

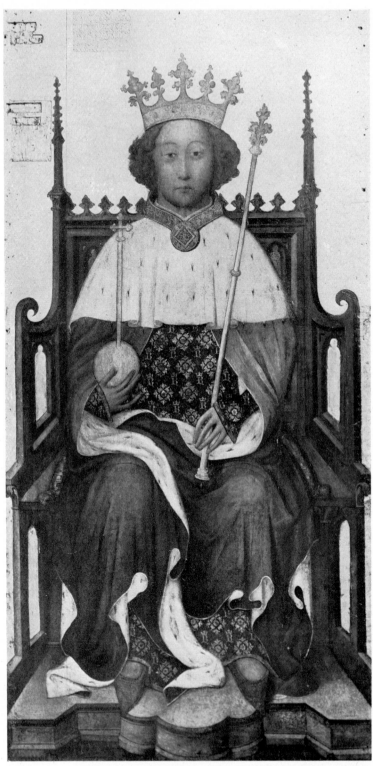

Unknown: Portrait of King Richard II. Fourteenth century (last decade). 7 ft by 3 ft 7 in. *South Side of Nave, Westminster Abbey, London*

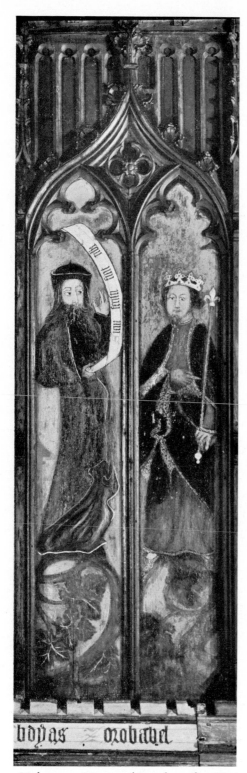
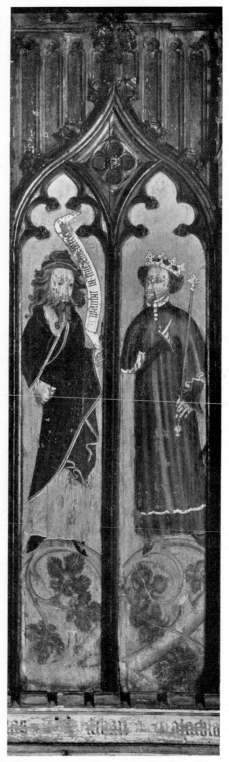

Unknown: Kings and Prophets, from Painted Ceiling. Fourteenth century (last decade).
Single figures approx. 4 ft 9 in. high. *Lady Chapel, St Helen's Church, Abingdon*

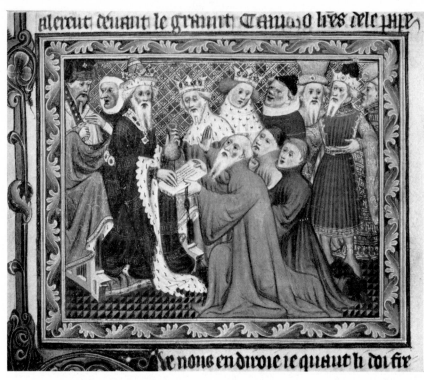

(A) 'Johannes': The Grand Khan, from Marco Polo, *Li Livres du Graunt Caam*.
c. 1400. Miniature 4¼ by 3½ in. *Bodleian Library, Oxford*

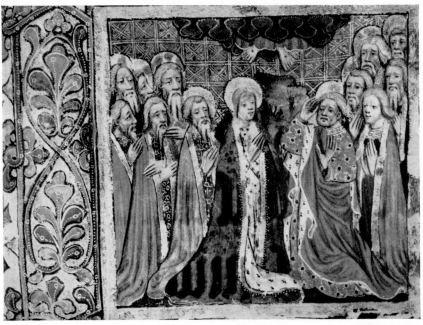

(B) Johannes Siferwas: Ascension, from Lovell Lectionary. Before 1408.
Miniature 3½ by 4 in. *British Museum*

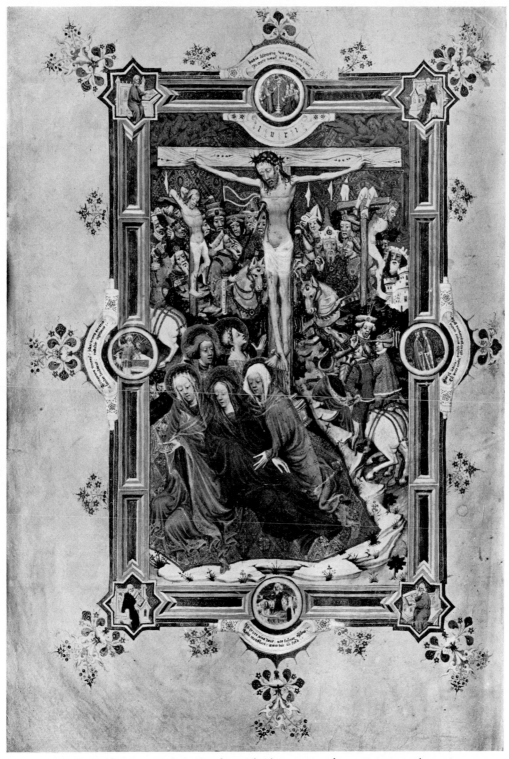

Johannes Siferwas: Crucifixion, from Sherborne Missal. 1396–1407. 21 by 15 in.
Duke of Northumberland, Alnwick Castle

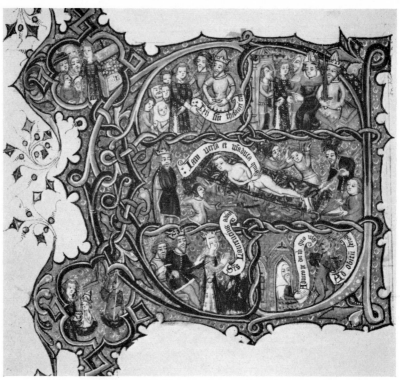

(A) London (Whitefriars?): St Lawrence, from Carmelite Missal. 1393–8. Initial 3½ in. square. *British Museum*

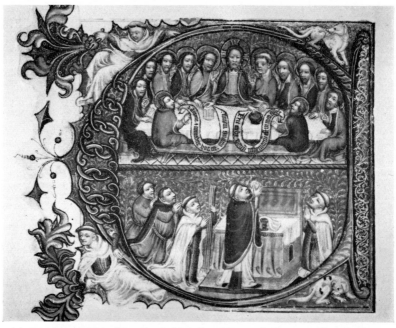

(B) London (Whitefriars?): Initial for Mass of Corpus Christi, from Carmelite Missal. 1393–8. Initial 4½ in. square. *British Museum*

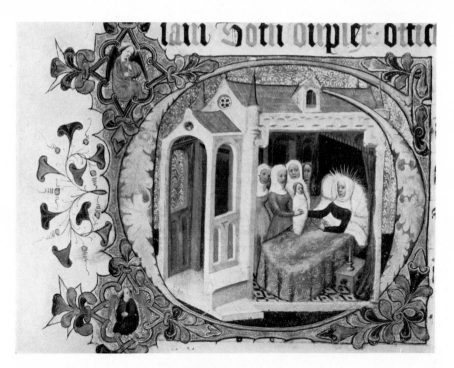

(A)
London (Whitefriars?):
Birth of the Virgin, from
Carmelite Missal.
1393–8. Initial 4½ in.
square. *British Museum*

(B)
London (Whitefriars?):
Presentation of Christ
in the Temple, from
Carmelite Missal.
1393–8. Initial 4½ in.
square. *British Museum*

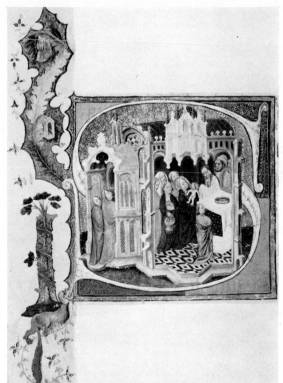

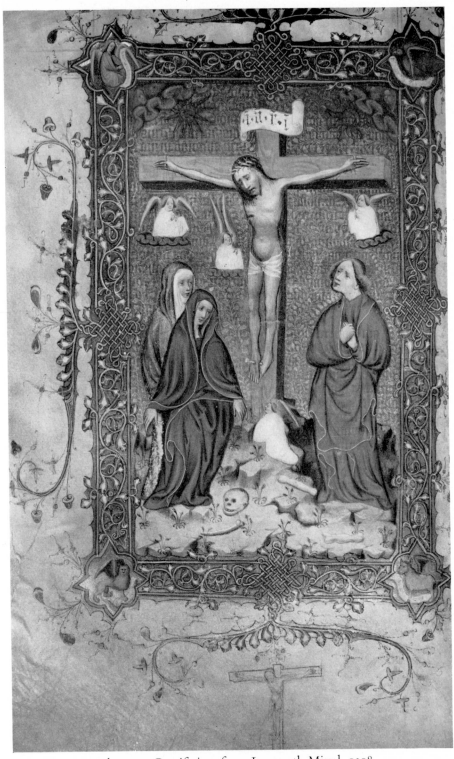

Unknown: Crucifixion, from Lapworth Missal. 1398.
16¾ by 10¾ in. *Corpus Christi College, Oxford*

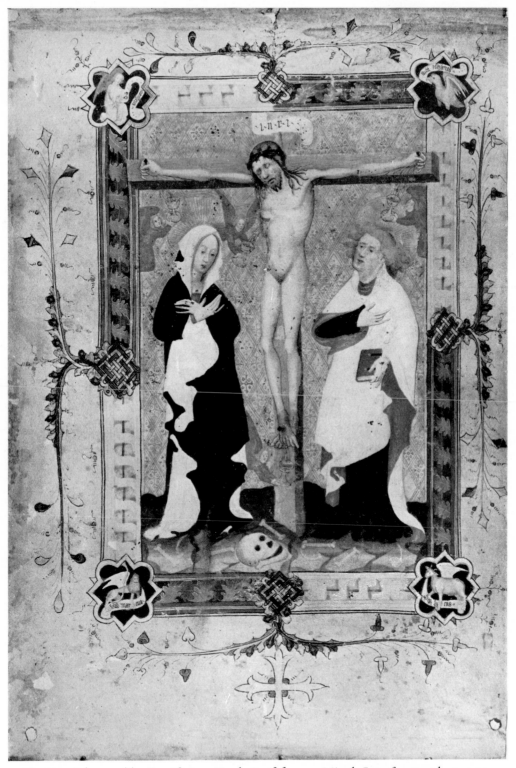

Herman Scheerre (?): Crucifixion, Single Leaf from a Missal. Late fourteenth century.
14¾ by 10¼ in. *A. Wyndham Payne, Sidmouth, Devon*

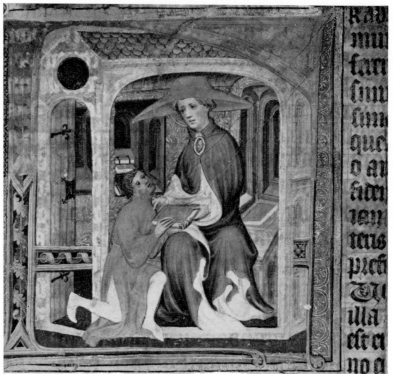

(A) Herman Scheerre (?): St Jerome, from Bible. *c.* 1410. Initial 4 in. square.
British Museum

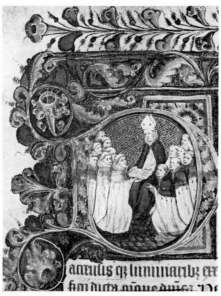

(B) Herman Scheerre: Archbishop and Clerics, from Chichele Breviary. Before 1416. Miniature 2 in. square. *Lambeth Palace Library, London*

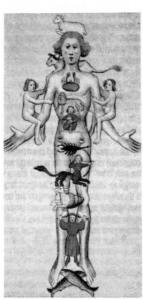

(c) Herman Scheerre (?): 'Zodiac Man', from Calendar of Nicholas of Lynn. Late fourteenth century. 4½ by 2⅜ in. *Bibliothèque Royale, Brussels*

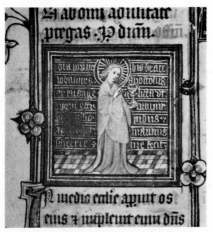

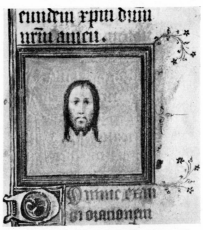

(A) Herman Scheerre (signed): St John the Evangelist, from Book of Offices. Early fifteenth century. Miniature 1½ in. square. *British Museum*

(B) Herman Scheerre: The Vernicle, from Book of Offices. Early fifteenth century. Miniature 1½ in. square. *British Museum*

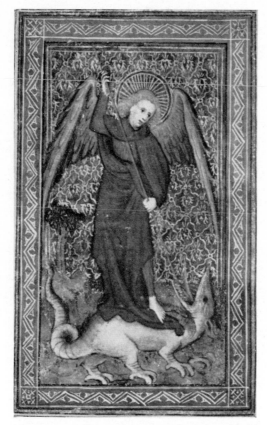

(C) Herman Scheerre (?): St Michael, from Book of Hours. 1405–13. 5⅞ by 4⅞ in. *Bodleian Library, Oxford*

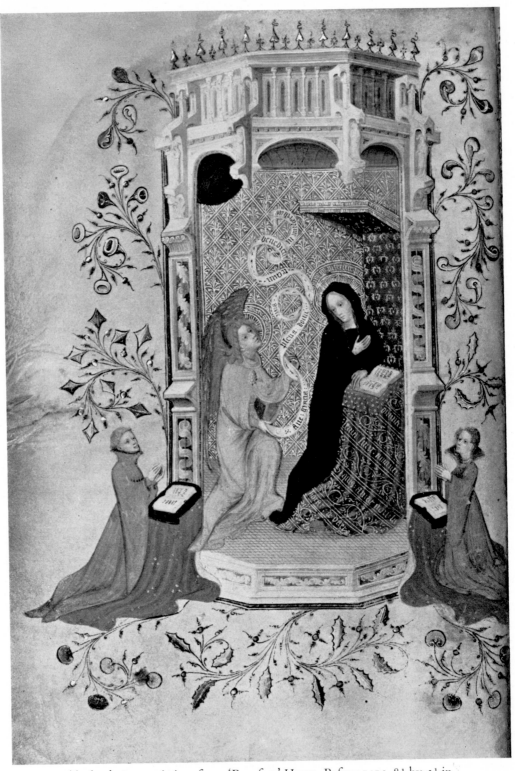

'de daer': Annunciation, from 'Beaufort' Hours. Before 1415. 8¼ by 5¼ in.
British Museum

172

Herman Scheerre (?): *Beatus*, from Psalter. Before 1415. 8½ by 6 in.
Bibliothèque Municipale, Rennes

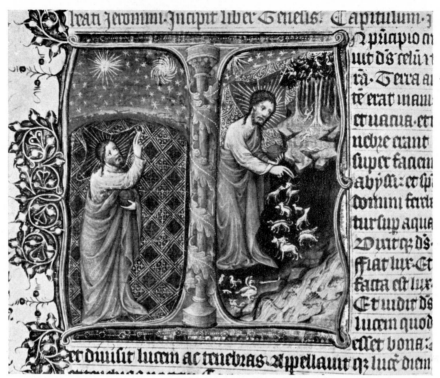

(A) Associate of Herman Scheerre: Creation of the Animals, from Bible. *c.* 1410.
Initial approx. 3½ in. square. *British Museum*

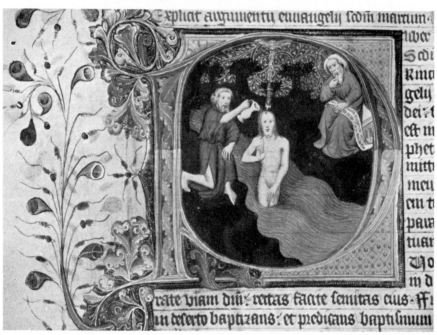

(B) Herman Scheerre (?): Baptism of Christ, from Bible. *c.* 1410. Initial approx.
4 in. square. *British Museum*

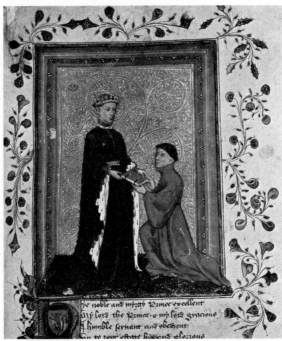

(A) Unknown Follower of Herman Scheerre:
Prince Henry and Hoccleve, from Hoccleve,
De Regimine Principum. Before 1413.
Detail 5⅜ by 4 in. *British Museum*

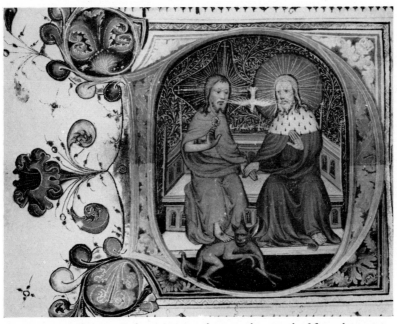

(B) Herman Scheerre Atelier: Trinity, from Psalter. Early fifteenth century.
Miniature 4⅜ by 4 in. square. *Biblioteca Nazionale, Turin*

175

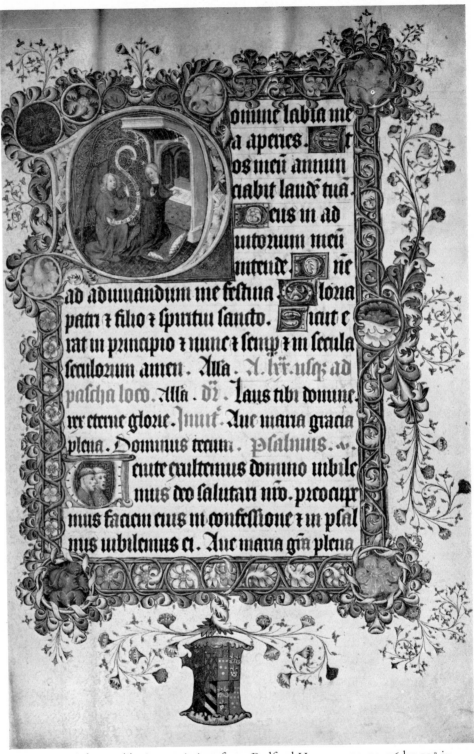

Herman Scheerre (?): Annunciation, from Bedford Hours. 1414–35. 16 by 10¾ in.
British Museum

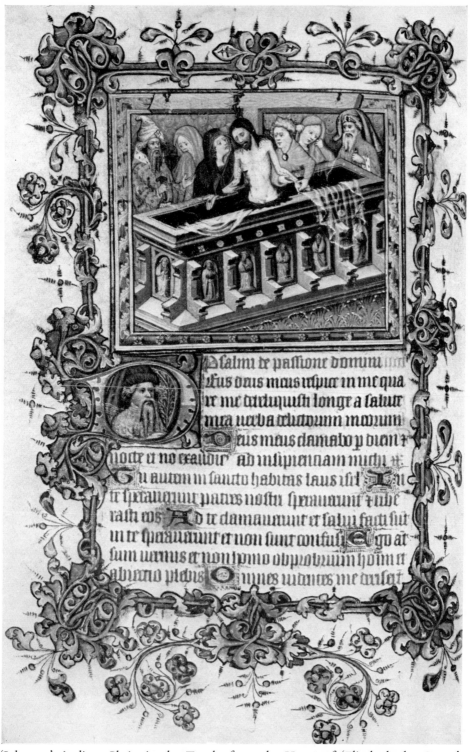

'Johannes' Atelier: Christ in the Tomb, from the Hours of 'Elizabeth the Quene'.
Fifteenth century (first quarter). 8½ by 6 in. *British Museum*

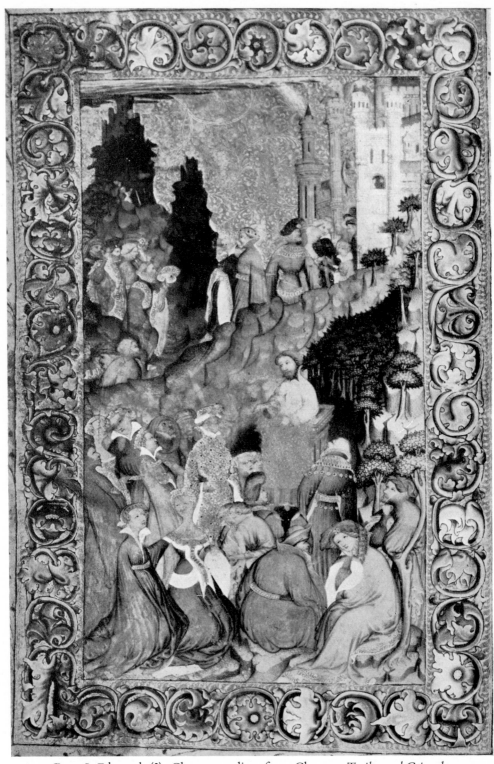

Bury St Edmunds (?): Chaucer reading, from Chaucer, *Troilus and Criseyde*.
Early fifteenth century. 12½ by 8⅝ in. *Corpus Christi College, Cambridge*

178

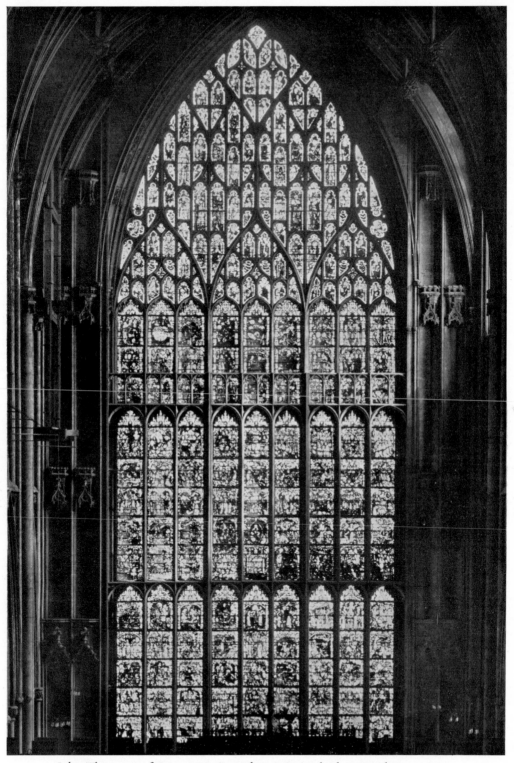

John Thornton of Coventry: Apocalypse, Stained Glass Window. 1405–8.
72 by 31 ft. *East Wall, Choir, York Minster*

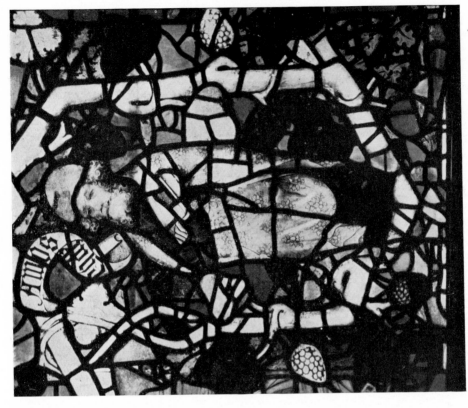

(B) Master Thomas of Oxford: Prophet Amos, from Jesse Window. 1380–6. Detail approx. 3 ft by 2 ft. *South Aisle, Choir, York Minster. Formerly in Antechapel, New College, Oxford*

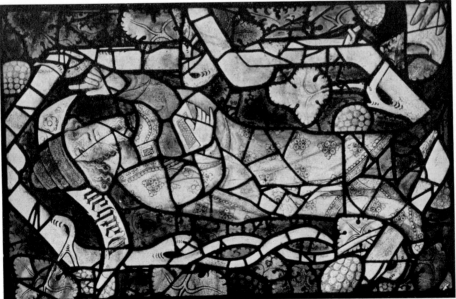

(A) Master Thomas (signed) of Oxford: Prophet Nathan, and Fragments including Hand of Jesse, from Jesse Window. *c.* 1393. Detail 3 ft 2 in. by 2 ft 1 in. *West Window, Thurbern's Chantry, Winchester College Chapel*

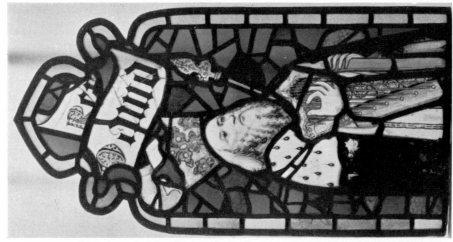
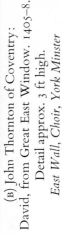

(B) John Thornton of Coventry:
David, from Great East Window. 1405–8.
Detail approx. 3 ft high.
East Wall, Choir, York Minster

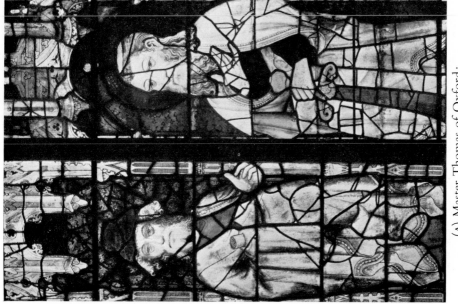

(A) Master Thomas of Oxford:
Prophet Zephaniah and St James, Stained Glass Panels
from Winchester College Chapel, Clerestory. c. 1400.
Each panel approx. 5 ft 9 in. by 1 ft 9 in.
Victoria and Albert Museum, London

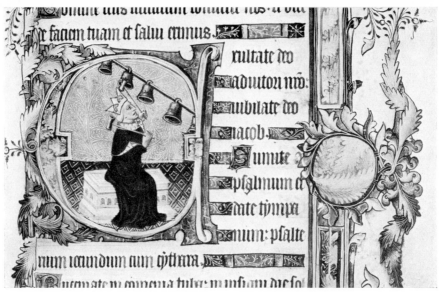

(A) Unknown: David Playing Bells, from St Omer Psalter. Fifteenth century (second quarter). Initial 3⅝ by 3¾ in. *British Museum*

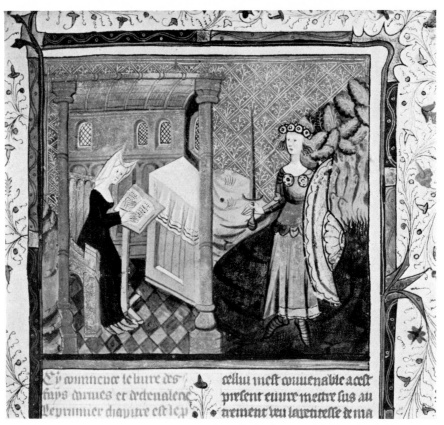

(B) London (?): The Author Writing, from Christine de Pisan, *Le Livre des fays d'armes*. Dated 1434. Miniature 4⅜ by 5¼ in. *British Museum*

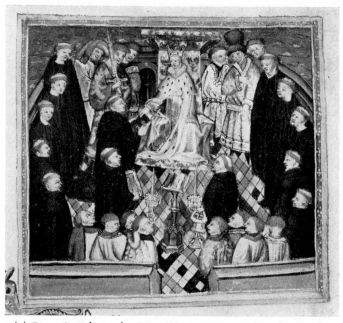

(A) Bury St Edmunds: King Henry VI receiving the Book,
from Lydgate, *Life of St Edmund*. 1433–4
Miniature 4 by 4⅜ in. *British Museum*

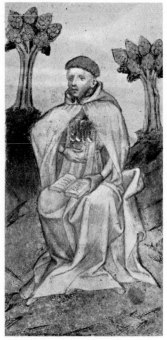

(B) Unknown: Richard the Hermit,
from *Desert of Religion*.
Fifteenth century (second quarter).
Detail 6½ by 3¾ in. *British Museum*

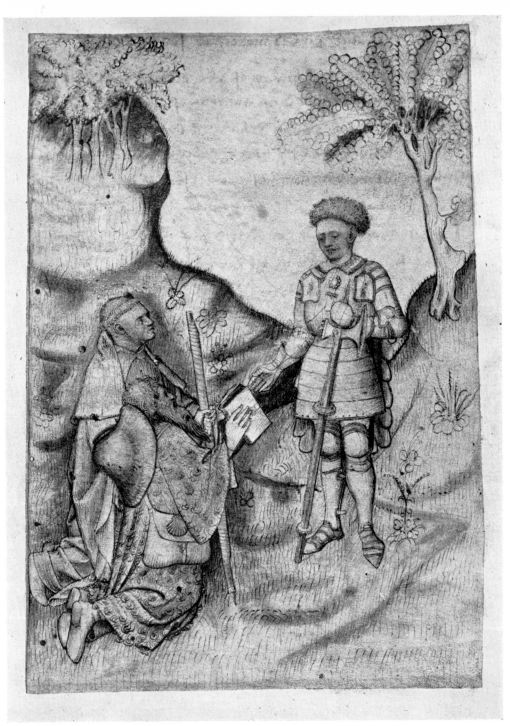

Bury St Edmunds (?): The Earl of Salisbury receiving the Book, from Lydgate, *The Pilgrim*.
Mid fifteenth century. Miniature 7⅛ by 5 in. *British Museum*

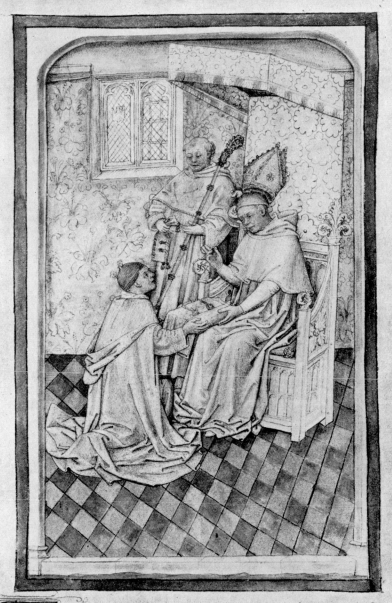

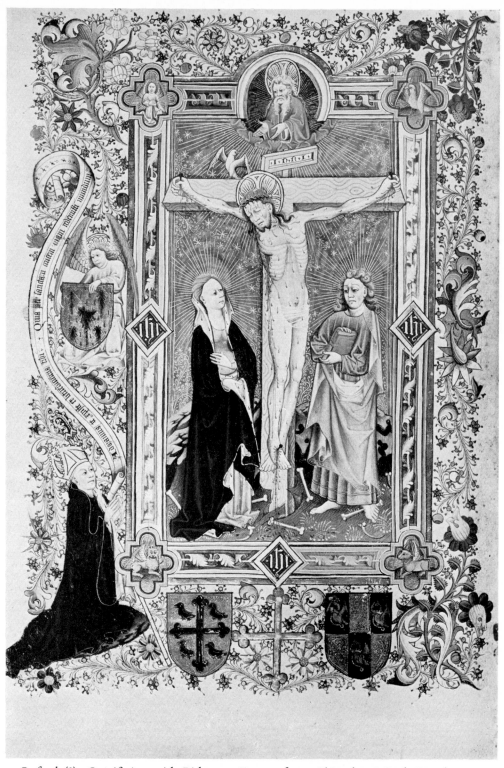

Oxford (?): Crucifixion with Bishop as Donor, from Abingdon Missal. Dated 1461.
14⅛ by 9½ in. *Bodleian Library, Oxford*

186

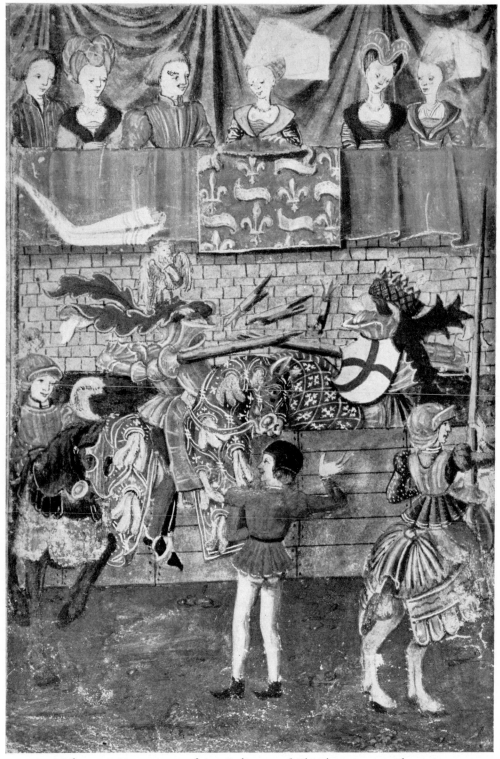

Unknown: Tournament, from *Ordinances of Chivalry*. *c.* 1470. 9⅝ by 6⅝ in.
Pierpont Morgan Library, New York

Ely (?): Life of St Etheldreda, Painted Panels. *c.*1425. Each panel 3 ft 10½ in. by 1 ft 9 in.
Society of Antiquaries, London

East Anglian: St Leonard and Female Saint, from Painted Screen,
formerly in St John Maddermarket, Norwich. 1451. 3 ft 4 in. by 2 ft 5½ in.
Victoria and Albert Museum, London

East Anglian: Two of the Nine Orders of Angels, from Painted Screen. After 1480.
Each panel approx. 2 ft 3½ in. by 7 in. *Barton Turf Church, Norfolk*

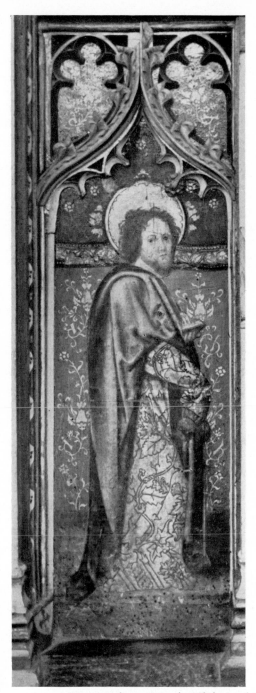
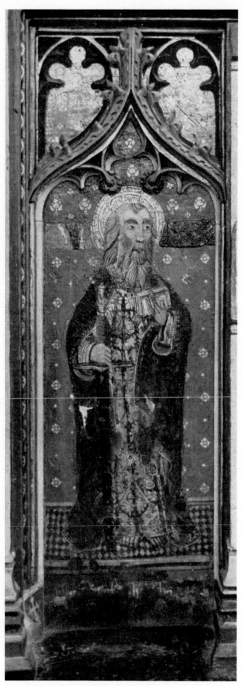

East Anglian: Apostles Philip and Paul, from Painted Screen. 1490–1510.
Each panel approx. 1 ft 7¾ in. by 5¾ in. *Cawston Church, Norfolk*

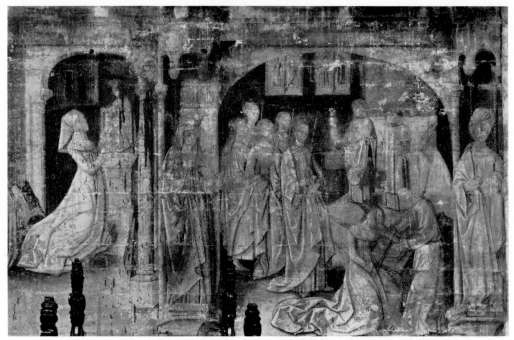

(A) William Baker (in part): Miracle of the Candle, from Wall Painting. 1479–88.
Detail 4 ft 10 in. by 6 ft 4 in. *North Wall, Eton College Chapel (Copyright Country Life)*

(B) William Baker (in part): Healing of the Knight's Brother,
Wall Painting. 1479–88. Detail approx. 4 ft 10 in. by 3 ft.
South Wall, Eton College Chapel (Copyright Country Life)

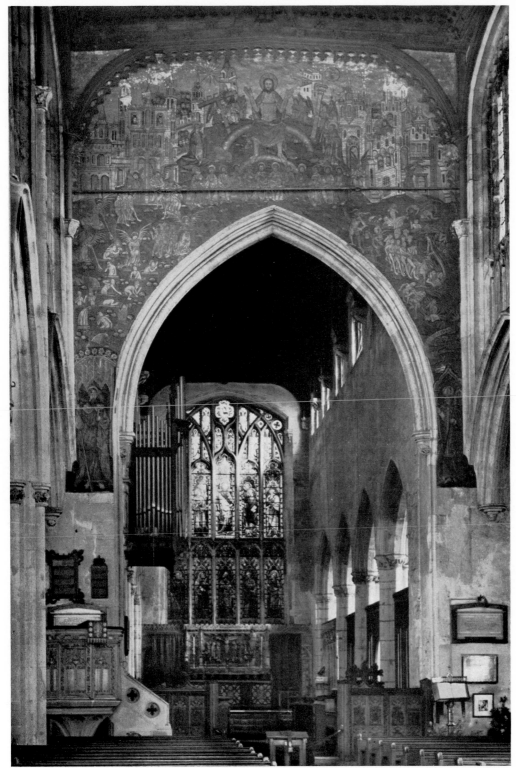

Unknown: Doom, Wall Painting. *c.* 1500. Approx. 22 ft wide. *Chancel Arch, St Thomas, Salisbury*

193

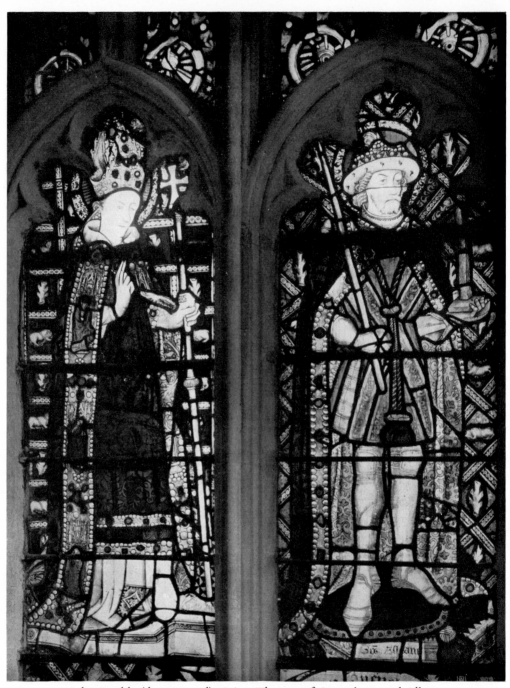

John Prudde (documented): Saints Thomas of Canterbury and Alban,
from Stained Glass Window. 1447–50. Each panel 4 ft 5 in. by 1 ft 8½ in.
East Window, Beauchamp Chapel, St Mary's Church, Warwick

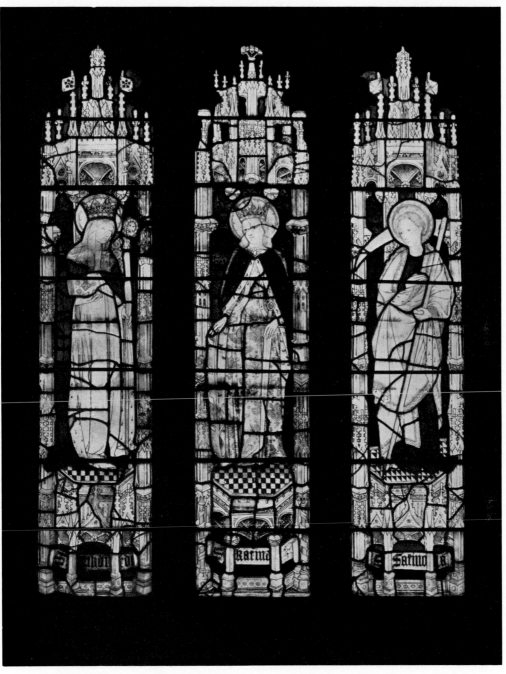

'John Glazier': Saints Etheldreda, Catherine, and Sativola, from Stained Glass Window.
1440–50. Each light 6 ft 9½ in. by 1 ft 3½ in.
South Window, East Wall, Antechapel, All Souls College, Oxford

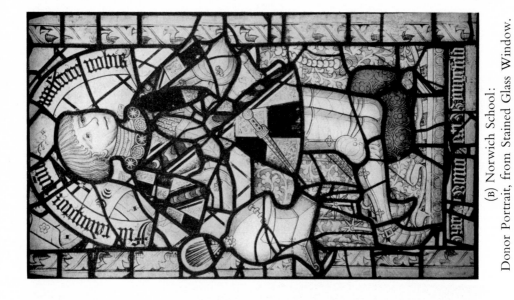

(B) Norwich School:
Donor Portrait, from Stained Glass Window.
Late fifteenth century. 2 ft 7 in. by 1 ft 6 in.
East Window, East Harling Church, Norfolk

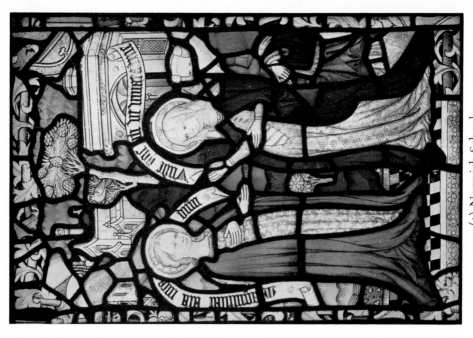

(A) Norwich School:
Visitation, from Stained Glass Window. *c.* 1440.
Detail 2 ft 6 in. by 1 ft 8 in.
East Window, St Peter Mancroft, Norwich

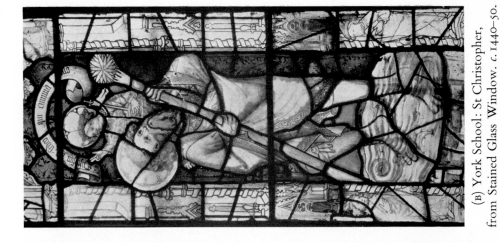

(B) York School: St Christopher,
from Stained Glass Window. *c.* 1440–50.
4 ft 6 in. by 1 ft 10 in. *East Window,*
All Saints in North Street, York

(A) York School: Miracle of St William,
from St William Window. *c.* 1421.
Detail 2 ft 2 in. by 1 ft 6 in.
North Choir Transept, York Minster

197

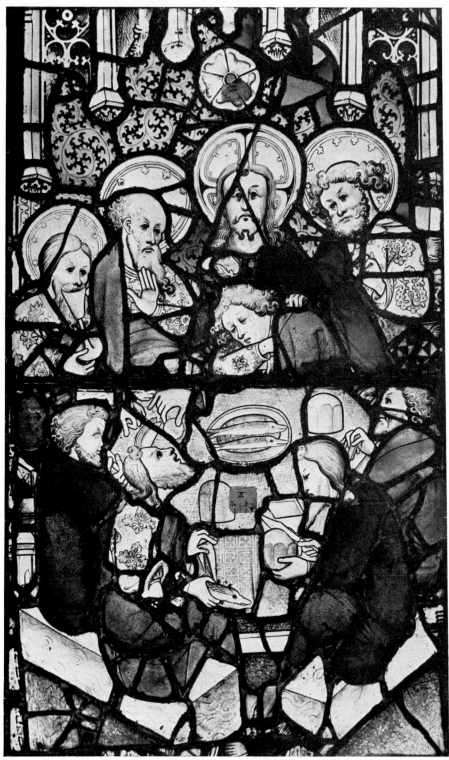

York School (?): Last Supper, from Stained Glass Window. *c.* 1430–40.
Detail 4 ft 6 in. by 2 ft 6 in. *East Window, Choir, Priory Church, Gt Malvern*

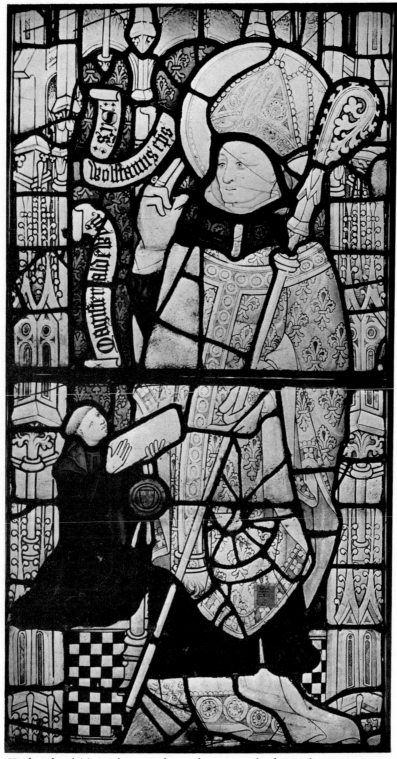

York School (?): Bishop Wulstan, from Founders' Window. *c.* 1460–70.
Detail 7 ft 6 in. by 2 ft 6 in. *North Clerestory, Choir, Priory Church, Gt Malvern*

199

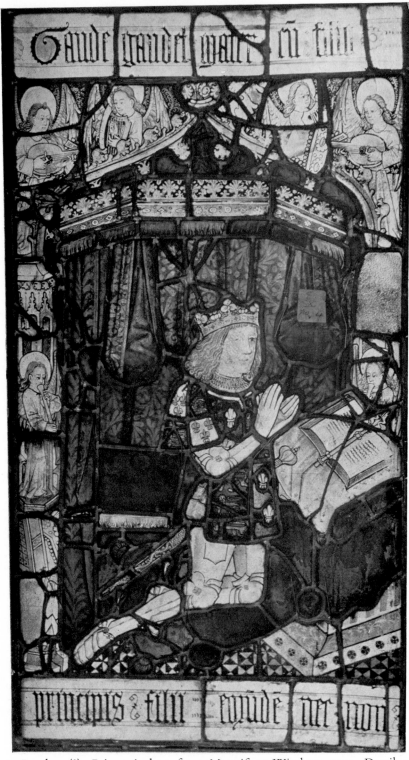

London (?): Prince Arthur, from Magnificat Window. 1501. Detail
4 ft 2 in. by 2 ft. *North Transept, Priory Church, Gt Malvern*

GENERAL INDEX

Numbers in italics refer to plates. Only the more important of the notes are indexed: in such cases the page on which the note appears, and the number of the note, are given, thus: 247[63]. Manuscripts are indexed, by their location, in the separate Index of Manuscripts which follows this index: the popular names of manuscripts which are mentioned in the text are included in this index, with a cross-reference to the location and number under which they will be found in the Index of Manuscripts.

A

Abingdon (Berks), St Helen, 163, 247[63]; *163*

Abingdon Apocalypse, *see* London, British Museum, MS. Add. 42555

Abingdon Missal, *see* Oxford, Bodleian Library, MS. Digby 227, and Oxford, Trinity College, MS. 75

Acanthus ornament, 6, 19, 29, 30, 33, 35, 36, 37, 58, 167, 176, 182, 201, 202, 220[10], 221[18], 222[32]

Ada School, 21, 22, 23, 31, 32, 37, 46

Adrian V (Pope), tomb of, 117

Ælfgyfu, 27, 42; *37a*

Ælfleda, 27, 221[11]

Ælfric, *Metrical Paraphrase of Pentateuch and Joshua*, *see* London, British Museum, Cotton MS. Claudius B.iv

Ælfwin, 42, 225[80]

Ælfwius, 226[17]

Æthelgar, Archbishop, 223[48]

Æthelred the Unready, 27

Æthelstan, 24, 27, 29, 30, 31; *20a*; Psalter of, *see* London, British Museum, Cotton MS. Galba A.xviii and Oxford, Bodleian Library, MS. Rawl. B.484

Æthelwold, 28, 35, 36, 38, 222[40]

Æthelwold, Benedictional of, *see* London, British Museum, MS. Add. 49598

Æthelwulf, 27

Agincourt, Battle of, 248[78]

Aidan, St, 9, 10, 216[24]

Ailred, St, 61

Alban, St, *111a, 194*

Alban and Amphibalus, SS., Lives of (M. Paris), *see* Dublin, Trinity College, MS. E.1.40

Albani (St Albans) Psalter, *see* Hildesheim, Library of St Godehard

Aldhelm, St, 10; *38*; *De Laude Virginitatis*, *see* London, British Museum, MS. Roy. 5 F. iii; London, Lambeth Palace Library, MS. 200

Alexis Master, 65–6, 229[21,25a,30]

Alfonso, Prince, 124

Alfonso Psalter, *see* London, British Museum, MS. Add. 24686

Alfred, King, 27, 28, 29

Alfred Jewel, 29

Alphege, 223[50]

Altichiero, 150

Amalekite Master (Winchester Bible), 81, 82, 84, 87; *84b*

Amesbury Abbey, 98, 99, 235[60]

Amiatinus, Codex, *see* Florence, Biblioteca Laurenziana

Amos (Bury Bible), 70–1, 74–5; *69a*

Angelic Hierarchy, 187–8, 250[20]

Anglo-Saxon Chronicle, 27

Anglo-Saxon style, 6–7, 18 ff., 28 ff.; and Irish, distinguished, 26, 200–1, 202

Animal ornament, 11, 19, 20, 22, 23–4, 25, 30, 200, 220[4]; on embroidery, 138; *see also* Birds, biting; Grotesques, animal; Lacertines

Anketil (metalworker), 229[25a]

Anne of Bohemia, 146, 147, 152

Annunciation (Beaufort Hours), 156–7, 167; *172*

Anselm, St, 47

Apocalypse: manuscripts, 110 ff., 237[83]; paintings: Clayton, 76; Kempley, 76–7; Westminster Chapter House, 147, 162–3, 246[59-61]; *156*; *see also* Cambridge, Trinity College Library, MSS B.10.2, R.16.2; Dublin, Trinity College Library, MS. K.4.31; Eton College, MS. 177; Lisbon, Gulbenkian Collection; London, British Museum, MSS Add. 42555, Roy. 15 D. ii, Roy. 19 B. xv; London, Lambeth Palace Library, MSS 209, 434; Malvern, Dyson Perrins Collection (former), MS. 10; New York, Pierpont Morgan Library, MS. 524; Oxford, Bodleian Library, MSS Auct. D.4.17, Douce 180; Paris, Bibliothèque Nationale, MS. fr. 403

Apocrypha Drawings, Master of the (Winchester Bible), 80, 81, 84, 231[70]; *83a*

Aquitaine, 77, 230[49]

Aratus, *see* London, British Museum, MSS Harl. 647, 2506

Ardagh Chalice, 215[7]

Armagh, Book of, *see* Dublin, Trinity College Library, MS. 52

Arnolfo di Cambio, 117

Arras, St-Vaast, 227[21]

Arthur, Prince, 195; *200*

Arundel, Thomas, Archbishop of Canterbury, 146, 153

Arundel Psalters, *see* London, British Museum, MSS Arundel 60, 155

H

I

INDEX OF MANUSCRIPTS

Numbers in italics refer to plates. Only the more important of the notes are indexed: in such cases the page on which the note appears, and the number of the note, are given, thus: 247[65]. Manuscripts frequently referred to by specific names are entered under their classification numbers in the collections that contain them: cross-references from the names will be found in the General Index.